THE UGLY RENAISSANCE

ALSO BY ALEXANDER LEE

The End of Politics: Triangulation, Realignment, and the Battle for the Centre Ground (with T. R. Stanley)

Renaissance? Perceptions of Continuity and Discontinuity in Europe, c. 1300–c. 1550 (ed. with P. Péporté and H. Schnitker)

Petrarch and St. Augustine: Classical Scholarship, Christian Theology, and the Origins of the Renaissance in Italy

THE UGLY RENAISSANCE

Sex, Greed, Violence and Depravity in an Age of Beauty

Alexander Lee

DOUBLEDAY New York London Toronto Sydney Auckland

Copyright © 2013 by Alexander Lee

All rights reserved. Published in the United States by Doubleday, a division of Random House LLC, New York, and in Canada by Random House of Canada Limited, Toronto, Penguin Random House companies. Originally published in Great Britain by Hutchinson, a division of the Random House Group Limited, London, in 2013.

www.doubleday.com

DOUBLEDAY and the portrayal of an anchor with a dolphin are registered trademarks of Random House LLC.

Book design by Michael Collica Jacket design by John Fontana Front-of-jacket painting: Last Judgement, detail of Saint Bartholomew by Michelangelo/Scala/Art Resource, NY

Library of Congress Cataloging-in-Publication Data Lee, Alexander (Historian) The ugly Renaissance / Alexander Lee. — First American edition. pages cm Includes bibliographical references and index.

Renaissance—Italy. 2. Italy—Social life and customs—To 1500.
 Degeneration—Social aspects—Italy—History—To 1500.

4. Italy—Civilization—1268–1559. I. Title.

DG445.L44 2014 945'.05—dc23 2013015480

ISBN 978-0-385-53659-2 (hardcover) ISBN 978-0-385-53660-8 (eBook)

MANUFACTURED IN THE UNITED STATES OF AMERICA

13579108642

First American Edition

For

James and Robyn O'Connor

and

Pit Péporté and Marian van der Meulen with much love and best wishes for their future together

CONTENTS

Flore	mce cd 1401	ix	
Florence, ca. 1491			
Author's Note			
Intro	duction: Between Heaven and Earth	I	
	I THE WORLD OF THE RENAISSANCE ARTIST		
Ι.	Michelangelo's Nose	9	
2.	In Peter's Shadow	21	
3.	What David Saw	43	
4.	The Workshop of the World	69	
5.	Michelangelo in Love	110	
	II THE WORLD OF THE RENAISSANCE PATRON		
6.	The Art of Power	145	
7.	The Men with the Midas Touch	163	
8.	Mercenaries and Madmen	203	
9.	The Unholy City	234	
	III THE RENAISSANCE AND THE WORLD		
10.	Filippo and the Pirates	279	
11.	Salomone's Crime	291	
12.	The Rising Crescent	309	
13.	Of Human Bondage	323	
14.	Brave New Worlds	337	
	Epilogue: The Window and the Mirror	351	

Contents

APPENDIXES

A	The Medici		355
В	Renaissance Popes		356
	Acknowledgments		358
	Notes		360
	Bibliography		398
	Illustration Credits		415
	Index		417

viii

FLORENCE, CA. 1491

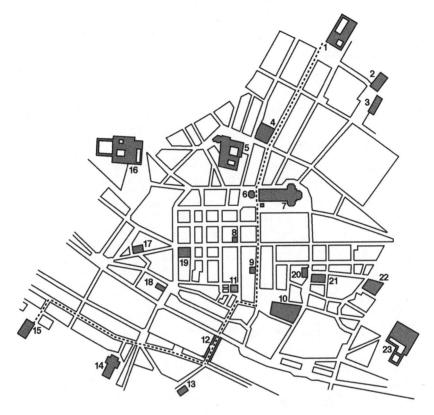

N.B.: MICHELANGELO'S ROUTE IS MARKED AS DOTTED LINE.

- 1. San Marco
- 2. Santissima Annunziata
- 3. Ospedale degli Innocenti
- 4. Palazzo Medici Riccardi
- 5. San Lorenzo
- 6. Baptistery
- 7. Duomo (Santa Maria del Fiore)
- 8. Mercato Vecchio
- 9. Orsanmichele
- 10. Palazzo Vecchio
- 11. Mercato Nuovo
- 12. Ponte Vecchio

- 13. Palazzo Pitti
- 14. Santo Spirito
- 15. Santa Maria del Carmine
- 16. Santa Maria Novella
- 17. Palazzo Rucellai
- 18. Santa Trinita
- 19. Palazzo Strozzi
- 20. Badia
- 21. Bargello
- 22. Stinche
- 23. Santa Croce

AUTHOR'S NOTE

It is necessary to address a few questions of method.

First, a note on geography. This book concentrates exclusively and unashamedly on the Renaissance in "Italy," and I am conscious that this geographical focus may be subject to some reasonable question. There was, after all, no Italy before 1871, and though humanists such as Petrarch did have a certain concept of what "Italy" meant, the notion was fairly amorphous. On the one hand, boundaries of any kind-least of all the hard-and-fast borders beloved of modern political debatesimply did not exist, and that which contemporaries might have thought Italian in some vague way quickly shaded off into other species of identity, particularly in places like Naples, Trent, and Genoa. On the other hand, even within those territories that might be defined as certainly "Italian," the existence of dialects (there was, after all, no such thing as the Italian language yet), independent statelets, and strong local loyalties makes any geographical generalizations somewhat dangerous. This is particularly true when it comes to the great North/South divide, a division that is so intense it continues to dominate Italian political debate today but is no less troublesome when applied even to the states of early Renaissance Tuscany, for example. Yet despite these reservations, it is possible to talk of "Italy" in relation to the Renaissance with some degree of useful meaning. As scholars have readily acknowledged, the cultural developments that occurred in the Italian peninsula (broadly conceived) between ca. 1300 and ca. 1550 do indeed seem to have certain common features that stand apart from the culture of the rest of Europe and that justify talk of "Italy" in this context. I cannot help but suspect that Renaissance humanists of Petrarch's stripe might have approved, if not on scholarly grounds, then at least for emotive reasons.

Having set out my "Italian" stall, I must point out that this book

focuses most heavily on two or three major cities-that is, Florence, Rome, and (to a lesser extent) Urbino. This is not to say that other centers do not get a look in. Venice, Milan, Bergamo, Genoa, Naples, Ferrara, Mantua, and a whole host of other cities all appear in the narrative where appropriate, and it would certainly not be accurate to pretend that the Renaissance did not touch every single town and city in Italy to one extent or another. But the focus on Florence, Rome, and Urbino-with a particular accent on Florence-is, I think, justified on two main grounds. First, Florence constitutes the historical and spiritual "home" of the Renaissance as a whole. Both contemporaries and modern historians have generally agreed that it was in Florence that the "Renaissance"-however we might wish to define it-began and grew to maturity. In their different ways, and to very different degrees, Rome and Urbino constituted major focal points for artistic and literary endeavor, albeit at a later stage. Second, any narrative has to have some measure of order, and a completely comprehensive study that showed no more favor to one city than another would be both inaccurate and unwieldy.

Second, a note on chronology. Anyone with even a passing knowledge of the subject of this book will be aware of how enormously difficult it is to put dates on the Renaissance. Given how very troublesome it has proved to define what the Renaissance actually was, it is perhaps unsurprising that historians have agonized not only over where the termini of the period lie but also over whether it is useful to think of it in terms of a "period" (in the true sense) at all. The chronological bounds I have chosen to use for this book-that is, the years between ca. 1300 and ca. 1550—are not intended to be either authoritative or definitive, but instead reflect the general sense of scholarly consensus and are meant simply to give a measure of structure to what is already a complex enough series of phenomena. I will not deny that such vagueness is rather ugly, but since it is something that all Renaissance historians have to deal with at some stage, I can't help but feel it is just one more example of why the "ugly" Renaissance is with us all in one way or another

THE UGLY RENAISSANCE

Between Heaven and Earth

GIOVANNI PICO DELLA Mirandola (1463-94) lived deep and sucked all the marrow out of life. There was nothing that did not interest and excite him. Having mastered Latin and Greek at an unfeasibly young age, he went on to study Hebrew and Arabic in Padua while still in the first flower of youth and became an expert on Aristotelian philosophy, canon law, and the mysteries of the Kabbalah before he was out of his twenties. Surrounded by the art of Brunelleschi, Donatello, and Piero della Francesca in Florence and Ferrara, he became a close friend of many of the most glittering stars of his day. A cousin of the poet Matteo Maria Boiardo, he was an intimate acquaintance of the enormously wealthy litterateur Lorenzo de' Medici, the classical scholar Angelo Poliziano, the Neoplatonic trailblazer Marsilio Ficino, and the firebrand preacher Girolamo Savonarola. He was, moreover, a writer and a thinker of breathtaking originality. Quite apart from penning a multitude of charming verses, he dreamed of uniting all the various branches of philosophy into a single, inspiring whole and longed to bring the religions of the world together.

In many senses, Pico is the paradigmatic example of the Renaissance man. In the course of his brief life, he captured the essence of a period in Italian history—covering the years ca. 1300–ca. 1550—that is commonly perceived as having been defined by an unparalleled explosion of cultural inventiveness and dominated by artistic and intellectual brilliance. A true *uomo universale* (universal man), he seems to have looked on the world with an unbounded sense of curiosity and excitement, and appears to have drawn on the art and literature of classical antiquity with every bit as much enthusiasm as he sought to craft a new and more glittering future for mankind that was filled with boundless hope and possibility. He conversed with artists who seemed to be reaching for

the stars, he mingled with rich and powerful patrons who seemed to live for art and culture, and he hungrily sought out new knowledge from different cultures and peoples.

It is perhaps no surprise that Pico's greatest work—the Oration on the Dignity of Man (1486)—has come to be seen as the unofficial manifesto of the Renaissance as a whole. A succinct summary of Pico's entire philosophical project, it had at its heart an unquenchable belief in man's potential. "I have read in the records of the Arabians," he began,

that Abdala the Saracen, when questioned as to what on this stage of the world, as it were, could be seen most worthy of wonder, replied: "There is nothing to be seen more wonderful than man." In agreement with this opinion is the saying of Hermes Trismegistus: "A great miracle, Asclepius, is man."

Man, Pico believed, was indeed a miracle. In his eyes, mankind possessed a unique capacity for reaching beyond the bounds of this earth and ascending to something altogether higher, better, and more extraordinary, through poetry, literature, philosophy, and art.

When one stands in any of the great centers of the Renaissance, it is hard not to be seduced by the feeling that Pico captured the spirit of the age with unusual precision. In Florence alone, the artworks that have come to be so indelibly associated with the period seem to testify to a truly miraculous flowering of the human soul. Michelangelo's *David*, Brunelleschi's dome, Botticelli's *Birth of Venus*, and Masaccio's *Trinity* all appear to suggest that life was touched with beauty, that patrons and artists aspired to something more than the petty concerns of everyday existence, and that the horizons of the imagination were becoming broader and more exciting with every passing day. Indeed, so intense is the sense of wonder that such works are inclined to inspire that it is sometimes difficult not to believe that their creators were not somehow *more* than merely human. So removed do they seem from worldly trivialities that they are apt to appear rather forbidding, almost godlike. "Miraculous" is certainly the word that often springs to mind.

Yet if Giovanni Pico della Mirandola's *Oration on the Dignity of Man* offers a neat summary of the luster that the Renaissance has accrued in the popular imagination, his life also contained a hint that something else was at play in this most remarkable of periods. Although Pico had

his head in the clouds, he was also a man with visceral urges and a fondness for the seamier side of life. Not only was he arrested on suspicion of heresy following his forays into religious syncretism, but he also got himself embroiled in a host of rather sticky situations as a result of his unquenchable lust. Shortly after his first visit to Florence, he seduced the wife of one of Lorenzo de' Medici's cousins, and, after being caught trying to elope with the love-struck woman, was horribly wounded and thrown into jail for a while. No sooner had he recovered than he leaped into something new, albeit of a rather different character. Finding that they had more than a little in common, Pico began a passionate friendship with Angelo Poliziano that blossomed into a smoldering sexual relationship. Even after they were poisoned—perhaps on the orders of Piero de' Medici—the bond between them was commemorated by their being buried side by side in the church of San Marco, despite the Church's strict injunctions against homosexuality.

At first glance, this seems to jar somewhat with Pico's image of man as a miraculous source of wonder and to compromise his own prestige as the archetypal Renaissance man. Yet all is not what it seems. Buried within the *Oration on the Dignity of Man*, Pico offered an insight that explained both his otherworldly sophistication and his all-too-earthy desires.

Only a little way into his discourse, Pico pictured God addressing His creation with an unusual frankness. At first, the divinity's words seem to reinforce Pico's belief in humanity's extraordinary capacities. Although "the nature of all other beings is limited and constrained" by divine law, God tells man,

you, constrained by no limits, in accordance with your own free will, in whose hand We have placed you, shall ordain for yourself the limits of your nature. We have set you at the world's center that you may from thence more easily observe whatever is in the world. We have made you neither of heaven nor of earth, neither mortal nor immortal, so that with freedom of choice and with honor, as though the maker and molder of yourself, you may fashion yourself in whatever shape you shall prefer.

But just at the moment when He seems to exalt mankind most fully, Pico's God turns this gift of free will into the core of a potent para-

dox. Rather than preordaining Renaissance man to untrammeled glory, God informs him:

You shall have the power to degenerate into the lower forms of life, which are brutish [and] you shall have the power, out of your soul's judgment, to be reborn into the higher forms, which are divine.

Although man did indeed have the capacity to ascend to the heights of heavenly beauty—Pico seems to suggest—he was also capable of plumbing the ugly depths of depravity. In fact, the two sides of human nature were closely interrelated. Angels and demons lived side by side in man's soul, locked in a strangely captivating symbiotic relationship. It was impossible to reach for the stars unless you also had feet of clay.

In this, Pico not only explained the apparent contradictions of his own character but also expressed a vital truth about the Renaissance more generally. However tempting it may be to succumb to the temptation of viewing it as a period of cultural rebirth and artistic beauty during which men and women were impossibly civilized and sophisticated, the achievements of the Renaissance coexisted with dark, dirty, and even diabolical realities. Corrupt bankers, greedy politicians, sexcrazed priests, religious conflict, rampant disease, and lives of extravagance and excess were everywhere to be seen, and the most ghastly atrocities were perpetrated under the gaze of the statues and buildings that tourists today admire with such openmouthed adoration. Indeed, as Pico himself exemplified, it would have been all but impossible for the greatest monuments of the Renaissance to have come into being had its foremost artists, writers, and philosophers not been mired in every kind of depravity and degradation. The one depended upon the other. If the Renaissance was an age of cultural angels, it was also a period of worldly demons.

Yet precisely because it is so very easy to be seduced by the beauty and elegance of the art and literature of the Renaissance, the uglier side of the period is all too easily forgotten and overlooked. Perhaps by virtue of the Romantic aura that surrounds its cultural achievements, the titillating private lives of its artists, the sordid concerns of its patrons, and the superabundance of intolerant hatred in its streets are regularly swept under the carpet and glossed over with the illu-

sion of unblemished perfection. At the level of historical accuracy, this tendency is unfortunate merely because it introduces a somewhat artificial separation between high culture and social realities. But at a much more human level, it is also unfortunate because it robs the period of its excitement, its vividness, and its true sense of wonder. For it is only by appreciating the seamier, grittier side of the Renaissance that the extent of its cultural achievements really becomes clear.

This book is a conscious effort to redress the balance. Looking at the hidden story behind the paintings that have come to dominate perceptions of the Renaissance in Italy, it seeks to examine anew three of the most important features of the Renaissance "story," all of which are readily apparent in the life of Pico della Mirandola, and each of which reflects a different component in the creation of the art and culture of the age. Examining the brutal social universe of artists, the dastardly concerns of their patrons, and the unexpected prejudices that accompanied the "discovery of the world," it shows that the Renaissance was much "uglier" than anyone might like to admit and—for precisely that reason—all the more impressive. And by the end of the journey, the Renaissance will not just appear to have been populated by angels and demons; it will never seem the same again.

PART ONE

THE WORLD OF THE Renaissance Artist

MICHELANGELO'S NOSE

I

N A FINE summer's afternoon in 1491, the sixteen-year-old Michelangelo Buonarroti was sitting sketching in the church of Santa Maria del Carmine in Florence. With a stick of chalk between his fingers and a sheaf of paper on his knees, he was busy copying Masaccio's celebrated frescoes in the Brancacci Chapel with "such judgement" that all those who saw his drawings were astonished.

Even as an adolescent, Michelangelo had begun to grow used to such admiration. Despite his youth, he had already earned a degree of celebrity and had acquired a correspondingly high opinion of himself. Carrying a letter of recommendation from the artist Domenico Ghirlandaio, he had not only been accepted as a pupil of the sculptor Bertoldo di Giovanni at the artistic school that had recently been founded in the gardens of San Marco, but had even been welcomed into the household of Lorenzo de' Medici, Florence's de facto ruler. Enraptured by the young man, Lorenzo had ushered Michelangelo into the company of the city's foremost intellectuals, including the humanists Angelo Poliziano, Marsilio Ficino, and Pico della Mirandola. Michelangelo flourished. He nurtured those skills that were to characterize the art of the period. Studying anatomy with extreme care, he honed the naturalistic style that had been in continuous development since the innovations of Giotto di Bondone, two centuries earlier. And devoting himself to the emulation of classical sculpture, he set out on the path that later led Giorgio Vasari to claim that he had "surpassed and vanquished the ancients." Following a suggestion made by Poliziano in this period, he carved a relief depicting the battle of the centaurs that was "so beautiful" it seemed to be "the work not of a young man, but of a great master with a wealth of study and experience behind him."

Michelangelo's fame and self-confidence were growing by the day, but as he was about to discover, so was the envy of his schoolfellows. Sitting next to him in the Brancacci Chapel that day was Pietro Torrigiano. Although three years older than Michelangelo, Pietro was another of Bertoldo di Giovanni's pupils and was also recognized as something of a rising star. Competition between the two was almost inevitable. Under Bertoldo's tutelage, they had been encouraged to compete, and they strove to outdo each other in imitating and surpassing the works of masters like Masaccio. Michelangelo was, however, too brilliant and outspoken for the rivalry to be entirely friendly.

As they sketched alongside one another in the chapel, Michelangelo and Pietro appear to have begun discussing who was better placed to take up Masaccio's mantle as Florence's finest painter. Given their surroundings, it was a natural subject. Despite being acclaimed as an artist of genius in his own lifetime, Masaccio had died before he could complete the frescoes in the chapel. His work had been completed by Filippino Lippi, although how successfully was a matter of personal opinion. Perhaps Michelangelo, who had spent many months studying the frescoes, observed that Lippi had been unable to match Masaccio's talent and that he himself was the only person capable of attaining—if not exceeding— the master's standards. He may simply have spoken derisively of Pietro's sketches, as was apparently his habit. Whatever the case, Michelangelo managed to enrage his friend. Talented but hardly brilliant, Pietro couldn't stand Michelangelo's ribbing.

"Jealous [at] seeing him more honoured than himself and more able in his work," Pietro began mocking Michelangelo. If his behavior in later years is anything to go by, Michelangelo might simply have laughed. Whatever the case, Pietro was furious. Clenching his fists, he punched Michelangelo squarely in the face. The blow was so hard that it "almost tore off the cartilage of [the] nose." Michelangelo slumped unconscious to the floor, his nose "broken and crushed" and his torso covered with blood.

Michelangelo was hurriedly carried back to his home in the Palazzo Medici Riccardi, where he is said to have been lying "as if dead." It did not take Lorenzo de' Medici long to learn of his plight. Storming into the room in which his stricken protégé lay, he flew into a towering rage and hurled every imaginable insult at the "bestial" Pietro. At once, Pietro saw the magnitude of his mistake: he had no option but to leave Florence. * * *

Unwittingly, the barely conscious Michelangelo was caught up in a moment that captured perfectly an important dimension of the world of late Renaissance art and that represented the fulfillment of what has become known as the "rise of the artist." Although he was only sixteen years old, he had already begun to hone that unique combination of talents that contemporaries would later describe as "divine." Skilled in sculpture and drawing, he was also devoted to Dante, learned in the Italian classics, a fine poet, and a friend to the finest humanist minds. Without any sense of irony intended, he was what we might now call a Renaissance man. What's more, he was recognized as such. Despite his age, Michelangelo had been feted by Florence's social and intellectual elite, and his ability had been honored with patronage and respect. The son of a comparatively modest bureaucrat from an obscure little town, he had earned the affection of the most powerful family in Florence because of his artistic skill. Lorenzo "the Magnificent"-himself a noted poet, connoisseur, and collector-treated him "like a son." Indeed, Lorenzo's son Giovanni and Giovanni's illegitimate cousin Giulio-each of whom would later become pope (as Leo X and Clement VII, respectively)—would address him as their "brother" ever after.

Two hundred years earlier, it would have been unthinkable for any artist to have been honored in such a way. In the eyes of most contemporaries, a late-thirteenth- or early-fourteenth-century artist was not a creator but a craftsman. The practitioner of a merely mechanical art, he was largely restricted to the confines of a provincial *bottega* (workshop) that was subject to the often draconian regulations of guilds.

Regardless of his ability, the artist's social status was not high. Although some early Renaissance artists occasionally occupied positions in communal government or came from magnate families, they were the exceptions rather than the rule. Most came from fairly humble backgrounds, as can be gauged from how little we know about their parents. Later biographers, like the snobbish Vasari, often skip over such details, and their silence suggests that carpenters, innkeepers, farmers, and even unskilled laborers may have sired some of the great names of early Renaissance art. What evidence we have seems to confirm this impression. Some artists were from very modest backgrounds and came from families engaged in the lowliest crafts. Giotto di Bondone, for example, was rumored to have been raised as a poor shepherd boy but was most probably the son of a Florentine blacksmith. For others, art—like carpentry—was a family business. Three of Duccio di Buoninsegna's sons became painters, and Simone Martini's brother and two brothers-in-law were all artists.

From the mid-fourteenth century onward, however, the social world of art and the artist had gradually undergone a series of radical changes. In step with the growing popularity of classical themes and the naturalistic style, artists were progressively recognized as autonomous creative agents endowed with learning and skill that set them apart from mere mechanics. When Giotto was made *capomaestro* of the Duomo in 1334, the priors of Florence acknowledged not only his fame but also his "knowledge and learning," terms that clearly distinguished the artist from mere craftsmen. Similarly, writing in his *De origine civitatis Florentiae et eiusdem famosis civibus* (ca. 1380–81), the Florentine chronicler Filippo Villani felt able to compare painters not with mere mechanics but with the masters of the liberal arts.

Although still reliant on the favor of patrons and bound by contractual agreements, painters and sculptors had seen their social position improve dramatically by the mid-fifteenth century. With art coming to be seen as a status symbol, artists themselves attained a higher status. Now it was not merely those from families of craftsmen who became artists. Although some continued to come from humble stock-such as Andrea Mantegna (1431-1506)—artists were increasingly the sons (and, in very rare cases, the daughters) of skilled tradesmen, affluent merchants, and well-educated notaries. Even those who could lay claim to noble origins-such as Michelangelo-could take up the brush or chisel without undue shame. Their social standing was measured not against their birth but against their ability. They could treat with their patrons on the basis of mutual respect, if not always with perfect equality. And their achievements could be celebrated by historians like Vasari in a manner previously reserved only for statesmen. Indeed, so high had artists risen that Pope Paul III is reported to have remarked that artists like Benvenuto Cellini (1500–71) should "not be subjected to the law."

But if Michelangelo embodied both the stylistic transformations and the social changes that had come to characterize the art of the period, he also exemplified another important dimension of the life of the Renaissance artist. Though the "rise of the artist" had improved both the esteem in which the visual arts were held and the social status of artists, it had not elevated artists themselves to a higher and more refined plane of existence. Artists like Michelangelo still had feet of clay. He had, after all, just had his nose broken in a childish brawl prompted by envy and exacerbated by arrogant boasting.

It was typical of his life. Entirely at home in the reception rooms of the mighty, he could be kind, sensitive, courteous, and funny. But he was also proud, touchy, scornful, and sharp-tongued. He was a frequenter of inns and no stranger to fights. Indeed, despite being a friend to popes and princes, he was no refined gentleman. As his biographer Paolo Giovio recorded, he was notoriously slovenly in his appearance and seemed almost to rejoice in living in the most squalid conditions. Scarcely ever changing his clothes, he was constantly accompanied by the noxious smell of the unwashed and seldom, if ever, combed his hair or cut his beard. He was a man of undoubted piety, but his passionate nature inclined him toward relations with both sexes. Although he later enjoyed a long and apparently romantic relationship with Vittoria Colonna, marchesa of Pescara, his surviving poems also address homoerotic themes. One of the many poems addressed to Tommaso de' Cavalieri, for example, begins with a striking and faintly blasphemous verse:

Here in your lovely face I see, my lord, what in this life no words could ever tell; with that, although still clothed in flesh, my soul has often already risen up to God.

As arrogant as he was talented, he was a dirty, disorganized, and tormented individual who was as easily embroiled in fights as he was bound to the will of popes, and as susceptible to Neoplatonic homoeroticism as he was to the reassurances of the Church and the blandishments of a cultured and elegant lady.

Michelangelo was not unusual in this respect. A devotee of illicit magic, Leonardo da Vinci was accused of sodomizing a well-known gigolo named Jacopo Saltarelli on April 9, 1476. Benvenuto Cellini was convicted of the same offense twice (in 1523 and 1557) and was only narrowly saved from a lengthy prison sentence thanks to the interven-

tion of the Medici; on top of this, he killed at least two men and was also accused of stealing the papal jewels. So, too, Francesco Petrarca (Petrarch)—often described as the father of Renaissance humanism fathered at least two children while in minor orders, and the music of the aristocratic composer Carlo Gesualdo reached its most sublime heights only after he had murdered his wife, her lover, and possibly also his son.

When its implications are unpacked, therefore, Michelangelo's broken nose appears to present something of a challenge. Superficially, it seems difficult to reconcile the idea of Michelangelo as the paradigmatically "Renaissance" artist with the image of Michelangelo the cocky and arrogant kid fighting in church. There is no doubt that these represent two sides of the same man, but the question is, how should the peculiar and apparently contradictory nature of Michelangelo's character be understood? How could the same personality create such innovative, elevated art and indulge such base habits? How, indeed, can Michelangelo's broken nose be reconciled with familiar conceptions of the Renaissance itself?

THE RENAISSANCE PROBLEM

The problem lies not with Michelangelo and his nose but with how the Renaissance itself is viewed. This might seem rather surprising at first. The word "Renaissance" has become such a commonplace that its meaning might appear obvious, even self-evident. Imaginatively linked with a time of cultural rebirth and artistic beauty, the very term "Renaissance" conjures up images of the rarefied world of the Sistine Chapel, Brunelleschi's dome, the Grand Canal, and the *Mona Lisa* and visions of artists like Giotto, Leonardo, and Botticelli.

Despite its familiarity, however, the word "Renaissance" is a very slippery term. Since the very beginnings of modern critical scholarship, historians have agonized over how best to understand this "rebirth," particularly with respect to the visual arts. A whole variety of different interpretations have emerged over the years, each of which speaks to a different aspect of our snapshot of the young Michelangelo.

For some, the defining characteristic of Renaissance art from Giotto to Michelangelo lies in a pronounced sense of individualism. While the Middle Ages could be thought of as a period in which human consciousness "lay dreaming or half awake beneath a common veil" of "faith, illusion, and childish prepossession," the great Swiss historian Jacob Burckhardt argued that the Renaissance was a time in which, for the first time, "man became a spiritual *individual*," capable of defining himself in terms of his own unique excellence, free from the constraints of the corporation or community. Although Burckhardt's words are heavily colored by the now-unfashionable spirit of nineteenth-century Romanticism, this interpretation has proved remarkably enduring. Even though more recent scholars have placed greater emphasis on the social contexts of artistic production (workshop, guild, and so on) than Burckhardt, Stephen Greenblatt has recast the essence of his argument in terms of the Renaissance capacity for "self-fashioning" and has thus not only demonstrated the continuing attraction of Burckhardt's reading but has also given renewed impetus to his understanding of the character of the Renaissance artist.

For other scholars, the distinctiveness of the "Renaissance" is to be found in the achievement of a greater naturalism in the arts. Proponents of this view need only point crudely to a comparison between the figures in Michelangelo's youthful *Battle of the Centaurs*, for example, and the facades of Chartres Cathedral to underscore the attractiveness and force of the definition. Within this interpretation, the elaboration of a complete theoretical understanding of linear perspective—the mathematical and practical expression of which was pioneered most especially by Lorenzo Ghiberti and Filippo Brunelleschi—represented a decisive change not only in the techniques of painting but also in the manner of sculpture.

For others still, the "Renaissance" consists in what is thought to have been a new interest in ornamentation, embellishment, and decoration. This explosion of enthusiasm for visual exuberance and overelaboration was, it is claimed, the framework within which both individualism and linear perspective emerged.

Yet by far the most important and influential school of thought views the "Renaissance" as a far more literal and even straightforward form of "rebirth" and presents all other developments—individualism, naturalism, exuberance—as the prelude to or corollary of the comprehensive rediscovery of classical themes, models, and motifs that appears to be evidenced by the artful trickery of the young Michelangelo's lost *Head of a Faun.* As one might expect from a cursory glance at Michelangelo's close links with the circle of humanists that gathered around Lorenzo de' Medici, this interpretation presupposes a close—and even incestuous—relationship between the visual arts and the literary culture of the humanists.

In that it relates most clearly to the literal meaning of the word "Renaissance" and seems to encompass so much that could be described as characteristic of the period, this interpretation is understandably the most attractive. Yet insofar as Michelangelo's crushed proboscis is concerned, this is exactly where the problems begin.

As a number of eminent scholars have observed, one of the merits of this interpretation of the Renaissance is that it is precisely how the leading intellectuals of the Renaissance saw their own times. The self-conscious writings of "the artistically-minded humanists and the humanistically-minded artists of the fourteenth, fifteenth, and sixteenth centuries" appear to betray a clear and unambiguous sense of living in a new period defined by the revival of the culture of classical antiquity.

The origins of this self-conscious sense of cultural rebirth can perhaps be traced back to the very beginning of the fourteenth century. While Dante Alighieri celebrated the renown of Cimabue and Giotto in the *Purgatorio*, it rapidly became common for readers of Horace's *Ars poetica* to employ the language of "darkness" and "light" to describe what they perceived to be the parallel revival of painting and poetry. Petrarch is often thought to have inaugurated the idea of a transition from medieval "darkness" to the pure "light" of antiquity in his *Africa*, and it was for his perceived revival of classical Latinity that he was celebrated alongside Giotto as one of the two harbingers of the new age by his friend Giovanni Boccaccio.

It is, however, during the fifteenth century that Renaissance "selfconsciousness" really comes to the fore and that we see full expression being given to the sense of living in an age of classical "rebirth." The feeling of pride that accompanied the idea can be glimpsed in a letter written to Paul of Middelburg by Michelangelo's friend Marsilio Ficino in 1492:

Our Plato in *The Republic* transferred the four ages of lead, iron, silver, and gold described by poets long ago to types of men, according to their intelligence ... So if we are to call any age

Michelangelo's Nose

golden, it must certainly be our age, which has produced such a wealth of golden intellects. Evidence of this is provided by the inventions of this age. For this century, like a golden age, has restored to light the liberal arts that were almost extinct: grammar, poetry, painting, sculpture, architecture, music, the ancient singing of songs to the Orphic lyre, and all this in Florence.

Ficino's reference to "golden intellects" is particularly important. Throughout the Renaissance, the idea of a "golden age" relied entirely on the contention that a few "golden" individuals had "restored to light" the cultural achievements of antiquity. Ficino's sense of pride demanded the celebration of a whole pantheon of great men. Thus, some sixty years earlier, the Florentine chancellor Leonardo Bruni hailed Petrarch (at Dante's expense) as "the first person with a talent sufficient to recognize and call back to light the antique elegance of the lost and extinguished style." Not long after, Matteo Palmieri acclaimed Bruni himself as having been sent into the world "as the father and ornament of letters, the resplendent light of Latin elegance, to restore the sweetness of the Latin language to mankind." So, too, in the arts, Palmieri observed that

before Giotto, painting was dead and figure-painting was laughable. Having been restored by him, sustained by his disciples and passed on to others, painting has become a most worthy art practiced by many. Sculpture and architecture, which for a long time had been producing stupid monstrosities, have in our time revived and returned to the light, purified and perfected by many masters.

This intimate relationship between a self-conscious age of "rebirth" and the creation of a pantheon of "golden intellects" was picked up and refined yet further in the sixteenth century by Giorgio Vasari. Vasari— who coined the word *rinascita* (rebirth; Renaissance)—set himself the task of assembling a series of biographies of "the most excellent painters, sculptors, and architects" responsible for restoring the longforgotten "pristine form" of antiquity. But Vasari also went one step further. His goal was not simply to formalize a canon of great men who had created and defined an age of "rebirth" but also to fashion an ideal of the artist as hero. Although he criticized many artists for their

unpleasant or "bestial" habits (such as Piero di Cosimo), Vasari left no doubt that the truly important, heroic artist—who was in part responsible for giving shape to the new age—was the artist whose life itself was a work of art. Michelangelo—whom Vasari knew personally—was just such a man.

The implications of this sort of evidence are significant. To say that such testimonies are the bedrock of our view of the Renaissance as a whole is not to say that we trust them absolutely. Indeed, precisely because they are so effusive, the self-conscious and self-congratulatory remarks of individuals such as Bruni, Ficino, Palmieri, and Vasari automatically arouse the suspicion of any self-respecting historian. Although Erwin Panofsky adamantly defended them as self-conscious affirmations of a verifiable cultural shift, there can be little doubt that such statements were perhaps more reflective of a tendency toward rhetorical hyperbole and wishful thinking than they were indications of contemporary cultural realities.

At the same time, however, these proclamations of a new age of cultural rebirth can't be ignored altogether and are actually the best guide to the period we have. Rose tinted and propagandistic though they may be, they provide the historian with a viable working definition of the "Renaissance" that can serve as the springboard for research. Even if it is possible to question whether Petrarch actually did revive the brilliance of Cicero's Latin in quite the way that Bruni claimed, for example, the *idea* of "rebirth" can still be used as a lens through which to view (and question) his works. Similarly, even if it is accepted that Giotto's campanile lacks any clear parallels in ancient architecture, it is nevertheless possible to acknowledge that contemporaries believed they were *trying* to revive antiquity and use that goal as the yardstick against which to evaluate the art of the period.

Yet if historians have been careful to avoid trusting the words of men like Ficino and Palmieri too much, they have nevertheless continued to indulge one vital part of the Renaissance "myth" in their quest to understand the period as a whole. Although the concept of rebirth has been the subject of incessant, critical scrutiny for well over a century, the Renaissance still tends to be thought of in terms of the works and deeds of "great men." More important, even if Vasari's often lavish praise has been viewed with skepticism, it has nevertheless proved almost impossible not to succumb to his vision of the Renaissance artist as a purely cultural figure. Despite the proliferation of studies on the social and economic history of the Renaissance, for example, there is still a tendency to think of the period as a litany of "big names," as a list of "golden boys," each of whom is viewed principally—even exclusively—as an agent of cultural production.

It is not difficult to see the allure of this idea of the Renaissance or to understand why it has become so familiar. On first arriving in a city like Florence, one finds it very hard to avoid. When one stands in the Piazza della Signoria, it's easy to imagine that the Renaissance was more or less exactly as Bruni and Palmieri described it. Surrounded by the classical elegance of the Loggia dei Lanzi and the *gallerie* of the Uffizi, and with statues by Michelangelo, Donatello, and Cellini looking down on the square, one is all too tempted to think of the Renaissance as a time in which heroically talented artists revived the culture of antiquity to create both cities and societies that were themselves works of art.

But this is exactly where the paradox lies. It's not that the implication of cultural and artistic "rebirth" is necessarily useless or invalid but rather that attempts to define the Renaissance in such terms inevitably exclude more than they include. In succumbing to the "great men" myth, the familiar definition of the Renaissance tends to exclude the everyday, the visceral, the sordid, and the distasteful. It tends to abstract literature and the visual arts from ordinary existence, as if it were possible to regard them as entirely distinct spheres of existence. It overlooks the fact that even the greatest artists had mothers, got into scrapes, went to the toilet, had affairs, bought clothes, and were occasionally very unpleasant people. It ignores the fact that Michelangelo had his nose smashed in for being cocky.

The result is a one-sided and incomplete image of what was undoubtedly a rich and profoundly "human" age. It effectively misrepresents entirely consistent human beings as conflicted or paradoxical figures when their artistic achievements appear to clash with decidedly downto-earth characters. It leaves historians anxious for order and meaning with no option but to set aside whatever traits seem inconvenient usually the most ordinary. In other words, by giving way to our comfortable old view of the Renaissance, we end up accepting Michelangelo the artist but dismissing Michelangelo the man.

There is no immediate need to offer a completely new definition of the Renaissance as a whole. But if Michelangelo's broken nose illustrates anything, it shows that the Renaissance can really be understood only when it is viewed as a whole—vicious brawls and all. In order to comprehend how Michelangelo was able to create so perfect a synthesis of classical and naturalistic elements in his sculpture at the same time as he was having his nose broken in idiotic fights, it is necessary to recognize that these were two interrelated dimensions of the same, all-too-human person and that the age in which he lived was similarly composed not just of soaring cultural achievements but also of seamy, boorish, violent, and deeply unpleasant trends. Put simply, if the Renaissance is going to be understood, Michelangelo must be put back into his real-life social context, and the swirling social world that gave birth to the man *and* the artist must be brought into focus. The "Renaissance" needs to be viewed not as it is conventionally seen but as the *ugly* Renaissance it was.

* * *

Returning to the beginning, therefore, it's clear that a pause needs to be made at exactly the moment at which Pietro Torrigiano's fist crashed into Michelangelo's nose. The bloodcurdling sound of bone and cartilage cracking is an occasion to stop and reconsider. As Michelangelo is left slumping to the ground, familiar ideas of the Renaissance also begin to fall away as a search is launched for the world that made it possible for this adolescent both to scale the heights of artistic genius and to plumb the lows of public brawling. This key moment must be approached afresh by imaginatively zooming out of Santa Maria del Carmine. First, it is important to look at Florence as a whole, and uncover the sights, sounds, and smells of the streets and squares. Only then will the dramas of social life that provide the immediate context for Michelangelo's fight gradually come to light. After a survey of the dramatic history of the institutions that frame the world of Renaissance art-business, politics, and religion-the world of home life and the inner workings of everyday existence in contemporary Florence will be examined, and the surprisingly ordinary, often rather sordid, concerns that filled Michelangelo's thoughts as he embarked on his career as an artist can be reconstructed. And finally, Michelangelo's mind itself can be opened up to examine how the swirling mass of daily experiences combined with beliefs, hopes, and systems of thought to produce the intellectual framework on which his art-and his broken nose-relied.

IN PETER'S SHADOW

2

HAT SORT OF city did Michelangelo encounter before his fateful fight on that summer's day in 1491?

Although the documentary evidence for this early part of his life is comparatively sketchy, his day would certainly have started at Bertoldo di Giovanni's school in the gardens of the Piazza San Marco. Arriving there in the early morning, Michelangelo would have found it already buzzing with activity. Among the rich collection of ancient statues and the higgledy-piggledy blocks of un-carved marble sat his friends, each carving away or drawing diligently. He may have called a cheerful greeting to Francesco Granacci-who would become a lifelong companion. Paper and chalk in hand, he would have approached Bertoldo to discuss the day's work. Michelangelo made it clear that he intended to spend yet another day sketching at the Brancacci Chapel. Bertoldo-who appreciated the boy's persistence but who understood the merits of good guidance-would likely have directed him to focus his attentions not on the more celebrated scenes but on one of the more compositionally challenging episodes from the cycle. Because he was already ailing from an unknown illness that would carry him to his grave only months later, it is difficult to believe that Saint Peter Healing the Sick with His Shadow (Fig. 1) would not have been at the forefront of Bertoldo's mind as he gave his advice. And so, dutifully assenting to his teacher's counsel, Michelangelo would have set off for Santa Maria del Carmine.

Although the peregrinations of any teenager are always hard to predict, his route through Florence would certainly have taken him past some of the city's most famous landmarks. From San Marco, not far from Brunelleschi's Ospedale degli Innocenti and the Medici family church of San Lorenzo, he would have passed his home in the Palazzo Medici Riccardi, the Baptistery, and the cathedral of Santa Maria del Fiore. Farther on was the great guild church of Orsanmichele and the Piazza della Signoria. His path would have taken him through the streets of the old city, across the Ponte Vecchio, and into the depths of Oltr'Arno before he reached his destination at Santa Maria del Carmine.

In many ways, Michelangelo's journey was a voyage through the history of the Renaissance itself. The buildings he would have passed are in many senses emblematic of the artistic and architectural achievements of the period. But while they are today treated very much as artifacts to be preserved and admired in pristine condition, Michelangelo would have seen them as buildings in constant use as religious, administrative, and communal structures in a living, breathing city that was the context for the art and culture of the Renaissance. Plunging into the heart of Florence, Michelangelo trod the streets in which the cultural innovations of the period emerged, and he passed visible proofs of the different influences that had conspired to drive those changes.

After emerging as independent states following the collapse of imperial authority in the early eleventh century, the city-republics and despotisms of northern Italy had cultivated new cultural forms geared toward the celebration and preservation of autonomous self-government. The elegance of classical Latin was studied and imitated by the highly educated bureaucrats who handled the ever-increasing burden of legislation, taxation, and diplomacy. Public officials like the Florentines Coluccio Salutati and Leonardo Bruni mined the ancient classics for a rhetoric of "republicanism," while their counterparts in despotic states looked to the literature of the Roman Empire for models of illustrious princes. Particularly in the struggle to protect their independence from other states, the cities consciously fostered a sense of urban liberty. Great public buildings such as Florence's Palazzo Vecchio were constructed to reflect the grandeur of the republic and to testify to the stability and endurance of communal government. Art was commissioned for public spaces that glorified either the independence of the city-states or the brilliance of the signori (lords). Grown rich on the profits of trade, business, too, contributed. Corporative organizations, such as guilds and lay fraternities, built grand edifices, such as Ognissanti, for their trade and funded public institutions, such as the Ospedale degli Innocenti. Wanting to celebrate their riches or to atone for the sins they had incurred in acquiring their wealth, the new urban merchant elite also eagerly

patronized the arts with a view to creating their own, very public image. Richly decorated family chapels proliferated, and fine palaces sprang up in their dozens.

But Michelangelo's walk was also a figurative journey through the social influences that shaped his life as both artist and man. A city is, after all, the ultimate stage of the social dramas of everyday life and is the cradle in which the artistic dreams of the Renaissance were born. It is where artists lived, worked, and died; it is where social habits, tastes, and conventions were formed and refashioned; it is where life and art coincided, interacted, and cross-fertilized. As he passed the churches, squares, palaces, markets, government buildings, and hospitals that constituted the stage of everyday life, Michelangelo's walk mirrored the social, economic, religious, and political concerns that shaped his career as a painter and sculptor and that defined his values and priorities as a human being. The sights, sounds, and smells he would have encountered on this journey were part of the weft from which the tapestry of his life and work was woven. The urban landscape in which Michelangelo and his contemporaries worked, played, and fought was, however, much uglier than the landmarks of his journey might initially suggest.

FLORENCE AND THE ILLUSION OF THE IDEAL

Florence in 1491 was a thriving metropolis.

From a population of around thirty thousand in ca. 1350, Florence had grown to become one of Europe's largest cities. As early as 1338, as the chronicler Giovanni Villani recorded, its inhabitants consumed more than seventy thousand quarts of wine each day, and around a hundred thousand sheep, goats, and pigs had to be slaughtered each year to keep pace with the city's appetite. By the mid-sixteenth century, it boasted no fewer than fifty-nine thousand inhabitants and was rivaled in size only by Paris, Milan, Venice, and Naples.

In 1491, Florence was an economic powerhouse. Despite its superficially unfavorable location—inland and at some distance from major trade routes—the city built on close links with the papacy and the kingdom of Naples to develop powerful mercantile and banking concerns, and succeeded in all but cornering the European cloth market. As Villani explained in 1338, around thirty thousand laborers were employed in cloth making, and the industry as a whole produced 1.2 million florins' worth of cloth each year, most of it for export. In the same year, eighty banks or money-changing businesses and six hundred notaries were listed, while some three hundred citizens were recorded as being merchants who worked overseas. Although there were intermittent crises—such as the famines of the early fourteenth century, the collapse of the Bardi, Peruzzi, and Acciaiuoli banks, and the Black Death of 1348—Florence was nothing if not resilient, and its expansion into new sectors—such as the silk industry—and the growth of the Medici and Strozzi banks contributed to the continuation of the city's economic miracle.

There was no doubt that the growth of wealth and the institutions of civic government had brought benefits. On the back of the emergence of humanism and the growth of a professional bureaucracy, standards of education and literacy reached levels that were not to be matched until well into the twentieth century and that would still be regarded as exceptional in many parts of the world today. In the mid-1330s, Villani recorded that eight to ten thousand boys and girls were learning to read in the city at that time, a figure which would suggest that 67–83 percent of the population had some basic schooling. While we could be forgiven for treating Villani's estimate with some skepticism, his testimony is borne out by the evidence of the catasto (tax records). In the catasto of 1427, for example, around 80 percent of the men in the city were literate enough to complete their own returns. By the same token, serious attempts were made to provide for the poor, the sick, and the needy. Designed by Brunelleschi, the Ospedale degli Innocenti was established as a tax-exempt institution in 1495 to care for orphans and to provide facilities for needy women entering childbirth. In 1494, the city opened a hospital for victims of the plague that ensured the city would be insulated against epidemic and that provided medical care for the sick.

Money and civic confidence had also transformed Florence's urban landscape. At the same time as private wealth was being poured into the construction of buildings such as the Palazzo Medici Riccardi, a deliberate effort had been made to imitate the architecture of antiquity and to create perfect cities. Vitruvius's *De architectura*—the most complete classical treatise on building methods and design—had been rediscovered in its entirety by the Florentine Poggio Bracciolini in 1415, prompting a flurry of architects to put the ancient writer's ideas into practice and to experiment with new approaches to the design and management of urban spaces. There was a veritable fetish for the ideal. Architects, artists, and thinkers vied with one another in producing the most utopian vision of city life, a tendency that is more than evident in *The Ideal City* (Fig. 2), painted by an anonymous artist toward the end of the fifteenth century.

This fetish for the ideal was mirrored by concerted efforts to put ancient architectural theory into practice, and as the confidence of citystates like Florence grew, the revival of the classical style became a powerful expression of civic identity and pride. There was a sense among Renaissance Florentines in particular that the utopianism of *The Ideal City* had been real in many ways and that their city was truly perfect. In his *Invective Against Antonio Loschi* (1403), the Florentine chancellor Coluccio Salutati described Florence with characteristically gushing enthusiasm. "What city," he asked,

not merely in Italy, but in all the world, is more securely placed within its walls, more proud in its palazzi, more bedecked with churches, more beautiful in its architecture, more imposing in its gates, richer in piazzas, happier in its wide streets, greater in its people, more glorious in its citizenry, more inexhaustible in wealth, more fertile in its fields?

Indeed, so pronounced was this sense of pride and excitement among Florentine intellectuals that an entire genre of literature devoted to the praise of the city was quickly developed. Written at approximately the same time as Salutati's *Invective*, Leonardo Bruni's *Panegyric to the City of Florence* (1403–4) was designed to provide its citizens with an image of their city capable of filling them with republican pride and confidence and was hence even more packed with praise.

Despite having some doubts as to whether his eloquence was sufficient to describe the majesty of Florence, Bruni described the city's many merits in exhaustive detail, beginning with an ostentatiously over-the-top celebration of the city's inhabitants. But what he wished to stress above all else was the urban environment and, in doing so, he provided a wonderfully lyrical expression of the loom on which the fabric of the Renaissance was woven. "What in the whole world," Bruni asked, "is so splendid and magnificent as the architecture of Florence?" "Wherever you go," he eulogized,

you can see handsome squares and the decorated porticos of the homes of the noble families, and the streets are always thronged with crowds of men . . . Here large groups of people gather to do their business and enjoy themselves. Indeed, nothing is more pleasant.

The private houses that lined the streets—"which were designed, built, and decorated for luxury, size, respectability, and especially for magnificence"—were particularly awe inspiring, and Bruni declared that even if he had "a hundred tongues, a hundred mouths, and a voice of iron," he could "not possibly describe all the magnificence, wealth, decoration, delights, and elegance of these homes." And above all these houses, all these churches, and all this splendor loomed the imposing edifice of the Palazzo Vecchio, the center of government in Florence. Like an admiral in his flagship, the proud palazzo seemed to Bruni to stand atop the finest city in Italy, looking down approvingly at the abundance of balance, peace, and beauty below.

It was a sentiment that grew only stronger as the years went by. In his *De illustratione urbis Florentiae*, published ca. 1583, but most probably written in the last years of the fifteenth century, Ugolino Verino observed that "every traveler arriving in the city of the flower admires the marble houses and the churches textured against the sky, swearing that there is no place more beautiful in all the world." Indeed, Verino like Bruni—was acutely conscious that his abilities were insufficient for the task of describing this most awe inspiring of cities. "How can I properly describe the paved and spacious streets," he asked,

designed in such a way that the traveler's journey is impeded neither by mud when it rains nor by dust during the summer, so that his shoes are not dirtied? How can I sufficiently praise the grand temple supported by majestic columns consecrated to the Holy Ghost [Santo Spirito], or the Church of San Lorenzo erected by the pious Medici . . .? What can one say about the great Cosimo's magnificent palace, or about the four large bridges crossing the Arno, the river which runs through the city before flowing into the Tyrrhenian Sea?

It was no surprise that—as Verino's near contemporary the merchant Giovanni Rucellai reported—"many people believe that our age . . . is the most fortunate period in Florence's history" or that Verino himself could mock the ancients by claiming that their "Golden Age is inferior to the time in which we now live."

It all looks too good to be true. And the fact is that it was too good to be true. Despite the fantastic praise that Salutati, Bruni, and Verino heaped upon Florence, the visible signs of the city's wealth coexisted with—and even depended upon—conditions that spoke to a very different mode of existence and that ultimately (if indirectly) contributed toward Michelangelo's broken nose.

Regardless of its wealth, Florence continually struggled to overcome the unpleasant effects of its thriving mercantile trade. The ostentatious displays of wealth indulged by the city's merchants were frequently the object of opprobrium, not least from the Dominican friar Girolamo Savonarola, whose attacks on the rich concentrated on their luxurious palaces, extravagant clothing, and lavish private chapels. It all struck a discordant note with the standards of living experienced by the overwhelming majority of ordinary Florentines. As mercantile fortunes rose, the wages of the unskilled fell. Poverty was always around the corner. Begging was rife, and crime was endemic. Lacking any clear conception of economics as a distinct sphere of activity, the city government continually and unsuccessfully grappled with vast disparities in wealth, poor standards of living, and rampant disease. For more than two centuries, Florence was rent by political divisions and social rivalries, tormented by incessant epidemics, racked by crime, and blighted by social marginalization. And all of this was acted out in the same streets and squares that Salutati, Bruni, and Verino were so desperate to celebrate as the centerpieces of a new and ideal world and through which Michelangelo passed in 1491.

Culture, Religion, Revolution: San Marco

The location of Michelangelo's school embodied these contradictions. Large and well-appointed, the convent and church of San Marco were home to a growing community of Dominican friars and looked every inch the embodiment of the calm and studious piety that Renaissance religious life might be thought to be.

Like the nearby Dominican church of Santa Maria Novella, San Marco was the archetype of the learned cloister. After receiving the massive sum of 36,000 gold florins from Cosimo de' Medici in 1437, it had been transformed into a sanctuary of art and learning. Adorned with frescoes by the convent's own Fra Angelico, it had been graced with a magnificent new library designed by Michelozzo, which it had promptly filled with a vast collection of the choicest manuscripts money could buy. Indeed, according to Verino's De illustratione urbis Florentiae, the library of San Marco contained "so many thousands of volumes written by the Greek and Latin fathers that it could rightly be called the archives of sacred doctrine." Coupled with the school for artists that Lorenzo de' Medici had established in the gardens outside, this rich repository of learning conspired to make San Marco one of the centers of Florentine intellectual life. By 1491, it had become a key meeting place for book-loving humanists like Pico della Mirandola and Angelo Poliziano (both of whom were subsequently buried in the church) and for artists hungry to learn from the sculptures in its garden. It was no surprise that Verino thought San Marco the place "where the Muses dwell."

The church was, moreover, the site of genuine devotion. Among San Marco's most treasured possessions and greatest attractions was the Christmas cradle, which has been on display since the fifteenth century and can still be seen today. Consisting of a large number of exquisitely carved figures, it captured the imagination of contemporaries (including Domenico da Corella) and served as the centerpiece of the city's annual Epiphany celebrations. This dramatic event was a magisterial interplay of light and darkness, filled with music, costume, and the scent of incense. By cover of night, friars dressed as Magi and angels led a procession of the city's most distinguished dignitaries into the church accompanied by burning torches. The carved Christ child was then symbolically brought to the cradle, where it was ritually adored by the "Magi" before being passed around to allow the congregation to kiss its feet. The atmosphere was apparently electric. An anonymous young man who witnessed the procession in 1498 observed that "paradise was in these friaries, and [that] such spirit descended to earth that everyone burned in love."

But San Marco was also rapidly becoming a hotbed of religious extremism, political intrigue, and outright violence. In July 1491-that is, at about the time Michelangelo's nose was broken-Fra Girolamo Savonarola was elected prior of the convent. A deeply learned and powerful orator, this gaunt and self-denying man was suffused with a passion for the simplicity of what he perceived to be the true life of Christian piety and was consumed with contempt for the frivolous trappings of wealth. The Advent before his election, he had preached a series of blistering sermons that condemned usury, greed, financial deception, and the celebration of riches but reserved his most bitter scorn for precisely those whose lavishness had made San Marco so important a center of culture-the Medici. He railed against luxury, "lascivious" paintings, fine clothing, and even the poetry of those who frequented the cloister. Since he studied and worked in the shadow of San Marco, it was perhaps inevitable that Michelangelo should have joined those who crowded to hear Savonarola's sermons. Although his enthusiasm was not quite as pronounced as that of Botticelli (who briefly gave up painting under the friar's influence), he could still recall the sound of Savonarola's powerful voice years later.

It was only narrowly that Michelangelo avoided seeing San Marco's final transformation into the epicenter of religious revolution. Metamorphosing from moral campaigner into political scourge, Savonarola masterminded the overthrow of Lorenzo de' Medici's son Piero and orchestrated the establishment of a short-lived but dramatic theocratic oligarchy from the convent. It was also at San Marco that Savonarola fell. While hundreds of worshippers were at prayer on Palm Sunday 1498, an angry mob laid siege to San Marco, demanding the friar's death. The church's gates were set on fire while the besiegers surged into the cloisters and scaled the walls accompanied by the frenzied ringing of the bells. Hurling tiles from the roof and brandishing swords and crossbows, the defenders—both friars and laity alike—fought back in a bloody pitched battle that claimed dozens of lives and lasted well into the night. As with Michelangelo's nose, however, the very violence that characterized San Marco's experience on that dreadful spring night was a product of precisely the same tendencies that had led it to become such a center of Florentine learning and devotion.

Streets, Squares, and Rituals: The Via Larga to the Piazza del Duomo

The peculiar mixture of elegance and brutality, culture and suffering, becomes more pronounced as we follow Michelangelo's path deeper into the city.

Walking down the via Larga, he passed his temporary home at the Palazzo Medici Riccardi. Designed for Cosimo de' Medici by Michelozzo, it had been completed only thirty years before, and its stylishly massive structure was a visible testament to the wealth, power, and cultural clout of the young Michelangelo's patrons. The street itself was, however, a different matter. Although broad and well proportioned by contemporary standards, the via Larga was unpaved and nothing if not filthy. Even close to the Palazzo Medici Riccardi, the abundance of excrement thrown from windows, or deposited wherever people found a space, would have been hard to ignore. As Michelangelo wrote in a poem years later:

Around my door, I find huge piles of shit since those who gorge on grapes or take a purge could find no better place to void their guts in.

Despite the stink of effluence, the street thronged with people from every stratum of society, and the air buzzed with the sounds of city life. As horses and carts carrying bolts of cloth, barrels of wine, or cargoes of grain rattled noisily along, august merchants and notaries gathered to discuss business or politics in their fine black and red robes, young men in loose doublets and tight-fitting hose stood together gossiping, shopkeepers argued with customers, and priests, monks, and friars walked along with their heads bowed. Holding simple bowls or merely proffering their hands, beggars desperately called for alms, while the sick and the lame pleaded pathetically from the ground.

At the end of the crowded via Larga, the way opened out into the Piazza del Duomo. Towering above him was the dome of Santa Maria del Fiore—the largest construction of its kind since antiquity—and the imposing structure of Giotto's campanile (bell tower). In front of him stood the Baptistery—erroneously thought to have been founded as a Roman temple in antiquity—complete with the huge bronze doors that Lorenzo Ghiberti had cast for the east entrance. It was Michelangelo himself who saluted the doors as being "worthy of heaven" and thereby inadvertently dubbed them the "gates of paradise."

Yet the square, too, was filled with people, activity, and noise. With the feast of Saint John (June 24) only days away, preparations for the festival would have been in full swing. The greatest celebration in the Florentine calendar, the festival spanned several days and was always a vast exercise in civic pride. Already, workmen would have been busy erecting the huge gold-colored awning around the Baptistery that would play host to the "mostra of the riches" on the first day of the celebrations. There, beneath this colossal tent, the merchants of the city would display the very choicest of their wares: the richest jewels, the finest silks, the most exquisite garments; everything, in short, that was of the highest quality and the greatest value. It was an opportunity not for profit but for the city to revel in its own wealth, to take pride in its own enormous prosperity, and to shame those poor foreigners who happened to catch a glimpse of what was on show.

On subsequent days, the square would throng with processions. Arrayed in the most lavish and exorbitantly over-the-top vestments, hundreds of clergy would march through the city to the cathedral, accompanied by trumpeting, singing, and chanting, where they would ritually dedicate the citizenry's riches to the city and to Saint John. Then processions of the citizen-soldiers beloved of Machiavelli, "moral" laymen—mostly merchants—and confraternities would display Florence's wealth once again in glorious fashion. And finally, the communes subject to the city's rule were compelled to march to the cathedral bearing symbolic gifts of candles and silks to do ritual homage to the very masters who had spent days rubbing their noses in their wealth and magnificence.

The festival was, however, also much more human and ended with a massive communal celebration. Much like its equivalent in Siena (which is still held annually today), the *palio* was a vast horse race run through the streets of Florence. If anything, however, the Florentine *palio* was more fun than its Sienese equivalent and was more a matter of winning bets than settling neighborhood scores. Starting in the meadows near the church of Ognissanti, the liveried jockeys spurred their horses

through the city, past Michelangelo's stopping point in the Piazza del Duomo, and on to the finish line at the now mostly destroyed church of San Pier Maggiore. For most Florentines, this was the high point of the entire festival.

Although the prizes on offer were not especially impressive, men like Lorenzo de' Medici often hired professional jockeys to scoop big wins on bets riding their ultraexpensive steeds. As the horses raced through the streets, the city came alive with the shouts of the crowd, the cries of fallen riders, and the incessant chatter of betting men swapping wagers. Writing to his friend Bartolommeo Cederni, the Florentine Francesco Caccini noted that in 1454, the weather had delayed the start of the race and even caused some to talk about cancellation, but by the time the race began at 7:00 p.m., "large quantities of money and all sorts of things" were gambled on the horses. The favorite, Andrea della Stufa's horse, Leardo, led for most of the palio, accompanied by endless cheering, but Andrea fell off just short of the cathedral and came in last. There was much grumbling. As Caccini reported, "Pandolfo lost eighteen florins, Pierfrancesco and Piero de' Pazzi fifty florins Because of the rain, Matteo Rinaldi lost eighty-four florins, and so did Pierleone, along with a lot of other people." In the aftermath, the Piazza del Duomo resounded with shouts of laughter, arguments over bets, and endless singing, dancing, and drinking. By the end of the night, the Piazza del Duomo was very far from the peaceful and restrained arena for art that it has become today.

POLITICAL DRAMAS: THE PIAZZA DELLA SIGNORIA

Michelangelo's path through the Piazza del Duomo would have gone past the base of the Onestà (the city's prostitution control board) and down the via dei Calzaioli. This was the financial and commercial center of the city; here were Orsanmichele—initially a grain market, but by then a church—and the palaces of the Arte della Lana and the Arte della Seta (the wool and silk guilds), the headquarters of the guilds that controlled both trade and government for much of Florence's history. Here, the crowds would have become thicker. Drawn to the shops that lined the streets, men and women elbowed their way through the throng to get at the best products, while tradesmen haggled over prices, and guild officials argued over regulations. In streets much narrower than the via Larga, the stench and the noise of the massed bodies would have been oppressive.

Past this stretch lay the nexus of civic power: the Piazza della Signoria. This elegant and well-appointed square was the heart of Florentine political life during the Renaissance. It presented an impressive sight that appeared to chime well with the grandeur of the festivities of Saint John the Baptist. Erected between the end of the thirteenth and the beginning of the fourteenth centuries, at the time when Dante Alighieri was active in civic government, the huge, Romanesque Palazzo Vecchio (also known as the Palazzo del Popolo) dominated the piazza. The home of the city's legislative and executive organs, it was the seat of the priors-the city's highest governing body-and the gonfaloniere di giustizia, the ultimate guardian of law and order. Fortresslike and austere, it was a powerful statement of Florence's civic identity and determination to protect its liberty. Some years later, Michelangelo's David (1501–4) would stand outside its door as an allegorical affirmation of the city's resistance to external domination. Alongside the Palazzo Vecchio stood the equally impressive but lighter and airier Loggia dei Lanzi, which had been constructed between 1376 and 1382 by Benci di Cione and Simone di Francesco Talenti as a meeting place for Florence's public assemblies. Consisting of three wide bays framed by Romanesque arches, its facade includes depictions of the cardinal virtues and is a reminder of the moral rectitude and openness with which Renaissance panegyrists wished to associate the Florentine Republic.

But the grand and imposing impression conveyed by the Piazza della Signoria conceals the dramas to which it played host and gives the lie to the impression conveyed by the celebrations in the Piazza del Duomo. This very public stage was the setting for scenes of violence and brutality that illustrate the nature of the social world in which Michelangelo was raised. It was here that Savonarola was burned after the siege of San Marco and the collapse of his theocratic regime. After weeks of brutal torture in the spring of 1498, he was burned at the stake in front of the Palazzo Vecchio, and his ashes were scattered in the Arno.

It was here, too, that the imbalances of wealth and political power burst forth in what became known as the Ciompi Revolt in the long, hot summer of 1378. Fueled by frustration at the factionalism paralyzing government, furious at their exclusion from the guilds, and angry at their poverty, skilled workers had joined with unskilled, propertyless laborers in rebellion, demanding access to the guilds and a greater say in city government. Attacking the *grassi* (fat cats), they took over the Palazzo Vecchio and installed the wool carder Michele di Lando at the head of a socially revolutionary regime in July. Although this popular regime was ultimately starved out of existence by a lockout, the revolt regained momentum in August, and violence once again filled the streets of the city. But they were no match for the *grassi*. Not to be outdone, the powerful oligarchs—in alliance with artisans frightened by the rebelliousness of their employees—reacted violently, and on August 31, 1378, a large crowd of rebels was cut to pieces in the Piazza della Signoria.

And it was here that Francesco Salviati, archbishop of Pisa, was hanged from a window of the Palazzo Vecchio by a lynch mob after the failure of the savage but abortive Pazzi conspiracy, staged in 1478, three years after Michelangelo's birth. By the mid-fifteenth century, Michelangelo's future patrons, the fabulously wealthy Medici family, had already established themselves as the de facto rulers of Florence, but their dominance had begun to ruffle feathers in a city traditionally restive and unstable. Together with the Salviati, the Pazzi family-also successful and ambitious bankers-resolved to oust the Medici from power with the tacit support of the pope. On April 26, 1478, in front of a huge congregation, Giuliano de' Medici was stabbed to death by a gang of conspirators (including a priest) in the Duomo. His brother, Lorenzo-who later doted on the injured Michelangelo-fled for his life while bleeding profusely and hid with the humanist Poliziano. But the coup faltered. Getting wind of what was afoot, the Florentines were galvanized into action. One of the conspirators, Jacopo de' Pazzi, was hurled from a window, dragged naked through the streets, and thrown into the river. The Pazzi were immediately erased from Florentine history and forfeited everything. Francesco Salviati himself was summarily lynched, and the twenty-six-year-old Leonardo da Vinci-then engaged in painting an altarpiece for the Palazzo Vecchio-sketched another conspirator, Bernardo di Bandino Baroncelli, twisting in the wind after he was hanged. Later in life, Michelangelo would tell Miniato Pitti of how he had been carried on his father's shoulders to see the execution of the remaining conspirators on April 28.

GAMBLERS, PROSTITUTES, AND IDLERS: THE OLD CITY

If San Marco, the Piazza del Duomo, and the Piazza della Signoria tell a story radically different from that told by Coluccio Salutati and Leonardo Bruni, the picture became even more vivid as Michelangelo left the square on his way toward the Ponte Vecchio, moving from the grand public buildings to the streets in which the drama of everyday social life was played out. A close look at *The Map of the Chain* (Fig. 3)—a panoramic view of Florence produced ca. 1471–82—reveals that beneath the massive structure of the Duomo and the Palazzo Vecchio lay a teeming mass of smaller and more modest buildings. Too numerous for the anonymous artist to depict in detail, they constituted a disorganized muddle, lacking any consistent style and bereft of any coherent sense of order. A mixture of houses, workshops, hostelries, and shops, their confused and cramped arrangement makes the buildings for which Florence is still famous look almost out of place.

Plunging into the heart of the old city, Michelangelo was confronted by the darkness of narrow *vicoli* (alleyways) overshadowed by hastily erected houses, a startling mixture of pungent smells, and the deafening noise of shouts and chatter. As he turned south toward the river, he would have been able to hear the hustle and bustle of the nearby Mercato Vecchio (Old Market), filled with stalls and street vendors selling everything from fruits and vegetables to meat and fish, and from sweetmeats and tasty treats to crockery and cloth. Even at a distance, the air teemed not just with the stench of fungibles gradually going bad in the Tuscan heat but also with the cries of market traders, the laughter of playful children, and incessant haggling over inflated prices.

In addition to legitimate trade, there were more nefarious forms of exchange going on, especially in the narrow streets close to the market through which Michelangelo would have passed. Gaudy prostitutes plied their wares from the early hours of the morning, bravos ran threatening fingers over the blades of their knives, pickpockets ran rampant in the confusion, deformed beggars rattled wooden bowls, and gamblers played dice on every corner. Every so often, petty fights would start. Even to Florentines, it was an arresting scene. As the poet Antonio Pucci put it a little more than a century before Michelangelo's journey: Every morning the street is jammed With packhorses and carts in the market, There is a great press and many stand looking on, Gentlemen accompanying their wives Who come to bargain with the market women. There are gamblers who have been playing, Prostitutes and idlers, Highwaymen are there, too, porters and dolts, Misers, ruffians and beggars.

In the streets nearby, the worldly delights that could be sampled in the *Mercato* could be enjoyed at greater leisure, and with greater abandon, in the numerous taverns and brothels that were a permanent feature of Florentine life. Whether a small wineshop serving the occasional plate of simple food or a large hostelry complete with stables and beds for travelers, inns were lively, debauched places full of the noise and stench of social life in the raw. People drank strong wines and hardy ales in abundance, danced with lusty barmaids, negotiated transactions, played cards, planned robberies, and brawled incessantly.

Frequented by high and low alike, the taverns Michelangelo encountered along his journey through Florence's oldest quarter were places in which lives often went to pieces, a fact that is vividly depicted in a Florentine devotional painting from the early sixteenth century. This nine-part moral allegory tells the story of Antonio Rinaldeschi, who was hanged in Florence on July 22, 1501. By nature a pious man, Rinaldeschi is depicted as having met his ruin at the Inn of the Fig. While sitting at a simple wooden table in the middle of a small courtyard, Rinaldeschi gets rather drunk and foolishly involves himself in a game of dice with an untrustworthy fellow. Inevitably, he loses and immediately flies off into a rage. Cursing God for his luck, he staggers off looking for trouble and-unable to find any more suitable outlet for his angerends by hurling dung at an image of the Virgin Mary near the church of Santa Maria degli Alberighi, just south of the Duomo. By the end of the sequence, he is arrested, convicted of blasphemy, and sentenced to hanging. Apart from the fact that Rinaldeschi repents before his death, the story was entirely typical of Florentine taverns.

Crime, inevitably, was a major feature of tavern life, and the city archives are full of accounts of violence, extortion, robbery, and even rape in such places. In the late fourteenth century, for example, two men called Lorenzo and Picchino were convicted of swindling a certain Tommaso di Piero of Hungary in the Crown Inn while the latter was on his way to Rome. After getting the poor Tommaso a little tipsy, Lorenzo and Picchino convinced him that they were wealthy merchants who had partners all over Italy. Persuading Tommaso to "sell" his horse to them for 18 florins, Lorenzo promised he would receive payment from his "partners" in Rome. To add insult to injury, Lorenzo and Picchino then "borrowed" a further 28 ducats from Tommaso to "buy" some imaginary jewels from a friend, again promising to reimburse him through business contacts in Rome. Needless to say, the guileless Tommaso never saw a penny of his money. Condemned in absentia, Lorenzo and Picchino were sentenced to be whipped through the streets, but of course they got away without a scratch.

At the bottom end of the scale, brothels were of much the same order as inns. Were it not for the rampant sex and even more rampant disease, it would, in fact, be comparatively hard to tell them apart from taverns. Indeed, the two often enjoyed extremely close relations. In 1427, it was reported that beneath the house of Rosso di Giovanni di Niccolò de' Medici at the entrance to the Chiasso Malacucina there were "six little shops" that were "rented to prostitutes who usually pay from 10 to 13 lire per month [for a room]." A certain Giuliano, an innkeeper, managed the whole operation. Giuliano kept the keys to all the rooms and put "whoever he wishes [into the rooms]." Presumably, he also collected the rents and took a cut of the profits, too.

Yet not all brothels were such small-scale affairs. It was principally for its larger whorehouses that this part of Florence was especially famous. Indeed, so renowned were the brothels of the old city that verses were penned in their celebration. In the liveliest of all, the poet Antonio Beccadelli (1394–1471; better known as Panormita) urged his book—*The Hermaphrodite*—to visit his favorite establishment and by way of recommendation provided a piquant little pen-portrait of the pleasures that his scandalously titled volume could expect:

Here is the congenial whorehouse,

a place which will breathe out its own signs with its stench. Enter here, and say hello from me to the madams and the whores, in whose tender bosoms you will be taken. Blonde Helen and sweet Mathilde will run up to you, both of them experts in shaking their buttocks. Giannetta will come to see you, accompanied by her puppy (the dog fawns on her mistress; her mistress fawns on men). Soon Clodia will come, her breasts bare and painted, Clodia, a girl sure to please with her blandishments.

Anna will meet you and give herself to you with a German song (as Anna sings she exhales the new wine on her breath); and Pitho the great hip-wiggler will greet you and with her comes Ursa, the darling of the brothel. The nearby neighborhood, the one named for the slaughtered cow.

sends Thais to greet you.

In short, whatever whores are in this famous city will seek you out, a happy crowd at your arrival. Here it's allowed to speak and perform dirty things, and no rejection will make your face blush. Here, what you can do and what you've long wanted to do, you will fuck and be fucked as much as you want, book.

In addition to privately run establishments, there were state-operated sex emporia. On the other side of the Ponte Vecchio in the area known as Oltr'Arno (literally "Across the Arno") was a site that had previously been set aside for the construction of a public brothel. It was planned by the priors in the quarter of Santo Spirito in 1415, and the city government hoped that by expanding the state's bordello business, it could ensure that prostitution—which could not be exterminated entirely could at least be controlled and regulated. The priors even coughed up 1,000 florins to build, furnish, and construct the brothel in Santo Spirito and another in the quarter of Santa Croce. Although the bordello in Oltr'Arno was never constructed, the more realistic members of the Renaissance elite freely acknowledged the good sense of such provisions.

Walking through the Old City and toward Oltr'Arno, Michelangelo had encountered the truly visceral side of Florentine life. It was perhaps no surprise that confronted with a similar array of sights, sounds, and smells, Petrarch felt moved to complain of contemporary existence in harsh terms a little over a century before. In a letter to his friend Lombardo della Seta, Petrarch described his surroundings in terms that did ample justice to the darker side of this part of the city. "To me," he declared,

this life seems the hardened ground of our toils, the training camp of crises, a theater of deceits, a labyrinth of errors . . . silly ambition, lowliest elation, futile excellence, base loftiness, darkened light, unknown nobility, a riddled purse, a leaky jug, a bottomless cave, infinite greed, harmful desire, dropsical splendor . . . a workshop of crime, the scum of lust, the forge of wrath, a well of hatreds, the chains of habits . . . the fires of sin . . . harmonious discord . . . simulated virtue, badness excused, fraud praised, disgrace honored . . . a kingdom of demons, a principality of Lucifer . . .

Michelangelo's thoughts may not have been so scathing, but he is likely to have been aware of the contrast between the grandeur of Orsanmichele and the world of crime, sex, and depravity that lurked below.

THE OTHER HALF: OLTR'ARNO

It was along the Borgo San Jacopo in Oltr'Arno that Michelangelo would also have encountered the humbler residential quarters of the city. Inhabited mostly by cloth workers in the late fifteenth century particularly wool carders, combers, and beaters—this area was undoubtedly lively—with a small but active market near the church of Santo Spirito—but cramped and dirty. In contrast to the major thoroughfares on the north side of the Arno, the streets were largely unpaved and filled with mud and filth. Trudging along on foot, Michelangelo would have had to take great care where he stepped and would probably have had to cover his nose from time to time. Despite the priors' repeated attempts to improve public hygiene, it was still a deeply unsanitary environment, and the awful smell of fish and rotting vegetables found in the Mercato Vecchio was still much better than the odor that rose from the streets in which poorer Florentines lived. For the most part, people relieved themselves wherever the opportunity presented itself, frequently tipping empty pots out of windows; but although certain parts of the city were equipped with dedicated cesspools, these were inadequate for the sheer volume of effluence produced by the city's growing population and often overflowed straight out into the road. In June 1397, for example, the city magistrates fined three men 10 lire for failing to construct an adequate cesspool and for allowing human excrement to fill the street. At the same time, it was common for animals to be driven through the streets, and while horses (and their droppings) were a part of everyday existence, it would not have been unusual for Michelangelo to have seen oxen drawing carriages, sheep being driven to market, or pigs snuffling in the dirt. Indeed, in advising Francesco "il Vecchio" da Carrara, lord of Padua, as to how a ruler ought to govern his state, Petrarch emphasized that a good statesman should take particular care to ensure that pigs did not run rampant through the city.

Lining these streets were a multitude of houses occupied by ordinary men and women. Although there were still some fairly "grand" palazzi in this area—such as that owned by the Nerli family—the majority of the dwellings bore the imprint of difficult lives. Despite the vogue for classical ideas in urban design, the homes of the poor were erected either in the absence of regulations or in defiance of occasional attempts at civic improvement and were consequently built in a ramshackle manner according to the limited resources available. Particularly in Oltr'Arno, these houses were narrow—with a frontage generally no more than fifteen feet—but deep and often very tall, regularly comprising up to four stories, and would typically be inhabited by a number of families renting a few cramped rooms for a few florins per year. Covered with a simple form of plaster, walls were commonly crisscrossed with threatening cracks and, lacking paint or decoration, presented a dull and forbidding appearance.

A feeling for the streets of Oltr'Arno can be gained from a roughly contemporaneous painting in the nearby church of Santo Spirito. In the background of his *Madonna del Carmine* (also known as the *Pala de' Nerli*; ca. 1493–96) (Fig. 4), Filippino Lippi painted a truncated view of the streets running westward from the Palazzo dei Nerli to the gate of San Frediano. Although the three-story palazzo is predictably imposing, the houses lining the road leading away from it are almost absurdly small. Their roofs tilting in apparently random directions, they are con-

structed in a comparatively flimsy and unplanned manner. The street itself is populated by a mixture of working men and women, animals, and children. Nearest to the palazzo, two pigs are shown snuffling in the dirt while a child runs past a two-wheeled wagon pulled by what judging by its size—is probably a mule. A little farther away, a man struggles with a heavily loaded packhorse, while another conducts some business through a window. And under the gate itself, walking out toward the fields beyond, is a woman, steadying a large platter of wares on her head with one hand and holding her infant child safe with the other. The mother's concern is an understandable testament to the standards of the area. If her little boy managed to defy the odds to survive his earliest years, he would count himself lucky to live much beyond thirty-five in Oltr'Arno.

IN PETER'S SHADOW

It would have been by means of precisely these streets that Michelangelo would have arrived at the doors of the church of Santa Maria del Carmine. On his journey from the gardens of San Marco, he would have seen his native Florence both as a city aspiring to the ideal and as a city of inequality, division, unrest, violence, and privation. Stepping across the threshold and into the hallowed calm of the church, he perhaps had cause to reflect on the dual character of his world as he walked toward the Brancacci Chapel.

Inside the chapel, to the left of the altar, was Masaccio's fresco *Saint Peter Healing the Sick with His Shadow.* In this piece, the serenely statuesque figure of Saint Peter is shown walking peacefully down a typical city street in the company of Saint John and an old man with a beard and a blue cap. Despite the amazement of the two onlookers to his right, Saint Peter seems almost unaware that his saintly shadow is miraculously alleviating the ailments of the paralyzed Aeneas of Lydda and his older, crippled companion.

Despite its religious theme, the fresco is a portrait of Michelangelo's Florence. Masaccio had striven to make the scene as naturalistic as possible and had attempted to bring the drama into the fifteenth-century city. Although clad in classical garb and modeled after a piece of antique statuary, Saint Peter is walking down a street lined by buildings that are recognizably contemporary. In the foreground, there is the rusticated facade of a palace belonging to a rich gentleman, and farther down the unpaved road there are two or three much simpler buildings covered with stucco and with their ill-supported upper stories jutting out over the street. What's more, there are not merely beggars but crippled beggars in the street. Even in Masaccio's fresco, riches and poverty coexist. It is, in other words, a scene that Michelangelo would have recognized as having been painted from life.

It's an idealized representation, just like the image of Florence given by Coluccio Salutati and Leonardo Bruni. As we have seen from Michelangelo's trip through the city, no fifteenth-century Florentine street would have been so neatly arranged or so clean and well constructed. The two—very restrained—beggars aside, there is no hint of the disorder, bustle, and noise that filled the city's roads and *vicoli*, and the street vendors, shopkeepers, robbers, prostitutes, and animals that Michelangelo would have encountered en route are entirely absent from Masaccio's scene. It was not so much a representation of reality per se as a representation of how Masaccio wanted reality to be. As such, the pictorial story of Saint Peter's shadow tacitly—and perhaps ironically testifies not only to the self-confident artistic utopianism of Renaissance Florence but also to the grim and often unpleasant character of the city that Masaccio and Michelangelo knew so well.

WHAT DAVID SAW

3

A LTHOUGH HE WOULD have been thoroughly acquainted with the hustle and bustle of city life in 1491, Michelangelo was as yet comparatively unconscious of the social, political, and economic forces that were influencing his life behind the scenes. An honored guest of Lorenzo de' Medici, a friend of leading humanists, and a pupil of Bertoldo di Giovanni, he would have had little reason to worry about money or to trouble about such distasteful subjects as politics and religion.

But all that was to change. On April 8, 1492, Lorenzo de' Medici died. He was succeeded by his son Piero. An unstable and intemperate young man, Piero lacked his father's political skill. As Francesco Guicciardini put it, "He was not only hated by his enemies, but also disliked by his friends, who found him almost intolerable: proud and bestial, preferring to be hated rather than loved, fierce, and cruel." He rapidly alienated the majority of the political elite. Tensions rose, and on November 9, 1494, Piero was expelled from Florence. In his wake, the fiery Dominican friar Girolamo Savonarola gradually asserted his control over the Republic.

Sensing the danger, Michelangelo fled Florence in mid-October 1493. Without a patron, without money, and without any clear plans, he traveled first to Bologna and then to Rome, where he determined to make a go of things as best he could. Although he had some notable successes especially the *Pietà*—several of his projects misfired badly, and he experienced no end of troubles with materials and payment. He struggled.

By late 1500, Michelangelo's situation was dire. On December 19, he received a heartfelt letter from his father, Lodovico. Lodovico was worried. His third son, Buonarroto, had just returned from visiting Michelangelo in Rome, and what he had heard had given him cause for concern. "Buonarroto tells me that you live with great thrift," Lodovico wrote, "or rather, in true misery." He was, as Lodovico warned him, in danger of falling into poverty. Indeed, Buonarroto had reported that Michelangelo was already suffering from a painful swelling on his side, brought on by impecunity and overwork. Now that Savonarola was gone and the old Republic had been restored, Lodovico begged his son to return to Florence. There, his fortunes might improve.

Michelangelo seldom took much heed of his father's advice, but on this occasion he relented. Putting his affairs in order, and taking out a loan from Jacopo Gallo to pay for the journey, he set out for Florence in the spring of 1501.

It was money that persuaded Michelangelo to return. He needed cash badly. From family and friends, he had learned that the Opera del Duomo—the four-man committee responsible for managing the affairs of the cathedral—was looking for someone to take on a project that had been in the air for more than thirty-five years. Back in 1464, a huge block of marble had been bought with a view to having a statue carved for one of the cathedral buttresses. Two artists had previously been given the task, and both had failed. Now the *operai* were keen to find someone new. Arriving back in Florence, dusty and dirty from his journey, Michelangelo had high hopes. Bankrolled by the Arte della Lana which controlled the Opera—it promised to be a lucrative project.

He was in luck. After briefly considering Leonardo da Vinci, the operai finally commissioned Michelangelo to carve the statue of David that would ultimately become one of his most famous works. Initially, the remuneration was modest. When the committee granted the twentysix-year-old Michelangelo the contract on August 16, 1501, it agreed to pay him 6 large gold florins each month for a fixed period of two years. Given the scale of the project, it was hardly generous. The best weavers in Florence were then being paid up to 100 florins each year-in other words, more than 38 percent more than Michelangelo was getting. Given that he would have had overheads to cover, he would probably have been left quite tight for cash. By February 1502, however, the statue was already "half finished," and the operai were sufficiently impressed not only to up Michelangelo's pay to 400 florins, but also to discuss, less than two years later, transferring the completed work to a more suitable-and public-location. This would easily have put him on a par with a well-paid manager at one of the branches of the city's major merchant banks. His financial position was now secure.

He never looked back: from this moment on, he stopped being a struggling sculptor who counted the coppers and became a man of means. More than that, he became a person to be reckoned with. With money behind him and with the *operai* in his pocket, he could count on the support of some of Florence's most powerful figures—including the *gonfaloniere di giustizia* (standard-bearer of justice; effectively the city's chief executive), Piero Soderini, and the businessmen Jacopo Salviati, Taddeo Taddei, Bartolomeo Pitti, and Agnolo Doni—and the backing of the city's major institutions: the guilds, the priors, and the Church. In the years that followed, he would go from success to success. The pieces he subsequently undertook—including the unfinished (and now lost) *Battle of Cascina* and the *Doni Tondo*—would cement his fame and bring him offers of employment from both Pope Julius II in Rome in 1505 and the Ottoman sultan Bayezid II in Constantinople in 1506.

There is no doubt that the eight years between his flight from Florence in 1493 and his return in 1501 marked a critical period in Michelangelo's development. Navigating the storms of poverty and uncertainty while still in the first flush of youth, he had transformed himself from an up-and-coming young trailblazer into an artist of international repute, as the *David* amply demonstrated even before its completion. Yet the course of Michelangelo's life during this period had been determined not by his own interests and preferences but by the shifting currents of politics, business, and religion. Dominating contemporary Florentine life and providing the context for everyday existence, the interaction and influence of each of these streams of activity had not only induced him to return to Florence but also prompted his hasty flight in the first place. What was more, the *David* itself was a product—whether direct or indirect—of all three.

In this, Michelangelo was not untypical. Still tied to the will of patrons, artists of all stripes were aware that their capacity to live, thrive, and survive in an unstable and unpredictable world depended on their ability to adapt to the changing demands of business, politics, and religion. Yet this is not to say that the role played by each of these spheres of activity in early-sixteenth-century urban life was as beautiful as the artworks to which they contributed. Indeed, quite the opposite. Just as the physical landscape of Florence revealed a hidden underside to the realities of the Renaissance, so the worlds of business, politics, and religion concealed an altogether uglier side to the art of the period. If we look at the personalities and the backgrounds of three of the figures whose influence helped shape Michelangelo's work, Jacopo Salviati, Piero Soderini, and Archbishop Rinaldo Orsini, the image of the world in which the *David* came to fruition is one of inequalities marked by vigorous exclusion, fierce rebellions, pitched battles, and tormented souls.

JACOPO SALVIATI: ECONOMIC INEQUALITIES

Jacopo Salviati was one of Florence's richest and most powerful men. A son-in-law of Lorenzo de' Medici, he was a bastion of the government, a towering personality in communal affairs, and a mainspring in the machine of the Florentine economy. The owner of the magnificent Palazzo Gondi, he was a man upon whom countless hundreds depended for their livelihoods and whose favor artists courted.

It was perhaps inevitable that a man with such enormous financial reserves at his disposal should have been a character in the life of the David. Michelangelo quite simply needed men like him. An artist's capacity to pursue his craft was reliant on his ability to make a decent living. This was not always easy. Although Raphael is reported to have "lived more like a prince than a painter" and Luca della Robbia became rich in the service of Francis I of France, many often had difficulty in making ends meet. Correggio was forced to become something of a miser in his old age, while Andrea del Sarto had to content himself "with very little." Indeed, Piero Lorentino d'Angelo, a pupil of Piero della Francesca's, experienced a poverty that was almost Dickensian. On one occasion, his sons begged him to slaughter a pig for the carnival celebrations, as was traditional. Having not even two pennies to rub together, Lorentino could do little more than pray, and his poor children went without. Their tears were, however, saved when Lorentino agreed to paint a picture for an impecunious patron in return for the much-hoped-for pig.

Reliant on the wealth and willingness of patrons, Michelangelo like all other Renaissance artists—was unwittingly tied to the fortunes of the Renaissance economy and, most of all, to the wealth of men like Salviati.

Salviati's wealth had grown out of his involvement in merchant banking. He had entered the business at exactly the right time. As will be explained more fully in a later chapter, Florentine merchant banking had originally emerged out of the massive explosion in trade that had occurred at the dawn of the fourteenth century as a means of facilitating commercial transactions across large distances. Within decades, super-companies had been formed that not only used branches scattered across the continent to engage in speculation but also operated as full-scale banks. The profits that could be made were already staggering even at this formative stage in the sector's development. As early as 1318, for example, the Bardi had a working capital of 875,000 florins. That was more than the king of France had to run his entire country. By the end of the fifteenth century, the money Salviati was able to make from merchant banking was on a whole new level.

But while Salviati had made a fortune out of lending and exchanging money, what had really allowed him to join the ranks of Florence's wealthiest men had been his willingness to invest so much of his cash in the city's second, and most characteristic, industry—the cloth trade. Consistently generating profits far in excess of those earned by the merchant banks, the wool and silk industry was the real engine of Florence's prosperity, and it was emblematic of the sector's immense importance that Michelangelo was commissioned to carve the *David* by a committee controlled by the Arte della Lana.

Salviati had chosen his investment well. Although the Salviati family's interests have been poorly studied, it is evident that their entry into the cloth industry (particularly the trade in silk)—which appears to date at least to the lifetime of Jacopo's pioneering kinsman, Alamanno di Iacopo (d. 1456)—was even better timed then their role in merchant banking. In the beginning, Florence's role in the cloth trade was limited simply to working up ready-made cloth that was imported from elsewhere in Europe. Before long, however, the city's merchants realized there was more money to be made from importing the very best wools from Spain and England and producing their *own* high-quality cloth for sale on the international market. Buoyed by capital investment from the new merchant banks and aided by the gradual decline of the cloth industry in Flanders, Florence weathered the shocks of the midfourteenth century to achieve a dominant position in European trade by ca. 1370.

The industry was fragmented. By the end of the fourteenth century, there were around a hundred competing woolen companies in Florence, each of which controlled no more than I-2 percent of the total

output. But the profits were enormous. In the period 1346–50, the company founded by Antonio di Lando degli Albizzi—which managed every aspect of woolen production, ran two workshops and a distribution workshop in Florence, and benefited from close links with Antonio's merchant bank in Venice—earned an annual profit of more than 22 percent, a figure that any company would envy today. So great was the growth of the wool trade, in fact, that toward the middle of the fifteenth century the merchant Giovanni Rucellai estimated that the city was worth around 1.5 million florins (about \$270.5 million when measured against the price of gold today and approximately \$739.5 million gauged against wage rates in 1450) in money and goods, and almost certainly underestimated its true value.

As it diversified into superlative silks and affordable cotton, the Florentine cloth trade entered its greatest period of growth in around 1501, that is, at about the time that Salviati was throwing himself into the business with full vigor. When Michelangelo started work on the *David*, annual sales of woolen cloth and silk were worth in the region of 3 million lire and continued to rise for the greater part of the century. Even the Buonarroti family couldn't resist the temptation to try their luck in the trade, and a few years later, in 1514, Michelangelo provided 1,000 florins to start a family wool business headed by Buonarroto. Veritable rivers of gold flowed into the city, and it was the wealth of men like Salviati that went to pay for major civic projects like *Il Gigante*.

As he proudly proclaimed to virtually anyone who would listen, Salviati was certainly one of Florence's richest men, riding high on the tide of commercial expansion. Yet his prosperity—and that of Florence as a whole—concealed some very ugly truths. His wealth relied on running his cloth business in such a way that appalling economic inequalities were inevitable and endemic poverty was unavoidable.

The overwhelming majority of the city's inhabitants were colossally poor. In 1427, roughly 25 percent of the city's total wealth was owned by 1 percent of households. Even more surprisingly, little more than 5 percent of the city's capital was owned by the poorest 60 percent of the population. Most people listed in the commune's tax records actually owned nothing at all.

This was a function of how Salviati's business worked. Like many other large-scale manufacturing industries, the cloth trade—which paid for the *David* and which accounted for the employment of 21 percent of the heads of all Florentine households in 1427—demanded a high level of specialization. In order to produce the cloths and silks, Salviati was obliged to break the entire process of production into a mass of small tasks, such as spinning, carding, dyeing, and weaving. Although some firms—such as Antonio di Lando degli Albizzi's company—managed to control most of the stages in cloth production, it was far more common that firms like Salviati's contracted out particular tasks to smaller workshops or individuals. Specialized workshops tended to operate out of cramped, rented premises—often part of a house in which one of the partners lived—clustered in particular quarters of the city. Individual artisans, such as weavers or spinners, almost always worked from home.

The "putting-out" system, as this is known, was commercially versatile and responsive. Salviati could react to fluctuating circumstances in an instant by changing whom he contracted to work on specific aspects of production, without risking the profitability of his venture as a whole. But by the system's very nature, Salviati had dozens of workshops and artisans at his mercy. His word was law, and he could make or break hundreds of individuals in a heartbeat. At the very least, it was in his interests to keep the people in his employ as poor as possible, and he had the bargaining power to ensure that he would always pay the lowest rates. In this, he was certainly not untypical. Niccolò Strozzi and Giovanni di Credi, for example, ran a highly successful cloth workshop together between 1386 and 1390, and the bulk of their costs went toward paying their various subcontractors on a piecework basis. The disparity in wages was huge. The carder Fruosino and the German weavers Anichino and Gherardo of Cologne were paid well, even handsomely, but others were not so lucky. Worse paid even than Giovanni di Neri, the shop boy, and Antonio di Bonsignore, an apprentice, were the twenty or so women who worked from home as spinners. But even here there seems little evidence of fairness. Whereas a certain Margherita received 2 lire for ten pounds of spun wool, Nicolosa was paid 2 lire 13 soldi for forty-three pounds. We can only guess at the reasons for this arbitrary behavior, but it does at least illustrate how piecework laborers-especially women, who accounted for a growing percentage of the cloth workforce—were entirely at the mercy of their employers.

Yet however frightening Salviati's phenomenal power over his employees may have been, cloth workers of all stripes were still at the better end of the scale. In 1344, two carpenters wrote to a friend

in Avignon asking for work because "the condition of the artisans and lower classes in Florence today is miserable, for they can earn nothing." Although this was written at a particularly low moment in the labor market's history, the sentiment was not untypical of the position of both skilled and unskilled laborers more generally. Many of those with whom Michelangelo was most closely acquainted-and whom he actually employed—were at the very bottom of the economic pile in Renaissance Florence. Michelangelo's stone-carver friends Topolino and Michele di Piero Pippo were skilled artisans, and most likely worked for cash for between ten and twelve hours a day, five days a week, but their wages consistently failed to keep pace with prices. For semiskilled or unskilled construction workers-such as the laborers known as "Stumpy" and "Knobby" whom Michelangelo employed on work at San Lorenzo years later-the situation was worse. They were generally employed either on an entirely piecework basis or on a dayby-day basis and were always paid worse in winter. Even in summer, construction workers' wages were so low that modern historians use them as a measure of poverty in Renaissance Florence.

JACOPO SALVIATI: STRUCTURING INEQUALITY

What made Jacopo Salviati so powerful a member of Florentine society and so important to the creation of the *David*, however, was not merely his wealth but his dominant position within the city's guilds (*arti*). The *operai* who commissioned Michelangelo to carve *Il Gigante* were, after all, drawn from the wool guild—the Arte della Lana—and their responsibility for this most important of projects reflects the broader importance of both guilds and their members to urban society. It was the guilds that were the real puppet masters of the Florentine economy, and having served as the prior of the entire guild system (that is, its representative in government) in 1499, Salviati was, in a sense, the master of them all.

The Arte della Lana was just one of Florence's twenty-one guilds. At its most basic, the guild was a highly exclusive self-preservation society for tradesmen. Within a particular trade, the guild regulated standards of workmanship, proficiency, and training and represented the interests of its members to the commune. But it was also much more than this. Possessed of wide-ranging powers, the guild performed a variety of other functions, including crisis management, arbitration, and discipline. In the event of a slump, it could limit the output of particular workshops or move the labor force around to avoid unnecessary disruptions. Similarly, if a quarrel arose between members, or between a member and someone outside, the guild could step in as a mediator. Perhaps most important, the guilds' emphasis on standards meant that a large proportion of their energies were spent ensuring obedience to regulations. Those who dared to pay their laborers too much or whose work was of an inadequate quality would find themselves prosecuted.

Florence's twenty-one guilds covered virtually every aspect of skilled or specialized trade. There were guilds for butchers (Beccai), bakers (Fornai), woodworkers and furniture makers (Legnaioli), lawyers and notaries (Giudici e Notai), stoneworkers, carpenters, and brick makers (Maestri di Pietra e Legname), traders in leather, skins, and fur (Vaiai e Pellicciai), and blacksmiths and toolmakers (Fabbri).

Not all of the guilds were, however, equal. The guilds were divided into fourteen "minor" and seven "major" guilds. The reasons for this were principally political, but the division reflected the comparative importance attributed to different trades within the Florentine economy. Those for local bankers (Cambio), international merchants (Calimala), and silk workers (Seta; Por Santa Maria) were, for example, accorded a higher status than those for hostelers (Albergatori) or locksmiths (Chiavaioli).

The highly exclusive and rigidly hierarchical Arte della Lana—the wool guild—was by far the most important and influential of all the Florentine guilds, and its activities are emblematic of the kind of business environment within which Michelangelo undertook his commission.

Insofar as it regulated the activities of the Florentine wool industry, the Arte della Lana was largely responsible for ensuring that the city remained at the absolute pinnacle of the European cloth trade. With its headquarters (the imposing Palazzo dell'Arte della Lana) opposite Orsanmichele and a stone's throw from the Piazza della Signoria, the guild was dominated by the wealthiest manufacturers in Florence and persistently strove to prioritize their concerns. Humbler workers, such as fullers, stretchers, and carders, were consistently excluded from the ranks of the Arte della Lana and were precluded from forming their own trade organization. As a result, they were at the mercy of the merchants and were in constant tension with the guild.

For those whose roles gave them some limited economic clout, strike action was always a possibility when conditions proved particularly difficult, and in 1370 the dyers used this as a means of demanding higher prices for colored cloths. But for the more menial laborers whose work involved only a limited amount of specialized skills and who possessed almost no economic leverage, the options were more limited. Beaters (who used willow branches to beat impurities out of recently washed raw wool and to help disentangle the fibers) and carders (who used flat combs to separate woolen fibers ready for spinning), for example, were crucial to the production of woolen cloth but were paid the bare minimum and constantly hovered on the threshold of destitution, especially when times were tough. Despite numbering around fifteen thousand in the 1370s and 1380s, these occupants of the lowest rung on the economic ladder—known as the popolo minuto—were categorically denied the chance to form the organizations that would have allowed them to bargain collectively and lacked the weight to have any effect in small numbers.

The persistent inequalities of the guild system were a recipe for conflict, especially in the wool industry. Early signs began to appear in the mid-fourteenth century, when the depletion of the population contrived to empower the dispossessed. In 1345, a certain Ciuto Brandini was convicted of organizing a guild for the *popolo minuto* of the wool industry. As the court records reported,

Together with many others who were seduced by him, he planned to organize an association . . . of carders, combers, and other laborers in the woolen cloth industry, in the largest number possible. In order that they might have the means to congregate and to elect consuls and leaders of their association . . . he organized meetings on several occasions and on various days of many persons of lowly condition. And among other things done in these meetings, Ciuto ordered that there should be a collection of money from those who attended these assemblies . . . so that they would be stronger and more durable.

Manifestly designed for collective bargaining, Ciuto's organization seems comparatively harmless to modern eyes. But to contemporary merchants, it was anathema. Ciuto's proto-guild was denigrated by the court as "wicked" and its objectives decried as aiming at committing "outrages . . . [against] those citizens of good condition who wished to prevent Ciuto . . . from accomplishing those objectives." For "outrages" read "reasonable pay," and for "citizens of good condition" read "greedy merchants."

This was just a taste of things to come. In the summer of 1378, these lingering resentments burst forth into new mutiny in the Ciompi Revolt. Still angry at being excluded from the guilds and distressed by the apparent impotence of civic government, the *popolo minuto* met in much the same way as in 1345 and drew up a list of grievances that they presented to the priors on July 21. Although the demands included clauses relating to debt and forced loans, the principal clauses sought to establish a separate guild for the "combers, carders, trimmers, washers, and other cloth workers" who had until that point been under the thumb of the Arte della Lana. Their demands were summarily dismissed by the priors.

Furious, the *popolo minuto* stormed the Palazzo Vecchio. There, they "threw out and burned . . . every document which they found" and refused to budge. The next morning, they elected Michele di Lando, "a wool-comber . . . who sold provisions to the prisoners in the Stinche," as the *gonfaloniere di giustizia* and began electing a completely new set of priors from their own ranks. After the bells were rung in jubilation, the freshly installed Signoria immediately set about enacting an even more dramatic reorganization of the guild structure than they had originally demanded.

Despite attracting support from some other quarters, it was a popular government, and in more ways than one it was truly revolutionary. But it couldn't last. The collective bargaining power of Michele di Lando's new guilds was simply not up to resisting the accumulated wealth of the Florentine merchant elite. Members of the Arte della Lana ceased trading, thus preventing Ciompi from the wool industry from earning their bread and butter. The coalition of interests that had underpinned the revolt shattered. A last-ditch effort was made by the Ciompi, but that too was smashed by the assembled might of bankers, merchants, and artisans in a violent pitched battle on August 31, 1378. The revolution was over, and the bitter inequalities of the guild system, baptized with the tears of the dispossessed, were consecrated as a permanent feature of the Florentine economy until the *arti* were finally—and totally—reorganized by Duke Alessandro de' Medici in 1534.

As one of the dominant forces within the guild structure, Jacopo Salviati wielded colossal influence not only over the workings of the Florentine economy as a whole but also over every stage of the *David*'s creation. At the dawn of the sixteenth century, as he worked on the statue, Michelangelo was every bit in thrall to the Florentine guilds as if he had been an active member of one himself. His monumental statue was commissioned by the city's most powerful *arte*; his other patrons were key players in the major guilds; his skilled assistants had their lives confined by guild regulations; and his unskilled workers were kept close to poverty by the guild structure. As an artist—even a *free* (non-guild) artist—Michelangelo was subject to the guilds and tacitly obliged to perpetuate the norms that they laid down for Florence's economic life.

PIERO SODERINI: POLITICAL INEQUALITIES

If Jacopo Salviati embodied the economic conditions on which the *David* depended, his good friend and colleague Piero Soderini encapsulated the political influences that were brought to bear on Michelangelo during the completion of the project.

A wizened and grim-faced figure, Soderini was the head of the Florentine state. Having spent much of his life in government service, he had been seen as a safe pair of hands after Savonarola's fall and had been appointed *gonfaloniere di giustizia* for life as a means of bringing some semblance of stability to the shattered city. Although far from perfect, he ruled wisely and justly and appears to have let a strong sense of public morality guide his judgment in all things. He had seen the vicissitudes of the last Medici and the Savonarolan regime and was determined to ensure that the city would enjoy what would be its last taste of "popular" government as fully as possible.

Acutely aware of the propagandistic potential of art, Soderini saw that commissions such as the *David* could play a vital role in fostering the civic spirit that he wished to serve as a bastion of public life for generations to come. This was certainly not a new idea. Almost two centuries earlier, comparable circumstances had been made visible in Ambrogio Lorenzetti's *Allegory of Good and Bad Government* in the Sala dei Nove in the Palazzo Pubblico in Siena. A rich and complex allegorical celebration of republican virtues, Lorenzetti's frescoes testify to his acute awareness of the tenor of contemporary political thought and to an ongoing dialogue between artist and communal officials. But given the political situation he had inherited, Soderini was keen to take special care with the *David* and involved himself closely with Michelangelo's project from the very beginning. Although originally commissioned by the Opera del Duomo, the statue was ultimately to serve as a celebration of republican "liberty." In its final position, outside the main doors of the Palazzo Vecchio, it was intended to be a potent symbol not merely of Florence's independence from external aggressors but also of the city's capacity for autonomous self-government. In Soderini's eyes, the *David* was an emblem of the strength and resilience of a city unified under the banner of republican freedom.

Like modern democracies, the Republic over which Soderini presided was divided into two parts. The executive was headed by the Signoria, which comprised eight priors—each of whom served a single two-month term—and Soderini himself, the *gonfaloniere di giustizia* who usually served for a similarly brief tenure, but, in Soderini's case, for life. Thus constituted, the nine-man committee was invested with tremendous clout. As Gregorio Dati observed some seventy years earlier, the Signoria was normally entrusted simply with the execution of the laws but had "unlimited power and authority" and could do whatever it thought fit in times of emergency.

Soderini's Signoria was, however, neither the sole repository of executive authority nor an organ of centralized policy formation. There were a host of other bodies that made up the executive. In addition to the sixteen *gonfalonieri* who advised the Signoria, there was the Dodici buoni uomini; the Dieci di balìa, which handled defense in times of war; the Otto di guardia, which oversaw the internal security of the republic; and a multitude of other magistracies that dealt with more highly specific needs, such as the supply of grain and the maintenance of bridges.

Supporting the Signoria and the other executive committees was a burgeoning bureaucracy of highly educated humanists. Heading this growing body of professional administrators was the office of chancellor—previously filled by luminaries such as Coluccio Salutati and Leonardo Bruni—but there were also a vast number of other posts, many of them filled by men who had an active hand in civic art, several of whom rose to quite spectacular prominence. Particularly prized by Soderini was the second chancellor, a rising young man by the name of Niccolò Machiavelli.

Legislation, on the other hand, was handled differently. In Soderini's time, the power to pass laws belonged to the Consiglio Maggiore. Consisting of a staggering three thousand members, the *consiglio* comprised roughly 20 percent of the adult male population over twenty-nine and was responsible for all decisions regarding the levying of taxes, the imposition of forced loans, and the conduct of foreign relations.

At the time he took Michelangelo under his wing, Soderini was proud to boast that Florence had the most "popular" government it had ever experienced. To modern eyes, it has an almost democratic feel to it. The sheer size of the Consiglio Maggiore appeared to guarantee a measure of popular participation, while the short periods for which executive offices were held ensured a high turnover of personnel that theoretically opened government up to the population at large. It was perhaps no surprise that speaking with regard to the reforms which paved the way for the early-sixteenth-century constitution, Leonardo Bruni had earlier declared:

Equal liberty exists for all . . . ; the hope of winning public honors and ascending [to office] is the same for all, provided they possess industry and natural gifts and lead a serious-minded and respected way of life; for our commonwealth requires *virtus* and *probitas* in its citizens. Whoever has these qualifications is thought to be of sufficiently noble birth to participate in the government of the republic . . . This, then, is true liberty, this equality in a commonwealth: not to fear violence or wrong-doing from anybody, and to enjoy equality among citizens before the law and in the participation in public office.

By the same token, the decentralized, almost byzantine character of Florentine government seemed to bristle with checks and balances.

In contrast to the city's past, there is little doubt that the Florentine government was exceptionally open and broad-based in 1501, and there is good reason to see the *David* as an expression of a genuine commitment to liberty.

For much of the fourteenth century. Florence's constitutional history had been characterized by long-standing tensions between "popular" and "oligarchic" tendencies that manifested stark socioeconomic inequalities and often had the effect of worsening the broader position of the popolo minuto. Government had been the exclusive preserve of the guilds. Every officeholder was chosen both by and from among the guild hierarchy, with significantly more influence given to the major guilds. This automatically excluded the thousands of laborers and artisans whose economic function debarred them from guild membership. Even then, being a member of an important guild was no guarantee of being able to take part in communal government. Elections as we know them today simply did not exist. Within each guild, a committee of scrutiny determined who was eligible to be considered for office, and the members who passed muster were subsequently put forward for election by sortition (choice by lot). Of the five to six thousand men who were theoretically eligible to take part in communal government in the late fourteenth century, perhaps as few as 30 percent ever held office. Given that the priors, the buonuomini, and the gonfalonieri were elected for two, three, and four months, respectively, the number of people who held these positions was remarkably small.

With scrutiny and sortition in the hands of a very narrow mercantile elite, not only was government the plaything of the wealthy, but politics was also exposed to endemic corruption. Manipulating networks of business and patronage, ultra-wealthy guildsmen worked behind the scenes to influence the selection of officeholders by using a mixture of bribery, nepotism, and threats. In 1361, eight people were convicted of offering bribes, while four were found guilty of accepting backhanders, and the whiff of comparable scandals was scented again in 1364 and 1367. In their chronicle, Matteo and Filippo Villani frequently complained of bribes being offered to committee members for favor at the scrutiny itself, and this in turn had a damaging effect on attitudes toward public office. As Matteo Villani wrote,

Citizens of simple mind and newly acquired citizenship, through bribery, gifts, and great expense, manage to get their names regularly included in the bags at the triennial scrutinies. There are so many of this sort that the good, wise, and prudent citizens of long-standing reputation are rarely able to attend to the affairs of the commune and can never support them fully ... Now each person regards the two months that he spends in the high office in terms of his own advantage, to favor his friends or harm his enemies with the influence of the government.

With its narrow social basis and in-built tendency toward corruption, the government of early-Renaissance Florence was inevitably vulnerable to internal weaknesses. The city was rent by factional conflict and violence, a fact that is attested to most eloquently by Dante's exile at the hands of his factional rivals, the Black Guelfs, in 1302. But most important, the oligarchic nature of Florentine government aroused resentment from those whose occupation or status precluded them from taking part in the political process. It is no surprise that the greatest unrest was found among the propertyless wage laborers who were so systematically excluded from the guilds. In addition to being a protest against the appalling conditions in which semi- and unskilled cloth workers were forced to work, the Ciompi Revolt was also a struggle for political representation. The Ciompi sought to establish a more equitable distribution of political power through a broad-based regime, albeit unsuccessfully.

Reform was inevitable. In 1382, a more overtly "popular" regime was instituted that would lay the foundations for the political world familiar to Michelangelo. The guilds were removed from the picture, eligibility for political office was widened dramatically, scrutinies were handled by a centralized body, and a conscious effort to cultivate a "civic" spirit emerged. In the decades that followed, *parlamenti*—large, public gatherings of the whole citizen body—were occasionally summoned to make major political decisions, and the Consiglio Maggiore was eventually established as an alternative to the smaller, more restricted councils that had gone before. The "people" (if one can speak in such terms) seemed finally to have achieved a share of power.

But appearances were deceptive. Far from being designed to broaden participation in a truly "republican" government, the reforms of 1382 were intended merely to secure the interests of the same narrow mercantile elites and to limit the incidence of unrest by creating the illusion of popular consent. The same small group of exceptionally rich individuals continued to dominate the course of Florentine politics—although seldom in the public view—while the poor and the unskilled remained on the very fringes of the political process.

Far from being an independent legislative body, the Consiglio Maggiore was heavily constrained. Not only was it permitted to vote only on measures introduced by the Signoria, but it was also forbidden to debate motions except in extremely specific, and very rare, circumstances. So too, the *parlamenti* were susceptible to open demagoguery, rabble-rousing, and bribery. More important, while the number of people eligible for executive office expanded, new—and much more nefariously inventive—restrictions were introduced to limit the freedom of the centralized committee of scrutiny. A whole slew of electoral controls (*accoppiatori, balie,* and *borsellini*) were brought in to ensure that the "right" people were selected for office.

The Republic retained its tendency toward oligarchy throughout the fifteenth and early sixteenth centuries. Although they seldom held office in person, the Medici family came to overshadow Florentine politics from 1434 until the 1492 expulsion of Piero de' Medici by manipulating both networks of patronage and the electoral controls that had been created at the end of the previous century. As Michelangelo would have witnessed during his time in Lorenzo de' Medici's household, this one family decided who was in and who was out and succeeded in establishing itself as the head of a ruthlessly powerful oligarchy. Indeed, Aeneas Silvius Piccolomini (later Pope Pius II) observed that Lorenzo's father, Cosimo, was "not so much a citizen as the master of his city." "Political councils," Piccolomini noted, "were held at his house; the magistrates he nominated were elected; he was king in all but name."

This is not to say that such a *reggimento* (regime) was without its critics. On the one hand, the Medici oligarchy inevitably generated enmities from families envious of their influence. It was precisely this that catalyzed the bloody but abortive Pazzi Conspiracy in 1478, in the course of which Lorenzo's brother, the rather handsome Giuliano, was stabbed to death in Santa Maria del Fiore and the ringleader, Jacopo de' Pazzi, was defenestrated by an angry mob. On the other hand, there were those who were ideologically opposed to the dominance of so limited an oligarchy and equated the Medici *reggimento* with tyranny. In his *Memorie*, Marco Parenti reported that Cosimo de' Medici had imposed "a sort of servitude" on the city that was contrary to liberty, and later the

former Medici loyalist Alamanno Rinuccini launched a vitriolic attack on Lorenzo for precisely the same reasons in his *Dialogus de libertate*. This line of attack was subsequently pursued by Girolamo Savonarola. Outlining his views in the *Trattato circa il reggimento e governo della città di Firenze* (1498), Savonarola inveighed against the "tyranny" of individual rulers who have regard only for their own interests, and contrasted this strongly with the "civil government" that Florence had (he believed) enjoyed in the period 1382–1434.

But criticism was not the same as ideological divergence. Perversely, very few-if any-of the Medici's critics attacked the underlying structure of Florentine politics. It was more a matter of personnel than principle. The Pazzi conspirators, for example, sought mainly to replace the Medici reggimento with their own, and few of the family's other enemies actually espoused clear constitutional reforms. Neither Parenti nor Rinuccini seems to have shown much interest in substantial political change, and even Savonarola's Trattato left some doubt as to how "civil government" differed from "tyranny" at a structural level. While particular oligarchs were sometimes resented, therefore, the system of politics that facilitated oligarchy remained almost unchallenged. The transition from Medicean oligarchy to Savonarola's "theocracy" and to the new Florentine Republic was thus little more than a matter of shuffling around the people at the top of the pile without disturbing the underlying structure. Indeed, the shuffling wasn't even particularly extreme in most cases: Michelangelo's patron, Piero Soderini, had served as a prior in 1481 and had been a close friend of Piero de' Medici's before being elected gonfaloniere a vita (standard-bearer for life) in 1502.

When Michelangelo returned to Florence in 1501, therefore, he encountered a political world that was alien but also familiar. The Florentine Republic was more committed to "republican" ideals than ever before but was as far from being a "popular" government as it had always been. The same built-in tendencies toward oligarchy that had characterized the Medicean ascendancy (1434–94) were still there. Although much was made of the introduction of "new" families into the executive, not a single member of the Signoria in 1501 belonged to a family that had not previously held office, and it was something of a miracle that Michelangelo's brother Buonarroto managed to get himself chosen as a prior in 1516.

Despite the intended symbolism of the David, Florence was no

closer to being a city of liberty and equality than it had been in the midfourteenth century. Though cloaked in the language of republicanism, profound socioeconomic differences continued to find expression in a culture of relentless political exclusion in which the poorest and least affluent were reduced to a merely passive role in the operation of government, and in which dissent was treated with uncompromising severity.

Against a historical backdrop of violence, factionalism, and revolt, Michelangelo and the *David* were preparing to take center stage in a political drama designed to deceive and delude the dispossessed and the downtrodden. Although it may have been intended as a symbol of liberty, the city over which the *David* watched was certainly not one dominated by political equality.

RINALDO ORSINI: RELIGION

Yet if Salviati and Soderini both made their presence felt while Michelangelo was at work on the *David*, his statue was every bit as closely informed by another, almost invisible figure. Hiding in the background, but taking an enthusiastic interest in the artist's work as it progressed just a few meters from the doors of the Duomo, was Rinaldo Orsini, the quiet, unassuming archbishop of Florence.

It was no surprise that Orsini concerned himself with Michelangelo's sculpture, albeit in a discreet manner. The project was, after all, religious. Although it was to become a powerful political symbol and owed its existence to the money generated by Florentine business, the *David* was cloaked in the language of faith and had for its subject a familiar biblical story. What's more, the *operai* had commissioned *Il Gigante* as an adornment for one of the cathedral buttresses, and it would have been all but impossible for Orsini not to have been at least mildly interested in the character of a work originally destined for his episcopal seat.

But there was also a more fundamental reason for Orsini—who is often left out of the statue's story—to have been a subtle presence in the *David*'s history. Orsini was the figurehead of Florence's religious life, and no matter how hardheaded Soderini and Salviati might have been, there was no getting around the fact that religion was an integral part of daily existence in Michelangelo's Florence. Although considerably less well-known than many of his predecessors, Orsini was the living embodiment of the glue that held society together.

At its most basic, religion provided a kind of framework into which everything else could be fitted. It was the stuff of time. It structured lives. The milestones of life-baptism, confirmation, marriage, death-all took place in church, while the liturgical calendar provided the framework for the passage of the year. Legal documents and court records were often dated not with reference to a particular day or month but in terms of religious festivals; and rents, too, were frequently collected on feast days. Religion also structured the day. Families worshipped together or separately with piety, often attending Mass or vespers at least once each day, and the chiming of the bells for the various celebrations furnished a largely clockless city with markers for work and leisure. It was, moreover, the stuff of place. The parish remained the basic unit of urban organization, and the local church not only grounded individuals in a locality but also provided a rallying point for communal organization. So, too, religion shaped and defined interpersonal relations of all complexions. Privately, families (especially the rich) cultivated the worship of particular saints in much the same way as the Romans had worshipped household deities (the lares and penates). Individually and collectively, guilds were endowed with a profound religious dimension—as the competition over the adornment of Orsanmichele demonstrates—while the existence of confraternities ensured that charitable activity remained rooted in the world of religion. Perhaps most important, religion was also the nodal point in the formation of urban identities. The greatest festival in the Florentine civic calendar was, after all, held on the days around the feast of Saint John the Baptist, while the figure of the Florentine Saint Zenobius was the source of enormous urban pride, as Ugolino Verino's praise testifies. That the David expressed a political message through the language of religion was not surprising.

But while the Church provided the warp and the weft for the tapestry of Florentine life, Rinaldo Orsini also presided over an institution that was more than just an abstract framework for daily existence. Even though he himself often remained in the background (perhaps as a consequence of the horrors of Savonarola's period of ascendancy), Orsini was responsible for binding the Church ever more closely to the conduct of secular life. Like all other archbishops, he had hundreds, if not thousands, of priests, monks, friars, nuns, and tertiaries under his control, and he did his utmost to encourage ever greater numbers of people to enter the religious life in one form or another. It was his job, in a sense, to make the boundary between the religious and the secular as porous as possible, and, by and large, he succeeded.

Thanks to the campaigning of Orsini and his underlings, sons often found that the religious life offered an attractively secure alternative to a worldly career, particularly in larger families, while poverty frequently made it necessary for dowry-less daughters to be placed in a convent. It would have been of some delight to the shy archbishop that Michelangelo's older brother, Lionardo, for example, became a Dominican friar, while his niece, Francesca (Buonarroto's daughter), was put into a convent after her father's death until her uncle could raise a suitable dowry. This arrangement did not always result in harmony within the home or within the cloister. It was not uncommon for daughters to react very badly to the idea of being shut away in a convent. In 1568, a fourteen-year-old Sienese girl attempted to poison her entire family by grinding up a mirror and mixing the mercurial powder into the salad at dinner as a means of dodging the wimple. Similarly, monks and friars often found that while the religious life made financial sense, it did not lead inevitably to humility and piety. After the death of his mother, Filippo Lippi's sister was no longer able to provide for him, and he was placed in a Carmelite convent at the tender age of eight. On reaching maturity, however, Lippi discovered that his cloistered existence did not sit at all well with his nigh-uncontrollable lust, and both his superiors and his patrons struggled unsuccessfully to keep him in check.

As Orsini was aware, however, the fact that a great many families had members in holy orders meant there was a good deal of crossover between the religious and the secular. This was not merely a matter of conventional exchange, of conversations in the street or chats after Mass. Sex was also a big part of the equation, and in this respect Boccaccio's *Decameron* offers some useful insights. Although monks and friars are sometimes presented as unwitting go-betweens, they more frequently appear in Boccaccio's tales as extremely active participants in wild sexual games. In one story, a Tuscan abbot conceives a passionate love for the wife of the pious Ferondo but is only able to extract from her a promise to satisfy his lusts when her sex-averse husband is in Purgatory, where he will realize the errors of his ways. Cleverly, the abbot drugs Ferondo so that he appears dead, then removes him from the tomb where he has been buried and locks him in a vault. When he awakes, Ferondo is convinced that he is in Purgatory. The abbot, meanwhile, cavorts with Ferondo's wife to his heart's content. In another tale, a Benedictine monk is caught having an affair with a young girl but avoids a severe reprimand by reminding the abbot that he, too, had enjoyed a few moments of pleasure with the same girl.

Predictably, this generated a good deal of criticism. Particularly during the early fifteenth century, Florentine literature had a strong anticlerical strain that concentrated most of all on gluttony and lustfulness among the clergy. Poggio Bracciolini and Leonardo Bruni, for example, were eager critics.

Yet the links between the religious and the secular worlds during Orsini's episcopate went deeper than mere sex. Far from being "merely" a prelate, Rinaldo Orsini was also a businessman. And this is where his shadowy presence in the history of the *David* begins to get really murky.

However firm the commitment to poverty may have been among the monastic and mendicant orders, monks, nuns, and friars all needed cash, and every ecclesiastical institution managed a wide range of financial interests. The Carthusian monastery at Galluzzo, just outside Florence, owned "a cloth factory in the Via Maggio, a tailor's shop in the Via del Garbo, a barber shop in the parish of S. Piero Gattolino, [and] a dwelling in the Borgo Ogni Santi." Equally, some religious houses in the city ran profitable business ventures from within their own walls. The Umiliati friars, for example, owned and ran a wool-producing factory near the river from the late thirteenth century onward. Convents were especially active in this regard. Francesco di Marco Datini's wife once wrote to her husband to tell him about the wonderful tablecloths she had ordered at one convent and the towels she had purchased from another. The secular clergy had the largest investment portfolios. Thanks to bequests and donations, individual churches and ecclesiastical positions possessed parcels of land, buildings, or even entire businesses that generated a steady income stream from rents and revenues. Some could return surprisingly vast amounts of money. Even though there were no fewer than 263 dioceses in mainland Italy (excluding Sicily and Sardinia), it was rare to find a bishop-and least of all an archbishop of Florence-who did not have a steady stream of gold flowing into his pockets.

While this all made ecclesiastical institutions major players in the Florentine economy, it also tied priests and prelates in particular to the vicious world of familial ambition. Due to the wealth accruing from benefices, Florence's most important families were naturally eager to supplement their collective worth by sending some of their members into the Church and by vying constantly for ecclesiastical preferment. In 1364, Francesco del Bene lobbied the papal secretary, Francesco Bruni, unremittingly to ensure that the church of Santa Maria Sopra Porta was given to his son, Bene, while Buonaccorso Pitti later engaged in a long and drawn-out battle with Niccolò da Uzzano in a vicious competition to obtain the hospital in Altopascio for his nephew.

Rinaldo Orsini was no exception to this. He had been installed as archbishop of Florence as a result of a petition made by Lorenzo de' Medici to Pope Sixtus IV in 1474. Although the Medici-hating Sixtus had originally wanted to appoint Jacopo Salviati's kinsman Francesco to the vacant see, Lorenzo was determined that Orsini get the job. It wasn't that he had any particular faith in Rinaldo's commitment to Christian virtue: he was far more interested in the fact that Orsini was his brotherin-law. By having his wife's brother installed as the next archbishop, Lorenzo hoped to consolidate his family's hold on power further and to divert the Church's revenue stream into the coffers of his own family.

That Orsini had been appointed as the result of Lorenzo de' Medici's scheming points to a further important dimension of the archbishop's role in Florentine life. By virtue of the intimate relationship between the religious and the secular spheres in Renaissance Florence, it would have been surprising had the Church's broader ties with politics and business not been equally incestuous. Indeed, precisely because of the familial and economic links binding the laity to the clergy, considerable crossover between the institutional worlds was inevitable. But while we are accustomed to seeing the archbishop of Canterbury hold forth on political and financial matters today, the relationship was much more intense and much less friendly during the Renaissance.

Just as the Papal States played a vitally important role in the politics of the Italian peninsula, the Church loomed large in Florence's domestic affairs. At one level, the richness of ecclesiastical benefices not only made the battle for preferment a key issue in the rivalry between families and factions but also made the taxation of Church properties a major point of friction between the archbishop and the constantly cash-strapped Florentine government. Whether successive prelates and priors liked it or not, they were locked in a never-ending and rather dirty exchange. At another level, however, the Church's wider economic and political importance made it essential to the functioning of Florentine business and a key consideration in the struggle for control of government. On the one hand, not only did the city's banks rely on the papacy's money, but the city often found that its very survival depended on its ties to the Papal States. Good relations were essential. On the other hand, the Church also needed to ensure that the Florentine government—like the Florentine banks—was onside. This necessitated active involvement in day-to-day politics. After falling out with the Medici, Pope Sixtus IV actively supported the Pazzi Conspiracy, and it was telling that Archbishop Francesco Salviati of Pisa was a key player in the abortive coup.

This dimension of the crossover between religion, business, and politics also catalyzed another, more dangerous form of tension. A certain element within the Church was always uncomfortable both with the seamy world of contemporary business and with the worldliness of priests and prelates. The practice of usury, for example, was consistently condemned by priests throughout the period, and the avariciousness of the financial sector was a constant target for attacks from preachers fired with the message of poverty and simplicity propounded by the mendicant orders. But to say that such attitudes informed criticisms of ecclesiastical vices is something of an understatement.

For purists, the Church should be a bastion of purity and simplicity, politics should be a branch of theology, and business should be moderated by Christian charity. In the eyes of a number of priests, the relentless pursuit of wealth, the constant competition for benefices, and the politicization of ecclesiastical affairs gradually came to symbolize not only the degradation of the faith but also the corruption of what should have been a godly republic. As early as the first decade of the fifteenth century, the Dominican friar Giovanni Dominici strongly defended the idea that government should be guided by virtue and that the service of the state was a Christian obligation, but at the same time he also inveighed violently against the greed and ambition of those who strove for power ("all the miseries of the world begin from ambition, pride of this world," he affirmed). Attacking factions and struggles, he lamented that "there is no justice but deception, power, money, friendships, or parents." To change this, Christian rebirth was necessary.

Toward the end of the century the Dominican friar Girolamo Savonarola struck out at the rich, concentrating on their luxurious palaces, extravagant clothing, and lavish private chapels. He was appalled by the competition for ecclesiastical offices and lambasted the willingness with which churches had been turned into dens of thieves, intent on defrauding the poor and the dispossessed. Not only had public morals and the Church been torn away from Christ's teachings, he asserted, but government itself had become a playground for tyranny. Giving voice to the resentments engendered by socioeconomic and political inequalities, he affirmed that the good of the people-the popolo minuto, the ill-paid laborers, the struggling pieceworkers, the elderly, and the young-had been forgotten in the pursuit of money. The whole of Florence needed to be reformed in keeping with a purist reading of Scripture. Government would be reorganized with virtue and charity at its heart; the Church would be purified; and business would be taught modesty and restraint. "Florence," Savonarola declared, "Christ is your king!" Within weeks of Piero de' Medici's fall, the friar had begun a veritable revolution. Thousands of young boys ran through the streets destroying anything that seemed to be an arrogant display of wealth; the Signoria was purged; and the whole of Florence was, as his critics observed, transformed into a convent. It was extreme, bloody, and violent, but it was perhaps nothing more than the natural outcome of the tensions arising from the interaction of business, politics, and religion.

By the time Michelangelo returned to Florence in 1501, Savonarola was dead, and the tides of religious extremism had all but vanished. Religion was still an integral part of Florentine life, and the links that bound it to the institutional worlds of business and politics were as strong as ever. They were alive and well in the person of Rinaldo Orsini. As the *David* testified, the language of religion was still central to the formation of civic identity and stood at the very core of Florence's self-image. Indeed, religion—as the deeply pious Michelangelo would have known all too well—still structured everyday life. But the sexual deviancy, the competition for benefices, the political intrigues, and the zeal for reform still simmered beneath the surface.

WHAT DAVID SAW

When the completed *David* was finally unveiled in the Piazza della Signoria on September 8, 1504, the statue gazed out at a snapshot of city life.

Everyone had come out for the great event. Arrayed on the *ringhiera*—the raised, stepped platform outside the main doors of the palazzo—were the doughty citizens who embodied the worlds of politics, business, and religion: the august Piero Soderini, dressed in fine red robes and glittering with jewels; the pudgy Jacopo Salviati, in his ridiculously overpriced clothes; and the proud Rinaldo Orsini, adorned in rich golden vestments. Yet in the square itself stood a swirling crowd of people, citizens and noncitizens, men and women, old and young, laity and clergy. Most were dressed in poor clothes, many purchased secondhand, and a good number went barefoot; some were carrying tools of their trade, having snuck out of the workshop for a few stolen moments.

It was a sight that encapsulated the influences that had brought Michelangelo to that moment. Beneath the statue's gaze was proof positive that Florence was a republican city, made rich by trade and ordered according to the ways of the faith, uniting all in admiration for Michelangelo's new statue. But it was also a city of profound socioeconomic inequalities fostered by guilds, a city of political exclusion concealed under a mantle of liberty, and a city torn between religious fervor and ecclesiastical abuses. Politics, business, and the Church were all there in the square: all deceptive in their appearance; all a source of tension, resentment, and violence; and all very much necessary to the art of the Renaissance.

The Workshop of the World

HILE MICHELANGELO WAS carving the David, his artistic life was undoubtedly structured by the shifting world of business, politics, and religion. But the institutional background only tells part of the story. However much the statue was imbued with meaning received from the tortuous inequalities of the period, the slow process of carving the David took place in the context of the mundane realities of day-to-day existence.

Michelangelo was admittedly a very secretive man in the years 1501–4. Having been given permission to carve the *David* in the workshops of the Opera del Duomo, near the cathedral, Michelangelo erected "a partition of planks and trestles around the marble, and worked on it constantly without anyone seeing it." He was already an experienced sculptor, but it was tough work. Whether he was hammering away at his chisel or using his bowed drill, it was strenuous, noisy, and extremely dirty. As Leonardo da Vinci recorded, the sculptor's work was

accompanied by great sweat which mingles with dust and becomes converted into mud. His face becomes plastered and powdered all over with marble dust, which makes him look like a baker, and he becomes covered in minute chips of marble, which makes him look as if he is covered in snow.

But despite his longing for secrecy, Michelangelo's work life was far from secluded. He was continually surrounded by people, and his workshop was always bustling with comings and goings. Assistants and apprentices were constantly hurrying to and fro with materials, and friends—like the talentless stone carver Topolino (Domenico di Giovanni di Bertino Fancelli)—were forever popping in. Day after day, Michelangelo received impromptu visits from the *operai*, keen for

4

updates on progress, from powerful communal figures, like the *gonfaloniere a vita*, Piero Soderini, or from prospective patrons like Taddeo Taddei, looking to commission yet more work or haggle over prices. Tradesmen brought their wares or demanded payment, tax assessors pressed awkward questions, or curious passersby nosed their way in for a peek. On top of this, there were the inescapable dinners with Lodovico and his brothers, family matters to attend to, or servants with whom to talk.

Michelangelo's workshop in the period 1501–4 provides a snapshot of the daily life of the Renaissance artist in the raw. It's a dimension of artistic production that is perhaps easy to forget when familiar conceptions of the "Renaissance" are called to mind. When we plunge into this social whirl, the worries and anxieties, the hopes and dreams, and the obligations and prejudices that conditioned the mind-set of the Renaissance artist and that shaped the content of much of the art of the period appear in vivid detail.

CIRCLES AND SODALITIES

Michelangelo's workshop would have swarmed with people from every corner of the city. In this respect, he was by no means untypical. Although his contemporary Piero di Cosimo was notoriously misanthropic, artists could not but live surrounded by a vast network of people. As Vasari reported, Filippo Brunelleschi was "always having to contend with someone or other," and Donatello was so plagued by requests and obligations that he claimed "he would rather die of hunger than have to think about such things."

But the hordes of people with whom Michelangelo would have had daily contact in the period 1501–4 were more than just an amorphous mass of random individuals. The overwhelming majority fell within distinct circles of social activity, each of which reflected a different sphere of contemporary social existence, was governed by its own values and rules, and carried with it clear obligations that provided the framework not only for work but also for the patterns of everyday life. The dynamics of these circles were, however, anything but reflective of the pure, ideal world conjured up by familiar conceptions of the Renaissance, and Michelangelo's sometimes pleasant, sometimes awful social world was typical of the period.

Family

The first and most important of Michelangelo's social circles was his family. In Renaissance Italy, there was no more important bond than this, and its significance is attested to by the attention lavished on it in works such as Leon Battista Alberti's dialogue *On the Family*. Much more so than today, the family was the primary determinant of the course and character of a person's social life. It not only contributed dramatically toward perceptions of social status but also addressed "a comprehensive array of human needs: material and economic, social and political, personal and psychological."

Returning to live in the family home in 1501, Michelangelo joined a bustling and busy household that was in many senses typical of a period in which the average size of the domestic sphere had grown in step with trends in population. Many artists of his age—particularly if unmarried—lived in households comprising an average of five people across two or even three generations in homes owned or in the names of the eldest male. Although his mother had died while he was still a child, his father continued to be in active control of the household, and Michelangelo had no fewer than five siblings, four of whom were still at home. The eldest brother, Lionardo, had entered the Dominican order some years before, but his sister, Cassandra, and his remaining three brothers—Buonarroto (1477–1528), Giovansimone (1479–1548), and Gismondo (1481–1555)—were just beginning to test their luck in the world under the umbrella of the family.

Michelangelo's redoubtable father, the fifty-seven-year-old Lodovico, controlled everything in the eyes of the law. What Michelangelo earned, he kept, but if his father helped him in any material sense, Lodovico could legally claim half of all of the profits. By the same token, Michelangelo could not enter into any contract without Lodovico's prior permission, and he could not even make a will without his father's say-so. Indeed, it was not until Michelangelo was thirty-one that he was formally emancipated from his father's control. That, at least, was the state of affairs in legal terms. In practice, things were more complex.

As is suggested by the letter he sent to Michelangelo in late 1500 warning him about his financial affairs (see previous chapter), Lodovico was an affectionate and doting father. But he also looked to his second son as the family's primary breadwinner and expected to be looked after. Perceiving himself to be an old man, far advanced in years, he told Michelangelo, "I must love myself first, then others. Until now, I loved others more than myself." Unmarried and happy to be welcomed back into the family fold, Michelangelo gladly undertook this obligation, and in this regard he somewhat resembled his contemporary Antonio Correggio, who, "for the sake of his family, . . . was a slave to his work." Only on rare occasions did Michelangelo complain that his support was underappreciated.

Lodovico was, however, also a little suspicious of Michelangelo, and one detects a hint of disapproval lurking beneath his affection. He was inordinately proud of his social status and deplored the fact that his son had chosen so insecure a career. He was something of a snob. He claimed ancestral ties with the Medici and, through his late wife, links with the powerful Rucellai and del Sera families. Although very far from wealthy, he hailed from a family that had made its money as bankers and cloth merchants (in true Florentine style) and that had a long history of public service. Lodovico himself had served as the Florentine podestà of the commune of Chiusi, and his name had been drawn out of the hat for public office on at least thirty-five occasions between 1473 and 1506. Although he felt that it was beneath his status as a gentleman to have an occupation, he had wanted Michelangelo to pursue a career in the cloth industry, or possibly law, and seems to have struggled to understand his son's choice. Happy as he was to accept Michelangelo's money whenever it was offered, he never really lost an opportunity to snipe at his son's choice of profession over family dinners. It's all too easy to imagine Michelangelo forcing himself to bite his tongue as he listened to yet another diatribe about how much better it would have been had be been a banker.

Simultaneously, relations with the rest of his family were a predictable mixture of emotional closeness and pent-up frustration, and in his letters he alternates between joy and reproach. Buonarroto who would later be elected a prior of Florence—was undoubtedly his favorite brother, but the others were a different matter. Giovansimone was a more difficult character. Although willing to throw himself into an investment venture with Giovanni Morelli, he was evidently lazy and ill-suited to business. Only a few years later, he and Michelangelo would quarrel violently about money and Giovansimone's willingness to leech off their father. The youngest brother of all, Gismondo, was to be of a similar bent, but as yet he remained in the background. Other, more distant family members were another matter altogether. Although he never shirked from his obligations, Michelangelo was also not immune to bitterness, and after the death of Lodovico's brother in 1508 he had no shame about describing his widowed aunt as "that bitch."

Friends

After family came friends. For Renaissance men, the bond of friendship was tighter and more intimate than we might be inclined to think today. It was, indeed, regularly idealized. For Petrarch, a friend was "much rarer and more precious than gold": he was "another self," a mirror of the conscience, and a light of perfect virtue. The ideal friend was chosen only for his inner merits: social standing had no place, and the bond, once formed, endured even beyond the grave. So close was the perfect friendship that Boccaccio was even able to imagine two friends—Titus and Gisippus—being willing to trade a wife (on the wedding night, no less) or sacrifice a career for each other's sake.

Friendship also had a deeply practical dimension. As the lively correspondence between the notary Lapo Mazzei and the Pratese merchant Francesco di Marco Datini reveals, friends gave—and expected material assistance. Mazzei, for example, offered Datini extensive advice on how to handle his tax assessment, how to deal with the collection of debts, and how to manage his daughter's marriage contract. In return, Datini sent Mazzei a choice gift of anchovies, countless barrels of wine, and even firewood. So, too, Petrarch recommended his friend Laelius (Lello di Pietro Stefano Tosetti) for a job with Emperor Charles IV in 1355, and the Florentine chancellor Coluccio Salutati helped to secure positions at the papal court for his humanist friends Poggio Bracciolini and Leonardo Bruni in 1403 and 1405. In the same vein, Fra Bartolomeo of San Marco taught Raphael the proper use of color, while Raphael taught his mendicant friend the principles of perspective.

Yet even more than this, friendship—as the framework for the exchange of news, views, and the odd bit of help—was the context for the development of habit, taste, humor, and outlook. As Giorgione's fondness for "entertaining his many friends with his music" suggests, it was the setting for laughter and tears, celebration and commiseration,

guidance and reproach, and few artists would ever have become the men they were without their friends.

Michelangelo's friends included an eclectic group. At the upper end of the social scale—close to his own familial status—were the merchant Jacopo Salviati and later the cathedral chaplain Giovanfrancesco Fattucci. These men were well-bred, and Michelangelo's correspondence is full of elegant, well-turned phrases, but in face-to-face interactions there is little evidence of formality. As is common today, these friendships were probably marked by any amount of silly banter and coarse humor. In the *Decameron*, for example, Boccaccio included a tale of how Giotto and his friend the renowned jurist Forese da Rabatta jokingly laughed at each other on a journey, the one for being horribly untidy after being drenched by the rain, and the other for being "deformed and dwarf-like . . . with a snub-nosed face that would have seemed loathsome alongside the ugliest Baronci who ever lived." Michelangelo, who loved a joke, probably couldn't resist indulging the same sort of goodspirited teasing with his well-heeled chums.

It is, however, telling that the majority of Michelangelo's closestand most enduring-friendships were with people of a lower social status. Unlike humanists such as Salutati, Bruni, and Bracciolini, who tended to form tight-knit (if occasionally fractious) circles from among their own sociocultural ranks, Michelangelo and many artists of the period often looked outside their profession for company. Although in later life he was to befriend Sansovino, Pontormo, and Vasari, he consorted with few artists in this period (excluding Francesco Granacci and Giuliano Bugiardini) and none of his standard. Instead, he preferred the company of stonemasons like Donato Benti, Michele di Piero Pippo, and the amusingly incompetent Topolino. Toiling together in the workshop or in the quarries of Settignano, they would also frequently have lunch together, and over a bottle of wine and a simple soup they would swap bawdy stories and the jokes of the street. The tenor of these friendships is indicated by a sheet of paper Michelangelo and his pupil-friend Antonio Mini passed between them years later in Rome. Mini sketched an appallingly misshapen giraffe, while Michelangelo countered with a beautifully executed drawing of a man showing off the glories of his anus. High-minded these gatherings were most definitely not. It is perhaps sobering to think of Michelangelo roaring with laughter at similar sketches while the David was standing half-finished behind him.

The Workshop Circle: Patrons, Assistants, and Apprentices

Outside the world of family and friends, the bulk of Michelangelo's social contacts inevitably related to work. But here again, we encounter an unexpected mixture of formal relationships and very human, often scatological behavior that reflects a combination of regimented obligations and irreverent habits that was typical of Renaissance artists.

Of greatest significance were, of course, the patrons. These included the consuls of the Opera del Duomo, the *gonfaloniere a vita*, Piero Soderini, and the merchants Taddeo Taddei, Bartolomeo Pitti, and Agnolo Doni. They were all august men and—as surviving portraits suggest—highly conscious of their status. Despite being an old and wizened man, hunched over with age, Soderini commanded respect with the finery of his clothes and the piercing gaze that peered out over his large, beak-like nose, while Doni, a younger and infinitely more handsome man, had the haughty mien appropriate to the wealth displayed by the multitude of gold rings adorning his fingers. Their perceptions of their own status were important. Although Michelangelo had previously enjoyed a very close relationship with Lorenzo de' Medici, his relations with patrons in this phase of his life were very much more businesslike.

The greater part of his time was, of course, taken up with detailed negotiations about major commissions, like the *David*. These could be tortuous. Patrons not only habitually demanded sketches or models of what they wanted, but also insisted on sometimes exhaustively detailed contracts and occasionally interfered later to quibble over execution or similar details. But there were also a host of patrons popping into the workshop to ask for smaller, more everyday pieces of work—such as the chimney decorations or wickerwork chests completed by Donatello, or the bronze knife that Piero Aldobrandini was later to commission from Michelangelo—commissions that artists were compelled to accept to appease the rich and powerful.

Whether the commission was large or small, however, there was always trouble, and the appearance of a patron at the workshop was more often than not met with a sigh or a terse greeting muttered through gritted teeth. Payment was a particular difficulty. In his autobiography, Cellini was scathing about tardy remuneration, and Vasari relates that Donatello smashed a bronze bust to smithereens in frustration at a Genoese merchant's unreasonable quibbling over the bill. Paralleling the experience of artists, the incomparably catty humanist Francesco Filelfo was even forced to beg his friend Cicco Simonetta—a statesman and noted cryptographer—for a loan because the duke of Milan's treasurer kept fobbing him off when he came to ask for his bill to be settled.

But there could also be more trivially irritating troubles. While painting some scenes from the lives of the Fathers of the Church in the cloister of San Miniato, for example, Paolo Uccello was aggrieved that the abbot would give him nothing but cheese for his meals. Cheese pies, cheese soups, cheese and bread: always cheese. Being "mild-mannered," he initially said nothing, but after a little while the parsimonious monotony of the diet became too much. Uccello left the monastery and refused to work there until he was given something better to eat.

Michelangelo had even more frustrating experiences. After the completed *David* had been moved to its final resting place outside the Palazzo Vecchio, Michelangelo was atop a ladder making last-minute adjustments when Piero Soderini himself appeared below him. With supreme self-confidence, Soderini complimented Michelangelo but wondered if the nose wasn't perhaps a fraction too thick. Descending politely to "check," Michelangelo discreetly picked up a handful of dust and ascended once again to make the "changes" Soderini had suggested. Pretending to tap with his chisel, he let the dust fall through his fingers. "Now look at it," he called to Soderini. "Oh, that's *much* better!" came the reply. "Now you've really brought it to life." Yet however irritating they may have been, patrons like Soderini paid the bills (in theory at least), and Michelangelo and his colleagues had to keep smiling.

Rather more pleasant—though not always so—were Michelangelo's relationships with his assistants and apprentices. It is not known just how extensive his workshop was in 1501–4, but while he was painting the Sistine Chapel a few years later, he employed a minimum of twelve people at any given time. Excepting old friends like Topolino and Granacci, most of those who worked with Michelangelo were young, mostly adolescents, and frequently lived in. In later years, he wrote to his father from Rome asking for help in finding just such an assistant and, in doing so, gave us a good idea of the sorts of people he surrounded himself with in his workshop:

I should be glad if you would see whether there is some lad in Florence, the son of poor, but honest people, who is used to roughing it and would be prepared to come here to serve me and do all the things connected with the house, such as shopping and running errands, and who in his spare time would be able to learn.

The relationship was naturally based on work and hence could often be punctuated with squabbles or even dismissal. Michelangelo continually had trouble with his assistants and had to sack several for poor workmanship, laziness, or even—in one particular case—because the lad in question was "a stuck-up little turd." On occasion, Michelangelo had to turn people away before they even got through the door: in 1514, for example, a father offered his son as an apprentice by recommending the boy as a sexual plaything rather than as an apprentice.

Usually, however, the relationship was close and frequently highspirited. Even though a daydreaming assistant had ruined one of his portraits through inattention, Botticelli positively encouraged good humor. On one occasion, he and one of his apprentices named Jacopo played a practical joke on his pupil Biagio by sticking paper hats onto the angels in one of Biagio's paintings to make them look like miserable old men. Simple stuff, perhaps, but childlike amusements helped the hard work go quicker.

Over the Counter, Through the Wall

On top of all this, and perhaps most commonly ignored by historians, were the mass of incidental, almost forgotten social interactions that supported the basic necessities of life. These, too, constituted a circle of sorts, in much the same way as we may think of our next-door neighbors, local shop owners, and even the postman as part of the loose circle of our everyday existence today. As in the modern world, there was little or no formal or theoretical apparatus governing behavioral patterns in this area of social life, but the importance of dealings with the multitude of tradesmen, market-stall owners, and servants should not be minimized. Michelangelo's correspondence—which is often addressed to family members care of a shop or a trading emporium—is littered with requests for bills to be settled or for orders to be placed, now for wax and paper, now for shirts and shoes. Quality and price were always of central concern, but so was a sense of fair play and decency, and we can glimpse in Michelangelo's letters hints of the chatty exchanges in the Mercato Vecchio or the angry arguments in shops that would have punctuated his days and defined his view of his place in the wider urban environment.

There were also neighbors to be considered, and they could not, in fact, be ignored in so community-minded a society as Renaissance Florence. Although often hidden from the historian's view, these more mundane social interactions-beyond the bounds of family, friends, patrons, and workshop-occasionally shine through in the evidence. While undoubtedly harmonious in some cases, what testimony we possess points toward something resembling a soap opera. Botticelli, for example, was enraged when a cloth weaver moved in next door to him. Eliding home and business, the weaver set up shop with no fewer than eight looms on the go all day, every day. The noise was deafening, and, what was worse, the vibrations of the looms caused the walls to shake to a ridiculous degree. Botticelli quickly found himself unable to work. Anger took over. Rushing upstairs, Botticelli balanced a huge stone on the very top of his roof (which was somewhat higher than the weaver's) and loudly proclaimed that it would fall unless the shaking stopped. Terrified of being crushed to death, the poor weaver had no option but to come to terms. Extreme though this incident may have been, there is no doubt that Michelangelo would have had to deal with similar sorts of concerns

As Michelangelo's social circles suggest, there was perhaps no clear, overall picture encapsulating the immediate society of the Renaissance artist, but a shifting web of overlapping, interlocking, and sometimes conflicting social networks. Formal obligations coexisted with idealized relationships, and bawdy jokes sat alongside angry arguments and ritualized but insincere expressions of respect. Duty to family and friends similarly interacted with fraught, or funny, relationships with apprentices and crossed the boundaries of class and social status as patrons entered the equation. Far from being elevated to the status of a highminded, truly independent individual, far removed from the hustle and bustle of ordinary existence, Renaissance artists like Michelangelo were always being swept along by the shifting currents of the society in which they lived, pulled always this way and that, shaped by the tastes of one group, the humor of another, and the demands of a third.

Most important, these shifting relationships, obligations, and values shine through in the art of the period. On the one hand, there is a clear conceptual and creative link to be drawn. Concepts of family and even the conflicted experiences of family life are implicit in Michelangelo's depiction of Mary, Joseph, and the infant Christ in the Doni Tondo and Ghiberti's bronze rendering of the sacrifice of Isaac on the doors of the Baptistery; the artist's dependent but fraught relationship with his patrons is glimpsed in Botticelli's inclusion of a sly, slightly disdainful self-portrait alongside Cosimo, Piero, and Giovanni de' Medici in the Adoration of the Magi (Fig. 5); the importance of friendship is seen in Taddeo Gaddi's inclusion of the figure of Amicitia among the virtues in the Baroncelli Chapel in Santa Croce; and the value of workshop banter shines through not only in many of Vasari's pen portraits of the artists but also in the multitude of playful details in larger artistic works that reflected the often fruitful relationship between the artist and his assistants. But on the other hand, the influence of these social circles can be seen at play beneath the surface of the artworks themselves. It was the obligations owed to family, friends, patrons, and even assistants that to a greater or lesser extent drove production itself; and it was the values thrashed out in the melting pot of these relations which shaped the form that production took.

Women

Perhaps the most striking thing about the evidence for the composition of Michelangelo's social circles in this period is the fact that it presents his social world as overwhelmingly male. With the fleeting exception of his elusive sister, Cassandra (whose date of birth is, tellingly, unknown), his "bitch" aunt, and the family housekeeper, women are all but invisible. He seems to have had almost nothing to do with them.

In some ways, Michelangelo's story in the period 1501–4 is not altogether remarkable in this respect. It is not that his reputed disinterest in women at this time was common. Indeed, quite the contrary. The majority of artists—even the misanthropic Piero di Cosimo—either married or pursued continual affairs with unabated enthusiasm, as was the case with Raphael. Nor was Michelangelo cut off from women any more than any other artists. Given that they made up 50 percent of the population of the city, ordinary life was, quite naturally, swarming with women at every turn, and no artist, however immune to female charms, could avoid female interaction whether inside or outside the family. Rather, the comparative invisibility of women speaks to a certain facet of gendered existence in Renaissance Italy and its reflection in the male-dominated written culture of the period.

Women were commonly regarded with a mixture of pious idealism, paternalistic condescension, and legal misogyny. For a host of poets and literary figures, they were very definitely the weaker sex. Even when writing a work specifically designed to praise the achievements of women—the *De mulieribus claris* (1374)—Giovanni Boccaccio felt obliged to point out that the celebration of outstanding women was necessary given the natural and profound limitations of their gender. Indeed, such achievements as they could claim were only due to their assuming "male" characteristics. "If we grant that men deserve praise whenever they perform great deeds with the strength bestowed on them," Boccaccio asked, "how much more should women be extolled almost all of whom are endowed by nature with soft, frail bodies and sluggish minds—when they take on a manly spirit, [and] show remarkable intelligence and bravery?"

This view, which was entirely commensurate with contemporary religious opinion, found expression in legal norms. Until she married, a young girl like Michelangelo's sister, Cassandra, was totally subservient to her father, and her function and status were determined in relation to the needs of the household. In the city's wealthiest families a modicum of education was seen as befitting a girl who would be used as a marital pawn in forging advantageous familiar alliances, but beyond a smattering of training in languages, music, and dancing, little attention was given to learning. "Book learning" remained a man's preserve. In less well-to-do families-perhaps including Michelangelo's own, which lacked a mother figure—an unmarried girl was little more than an unpaid servant. Education was not a high priority, and that Paolo Uccello's daughter "had some knowledge of drawing" alone was something of a surprise. In most Florentine households, the daughter might be expected to help with backbreaking domestic chores and contribute to the family income from an early age by selling produce at the market,

working looms, or spinning wool with her mother. Above all else, however, she had to protect her most precious asset: her virginity.

Marriage was a woman's ultimate goal: in the Renaissance mind, it was what a girl had been born for. Legally speaking, it was possible for her to marry at any point after her twelfth birthday, but the age at which a girl took the leap very much depended on her family's socioeconomic status. If she hailed from a patrician background, her family would arrange for her to marry a suitable husband when she was between thirteen and fifteen, always with the goal of achieving a suitable familial match, and conventionally endowed with a satisfactory dowry. The girl seldom had any choice in the matter. Indeed, she could expect to have virtually no say in any part of the wedding arrangements either: in 1381, Giovanni d'Amerigo Del Bene complained that the satin gown desired by his future daughter-in-law was "too lavish" and sought to arrange a more suitable garment with her prospective husband, Andrea di Castello da Quarata. Although the poor girl's mother was unhappy with the marriage, Giovanni simply dismissed her behavior as "bizarre" and undignified. Lower down the social scale, girls tended to marry when they were slightly older. But even here, few were given much say in the selection of a husband, and many found themselves hitched to much older men. At the average Florentine wedding, the groom could be expected to be twelve years older than his bride.

If anything, a woman's legal status actually deteriorated after marriage. Like those of virtually every other city in Italy, Florence's municipal statutes deprived a married woman of the right to enter into contract, to spend her own income, to sell or give away property, to draw up a will, or even to choose a burial place without her husband's approval. Legal separation was virtually impossible to obtain, and complete divorce was simply not recognized, even in cases of brutality and manifest adultery.

At the same time, a young married girl also found herself subject to the exacting expectations of Florentine society. It was anticipated that she would devote herself entirely to her family, and most especially to her husband. A glimpse of what this entailed can be found in the Venetian Francesco Barbaro's aptly named treatise *On Wifely Duties*, which he presented to Lorenzo de' Medici and Ginevra Cavalcanti on the occasion of their marriage in 1416.

For Barbaro, there were three wifely duties necessary to a praise-

worthy marriage: "love for her husband, modesty of life, and complete care in domestic matters." Of these, perhaps the most important was the third, for which women, being "by nature weak," were especially well suited. It was a demanding duty. A noblewoman like Ginevra was expected to manage the household, particularly by ordering her servants appropriately, appointing "sober stewards for the provisions," arranging for food and accommodation for the household staff, and managing the domestic accounts. On top of this, there was the education of children, especially girls, to be attended to. In less august households, including those of artists such as Lorenzo Ghiberti and Paolo Uccello, but most particularly in the homes of the popolo minuto, the wife was expected to assume responsibility for everything: cooking, cleaning, washing, darning, and any other such tasks that her husband might select. Where money was needed, the wife could also be compelled to undertake some sort of menial occupation. Although millinery and lace-making had always been the preserve of women, most women were limited to spinning, laundering, nursing, and the like, or found work in cookshops and taverns or as domestic servants like the Buonarroti family's longtime housekeeper, Mona Margherita. Whatever they did, they were poorly paid.

Modesty was a rather more complex obligation but no less regimented. In this regard, dress was particularly important. For Barbaro, a wife should "wear and esteem all those fine garments so that men other than their own husbands will be impressed and pleased," and she was obliged virtually to forget her own tastes. This was a view that Michelangelo's fellow artists clearly shared. Perugino, for example, took so much pleasure in his wife wearing nice clothes that "he very often attired her with his own hands." What Perugino's wife thought of the elegant but modest attire that was foisted on her is not recorded. The same degree of modesty, Barbaro claimed, applied to "behavior, speech, dress, eating, and"-saving the best until last-"lovemaking." Even in the act of procreation (for which marriage was designed), the woman was expected to safeguard both her virtue and that of her husband. Ideally, she should remain covered-to the point of being fully dressed—while having sex. It hardly needs saying that sexual modesty was expected to include an absolute fidelity to the husband that could brook no question. As Matteo Palmieri expressed it, even the faintest

hint of infidelity should be regarded as "the supreme disgrace" that was "worthy only of public humiliation."

Love was similarly stringent. Far from being the romantic love of today, the idea of *amore* that was foisted upon women like Michelangelo's poor sister, Cassandra, was in almost all senses equivalent to mere subservience. As Barbaro argued, a woman should

love her husband with such great delight, faithfulness, and affection that he can desire nothing more in diligence, love, and goodwill. Let her be so close to him that nothing seems good or pleasant to her without her husband.

Tellingly, this meant not complaining under any circumstances. Wives must, Barbaro believed, "take great care that they do not entertain suspicion, jealousy, or anger on account of what they hear." If her husband was drunk or committed adultery or wasted the household income on gambling, she just had to smile and carry on.

Should the man find something to complain about, however, the situation was quite different. Boccaccio went to great lengths to praise the fictional Griselda for demurely enduring the almost ritualized humiliation doled out by her husband, a story commemorated in a series of three paintings (now in the National Gallery in London) designed for the decoration of a home by the "Master of the Story of Griselda" ca. 1494. Beatings and domestic violence were accepted and even encouraged. In his *Trecentonovelle*, Franco Sacchetti blithely pointed out that "good women and bad women need to be beaten." Although there are records of women petitioning the courts for redress after suffering brutality, such cases are rare.

If this picture is to be believed, Giorgione's early-sixteenth-century painting *The Old Woman* (Accademia, Venice) (Fig. 6) provides us with an image of the fate of many women in Michelangelo's Florence. Perhaps in her fifties (but possibly younger), Giorgione's sitter exemplifies a careworn life of backbreaking labor and legal subjugation. Her thin hair, barely covered by a pitiful cloth cap, hangs down in strands over her wizened, wrinkled face. Her eyes are sallow, surrounded by bags, and her mouth hangs open in exhaustion to reveal numerous missing teeth. Her simple pinkish gown and white shawl are of poor quality, and their careless arrangement suggests that hope has been all but forgotten. She points to herself while holding a scroll reading "col tempo" (with time). It is almost a gesture of warning. Were any women from artisanal families to have seen this picture, this is how they could expect to look and feel as death drew near.

As with so much in the Renaissance, however, the theory didn't quite match the reality, and while women are absent from accounts of Michelangelo's life between 1501 and 1504, there is every indication that they played a much more diverse range of roles in daily existence than the biographies of Vasari and Ascanio Condivi suggest.

Although subject to legal restrictions, women often performed a wide number of economic functions, especially if they were widowed. On occasion, married women could be found taking on some of the administrative work in their husband's workshops, and many records in the Florentine archives testify to women being involved in hiring workers, paying wages, and keeping accounts. More than that, we find women conducting business in their own names. Taking advantage of offers of credit, they engaged in numerous, and quite sizable, purchases; they borrowed money, and they made wills as they saw fit. Similarly, there are instances of married women acting as midwives, moneylenders, and artisans in some trades. Michelangelo did a good deal of business with women during his time working on the *David*, and later in life praised Cornelia Colonelli for managing the affairs of her deceased husband, Urbino, so well.

By the same token, women increasingly demonstrate a considerable degree of education and learning. Despite coming from humble stock and restricting herself predominantly to domestic subjects, Cornelia Colonelli was one of Michelangelo's most devoted correspondents toward the end of his life. So, too, women often appear as independent cultural actors. Although scholars have paid increasing attention to women as autonomous patrons of art and literature in recent years, it is vital to recognize that women also increasingly figured as creative agents. Some years later, Michelangelo's love interest Vittoria Colonna was not only charming but also eloquent and extremely well-read, and noblewomen such as Isabella d'Este are beginning to be appreciated as original and often daring thinkers. There are even incidents of Michelangelo's encouraging women to engage in his own profession. As an old man, he warmly encouraged Sofonisba Anguissola to continue with her painting and was thanked in fulsome terms by her father.

Nor was marriage quite the bed of obedient roses that Barbaro depicted. Boccaccio's tales are littered with examples of thoroughly independent brides giving their husbands what for, and it is not hard to find other examples from literature that testify to the same level of autonomy, especially in the management of domestic affairs. In a poetic letter to Iñigo d'Avalos and Lucrezia d'Alagno, for instance, the rather scabrous Francesco Filelfo observed that

A wife . . . wears out her husband's ears with quarrelsome words. She inveighs against her maidservants. She falsely accuses her serving men: the estate manager brings the plough to the ground too late; the barn is broken and the wine is going bad, she reports. Never is there a moment of peace. First she grumbles and then she complains about her servants' sleeping. She condemns as bad those things she knows are good. Nor does she think anything is enough. A wife is greedy in every way. She wants to fill her home with money.

Forbidding though such a wife might sound, she certainly wasn't meekly subservient to her husband. There is a hint that Michelangelo's "bitch" aunt may have been of the same mold.

Similarly, in married life, the obligations of modesty and love were not always observed to the letter. Despite Perugino's fondness for dressing his wife, women could and did act as major agents of fashion and often dressed in a daring, not to say provocative, manner.

At various points in the fifteenth and early sixteenth centuries, Florence—like many other Italian cities—introduced sumptuary legislation designed specifically to place limits on the daring and luxurious nature of women's dress, and this is testimony as much to the irrepressible tastes of contemporary women as to the occasional bigotry of communal government. In 1433, for example, the priors established a magistracy "to restrain female ornaments and dress" and highlighted the perceived need to prevent women from overexciting the men of the city with their racy clothes. The new officials were "to restrain the barbarous and irrepressible bestiality of women, who, not considering the fragility of their nature, but rather with that reprobate and diabolical nature, they force their men, with their honeyed poison, to submit to them. But it is not in accordance with nature for women to be burdened with so many expensive ornaments." So, too, in the 1490s, Savonarola inveighed forcefully against female luxury, and at his bidding the *fanciulli*—marauding groups of young boys—would persecute women not wearing "decent" clothes. No end of "indecent" dresses, furs, and other accoutrements were thrown into the flames in Savonarola's "Bonfire of the Vanities" on February 27, 1498.

Savonarola and sumptuary legislation aside, there is no doubt that women dressed with an eye both to fashion and to flirtation. In one of his more charmingly piquant verses, the usually broad-minded Giovanni Gioviano Pontano felt compelled jokingly to ask a certain Hermione to cover up:

Me, congealed already by cold age, You're heating up unpleasantly. And so I'm telling you to clothe those shining breasts And veil your bosom with a decent halter. Those milky breasts, why carry them about, Those very nipples, naked and exposed? Are you really saying "Kiss these breasts, Caress these glowing breasts." Is that your meaning?

Such a verse conjures up images such as Piero di Cosimo's portrait of the Genoese noblewoman Simonetta Vespucci (ca. 1453–76)—who was reputedly the most beautiful woman of the age and whom Michelangelo would certainly have heard of during his youth—in the guise of a virtually naked Cleopatra (Fig. 7).

While it may be true that Michelangelo had little romantic interest in women at this point in his life, therefore, his biographers' silence about the fairer sex should be treated with some caution. This reticence appears to be more fully informed by constructions of the proper role of women than it is by Michelangelo's actual social interactions with them.

As wives, mothers, and daughters, they were active and occasionally even dominant figures in the family life of artists like Michelangelo, enduring burdensome responsibilities and legal restrictions, it is true, but also giving shape to domestic life and assuming a powerful role as sources of financial and creative inspiration. In some cases, they were independent economic actors in their own right and were encountered by male artists either as formidable tradespeople to be reckoned with or as "partners" in making ends mcct. But more than that, they were also far from being modest and repressed: they were the engines of fashion and the dynamos of passion.

Although Giorgione's *Old Woman* represents one feature of female life experiences, the diverse roles played by women in Michelangelo's Florence are also reflected in the multifarious ways in which they appear in art. Indeed, some works are unintelligible without recognizing that a woman's place in Renaissance society went beyond the harsh restrictions of law and social convention. As many artists recognized, women were to be seen not merely as stereotyped sexual objects or matronly drudges but also as strong-minded, assertive beings in command of themselves.

The work of one of Michelangelo's contemporaries illustrates this amply. Although Sandro Botticelli's Portrait of a Lady Known as Smeralda Bandinelli (V&A, London) shows the demure, respectable matron described by Barbaro, his Return of Judith (Uffizi, Florence) and Portrait of a Young Woman (Städel, Frankfurt) reveal the complexity of the social picture. In the Portrait of a Young Woman, the subject-possibly Simonetta Vespucci-is ravishingly beautiful and elaborately and inventively arrayed in the most fashionable clothing (Fig. 8). There is a hint of exoticism in the feather in her hair: few traces can be seen of conventional Florentine sumptuary laws. Similarly, her learning and humanistic tastes are revealed by the "seal of Nero" she wears on a pendant around her neck, while the "necklace" formed by her braided hair seems to suggest that she is the only person capable of binding herself to anything. She's a woman in control of herself, a cultural agent in her own right, and a pioneer of daring fashion. So, too, in the Return of Judith, the same characteristics are seen even more clearly (Fig. 9). Although the biblical figure of Judith was often held up as a symbol of chastity, justice, and fortitude as a consequence of her having beheaded the lustful and proud Assyrian general Holofernes, Botticelli invests his rendering of her return to the Israelites with a sense of female independence and perhaps even of sexual autonomy. Accompanied by a serving girl bearing Holofernes's head, Botticelli's Judith is strikingly beautiful yet also fully in control of her own femininity. Though a member of the "weaker sex," she carries an inescapably "masculine" and empowering sword and strides with the assurance of one who is more than able to manage herself no matter how salacious or overbearing the male attention. She is her own mistress and clearly takes no messing around from anyone.

House and Home

In the same way as Michelangelo consorted with people from a wide range of social groups—from patricians to paupers—the homes that he and his acquaintances inhabited reveal multiple, rich layers of variation in patterns of domestic life, embracing everything from the sublime to the sordid, and testify to only one point of consistency—a reality quite distinct from familiar images.

Palazzi

To be sure, Michelangelo was no stranger to the palatial residences of Florence's greatest families. Having lived in the Palazzo Medici Riccardi ten years before, he resumed his acquaintance with such grand buildings on his return to the city in 1501. Courting the favor of influential patrons and enjoying the companionship of powerful friends, he would have spent a good deal of time around palazzi, whether sitting outside on the banchi (wood or stone benches) that were erected around the sides of such homes for clients to await their patrons, or strolling around in the comparative intimacy of inner courtyards. He would, for example, certainly have visited Taddeo Taddei's "most commodious and beautiful" palace in what is now the via de' Ginori (just behind the Palazzo Medici Riccardi) to discuss a commission for a sculpted tondo depicting the Virgin and Child with the infant John the Baptist, and Bartolomeo Pitti's rather unfashionable palazzo in Oltr'Arno-later to be purchased and enlarged by the Medici-to finalize the arrangements for a similar project.

The sole function of palazzi was to impress. Impossibly expensive to build, palazzi were "utterly non-productive as investments" and served only to glorify the wealth of the owner, as Leon Battista Alberti explained in his treatise on architecture. As such, even the most modest palazzo tended to be enormously large. A typical Florentine palace of the mid-fifteenth century had three main floors but stood as high as a modern ten-story building. Similarly, one of the finest examples of palatial architecture, the Palazzo Strozzi, covers an area more than twice that of the White House and utterly dwarfs the presidential residence.

But palazzi were not all that they seemed. The harmoniously proportioned buildings that can be seen in Florence today are generally the product of much later, post-Renaissance remodeling and belie the realities of the hundred or so "palaces" scattered around Renaissance Florence.

The exterior size of palazzi is particularly misleading. Although they were colossal in scale, they were actually built to house a relatively limited number of people and contained only a small number of rooms designed for living. In the majority of cases, each palazzo was intended to house only a single, nucleated family. Thus, the average palace comprised roughly a dozen habitable rooms, most of which were on the *piano nobile* (first floor). Each of these rooms was, however, on a monumental scale. In the words of one historian, the Renaissance palace was characterized principally by "the luxurious inflation of private space around the nucleus of a relatively modest-sized apartment." The size of such rooms—including the bedroom—can be glimpsed in works such as Domenico Ghirlandaio's fresco *Birth of Mary* in the Tornabuoni Chapel in Santa Maria Novella (Fig. 10).

Most misleading of all is the impression of order conveyed by some of the better-known palaces surviving today. Palazzi were hopelessly confused buildings until at least the middle of the sixteenth century. Even at the simplest level, the chaotic nature of Florentine building practices meant that it could often prove difficult to establish where a palace began and ended. Toward the end of the fourteenth century, for instance, Pagolo di Baccuccio Vettori found that the structure of his palazzo was so intertwined with that of his neighbors that he couldn't say exactly where his property began and another's ended.

Even at the level of functionality, Florentine palaces were quite confused places. Although the apartments on the *piano nobile* and above were almost exclusively residential, much of the ground floor could often be given over to different uses, and it was only by the time of Michelangelo's death that palazzi became consolidated into cohesive residential structures. For much of the fourteenth and fifteenth centuries, it was common—even normal—for palaces to have a series of archways giving onto the street that served as the entrances to shops housed within the building itself. For even the greatest men, home life was always accompanied by the sounds and smells of the trade conducted within their own walls, and the grand palace effectively blurred into the street.

The Buonarroti Family Home

Despite—or perhaps because of—the frequency with which Florence's great families described their homes as palazzi, it was sometimes difficult to tell the difference between a relatively small palazzo and a large private house. Although there was certainly a disparity of scale, the houses of the well-to-do were in many ways similar to palazzi, and it was with a conscious effort to ape the ways of the powerful that professional men like the accountant Michele di Nofri di Michele di Mato (I387–I463)—whose description of his home is perhaps the only of its kind to survive—constructed their dwellings. Indeed, so strong are the similarities with regard to the character of rooms and the nature of furnishings that it has rightly been observed that "viewing the material worlds of different social strata as discrete separate entities is misleading."

It was this sort of house that the Buonarroti family had inhabited in Florence during Michelangelo's childhood and that he probably returned to in the period 1501–4. He was also to purchase three examples of this type of habitation for 1,050 large florins on March 9, 1508. In common with the palaces of his patrons, they were noisy buildings. Like the accountant Michele's house—which was sandwiched between other residential properties and a silk workshop (*filatoio*)—the Buonarroti family home (and Michelangelo's later properties) would have been nestled among a multitude of shops, inns, emporia, and worse. Only a few hundred meters away, on the site of today's Teatro Verdi, was the Stinche, the prison most famous for housing convicted murderers and traitors prior to execution. On still nights, you can imagine the distant cries of the condemned mingling in the air with the stench of horse dung and rotting vegetables trodden into the streets.

Above street level, Michele the accountant's house contained nine rooms. On the first floor, there was a living/reception room, a master bedroom, a study, and a smaller bedroom. Given the Renaissance penchant for mezzanine levels and Michele's own rather confused description, it is difficult to determine the arrangement of the remaining floors with any precision. It is, however, clear that the second floor was dominated by a large kitchen (complete with imposing fireplace), a porch, and a terrace open to the elements. A third floor contained two or three rooms, including a servant's room and a storeroom/pantry (*anticamera*). Their arrangement aside, the fact that Michele could distinguish between rooms on the basis of their function is telling. In earlier centuries, it had been uncommon to use any particular room for a fixed purpose, and any given area of a house of this variety could be devoted to a number of different tasks. It was only by the time Michele purchased his house that rooms were being set aside specifically for cooking and eating and that interior spaces such as the *studio* were being clearly identified as such.

The most revealing feature of Michele's house is, however, its contents. The increasing clarity with which rooms were being defined had led to a new attitude toward interior decoration. As bedrooms, kitchens, and studies became established as such, there was a need for more, increasingly specialized furniture appropriate to the function of each room. Chairs, tables, and chests became more common and, especially when placed on the *piano nobile*, more elaborate. Cupboards—so common now that we barely give them a thought—started to come into fashion, initially as a luxury item. Michele also lists a daybed (*lettuccio*) with a decorated backboard (*capellinaio*) and a large, possibly painted, chest (*cassone*). These testify not merely to the increasing "domestication" of interior space in the homes of the comfortably off, but also to the rise of comfort and decoration as major concerns.

Most telling of all, however, is the presence of weapons. In contrast to the impression of security and stability conveyed by the proliferation of furniture, it is clear from Michele's description that the Renaissance home was still liable to be attacked by violent mobs or caught up in the midst of destructive riots. Like his patrician acquaintances, Michele made sure that there were a number of weapons—especially swords—in strategic locations. On a mezzanine level above his study, he kept a cache of arms. He was, however, particularly eager to stress that a stash of weapons was also stored right next to the front door. It is an illustration of the brutality to which middle-class homes were vulnerable that many Renaissance treatises on ideal homes emphasize that this is the *best* place to keep arms. Comfort cost money; money carried risks; and risks demanded weapons.

The Artisan's Home

Although Michele's house provides a good indication of the nature of Michelangelo's family home and his future properties, it gives little impression of how the majority of his friends and other artists actually lived between 1501 and 1504. While it may be reasonable to draw attention to continuities in certain features of material culture (tableware, devotional items, and so on), there was a world of difference between an accountant's house and an artisan's home. The people who were perhaps closest to Michelangelo—like Topolino and Michele di Piero Pippo—as well as a good many artists, would have lived in a much more modest way. Even so successful and renowned an artist as Donatello lived in "a poor little house which he had in the Via del Cocomero, near the nunnery of San Niccolò."

Although naturally subject to even greater variation than palaces or larger homes, the houses inhabited by the majority of artisans had a number of common characteristics and can be thought of primarily along the lines of the buildings Michelangelo would have encountered on his journey through Oltr'Arno en route to Santa Maria del Carmine. Of basic and frequently ramshackle design, these houses were perhaps easier on the eye (and the nose) from the outside than they were inside. Made of densely packed earth or broad wooden boards, the floors were simple and dirty. There were few windows, and even then they were, for many centuries, protected from the elements only by wooden shutters and secured against unwanted entry by the occasional use of crude iron bars or grilles.

With only a few small doorways and windows, such houses were invariably dark and dingy. For the same reason, ventilation was variable: while they were open, windows and doors could allow air to circulate tolerably well, but when closed, they offered very little protection against the elements. During the intense heat of summer, it was sometimes possible to keep a house relatively cool, but in winter it was extremely difficult to keep out the perishing cold. This was a serious problem. In most households, there was only one fire—normally set in the middle of the largest room on the ground floor—which served both for cooking and for heating. The need to focus the fire for cooking left many parts of the building unheated, and the fact that cloths hung across doors or windows constituted the only form of insulation left most of the house freezing cold in winter months. But the more effort was made to conserve heat, the more unpleasant the atmosphere became.

For many artisans, such as weavers or spinners, a small and limited home was also a workshop. In some cases, guild-based workshops could make up the ground floor of a building, while the upper stories were given over to living quarters along much the same lines. But more commonly, there was often nothing to distinguish the workshop from the home at all. At the time Michelangelo returned to Florence, for example, his contemporary Piero di Cosimo was living and working in a house that his late father (a toolmaker of very modest means) had bought in the via della Scala, not far from Santa Maria Novella. It was also shortly after completing the *David* that the Opera del Duomo actually constructed a house for Michelangelo to provide him with somewhere to carve statues of the twelve apostles for the cathedral, and it is conceivable that he took up residence there.

When he ultimately left Florence for work in Bologna, Michelangelo told his younger brother Giovansimone that he was living in the most awful surroundings and had been forced to share his bed (the only bed in the house) with his three assistants. As this suggests, the houses that many artists—especially those less affluent than Michelangelo—lived in were very much like sardine cans, albeit with fractionally less privacy and order.

But most of all, the artisan's home would have been a smelly and unpleasantly dirty place. With the stench of cooking, sweaty bodies, and animals filling the house, cleanliness was a natural concern. Although many accounts show housework to have been absolutely backbreaking, especially in houses with earth floors and rudimentary bedding, washing would have been a particularly troublesome chore. For the most part, the fact that the nearest source of water was often a well serving dozens of houses in the quarter made washing clothes a social activity. Wives and housekeepers would gather to rinse the dirt out of their simple clothes, swapping gossip, arranging marriages, and trading insults all the while. The "clean" washing was laid out to dry on the grass or, more likely in the center of Florence, hung on makeshift lines stretched between the ramshackle houses. In such a densely populated, dirty, and dusty city as Florence, it's not hard to imagine that clothes would have been only very slightly cleaner after washing than they were to begin with.

In general, simple pragmatism meant that bodily cleanliness was

not a major priority for ordinary folk, and a hot bath was a rare luxury. On the rare occasions when contemporary accounts speak of bathing. it is depicted as an activity limited to the upper classes (for whom it was often a ritual or social practice) or as confined to the bathhouses scattered around the larger towns, until their reputation for being harbors for disease and prostitution caused the majority of them to be shut down in the early seventeenth century. At most, Florentine men and women of modest means would have washed their hands occasionally. and splashed their faces with a little water if they wanted to impress. It is perhaps no surprise that body odor became a major indicator of social standing in Renaissance Florence. But it is arresting to note that until very late, most people actually had a horror of keeping clean, even in the face of abject poverty. After having been told of the straitened circumstances in which Michelangelo was living in Rome in 1500, for example, his father wrote to offer advice that testified to contemporary attitudes. "Live carefully and wisely," he urged, "stay moderately warm. and never wash; give yourself rubdowns and don't wash yourself."

HEALTH AND SICKNESS

Given the cramped and unhygienic nature of many of Florence's residential areas, it is no surprise that sickness and disease were permanent parts of everyday life, and it was entirely representative of ambient conditions that Lodovico should have drawn attention to Michelangelo's poor health in urging him to return home.

Despite his longevity (he would live to be eighty-eight), Michelangelo suffered from a host of illnesses throughout his life, most of which were brought on by living conditions and diet. As a child he was somewhat sickly, and as an adult he frequently complained of illness. The painful swelling in his side that Lodovico had mentioned in 1500 was a taste of things to come. While painting the Sistine Chapel, he developed a goiter (usually caused, as he noted, by bad water in Lombardy) and by 1516 was lamenting that sickness had made him unable to work. By the time he was an old man in Rome, his condition really did begin to deteriorate. His face was "a sack for gristle and old bones," a "ghastly" sight, and he couldn't even sleep for his catarrh. What was worse, he developed a painful urinary problem that made going to the lavatory difficult and woke him up at awkward hours: Urine! How well I know it—drippy duct compelling me awake too early, when dawn plays at peekaboo.

Around the time he wrote this self-mocking verse, he became so sick that friends began to fear for his life for the first time.

Michelangelo was certainly not untypical of his times. The high incidence of illness is visible in surviving portraiture and in a general fascination with the grotesque during the Renaissance. Leonardo's sketch of a grotesque woman—later worked into a full portrait by the Dutch artist Quentin Matsys—is probably a depiction of a sufferer of Paget's disease (a condition that causes the enlargement and deformation of the bones), while it has been speculated that the sitter's peculiar hand gesture in Botticelli's *Portrait of a Youth* (National Gallery of Art, Washington, D.C.) points to early-onset arthritis (Fig. 11). Similarly, Masaccio's fresco *Saint Peter Healing the Sick with His Shadow* in the Brancacci Chapel depicts a kneeling figure severely disabled by a congenital disorder that has left his legs painfully withered.

While it is true that not all illness was quite as severe or as disfiguring, diseases and sickness were nevertheless rampant in Renaissance Florence, and Michelangelo's own experiences were a testimony to the extent to which poor living conditions could wreak havoc with people's lives, even among socioeconomic elites. In April 1476, for example, the noted beauty Simonetta Vespucci died from pulmonary tuberculosis at the age of only twenty-two, an illness that was perhaps exacerbated—if not brought on-by damp conditions. Inadequate diet frequently caused urinary or kidney problems comparable to those experienced by Michelangelo, and eye infections were especially common. Catarrh-from which Michelangelo complained of suffering—was prevalent and most commonly affected the elderly, sometimes with unexpectedly severe effects. According to Vasari, Piero della Francesca "went blind through an attack of catarrh at the age of sixty." Similarly, dropsy (edema), caused by malnutrition, claimed the life of Michelangelo's friend Jacopo Pontormo. It hardly needs saying that tooth decay-while clearly not fatalwas a serious problem and tormented Cellini severely.

But in the squalid and overcrowded residential areas of the city, there were a multitude of maladies that carried off hundreds every year. The streets themselves were occasionally host to disfigured lepers who wandered into the city in defiance of the long-standing prohibition on their entering the gates, and who rang bells to warn passersby of their presence. The home was, however, the principal site of illness. In winter, damp, cold houses were the ideal environment for bronchitis, pneumonia, and influenza. Infants and the elderly were especially vulnerable and died in droves. In the hot, sticky summers, dysentery—nurtured by the inadequacy of the water supply—was rampant, while diarrhea caused by food that had gone off in the heat—regularly proved deadly to children.

Typhus—which was described by Girolamo Fracastoro in his treatise *De contagione* (1546)—was a constant threat. Possessing only a few sets of clothes and unable to keep houses properly clean, the Florentine poor were continually plagued by lice, and thus had no defense against typhus. When an epidemic struck—as it regularly did—it would spread from house to house, and from family to family, with breathtaking speed. In the pressure-cooker environment of the Stinche, typhus could wipe out hundreds in the blink of an eye. Michelangelo's work on the *David* only just predates the worst outbreak of typhus in Italy, which extended from roughly 1505 to 1530.

In a similar vein, malaria was a depressingly regular feature of life, especially in areas like Florence and Ferrara that were surrounded by marshes and lakes which provided the ideal home for the mosquitoes that spread the disease. Especially in summer, it would hit the city with a vengeance. Often laboring in the fresh air and with little understanding of how the disease was communicated, working men and women regularly fell victim. It could occasionally prove fatal. As Alessandra Strozzi recorded in her correspondence, her son Matteo had died less than a month after contracting the disease. More often, it was merely painful, unpleasant, and incapacitating. One of its more prominent sufferers was Benvenuto Cellini, who may well have first contracted the illness in his youth in Pisa but who attributed the sickness to "unhealthy air." Subsequent attacks left him "raving" in his delirium so severely that he inadvertently offended the duke of Mantua. Finding himself unable to work, he began to fear for his life.

Shortly before Michelangelo returned to Florence to begin work on the *David*, however, a new disease had arrived in Europe that was less susceptible to becoming an epidemic but was no less serious. Making its first appearance in Europe in the 1490s, courtesy of Columbus and those who had followed him to the Americas, syphilis rapidly took hold. It perplexed doctors seeking to diagnose Michelangelo's patron Alfonso d'Este in 1497 and claimed the life of no less a figure than Francesco II Gonzaga, marquis of Mantua (1466–1519), who began an affair with Lucrezia Borgia in 1503. The disease caused panic, not only because of its unfamiliarity, but also because of its appalling effects. As the Veronese doctor Girolamo Fracastoro observed,

In the majority of cases, small ulcers begin to appear on the sexual organs . . . Next, the skin broke out with encrusted pustules . . . and they soon grew little by little until they were the size of the cup of an acorn . . . Next these ulcerated pustules ate away the skin . . . and they sometimes infected not only the fleshy parts but even the very bones. In cases where the malady was firmly established in the upper parts of the body, the patients suffered from pernicious catarrh which eroded the palate or the uvula or the pharynx or tonsils. In some cases the lips or eyes were eaten away, or in others the whole of the sexual organs . . . Besides all of the above symptoms, as if they were not bad enough, violent pains attacked the muscles [which were] persistent, tormented the sufferer chiefly at night, and were the most cruel of all the symptoms.

The sudden appearance and mysterious etiology of syphilis baffled and terrified the Florentine public, and it seemed that the contagion could only be explained as a punishment from God. But the truth was less complex. Transmitted principally through sexual contact, syphilis found its ideal home in the overcrowded houses of the Renaissance city, where brothels did swift business and people lived (quite literally) on top of one another. While it was liable to strike at random, it was a grim inevitability that it became endemic in Florence's poorer quarters.

But by far the worst disease in Renaissance Florence was the bubonic plague. From its first appearance in 1348, plague epidemics were a regular and terrible feature of Florentine life. Carried by fleas jumping from rats to humans, the disease found a perfect breeding ground in the filth of the city's unpaved streets and chaotic roads. In the absence of any useful medication, and in the cramped, unhygienic conditions in residential areas, infection spread quickly and with often devastating effects. Historians estimate that 30 percent of the Florentine population died in the Black Death (1348–50), and subsequent outbreaks regularly claimed hundreds, if not thousands, of lives. Although the epidemics of 1374 and 1383 appear not to have been quite so severe, the outbreak of 1400, for example, claimed the lives of more than 12,000 individuals and carried off 5,005 people in July alone.

Michelangelo and the artists of the Renaissance were acutely conscious of the risk. Only four years after he completed the *David*, for example, plague broke out with particular venom in Bologna, and letters flew back and forth between Michelangelo and his friends there. Giorgione fell victim to the pestilence in 1510 during his dalliance with a "certain lady" who had unknowingly contracted the malady. Michelangelo's own brother Buonarroto would fall victim to the plague in October 1528. The disease brought terror. After sleeping with the adolescent maid of the Bolognese prostitute Faustina, Cellini fell ill with a sickness with similar symptoms and was petrified that he might have come down with plague. Death lurked around every corner, or, in some cases, in every bed.

SEX AND DESIRE

Despite the continual threat of sickness, the domestic world of the Renaissance was permeated by sex, and as the incidence of syphilis suggests, it would be no exaggeration to say that—religious sentiments and moral prejudices notwithstanding—the home was the workplace of desire. Even if Michelangelo himself appears to have had little appetite for sex (male or female) at this stage in his life, he was quite literally surrounded by it, and it could not but have influenced his outlook on existence.

Premarital Sex

However much ecclesiastical moralists like San Bernardino of Siena might have wished otherwise, sex was most definitely not restricted to the marital bond, and Michelangelo's social circles would have been suffused with premarital liaisons.

Although forbidden, it was almost expected that unmarried men

would indulge in a little light fornication. Typical of the attitude of the period in this regard was the behavior of a number of Michelangelo's contemporaries and near contemporaries. Never one to contemplate marriage, Raphael, for example, conducted an endless stream of love affairs "with no sense of moderation" whatsoever. Even worse was Fra Filippo Lippi. Despite being in holy orders, Lippi was reported to be "so lustful that he would give anything to enjoy a woman he wanted if he thought he could have his way." As Vasari reported,

His lust was so violent that when it took hold of him, he could never concentrate on his work. And because of this, one time or another when he was doing something for Cosimo de' Medici in Cosimo's house, Cosimo had him locked in so that he wouldn't wander away and waste time. After he had been confined for a few days, Fra Filippo's amorous or rather his animal desires drove him one night to seize a pair of scissors, make a rope from his bedsheets and escape through a window to pursue his own pleasures for days on end.

The same was no less true of girls, whose amorous adventures were just as pronounced. So rampant was the sexual experimentation of young females that in 1428 a law was promulgated in Belluno which stated that no woman over twenty could be assumed to be a virgin unless there was conclusive proof of her purity.

This sort of behavior might have been innocent enough, but it also had a more nefarious dimension. Mostly committed by men—or groups of men—outside wedlock, rape was a distressingly common feature of everyday life. There are, for example, endless accounts of humble women being hijacked in alleyways or on country roads by sexually predatory men, and it was partly to cater to the legions of abandoned illegitimate children born of rape that the Ospedale degli Innocenti had been founded. Far more terrifying was the high incidence of sexual predation against female children. Between 1495 and 1515, "over one-third of the forty-nine documented victims of convicted rapists were girls between the ages of six and twelve, and at least half were aged fourteen or under; numerous others were seduced without force or were sodomized."

Marriage

Yet the paradigmatic setting for sex was, of course, the marriage bed. Although some rather extreme male writers, such as Gianmario Filelfo, advocated celibacy even within wedlock, procreation was generally considered to be the principal function of all women, and the production of children was perceived as the object of marriage. It was thus quite natural that sex should have been the central feature of married life. But while women—though bound by the "conjugal debt"—were supposed to refuse "illicit" sexual acts that aimed at pleasure rather than procreation, it is clear that married couples commonly enjoyed active and exciting sex lives. Even in his old age, Pontano was able to pen a verse to his wife, Ariane, which spoke to their healthy sexual relationship in their declining years:

Wife, your elderly husband's delight, Love and trust of our chaste bed, You who keep my old age fresh, Who set an old man's cares to flight, And help me triumph over old age, A grey head singing of youthful passion; But, as if fires of youth return And you were at once first love and new, First passion, headlong rush, I want to fan those ancient flames.

Michelangelo's father, Lodovico, was of the same cast of mind. After marrying for the second time, in May 1485, he gladly threw himself back into the universe of marital sex.

Within this context, contemporary religious teaching dictated that men were always supposed to be on top and that sex be restrained to the most basic activities. Oral sex was definitely taboo, and by the latter part of the fifteenth century heterosexual sodomy in particular was placed high on the list of carnal offenses. But as we might expect, the realities were quite different. Although the immediate context for his comments was somewhat removed from marriage, Beccadelli's views on this subject might be taken as broadly representative of the practices of marital sex during the Renaissance. Not only was he a cautious enthusiast of women being on top, but he also spoke highly of sexual variety. "Why," the character Lepidinus asked Beccadelli, "is a man never able to give it up once he's fucked someone in the arse or mouth?" Whether Michelangelo agreed or not is open to speculation, but many of his friends would have asked themselves a similar question with a knowing smile.

The extent to which married couples indulged in such conjugal jollity presents us with a rather striking point. The nature of ordinary domestic life—even in "middle-class" houses—was not exactly oriented toward privacy. Small and cramped, with multiple generations under the same roof and many people sharing a room, Renaissance houses did not leave much space for discretion. Whatever happened between a husband and a wife would almost certainly have been heard—if not seen—by a host of other people, from children and servants to apprentices and lodgers. While shame was thus an integral part of the theory of wifely modesty, there could have been little shame about the sexual act in daily life at home.

Extramarital Sex

Marriage did not, however, mean fidelity. Infidelity among married men was so prevalent as to be almost a fact of life. Even a devoted husband like Pontano was painfully conscious that marriage could become something of a bore and that the sexual appeal of a long-beloved wife could wane. Men habitually looked elsewhere for amusement. Francesco II Gonzaga's affair with Lucrezia Borgia, and Giuliano de' Medici's lustful attitude toward Simonetta Vespucci, were characteristic of the contorted sexual lives of socioeconomic elites, but there were also a host of other configurations. Female servants and slaves were particularly common targets of married men's desires. A few years after the *David* was completed, Michelangelo's brother Buonarroto only acquiesced in his wife's request for a young female servant on the grounds that "a man can use a young woman to serve him in bed better than the old ones" and evidently expected his wife to put up with this blatant but fairly common—act of domestic adultery.

Married women, too, were thought to have a "powerful yearning for semen," and the lure of extramarital sex was all but irresistible. The sexual appetites of women—and especially married women—were almost proverbial, and many male writers despaired of a wife's capacity for fidelity. As Domenico Sabino wrote in his dialogue *On the Conveniences and Inconveniences of Wives* (1474), "It is much easier to defend an unfortified citadel on a low plain than to keep a wife free from shameless lust"; in fact, it was, he lamented, "almost impossible to protect what everybody desires." So common was female adultery that Cristoforo Landino felt able publicly to mock his friend Bindo "the one-eyed" for being cuckolded:

Is it any wonder, Marco, if, having but one eye, you can't keep adulterers away from your wife? Once upon a time Junonian Argos had a hundred, But still the nymph he guarded wasn't guarded for long.

Even entrusting his rampant spouse to the care of the clergy offered little hope, for they would have been as willing to satisfy her pleasures as anyone else: as Landino put it, she was just "a lamb entrusted to a wolf."

A sense of just how endemic female adultery was in Renaissance Florence can be gauged from the extent to which it figures in contemporary literature. In the *Decameron*, for example, Boccaccio titillates his reader with tales of passionate wives who are unsatisfied with their husbands and succeed in making their cuckolded husbands look foolish.

In one tale loosely derived from Lucius Apuleius's *Metamorphoses*, a charming, beautiful woman named Peronella is married to a poor bricklayer. While her husband is away at work, she catches the eye of the young Giannello Scrignario, and they quickly begin an affair. The pleasure seems unbelievable, but one day she is terrified when her husband returns home unexpectedly. Fearful that he will discover her secret, the quick-thinking Peronella hurriedly hides Giannello in a tub while she goes to open the door. No sooner has her husband stepped across the threshold than she begins berating him for their poverty and bursts into tears to emphasize her point. In an attempt to pacify his wife, the bricklayer tells her that he has solved their money problems: he has sold the very tub Giannello is hiding in for 5 silver ducats. In a flash, Peronella flies on the offensive. How could he accept so little? She has, she claims, found a man who would pay 7! Pointing to the tub, she tells her husband that the client—Giannello—is busy inspect-

ing it from the inside as they speak. Catching on, Giannello climbs out and informs Peronella and her husband that he'd be happy to buy it on the condition that the dirt is removed from the inside. Delighted, the bricklayer immediately offers to scrape it clear and clambers inside to begin work. While her husband is busy scraping away, Peronella leans over the mouth of the tub, as if to direct his work, while Giannello "in the manner of a hot-blooded stallion mounting a Parthian mare . . . satisfied his young man's passion" from behind. Once they have finished, the cheeky Giannello gets the poor bricklayer to carry the tub all the way back to his house.

In another tale, one Madonna Filippa is actually discovered by her husband, Rinaldo de' Pugliesi, in the arms of her handsome young lover, Lazzarino de' Guazzagliotri. Restraining his desire to kill her on the spot, Rinaldo rushes to the city authorities to denounce his wife for adultery and is convinced that he has enough evidence to have her convicted and put to death. When the court is convened, however, Madonna Filippa plays a clever trick. Forcing her husband to admit that she had willingly granted him whatever he required in the way of sex, she then asks the magistrate a pointed question. "If he has always taken as much of me as he needed and as much as he chose to take," she inquires, "what am I to do with the surplus? Throw it to the dogs? Is it not far better that I should present it to a gentleman who loves me more dearly than himself, rather than allow it to turn bad or go to waste?" With the onlookers rocking with laughter, the magistrate is compelled to admit that she has a point and sets her free, much to her embarrassed husband's chagrin. The question of what to do with the "surplus" was evidently much on the minds of many women in Michelangelo's Florence.

Prostitution

Prostitution was a major feature of urban life, and however chaste Michelangelo may have been while he was carving the *David*, it is inconceivable that his sexual attitudes were not at least touched by the sheer number of prostitutes whom he would have encountered while walking through the streets of Florence. Indeed, prostitutes played a prominent role in the everyday lives of many of the most prominent literary and artistic figures of the period. Beccadelli was apparently almost addicted to frequenting brothels, and his *Hermaphrodite* is dominated with paeans to his favorite whores. Cellini, too, was an avid patron of prostitutes and evidently thought the practice of paying for sex so commonplace that he had no shame whatsoever about admitting to his adventures in his *Autobiography*. Similarly, Boccaccio's *Decameron* includes at least two stories dedicated explicitly to prostitution and one in which the manipulation of sex for profit is implicit.

As with marital sex, views of prostitution were replete with double standards. Officially, of course, the Church strictly proscribed prostitution, and the cities of Renaissance Italy had begun by acknowledging that the sale of sex was an affront to public morality. Prostitutes were expelled from Venice in 1266 and 1314 and from Modena in 1327. But despite this, there was a strong tradition of viewing the practice as a necessary evil. Both Saint Augustine and Saint Thomas Aquinas had recognized that since the cup of male desire would always run over, prostitution was necessary to prevent the spread of fornication or sodomy in a sexually frustrated society. Renaissance legislators were inclined to agree, and Filarete (Antonio di Pietro Averlino; ca. 1400–ca. 1469) even included a vast public brothel in his plan for an ideal city (Sforzinda).

Florence, in particular, moved relatively quickly toward the acceptance and then the regulation of the sex trade. Initially, tolerance was grudging. By 1384, the priors had acknowledged the presence of prostitutes but had obliged them to wear clothing (bells, high heels, and gloves) that marked them out both as a distinct group and as a source of the "contagion" of lust. Though prosecutions were not irregular, the integration of prostitution into the body social had become even more pronounced by around 1400. Sex workers were still forbidden to ply their trade in certain areas, but control-rather than stigmatizationbecame the watchword. On April 30, 1403, the city established a magistracy known as the Onestà (Office of Decency) that was explicitly charged with overseeing the affairs of prostitutes. Initially housed in the church of San Cristofano, at the corner of the via Calzaiuoli and the Piazza del Duomo, the Onestà was, by Michelangelo's time, established a little farther south, in the alley now known as the vicolo dell'Onestà, near Orsanmichele. From here, the eight-man magistracy provided for the establishment of at least three public brothels (in 1403 and 1415) and presided over the "registration" of prostitutes. Barely thirty years later, seventy-six women had enrolled as state-sanctioned whores (most of

them of foreign origin), and prostitutes were taxed at a special rate to help pay for Florence's growing expenses. Moreover, prostitutes provided a valuable legal service. In situations in which a woman petitioned the courts for an annulment of her marriage on the grounds of non-consummation, a prostitute could be brought in to testify to the impotence of her unfortunate husband.

By 1566, the acceptance of prostitution had become so widespread that the great public brothel in the Mercato Vecchio was deemed a good investment and was purchased by three exceptionally respectable citizens: Chiarissimo de' Medici, Alessandro della Tosa, and Albiera Strozzi. The year before, a complete catalog of the names and addresses of the best prostitutes had even been published in Venice (*Catalogo di tutte le principale e più honorate cortigiane di Venezia*).

The scale of the sex industry in Michelangelo's Florence is, however, belied by the rather hopeful actions of the Onestà. The numbers of prostitutes working in the city by 1501 massively exceeded the "official" figures, and there is no doubt that unlicensed private brothels abounded, as is suggested by the art of the period. In Francesco del Cossa's *April* in the Palazzo Schifanoia in Ferrara, for example, scantily clad prostitutes are shown running quite publicly in the Palio, under the gaze of a young gentleman and a child (Fig. 12). Prosecutions for "unofficial" prostitution continued at a rapid pace, and there are ample records of men quite openly selling their wives and daughters into prostitution. As Beccadelli's enthusiasm for the prostitute Ursa demonstrates, these women became not just sexual intimates but also friends and sources of inspiration.

Homosexuality

The apparently rampant heterosexual sex in Michelangelo's Florence should not obscure the widespread incidence of homosexual relations in the period, and despite his comparative indifference at this point, it is worth noting that more than a few questions have been raised about Michelangelo's own sexual orientation later in his life.

Like premarital and extramarital sex, homosexuality was commonly regarded as a heinous sin to be spoken of in tones of awe and horror. Normally grouped together with masturbation and bestiality, homosexual intercourse was frequently attacked by laymen like Poggio Bracciolini—who compared it to heterosexual fornication—as well as by churchmen of the day. The irascible Bernardino of Siena (1380–1444) was particularly vehement in his condemnation. In a series of Lenten sermons delivered at Santa Croce in 1424, Bernardino cataloged the sins to which Florence was most prone and devoted no fewer than three of his nine sermons exclusively to sodomy. He began comparatively gently, by tracing the origins of Florentine homosexuality to the population decline of the mid-fourteenth century. But by the time he reached his final sermon, Bernardino had whipped himself up into a foaming frenzy of hatred. Condemning both the sin of sodomy and those who attempted to have convicted sodomites released from prison, he cried, "To the fire! They are all sodomites! And you are in mortal sin if you seek to help them." So powerful was his rhetoric that the congregation immediately rushed outside and started building a bonfire on which to roast the city's homosexuals.

Although Bernardino's sermons were remarkable for the sheer intensity of his grievance, he was nevertheless broadly representative of the Church's position and of the Florentine government's attitude toward the "pestiferous vice." The city's magistrates took a very dim view of homosexuality. Having established a special magistracy to root out homosexuality in 1432 (the Office of the Night), the city imposed harsh penalties on those convicted of homosexual practices, and a variety of punishments-including the death penalty-were permitted. A little before the magistracy came into existence, a certain Jacopo di Cristofano was found guilty of sodomizing two young boys: he was fined 750 lire, sentenced to be whipped through the streets of the city, and ordered to have his house burned down (if he owned it). Prosecutions were avidly pursued. During the seventy years the Office of the Night was active, it has been estimated that around seventeen thousand men were accused of sodomy, and it is not without reason that Florence has been described as having "carried out the most extensive and systematic persecution of homosexual activity in any premodern city."

But, as with other areas of sexual activity, the severity of legal and moral strictures is perhaps more reflective of the sheer prevalence of homosexual activity than of anything else. Indeed, the Florentine authorities were prepared to indulge in a certain degree of official hypocrisy and a good deal of double standards.

While those who practiced homosexual acts were arrested and pros-

ecuted with relentless zeal during the fifteenth and very early sixteenth centuries, their treatment was not quite as harsh as the letter of the law might lead us to expect. Although seventeen thousand men were accused of sodomy while the Office of the Night was in existence including Leonardo da Vinci—fewer than three thousand were actually convicted, and those who were received punishments that were lenient in comparison with the sentences that could have been imposed.

In part, this is related to the fact that the majority of "homosexual" activity was actually practiced by men who either were married or would—in today's language—self-identify as "straight." It was not so much a matter of preference as of urges. A lot of men were simply too randy to limit themselves to one gender. In Domenico Sabino's dialogue on wives, for example, the character Emilia observes that "men are not satisfied with servant girls, mistresses, or prostitutes, but resort to boys in order to relieve their wild and mad lust." By the same token, Beccadelli's *Hermaphrodite* discusses heterosexual and homosexual sex without any sense that a married man should limit himself to one or the other.

In part, however, it is also related to the variation that was perceived to exist *within* homosexuality itself. As a reflection of the moral distinction that contemporaries were wont to draw between active and passive partners, and between old and young lovers, by 1564, dominant older men were normally fined 50 *scudi d'oro* and imprisoned for two years, while the younger, passive partner was usually given fifty lashes. If they could find a reason to be more lenient, it seems that judges seized it with some enthusiasm.

But to a considerable extent, the Florentine magistrates' willingness to turn the occasional blind eye to the homosexual practices they so forcibly condemned was a function of the Renaissance enthusiasm for the notion of platonic friendship. Through his commentary on Plato's *Symposium*, Marsilio Ficino—Michelangelo's youthful friend gave new life to the idea of a close intellectual and spiritual friendship between men, a notion that rapidly became common currency among the circle of Florentine humanists known, somewhat misleadingly, as the Platonic Academy. While this intimate bond was defined primarily by the proximity of two souls in pursuit of the ideal, it was not unusual for it to be invested with a distinctly physical dimension. In the *De amore* (1484), for example, Ficino suggested that homoerotic attraction was an integral part of a true Platonic friendship and went so far as to suggest that love between men was almost more natural than love between men and women. Homoeroticism and male same-sex relations were thus given a form of intellectual justification that could facilitate and even excuse homosexual practice in a social environment that was officially opposed to such activity. Ficino himself was often suspected of being a homosexual, and there is more than a passing hint that Michelangelo absorbed some of his friend's thought on the subject.

So distinct were legal and moral norms from the sexual realities that the Florentine Office of the Night seems to have concentrated its efforts more on policing rape and male prostitution than on exterminating homosexual acts, for which it appears to have indulged a pragmatic form of toleration. In the complex and intellectually charged world of Florentine homosexuality, men who professed fidelity to each other were occasionally regarded as "married" by the Office of the Night, especially if they had sworn an oath to that effect over a Bible in church. There is some evidence that same-sex unions even received a blessing in liturgical ceremonies in some places in central Italy, and there is reason to believe that similar practices may have been found in Florence.

There was, in fact, every reason not merely to tolerate but even to encourage homosexual relationships of this variety. Settled partnerships were often applauded by families who recognized that a homosexual "marriage" could be as socially advantageous as its heterosexual equivalent. Provided that the match was astutely made, it could bring with it influence, protection, and wealth. Friends frequently accepted gay marriages, and while there was no subculture as such, the formation of homosexual networks acted as a powerful vehicle for men to further each other's interests in the world of work and business.

Despite Michelangelo's apparent disregard for sex during the period 1501–4, the atmosphere of Florence would have been charged with sexual energy. The sparks flew in every direction. Regardless of the strictures of law and morality, people were at it all the time and from a remarkably young age. Frustrated young men, lusty young girls, bored housewives, and wandering husbands seem almost never to have passed up an opportunity to amuse themselves with others or to indulge the rich variety of the city's brothels. So, too, same-sex relationships between men were—if anything—every bit as prevalent and flexible as in today's

world. And in the cramped world of Renaissance housing, nothing but nothing—was ever private.

The Workshop of the World

And so the drama of everyday life went on. The workshop—the nexus of Michelangelo's life—was the epicenter of artistic production, but it was also a nodal point for social life, the setting for all of the cares and concerns that dominated ordinary existence. It was, in a sense, not so much a workshop as the workshop of the world of the Renaissance artist. Looking at the comings and goings in an average day, we can see that art was not just a matter of high-minded, abstract creativity but an enterprise overshadowed by the worries of home life, the pleasures of friendship, the troubles of business, the agonies of ill health, and the conflicting impulses of desire. As Michelangelo's workshop shows, Renaissance art was much uglier, but also much more ordinary and human, than familiar conceptions of the period might suggest.

MICHELANGELO IN LOVE

N THE AUTUMN OF 1532, Michelangelo was working at his house at Macel de' Corvi in Rome. Since finishing the *David* twenty-eight years earlier, he had experienced a sequence of unremitting artistic triumphs, and after he had completed the Sistine Chapel ceiling in 1512, the never-ending series of commissions that came his way had obliged him to shuttle continually between his native Florence and the Eternal City. It had, however, been an old project that had brought him back to Rome in the autumn of that year. Briefly abandoning his work on the Florentine church of San Lorenzo, he had traveled south to renegotiate his contract for the design of Pope Julius II's tomb, an enterprise on which he had been engaged since 1505 but which was still nowhere near completion.

It was while Michelangelo was tinkering with his designs for the tomb one afternoon that an otherwise obscure sculptor named Pier Antonio Cecchini came to visit. An old and trusted friend, Pier Antonio had got Michelangelo's Roman house ready for him and often popped in for a chat. Although little is known about his life, he seems to have been a good fellow, and Michelangelo would have greeted his arrival that day with pleasure. But as Pier Antonio stepped across the threshold, Michelangelo would have seen that an otherwise enjoyable, if conventional, distraction was becoming an unforeseen delight.

In a break with habit, it seems that Pier Antonio had not come alone. He had brought with him a young friend named Tommaso de' Cavalieri. It was perhaps only natural for Pier Antonio to have brought the two together. Given that Tommaso's family lived not far away in what is now the Largo Argentina, they were virtually neighbors. What was more, the Cavalieri were noted collectors of classical sculpture, and Tommaso was particularly fond of art.

But Tommaso de' Cavalieri himself was also no ordinary young

5

nobleman. At barely twenty years old, he was a true Renaissance heartthrob. As the portrait Michelangelo later drew of him shows, he possessed a simple, unaffected beauty. His skin was clear, his eyes were large and honest, and his features were so delicate as to be almost feminine. Although the scion of a noble house, he had none of the hauteur that might have been expected, and his apparent modesty was set off by his fashionable yet understated dress. What was more, he was certainly highly cultured. Having received the thorough humanistic education that befitted his station, he could discourse on poetry, philosophy, and painting with sensitivity, sophistication, and grace.

What exactly passed between the two men at their first meeting is not known, but it is clear that the fifty-seven-year-old Michelangelo was immediately besotted with Tommaso. For all his creative brilliance, the artist later confessed that he could think of nothing to compare to Tommaso's "loveliness," and despite the disparity in their ages his heart was filled with an all-consuming passion.

It was the beginning of an intense, emotionally charged relationship that would dominate Michelangelo's thoughts until the end of his life. But it was not without its difficulties. At times during the next thirtytwo years, even the thought of the younger man could give him the most intense pleasure. Yet at the same time, it could also cause him great pain. Although he gave his heart and soul to Tommaso, Michelangelo's extravagant feelings were not always reciprocated in quite the same fashion. As early as 1533, he remarked upon Tommaso's "fear," and the young man's occasional coldness thereafter continued to torture him. Now and again, he even started to question whether such love—or was it lust?—was not wrong.

Although Tommaso and Michelangelo spent a great deal of time together over the next three decades, their relationship was played out principally through the arts of which the older man was a master. Not long after their first meeting, they began a tender and affectionate correspondence, and a constant stream of letters coursing with barely concealed emotion passed between them. Verse came no less easily to Michelangelo, and love "would provoke a poetic outpouring that was unprecedented." Art, too, became a medium for his passion. By the end of 1532, Michelangelo had already sent Tommaso a gift of two exquisitely composed drawings and later followed this with two further compositions on classical themes. These poems and gift drawings are a powerful evocation of the cultural and intellectual world in which his feelings were forged. Confronted with the delicacy of Michelangelo's works, it is difficult not to be struck by the extent to which he adapted patterns of "Renaissance" thought to his own purposes, and by the degree to which artistic production worked in dialogue with the humanistic enthusiasm not only for reviving the spirit of classical literature but also for "reliving" the culture of antiquity.

But at the same time, Michelangelo's poems and gift drawings also show that the cultural and intellectual developments that characterized the period were shaped by the realities of personal experience and everyday life. Instead of being a product of high-minded ideals or attractive little parlor games, the verses and drawings that Michelangelo sent to Tommaso de' Cavalieri were outpourings of his very soul and used ancient and contemporary tropes not only as a means of understanding his conflicted feelings but also as a vocabulary with which to give voice to his love, his passion, and his uncertainties.

As such, the ins and outs of Michelangelo's relationship with Tommaso de' Cavalieri offer an ideal opportunity to examine the intellectual world of the Renaissance artist and to reevaluate the familiar tendency to divorce literary and artistic production from more "human" concerns. Although love and sex were certainly not the be-all and endall of Renaissance thought, they were a node around which literature, art, and philosophy worked in tandem with grim and gritty realities in a manner emblematic of the broader interaction between the literary and artistic innovations of the age and the hopes and fears of real people. And insofar as Michelangelo not only drew on a rich and varied cultural heritage but also adapted the experiences of other Renaissance men and women to his own feelings-experimenting always with their vision of love and sex and playing the parts of those who had gone before him in an attempt to find what best fitted his own happy, tortured feelingshis works offer a lens through which to view the dynamics that linked the often sordid details of everyday existence to the highest realms of culture.

By unpicking the various "acts" in the drama of Michelangelo's relationship with Tommaso, we can see not only the different phases in the evolution of the intellectual world of the Renaissance artist but also the lives—and the experiences of love and sex—that shaped that world. Linking literary and artistic production with the "real" world of conflicting emotions will reveal a world that is far removed from our familiar conceptions of the period, a world born not of the purely aesthetic concerns of otherworldly beings removed from the joys and sorrows of ordinary people, but among unrequited passions, broken hearts, sexual obsessions, and suffering.

ACT I: IDEALIZATION

Throughout the early months of their relationship, Michelangelo was prone to idealizing Tommaso de' Cavalieri. As he saw it, he had lost his heart not to just another person but to a living embodiment of a physical, moral, and cultural ideal. Indeed, as Michelangelo wrote in an early poem, the young man's beauty had been "made in heaven to give us proof of work divine." In the face of such perfection, he imagined himself to be utterly powerless. In his verse, he spoke of a personified Love that held him in its iron grip and that—having revealed the ideal appeared in the guise of a domineering master who had enslaved him irrespective of his will.

This image of the beloved as the embodiment of an ideal beauty and virtue and of Love as a hard and uncompromising captor points toward the very origins of the Renaissance conception of love and sex. Here, there can be little doubt that Michelangelo was playing the part of Dante.

As early as the 1320s, Dante Alighieri had been celebrated for having "brought back dead poetry from the darkness to the light," and like many of his contemporaries Michelangelo had grown up in an atmosphere in which Dante was celebrated as an incomparable genius, worthy of comparison with the great poets of antiquity. Having studied the *Commedia* as a schoolboy, Michelangelo was trained to view Dante's work as the very model of Italian vernacular poetry. But his was no mere technical admiration. The enthusiasm he had first felt on delving into Dante's works was fueled by his introduction to the circle of humanists who surrounded Lorenzo de' Medici in Florence and by his acquaintance with Cristoforo Landino's highly influential commentary on the *Commedia*. In later years, he would deepen his knowledge by reading Dante with Giovanfrancesco Aldovrandi in Bologna and found himself filled with adoration for the treasures he continued to discover. As he was later to observe, Dante was a "radiant star" whose "splendour burned too brightly for our dim eyes." Indeed, for Michelangelo, as for Boccaccio and earlier poets, Dante was sufficiently divine for his death to be regarded as a "return" to the heavens from which his genius sprang.

But although Dante offered Michelangelo a natural—even obvious archetype for the exploration of an all-consuming desire for a semidivine ideal in verse, this is not to say that Dante's contribution to Renaissance conceptions of love and death could be viewed through rose-tinted spectacles. Quite the reverse. Dante's experience of love was born of an unrequited passion and years of painful, agonized frustration.

Dante's story begins on May I, 1274, when the poet was just shy of his ninth birthday. Running around playing at a May Day party given by the influential Florentine Folco dei Portinari, the young Dante was blissfully ignorant of life and concerned only with the most innocent of games when he saw something that would change the entire course of his life. Her name was Beatrice. Although barely more than eight years old, Folco's daughter was already striking: it was not merely her beauty and dress but also—and more importantly—the goodness she seemed to radiate. Dante was dumbstruck. The moment he saw her, as he later recorded in *La vita nuova*, "the vital spirit, which dwells in the inmost depths of the heart, began to tremble so violently that [he] felt the vibration alarmingly in all [his] pulses, even the weakest of them." There could be no doubt of what it meant. "From then on," Dante confessed, "Love ruled over my soul."

Thenceforth, the young Dante's days revolved entirely around Beatrice. Her image was constantly before his eyes, and his mind was filled only with thoughts of her. From day to day, he wandered endlessly around Florence in the vain hope of catching even the faintest glimpse of his beloved. Then, one day, nine years later, he saw her again, "dressed in purest white, walking between two other women of distinguished bearing." Dante trembled with excitement and anticipation. She turned her gaze toward him and gave the most courteous of greetings. It was little enough, but it was sufficient for Dante to "experience the height of bliss." He was a prisoner of love and the hopeless captive of Beatrice herself. Returning to his room in transports of joy, he had a vision of Love, cloaked in clouds the color of fire and holding Dante's own heart in his hand. As he later wrote: Joyful Love seemed to me and in his keeping He held my heart; and in his arms there lay My lady in a mantle wrapped, and sleeping. Then he awoke her and, her fear not heeding, My burning heart fed to her reverently. Then he departed from my vision, weeping.

So intense was Dante's obsessive love for Beatrice that the constant strain of thinking about her beauty made him ill. His friends became worried and, seeing that it was a girl who was causing his condition to deteriorate, pressed him to reveal her name. Gallantly, he refused to share his secret, but the gossip which spread quickly became sufficiently intolerable that Dante felt obliged to pretend he really loved someone else entirely.

It was a foolish mistake. Before long, Beatrice had heard that Dante was in love with another person. Given that she had previously guessed he had feelings for her, she was extremely annoyed. When they next met in the street, Beatrice pointedly snubbed him. Dante was devastated. "I was so overwhelmed with grief," he wrote in *La vita nuova*, "that . . . I went to a solitary place where I drenched the earth with bitter tears."

Setting aside all pretense, Dante no longer made any secret of his love for Beatrice. But though he hoped always that her heart would soften, his passion was unrequited. Little by little, he became a laughingstock. At a wedding, his rather affected swooning at his beloved's beauty attracted the mockery of all present: even Beatrice poked fun at him.

After he endured this humiliating episode, some of the ladies who had laughed at Dante suggested a solution to his sorrows. There was of course nothing wrong with his love, but his error lay in his response to Beatrice's disdain. Although he had previously written a great deal of poetry in the courtly tradition, his verses had been entirely devoted to self-pity, and he had suffered as a consequence of his willingness to wallow in despair. Since all agreed that Beatrice was as near to human perfection as could be found, Dante should concentrate not on his pain but on her incomparable beauty and virtue. In praising her in poetry, he could live his love in a different—and perhaps more edifying—manner. Beatrice would inspire a new art, and that art would prove to be Dante's salvation.

The transformation was instantaneous. Rather than picturing Beatrice merely as a prospective mistress or as an enchanting object of love, Dante crafted a poetic image of his beloved as an ideal of beauty, the very paradigm of all that was pure and good. She became a reflection of the divine, a model of virtue, and the inspiration for a powerful, redemptive poetry. In turn, Dante's love ceased to cause him pain and instead—through his art—came to be the centerpiece of his moral universe.

Beatrice's unexpected death on June 8, 1290, devastated Dante. He seemed almost to lose his mind with grief, and though he resolved never to speak about her "departure," the final parts of *La vita nuova* testify to the extent to which the tragedy weighed upon his heart and mind. Yet however heartbreaking her passing might have been, her death only seems to have intensified Dante's idealization of her as the archetype of virtue and beauty. From beyond the grave, she became the epitome of philosophy and heavenly perfection, a yet more powerful incentive to write, and a fixed star by which the shattered bark of Dante's life could set its course.

Dante's new attitude toward his love for Beatrice was most fully and clearly expressed in the first canto of the Paradiso. Opening his narrative with a heartfelt plea to Apollo-the god of poetry and wisdom-Dante begs to be given sufficient skill to sing of the "blessed kingdom" he is about to enter, and longs to be granted the laurel crown that symbolizes both love and literary genius. His plea ended, he is then amazed to see Beatrice appear before him, her gaze fixed upon the sun, contemplating the majesty of creation. Whereas Virgil had been Dante's guide through Hell and Purgatory, it is clear that Beatrice will be his companion through the ethereal realm. Her role is telling. Rather than being merely an "expositor, . . . Beatrice is a superior intelligence . . . an instructress who explains the mysteries of nature, the structure of the heavens, the phased ascent from earth to the celestial empyraean." Her beauty becoming ever more pronounced as their journey progresses, she unveils the universal truths and heavenly goodness that are both the subject of Dante's verse and the object of his life. Although they are overlaid with elements of Aristotelian and Averroistic philosophy, it is clear that what virtue and beauty he perceives, he perceives because of her.

Abashed and a little timid at first, Michelangelo could not resist picturing himself as a new Dante and casting Tommaso in the role of a more passive—and perhaps rather nicer—Beatrice.

Act 2: Guilt and Sorrow

Unfortunately for Michelangelo, the imitation of Dante only took him so far. There was, he rapidly discovered, a lot more to his relationship than could be modeled in Dantean terms. And—what was more—his feelings were more tortured than even Dante had experienced. Far from being content merely to worship the ideal that Tommaso represented, Michelangelo struggled with the implications of this idealism, and this feeling creeps through with particular force in the second phase of their relationship. As Bartolomeo Angiolini observed in mid-1533, Michelangelo's poetry had begun to express a palpable sense of suffering.

The slightest coolness from Tommaso could cut Michelangelo to the quick. As it was, the young man was often more than a little standoffish. Although he claimed to esteem the artist more highly than anyone else on earth, his correspondence is occasionally somewhat distant and formal. At times—and especially during their separation in 1533—Tommaso even teased him in a manner that hovers between friendly raillery and youthful cruelty.

The feelings of being punished for having come too close, too quickly, are perhaps expressed most eloquently in *The Fall of Phaethon* (Fig. 13), a drawing (of which three versions exist) that Michelangelo appears to have sent to Tommaso at around the time of Angiolini's letter. Phaethon, having persuaded his father, Helios, to let him drive his chariot across the sky, is soon frightened by the heights to which he has risen. In panic, he veers wildly across the heavens until Zeus is compelled to strike him down with a thunderbolt. That Michelangelo pictures himself as Phaethon is clear.

But Michelangelo's torment was also a product of a deeper and more disturbing sense of uncertainty. He was, as he recognized, powerless to resist the assaults of love, but the fact that this love often shaded off into homoerotic lust prompted a crisis of conscience. Although there was a vogue for close—and even intimate—relations between men in contemporary Italy, Michelangelo seems to have been conscious of the vicious terms in which homosexuality was condemned by secular and religious authorities. As a devout Christian, he knew that Tommaso should be a reminder of God's goodness and that such sexual desire was wrong.

This burgeoning sense of guilt was well illustrated in one of a pair of drawings Michelangelo sent to Tommaso as a New Year's gift at the end of 1532. Depicting the story of *The Punishment of Tityus* (Fig. 14), it dramatized a mythological tale of divine retribution. In punishment for having attempted to rape Zeus's concubine, Leto, the giant Tityus had been hurled down into the deepest pits of Hades to endure horrific suffering. In Michelangelo's gift drawing, he is shown lying prostrate on the rocky ground of the underworld, while a monstrous eagle pecks hungrily at his liver. Picturing himself as Tityus, the pious Michelangelo not only showed that he harbored an irrational, physical passion for Tommaso but also demonstrated his fear of being punished for all eternity for his lust.

The feeling of guilt points toward the second phase in the evolution of Renaissance conceptions of love and sex and to another great influence on Michelangelo: Petrarch, perhaps the most important of Dante's intellectual heirs. While staying in Bologna shortly after his hurried departure from Florence in October 1494, Michelangelo read Petrarch's vernacular verse alongside Dante's love poetry with Giovanfrancesco Aldovrandi, and in the years that followed, he nurtured an affection for the former that was at least as great as—if not greater than—his fondness for the *Commedia* and *La vita nuova*.

Insofar as Michelangelo's relationship with Tommaso de' Cavalieri is concerned, Petrarch's real importance lies in his transformation of Dantean themes to encompass a sense of sorrow and guilt. While drawing on Dante's love for Beatrice as a model for his own experiences, Petrarch added an entirely new ingredient to the mixture that was born of an altogether darker combination of torment and suffering.

It was in Avignon on April 6, 1327, that Petrarch set out on a journey that would transform the course of his life. Early that morning, not long after dawn, he arrived at the church of Saint Clare for the Easter Sunday Mass. At twenty-two, he was quite the dandy. Arrayed in brightly colored and heavily perfumed clothes, he had, as always, gone to great trouble over his appearance. As he later reminisced, he regularly spent hours curling his hair in the latest fashion and fretted incessantly whenever he went out for fear that the breeze would disturb his carefully arranged locks. What was more, he considered himself a man of the world. By the standards of the day, he was certainly well educated. Having been trained in Latin grammar and rhetoric by Convenevole da Prato in nearby Carpentras, he had gone on to study law at the universities of Montpellier and Bologna, two of the finest institutions of learning in Europe. But even though he was well placed to carve out a future for himself as a lawyer, he had decided not to pursue the career for which he had been intended. After his father's death the previous year, he had inherited a sizable sum of money and had returned to Avignon to live a life of refinement and leisure, free from parental pressure and financial worries. He was a dreamer, with few aspirations other than to look good.

Easter Sunday was an opportunity to be seen, to strut around, and to be admired. The little church of Saint Clare would have been packed. Then the seat of the exiled papacy, Avignon was a thriving, bustling city, and this was the culmination of Holy Week. It was in this cramped little church that a young girl first caught Petrarch's eye.

Her name was Laura. Petrarch gives us little clue as to her full identity—the best guess is that she was perhaps Laura de Noves, an ancestor of the notorious Marquis de Sade—but it is at least clear that at sixteen or seventeen years old she was already beautiful beyond compare. She took Petrarch's breath away. As he later recalled, there had never been "such lovely eyes, either in our age or in the first years"; they melted him "as the sun does the snow." From that moment, he was in love—hopelessly, utterly, and completely. The mere sight of her was a source of sheer ecstasy, and though there was occasionally a platonic dimension to Petrarch's feelings, there is no doubt that—unlike Dante's affection for Beatrice—his passion was primarily physical in character.

But just as Dante had found with Beatrice, Petrarch's love was unrequited. Although the mere sight of Laura had set his heart afire, she had not been struck by Cupid's arrow. It was not that she spurned him or mocked him as Beatrice had tormented Dante. She was simply indifferent to him and gave Petrarch no sign of affection or even of recognition. If he burned with passion, Laura was the original ice queen. She was, in every sense of the word, unattainable; indeed, Petrarch hints that she might already have been married. The trope of ice and fire recurs frequently in his poetry as a metaphor for the contrast between the two.

It was all so evocative of the myth of Apollo and Daphne that Petrarch could not resist using the story (which was later painted by Pollaiuolo) (Fig. 15) as a metaphor for his dilemma. Like Apollo, he was condemned to pursue a woman who fled from the very name of love, and yet, just as he seemed to catch up with the fleeing nymph, she escaped his grasp. The fact that Jupiter transformed Daphne into a laurel tree (Greek: $\Delta \dot{\alpha} \phi v \eta$; Latin: *laurus*) to save her from Apollo—the god of poetry and wisdom—seemed a telling detail.

For the next twenty-one years, Petrarch was tormented both by his love and by Laura's coldness, and there are more than a few echoes of Dante in his accounts of this period. Petrarch's life became one of longing and despair. Sometime after first seeing her, he purchased a little house in nearby Vaucluse in the hope of "curing" himself of his attachment. But despite his bucolic solitude, Love followed him everywhere. A "hunter" of Laura, he had himself become the hunted. In one poem, he even compares himself to Actaeon, who was transformed into a stag for having seen the naked Diana bathing and who was pursued forever by his own hounds, the very emblems of desire.

He was led ever deeper into a hopeless labyrinth from which there was no exit. Filled with sorrow, he wandered "through fields and across hills" and "from mountain to mountain," consumed by love and grief. His feverish mind played tricks on him. His thoughts were no longer his own. Everywhere he turned, he seemed to encounter Laura. He saw her in the rocks and rivers and heard her voice in the morning breeze. Long after their first meeting, he would still see her "in the clear water and on the green grass and in the trunk of a beech tree and in a white cloud . . . and in whatever wildest place and most deserted shore I find myself." Much of the time, he felt he was experiencing a living death and sometimes longed to die.

In the midst of his misery, Petrarch turned to poetry, and in this respect his thought began to diverge somewhat from Dante's. Drawing on both his classical learning and his deep familiarity with the troubadour tradition, he began work on the *Canzoniere* (Songbook)—the epic collection of poetry for which he is best known—as the vehicle through which to express his emotions. Consciously equating *amor* with *gloria*, he hoped to win Laura's hand through literary fame.

Yet what really set Petrarch apart from Dante was the agony that lay beneath these layers of suffering and ambition. Despite being crowned poet laureate in Rome in 1341, Petrarch was troubled by the fact that unrequited love and glory seemed to bring him only sorrow, a question that had apparently not concerned Dante too greatly. It seemed to pose a profound—and deeply moral—problem. Why was it that no matter what he did, he was completely unable to find happiness or even solace?

It was precisely this question that Petrarch addressed in the *Secretum*, perhaps his most intimate and autobiographical work. At the beginning of the dialogue, he pictured a fictional representation of himself brooding on his mortality and consumed with misery. Although he is terrified of the imminence of death, "Franciscus" is unable to understand how best to shake off the sorrow that affects his soul.

Miraculously, a mysterious woman-the personification of Truthappears before him and tells him that his condition is the consequence of looking for happiness in all the wrong places. The better to explain this, she invites the ghostly figure of "Augustinus"-representing Saint Augustine-to guide Franciscus. As Augustinus explains, what Franciscus considers happiness isn't happiness at all. Both his unrequited love for Laura and his quest for poetic glory are grounded on the belief that happiness can be found somewhere here on earth. But, says Augustinus, such a belief is absurd. Since all temporal things will inevitably change, disappear, or die, any attempt to find happiness in them is doomed to failure. Being rooted in this world, love, sex, and glory in particular bring Franciscus nothing but grief and despair, and the unfortunate man is obliged to confess that it is "want, grief, ignominy, sickness, death, and all such ills" that cause him such torment. As Augustinus explains, "true" happiness consists only in the immortal and unchanging. It can only be found in the company of God after death. Slowly but surely, he persuades Franciscus that the one sure way to earn such joy is to shed all his worldly desires and devote himself to virtue.

The solution, Augustinus explains, is to meditate on death with greater sincerity and fervor. If Franciscus were to recognize the reality of his mortality and the inevitability of his own death, he would, Augustinus claims, not fail to realize the foolishness of seeking happiness in transient things. Equipped with a proper understanding of the true nature of the "self"—the immortal soul imprisoned within a mortal body—Franciscus would naturally concentrate his attention on preparing his soul for the next life and would devote himself unhesitatingly to virtue.

Although Petrarch was intellectually convinced by his own argument, he was still not fully persuaded, and as 1347 drew to a close, the fires of his love still burned as brightly as ever. But then a tragedy of such magnitude struck Italy that he could not help but be convinced.

In early 1347, just as Petrarch was completing the first draft of the *Secretum*, the Black Death arrived. Brought from the East on twelve Genoese galleys, it first hit the port of Messina in Sicily, before spreading swiftly and inexorably throughout Italy. After hitting Catania, the nearest coastal city, it had infected most of Sicily within weeks. Three months later, in January 1348, the disease reached Genoa, carried by galleys bringing spices from the East, and tore down the Ligurian coast with breathtaking speed. By spring, it had reached Florence, and before summer had arrived, virtually every town and city from Palermo to Venice was in the grip of the mysterious and appalling sickness.

A sense of bewilderment and confusion took hold as people scrambled for some way of treating the disease. Special plague hospitals, often staffed by volunteers from among the mendicant orders, were hastily established in many cities, and in Venice surgeons were granted a rare dispensation to practice their art. But in the absence of any clear understanding of how the plague was spread, there was almost no hope. In Pistoia, the importation of cloths or linens was forbidden, markets were carefully controlled, and all travel to places known to have fallen victim to the plague was banned. In Milan, much harsher measures were employed. When the plague first struck, the three houses in which it was found were completely sealed. The doors were nailed shut, the windows were bricked up, and the people inside—whether healthy or sick—were left to die.

But it was all to no avail. Throughout 1348, the plague raged unabated. It struck indiscriminately: rich and poor, old and young, men and women, all fell victim to the infection. The mortality rate was appallingly high. Although historians continue to debate the exact figure, at least 45 percent—and perhaps as much as 75 percent—of the population was wiped out in the space of three years of horror. The *Chronicon Estense* recorded that in just two months sixty-three thousand people died, and in the thriving port of Venice around six hundred people were dying every day at the height of the plague. In Florence, Marchionne di Coppo Stefani estimated that ninety-six thousand deaths occurred between March and October 1348. In Bologna, it was reported that six out of every ten individuals succumbed, and one chronicler claimed that in the comparatively modest town of Orvieto more than 90 percent

of the inhabitants fell victim to the plague between the spring and the autumn of 1348.

Predictably, the plague had a colossal impact on moral attitudes. Preachers, penitents, and artists developed a preoccupation with mortality and sin. Acutely conscious of the fragility of life and seeking to explain the pestilence as a punishment for moral lassitude, they began to find particularly potent meaning in the theme of the *triumphus mortis* (triumph of death). Francesco Traini's depiction of precisely this topic in the Camposanto in Pisa shows a scene teeming with figures suffering from the plague that provides a sense of the guilt brought on by the imminence of death. Hovering above a mass of corpses, two small, winged creatures hold aloft a parchment scroll bearing the following inscription:

Knowledge and wealth, Nobility and valor Mean nothing to the ravages of death.

By way of illustrating this point, a huge, sinister woman with clawed feet and bat-like wings flies over the middle of the scene, a terrifying embodiment of Death itself. Her attendants circle around. Cackling demons sweep down to carry sinners off to Hell, while a few pacific angels pluck innocent children away for the peace of Heaven. Watching the whole scene from the cliff top, two bearded priests reflect on the state of mankind and anxiously study the Bible. It is unclear what text they are reading: perhaps they are searching for words of consolation, perhaps they are looking to follow the teachings of Christ more avidly, or perhaps they are finding in Revelation the chilling sense that they are indeed witnessing the end of times.

Petrarch—no less than Traini—was profoundly affected by the plague and by the moral transformation it brought about. Traveling between Parma and Verona in the early months of 1348, he saw the appalling effects of the pestilence firsthand. Almost every day he received news that another friend or relative had died, and his letters such as that written on hearing of the death of his kinsman Franceschino degli Albizzi—are filled with heartrending lamentations. But the worst was yet to come.

On May 19, 1348, Petrarch received a terrible letter from his friend

"Socrates" (Ludwig van Kempen). Laura was dead. He was heartbroken. "My lady is dead," he wailed, "and my heart has died with her." He had no desire to linger further in life. As he put it in one particularly affecting sonnet:

Life flees and does not stop an hour, And Death comes after by great stages; And present and past things, Make war on me, and the future also,

And, remembering and expecting both weighs Me down on this side, and on that . . .

I see the winds turbulent for my voyaging,

I see storm in port, and wearied now, My helmsman, and the masts and lines broken, And the beautiful stars, at which I used to gaze, extinguished.

But gradually, he came to revisit Augustinus's words in the *Secretum*. Now it was painfully clear that no real happiness could be found on earth—not when someone as dear to him as Laura could be snatched away so cruelly. Her death seemed to illustrate how fragile the world was and how foolish worldly desires really were.

His love underwent a last and dramatic metamorphosis. In place of the burning, sexual passion that had consumed him in his youth, Petrarch found himself drawn to Laura's memory by a more spiritual longing. He continued to love her, not for her body, but for her soul. In Petrarch's verse, Laura herself is transformed. The taunting mistress now became a figure of redemption, a spirit capable of leading him to virtue. In one particularly telling poem, Petrarch flees the scorching effects of temptation and seeks refuge beneath the branches of the laurel tree that represents his beloved. The "beautiful leaves" protect him from the storms of worldly desire, and as he contemplates its virtuous shade, the laurel is transformed once again, assuming the form of a crucifix. From beyond the grave, Laura pointed the way not to lust or glory but to heaven. It was an enduring idea. This image—which was later picked up and developed by Pietro Bembo (1470–1547), Serafino Ciminelli dell'Aquila (1466–1500), and in Matteo Maria Boiardo's *Orlando innamorato* (1476–83)—was ultimately to find its expression in Baldassare Castiglione's claim that "the kinds of beauty which every day we see in corruptible bodies" were unworthy of the affections of a noble lover.

Death had indeed triumphed, and the terrible sufferings the pestilence had brought were a reminder of the need to put away worldly pleasures. Mindful of the fleetingness of life and the imminence of judgment, man should repudiate sex; and even love-in its conventional form-should be despised. In its place, man should cling to virtue and pursue the love of the divine in the hope of attaining happiness in the next life. Even though Petrarch repeatedly failed to adhere to his own dictates (and even went on to father a number of children while in holy orders), he clearly acknowledged that chastity and devotion represented the only way forward. As Gherardo di Giovanni del Fora's The Combat of Love and Chastity (ca. 1475–1500) illustrated, the sharp arrows of desire should break against the soul's chaste shield (Fig. 16). Forged in the dark night of sorrow, it was a grim ethic that made man an insensible pilgrim in the body and required life to be lived with closed eyes on bended knee. And what was more, the tense relationship between love, sex, and death that underpinned it seems to have appealed to Michelangelo for some time.

Act 3: The Pleasures of the Flesh

As The Punishment of Tityus suggests, Michelangelo seems to have taken to heart the Petrarchan dichotomy between physical desire and death. Throughout the verses he addressed to Tommaso de' Cavalieri, he went to great lengths to stress that—because he recognized his own mortality—his love was utterly chaste. This was, indeed, the basis on which Michelangelo pleaded for greater intimacy with the distant young man. "Your soul," he claimed in a poem written in 1533, "more willing to respond / than I dare hope to the chaste fire that glows / within me, will have pity and draw close."

But despite his protestations, Michelangelo's demeanor seemed to suggest that his intentions were not altogether pure. Already in late 1532 or early 1533, tongues had begun to wag. Gossips began to speculate that Michelangelo, far from being chaste, was in fact a dirty old man. When this reached Tommaso's ears, he was unable entirely to dismiss his suspicions and actually refused to see the artist for a while. Distraught, Michelangelo felt obliged to pen a verse rejecting the accusations.

Although Michelangelo had sincerely endeavored to conquer his physical passions, he had been unable to succeed. Even as he protested his chastity, he admitted that he wanted to have "my sweet and longedfor lord forever stay / folded in these unworthy, ready arms." At times, he actually seemed to revel in his sexual longings and gave way to his libido with unashamed excitement while simultaneously recalling his pious intentions.

In attempting to justify his lust, Michelangelo came to turn Petrarch's argument on its head. Precisely because life was so short and sin resulted in damnation, he felt he really should just surrender himself to the passion that he was unable to conquer entirely. In a verse written in ca. 1534–35, he confessed that he was still pained by the realization that the "misery" of his affection for Tommaso was more important to him than virtue, but since God had not punished him by striking him dead, he could see no reason to refrain from his desire. And since he was unable to resist the lust that would surely land him in Hell after death, Michelangelo believed that Tommaso's embrace might be the only taste of Heaven he could hope to experience. A powerless captive of the young man's beauty, he was forced to conclude that it would be best to play the devout, lustful martyr until he died. As he put it at the end of the verse:

If only blest when caught and conquered here, no wonder I remain, naked, alone, the prisoner of a well-armed cavalier.

In succumbing to physical passion in defiance of the pains of death, Michelangelo set himself at a distance from both Dante and Petrarch. Yet as he was diverging from two of the more dominant literary constructions of love, he was simultaneously drawing on an entirely different tradition of thought that used the fragility of human existence as justification for the unfettered indulgence of sexual pleasure. Here, Michelangelo was not so much reenacting the experiences of an individual figure as playing the role of a priapic Bacchus that represented the spirit of an entire period of Renaissance history. It consisted of two parallel strands, each of which brought together art and life in a manner that was even more intense—and even more exciting—than anything that had gone before.

Carpe Diem: Sex and Death

Initially, it was the experience of the Black Death that paved the way for the triumph of pleasure. With death lurking around every corner, people not only became more acutely aware of the imminence of the afterlife but also came to realize that life should be lived to the full while it lasted. As Boccaccio observed in the prologue to the Decameron, the constant danger of infection pushed people to extremes. While some chose to lock themselves away in a desperate bid to avoid the pestilence, others were convinced that the best way to ward off the plague "was to drink heavily, enjoy life to the full, go round singing and merrymaking, gratifying all of [their] cravings whenever the opportunity offered." Those who were of this opinion were driven to ever more indulgent excess by the realization that life was more precious than they had ever thought. Strict sumptuary laws governing dress were all but forgotten, and there was suddenly a profusion of beautifully colored fabrics, delicate, fascinating embroidery, and risqué dresses for women. Pleasure became a way of life, and promiscuity appears to have increased no end. With crucial social barriers broken down by the fragmentation of family life, people gave themselves over to merrymaking and rampant sex whenever the occasion presented itself. Even monks and friars broke "the rules of obedience and [gave] themselves over to carnal pleasures, thereby thinking to escape, and . . . turned lascivious and dissolute."

Having witnessed the arrival of the plague firsthand, Boccaccio was deeply affected by this new, pleasure-loving ethic. Although many of his early works betray a strongly amorous and even erotic spirit—especially *Il ninfale fiesolano*, the "aggressive and sadistic details" of which have occasionally been condemned as being "in execrably bad taste"—the lusty prose of his youth had always concealed a note of moral uncertainty, and he had even been moved to pen the wildly self-critical (but startlingly misogynistic) *Corbaccio*. After the first onslaught of the Black Death, however, Boccaccio shed his doubts. By the time he came to write the *Decameron*, he had fully embraced the unashamed joie de vivre of the post-plague period.

Widely regarded as Boccaccio's prose masterpiece, the *Decameron* is set in Florence at the very height of the plague. Appalled by the devastation, its central characters—seven young women and three young men—decide to take refuge from the pestilence at a country estate just outside the city. Surrounded by "delectable gardens and meadows," they devote themselves to "feasting and merrymaking" and determine to while away the ten days that follow by telling stories. It is the content of these tales that really testifies to the profound shift in attitudes toward desire in fourteenth-century Italy. Although some of the stories—such as the tale of Griselda—deal with questions of virtue and honor, the vast majority are lusty, bawdy yarns that teem with cuckolded husbands, randy monks, drinking binges, and almost continual fornication.

The imminence of death had persuaded Boccaccio that life could be more fun with a bit more sex. Yet he was still far from being a libertine and was careful to guard against the charge of outright immorality by adding a moralizing conclusion to some of his stories, as a formulaic nod to the vestiges of propriety. A good example is provided by the story of Berto della Massa, a young rogue who decides to disguise himself as a friar to pursue his nefarious desires more easily. Taking the name of Friar Alberto, he heads off to Venice, where he promptly conceives a burning lust for Monna Lisetta da Ca' Quirino, "a frivolous and scatterbrained young woman," who comes to him for confession. In order to overcome her moral scruples, he persuades her that the archangel Gabriel has fallen in love with her and wishes to visit her at home that evening. Disguising himself with a pair of fake wings, Friar Alberto then appears in her bedroom and deludes the naive, awestruck Monna Lisetta into letting him have his wicked way. Only when her relatives discover his ploy and burst in on him during the act does his fun come to an ignominious end. After jumping out the window into the Grand Canal, he is ultimately caught, tied to a pillar near the Rialto, and covered with honey to attract flies. It is plain that this is meant to be a "moral" ending. But while the storyteller (Pampinea) observes that Berto della Massa "got the punishment he deserved" and expresses her wish that "a similar fate should befall each and every one of his fellows," it is equally clear that the function and appeal of the story is to amuse with humor and to excite the passions with ludicrous sexual adventurism. Rather than transforming the tale into a morally improving story, Berto della Massa's comeuppance only increases its entertainment value.

For the most part, however, Boccaccio simply didn't bother to conceal his celebration of sexual pleasure. At times, he was quite explicit and cheerfully played with Christian concepts to underscore the merit of enjoying life while it was still possible. Perhaps the best example is found when his characters set themselves to proving that nothing can possibly eradicate humanity's natural desire for sex. In one story, a beautiful fourteen-year-old girl from Barbary named Alibech is so captivated by the Christian faith that she decides to run away to the desert so she can learn about religion from one of the devout hermits who reside there. After much wandering, she is eventually taken in by the pious young Rustico, who is determined not only to teach her virtue but also to resist her charms. But after giving her a harsh lecture about the importance of serving God by "putting the devil back into Hell," Rustico discovers that his moral fiber isn't quite as tough as he had first thought. Within minutes, he is unable to suppress a raging erection. The exchange that follows is a tour de force of Boccaccio's ethic. "Rustico," Alibech asks,

"what is that thing I see sticking out in front of you, which I do not possess?"

"Oh, my daughter," said Rustico, "this is the devil I was telling you about. Do you see what he's doing? He's hurting me so much that I can hardly endure it."

"Oh, praise be to God," said the girl, "I can see that I am better off than you are, for I have no such devil to contend with."

"You're right there," said Rustico. "But you have something else instead, that I haven't."

"Oh?" said Alibech. "And what's that?"

"You have Hell," said Rustico. "And I honestly believe that God has sent you here for the salvation of my soul, because if this devil continues to plague the life out of me, and if you are prepared to take sufficient pity upon me to let me put him back into Hell, you will be giving me marvellous relief, as well as rendering incalculable service and pleasure to God, which is what you say you came here for in the first place."

"Oh, Father," replied the girl in all innocence, "if I really do have a Hell, let's do as you suggest just as soon as you are ready."

"God bless you, my daughter," said Rustico . . .

At which point he conveyed the girl to one of their beds, where he instructed her in the art of incarcerating that accursed fiend.

Boccaccio—perhaps like his audience—didn't see any problem with this. In fact, in the conclusion to the story, he praises Rustico for preparing Alibech for her subsequent marriage to Neerbal, before adding that ladies should "learn to put the devil back in Hell, for it is greatly to [God's] liking and pleasurable to the parties concerned, and a great deal of good can arise and flow in the process."

The belief that the imminence of death almost obliged one to indulge sexual desire endured well after the worst effects of the plague had subsided, and it had found its way from the *Decameron* into the mainstream of Renaissance culture by the middle of the fifteenth century. Although Petrarch's self-denying morality continued to be admired and imitated, even his most devoted admirers began to cultivate the pleasure principle, and followed Boccaccio in justifying sexual abandon with reference to the uncertainties of life.

One of the clearest illustrations of the triumph of pleasure—and its relationship to death-is provided by the carnival songs (canti carnascialeschi) that became popular in Florence from the middle of the quattrocento onward and that may even have been instigated by Lorenzo de' Medici himself. Specially commissioned for the occasion by a wealthy patron or a brigata (company of friends), such songs were a dramatic combination of musical excitement and visual display and were usually performed by professional singers on a richly decorated wagon. They were, by definition, titillating affairs. Yet two of the most popular canti of the high Renaissance testify to the symbiotic relationship between mortality and sex in the cultural imagination and to the importance of divine judgment in heightening pleasure. Performed on a positively funereal carriage filled with singing skeletons, the "Canzona de' morti" (Song of death) begins with a reminder that "anguish, tears and penance / torment us constantly" and proceeds to emphasize that death comes to us all, often unexpectedly. "We were once as you are now," sang the skeletal performers, "You will be as we; / We are dead as you can see, / Thus dead will we see you." But while it was a terrifying display of human frailty, its function in the carnival appears actually to have complemented the spirit of sensual abandon. In the Trionfo di Bacco e Arianna (Triumph of Bacchus and Ariadne), Lorenzo de' Medici

followed Boccaccio in using the imminence of death as a reminder of the importance of seizing sensual opportunities. Lorenzo summed it up nicely in the famous ritornello:

How beautiful is youth, Which flies away nonetheless! Let him who would be happy seize the day, For tomorrow may not come.

If death and possibly Hell await, Lorenzo seemed to ask, why not enjoy life while you still can? As a young man, Michelangelo would certainly have heard this question posed—perhaps by Lorenzo himself—and there is a sense that it still lurked in his mind after he met Tommaso de' Cavalieri.

From the Dignity of Man to a Theory of Pleasure

There were good practical reasons for Boccaccio and Lorenzo de' Medici to advocate sexual abandon in the face of death, but there still remained the problem of how to deal with the moral and religious issues that they tried to sweep under the carpet. Although "why not?" was a sufficient basis for bawdy storytelling and carnival revelry, it wasn't exactly a compelling philosophical response to the theological injunctions against carnal pleasure, or an effective riposte to Petrarch's grim and self-denying morality.

The central obstacle to sexual indulgence was the distinction between the body and the soul or intellect. For Petrarch, the soul was an unwilling prisoner of the body. The physical world was a lower, "perverted" form of reality, while the spiritual or intellectual realm that could be enjoyed only after death was the only genuine source of truth and happiness. Man would only be "himself" when he was freed from his corporeal form, and could only earn this reward by shutting himself off from earthly temptation.

For the Ligurian humanist Bartolomeo Facio (ca. 1400–57), physical pleasure was the antithesis of human dignity. In his treatise *De hominis excellentia* (On the excellence of man), Facio explained that while man had been created in God's image and likeness, only the soul was divine and celestial. In contrast to the body, which rotted and decom-

posed after death, the soul was immortal and capable of returning to its heavenly origins. Thus it was clear that man's dignity lay not in the actualization of corporeal pleasures but in the life of the soul and the contemplation of God. Facio even went so far as to castigate those blind men who, "forgetful of their excellence and dignity, seek . . . corrupt and fleeting things so eagerly." Sex, in other words, was most definitely infra dig.

By the mid-fifteenth century, however, this long-accepted dichotomy began to be challenged. Perhaps inspired by the sheer physical terror of the plague, men and women started to question whether the body and the soul were really all that different, and tentatively began to ask whether man didn't possess a little more dignity than Petrarch and Facio had given him credit for.

It was the eclectic Florentine polymath Giannozzo Manetti (1396-1459) who broke the mold. Opposing the tough and uncompromising morality of previous centuries in his De dignitate et excellentia hominis (On the dignity and excellence of man), Manetti set out to offer a much more positive view of human nature. His approach was certainly original. It wasn't that he disagreed with Petrarch, Facio, or even the forbidding medieval Pope Innocent III on fundamentals. He was quite happy to acknowledge that there was a difference between the body and the soul. But for Manetti, this didn't mean that life had to be miserable. Quite the opposite. In Manetti's view, God had created the world for man's use. And although humanity did possess two natures corporeal and spiritual-God had not only created man as a whole person but had also given him all the faculties necessary to fulfill his purpose within the scheme of creation. Created in God's image, man had been endowed with a whole range of abilities-reason, intelligence, sight, hearing, taste, touch, smell, and so on-that allowed him both to interpret the physical universe in accordance with the inclinations of his soul and to manipulate everything around him according to his own reason for the sake of salvation. Man thus became an almost Promethean inventor, capable not only of enjoying the world around him but also of shaping his own destiny. Rather than being condemned to endure the fickleness and instability of earthly existence-as Petrarch and Facio had believed-man was both the master and the measure of all things. As a consequence, Manetti believed that man was "the most

beautiful, the most ingenious, the most wise, the most opulent, and the most potent" of all animals.

This was exciting in and of itself, but its implications were even more earth-shattering. From Manetti's reasoning, it seemed that God had ensured that man would pursue the right path by making some things more enjoyable than others. What was necessary became pleasurable, and it was the pursuit of pleasure that had led humanity not only to survive but also to become civilized. As Aurelio Lippo Brandolini (ca. 1454–97) argued in his *Dialogus de humanae vitae conditione et toleranda corporis aegritudine* (Dialogue on the condition of human life and on bearing bodily sickness),

Since a certain pleasure and delight has been attached by nature to those things which pertain to human nourishment and propagation lest anyone should neglect his life or his offspring through boredom or labour, and thereby cause the human race itself to come to an end, necessity is gradually converted into luxury; nor is only what is sufficient sought but what lust desires, and things by degrees have come to the point that men think that they can in no way live without wheat, wine, wool, buildings, and many even not without odours, unguents, plumes, and other delights. And apart from this condition there originated for men agriculture, navigation, construction of buildings, innumerable gainful arts, from this finally all labours so that they may be fed in elegance, abound in clothing and buildings, enjoy those pleasures which [are sometimes called] so miserable and so troublesome.

Physical pleasure was, in other words, an intrinsic part of human existence: men and women simply *had* to enjoy themselves in order to fulfill their roles in God's plan for humanity. "It will be difficult," Manetti argued,

if not impossible, to say how greatly man is taken by the pleasures which arise from seeing beautiful bodies, from hearing sounds and harmonies and other great and varied things, from smelling flowers and other similar odours, from tasting sweet foods and suave wines, [and] from touching the softest substances ... Therefore, if men . . . enjoyed more pleasures in life than they are tormented by troubles and anguish, they ought to be joyful and consoled, rather than complain and lament; especially since nature supplies more remedies for cold, heat, labours, pains, and diseases . . . that are soft, sweet, and abundantly pleasurable; for just as when we eat and drink in driving away hunger and thirst we are marvellously pleased, so when we get well, when we cool off, when we rest, likewise we have pleasure.

This was even more true when it came to sexual pleasure, and Manetti made use of quasi-Darwinian arguments in contending that sexual ecstasy had been created for a very definite reason:

Those [pleasures] which are generally and specifically perceived by the touch of the genitalia seem in a certain way more delightful than all other touchable things. The philosophers say that this was done by Nature . . . not blindly or by chance but by certain reasons and for evident purposes, so that far greater pleasures are received in eating and drinking because she gave priority to the preservation of the species over that of individuals.

If man did *not* enjoy physical pleasures, Manetti argued, he was not only forgetting his own nature but also harming both himself and humanity as a whole.

Exciting and inspiring though Manetti's argument may have been, he nevertheless allowed his critics scope for disagreement. Even if it was accepted that humanity had an obligation to enjoy all the pleasures life had to offer, the fact that Manetti continued to distinguish between body and soul raised a question about whether there was, in fact, a *scale* of happiness. Physical pleasures were all well and good, a critic might have said, but the soul was still the noblest part of the whole man: this being so, it was only fair to ask whether the pleasures of the soul were not still superior to the pleasures of the body.

It was left to Manetti's compatriot the priest-philologist Lorenzo Valla (ca. 1407–57) to solve this problem. Truculent, irascible, and powerfully argumentative, Valla patched up the gaps in Manetti's thinking to offer a strong defense of physical pleasure in the *De voluptate* (1431). Conceived as a dialogue between three friends, each of whom repre-

sents a different school of philosophy, this work was devoted to exploring the relative merits of the lives of pleasure and contemplation and, in doing so, concentrated heavily on the nature of happiness.

Valla began by observing that Aristotle had identified three ways of living—the life of pleasure, the civil or political life, and the contemplative life—and noted that each of these was pursued both for its own sake and for the sake of happiness. Yet, Valla argued, there was a problem inherent in this distinction. How could you say that *all three* modes of living were pursued for their own sake *and* for the sake of happiness at the same time? This suggested that happiness was both intrinsic to all three, yet somehow different. It couldn't be both at once. Since happiness had to be an absolute state, it was obvious to Valla that if happiness was to be found, all three ways of living had to be combined. None was superior to the others, and all was a part of the "good life." Pleasure, in other words, was a necessary part of happiness.

Valla was, however, no fool. He knew that this view would arouse more than a little opposition. In particular, he anticipated that some of his stuffier friends would try to argue that even if "pleasure" was a part of happiness, there were different ways of understanding the concept. Indeed, Valla knew that someone would inevitably argue that intellectual pleasure was superior to physical pleasure and that "contemplation" was the ideal way of living. Determined to head critics off at the pass, Valla immediately smashed this argument to pieces.

Since the word "pleasure" is used to describe both intellectual and physical enjoyment, Valla believed that the two were identical: both formed a part of what pleasure really was. It was foolish, he believed, to draw an artificial distinction between the two: although corporeal enjoyment and spiritual enjoyment were subtly different modes of experience, both body and soul still enjoyed the same pleasure. It was thus impossible to defend a contemplative life as something distinct or better. Even if one could speak of a contemplative life, Valla—like Epicurus argued that since all types of enjoyment are identical, contemplation actually aimed at pleasure, which was both intellectual and physical. When this was turned on its head, it was apparent that the pursuit of pleasure was, in fact, a part of contemplation, and thus it was obvious that sensuality was the best—indeed the only—virtuous way of life.

Between them, Valla and Manetti had produced a more positive and exciting vision of human existence and a workable theoretical justification for the new spirit of sensual indulgence that had been described with such passion and joy by Boccaccio and Lorenzo de' Medici. Far from being infra dig, sex and pleasure were, in fact, the *essence* of human dignity. And it was a lesson that Michelangelo seems to have taken strongly to heart.

ACT 4: RESOLUTION

Having idealized Tommaso de' Cavalieri in imitation of Dante, tormented himself with sorrow and self-hatred in the manner of Petrarch, and given way temporarily to his lusts with all the enthusiasm of Boccaccio, Valla, and Lorenzo de' Medici, Michelangelo finally found himself in a quandary. He was, in a word, torn. On the one hand, he loved the distant and occasionally cold Tommaso as the embodiment of all that was good and true, and was compelled by the imminence of death to shrink from all but the purest and most spiritual form of love. But on the other hand, he was also driven by an irrepressible sexual desire that he enjoyed, celebrated, and extolled. Drawing on rival traditions of Renaissance thought to give expression to the conflict, he was tearing himself apart. He needed to find a way of reconciling the two sides of his character. He needed to find a way of uniting love, sex, and death.

As 1533 drew on, Michelangelo had a revelation. There is no telling whether it dawned on him slowly or came all of a sudden, but the light of a solution began to shine through the clouds of his tortured relationship just as the sniping gossip of friends was beginning to bite. He began to see that there need not be any conflict at all. Earth and heaven were bound together in a chain of goodness and splendor that linked the body directly with God himself. What made Tommaso so beautiful—and so titillating—was not the fact that he *represented* all that was perfect but rather the fact that his beauty was itself a part of the divine. The pleasures of the flesh, the love of the ideal, and the longing for virtue could all come together at once. Michelangelo could love Tommaso physically *and* spiritually at the same time. Indeed, this new form of love seemed almost like an act of worship in itself. In a blaze of inspiration, Michelangelo scribbled it all down in one of his most revealing verses:

Here in your lovely face I see, my lord, what in this life no words could ever tell; with that, although still clothed in flesh, my soul has often already risen up to God. And if the foolish, fell, malevolent crowd point others out as sharing their own ill, I do not cherish less this yearning will, the love, the faith, the chaste desire of good. To wise men there is nothing that we know more like that fount of mercy whence we come than every thing of beauty here below; nor is there other sample, other fruit of heaven on earth; he who loves you with faith transcends to God above and holds death sweet.

The same sentiments shone through in The Rape of Ganymede (Fig. 17), the second of the two gift drawings that Michelangelo sent Tommaso at the very end of 1532. This depicted a tale of divine infatuation. As Tommaso would have known from Ovid's Metamorphoses, Ganymede was just a humble Trojan shepherd, but his extraordinary good looks had inflamed Zeus's passion. Lustful and impulsive, the god had to have Ganymede for himself. In Michelangelo's picture, Zeus, having transformed himself into an eagle, is shown carrying the lad up to Olympus to be his cup bearer. But far from showing any surprise, Ganymede seems to be caught between a loving swoon and an expression of pure ecstasy. Here, Michelangelo seems to have pictured himself in the place of both characters at the same time. Like Zeus, he clearly burned with a powerful desire for the boy's physical form and longed to snatch the handsome youth away for an eternity of platonic pleasure; and, like Ganymede, he felt himself carried heavenward by a love that he was powerless to resist. The love of the physical, in other words, became not merely an act of worship but also a transcendent experience. Everything-love, physical passion, spiritual closeness, religious belief-came together at once.

In this final "act" of the drama of his relationship with Tommaso de' Cavalieri, Michelangelo was reenacting a part of his own youth. As a young man in the household of Lorenzo de' Medici, he had been welcomed into a circle of humanists, the most prominent members of which included Marsilio Ficino and Giovanni Pico della Mirandola. Avid students and translators of Greek philosophy, these Neoplatonists (or, as Richard Mackenney has revealingly termed them, these "Neo-Neoplatonists") had succeeded in reconciling the disparate strands of Renaissance thought in an environment that was permeated not only by the reckless adoration of physical beauty but also by the inexorable expansion of intellectual horizons. And while there is no direct evidence of Michelangelo's ever having studied their works in any depth, there can be little doubt that he was exposed to their ideas in the heady atmosphere of intellectual debate and sensory indulgence that filled the Palazzo Medici Riccardi. Years later, it was to the half-remembered reminiscences of adolescent discussions that Michelangelo turned in resolving his inner torments, and it was Ficino and Pico della Mirandola who served as the models for this last and most compelling phase in the evolution of his love for Tommaso de' Cavalieri.

True "Renaissance" men by virtue of their immense learning and kaleidoscopic interests, Marsilio Ficino (1433-99) and Giovanni Pico della Mirandola (1463-94) were both eclectic, excitable, and intellectually vigorous individuals who were not insensible either to the colossal variety of creation or to the pleasures of the physical world. A student of the Greek scholar Georgius Gemistus Plethon, Ficino was the first to translate the entirety of Plato's works into Latin and, despite being in holy orders, nurtured strong but latent homoerotic desires that found expression in his passionate letters to Giovanni Cavalcanti. So, too, the noble Pico not only became fluent in Latin and Greek at an early age but was also particularly unusual for his deep knowledge of Arabic and Hebrew. He pursued a remarkable form of syncretism that embraced everything from Plato and Aristotle to the Kabbalah and the writings of Hermes Trismegistus at the same time as he was conducting a scandalous affair with one of Lorenzo de' Medici's married cousins and being accused of heresy by Pope Innocent VIII. In contrast to Ficino, who died in his own bed at Careggi, Pico was poisoned, perhaps as a consequence of his close ties to Savonarola.

But of their amazingly wide interests, what attracted and influenced Michelangelo the most was the one that grew out of the social environment in which they gathered. Although there has been some doubt whether it can be described as an academy, Ficino and Pico—along with others, including Cristoforo Landino—formed part of a large group that would meet regularly at the Medici villa at Careggi at the invitation of Lorenzo the Magnificent to discuss the very latest ideas. The atmosphere (of which Michelangelo saw only a pale shadow at the Palazzo Medici Riccardi) was constantly abuzz with excitement. Fueled by the rediscovery and translation of Platonic and Neoplatonic texts, these most extraordinary of men were surrounded at Careggi by a veritable cult of beauty, a palpable sense of joy at the immense possibilities of the human mind, a love of friendship, a latent sexual tension, and a power-ful desire for the new learning to be reconciled with the Christian faith. In these intellectually vibrant gatherings, Ficino and Pico encountered a broadening of the horizons of human experience beyond the limits of anything that had been imagined before, and—what was more—they felt an irrepressible need to bring everything together into one satisfying system of thought that both explained and justified the essence of all they found at Lorenzo's villa.

Out of this environment grew a fascination for the unity of all creation. This idea—which ultimately brought into play a truly exciting conception of human dignity and a passionate commitment to love revolved around two other, closely connected ideas. On the one hand, everything was linked. Rather than consisting of two very distinct realms—the spiritual or heavenly and the physical or worldly—the Neoplatonists conceived of the universe as a series of hierarchies, each of which was linked to the others in a chain of decreasing perfection. On the other hand, each of the hierarchies in the chain was defined by the extent to which it manifested Platonic "forms" or "ideas." Thus, while the "cosmic mind"—the highest and most perfect of the hierarchies was an incorruptible realm of Platonic ideas and angels, the "realm of nature"—which humans inhabit—consisted of a corruptible compound of form and matter.

The implications of this were important. Although the different hierarchies were in some senses distinct, they were nevertheless bound together by "a divine influence emanating from God." All participated in God himself by virtue of their creation, and each hierarchy necessarily reflected the character of those above it. The forms and ideas in the "cosmic mind," for example, were the "prototypes of whatever exists in the lower zones," and by extension everything in the "realm of nature" was a less perfect manifestation of its prototype in the higher realms. As Pico put it in his *Heptaplus*: Everything which is in the totality of worlds is also in each of them and none of them contains anything which is not to be found in each of the others . . . whatever exists in the inferior world will also be found in the superior world, but in a more elevated form; and whatever exists on the higher plane can also be seen down below but in a somewhat degenerate and, so to say, adulterated shape . . . In our world, we have fire as an element, in the celestial world the corresponding entity is the sun, in the supra-celestial world the seraphic fire of the Intellect. But consider their difference: the elemental fire burns, the celestial fire gives life, the supra-celestial loves.

The Neoplatonists believed that since the "realm of nature" was relatively low down in the scheme of creation, perfect beauty could not exist here on earth. By extension, anything that *was* in some imperfect way beautiful was a manifestation of a more sublime, heavenly beauty, and hence reflected a fragment of a higher "idea" or truth. Thus, even though man possessed an imperfect body, his physical form could sometimes reflect a measure of the ideal, while his rational soul—being incorporeal—was a yet more direct reflection of divinity.

If this was true, Ficino and Pico reasoned, it seemed possible for man to transcend the limits of his corporeal existence and achieve a sort of "union" with the higher, divine "idea" on which all else was modeled. This was all a matter of contemplation, for which man, being uniquely endowed with a sense of reason that allowed him to "ascend" and "descend" to higher and lower realms, was ideally suited. For it was in contemplation that "the soul withdraws from the body and from all external things into its own self . . . and there it discovers not only its own divinity, but in a gradual ascent, the intelligible world, the transcendent ideas, and God Himself, their common source." On ascending to this ultimate realm of the divine idea—an experience that Ficino, following Plato, described as a "divine frenzy" and attributed to the Hebrew prophets and the ancient Sibyls—man felt an incomparable bliss, a sense of pure and consuming ecstasy.

This idea of contemplation and ecstatic union was intimately linked to ideas of love. What had motivated God's creation of the universe was love. This love had manifested itself in a beauty that pointed the way toward God Himself. The life of contemplation—which aimed at transcendent union—thus entailed a full recognition of the essential character of beauty, and hence led to a desire for the ultimate fulfillment of beauty itself. This desire was, for Ficino and Pico, nothing more than love. To put this another way, contemplation required love, and love required a longing for beauty. The enjoyment of beauty was thus implicitly linked to ecstasy and even worship.

Although there are many different interpretations of the painting, it seems likely that it was this idea that Sandro Botticelli encapsulated in *The Birth of Venus* (ca. 1486), which was perhaps intended for the Medici villa at Careggi. In this most instantly recognizable of images, Botticelli depicted the goddess Venus (who had sprung out of the severed testicles of Uranus after they had been thrown into the sea by Cronos) being blown ashore on the island of Cythera. Classically beautiful, she is every inch the goddess of love. But the desire and love that her beauty inspires are not only somewhat chaste (as is suggested by the iconography of the shell on which she is standing and by the robe with which Horae, goddess of the seasons, is about to clothe her); they are also intended to point toward the heavenly realms. Her beauty emphasizes that she represents a divine love, and the ecstasy she inspires is bound up with contemplation of this fact.

Ficino pushed the boundaries of contemplation even further and consciously set out to revive the notion of platonic love in his translation of and commentary on Plato's *Symposium*. The essence of contemplation, Ficino argued, could be identified with the love of others and with a friendship between those pursuing the same goal. What he had in mind was, of course, a powerful, spiritual bond between likeminded individuals, but although he was careful to avoid condoning unrestrained sexual passion, his identification of contemplation with the "desiderio di bellezza" also obliged Ficino to imbue this bond with a shared celebration of beauty—especially homoerotic beauty.

The result was a powerful resolution of long-running uncertainties in Renaissance thought. Pointing to the unity of all creation, the Neoplatonists exalted man's capacity to reunite himself with God through a form of contemplation that demanded not only an exultant enjoyment of beauty (as a reflection of the divine) but also a deep and lasting love between individuals. This love was itself an act of worship and transcendence: it took the individual out of himself and elevated him heavenward, and it bound religious belief, the wonders of the physical world, and the soaring possibilities of the mind together in a single, semi-orgasmic whole.

It was in this dimension of Neoplatonism that Michelangelo found his salvation. Unable—or perhaps unwilling—to pursue a fully sexual relationship with Tommaso de' Cavalieri, he had at last found a means of worshipping him as a reflection of the divine, of loving him as the very model of human beauty without fear of sin, and of enjoying the rapture that he knew so well. Abandoning the self-flagellating morality of Petrarch and the unsatisfying libertinism of Boccaccio and Valla, he learned from Ficino and Pico that Tommaso could become his own Venus, a demigod who pointed the way toward Heaven and could be adored physically, spiritually, and chastely.

In the years that followed his first meeting with Tommaso de' Cavalieri, Michelangelo had undergone the extremes of pain and pleasure. He had loved deeply, he had been saddened by rebuffs, he had been tormented by guilt, and he had found ecstasy in adoration. But perhaps most important, in his verses and drawings, he had sought to understand and express his innermost feelings through the ideas and images that had arisen out of others' experiences of the world and of love. Often turning to the language of classical antiquity, he had relived the joys and the sorrows of those such as Dante, Petrarch, Boccaccio, Manetti, Valla, Ficino, and Pico in an attempt to find solace and satisfaction. And in doing so, he had reenacted the personal dramas that had inspired and motivated the cultural masterpieces of the Renaissance. As such, Michelangelo's fraught relationship with Tommaso can be seen as a microcosm of the Renaissance itself that underscores the extent to which the intellectual world of the Renaissance artist was derived not from high-minded ideals divorced from reality but from a desperate attempt to comprehend the grim and delightful experiences that made up everyday life.

PART TWO

THE WORLD OF THE Renaissance Patron

THE ART OF POWER

6

N THE AFTERNOON OF April 17, 1459, the fifteen-year-old Galeazzo Maria Sforza arrived at the Palazzo Medici Riccardi accompanied by a large retinue of magnificently attired horsemen. A handsome and eloquent young man, he had the dignity and good sense of a prince twice his age, and despite his youth he had been sent to Florence on an important diplomatic mission by his father, the duke of Milan. Having been greeted by the priors earlier that day, he had come to the home of Cosimo de' Medici—the city's de facto ruler—to begin negotiations.

An old hand at the game of international politics, the sixty-nine-yearold Cosimo would have given great thought to where in the palazzo to meet his young guest. First impressions mattered, and no more so than where diplomacy was concerned. But while courtly convention would have recommended one of the grand public rooms on the *piano nobile* as the most fitting place to receive so aristocratic a visitor, the nature of the deal they were to discuss may well have persuaded Cosimo to wait for Galeazzo Maria in the smaller and more intimate setting of the palace's private chapel. It would have been a shrewd choice.

Having come from the ducal court of Milan, Galeazzo Maria Sforza was used to magnificence. But what he would have seen as he crossed the threshold would have surprised the son of even the most lavish prince. The tiny chapel—which would have barely been big enough to contain his entourage—exploded with life and color. Three entire walls were given over to the rich, exuberant frescoes of the *Journey of the Magi to Bethlehem* (Fig. 18), and although they would have been incomplete at the time of Galeazzo Maria's visit, they would have inspired awe in any man of taste and refinement. Set in a "fairy world of gaiety and charm," the scenes showed the three kings traveling "in truly royal state through a smiling landscape." Packing his images with realistic details, the artist—Benozzo Gozzoli—had perfectly captured the opulence and excitement of the biblical procession. Absolutely no expense had been spared. In obedience to his patron's wishes, Gozzoli had adorned the figures with the most radiant, dazzling clothes possible and had certainly not skimped on the most expensive gold and ultramarine paints.

But if Galeazzo Maria's first reaction would have been one of amazement, Cosimo would have wanted him to look beyond mere surface beauty. There was much more to the chapel than first met the eye. For all their richness and vibrancy, Gozzoli's frescoes weren't just telling the story of the Magi. They were doing something else entirely.

Although there was a deliberate echo of the spectacular processions held in Florence every Epiphany, the *Journey of the Magi to Bethlehem* was transforming a biblical story into a glorification of the Medici's wealth and power. Each of the characters in Gozzoli's frescoes was a portrait of one of the participants at the Council of Florence, which had met in 1439 in an attempt to reconcile the Eastern and Western Churches. And naturally, the Medici were given the starring roles.

There, on the south wall, dressed in fine, oriental robes, and wearing a turbaned crown, was the former Byzantine emperor John VIII Palaeologus, playing the role of Balthazar. Next to him, playing the part of Melchior on the west wall, was Patriarch Joseph II of Constantinople, riding a donkey and wearing a long white beard. And on the eastbut still unfinished—wall, there appeared the crucial scene. Caspar, the third and youngest of the Magi, was played by a handsome young man dressed in a magnificent golden cloak and could only be an idealized representation of Cosimo's grandson Lorenzo "il Magnifico," then a boy of ten. Behind him appeared Cosimo himself, accompanied by his son Piero-the Gouty-and a host of exotic servants. And in the crowd of figures following them, Galeazzo Maria would have glimpsed the heads of prelates, including Isidore of Kiev and Cardinal Aeneas Silvius Piccolomini (who was to become Pope Pius II), notable scholars—such as the Greeks Argyropoulos and Plethon-and artists, including Gozzoli himself. At the far left of the scene were two unfinished figures, but it was clear from the horses alone that they were destined to be portraits of powerful nobles. In fact, one was already recognizable as a portrait of Sigismondo Pandolfo Malatesta, lord of Rimini, while the other would shortly depict Galeazzo Maria himself.

It was a remarkable conceit. Although it was not unusual for patrons

to be included as "participants in, or witnesses to, sacred dramas," what made the *Journey of the Magi to Bethlehem* unique was the fact that the biblical story had been infused with echoes of civic ritualism before being totally annexed to the Medici's sense of pride. Indeed, "never before had an entire family integrated itself so explicitly into sacred history." And not for a long time afterward would any family dare to use art so obviously to display such a powerful sense of self-confidence and ambition.

THE RISE OF THE PATRON

On looking more closely at Gozzoli's frescoes, Galeazzo Maria Sforza could not have helped recognizing that in Cosimo de' Medici he had met a man of supreme culture and refinement. Not only had he had the good taste to commission a truly breathtaking series of paintings from one of Florence's most brilliant artists, but he had also had himself depicted in the company of some of the foremost intellects of the day. There was no doubt that he was a very sophisticated human being, and there was little question that he was exactly the sort of person whom anyone would trust with money or political power.

This was precisely what Cosimo had intended. It was an image he had worked hard to cultivate. Having made an absolute fortune out of banking, he took immense pleasure in acquiring a thorough knowledge of the arts and in employing the very best artists. Having commissioned Michelozzo to redesign the Palazzo Medici Riccardi, he had enthusiastically bestowed his patronage on the most talented artists of the day. Works in their dozens were sought from Donatello, Brunelleschi, Fra Angelico, and Fra Filippo Lippi, and the family palazzo thronged with the constant buzz of artistic debate. Cosimo was always welcoming new talent into his house, befriending those of particular ability, considering new commissions, and discussing models and sketches for future projects.

Cosimo had endeavored to foster a reputation not merely as a patron but also as a learned connoisseur in his own right. Supported by his seemingly endless reserves of cash, artists, poets, and musicians competed with one another to celebrate his learning in the most extravagant terms and—in keeping with Cosimo's image of himself—lost no time in equating his cultural sophistication with public virtue. As his great friend the bookseller Vespasiano da Bisticci put it: When giving an audience to a scholar, he discoursed concerning letters; in the company of theologians, he showed his acquaintance with theology, a branch of learning always studied by him with delight. So also with regard to philosophy . . . Musicians in like manner perceived his mastery of music, wherein he took great pleasure. The same was true about sculpture and painting; both of these arts he understood completely, and showed much favour to all worthy craftsmen. In architecture he was a worthy judge; and without his opinion and advice no public building of any importance was begun or carried to completion.

By virtue of his learning and patronage, Cosimo had succeeded in appearing to be all things to all men. His discernment was not only laudable in its own right but deserved particular praise because of his willingness to place it at the disposal of his city. Who, Vespasiano seemed to ask, could possibly dislike such a man? Enamored with his patronage and learning, a contemporary later mused, "Ah, how much discretion he showed in uncertain things, how much love of country filled his waking thoughts!"

The Journey of the Magi to Bethlehem was just the latest installment in a lengthy campaign to project a dazzlingly impressive image of Cosimo's sophistication and wealth, and testified to the tremendous lengths he was prepared to go to ensure this impression was communicated to maximum effect. Far from having simply paid Gozzoli to get on with the decoration of the chapel, Cosimo and Piero de' Medici had worked closely with the artist. They had, in fact, been actively involved in the creation of the frescoes themselves and had good cause to think of themselves as co-creators. Drawing on their appreciation of the character and power of art, they had exercised a palpable control over the content and design of the work itself both by imposing specific contractual obligations on Gozzoli and by maintaining an ongoing dialogue with the artist. In this way, Cosimo and his son had succeeded in harnessing Gozzoli's skill to their own cultural aspirations and had ensured that they would be perceived as laudable, public-spirited connoisseurs of the most impeccable learning. Binding the artist to their will, they had effectively given their status a big boost.

As a manifestation of Cosimo's efforts to better his standing through art and culture, the *Journey of the Magi to Bethlehem* illustrates the importance of patronage to the development of Renaissance culture and represents the culmination of what might be called the "rise of the patron." Paralleling—and fueling—the "rise of the artist," this process of development had involved a transformation not just of the social and intellectual background of patrons but also of the manner in which patrons interacted with artists. And as a result it was to have monumental effects on the manner in which art itself was produced.

Insofar as Renaissance patronage revolved around spending money on works of art, two main factors contributed to the "rise of the patron." On the one hand, the Renaissance had witnessed the socioeconomic transformation of the "culture business." Artistic patronage was, of course, nothing new. Since the earliest times, the patronage of art had been acknowledged to be a sure indicator of wealth and status, and powerful figures from Augustus and Maecenas to Charlemagne and Frederick II had augmented their public standing through lavish spending on the arts. But as a result of the radical political and economic changes of the Renaissance, there had been an explosion in the number and range of patrons who were actively involved in commissioning works of art. With the expansion of trade and the fragmentation of political authority from the mid-thirteenth century on, those who had the money and the motivation to commission artworks that testified to their power and status became dramatically more numerous.

By the early fifteenth century, it was not merely emperors, kings, and popes who were investing in architecture, painting, and sculpture; local lords (*signori*), communes, guilds, merchants, notaries, and even humble tradesmen were also getting in on the act. From small devotional works to enormous secular paintings and elaborate bequests to mendicant churches, everybody who could afford to was buying art, eager to bask in the glory of their purchasing power. The Medici—who had risen from very obscure origins in the Mugello—were just one of the more striking examples of patrons who had suddenly become extremely wealthy and wanted to cloak themselves in the splendor that had previously only belonged to the truly great.

On the other hand, the political and economic changes of the early Renaissance had occasioned a shift in the value that this new class of patrons attached to the learning on which art depended, and thus also in the appetite for culture in itself. At least as early as the mid-thirteenth century, it had become clear that it was impossible to manage the affairs of a territorial state without a body of people who had a good grasp of Latin and the liberal arts. Laws needed drafting, records needed to be kept, embassies needed to be dispatched, and people both high and low needed to be persuaded. The study and emulation of classical literature—which historians have recognized as one of the defining characteristics of humanism—thus became an essential prerequisite not only for the growing class of professional bureaucrats (such as Coluccio Salutati and Leonardo Bruni) but also for mercantile oligarchies and noble *signori*.

But as learning became more and more essential to the practice of government, it also became an essential status symbol and a mark of the "virtues" necessary for public life. Anybody who wished to be thought well suited to political power rapidly realized it was vital to gain a thorough acquaintance with the latest cultural and intellectual trends. It was typical, for example, not only that Petrarch advised Francesco "il Vecchio" da Carrara to cultivate his appreciation of the liberal arts so that he might rule justly and wisely, but also that Machiavelli viewed the true prince as a man of learning as well as a man of action. But it was also no surprise that before long the repertoire of "necessary" skills had expanded to include an acquaintance with the visual arts and vernacular literature as well as with the ancient classics. In *The Book of the Courtier*, for example, Baldassare Castiglione argued, "I should like our courtier to be a more than average scholar at least in those studies which we call the humanities." "And," Castiglione continued,

he should have a knowledge of Greek as well as Latin, because of the very different things that are so beautifully written in that language. He should be very well acquainted with the poets, and no less with the orators and historians, and also skilled at writing both verse and prose, especially in our own language.

The same was no less true of painting and sculpture. For Castiglione, it behooved the courtier to acquire a good knowledge of these arts, not only because they could confer "many useful skills . . . not least for military purposes," but also because they could give him a full understanding of the complexity and majesty of the world he would help to govern.

As the liberal arts came to be seen as integral markers of status, the new class of patrons wished to display their learning by patronizing artists and litterateurs to as great an extent as possible. A household, court, or city that thronged with painters, sculptors, poets, and philosophers was, by definition, worthy of respect and esteem. It was for this reason that the "mirrors of princes" written during this period stressed the importance of patronizing the arts, and everyone who engaged in patronage—especially Cosimo de' Medici—learned that lesson well.

As a result of the significance that art had assumed both as a status symbol and as a display of learning, the new class of clever, knowledgeable patrons fostered ever closer relationships with the artists they employed. Used to the practicalities of business and government, they understood the importance of contracts and wanted to make sure they would get the best value for their money. Just as Michelangelo would later see when Piero Soderini offered his "advice" on the David, patrons-whether private individuals or representatives of institutions-were keen to suggest little changes and even to demand sweeping revisions. Cosimo and Piero de' Medici in particular were constantly engaged in dialogue with the artists they commissioned. Around the time of Galeazzo Maria's visit, for example, Piero asked Gozzoli to remove the angels from his frescoes on the grounds that he found their presence disturbing and contrary to the contractual agreement. But while Gozzoli was generally happy to listen (although he did not, in fact, remove the angels), the Medici's interventions were not always popular. Having devoted tremendous effort to making a "large and very beautiful model" of his design for the Palazzo Medici Riccardi, for example, Filippo Brunelleschi was horrified when Cosimo rejected it as being too ostentatious and was, in fact, so enraged that he smashed the model to smithereens.

By the time Galeazzo Maria Sforza arrived in Florence to meet Cosimo de' Medici, the patronage of art had reached extraordinary heights not only due to the growing number of people who wanted to demonstrate that they had "arrived," but also as a result of the remarkable value that had come to be placed on learning and the arts. For "new men" and emergent institutions, works like Gozzoli's *Journey of the Magi to Bethlehem* represented a sure way of expressing their status through patronage and of revealing their public merits through discernment. And to ensure that they would get exactly what they wanted, they were not afraid to bind artists ever more closely to their will with contracts and ongoing negotiations.

With this in mind, it is perhaps no coincidence that Renaissance

patrons of the arts are today often seen as cultural supermen in their own right. Given their stated devotion to the cultivation of painting, sculpture, architecture, music, and literature, and the huge amount of effort they devoted to employing the very best talent, it is often easy to view them as paragons of good taste and to regard them with the awe that is commonly inspired by the works they commissioned. Given the closeness of the relationship between artists and patrons, it is difficult not to succumb to the temptation to view the latter as harbingers of a golden age whose importance is equal to that of those who worked for them. If we stand in Galeazzo Maria Sforza's place and look up at the *Journey of the Magi to Bethlehem*, Cosimo de' Medici and his ilk do indeed seem to be bathed in an aura of supreme culture that carries with it a sense of public virtue and decency. What man of taste could possibly be bad?

The Power of Art

But this was only part of the story. Just as there is good reason to resist the temptation to view artists as near-perfect beings endowed with superhuman brilliance, so a deeper look at the social world of the Renaissance patron and the ends that patronage was intended to serve cautions against looking at such men through rose-tinted spectacles. It all stems from the fact that art wasn't just art.

As Galeazzo Maria Sforza peered closer at the *Journey of the Magi to Bethlehem*, he would have become conscious that the Medici had contrived to use the frescoes to communicate a specific political message that went well beyond a simplistic celebration of their status and learning. Surveying the figures portrayed in the paintings—from artists and philosophers to prelates, *signori*, emperors, and patriarchs—and decoding their hidden meaning, he would gradually have seen that the whole point of the chapel was to "legitimate [the Medici's] domination of Florentine politics" through art.

This was no small matter. Officially, Cosimo was nothing more than a private citizen. It had been years since he had last held any public office. Yet it was nevertheless an accepted fact that he was the dominant force in Florentine political life. Like a spider sitting at the center of a gigantic web, he manipulated a network of clients, contacts, and friends into doing his bidding in the Signoria and used a mixture of bribery and coercion to ensure that his word was law. As Pope Pius II noted, Cosimo was refused nothing. In matters of war and peace his decisions were final and his word was regarded as law, not so much a citizen as master of his city. Government meetings were held at his house; his candidates were elected to public office; he enjoyed every semblance of royal power except a title and a court.

Although Florence still prided itself on being a republic in 1459, this was little more than a polite fiction. Florence was Cosimo's. He was king in all but name.

The Journey of the Magi to Bethlehem was part of a gigantic publicity campaign aimed at endowing Cosimo and his heirs with an aura of political legitimacy, and it was primarily for this reason that the Medici had taken such tremendous care to discuss every last detail of the frescoes with Gozzoli. On the one hand, the Medici were implicitly pointing to the "heavyweights" who were backing them up. By surrounding themselves with portraits of the great and the good, the Medici not only projected an image of a fully functioning political network but also provided a model for the networks they wished to create in future. And on the other hand, the dynamics of visual role-playing were an unabashed assertion of the Medici's political status. In being cast in the role of Caspar, the young Lorenzo de' Medici was being placed on a par with Emperor John VIII Palaeologus and Patriarch Joseph II. Cosimo's family, in other words, "presented themselves as worthy companions of kings, prince-like in honour and rank if not in name." Taken as a whole, the frescoes were an unambiguous affirmation of Cosimo's boundless confidence and ambition and an unmistakable statement of the Medici's intention to remain the masters of a powerful and dynamic city that saw itself as the center of the cultural and political universe.

By virtue of the subtle political message embedded within the imagery, Gozzoli's frescoes reveal a rather different side to the "rise of the patron." The *Journey of the Magi to Bethlehem* points to the fact that patrons knew that as a form of PR that could be manipulated and shaped at will, art was power.

This had grown out of the same dynamics that had stimulated the nicer, more refined aspects of the "rise of the patron." It was all a matter of legitimacy. There was a pressing need for a sense of authority in the political sphere. The collapse of imperial authority had led northern Italy to crumble into a patchwork quilt of competing city-states between

the Alps and the Patrimony of St. Peter. In some, like Florence, Siena, Perugia, and Bologna, bourgeois tradesmen succeeded in dislodging the remnants of the nobility and establishing republics in which "citizens" were nominally supreme. In others, like Milan, Padua, and Mantua, the cities subjected themselves (willingly or unwillingly) to the rule of an all-powerful *signore*, or lord. Despite their differences, however, both the city-republics and the "despotisms" faced a common challenge. Confronted with the constant threat of external domination and the persistent dangers of factionalism and civil strife, the cities needed to come up with some method of defending both their right to exist as autonomous states and the legitimacy of their system of government.

But there was also an equally pressing need for a sense of moral rectitude in the economic sphere. Made rich by the expansion of trade, merchant banking, and the cloth industry, the communes and despotisms were packed with newly wealthy oligarchies that struggled to justify their importance in government, as well as the colossal wealth they had acquired.

The emergence of humanism offered a range of different means of addressing this double-headed need for legitimacy, and the highly educated notaries and bureaucrats who increasingly kept the city-states running devoted their knowledge of classical thought to providing the wealthy and powerful with much-needed intellectual support.

Yet however important literature and political philosophy may have been in investing the city-states with a sense of legitimacy, they only went so far. The audience for works of this variety was highly restricted, and given that it was most frequently composed either by bureaucrats and officials (rather than oligarchs and despots) or by literary hacks desperate to curry favor, it is even tempting to ask whether such works ever went beyond self-congratulatory backslapping.

An alternative route to legitimacy was to substitute confident affirmation for literary defense. Coupled with broad-based economic growth and the gradual development of artistic techniques, the new learning exposed those seeking to bolster their positions to the potential value of architecture and the visual arts as an instrument in the games of power. Indeed, equipped with a profound knowledge of the liberal arts, the rich and the powerful were conscious that painting and sculpture opened up possibilities that were all but inaccessible to literary—and even oral—culture. Retaining a close grip on the design and composition of artworks and architectural projects, patrons recognized that visual representations of power could employ a much more varied, flexible, and subtle vocabulary than could ever be expressed in writing and were capable of addressing issues that were virtually impossible to defend on paper. Political relationships could be discreetly modeled, wealth could be celebrated, and bonds could be forged with other groups and individuals through the arrangement and use of a vast array of iconographical features. What was more, through art or architecture, it became possible for patrons to communicate highly sophisticated and elaborate images of legitimacy and authority to broad sections of a society that was still preponderantly illiterate or semiliterate at best. Thus, although there is no denying the "rise of the artist," patrons simultaneously found that the need for legitimacy transformed them into "sophisticated and, in some cases, highly professional image makers."

From the late thirteenth century on, art's unique power to confer legitimacy on cities, institutions, and individuals led to an explosion in what might be called the "image market." The emergent city-states were among the most obvious patrons pouring money into art. Public buildings began to be constructed that reflected their grandeur. The town halls of Florence (1299–1314) and Siena (1298–1310) were conceived as testimonies to the stability and endurance of the communes, while fortresslike palaces such as the Palazzo Ducale in Mantua and the Castello Sforzesco in Milan (begun ca. 1310–20) served to emphasize that precisely the same qualities applied to the signori who dominated the "despotic" states. So, too, art was commissioned for public spaces that glorified either the independence of the communes or the relentless brilliance of the despots. In communal Siena, for example, the Council of the Nine called in Ambrogio Lorenzetti to paint the monumental Allegory of Good and Bad Government (1338–39) on the walls of the Sala dei Nove in the Palazzo Pubblico as a visual demonstration of the merits of republican government. And later, between 1465 and 1474, Andrea Mantegna was commissioned to decorate the Camera degli Sposi in the Mantuan Palazzo Ducale with frescoes depicting the signore Ludovico Gonzaga surrounded by his family and meeting with his son Cardinal Francesco Gonzaga, the emperor Frederick III, and Christian I of Denmark at Bozzolo on January 1, 1462. After a stuttering start to the Renaissance, even the papacy grabbed hold of patronage with both

hands, and by the mid-fifteenth century the popes had become some of Italy's most powerful and influential patrons of the arts.

Institutions were also prepared to draw on the new learning to collaborate with artists in creating sophisticated and "acceptable" public images. Religious confraternities and guilds invested heavily in patronage, and there is perhaps no better illustration of this than the richly decorated exterior of Orsanmichele in Florence, which was adorned with statues by virtually all of the leading artists of the day. Private citizens, too, got involved. Whether as obscenely wealthy merchants, powerful oligarchs, or warlike courtiers, individuals followed both the communes and the despotisms in using painting and sculpture to legitimate their dominance of governance, counsel, and wealth. Everyone who was anyone, in fact, was clamoring for art as a form of power.

So successful was art at communicating legitimacy that it was perhaps inevitable that learned patrons should have used their clout to push painting and sculpture in new and ever more innovative directions aimed at the same objective. Before long, the logic of this process led not only to the increasing "secularization" of religious themes in the service of patrons' ambitions, but also to the blurring of the distinction between "public" and "private" and to the expansion of the iconography of status. Cosimo de' Medici, his immediate heirs, and his more adventurous contemporaries were at the forefront of this development and, armed with an impressive arsenal of intellectual resources, successfully railroaded artists into embracing new forms that reflected their own aspirations. A rich combination of visual exuberance, artistic brilliance, and overarching ambition, Gozzoli's *Journey of the Magi to Bethlehem* is perhaps the first and fullest expression of this willingness to encourage artistic innovation in the pursuit of legitimacy.

Although there is always a temptation to conflate the character of patrons with the beauty of the paintings and sculptures they commissioned, the "power of art" demonstrates that patronage—particularly large-scale patronage—was habitually used to serve very cynical, realworld purposes and testifies not to the culture and learning of those holding the purse strings but to the deep-seated illegitimacy of those who cultivated the arts most strenuously. Lurking beneath the surface of every major painting or fresco was another, much darker story of patronage and raw power. But even this only begins to hint at the true ugliness of the Renaissance patron.

The Art of Power

Young though he may have been, Galeazzo Maria Sforza would have been able to see that Cosimo de' Medici had worked with Gozzoli to produce a potent illustration of the legitimacy of his rule in Florence. But he would also have been able to see that Cosimo had a greater need than most for precisely this form of artistic legitimacy. What was more, it would have been obvious that he was being shown Gozzoli's frescoes for a very specific reason.

Far from being an unusually successful, self-made man whose manifest abilities had obliged him to assume the burdens of power unwillingly, Cosimo de' Medici had not risen to the top by his wealth and good sense alone. Though he was rich and sophisticated, Cosimo was little more than a moneygrubbing, power-hungry megalomaniac who had achieved his position of ascendancy through a combination of corruption, violence, and brutality.

Having made huge profits from lending money at interest and speculating on highly volatile markets, Cosimo had deployed his vast resources in the service of his unbounded ambitions. Although he rarely deigned to hold public office, he was not ashamed to buy the influence he craved, and he openly purchased votes when he had to. Working behind the scenes, he had a ruthless attitude toward opposition. In the early years of his political adventurism, he simply threw his financial weight around until he got his way. After being exiled by the faction headed by Palla Strozzi and Rinaldo degli Albizzi in 1433, he effectively blackmailed Florence into recalling him by starving the city of muchneeded cash. Immediately upon reentering Florence in 1434, he had Strozzi and Albizzi exiled for life. And that was just the beginning.

Only a year before Galeazzo Maria Sforza's arrival, Cosimo had embarked on a ferocious and uncompromising coup. Posting armed men around the square, he forced a public *parlamento* to rubber-stamp a new constitution that would give him absolute control over the Signoria, and made sure that any dissenting voices would be squashed by securing the support of foreign mercenaries. What was more, he had no qualms about embarking on a campaign of persecutions. His remaining enemies—dyed-in-the-wool republicans, or Strozzi loyalists—were disbarred from political office, and a new council (the Cento) was set up to ensure that his bidding would be done without question. By 1459, Cosimo was firmly in control of Florence. But even though he tried to do some good for the city (as the merchant Marco Parenti observed), the stain of illegitimacy and illegality clung to him indelibly. As Pius II recorded in his *Commentaries*, Cosimo remained the "illegitimate lord" of the city and would always be guilty of keeping "its people in cruel servitude." And no matter how hard he tried to suppress opposition, a certain segment of the population would always strain against the ties with which he had bound them.

Cosimo had sacrificed any chance of enjoying lawful authority and had to work doubly hard to craft an artificial aura of legitimacy. With the same ruthlessness that had driven him to hack his way to the pinnacle of power, he looked to the arts for something more than a vague, sentimental form of respectability. The peak of a lengthy campaign of careful patronage, the *Journey of the Magi to Bethlehem* was designed to cover up his many vices. With a genuine sense of cunning, Cosimo had harnessed Gozzoli's artistic ability to help remove the horrible taint of tyranny and to present him as a benevolent *pater patriae* with whom all right-thinking (that is, credulous) citizens could sympathize.

Given the means by which Cosimo had seized control of Florence, it would have been vitally important that Galeazzo Maria Sforza recognize the frescoes as a powerful illustration of the Medici's power. In revealing the stability and strength of his family's (ultimately illegitimate) position, Cosimo was making a decisive power play through pictures. It all boiled down to a question of mutual benefit, and Gozzoli's frescoes were a visual component in a broader game of horse-trading that would not be out of place in a Mafia drama.

Long experience had taught the Sforza and the Medici that they needed each other. In 1440, Galeazzo Maria's father, Francesco, had seized control of Milan from the Visconti with Florentine backing, backing that Cosimo had been instrumental in arranging. And only the year before, in 1458, Cosimo's coup had been made possible by a castiron guarantee of military support from Francesco. The alliance had served not only to unite the two states in peace but also to keep the two families in power in the face of internal and external threats. If it was to last, each side needed to be sure of the other. Knowing he relied on Florentine support, Francesco could easily dump the Medici if he suspected that another family was better placed to ensure the money and diplomatic ties he needed. By underlining the towering strength and stability of Medici power in the *Journey of the Magi to Bethlehem*, Cosimo was subtly pointing out that his family was firmly in control of the city and still more than capable of keeping up its end of the bargain. The frescoes were, in other words, intended to make Francesco and Gale azzo Maria an offer they couldn't refuse.

Having given Galeazzo Maria the opportunity to appreciate the full meaning of the chapel's decorations, Cosimo would have been sure that, despite his dirty and disgraceful past, the Sforza-Medici axis would remain solid. In fact, despite minor fluctuations, it would remain the mainstay of Italian politics for the next two decades. And, most important of all, Cosimo knew that he had got his way not through complex and tedious negotiations but through art.

The lesson appears not to have been lost on Galeazzo Maria Sforza. Upon acceding to the ducal title in 1466, he swiftly earned a reputation for his patronage of the arts and, striving to outdo the Medici in all ways, was recognized by many of his contemporaries as the very image of the dashing, cultured prince. As one put it,

He was most magnificent in furnishings, and in his way of life, and splendid beyond measure in his court. He presented very rich gifts to his attendants . . . and with great salaries he attracted men skilled in whichever science.

He was renowned for his love of painting. Having patronized artists such as Bonifacio Bembo and Vincenzo Foppa, and having poured money into enormous projects such as the imposing frescoes of the Portinari Chapel, he would periodically indulge excited flights of fancy and would reward those who answered his call with a legendarily openhanded generosity. On one occasion, for example, Galeazzo Maria took it into his head to have a room decorated with elaborate paintings of "noble figures" in a single night and spared absolutely no expense in pursuit of the whim. His first love was, however, music. Filled always with the sound of the most innovative and enchanting melodies, his court became famed for the plethora of talented musicians (mostly from the Low Countries) whom he summoned to Milan at enormous cost.

Galeazzo Maria's lavish patronage of the arts ensured that his prestige in Milan was colossally high in the early years of his reign, and even his father's usurpation seemed to recede from the popular memory as his court became famed as the most glittering in Europe. Thanks to his growing reputation as a cultural leviathan, he earned the respect and admiration of the kings, popes, *signori*, and oligarchs who were privileged enough to see or hear the works he had commissioned. Indeed, so close was the link between art and perceptions of power that Lorenzo de' Medici even kept Pollaiuolo's portrait of Galeazzo Maria in his bedroom.

But like Cosimo de' Medici's, Galeazzo Maria Sforza's patronage of the arts was designed to conceal much darker and nefarious realities. It was all just a smoke screen. Without his strong-willed and disciplinarian father around to hold him in check, Galeazzo Maria rapidly became a sadistic and sexually incontinent sociopath. Suspecting him (not without reason) of murdering his mother, Bianca Maria, the people of Milan came to fear him for his wanton savagery and heinously bad temper, which was so bad as to attract the criticism of Machiavelli himself. He delighted in seeing men tortured—occasionally even inflicting the worst pain himself-and even had a priest starved to death. None, however, had more reason to be afraid than the women of the duchy. Although he was also thought to have had a homosexual relationship with the Mantuan ambassador Zaccaria Saggi, he had no qualms about coercing any woman who took his fancy into succumbing to his violent sexual tastes. Neither age, nor status, nor the bond of matrimony could stop him. Even nuns were not safe, and he seems to have developed a particular fondness for breaking into nunneries to have his way with the sisters. Indeed, it was no surprise that when Galeazzo Maria was eventually assassinated at the age of only thirty-two on December 26, 1476, his three murderers had all suffered from the duke's excesses: both Giovanni Andrea Lampugnani's wife and Carlo Visconti's sister had been raped by their liege lord, while the more bookish Girolamo Olgiati's tutor, Cola Montano, had been whipped through the streets of Milan on a trumped-up charge. Short though his reign may have been, it was only through the loyalty of his courtiers and the impact of his patronage that Galeazzo Maria managed to cling to power for quite as long as he did.

In the moment of silent accord between Galeazzo Maria Sforza and Cosimo de' Medici, and in the forms of patronage it later inspired in Milan, the *Journey of the Magi to Bethlehem* illustrated the full implications of the "rise of the patron." On the one hand, it represented the fulfillment of the intricate processes that had transformed the relationship between artists and patrons. On the back of a series of radical political and economic changes that had their origins in the collapse of the old Empire, a new breed of patrons had emerged who not only placed an increasingly high value on learning as a symbol of status but who were also willing and able to use patronage as a means of endowing themselves with a highly focused air of legitimacy. Working in ever closer partnership with the artists they commissioned, they became the "cocreators" of Renaissance art and contrived to direct the arts toward ever new flights of innovation in the service of their needs.

On the other hand, the Journey of the Magi to Bethlehem also demonstrated that this new breed of patrons was often composed of deeply unpleasant and highly dangerous individuals who were spurred on to ever more ruthless flights of ambition by the opportunities created by the same forces from which the "rise of the patron" had emerged. Although they certainly sought to project an image of legitimacy through art, their need for legitimacy was all the more acute by virtue of the illegal, immoral, and frequently violent means by which they had risen to prominence, and by extension their need to indulge in patronage was all the more extreme. It was this most devilish class of men (and occasionally women) who were the epitomes of the "rise of the patron," and though they remained "co-creators," the art they commissioned was often designed to cover up the most heinous of crimes. Indeed, the more remarkable and beautiful the art such a patron commissioned, the more heinous his offenses, and the more cynical his intentions. So, while Cosimo de' Medici and Galeazzo Maria Sforza were renowned as the greatest patrons of their age, they were also among the most ghastly people of the entire period, and the arts they fostered are as much a testimony to their moral turpitude as they are to the skills of the artists themselves.

The implications of this are significant. If patrons were every bit as important as artists in shaping the form and direction of Renaissance art, it is impossible fully to understand the art of the period without uncovering the social world they inhabited and peering into the dark and dastardly details of their private lives. Rather than allowing ourselves to be seduced by the splendor of the works they commissioned, it is essential to uncover the world behind the paintings, a world populated not by the perfect mastery of color and harmony that is usually associated with the Renaissance but by ambition, greed, rape, and murder.

Hidden among the multitude of faces in the *Journey of the Magi to Bethlehem* are the portraits of three men who are emblematic of the three most important types of patrons in the Renaissance. When the lives and careers of bankers, mercenaries, and popes are traced, a new and utterly different Renaissance becomes clear: a Renaissance in which nothing is what it seems, and which is uglier still.

The Men with the Midas Touch

7

T WAS CLEAR that Cosimo de' Medici was keen to use Gozzoli's frescoes to display his wealth and power, but Galeazzo Maria Sforza would have noticed that the *Journey of the Magi to Bethlehem* also seemed to point toward another, rather different side of the aging banker's character. Despite the splendor and confidence of the composition, Cosimo had chosen to have himself portrayed in a deliberately understated manner. Far from occupying pride of place—as might have been expected—he appeared at some distance from the center of the drama. Riding a humble donkey, he meekly followed in the wake of his son Piero. He almost seemed to blend into the crowd behind. His golden reins and fur-trimmed cuffs notwithstanding, there was little in the way of ostentation. His clothing was simple, even penitential. Even his conical red hat seemed to have been designed to minimize his visual impact. Indeed, the whole impression was one not of pride or ruthlessness but of a self-effacing modesty and humility.

It was a puzzle. Though he could do almost anything he pleased in business and politics, Cosimo was—as Galeazzo Maria was to learn— "anxious to remain in the background, hiding his great influence and acting, when need arose, through a deputy." Ten years before Machiavelli had even been born, Cosimo seemed to have had an intuitive appreciation of the value of dissimulation.

But Galeazzo Maria would have found it hard to avoid the suspicion that, for all his influence, Cosimo wanted to appear humble. He was, after all, well-known for his occasional attempts to flee the life he had created for himself. Galeazzo Maria would have heard rumors that Cosimo was fond of shutting himself away in a cell that was kept for his use in San Marco and devoting himself for days on end to silent prayer or pious discussions with his friend Fra Antonio Pierozzi. With Cosimo seated quietly on his donkey, there was more than a whiff of the genuine penitent about his portrait.

As a snapshot of Cosimo's life, character, and "public image," the *Journey of the Magi to Bethlehem* would have presented Galeazzo Maria with a strangely confused and even contradictory picture of the man standing in front of him. Lavish ostentation, political chicanery, and coldhearted cunning appeared alongside a meekness that hovered between Machiavellian deceit and heartfelt piety. The old man was an "indecipherable sphinx." It was almost as if there were not one Cosimo but two or even three.

But despite its apparent contradictions, what Galeazzo Maria would have seen was an entirely consistent and coherent image of Cosimo de' Medici. Although unusual for the scale of his political and financial influence, Cosimo was the embodiment of the Renaissance merchant banker. The means by which he had acquired his wealth and power writ large into Gozzoli's frescoes—were an encapsulation of the process by which this new breed of businessmen had emerged and the cunning they had employed. At the same time, his urge for magnificence, atonement, and dissimulation was a vivid illustration of the altogether novel challenges that had confronted successive generations of devious merchant bankers. And perhaps most important of all, the *Journey of the Magi to Bethlehem* summed up the extent to which Cosimo and his mercantile predecessors had used their patronage of the arts to craft a public image that responded to each of these problems.

By tracing the surprising and often shocking path that had led Cosimo de' Medici to become the person who would have caused Galeazzo Maria Sforza such uncertainty, it is possible to see the shadowy and unpleasant world of the Renaissance merchant bankers, and the ugly and cynical concerns that underpinned their remarkable role as some of the Renaissance's foremost patrons of the arts. Although inextricably bound up with the world of political chicanery, corruption, and coups, it's a tale of high finance, enormous profits, and—inevitably moral bankruptcy that puts the scandals surrounding today's merchant bankers in the shade. And as the story behind the *Journey of the Magi to Bethlehem* unravels, it becomes clear that this breed of super-wealthy men lived very far removed from the beauty and splendor of the works they commissioned.

FROM MONEY CHANGERS TO BANKERS

In many senses, the Renaissance was the golden age of merchant bankers. Even more so than today, they were defined by their staggering wealth. But in 1459, no banking family was as fabulously rich as the Medici. They made Croesus look like a pauper. Between 1435 and 1450, for example, Cosimo de' Medici personally made a profit of 203,702 florins. If Giovanni Rucellai's estimate is to be believed, this figure alone was the equivalent of some 13 percent of Florence's total worth. But this was just profit, and the profit of a single member of the family at that. When the full range of the Medici's investments is taken into account, their wealth easily exceeded that of any of the greatest states in Europe.

Yet the Medici had not always been rich. Their money had been amassed slowly and patiently by generations of men graced with cunning and driven by a burning desire for cash. They had come a long way, and the road they had traveled neatly embodied the route by which merchant banking itself had emerged in Renaissance Italy.

Like those of many other banking families, the origins of the Medici are shrouded in mystery. In later centuries, they were fond of claiming descent from a legendary knight called Averardo, who was supposed to have killed a marauding giant under the Carolingians. But what little evidence survives seems to suggest rather more prosaic roots. As their name implies, they might well have started out as doctors or apothecaries. For most of Cosimo's contemporaries, however, it seemed more probable that they had begun as humble pawnbrokers. All that can be said with any certainty is that when they first appear in the historical record in the early thirteenth century, they had somehow discovered a talent for working with money.

At this time, the economies of the city-states of northern Italy were just beginning to take off. The trade in cloth and grain was beginning to expand, and regular markets were springing up around Europe. Italian merchants were soon trading not only with other cities on the peninsula but also with states far beyond, from England and the Low Countries to Egypt, Cyprus, and even Kievan Rus'. Indeed, as Francesco Balducci Pegolotti explained in the *Pratica della mercatura* (ca. 1335–43)—perhaps the earliest commercial handbook of its kind—a serious trader could not expect to get anywhere in life without a working knowledge of at least five or six different languages and a good familiarity with the types of goods that were traded in a score of different ports and markets around the Mediterranean.

But even though trade was starting to boom, commerce was obstructed by one very serious practical difficulty. It was a matter of money. Although today paper money, credit cards, electronic bank transfers, and established rates of exchange make it possible to execute a transaction quickly and easily anywhere in the world, none of these things existed in the thirteenth century. Coin and bullion were the only mediums for monetary exchange, and since each city had its own coinage, a huge variety of currencies was in circulation, the exchange rate between which was a matter of guesswork. Simply going to the market to buy a few odds and ends could be a chore when you had to carry around bundles of heavy coins and argue with the stallholder about the value of the strange collection of foreign coins you had in your purse. High-value business across larger distances could be even more complicated. Obliged to carry cumbersome chests of coins or stacks of bullion on long journeys, a tradesman ran the risk not only of being robbed en route but also of being slowed down by the sheer weight of the money he was carrying. Even if a merchant arrived at his destination in good time and with his capital reserves intact, he was in danger of losing a good deal of money in negotiations that-by their very nature-involved working in a multitude of unfamiliar currencies. Although Pegolotti's Pratica della mercatura included a careful survey of the relative fineness of some of the more common gold and silver coins in use around the Mediterranean, such tables were simply inadequate to guard against the shifting and uncertain character of the financial world.

Two Medici, Ugo and Galgano, set up shop as small-time moneylenders as early as 1240, but it was the fact that a certain Ardingo and his siblings opened a money-changing business in the Mercato Vecchio a few decades later that showed they knew which side their bread was buttered on. It was this profession that offered the only real solution to the problems of trade, and it was as money changers—not as moneylenders—that the great merchant banks started life.

Initially, money changers like the Medici acted simply as agents of financial order in a world of monetary chaos. Usually operating out of a small shop near a city market, they would exchange a confusing mishmash of different currencies for a roughly equivalent value in uniform coinage. It was a bustling, busy way of life. Although painted some two centuries after the Medici brothers opened their shop in the Mercato Vecchio, Marinus van Reymerswaele's *The Moneychanger and His Wife* (1539; Prado, Madrid) gives a good impression of the sorts of practices that made up the money changer's trade (Fig. 19). Surrounded by bags of money and overflowing piles of paperwork, the money changer is shown weighing coins carefully to test their fineness and checking his values against the manual in his wife's hands. It was a long and laborious process, but people like the Medici were able to console themselves that they could make plenty of money out of transaction charges and the massaging of fluid rates of exchange.

As trade became more brisk and merchants needed to carry larger volumes of cash around with them, these money changers started to allow people to deposit sums of money with them for safekeeping. The primitive current accounts that were thus created could be treated in much the same way as today. Money could be paid in by the account holder or his debtors and paid out according to the holder's instructions. This all made trade a good deal easier, but since it was initially founded on face-to-face interactions across a banking table, there was still a little way to go before the serious problems of large-scale international trade could be tackled and before significant profits could be made.

The first truly dramatic innovation was the bill of exchange. Having emerged in Genoa toward the end of the twelfth century, this allowed merchants to avoid the dangers of transporting large quantities of coin/bullion and facilitated international currency exchange. If a merchant in Florence (the payer), for example, wished to make a payment to someone in Bruges (the payee), he would hand over the necessary sum of money to the Florentine branch of his chosen bank, plus a certain commission, and would receive a bill of exchange for that value in return. The Florentine payer would then send this bill to the payee in Bruges, who could redeem it for the agreed sum in the local currency from the Bruges branch of the same bank or its factors. Although there were obviously risks involved, the banker made his profit on the basis of the rate of exchange that was agreed. A closely related, and similarly profitable, device was the letter of credit, which functioned much like a modern traveler's check.

The second important profit-generating development was the interest-bearing loan. This was facilitated by the prior evolution of

deposit accounts (which could be encouraged by banks offering interest on savings) and the fact that bills of exchange also allowed the banker a "window" within which he had access to the sums of money being transferred. With a substantial amount of raw cash on hand, the banker could use this capital to offer substantial loans for a set period of time, for a set rate of interest. Sometimes a loan could be offered against a surety, such as jewelry, but often it was simply agreed on the basis of trust.

There is little doubt that the Medici cottoned on to the potential of these innovations fairly quickly, and with the profits they made from bills of exchange, letters of credit, and interest-bearing loans, they began to invest in property and the wool trade in the first half of the fourteenth century. Before long, being "like a Medici" became a byword for affluence among the shopkeepers of the Mercato Vecchio.

The Art of Atonement

But as the Medici began to make their money, they ran up against a serious challenge. Although there were few—if any—practical obstacles to the profits that could be made from early forms of banking, the practices intrinsic to the industry raised some troubling moral issues.

The Church had long regarded the avaricious pursuit of wealth as one of the most troubling impediments to Christian virtue. Christ had, after all, warned that it was easier for a camel to pass through the eye of a needle than for a rich man to enter the Kingdom of Heaven and had urged all those who wished to follow him to give away all they had. This, indeed, had been the inspiration for Saint Francis of Assisi's celebration of poverty as the only true calling for a devout Christian in the early thirteenth century. Facilitated by both the success of the mendicant orders and the growth of trade, such a line of thought struck a ready chord in the commercial centers of early Renaissance Italy. Equipped with a burgeoning commercial sector and a certain suspicion of wealth itself, Florence provided an ideal setting for the reception of Franciscan ideals into the mercantile consciousness, and it was in this spirit that in the early fifteenth century Poggio Bracciolini devoted an entire treatise to condemning avarice, and Cristoforo Landino penned a savage verse against covetousness.

But if the pursuit of wealth was bad enough in the abstract, bank-

ing itself rapidly came to embody the very essence of avariciousness. If ordinary traders were susceptible to greed, bankers were plainly wedded to it by virtue of the fact that they lent money for a profit. This practice of "usury"—lending money at interest—had been identified as a mortal sin in the New Testament and had been expressly forbidden by the Church since the Council of Nicaea in 325. The reason for this was that in demanding interest, bankers were guilty of "charging" people for nothing. "To take interest for money lent is unjust in itself," claimed Saint Thomas Aquinas, "because this is to sell what does not exist, and this evidently leads to inequality, which is contrary to justice." Usury was, in other words, basically the same as theft. And those who made the most money of all out of merchant banking were those whose souls were most heavily stained with sin. This, indeed, was precisely the line wheeled out in Florence in the sermons of the fiery Franciscan preacher San Bernardino of Siena (1380–1444).

The awful wrongs that the Church associated with banking were hammered home time and again in the literature of the early Renaissance. Indeed, literary works could be more forceful even than theological treatises in their condemnation of usury. In the De avarita, for example, Bracciolini went out of his way to condemn usury as the archetype of avarice and even attacked the notoriously vicious Bernardino of Siena for not making his listeners fully aware of the "horror of such a crime." None, however, harbored a more virulent hatred of interest-bearing loans than Dante. In the Inferno, Dante described the fate of usurers in vivid detail. Wearing money sacks bearing heraldic crests around their necks, "dishonest" moneylenders are depicted squatting on the bottommost rim of the seventh circle of Hell, vainly trying to fend off the flames like dogs pawing at fleas. Among their number, Dante spied representatives of two noted Florentine banking families-the Gianfigliazzi and the Obriachi-and paused to speak to the wailing figure of Reginaldo degli Scrovegni, a Paduan usurer who predicted the imminent arrival of his compatriots Vitaliano del Dente and Gianni Bujamonte of Florence.

The bankers of the early Renaissance were deeply affected by the harsh line their contemporaries took against usury. The possibility of spending an eternity in Hell was a very real fear, but even if their sins were not sufficient to merit perpetual damnation, there was still good reason to be afraid. Only a little before the explosion of Italian commerce, theologians had developed a full-fledged conception of Purgatory as the antechamber of the underworld, and it was generally accepted that it was in this place of suffering and torment that any sins that had not been atoned for would be punished. The threat of Purgatory was enough to strike fear into the heart of even the most skeptical of bankers. In later years, Giovanni di Bicci de' Medici was to seek guidance on this matter from prelates, and his son Cosimo was sufficiently troubled by the perceived immorality of usury to engage in regular, protracted discussions with friends in holy orders about how best to expunge the banker's sins.

The sacraments of the Church offered the most obvious solution. Whenever a banker was at death's door, his family—or the doctor in attendance—would send for the priest. The dying man would then confess his sins, and, provided he was contrite, the priest would then give him extreme unction, wiping his soul clean for its passage into the afterlife. It was simple and—in theological terms—effective. The only problem was, however, cynicism. Although atheism was unthinkable, bankers raised in the Catholic faith were nevertheless apt to sneer at the very idea of making an honest confession.

In the *Decameron*, Boccaccio gleefully tells of how a Pratese notary named Ser Cepperello is unexpectedly struck down by a fatal illness in Burgundy. A deeply sinful man, given to cheating, stealing, drinking, gambling, and whoring, Cepperello has enough faith to recognize that he needs to give a deathbed confession but is shrewd enough to realize that a truthful confession would give Italian merchants a bad name in the Low Countries. Without hesitation, he summons a friar noted for his holiness and "confesses" to a pack of lies that make it seem that butter wouldn't melt in his mouth. Much impressed with his "virtues," the friar duly gives Cepperello extreme unction. So successful are Cepperello's lies that after his death, the naive friar ensures that he is celebrated as a saint, much to the amusement of Boccaccio's *lieta brigata*.

But this left bankers with a problem. If the idea of making an honest confession was laughable, how could the sin of usury be expiated? How could they reconcile their appetite for profits with their desire to stay out of Purgatory?

Bankers were nothing if not practical men. If confession and extreme unction were not to be relied upon, they could at least put their faith in cold, hard cash. Although he might not be able to talk his way through the Pearly Gates, a banker could at least hope to buy his way into Heaven.

At the same time as a priest was called to a banker's deathbed, a notary would also be summoned. His task was to draw up a final will at the dying man's bedside, and in the will lay another great hope for last-minute salvation. Most wills—especially those of bankers and merchants—included clauses (known as *mala ablata*) which stipulated that a certain sum of money should be given to the Church in proportion to the sins committed. In return, it was expected that priests, monks, friars, and even ordinary worshippers would offer prayers for the soul of the deceased and thus help to rescue him from the sufferings of Purgatory.

This practice was later condemned in no uncertain terms by Fra Giovanni Dominici (d. 1420) and Antonino Pierozzi, the future archbishop of Florence, but the idea of bequeathing money in restitution for the sin of usury proved remarkably popular, and the greater part of bankers took advantage of the option to insure themselves against their wicked ways. A typical example is found in the will of Michele di Vanni Castellani, which was drawn up in Florence in 1370. Although he claimed he had not obtained any illicit income, Michele added:

I bequeath 100 florins to the bishop as compensation for money which I may have gained illegally, and this should be used in benefit of the souls of those from whom I received the money.

Just to make sure, he also lavished a similar amount of money on the Franciscans, the Dominicans, the Augustinians, and the Carmelites of Florence.

There was, however, a nagging doubt. Even if money was bequeathed to the Church—sometimes with an explicit statement of how many prayers and masses were to be said for the deceased—this only went a certain way to guaranteeing that ecclesiastics and the faithful would keep the soul of a dead banker in mind. Thankfully, art came to the rescue.

Perhaps the simplest and most straightforward means of keeping a banker's memory alive was for him to commission a lavish tomb, either directly or by instructing his relatives to make the necessary arrangements. Commonly including a carefully designed effigy of the

deceased and a series of accompanying inscriptions stressing his or her qualities, such sepulchres were obviously intended to ensure that the patron would be remembered after death, not merely by passersby or even by the city at large, but also-and most specifically-by those whose prayers would be necessary for the dead man or woman to merit a place in heaven. Thus, Niccolò Acciaiuoli-the scion of his family's banking house, the chancellor of the kingdom of Naples, and a friend of Petrarch's-not only had an elaborate tomb carved for himself in the certosa of San Lorenzo, outside Florence, but also made doubly sure that the monks would pray for his soul by leaving them a huge bequest on the condition that a thousand masses would be said for him in the first year after his death. No amount of money was too much for such sepulchral endeavors. In 1471, for example, the Florentine merchant Piero del Tovaglia summarized contemporary opinion when he observed, "If I spend 2,000 florins on my house, my dwelling on earth, then five hundred devoted to my residence in the next life seems to me money well spent."

As art gradually began to gain in stature, however, other—more obviously demonstrative—options also emerged. At least from the beginning of the fourteenth century, bequests were often made with the stipulation that the money be spent on commissioning an altarpiece or on decorating a chapel, especially for the churches of the mendicant orders. In this way, it was thought, there would be almost no way that the faithful could forget to pray for the donor.

Particularly in the first half of the fourteenth century, this proved an amazingly popular solution to the immorality of usury, especially among Florentine bankers. Indeed, the more money banking generated, the more intense was the competition between families to display their moral credentials through such artistic bequests. Heated games of devotional one-upmanship blew up around the patronage of chapels in major churches, and nowhere more so than in Florence. In the years after the Black Death, for example, Santa Maria Novella "had chapels endowed by the Rucellai, Bardi, Guidalotti, and Strozzi, while patronage rights in the choir behind the main altar were claimed by the Ricci and Tornaquinci," and in 1348 Turino Baldesi left the church the enormous sum of more than 300 florins to have the whole Old Testament painted "from beginning to end." Even more strikingly, in the same period, the "Peruzzi, Baroncelli, Cavalcanti, Tolosini, Cerchi, Velluti, Castellani, Rinuccini, Ricasoli, Alberti, Machiavelli, and several other families all had chapels" in Santa Croce, and the Bardi family alone had secured rights over a further four.

Not uncommonly, such bequests divided responsibility for largescale commissions between the family of the deceased and the church or monastery in which the work would be housed. The Strozzi Chapel in Santa Maria Novella in Florence is a particularly good example. A noted banker from a distinguished and wealthy family, Rosello Strozzi set aside money in his will to atone for his sins in this manner. His youngest son, Tommaso, then arranged to fund the adornment of a chapel in the left transept, with frescoes showing Heaven, Hell, and Purgatory by Nardo di Cione and a magnificent altarpiece by Orcagna (Andrea di Cione) in 1354. Throughout the proceedings, however, Tommaso Strozzi—like many early patrons—worked in harmony with the Dominican friars to ensure that the works commissioned were mutually acceptable.

But if bankers were going to spend good money on works of art in the hope of atoning for their sins, they increasingly wanted to make sure they would be in full control, even from beyond the grave. From the beginning of the fourteenth century onward, bankers and patrons began to tussle for influence over the direction that commissions would take. Perhaps inevitably, the men holding the purse strings rapidly gained the upper hand, and works designed to wipe away the stain of greed, avarice, and usury came to be more closely tailored to the patrons' immediate moral needs.

The Arena Chapel in Padua is perhaps the clearest case in point. A towering jewel of early Renaissance art, the chapel harks back to Dante's condemnation of the Paduan banker Reginaldo degli Scrovegni. Tormented by the immorality of his father's usury, Reginaldo's son, Enrico, decided that the only way for the family to free itself from the stain of sin was for him to push patronage to its absolute limits. After purchasing a piece of land from the Dalesmanini family, Enrico acquired permission to erect a family chapel on the site and immediately commissioned Giotto di Bondone to adorn the interior with a dazzling cycle of frescoes depicting the lives of Christ and the Virgin Mary. And to ensure that the devout would offer prayers for him and his father, Enrico took the added precaution of soliciting a papal indulgence for all those who visited the chapel, much to the annoyance of the monks at the nearby Eremitani Church.

But to say that Renaissance bankers were concerned for the fate of their souls is not to tell the whole story. Although they were extremely worried about what would happen to them after death, they were equally concerned that the Church's tough stance on usury gave them a very bad name. And if you were a banker, no amount of artistic "death insurance" could make up for the fact that the average man on the street thought you were irredeemably immoral. Bankers needed not just to atone for their sins but to be *seen* to atone for their sins.

One of the great advantages of the new forms of patronage that had begun to appear at the start of the fourteenth century was that bankers were able to project a powerful image of piety and repentance while actively bidding for the prayers of the faithful. Art, in other words, allowed bankers to subvert reality and gloss over their misdeeds. Even if people attending Mass in Santa Maria Novella did not actually pray for the soul of Rosello Strozzi, for example, the visual impact of the family chapel would have gone a long way toward convincing them that Tommaso Strozzi was actually a very devout individual concerned to make reparation for his sins. So, too, it was difficult for anyone visiting the Arena Chapel not to be persuaded that Enrico degli Scrovegni nurtured a sincere faith and was earnestly striving to reconcile himself with God.

As the relationship between artists and patrons became ever closer, bankers were able to push the bounds of "moral PR" even further. Taking active control over the design and composition of the works they commissioned, bankers were able to emphasize their piety and contrition by having themselves included as participants in or witnesses to scenes from Christian history, ensuring that the works' intended audience would perceive them as more moral individuals than their business practices would otherwise suggest. It was with this in mind that Enrico degli Scrovegni, for example, had a portrait of himself offering a model of the chapel to the Virgin included in the *Last Judgment*, on the entrance wall of the Arena Chapel, and that Giovanni Tornabuoni had a portrait of himself kneeling in prayer, with his hands crossed piously across his chest, included in Ghirlandaio's frescoes for the family chapel in Santa Maria Novella late in the next century. The early Medici appear to have had only a limited involvement in artistic patronage, but from the very beginning of their careers as bankers they were highly conscious of the sinfulness of usury and the extent to which they could atone for their sins through patronage of the arts. Having watched and learned from others throughout the late thirteenth and fourteenth centuries, they later embraced—and mastered all forms of artistic atonement, not least insofar as their patronage of Benozzo Gozzoli was concerned. That Cosimo de' Medici chose to have himself depicted as a penitent in the *Journey of the Magi to Bethlehem* was a powerful expression of the Medici's quest for redemption. This dimension of his portrait was entirely in keeping with his family's development of a long-standing trend among Florence's shady bankers and wholly reflective of his own awareness of the perceived immorality of his own usury.

FROM BANKERS TO MERCHANT BANKERS

Despite Cosimo's subsequent wealth, the Medici were—comparatively speaking—late starters when it came to the banking trade. By the midfourteenth century, they had become affluent, but they were still far from rich and were perhaps even knocked back a little by the advent of the Black Death. Although a respected member of communal society, Foligno di Conte de' Medici, for example, complained bitterly about the modesty of the family's means in 1373. At around this time, "a large proportion of the Medici were in very modest economic circumstances," and "only five or six could be classified as moderately wealthy." Indeed, in 1363, the tax assessments for two members of the family revealed them to be no better off than ordinary cloth workers and substantially worse off than many shopkeepers.

The Medici's problem was that they were still thinking too small. Despite their tentative investments in other sectors, they hadn't actually made the leap from being relatively modest bankers to being colossally ambitious *merchant* bankers. And it was in merchant banking that the real money was to be made.

The essence of the merchant banker's art lay not in making loans per se but in using loans to serve much greater purposes. As its acknowledged masters—the Bardi, the Peruzzi, and the Acciaiuoli—knew, truly gigantic loans could be exchanged for trading concessions abroad. These concessions could then be used as the basis for dealing in large-scale and highly profitable exports. The Peruzzi, for example, agreed to lend the cash-strapped Edward III of England huge sums of money (Villani estimated that they handed over around 780,000 florins through the years) in return for lucrative privileges that allowed them to circumvent customs duties and corner the enormously valuable wool trade. By the same token, the grain trade with southern Italy opened up similarly profitable opportunities, and many Florentine merchant bankers turned their lending potential toward the exploitation of the kingdom of Sicily. Perhaps the shadiest opening was, however, the prospect of gaining lucrative tax farming privileges. Instead of paying back loans directly, cities or rulers could offer merchant bankers the opportunity to recoup the money they lent by collecting certain taxes for a given period of time; in this case, the banker's objective was to collect more than he had lent, by whatever means necessary.

Whichever mechanism was chosen, a merchant bank needed four things to make this whole idea work. First, it needed an established network of foreign branches or agents able both to tender loans and to manage the trading side of the venture on the ground. Second, it needed enormous deposits from reliable investors. Third, it needed the ability to sustain huge loans. And fourth, it needed to be willing to strike rather questionable deals with unpredictable foreign potentates and to gamble on the shifting outcomes of international politics. If these were in place, there was no limit to the money that could be made. The only real danger was the temptation to lend too much to bad debtors in pursuit of ever-larger concessions, as the Bardi and the Peruzzi found to their cost when Edward III "defaulted" on his loans in 1339. Unlike today, no merchant bank—no matter how huge—was too big to fail. But provided loans and trade were managed astutely, merchant banking was a recipe for printing money.

By acting both as bankers and as merchants in the international arena, and by launching themselves into the shady world of big-time deals, such "super-companies" rode the crest of Italy's commercial wave and took wealth to a whole new level. The Peruzzi company, for example, saw its net capital grow from an already huge 124,000 *lire a fiorino* in 1300–1308 to a massive 149,000 *lire a fiorino* in 1310–12, and even on the edge of bankruptcy the family firm had assets worth some 90,000 *lire a fiorino* in 1331–35. Indeed, so massive were their resources that they were

able to loan Edward III no less than 175,000 florins in 1337 alone (about \$31.5 million in gold terms; about \$164,937,500 measured against wages). Even after the cataclysmic crash that followed the English default, Florence's merchant bankers could still expect to make vast amounts of money very quickly. One of the greatest Florentine success stories of the period was that of the Serristori. Despite only starting out as merchant bankers in the early years of the fifteenth century, the Serristori were catapulted to the very pinnacles of wealth within a few decades. In 1427, Antonio di Salvestro di ser Ristoro personally declared net assets of around 35,000 florins (about \$6.3 million in gold terms; about \$16,240,000 measured against wages) and used his loans to leverage his interest in exporting textiles and importing wood, silver, alum, sugar, and all manner of other things. Within a few years, Antonio's resources had grown so large that he-the grandson of a humble notary-was able to marry his sons into the greatest of Florence's patrician families, the Strozzi, the Pazzi, and the Capponi.

It was Cosimo's father, Giovanni di Bicci, who transformed the Medici's fortunes by taking the next step. He did not, it must be admitted, immediately strike his contemporaries as a pioneering go-getter. With a high forehead, bulging, heavily hooded eyes, and tight lips, he was quiet, retiring, and ineloquent. He was almost forgettable. What was more, his beginnings were far from auspicious. Giovanni had inherited only very little from his father, Averardo, and had started out in a modest way as a petty moneylender in Florence. Yet in contrast to many of his predecessors, his unassuming appearance concealed a burning ambition and a clear knowledge of where the future was pointing. More than anything else, however, his sudden jump up from mere banking helps to illustrate just how shady Renaissance merchant banking could be.

Giovanni got his big opportunity when he went to work as a managing partner in the Rome branch of the bank owned by his father's second cousin Vieri di Cambio. This experience opened his eyes for the first time to the full possibilities of merchant banking. Equipped with a clear vision of how money was to be made, he founded his own company in Rome after Vieri's death in 1395. He then returned to set up a new partnership in Florence in 1397 and a new branch in Venice a few years later.

It was, however, in Rome that Giovanni made his money. On strik-

ing out on his own, he had set his eyes on the Church. It was a shrewd move. The Church had a uniquely attractive combination of attributes. On the one hand, it had colossal holdings and reliable revenues streaming in from every corner of Europe. And on the other hand, the papacy's need for cash often far outstripped the Church's short-term income. It was the ideal client, and its vast territorial resources meant there were plenty of commercial privileges to be traded. The only problem was that in the past only a single banker had been appointed to handle Church business; and it wasn't the Medici.

Giovanni's strategy revealed not only his astuteness in taking advantage of opportunities but also the shallow, underhanded methods that merchant bankers had to employ. In 1378, the Great Schism tore the Church apart. Instead of there being only one pope, there were suddenly two, and then three, rival pontiffs vying for primacy, each of whom needed a banker.

When Pope Alexander V (who headed the Pisan Obedience) died in 1410, Giovanni saw his chance. For more than a decade, he had been banker to the Neapolitan cardinal Baldassare Cossa, and having become fast friends, the two men seem to have struck a deal. Lending him the 10,000 florins he needed to bribe the other cardinals, Giovanni allowed Cossa to buy his way to the papacy. In return, Cossa—now enthroned as Pope John XXIII—entrusted Giovanni with the massive resources of the Pisan papacy, widely acknowledged to be the most "legitimate" of the three. So successful was Giovanni at handling papal finances that even after John XXIII's deposition and the reunification of the Church in 1415, the Medici were ultimately confirmed as the Church's sole bankers in 1420.

It was corrupt, deceitful, and cunning. But from that moment on, the profits that could be made were almost limitless. Taking over the family's business interests on his father's retirement in 1420, Cosimo pushed the Medici bank to ever greater heights of success and profitability. Making the most of his control of papal banking, Cosimo ensured that Church business accounted for an amazing 63 percent of the company's profits between 1420 and 1435. Reestablishing the bank on a new footing, he then massively expanded its operations, opening branches in Ancona, Avignon, Basel, Bruges, London, Geneva, and Pisa to make the most of international trade.

Although he was shrewd enough to avoid investing too much of his

money in (taxable) assets such as land or property, Cosimo's wealth soon outstripped that of those who had hitherto been regarded as the richest men in Florence. Even the famously rich Palla Strozzi was overshadowed by his Medici rival by the third decade of the century. Indeed, so fantastically prosperous had Cosimo become by 1459 that Giovanni Rucellai observed that he was "probably not only the richest Florentine, but the richest Italian of all time." It is, however, revealing that while Rucellai praises Palla Strozzi for having earned his wealth "honestly," he remains pointedly silent about the manner in which Cosimo had made his money.

THE ART OF MAGNIFICENCE

The art of merchant banking made the ethical problems of moneymaking much more serious. Although the profits were huge, there was no getting around the fact that they depended on a more relentless pursuit of usury than had ever been attempted before. What was more, the underhanded methods, backroom deals, and outright extortion that were part and parcel of the game of international finance left merchant banking open to accusations of outright immorality.

When Cosimo de' Medici took over control of the family business in 1420, he assumed responsibility for a commercial enterprise that was not only more profitable but also more heavily tainted by wickedness than ever before. Cosimo's fortune was inescapably marked by the moral stigma attached to usury, and the richer he grew, the more indelible the stain of sin became. What was worse, not merely was he a usurer, but he also used usury to bribe or blackmail cash-strapped potentates. He was holding the Church to ransom and was even encouraging simony and corruption in the Curia itself. Whichever way you looked at it, Cosimo's mastery of merchant banking was every bit as morally bankrupt as it was financially rewarding.

It was perhaps inevitable that the new breed of merchant bankers should have felt an especially intense need to spend ever greater sums of money on the "art of atonement," and it is no exaggeration to say that the superabundance of richly decorated chapels and churches for which Florence, in particular, is famed testifies both to the guilt felt by patrons and to the desperation with which they clamored to save their blackened souls through art. Being richer than any others, the Medici felt the need for artistic atonement more acutely than most, and they led the field in terms of the variety and scale of their bequests. Having watched and learned from others throughout the fourteenth century, Giovanni di Bicci and Cosimo embraced—and mastered—the practice of using patronage for this purpose in the early fifteenth century. They positively lavished money on bequests and gifts. Works such as Fra Angelico's *Madonna and Saints* were given to convents and churches, and individual chapels (such as that in Santa Croce) were funded after the manner of the Bardi and the Peruzzi by other members of the family. Similarly, they took very great care to ensure that their tombs were placed in locations that would virtually guarantee the prayers of the faithful. Giovanni di Bicci was buried in the middle of the Old Sacristy in San Lorenzo, while Cosimo went one step further in having himself interred right in front of the high altar in the main church.

Yet it would be mistaken to believe that Italy's super-rich merchant bankers patronized the arts purely for the sake of their rotten souls. Even in the early fourteenth century, the more affluent members of the mercantile elite had begun to feel the need to show off a little, and it was certainly not uncommon for atonement to shade off into display. The endowment of family chapels and the inclusion of portraits in fresco cycles, in particular, could easily be interpreted as expressions of a latent desire to exhibit wealth to the public. By the early decades of the fifteenth century, however, merchant bankers found themselves in possession of fortunes so vast that their wealth rivaled—and, in some cases, even exceeded—that of the crowned heads of Europe. With money also came status, and-finding that kings, popes, and princes were dependent on the credit they could offer-they had difficulty resisting the feeling that they were a cut above the ordinary citizen. Their pockets bulging with cash and their chests puffed out with pride, merchant bankers simply could not resist the temptation to display their wealth and prestige through ever more inventive displays of conspicuous consumption.

Embarking on one of the greatest spending sprees in history, the merchant bankers of Renaissance Italy rapidly found that there were no limits either to the money they could spend or to the things they could spend it on. Of course, like many of the modern world's richest men and women, they found a certain satisfaction in giving large and very public donations to charitable institutions. But there were more gratifying and direct ways of satisfying their need for recognition. Dazzling jewels, fine brocades, clothes embroidered with golden thread, rich silks, and the finest Arabian horses were purchased with almost wanton abandon. Vast banquets with dozens of dishes for hundreds of guests were given day after day; huge, bacchanalian dances were thrown on the smallest pretext; and households thronged with armies of liveried servants. Splendor was the only thing that really mattered.

Most of all, however, merchant bankers poured money into the patronage of the arts. Eager to have their wealth displayed for posterity, they commissioned carefully arranged portraits in greater numbers than ever before: the example of Antonio Rossellino's bust of Francesco Sassetti is a typical early case in point. Latching onto the growing social value attached to classical learning, they paid artists to produce playful paintings on ancient themes, or statues of nymphs and gods in stone and bronze, and began collecting antique originals with unbridled enthusiasm.

But at least in the early years of the fifteenth century, merchant bankers focused their attention most especially on architecture and sought to use this medium as the most dramatic and impressive means of showing off their wealth. As shared social spaces that served as focal points for community activity, churches in particular caught their eye as offering rich potential for the affirmation of status. More concerned with prestige than with atonement per se, they sought out every opportunity to rebuild and extend churches and monasteries in as public a manner as possible. Although contemporaries such as Palla Strozzi, Tommaso Spinelli, and the Pazzi family all contributed lavishly to the construction of new chapels, cloisters, and convents, Giovanni di Bicci and Cosimo de' Medici stood head and shoulders over everyone else. In 1419, Giovanni agreed to pay for the construction of the Old Sacristy at San Lorenzo-employing Brunelleschi for the task-and after 1440, Cosimo assumed responsibility for rebuilding the entire church, thus transforming the whole into a gigantic shrine to the Medici family. Only a few years earlier, Cosimo had paid for the remodeling of San Marco and had stacked its library with the choicest manuscripts that money could buy. Not long after, he followed this up by taking on the task of rebuilding the Badia Fiesolana in comparable style. The competition between merchant bankers for a financial interest in the

Badia Fiorentina was, however, so intense that not even Cosimo could get a look in.

Yet despite the enormous sums spent on ecclesiastical building projects, nothing compared with the amount of money that was poured into palazzi and villas. At the end of the fourteenth century, the homes of even the richest merchant bankers had been relatively unprepossessing, even if they were a little larger than most. Giovanni di Bicci de' Medici, for example, spent most of his adult life in a comparatively unremarkable house in the via Larga, and even when he moved to a fractionally bigger house in the Piazza del Duomo, the family residence remained modest. The explosion in merchant bankers' fortunes in the early fifteenth century, however, catalyzed a sudden vogue for enormous and richly decorated palazzi. Their worth was vast. According to some recent estimates, the average merchant banker's palazzo had a value of between 1,500 and 2,500 florins, while the most elaborate, built by Filippo Strozzi and his heirs, cost almost 40,000 florins, more than a thousand times the annual wage of the most skilled workman. No price, indeed, was too high. As Giovanni Rucellai put it, "I think I have given myself more honor, and my soul more satisfaction, by having spent money than by having earned it, above all with regard to the building I have done." In size and richness, these family palazzi were no less impressive. Significantly bigger even than the White House, the Palazzo Strozzi is reflective of the heights to which palatial ambition and ostentation could rise, and the fact that the Rucellai (whose palace was designed by Leon Battista Alberti in ca. 1446–51), the Pitti (who commissioned their palazzo in 1458), and the Tornabuoni later strove to outdo one another in grandeur testifies to the extent to which the prestige of a merchant banker was bound up with the size of his home. None, however, came close to Cosimo de' Medici as far as scale and opulence were concerned. Even though Cosimo rejected Brunelleschi's original plans as being "too sumptuous and magnificent," the Palazzo Medici Riccardi was so grandly appointed and luxuriously decorated that, as Vasari later recorded, "it has comfortably accommodated kings, emperors, popes, and as illustrious princes as there are to be found in Europe, and won endless praise for the magnificence of Cosimo and for Michelozzo's outstanding talent in architecture." Nor was the Palazzo Medici Riccardi Cosimo's only home. Again employing Michelozzo for the task, he "restored the palace of Careggi [two miles from Florence], richly and magnificently," and built a completely new, fortresslike villa at Cafaggiolo in the Mugello.

It was obvious to anyone who cared to look around the streets of Florence that having rapidly acquired colossal fortunes, Renaissance merchant bankers—much like modern-day hedge fund managers or Russian oligarchs—wanted nothing more than to spend their money on showing off their wealth and status. Yet having begun to splurge on art and architecture on an altogether new scale, they ran into an entirely new set of problems. Quite apart from the perceived immorality of usury, it became clear that both wealth and spending came with their own, rather troubling, ethical issues.

On the one hand, there was the problem of wealth itself. Put simply, money bred resentment and moral disapproval. Regardless of how it had been obtained, it had long been regarded as an obstacle to virtue and as an impediment to public-spiritedness. The Franciscan ideals that had dominated civic spiritualism in the fourteenth century had led to a certain popular disdain for riches. In the De seculo et religione (1381), for example, Coluccio Salutati had captured the tenor of contemporary opinion in praising poverty as the status most befitting piety, and in associating wealth with greed. But despite the profound economic changes of the early fifteenth century, this contempt for Mammon's fruits remained deeply entrenched in the religious imagination. Writing in either 1445 or 1446, for example, Bartolomeo Facio contended that "riches bring no satiety to man, but greater greed, rather, and thirst," and consequently opined that no one "who practices commerce and profit-making" could attain the true "riches" of the Christian faith "even if he possesses the fortune of Cosimo." This fed into a long-running social mistrust of riches. Although the Ciompi Revolt (1378) had been comprehensively crushed, the humble folk of Florence who flocked to hear firebrand preachers attack the opulence of the rich retained a deep resentment of the grassi (fat cats) simply because they were wealthy.

On the other hand, ostentatious spending was itself problematic. Still deeply attached to the ideal of poverty, the stricter of the mendicant orders continued to denounce showy expenditure as nothing more than an expression of self-love. Large palaces, richly decorated chambers, fine clothing, and eye-popping jewels were all condemned. Indeed, preachers such as Fra Giovanni Dominici and Cosimo's own friend Antonino Pierozzi even denounced those who gave large amounts of money to charity on the grounds that such gifts were inspired more by pride than by Christian *caritas*.

The key to legitimating wealth and lavish spending lay in the manner in which both were presented. As many of the humanists who gathered around Florentine merchant bankers in the early fifteenth century realized, half of the problem lay with the common conflation of riches with greed. Artificial though the distinction might have been, it was argued that the two did not always go hand in hand, least of all at a moral level. Wealth was, after all, just a pile of cash. It wasn't a process but a fact. However a person's fortune had been obtained, therefore, it was illogical to have any disdain for money itself. The mere fact of being rich didn't make a merchant banker a bad person. In his commentary on the pseudo-Aristotelian *Economics* (1419), for example, Leonardo Bruni suggested that far from being an impediment to Christian virtue, riches were "neither good nor bad in themselves." As Poggio Bracciolini argued in his De nobilitate (1440) and as Francesco Filelfo explained in his De paupertate (ca. 1445), wealth was morally indifferent, and it was impossible to judge a merchant banker for being filthy rich.

Nevertheless, it was still possible to judge the wealthy for the manner in which they spent their money. Clearly, some forms of expenditure were considered immoral. By virtue of the contempt in which usury was held, few denied that the idea of reinvesting profits to make money "breed" was anathema. By the same token, truly excessive spending was equally undesirable. But at the same time, it was also clear that the total avoidance of expenditure was to be shunned. The miserly tendency to hoard cash for its own sake was a classic paradigm of senseless greed, every bit as bad as wanton profligacy.

There was, however, a middle way. A certain level of spending was regarded as socially acceptable. For Leon Battista Alberti—who was himself the illegitimate child of a Florentine merchant banker—there was no harm at all in money being spent on extensions to churches or in decorating private houses with a cheerful liberality. Such playful indulgences could, he argued, only bring pleasure, and no one could possibly find anything amiss about a bit of pleasure, provided it remained within the bounds of propriety.

But some spending could actually be presented as a manifestation of public virtue. Perhaps inspired by the efforts to justify the lavishness of signorial courts in the previous century, the humanists of the early fifteenth century came to develop a complete "theory of magnificence" that attributed a definite moral value to merchant bankers' patronage of the arts, and especially to architecture.

Perhaps the fullest and most forceful defense of "magnificence" (which literally means "doing great things") was offered by the Augustinian canon Fra Timoteo Maffei (ca. 1415–70) in his *In magnificentiae Cosmi Medicei Florentini detractores* (ca. 1454–56). Grounded in the forms of patronage that Maffei saw springing up around him, this dialogue was intended specifically to rebut the criticisms that had been leveled against the enormous sums Cosimo de' Medici had already spent on his ecclesiastical building projects. Drawing heavily on Saint Thomas Aquinas's *Summa theologiae*, Maffei argued that Cosimo's construction and decoration of Florentine churches and monasteries could be viewed not as an expression of his overweening pride and arrogance but as manifestations of a desire to celebrate God's majesty and incite men to virtue. Far from being contemptible, Cosimo's extravagant patronage only testified to his virtue and merited the approval of all true believers. As Maffei put it:

All these things deserve extraordinary praise and should be recommended to posterity with the utmost enthusiasm, since from Cosimo's Magnificence in building monasteries and temples it will have had divine excellence before its eyes, and it will consider with how much piety and with how much thankfulness we are indebted to God.

The more merchant bankers like Cosimo spent on ecclesiastical building projects, the more they revealed themselves to be truly virtuous and devout men.

It should, of course, be noted that Maffei limited himself to talking only about churches and monasteries; but it did not take too much imagination to transpose the basic thrust of his argument to the more secular setting of civic society. As both Francesco Filelfo and Leon Battista Alberti argued, "magnificence"—that is, a willingness and capacity to spend on a grand scale—was a virtue that could be applied to all forms of artistic patronage, provided only that the viewer could believe that the patron had been driven by motives other than mere selfglorification. In constructing an enormous palazzo, for example, a merchant banker, it was thought, was not simply serving his own ends but also conferring great honor on his family and on his city. Families and cities were, after all, known by their monuments. Splendor was thus thought of as a profoundly social virtue that manifested both a familial devotion and a public-spirited commitment to enhancing the prestige of the commune. Indeed, the more fabulously decorated and grandly conceived a palace was, the greater the owner's virtue was thought to be. This was expressed with unusual clarity and force by Giovanni Pontano, writing in 1498:

The magnificent man is made great through great expenditure. Thus the works of the magnificent man consist in illustrious palaces, in churches of excellent manufacture, in theatres, in porticoes, in streets, in sea-ports . . . But since magnificence consists in great expense, it is necessary that the size of the object itself be sumptuous, and imposing, otherwise it will not justifiably excite either admiration or praise. And impressiveness, in turn, is obtained through ornamentation, the extent and the excellence of the material, and the capacity of the work to last for a long time. Without art, in truth, nothing, whether large or small, will merit true praise. Thus if something is tawdry and lacking in ornament, or made in a low-cost material which will not guarantee longevity, it truly cannot be great, nor should it be held to be so.

The success of this new conception of wealth and spending is easy to gauge. So seductive is the humanistic theory of magnificence that even today merchant bankers like Cosimo de' Medici seem to be cloaked in the same aura of superhuman cultivation as artists. But it is nevertheless important to remember that the theory of magnificence was nothing more than a way of dressing reality up in more socially acceptable terms. However much humanists like Alberti and Maffei endeavored to celebrate the chapels, churches, and palazzi springing up around Florence as manifestations of a deep-seated sense of public virtue, they were writing with the express intention of defending super-wealthy merchant bankers against the accusations of what we might today call the 99 percent. They were definitely not describing reality.

For all the humanistic window dressing, the "art of magnificence" was nothing more than a gigantic exercise in conspicuous consumption

and self-glorification. By endowing chapels, funding the reconstruction of churches and monasteries, building great palaces, and decorating their homes with the finest art that money could buy, merchant bankers like Cosimo de' Medici were consciously endeavoring to show off their immense wealth and to provide a very visible affirmation of their own financial dominance.

Yet precisely because the "art of magnificence" was the product of wealth, it also concealed the dark and unpleasant methods on which merchant banking was founded. Every brick, every brushstroke, testified to the usury, extortion, and downright dirtiness that was essential to every fortune made.

Despite its rather seedy underside, it is the "art of magnificence" that features most prominently in the *Journey of the Magi to Bethlehem*. Although Cosimo was careful to ensure he was portrayed in the penitential manner appropriate to atonement, the glittering finery of the frescoes is a testimony to the merchant bankers' longing to show off their wealth and use their filthy lucre to portray themselves—rather deceptively—as virtuous citizens of the republic.

FROM MERCHANT BANKERS TO MASTERS

In the years between their first appearance in the historical record and Galeazzo Maria Sforza's visit to Florence, the Medici had gone from being humble money changers to being enormously wealthy merchant bankers capable of lavishing huge sums on the arts of atonement and magnificence. Yet this was only part of the story. As their commercial fortunes changed, they saw their political fortunes alter at the same time. Although they had begun as mere bit players in the drama of communal life, by 1459, Cosimo de' Medici had emerged not only as the richest man in the city but also as the uncrowned king of Florence. It was a remarkable journey for any family, but the factors that propelled him and his family from obscurity to the very pinnacles of power and influence were emblematic of the intimate relationship that developed between merchant banking and politics in the early Renaissance. And if the commercial practices of merchant bankers seemed dark and murky, the political world they inhabited was even darker. Strikingly modern in many ways, it was a world far removed from our familiar conceptions of the Renaissance. What is really significant, however, is not so much

187

the political shenanigans in which merchant bankers became involved as the economic factors that allowed them to carve out a dominant position in the world of politics.

Given the guild-based structure of Florentine politics, bankers and merchant bankers found themselves drawn inexorably into public life. It was, however, more than a matter of institutional ties. The more successful merchant bankers became, the more heavily their affairs became entangled with the politics of the Renaissance city. More so even than today, their fortunes were bound up with the actions of government. There's no doubt they had the most to gain from government. As Gene Brucker has rightly observed, the most striking feature of the Signoria is that "it governed for the benefit of the rich and powerful, and often to the disadvantage of the poor and the lowly." It was the urban elite who received the lion's share of lucrative sinecures, who benefited most from the manifest inequalities of the tax system, and who received secure dividends from shares in the Monte (Florence's funded debt). But at the same time, they also had the most to lose. As the worrying effects of the Ciompi Revolt had suggested, slight alterations to tax rates, wage levels, or the management of the Monte could have far-reaching implications for the most modestly sized enterprises, while decisions about foreign affairs, war and peace, and the levying of forced loans could have a truly monumental impact on the fortunes of the city's merchant bankers.

As far as Florence's richest citizens were concerned, business and politics were two sides of the same coin, and given how high the stakes could be, they were in no doubt that government was quite simply too important to be left to chance, or worse, to common tradesmen. Although the structure of Florentine government was already heavily geared toward the interests of the wealthiest by the late fourteenth century (see chapter 3), there emerged a narrow group of super-rich patricians bent on annexing public policy to their own interests and on keeping the reins of power in their grasp.

Conscious that the Florentine constitution was ostensibly "republican," these patricians knew that if they were to control government, they had to find a way to bend the rules. They began by rigging elections. Unlike today, however, there were no ballot boxes to stuff. Officeholders were chosen in a deliberately "random" way, with the names of successful candidates being drawn from a sack. Yet chance could still be nudged in the right direction. Although all guild members were theoretically eligible for office, committees of scrutiny decided whose names should be put in the sack. Composed entirely of guild patricians, these committees thus determined who would be in and who would be out. But too much was still being left to chance. After 1387, two—and later three—of the eight seats on the priorate were reserved for a special class of preferred candidates whose names were drawn from separate, smaller pouches (*borsellini*) and who had all been preselected by the committees. Even if selections were still officially done by chance and new families were progressively introduced into the ranks of officeholders in the years following the Ciompi Revolt, Florence's patricians could be sure of having "preselected" a majority of the priors.

It was all very well to rig elections. But bitter experience had taught the patricians that restricting office holding too tightly could lead to disaster. Too narrow a base of power looked much too suspicious to be credible. It was clear that the "right sorts of people" had to include a wider range of citizens than in the past. Still, there was no point in having the right sorts of people selected for office if you couldn't be sure of controlling them. The key to making the committees of scrutiny an effective instrument of power was the transposition of personal, business relationships to the political sphere. Although they often served as priors, the top patricians would ensure that even if they weren't personally selected, the Signoria would be packed with their relations, their business partners, or their dependents-in Mafia terms, people they could describe as "friends of ours," "made men." By stacking the government with handpicked individuals who were bound to them either by commercial ties or by the bonds of marriage, the mercantile elite could be certain that their placemen would be absolutely loyal to their interests. As the insightful chronicler Giovanni Cavalcanti put it, "Many were elected to the offices, but few to the government." The business of politics and the politics of business had thus become one, with patronage and family providing the crucial mechanisms of control from behind the scenes.

Merchant bankers swiftly found that they were unusually well placed in this system. Although far from dominant, their involvement in a wide variety of trading concerns and their unique role as providers of credit not only allowed them to nurture peculiarly extensive networks of clients, but also gave them a disproportionate influence in affairs of state. Simply by virtue of their financial clout they rapidly became some of the strongest and most nimble players in communal politics.

Florence stands out as the most striking example of a city dominated by mercantile elites who were themselves overshadowed by merchant bankers, but it was far from unique. Despite being subject to foreign powers at various points during the Renaissance, the maritime republic of Genoa was similarly governed by a narrow clique of merchants and—most important—merchant bankers. After a destructive civil war and especially following the exclusion of old, aristocratic families from the political process by the first doge, Simone Boccanegra, in 1339, the city was all but run by a "popular" junta of mercantile families such as the Montaldo and the Adorno. Even Venice—which, in 1297, restricted access to the Great Council to a limited and hereditary nobility—found itself increasingly dominated by the interests of long-distance traders and merchant bankers, including Marco Corner (doge 1365–68) and Niccolò Tron (doge 1471–73), whose magnificent tomb can still be seen in the Basilica of Santa Maria Gloriosa dei Frari.

In Florence, it was no surprise that the Medici gradually found themselves drawn into the political world and slowly gravitated from the fringes of the "ruling class" to the centers of power. The first member of the family to be elected to the Signoria had assumed office as far back as 1291, and over the next century they were chosen to serve on a further fifty-two occasions. At times, they had stumbled into the middle of some of Florence's most dramatic political storms. One of their number, Salvestro de' Medici, had been *gonfaloniere di giustizia* in the turbid months leading up to the Ciompi Revolt in 1378, and another, Vieri di Cambio, had been part of the tightly knit group of magnates who set themselves to rebuilding the shattered republic after the rising had been crushed.

Giovanni di Bicci de' Medici was no exception. As the first member of the family to become truly wealthy, he was received into the inner circle of Florentine politics almost as a matter of course. Ushered into government by his distant cousin Vieri di Cambio, he was selected as a member of the Signoria in 1408 and 1411 and was later chosen to serve as *gonfaloniere di giustizia* in 1421. He entered the Signoria at a key moment. Between the late fourteenth and the early fifteenth centuries, Florence embarked upon an age of what has become known as "consensus politics." The effect of the cunning constitutional cheats developed in the years following the Ciompi Revolt had been to consolidate the position of a relatively small group of super-rich families as a ruling class. Composed largely of merchant bankers bound together by common interests and the common cause of war against Milan, it was more clearly defined and cohesive than ever before. And since it combined broadbased support, rigorous electoral oversight, and complex networks of social control, the regime established by the ruling elite was, in many senses, much more secure than anything Florence had ever seen. A telling illustration of this is provided by Cavalcanti's tale of how the patrician Niccolò da Uzzano, having slept through the majority of a crucial debate on foreign affairs, suddenly woke up and announced a policy that he had already decided upon with "other powerful men" and that was unanimously approved without further discussion. "Consensus"both within the patrician class and between the elite and its lower-status placemen-was the order of the day: everyone could feel involved, and the leadership group could put faith in the stability of its hegemony. So great was the confidence of this patrician elite that it consciously propagated an image of a united and harmonious Florence prospering under the rule of a "better" class of people. In his Panegyric to the City of Florence (1403-4), for example, Leonardo Bruni affirmed that "in Florence, it has always happened that the majority view has been identical with [that of] the best citizens."

Giovanni di Bicci was, however, unusually reluctant to be drawn too deeply into the political fray. Preoccupied with his business, he was well-known for his intensely private nature. He made a show of withdrawing as far as possible from the rough-and-tumble of political debate and shied away from the limelight as far as he was able. He accepted his election as a prior and as *gonfaloniere* only with serious reservations and avoided taking part in the *pratiche* (advisory meetings). As he advised his sons on his deathbed:

Do not appear to give advice, but put forward your views discreetly in conversation. Be wary of going to the Palazzo della Signoria; wait to be summoned, and when you are summoned, do what you are asked and never display any pride should you receive a lot of votes ... Avoid ... political controversy, and always keep out of the public eye. Given the choice, he claimed he would have preferred to steer clear of politics altogether.

Far from being a shy and misanthropic aberration, however, Giovanni di Bicci was actually a rather cunning realist. Despite the rhetoric of unity and harmony, Florence's patricians were deeply divided by the time he was coerced into office for the first time. Although the city's richest men were united by certain common interests, this was insufficient to sustain long-term coherence within the ruling class. While they may have had some objectives in common, this did not mean either that they agreed about the means to be employed or that they did not have a whole host of other, more important goals that competed with one another.

Conflict was inevitable. Business rivalries rapidly blurred into political rivalries, and as new factions formed, disputes boiled over into civil disturbances that harked back to the dark days of the early fourteenth century. The stakes were high, and the struggles were bitterly, if not always violently, fought. In the mid-1390s, for example, Maso degli Albizzi and Rinaldo Gianfigliazzi succeeded in gaining a momentary hold over the Signoria and immediately had their rivals Filippo Bastari and Donato Acciaiuoli exiled. Only a few years later, in 1400, a "conspiracy" was uncovered, and two members of the Ricci family were accused of heading a plot to kill the Albizzi-Gianfigliazzi faction, a drama vividly recounted by an anonymous Florentine diarist. A sequence of similar such "coups," banishments, and confiscations followed as the Albizzi warred with their rivals for control of government.

As an ambitious merchant banker, Giovanni di Bicci saw how easily he could be drawn into such factional disputes and how devastating the effects could be. His own relatives had got caught up in the maelstrom on several occasions, often in the most damaging way possible. The family was not immune to dividing against itself. In the 1370s, for instance, Vieri di Cambio had ended up on the opposite side to his cousin Salvestro. And when the Medici *did* take sides, they often ended up on the wrong one. In the aftermath of the Ricci conspiracy, several of their number had been implicated. Unwilling to risk exile or the confiscation of his property, Giovanni preferred to keep his distance.

The big problem was that although Florence had a lot of wealthy merchant bankers, none of them was dominant. As long as the financial clout of the major families remained broadly comparable, none could expect to acquire an unquestionable hold on political power. All that was about to change. By the 1420s—that is, just as Cosimo de' Medici was taking over control of the family bank—the center of gravity was shifting. Cosimo discovered that as management of the papal accounts swelled his coffers, he was in control of an extremely large network of clients working in a wide range of industries and including people who were exceptionally wealthy in their own right. At the same time, financial pressures on the Florentine Signoria were about to ensure not only that merchant bankers were to be consecrated as the dominant figures in civic politics, but also that power would be concentrated in the hands of a rapidly narrowing group of the super-wealthy.

The key issue was debt. Although the relatively limited role played by communal governments in the late Middle Ages had kept budgets mostly balanced, the spiraling costs of prolonged wars and the increasing complexity of the administrative apparatus of emergent states contrived to send overheads skyrocketing. While trade continued to boom, ordinary tax revenues were simply inadequate to keep up, and the city-states scrabbled around desperately for a solution to a mounting cash-flow crisis. It was in this heady atmosphere of impending financial disaster that the idea of government debt was born. Communes had no option but to borrow money wherever they could, and while the first green shoots of the modern bond market burst forth from the sterile soils of the cities' empty coffers, the notion of the bailout was also given its first airing. But whereas in today's world, governments staring bankruptcy in the face can pin their hope on avaricious bond traders or, at worst, a hefty injection of capital from the International Monetary Fund or the European Central Bank, in the Renaissance the cash-strapped communes of northern Italy had only one recourse-the seemingly bottomless reserves of the merchant bankers. More than anything else, it was debt that catapulted the merchant bankers to the forefront of urban politics and catalyzed the gradual collapse of broadbased "republican" regimes into barely concealed tyrannies.

Almost every state in northern Italy experienced a debt crisis of one sort or another during the Renaissance, and none appear to have been more vulnerable than the city-republics. Genoa—often unjustly overlooked by historians of the period—was convulsed by a series of crippling financial crises from the first dogate of Simone Boccanegra through the very beginnings of the fifteenth century, and it is no understatement to say that its chronic inability to meet its financial obligations not only underpinned the growing dominance of the new mercantile elite, but also inspired the city's decision to submit itself to foreign domination at various points. No city is, however, a better illustration of the impact of debt on the position of the merchant bankers than Florence.

In 1424, Florence had become embroiled in a major conflict with Milan that lasted—on and off—for the next nine years. Things went badly from the beginning, and as the war spiraled out of control, the city found itself increasingly dependent on the services of mercenaries. The costs of maintaining a largely mercenary army were exorbitantly high, and although Florence was no stranger to paying enormous sums for its military adventures, this was on an altogether different scale. For much of the war, Florence faced bills of almost 500,000 florins per year, far above the sums it could raise from taxation. Running a deficit that peaked at 682,000 florins in 1426, the city needed to find a way of raising more money, and fast.

Despite its unpopularity, the *catasto*—a new form of property taxation—was the obvious solution. From 1427 on, every household in Florence was compelled to submit a declaration of its net worth (less exemptions), which the city would then use as the basis for its assessment of tax liabilities. A household's net assets were taxed at a rate of 0.5 percent at each collection, and the city could announce collections several times a year. As the surviving records show, it was one of the more equitable forms of tax ever to be seen in Florence. Many poorer households did not pay any tax at all, and the greater part of the burden fell on the richest members of society, that is, on the merchant bankers. Whereas some owed no more than a few soldi, Palla Strozzi's declared net wealth of 101,422 florins meant he owed 507 florins at each collection, and Giovanni di Bicci's declared assets of over 79,000 florins lumbered him with a bill of 397 florins.

The only problem was that because the cost of war was so high, the city had to impose many collections each year. Between 1428 and 1433, it has been calculated that a grand total of 152 collections were gathered in. And because the *catasto* evaluated tax in relation to assets rather than income, the sheer number of collections meant that—even at a low rate of taxation—tax bills were becoming a crippling burden for many Florentines. As John Najemy has observed, "entire patrimonies were being consumed" as families tried desperately to sell property off

just to pay what was demanded of them. Even the famously rich Palla Strozzi, whose wealth was tied up in land, had to beg for a reduction in his assessment in 1431. Florence was bankrupting itself.

The city decided to remedy its growing cash-flow crisis by borrowing large sums from its wealthiest citizens. A body of merchant bankers known as the Officials of the Bank was charged with raising and setting the terms of these loans, and in the majority of cases they too were major lenders. Much like the board of the Federal Reserve, the Officials were responsible for keeping Florence solvent, and it has been calculated that they secured loans of about 200,000 florins each year.

It was this combination of war, crippling *catasto* collections, and government borrowing that transformed the character of Florentine politics and catapulted Cosimo de' Medici to power. The *catasto* did not hit the Medici quite as hard as it hit other prominent merchant-banking families. Their investments in land and property were limited, and they carefully kept their money moving around, so that their tax liabilities were lower, and their assets were less seriously damaged by the collections. Nevertheless, Cosimo de' Medici and his business associates not only dominated the Officials of the Bank but also accounted for the greater part of the loans made to the Signoria. Surviving records show that no less than 46 percent of all loans came from just ten people either drawn from the Medici's ranks or allied with them by business and patronage. Cosimo and his brother, Lorenzo, personally accounted for no less than 28 percent. It is no exaggeration to say that Florence was financially dependent on the Medici—and most particularly on Cosimo.

Although Cosimo shared his father's distaste for holding public office, his financial resources ensured that he was rapidly emerging as the dominant force in Florentine politics. Consciously or not, he was effectively buying Florence wholesale. In the faction-ridden and fiercely competitive world of politics, rumors began spreading that he was planning to seize control of the government.

By the summer of 1433, Rinaldo degli Albizzi and Palla Strozzi had become frightened by Cosimo's growing influence. Concerned that they were about to be "bought" out of power in the very near future, they decided they had to act. As soon as Cosimo was out of the city at his estate at Il Trebbio, they packed the Signoria with their own partisans and prepared to get rid of him for good. Summoned back to Florence from his vacation at short notice, Cosimo was arrested and locked in a cell in the tower of the Palazzo della Signoria. At the bidding of Albizzi and Strozzi, a special committee (*balia*) was then hastily set up to act as the kangaroo court they needed to dispose of Cosimo. But things didn't go entirely to plan. Although Albizzi argued passionately for execution, the *balia* shrank from imposing the death sentence. After weeks of heated debates, on September 28, Cosimo, his brother, Lorenzo, and his cousin Averardo were exiled.

Rinaldo degli Albizzi was exultant. He would, of course, have preferred to have had Cosimo killed, but the mere fact that Cosimo was out of the way seemed to provide a good enough reason for celebration. It was a grotesque mistake. No sooner had he receded from sight than it became clear that Florence was now stuck. With the Medici in exile, the city over which Rinaldo degli Albizzi presided was quite simply unable to pay its bills. What was more, the economy as a whole was dealt a hammer blow by Cosimo's absence. Without Medici money lubricating the wheels of commerce, business was grinding to a halt. The Signoria couldn't even content itself with confiscating Cosimo's legendary sacks of money, as these, too, had been hidden away months before. Only when it was too late did Albizzi realize that Cosimo was effectively blackmailing the city.

Disaster followed. Within months, economic troubles, tax hikes, and a series of cataclysmic military defeats had made Rinaldo degli Albizzi's regime hideously unpopular. His allies began to abandon him. Even Palla Strozzi grew colder. His grip on the Signoria weakened, and forced to choose between civic bankruptcy and a Medici hegemony the city's mercantile elite selected a decidedly pro-Cosimo Signoria in August 1434.

Rinaldo degli Albizzi's political career was over. The new Signoria immediately sent him into exile along with Palla Strozzi and overturned his "reforms." Most important of all, Cosimo de' Medici and his relatives were recalled with honor. The city needed his money more than it needed the "liberty" that Albizzi had claimed to defend.

When he arrived back in Florence in the autumn of 1434, Cosimo found himself the unchallenged master of the city. Broken by war, strapped for cash, and with no other source of loans, the Florentines needed Cosimo to act as their godfather, and though he was to be granted the title of *pater patriae* (Father of the Nation) after his death, he was nothing more than a very wealthy *padrino*.

Cosimo used his position to the full and consolidated his grip on power. He brought some former enemies over to his side, exiled others with ruthless efficiency, enlarged his networks of control, and centralized decision-making processes within his own household. He even pushed through a new constitution that placed authority in "his" council, and struck a deal with the Sforza of Milan to guarantee military support in the event of any unforeseen opposition. By 1459, he had achieved the kind of security that Mafia godfathers can only dream of.

The plots, counterplots, and brutal reprisals that facilitated Cosimo's rise to the top of the political food chain were certainly unique, but the trajectory he followed exemplified the degree to which the wealth of the merchant bankers had become synonymous with raw power. By virtue of the trade they plied, merchant bankers were obliged to form broad-based networks that combined business interests and familial ties, and thus assumed a naturally dominant role in the practices of communal politics. At the center of these overlapping circles of influence, the wealthiest merchant bankers-such as Cosimo de' Medicihad at their disposal a ready-made political machine that could easily be translated into government itself. Similarly, the parlous state of civic finances in communes up and down Italy virtually guaranteed that the richest merchant bankers would become the very cornerstone of political action. Escalating costs, inflexible systems of tax collection, and hopelessly inadequate revenues meant that enormous loans were the only way that many cities could hope to remain solvent, and since merchant bankers—and the tightly knit networks of which they were a part-were the only people who had the kind of money needed, it was inevitable that governments would sell out to their wishes. But perhaps most important of all, the stakes that were involved and the rivalries that emerged out of this situation ensured that if a merchant banker was to survive, he needed a very particular set of skills. If he were rich, but not colossally so, he needed to throw moral scruples to the wind and throw his lot in with the biggest fish in the pond. If he were very rich, however, he needed to ensure not only that his moneybags were bigger than anyone else's but also that he would always be the most ruthless and cunning man in town. Greed may have been good in the world of the Renaissance merchant banker, but insofar as the big prizes were concerned, Gordon Gekko wouldn't have been a patch on Cosimo de' Medici.

THE ART OF DISSIMULATION

The merchant bankers' rise from business moguls to political masters was undoubtedly a matter of great satisfaction for those who made it to the top. Having secured control of government, they had equipped themselves with the ideal tools with which to further their commercial interests, and had opened the doors to untold wealth and influence. Yet at the same time, they encountered a fresh series of challenges that went to the heart of their own nefarious methods. Lacking the security that noble titles conferred on other despots, they were unable to indulge the art of magnificence too much. It was dangerous to publicize their preeminence in cities that were—officially at least—republican, where ordinary citizens were liable to take umbrage at having their political impotence made too obvious. And the fact that authority resided in a network of personal relationships operating behind the organs of government meant they had to take care not to alienate their allies.

As the uncrowned king of Florence, Cosimo de' Medici was highly aware of these concerns. He had, in fact, learned the hard way. Early in his political career, as part of his campaign of investing lavishly in magnificent palaces and grand ecclesiastical projects, he had made the mistake of having his family coat of arms (which consisted of seven red balls, or *palle*, on a gold background) displayed prominently on everything he paid for. Before long, it was almost impossible to walk down a street without feeling Cosimo's influence. Not surprisingly, many Florentines—especially those from the Albizzi faction—took offense, and the irascible Francesco Filelfo launched a series of bitter attacks on him for this reason. The "art of magnificence" could be taken too far. Referring to the ubiquity of the Medici arms, Filelfo joked that Cosimo's pride was said to be so overweening that he had emblazoned "even the monks' privies with his balls."

Like many other merchant bankers in a similar position, Cosimo learned that he had to appear to remain in the background and to communicate a sense that he was just one part of a broad network of power by using art to represent political alliances and to forge new ties. He needed an "art of dissimulation."

There is perhaps no better illustration of this than the *Journey of the Magi to Bethlehem*. The fact that Cosimo the penitent shrank from the center stage and had himself depicted surrounded by a host of influ-

ential and powerful figures vividly testifies to his desire to give the impression that he was a humble man who nevertheless found himself at the center of an almost accidental web of political, intellectual, and financial ties.

But while Cosimo may have been an unusually prominent case in point, the same desire to use art to display political connections was shared by merchant bankers of rather more modest means. Family chapels were the ideal settings for this art of dissimulation, and Florence is literally packed with vivid examples, but three works in particular repay closer examination, each concealing a murky political drama of its own.

Filippino Lippi's fresco Raising of the Son of Theophilus and Saint Peter Enthroned in the Brancacci Chapel in Santa Maria del Carmine (Fig. 20) is not so much a depiction of a religious scene as a visual expression of the dynamics of power in Renaissance Florence. The patron, Felice di Michele Brancacci, was a prosperous silk trader whose prominence as one of the city's maritime consuls derived both from his wealth and from his marriage to the daughter of Palla Strozzi. But he was also a somewhat nervous fellow. Although he was sufficiently rich and well connected to carry a certain political weight, he was not so important a figure that he did not feel threatened by the dramatic shifts occurring in Florentine politics in the early 1420s. Needing to appear both powerfully "wired in" and somehow distant, he entrusted Filippino Lippi with casting him and a panoply of well-known Florentines in the role of witnesses to the miraculous resurrection of Theophilus's son. Among the crowd of bystanders, it is possible to glimpse the faces not merely of Brancacci himself but also of the chancellor Coluccio Salutati, the poet Luigi Pulci, the merchant Piero di Francesco del Pugliese, Piero di Iacopo Guicciardini (father of Francesco, the historian), and Tommaso Soderini (father of Piero, later to become gonfaloniere a vita).

The conceit was impressive, but it did not do Brancacci much good. Despite the clever, double-handed visual game in Lippi's fresco, Felice di Michele Brancacci ended up on the wrong side of the Albizzi-Medici struggle and was eventually exiled alongside his kinsman Palla Strozzi in 1434.

More successful, and perhaps more ambitious, was the manner in which Giovanni Tornabuoni had himself depicted by Domenico Ghirlandaio in the frescoes of his family chapel in Santa Maria Novella some

decades later (ca. 1485–90). Tornabuoni was an unusually well-placed individual and was-by any standard-at the center of Florentine political life during Cosimo de' Medici's ascendancy. He was a wealthy merchant, and his business connections had led him to become the Medici bank's treasurer to Pope Sixtus IV, a Florentine ambassador, and gonfaloniere di giustizia. What was more, he was also the uncle of Lorenzo the Magnificent. In commissioning Ghirlandaio to decorate the walls of the chapel, however, Tornabuoni took care to ensure that he and his kinsmen were shown not as dominant figures but as members of a much wider group. In the Expulsion of Joachim (Fig. 21), for example, his son, Lorenzo, is shown standing alongside Piero di Lorenzo de' Medici and two figures who may represent Alessandro Nasi and either Giannozzo Pucci (later to be accused of leading a pro-Medici plot against Savonarola) or a certain Bartolini Salimbene. So, too, in the Apparition of the Angel to Zechariah (Fig. 22), almost all of the male members of the Tornabuoni family are depicted surrounded by powerful individuals closely involved with the running of the Medici bank, including Andrea de' Medici, Federico Sassetti, and Gianfrancesco Ridolfi, and others with intimate ties to the governing elite, such as the chronicler Benedetto Dei. To further emphasize the cultural bonds between the Tornabuoni and the Medici, Ghirlandaio was also requested to include portraits of the humanists Marsilio Ficino, Cristoforo Landino, Angelo Poliziano, and (most likely) Demetrius Chalcondyles in the left foreground.

A similar—if rather more aspirational—approach was adopted by the Cambio broker Gaspare (or Guasparre) di Zanobi del Lama. A rather shady character with more than a few stains on his reputation, Lama was a relatively modest banker with only very tenuous links to the Medici. His ambition, however, far outstripped both his accomplishments and his moral standing, and he sought to use art to give an artificially inflated impression of his ties to the dominant merchant-banking elite. After commissioning Sandro Botticelli to paint the *Adoration of the Magi* (ca. 1475) (Fig. 5) for his family's chapel in Santa Maria Novella, Lama took a leaf out of Tornabuoni's book and instructed the artist to fill the scene with prominent figures from the world of politics and banking as a means of signaling his "intimacy" with Florence's most influential personalities. The Medici are cast in the roles of the three kings. Although dead, Cosimo is given pride of place, shown kneeling directly before the Virgin and Child, and is depicted with an arresting vividness (indeed. Vasari later commented that it was "the most convincing and natural of all the surviving portraits" of the old *vadrino*). Kneeling farther toward the foreground are Cosimo's sons, Piero (in a red robe) and Giovanni (in a long white robe). By way of completing the Medici "set." Lama also had Piero's own sons, Lorenzo il Magnifico (left) and Giuliano (right, next to Giovanni) shown flanking the central scene. Just to make sure his links with the Medici circle were clear, portraits of Filippo Strozzi and Lorenzo Tornabuoni were also inserted alongside images of noted cultural figures including Poliziano, Pico della Mirandola, and even Botticelli himself. Yet for all his heavy-handed showiness. Lama had enough political sense not to have himself set on a par with the Medici. Evidently acquainted with the subtlety that was appropriate to the "art of dissimulation," he had himself depicted as just one of the many figures in the group on the right of the painting. His curly gray hair clearly showing, he is peeking out from behind Giuliano de' Medici, in a light blue tunic. And though he fixes the viewer with a piercing gaze, his intention was to hint at his supposed connections rather than to broadcast his ambitions too boldly.

This, indeed, was the essence of the "art of dissimulation." However strong the impulse toward magnificence may have been, Renaissance merchant bankers knew that too overt a display of political influence was bad for business. Carefully managed, patronage of a skillful artist allowed them to represent and create networks of power on a canvas or in a fresco in such a way that an individual could project an aura of prominence yet still remain among the crowd.

Quite apart from the artistic achievements that this form of patronage generated, the beauty of the "art of dissimulation" was that it proclaimed and concealed the dodgy practices that had allowed merchant bankers to dominate the urban politics of the Renaissance. In revealing the networks that controlled government, it highlighted the incestuous relationship between business and politics. In doing so, it also discreetly hinted at the role that debt had played in handing near-absolute power to the individuals who stood at the center of those networks. And in emphasizing such networks over individual status, the "art of dissimulation" discreetly acknowledged the moral stain that accrued to those who had bought their way to the top. Like Mafia consiglieri, bankers like Tornabuoni and the embarrassingly ambitious Lama showed off that they were "made men" by signaling their ties to their Medici bosses, while the Medici themselves—the *capi dei tutti capi*—ensured that there was always a raft of dependent "friends" between them and the public gaze.

* * *

Although he could not entirely overlook the broader message he was intended to derive from the *Journey of the Magi to Bethlehem*, Galeazzo Maria Sforza would have recognized in the portrait of Cosimo de' Medici a neat encapsulation of the evolution of the merchant banker's craft, and of the manner in which merchant bankers had adapted their patronage of the arts to address the moral challenges they faced.

In Cosimo's portrait was inscribed the path that had led the Medici from humble beginnings as money changers to an unrivaled position as bankers to the papacy, and thence to the mastery of Florence. At the same time, his portrait was also testimony to the tremendous guilt of usury, the embarrassment of riches, the allure of ostentation, and the annexation of government to business interests. But most of all, the different layers of meaning embedded in the wizened old man's painted figure showed that merchant bankers like Cosimo knew how to use the arts to craft a public image far removed from the seamy realities of life.

As Gozzoli's frescoes show, nothing was quite what it seemed. The more powerful the penitence written into a piece of art, the more greedily the patron had exploited, extorted, and embezzled the money of his clients; the more magnificent the decoration of a chapel or altarpiece, the more prominently bribery and coercion had underpinned profitmaking schemes; and the more determinedly a patron hid among his friends and associates, the more certainly had he used his wealth to buy into government itself.

Mercenaries and Madmen

URNING FROM THE portrait of Cosimo de' Medici, Galeazzo Maria Sforza's eyes would have fallen on a proud figure on the far left of Gozzoli's *Journey of the Magi to Bethlehem* whom he would have recognized immediately as Sigismondo Pandolfo Malatesta, the "Wolf of Rimini." Riding a tough chestnut steed bred for war, he was every inch the battle-hardened soldier. His chest—puffed out with pride—was broader than any other, his neck was thick as a bull's, and his handsome jaw was set into a look of hardy resolve. Pointedly hatless, he looked ready for action, positively itching to snatch his sword from its scabbard and have at the enemy. But at the same time, he had a certain panache about him. His clothing was of the highest quality, and his whole bearing radiated a sense of taste and muscular refinement.

Galeazzo Maria would have been compelled to admit that it was a good likeness. He would already have had the opportunity to study Sigismondo at close quarters. Only a few years earlier, the Wolf had sold his services to Duke Francesco of Milan and had often been to the court for councils of war. What was more, Sigismondo had a reputation that preceded him. Not only was he famed as a brave, fearless warrior with an almost unparalleled gift for strategy, but he was also known for his humanistic tastes and had become famous for his patronage of the arts. Indeed, Galeazzo Maria would have found it difficult to disagree with Pope Pius II's contention that "in both mind and body, he was exceedingly powerful, gifted with eloquence, and great military skill, a profound knowledge of history and more than a passing knowledge of philosophy." As the pontiff opined, "Whatever he attempted, he seemed born to do."

But what Gozzoli's portrait didn't show—at least not directly—was that there was another, much darker side to the Wolf of Rimini. For all of Sigismondo's merits, "the evil side of his character had the upper hand." This, in fact, was something of an understatement. Despite praising him for his courage and learning, Pius II was in no doubt that he was "the worst of all men who have ever lived or ever will live, the shame of Italy, the disgrace of our age."

Sigismondo's portrait in Gozzoli's frescoes presented something of a paradox. On the one hand, here was a man who was famous—or, rather, infamous—for having "no tolerance for peace" and for being "a devotee of pleasure, patient of any hardship, [and] eager for war." And yet he was evidently a man of culture and refinement. Sigismondo was wellknown for his lavish patronage of the arts, and Cosimo de' Medici—no mean judge of men—thought sufficiently highly of him to include his portrait among the most eminent and learned men of the day.

The paradox went deeper still. Sigismondo was, in many senses, typical of a very particular-but often overlooked-breed of Renaissance patrons, and his portrait was just a tiny snapshot of the world they inhabited. However much Pius II liked to disparage him as the "worst of all men," Sigismondo was the embodiment of the condottieri of the period, the very archetype of the new mercenary generals who had come to dominate the art of war and who held the fate of Italy in their hands. Violent, brutal, and brilliant men, they raped, pillaged, and murdered their way across the peninsula, earning the disdain of the powerful and casting a shadow of fear wherever they went. Yet, at the same time as their stature and importance grew, they came to play an increasingly important role in the arts, first as the objects of a cult of civic commemoration and later as patrons in their own right. Indeed, they were almost obsessed with the arts. Though their hands were stained with blood, they commissioned paintings, sculptures, churches, and palaces of unparalleled beauty, and their patronage served to elevate artists like Piero della Francesca to the pantheon of European culture.

If Sigismondo's apparently perplexing appearance in Gozzoli's *Journey of the Magi to Bethlehem* and his bewildering obsession with the arts are to be understood, it's necessary to look behind his portrait and uncover the strange story of the condottieri's preoccupation with culture, from its origins in the confused warfare of the early Renaissance to its ultimate and terrifying refinement in the mid-fifteenth century. It's a tale far removed from familiar conceptions of Renaissance patronage: a drama of war and betrayal in which the stars were little more

than hired thugs who teetered constantly on the edge of madness, and who rampaged ruthlessly around Italy with bad attitude and seriously good taste. Indeed, the story is much like a good old shoot-'em-up Western, except that the good aren't so great, the bad are a lot worse, and the ugly really, really like art.

The Art of War

The Renaissance was the golden age of mercenaries. From the very beginning of the period, condottieri dominated the political and military life of Italy and had a stranglehold on the states of the peninsula. Although mercenaries had been commonplace since antiquity, their position in Renaissance Italy was without precedence, and they owed their frightening preeminence to the progressive evolution of warfare from the end of the Middle Ages onward.

By the dawn of the fourteenth century, it was clear not only that the anarchically fragmented states of Italy were doomed to exist in a condition of near-perpetual conflict, but also that war itself was becoming more technologically advanced. Although it was painted in the early fifteenth century, Paolo Uccello's three-part Battle of San Romano (Uffizi, Florence; National Gallery, London; Louvre, Paris) vividly illustrates the growing complexities of warfare (Figs. 23-25). Commemorating a battle between Florence and Siena in 1432, Uccello's scene is a powerful evocation of the violent chaos of war, and the sheer, bloody confusion of it all almost defies the artist's desperate attempt to use perspective to introduce a measure of order. But among the vicious disorder of the fighting, Uccello also included representations of two of the most important technological developments in early Renaissance warfare in the background to the first two panels (Niccolò Mauruzi da Tolentino at the Battle of San Romano; Niccolò Mauruzi da Tolentino Unseats Bernardino della Ciarda at the Battle of San Romano). Here, in the fields, a number of armored men are either drawing or firing crossbows (balestieri), and it was the crossbow that was the key to everything. Along with the longbow, it had transformed the whole nature of armed conflict. With a greater range, impact, and accuracy than anything seen before, the crossbow and the longbow were far superior to the bows and arrows of the Middle Ages, and—as the Battle of Agincourt was to show—could lead to whole-scale slaughter if properly used.

This had serious implications for the way armies fought. Most obviously, it changed the nature of armor. The crossbow and the longbow rendered the chain-mail armor previously favored by infantrymen and knights almost useless, and demanded the introduction of heavier plate armor and—in some cases—protection for horses. It is for this reason that in Uccello's scenes all of the cavalrymen wear complete suits of armor and even the infantrymen in the background are shown wearing metal cuirasses. These technological shifts also changed the way the all-important cavalry fought. At risk from being shot by crossbow bolts or longbowmen (note the toppled horse in the second of Uccello's panels), knights could no longer expect to function alone: they needed a horse or two in reserve and a team of supporting infantry to provide suppressing fire and additional protection. The fighting unit of a knight and two or three foot soldiers became known as a lance.

These technological changes made warfare a more professional affair. Crossbows and longbows required a good deal of practice if they were to be used properly, while a lance needed to train together for some time to be fully effective. What was more, plate armor, replacement horses, and even crossbows were expensive, highly specialized items. This posed something of a problem. Even the wealthiest citizens could not be expected to possess such equipment or expertise as a matter of course, and the growing ferocity of the Italian arms race made it impractical for any state to pin its hopes on the meager capabilities of a homegrown volunteer force. Compelled to fight ever-longer and more demanding campaigns, Italian city-states and signori were obliged to look elsewhere. If they were to have any success in war, they needed to be able to employ complete units of fully equipped, well-drilled professionals and had to be prepared to use some of their newfound wealth in arming themselves as well as they could. Mercenaries were the only solution. From around 1300, "professional mercenaries" hired in large companies "replaced largely native troops as the main components of Italian armies," while their leaders-the earliest condottieri-replaced indigenous generals as the strategic masterminds of each campaigning season. In fact, the three commanders depicted in The Battle of San Romano-Niccolò Mauruzi da Tolentino, Micheletto Attendolo, and Bernardino Ubaldini della Carda—were all condottieri.

During the fourteenth century, the immediate need for sizable numbers of highly skilled mercenaries was met by the sudden and rather unexpected influx of foreign soldiers into Italy. They came to Italy from all over the continent and by a variety of different routes. Some, especially Germans and Englishmen like Sir John Hawkwood, were looking for employment after serving in campaigns elsewhere in Europe. Others, mostly Hungarians, Frenchmen, and Catalans, had originally come to the peninsula on invasions launched by foreign rulers such as Louis the Great of Hungary and the Avignon popes, and had stayed behind in the hope of earning a living from their fighting skills. The "foreignness" of these companies was, from the very beginning, a distinct advantage. Nonnatives were unlikely to take sides on "ideological" grounds and hence could be swayed by cash, and at the same time they allowed Italian states access to the very latest military technology (crossbows, longbows, and so on), the masters of which were, by common consent, largely from northern Europe.

The earliest known companies—such as those led by William della Torre and the deliciously named Diego de Rat—were comparatively small, numbering anywhere between nineteen and eight hundred men, and appear to have had a relatively loose structure. By the third decade of the fourteenth century, they had grown to be fairly sizable, wellorganized units with a defined identity and leadership structure, and some—like the Company of Siena or the Company of the Cerruglio are known to have comprised troops from a number of different nationalities. Some were fairly specialized units, being devoted exclusively to infantry or cavalry, but many were composite bands that addressed all military needs simultaneously. The largest, the Great Company (led by Werner of Urslingen and later by Fra Moriale), Sir John Hawkwood's White Company, and the Company of the Star, could comprise as many as ten thousand soldiers and twenty thousand camp followers.

Most cities and *signori* employed condottieri and their companies on the basis of short-term contracts (*condotte*, from which condottieri derived their name), normally lasting between four and eight months. The duration of these contracts probably reflects a certain wariness of bearing the cost of mercenaries for longer than was absolutely necessary. But this did not mean that mercenary companies were here-todayand-gone-tomorrow bands. Although they did flit between employers as the whim took them, the majority had their contracts reissued time after time. The German captain Hermann Vesternich, for example, was kept on the Florentine payroll for nearly twenty years (1353–71, 1380) on the basis of rolling four-month contracts. At the same time, some truly outstanding condottieri could be given longer contracts that would be renewed numerous times over much longer periods. Along with his fellow Englishmen John Berwick and Johnny Liverpool, Hawkwood was contracted for a year at a time, on the tacit understanding that his contract would be continued almost indefinitely. By the same token, the short duration of such contracts did not mean they were financially unrewarding. Quite the reverse. Highly valued for their skills, Englishmen, in particular, could command enormous salaries, sometimes far in excess of the monetary rewards given to a state's highest officials.

Once employed, foreign condottieri often proved themselves both effective and loyal. Given that they were campaigning far from home and had no immediate ties to Italy itself, there was little danger of their wanting either to become too embroiled in the complex politics of the faction-torn peninsula or to carve out territorial states for themselves. By the same token, those companies headed by Italians exiled from their native cities were normally happy to stay aloof from the dirty world of politics inhabited by their masters. War was their business, pure and simple, and as long as the cash kept rolling, they would keep fighting.

The Good: The Foreign Condottieri and Mercenary Monuments

That the states of northern Italy had reason to be extremely thankful for the unexpected arrival of these early, foreign condottieri can readily be seen in Santa Maria del Fiore in Florence. It was here, in 1436, that the Florentine Signoria commissioned Paolo Uccello to paint a large funeral monument to one of the city's most respected public servants (Fig. 26). "A beautiful work of extraordinary grandeur," it was a remarkable—even overpowering—statement of the commune's esteem, and although moved on a number of occasions, it was designed to be seen by anyone who came to worship. It was unusual, to say the least. Although the Duomo was the epicenter of civic and religious life, it was normally seen as being "above" such things. For anyone to be commemorated in such a manner was a high honor indeed, but for a foreigner—and a "barbaric" Englishman who earned his bread by renting out his sword—to be marked in such a way was almost beyond belief.

Then again, Sir John Hawkwood was no ordinary man. A condottiere of the highest order, he was known as one of the foremost soldiers of the day. As the inscription beneath Uccello's equestrian portrait explains, this "British knight" was the "most prudent leader of his age, and most expert in military matters." Born somewhere in southeast England, he had served in France under Edward III during the Hundred Years' War and, following a brief cessation in hostilities, set himself up as a mercenary captain in Burgundy in around 1360. It was while campaigning with the White Company against the papacy in Avignon, however, that he first came to the notice of the Italian states. Respected for his courage and leadership, he was invited to take up arms in Italy for the first time in 1362. Over the next few years, he campaigned tirelessly throughout the North of the peninsula for various employers, but it was in 1377 that he found his métier after being persuaded to take up arms for Florence at the height of the War of the Eight Saints (which Florence and its allies waged against the papacy between 1375 and 1378). For the next seventeen years, Hawkwood would serve almost continuously as the city's "most effective captain and the most accomplished soldier in all of Italy." Leading the Florentine forces in the war against Milan, he earned a reputation both as the "savior" of the city's liberty and as the most loyal of its mercenary commanders. So great was its gratitude that he was granted citizenship and a handsome pension, and on his death in 1394 he was honored with a state funeral. Though belated, Uccello's magnificent funerary monument was just one more testament to the tremendous esteem in which he was held by the city of Florence.

Although he was undoubtedly an outstanding example of the foreign mercenary general, Hawkwood's equestrian portrait was emblematic of the manner in which art could be used to celebrate and extol such figures. Lacking either permanent abodes or territorial interests, early condottieri like Hawkwood were naturally somewhat removed from the ordinary practice of artistic patronage, but they were held in such high regard that states often hired artists to give visual expression to their gratitude. Even more impressive than Hawkwood's own monument, for example, was the fresco of *Guidoriccio da Fogliano at the Siege of Montemassi*, once thought to have been painted by Simone Martini for the Sala del Mappamondo in the Palazzo Pubblico in Siena in around 1330.

But while Uccello's equestrian portrait of Hawkwood was a heartfelt

expression of esteem, it also testified to a different dimension of the early condottieri's habits. For all of their many laudable characteristics, the early condottieri weren't paragons of virtue. In fact, they weren't very decent people at all, and especially not the gallant English knight depicted by Uccello.

Hawkwood's much-vaunted reputation for loyalty perhaps gives a false impression of the fidelity of the early condottieri. Neither foreign mercenaries nor Italian exiles seem to have lusted after territorial aggrandizement, but they were passionately addicted to cash.

While wars were raging, mercenary generals had absolutely no hesitation in switching sides if the price was right. This was precisely how Hawkwood first came into Florentine service in 1377. Two years into the War of the Eight Saints, Pope Gregory XI had made peace with Florence's most important ally, Milan. Having thus shattered the antipapal alliance, Gregory, it was widely expected, would attempt to bring the conflict to a swift end by sending Hawkwood—then one of his most senior commanders—on a campaign against Florence itself. To avoid such a devastating eventuality, Florence offered Hawkwood a bribe of 130,000 florins to come over to its side. Recognizing the dangers of such treachery, communes and *signori* were soon willing to pay insanely high salaries to the better condottieri in times of peace and war not only to make it worth the mercenaries' while to stay loyal but also to price their enemies out of the market.

Even during peacetime, however, the early condottieri felt no compunctions about using their monopoly on violence to get what they wanted. In practice, this meant nothing more nor less than heavily armed extortion, and once again Hawkwood was the acknowledged master. In 1379, Florence was at peace, and hence had no need to employ a large number of mercenaries. Yet by leading a band of marauders through the Tuscan countryside and threatening to wreak havoc on the inhabitants, Hawkwood gave Florence no choice but to keep him and one thousand lances on the payroll and hand over a hefty sum of money into the bargain. In part, high salaries can also be understood as ongoing bribes to ensure good behavior.

Mercenaries and their commanders were violent, unpleasant human beings inured to war and accustomed to violence. Even among the "better" condottieri, savagery was a way of life. Their campaigns were often waged with a brutality that went far beyond any strategic justification.

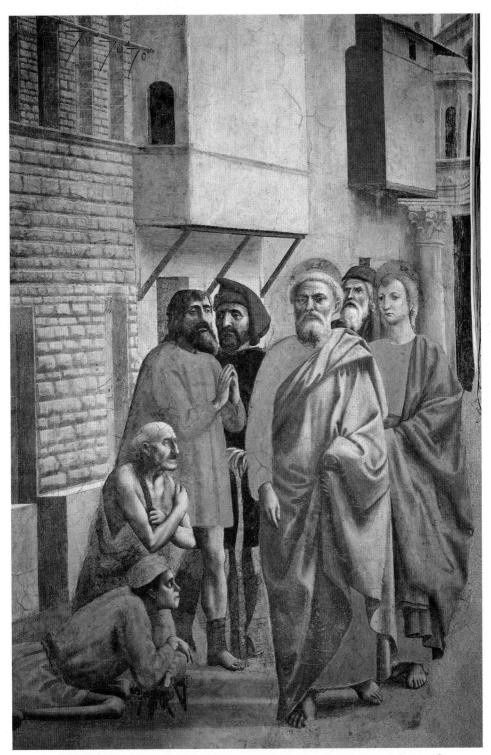

Fig. 1. Masaccio, *Saint Peter Healing the Sick with His Shadow*. A neat encapsulation of public life in Renaissance Florence that not only embodies the idealistic urban aspirations of a city grown wealthy on trade and commerce but also hints at a world in which disfigured beggars, filthy streets, open brothels, and ramshackle houses were very much the norm.

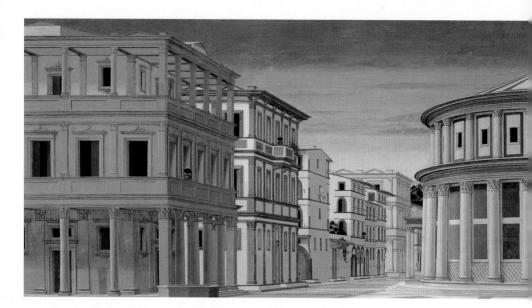

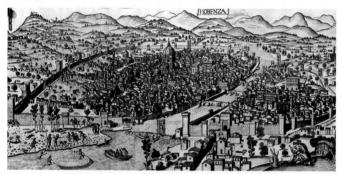

Fig. 3. Francesco Rosselli, *The Map of the Chain.* This panoramic view of Florence reveals that beneath the massive structure of the Duomo and the Palazzo Vecchio lay a teeming, disorganized muddle of houses, workshops, hostelrics, and shops that were the stage on which the drama of everyday life was set.

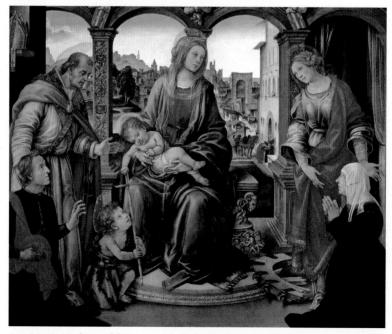

Fig. 4. Filippino Lippi, Madonna del Carmine (Pala de' Nerli). Behind Mary is a typical Oltr'Arno scene.

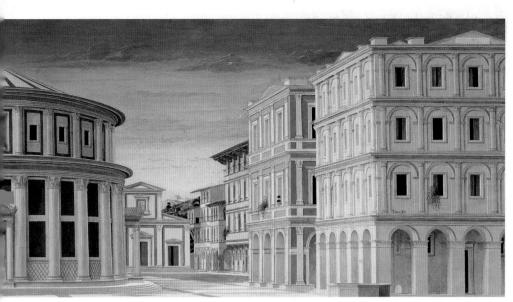

Above: Fig. 2. Anonymous, *The Ideal City*. A utopian vision of city life that was inspired by Poggio Bracciolini's rediscovery of Vitruvius's *De architectura* in 1415 but that was lamentably far from urban realities.

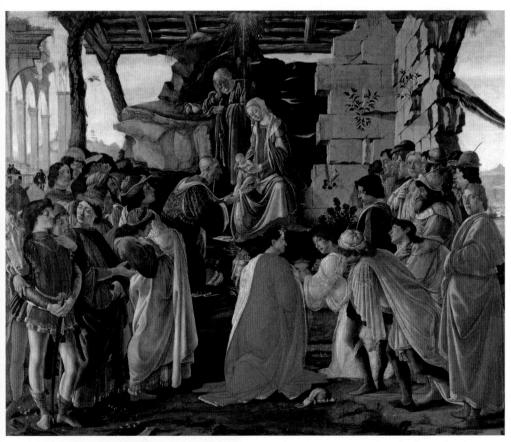

Fig. 5. Sandro Botticelli, *Adoration of the Magi*. To show his "intimacy" with Florence's de facto rulers, the ambitious Gaspare di Zanobi del Lama had himself depicted alongside the Medici and their circle in this fanciful scene.

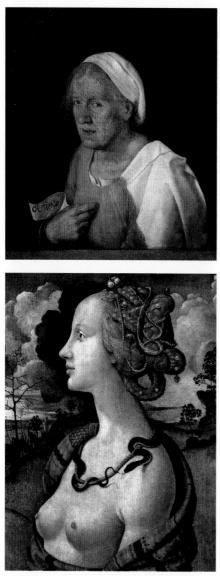

Top: Fig. 6. Giorgione, *The Old Woman*. The scroll reading "*col tempo*" (with time) is a warning of what awaited many Renaissance women.

Bottom: Fig. 7. Piero di Cosimo, *Portrait* of Simonetta Vespucci. Reputedly the most beautiful woman of the age, Simonetta Vespucci is depicted in the guise of a virtually naked and wildly titillating Cleopatra.

Right: Fig. 9. Sandro Botticelli, *Return of Judith*. A biblical tale transformed into a statement of female independence.

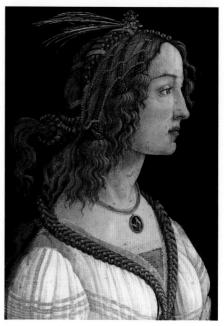

Fig. 8. Sandro Botticelli, *Portrait of a Young Woman*. The exotically dressed subject of this painting—possibly Simonetta Vespucci—testifies to the fact that women often acted as the pioneers of daring fashions and could be autonomous cultural agents in their own right.

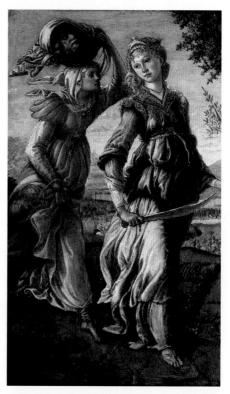

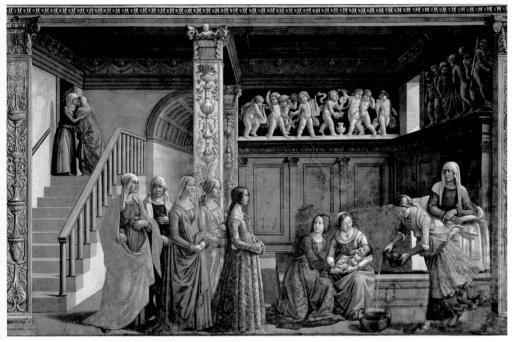

Fig. 10. Domenico Ghirlandaio, *Birth of Mary*. A Renaissance palazzo usually comprised about a dozen habitable rooms, each of which was on a monumental scale.

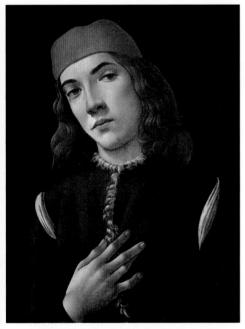

Fig. 11. Sandro Botticelli, *Portrait of a Youth*. The sitter's unusual hand gesture suggests early-onset arthritis.

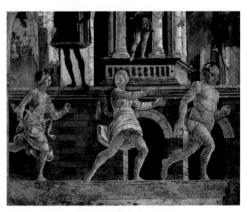

Fig. 12. Francesco del Cossa, *April* (detail). Prostitutes were not just sexual companions but also friends and muses.

Fig. 14. Michelangelo, *The Punishment of Tityus*. In this dramatization of a mythological tale of divine retribution, Michelangelo not only showed that he harbored an irrational physical passion for Tommaso but also demonstrated his belief that he would be punished for all eternity for his lust.

Fig. 15. Antonio del Pollaiuolo, *Apollo and Daphne.* Like Apollo, Petrarch could not prevent his beloved from fleeing from his passion.

Previous page: Fig. 13. Michelangelo, *The Fall* of *Phaethon*. A mythological metaphor for the artist's tortured feelings for Tommaso de' Cavalieri.

Fig. 16. Gherardo di Giovanni del Fora, *The Combat of Love and Chastity*. Petrarch's solution: the arrows of desire should break against chastity's shield.

Fig. 17. Michelangelo, *The Rape of Ganymede*. Picturing himself as both Zeus and Ganymede, Michelangelo showed that he was carried away by an irresistible passion and longed to snatch Tommaso away for an eternity of pleasure.

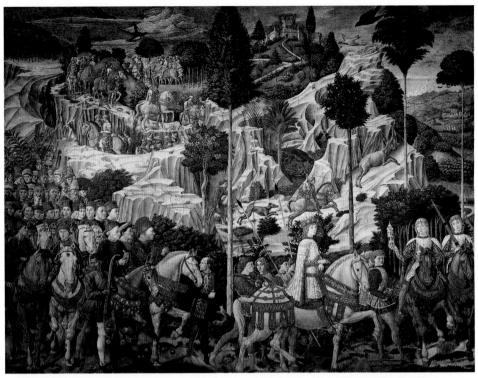

Fig. 18. Benozzo Gozzoli, *Journey of the Magi to Bethlehem* (east wall). In the role of Caspar, Lorenzo de' Medici leads the procession, followed by his father, Piero, and his grandfather Cosimo. Behind them, Gozzoli painted a host of cultural and political figures designed to show off the family's power. To the left of the painting are equestrian portraits of the condottiere Sigismondo Pandolfo Malatesta (left) and Galeazzo Maria Sforza, heir to the duchy of Milan (right). In the third row of the crowd, just above a portrait of Gozzoli himself, can be seen the glum-looking figure of Aeneas Silvius Piccolomini, later to become Pope Pius II.

Fig. 19. Marinus van Reymerswaele, *The Moneychanger and His Wife*. The money-changing business set up by Ardigno de' Medici and his siblings would have looked similar.

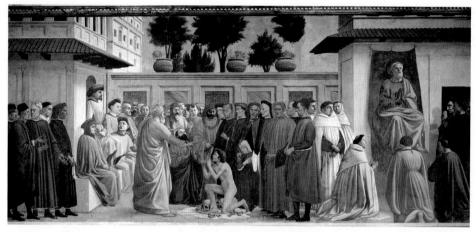

Fig. 20. Filippino Lippi, *Raising of the Son of Theophilus and Saint Peter Enthroned*. A veritable Who's Who of early-fifteenth-century Florentine political life.

Fig. 21. Domenico Ghirlandaio, *Expulsion of Joachim*. On the left, Lorenzo Tornabuoni stands alongside Piero di Lorenzo de' Medici and two other Medicean supporters.

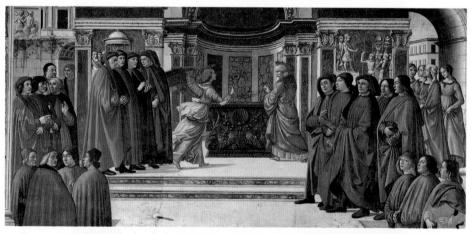

Fig. 22. Domenico Ghirlandaio, *Apparition of the Angel to Zechariah*. The male Tornabuoni are shown surrounded by powerful figures linked with the Medici regime. In the left foreground, portraits of Marsilio Ficino, Cristoforo Landino, Angelo Poliziano, and Demetrius Chalcondyles have also been included.

Fig. 23. Paolo Uccello, Niccolò Mauruzi da Tolentino at the Battle of San Romano.

Fig. 24. Paolo Uccello, Niccolò Mauruzi da Tolentino Unseats Bernardino della Ciarda at the Battle of San Romano.

Fig. 25. Paolo Uccello, *The Counterattack of Micheletto da Cotignola at the Battle of San Romano*. This three-part depiction of Florence's victory over Siena in 1432 is a powerful evocation of the violent chaos of Renaissance warfare. It is, however, also a neat illustration of the technological changes that transformed the way armies fought and that paved the way for the rise of mercenary generals.

Fig. 26. Paolo Uccello, *Funerary Monument to Sir John Hawkwood*. Commissioned by the Florentine Signoria in 1436, this unique monument was a heartfelt expression of esteem for a much-loved mercenary general. But it also testifies to the terror that treacherous and savage condottieri could inspire.

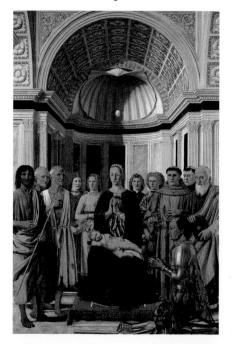

Fig. 27. Pedro Berruguete, *Portrait of Duke Federico and His Son Guidobaldo*. Originally commissioned for Federico da Montefeltro's bedchamber in Urbino's fairy-tale Palazzo Ducale, this portrait is an intimate depiction of the most successful condottiere of the fifteenth century and shows the extent to which the patronage of art and culture could be fostered to cover up the most heinous of crimes.

Left: Fig. 28. Piero della Francesca, *Montefeltro Altarpiece*. Like contemporary merchant bankers, condottieri enthusiastically had themselves depicted as witnesses to or participants in scenes from religious history as a means of scrubbing away the bloody stains on their souls.

Fig. 29. Piero della Francesca, *Sigismondo Pandolfo Malatesta Praying in Front of Saint Sigismund.* Far from illustrating his piety, this fresco was a conscious celebration of Sigismondo Pandolfo Malatesta's militaristic prowess and overweening ambition, as well as a pointed political dig at the pope's expense.

Fig. 30. Giulio Romano, Giovanni da Udine, and others (after Raphael), *The Council of the Gods*. Depicting a scene of drunken revelry taken from classical mythology, this shows that the greed, gluttony, and lust of the papal court often found their way into the decorative schemes of palaces belonging to Rome's ecclesiastical elite.

Fig. 31. Melozzo da Forlì, *Sixtus IV Appoints Bartolomeo Platina Prefect of the Vatican Library*. Surrounding the pontiff are four of his nephews, two of whom were already cardinals. Fig. 32. Raphael, *Portrait of Pope Leo X and His Cousins Cardinals Giulio de' Medici and Luigi de' Rossi*. Portraiture was a favored means of displaying "dynastic" power within the Curia.

Fig. 33. Filippo Lippi, *Barbadori Altarpiece*. Painted circa 1438, this work might reflect the artist's supposed experiences as a slave in the Hafsid kingdom of North Africa. The pseudo-Kufic script on the Virgin's hem is simultaneously a sign of broadening horizons and a crude imitation of Arabic orthography.

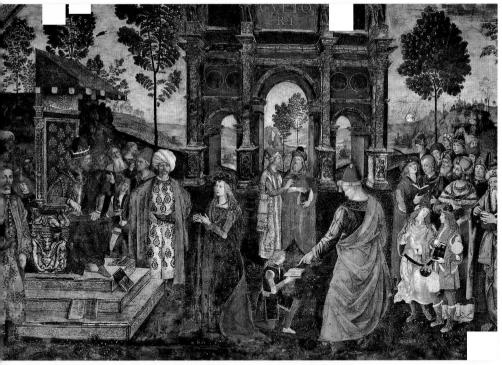

Fig. 34. Pinturicchio (Bernardino di Betto), *Disputation of Saint Catherine*. Pope Alexander VI's illegitimate daughter Lucrezia appears in the guise of Saint Catherine in this fresco adorning the Borgia Apartments in the Apostolic Palace.

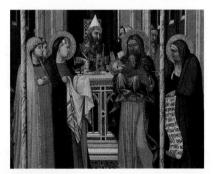

Fig. 35. Ambrogio Lorenzetti, *Presentation at the Temple*. Although Mary's earrings reflect her Jewish identity, details such as this fueled anti-Semitism.

Fig. 36. Paolo Uccello, *Miracle of the Profaned Host*. Accusations of host desecration were frequently fabricated to bolster support for campaigns of anti-Semitic persecution.

Fig. 37. Costanzo da Ferrara, *Standing Ottoman*. After the fall of Constantinople, artists and humanists flocked to the city to study the Muslim East.

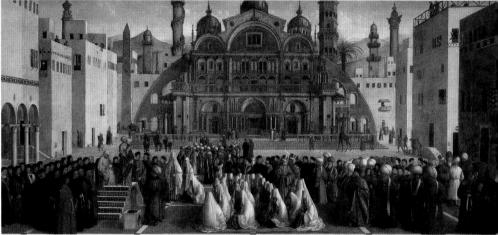

Fig. 38. Gentile and Giovanni Bellini, *Saint Mark Preaching in Alexandria*. Based on observations made at the Ottoman court, this work displays an acute knowledge of Muslim costume and mores yet locates the drama in a recognizably Venetian setting.

Fig. 39. Andrea Mantegna, *Adoration* of the Magi. The kneeling figure of Balthazar reflects the Renaissance willingness to accept black Africans as "children of God."

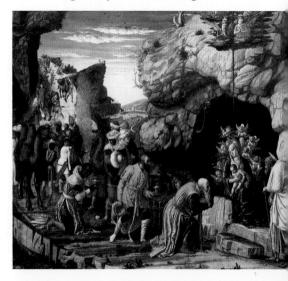

While praising the thirteenth-century condottiere Farinata degli Uberti (d. 1264), for example, Leonardo Bruni was compelled to admit that even so outstanding a general "behaved more unforgivingly towards his adversaries than is consistent with the moderation of civilized conduct." Just how unforgivingly can be gauged from Hawkwood's actions in the next century. In 1377, Hawkwood was responsible for butchering the entire population of Cesena and presided over the massacre of some five thousand civilians. It was the awareness of this fact that underpinned the many attacks on condottieri in contemporary literature. Lamenting the use of German mercenaries during the siege of Parma in 1344-45, Petrarch not only bemoaned the "venal hearts" of the foreign soldiers who could so easily turn from "followers" to "enemies" but also drew attention to the "Teutonic rage" that had stained the grass red with Italian blood needlessly spilled. Indeed, it was no coincidence that communes had caricatures of naughty condottieri undergoing horrible punishments painted in public places as frequently as they commemorated the same men with imposing monuments.

Condottieri were addicted to anarchy and death. Their bands were given to wholesale outlawry, often in the lands of their erstwhile employers. Plundering, looting, and raping wherever they chose, mercenaries could enrich themselves with great ease while leaving suffering and chaos in their wake. Condottieri themselves were, however, often even worse than the troops they commanded. Many were almost sadistic in their cruelty. Malatesta da Verucchio (1212–1312), for example, secured his family's rule of Rimini by assassinating all of his rivals with unusual viciousness, thereby earning a place in Dante's *Inferno*. His son was no better. On discovering that his wife, Francesca da Polenta, was conducting an adulterous affair with his brother Paolo, Giovanni Malatesta (1240/44–1304) slaughtered them both with his own hands.

This casts Uccello's portrait of Hawkwood in a very different light. Far from merely wishing to commemorate the crack commander of a highly prized company of professional troops, Florence was also more than a little afraid of the man on whom it had come to depend so profoundly. Although they might have represented the best of what mercenaries could be during the Renaissance, Hawkwood's equestrian monument shows that the good were not so good, and that the magnificent artworks erected in their memory are a testimony more to the fear they instilled in others than to the virtue they embodied.

THE BAD: LORDS OF WAR AND KINGS OF PATRONAGE

Not only was the character of the condottieri to change significantly in the century after Hawkwood's death, but the moral standing of mercenary generals was also to take a dramatic turn for the worse. And, like so much else in the Renaissance, these changes were to catalyze a seismic shift in the way mercenaries approached art: a shift that transformed them from being the objects of patronage to being patrons in their own right.

Originally commissioned for the ducal bedchamber in the Palazzo Ducale in Urbino, Pedro Berruguete's *Portrait of Duke Federico and His Son Guidobaldo* (ca. 1476–77; Galleria Nazionale delle Marche, Urbino) is an intimate depiction of one of the most prominent condottieri of the fifteenth century (Fig. 27). Seated on a high-backed chair, Federico III da Montefeltro, duke of Urbino, is shown reading a finely bound codex in a full suit of armor while his son and heir stands at his side. He is the very image of the learned warrior-knight. His nobility is beyond question. While his stoat-trimmed crimson mantle testifies to his aristocratic title, he discreetly shows off the symbols of his chivalric nature. Around his neck hangs the pendant of the Order of the Ermine, bestowed upon him by Ferrante I of Aragon, king of Naples; on his left leg can be seen the Order of the Garter, which he received from Edward IV of England; and on the shelf in front of him sits a jeweled miter presented by the Ottoman sultan.

In depicting his patron in such a manner, Berruguete encapsulated the highest points of Federico's glittering career as a condottiere, as well as the essence of the second generation of Renaissance mercenary generals. During the ferocious battles of the fifteenth century, and especially in the course of the Lombard Wars of ca. 1425–54, the nature of warfare had changed dramatically. Campaigns had become more brutal, conflicts had started to last for longer periods of time, and alliances between increasingly centralized states had made wars altogether larger-scale affairs. The "art of war" had now evolved into "military science." Neither city-republics nor *signori* could rely on hiring loose bands of unreliable and itinerant foreigners to meet the latest unexpected crisis. They began thinking in terms of long-term defensive strategies. And for this, they needed clearly defined military units that were not only better equipped and trained but also more hierarchically arranged and better disposed to giving loyal service on a semipermanent basis.

A new breed of condottieri started to emerge. They increasingly came to be landed Italian natives, often the younger sons of noble houses in search of betterment. With land at their disposal, men like Jacopo dal Verme (1350-1409), Facino Cane (1360-1412), and Muzio Attendolo Sforza (1369–1424) could count on a ready supply of men, had the steady revenues to equip their troops, and could be relied upon to put a dependable number of soldiers into the field. This being so, the nature of their relationship with their employers also changed. The increasing weight and professionalism of mercenary armies made them more valuable, and not only did certain condottieri gain appointment as captains general for life, but a great many commanders were also offered unprecedented rewards in an effort to guarantee their fidelity in the long term. Quite apart from the vast sums of money conventionally paid to skilled generals, cities and signori began to hand over entire palaces (sometimes even towns) and to bestow noble titles on their most senior condottieri (a practice technically known as infeudation). By giving them land, wealth, and a quasi-feudal link to the employer-lord, cities and signori hoped they would have a powerful reason to remain loyal and to serve well. In a sense, it was an attempt to turn mercenary companies into citizen armies.

Federico da Montefeltro seemed to demonstrate just how effective the results of these changes could be, and Berruguete's depiction of him in all his finery is a testament to the impressive success he came to embody. The illegitimate son of Count Guidantonio da Montefeltro, Federico had taken up arms as a mercenary for the first time when he was only sixteen and, having found himself naturally suited to the art of war, racked up a string of brilliant victories, often against almost overwhelming odds. He single-handedly saved Milan from being overrun by the Venetian forces led by Bartolomeo Colleoni at the Battle of Riccardina (Molinella) in 1467, earned the gratitude of Pope Pius II for checking the ambitions of Sigismondo Pandolfo Malatesta, and was lauded to the skies for successfully besieging Volterra on Florence's behalf in 1472. So towering a figure did he become that he was often paid huge sums of money simply to refrain from fighting: during a war against Ferrara in 1480–82, for example, Venice offered him 80,000 florins just to stay at home. Military success brought Federico enormous wealth, a raft of coveted honors, and the admiration of Europe's greatest potentates. By the close of his mercenary career in 1474, he had been raised to the ducal dignity, granted the title of apostolic vicar, named commander in chief of the armies of the Church, and inducted into some of the highest orders of chivalry in existence.

As Berruguete's portrait indicates, Federico had acquired a dazzling reputation as one of the foremost military commanders of his day and seemed to have epitomized all that was good about the fifteenthcentury condottiere. As early as 1464, Gianmario Filelfo—the son of Francesco—had hailed him as a new Hercules and had devoted his epic poem, the *Martiados*, to celebrating Federico's near-mythical status as a warlike hero, an image that was repeated in magnificent style in Pierantonio Paltroni's laudatory biography. Even the Florentine Cristoforo Landino observed in his *Disputationes Camaldulenses* that he was certainly "worth comparing to the best captains of the ancient era." After his death, Federico was singled out by Baldassare Castiglione for having been "the light of Italy." There was, he claimed, no lack of witnesses

to his prudence, humanity, justice, generosity, and unconquerable spirit, and to his military skills, which was brilliantly attested by his many victories, his ability to capture impregnable places, his swift and decisive expeditions, his having routed many times with few troops great and formidable armies, and his never having lost a single battle. So we can fairly compare him with many famous men of the ancient world.

Federico was, indeed, almost a walking advertisement for the "modern mercenary general."

What was more, the fact that Berruguete portrayed Federico reading a codex clearly revealed the duke's passionate interest in learning and the arts, and in this respect, too, the artist proved himself to be an acute observer of the changes that military advancements had wrought on the cultural outlook of condottieri in the fifteenth century. Now that they were wealthy, titled individuals, they found they wanted to legitimate the social position they had acquired through force of arms by using art to cloak themselves with an aura of respectability. And to do this, they needed to ensure that their art would celebrate their strengths and gloss over the more questionable side to their occupation.

Berruguete's decision to portray Federico in full battle dress testified to the condottieri's preoccupation with recasting the undeniably militaristic side of their lives. No matter how successful or powerful they may have been, they were aware that most people viewed the way they earned their daily bread as dreadful. A soldier's life may not have been a happy one, but a mercenary's life was—as Machiavelli's comments in *The Prince* alone illustrate—at best, one of unreliability and treachery, and, at worst, one devoted to the science of slaughter. As their social position improved, condottieri naturally wanted some way of overcoming this unfortunate, if entirely justified, public image.

The humanists' preoccupation with the classics offered a way forward. Ancient history and mythology were replete with emperors, generals, gods, and heroes who were certainly not whiter than white but who were nevertheless lionized purely for their strength and fighting abilities. In spite of attempts to see certain tales as allegories of Christian morality, might was generally right, and displays of courage—in almost any context—could be equated with virtue. Hercules, Cadmus, Perseus, and Theseus were acclaimed by the humanists as models of aggressive, muscular goodness, while the emperors Hadrian and Trajan—along with Julius Caesar, whose monarchy/tyranny was otherwise open to debate—were held up as the acmes of the warlike prince.

However, such texts often had a relatively limited audience. Mercenary generals wanted a bigger public. The patronage of art offered the ideal opportunity to make the desired connections with ancient heroes more explicit.

One of the most obvious and highly favored vehicles for this was funerary art, and there is no more dramatic or impressive example than the chapel constructed by Bartolomeo Colleoni in his native town of Bergamo at some point in the 1470s. As all of his contemporaries knew, the project had been dear to Colleoni's heart for a long time. Indeed, he was so hell-bent on building the chapel that he was reputed to have marched his troops into the town and demolished the old sacristy abutting Santa Maria Maggiore so that the chapter of the church would have no opportunity to object to the site he intended for his monument. Apocryphal though the tale may be, there was no doubt that Colleoni had his heart set on making the chapel the perfect testament to his "virtuous" character and worked closely with his architect, Giovanni Antonio Amadeo, to ensure that iconographical details would be included that would speak to the "goodness" of all he had achieved. The facade is particularly revealing. On either side of the great rose window, Colleoni had placed two tabernacles, one containing a bust of Julius Caesar, the other a bust of Trajan. The implied parallel was clear. He was an "undefeated general" (as the inscription on his tomb claims), and his military genius matched that of both Caesar and Trajan, whose moral rectitude and feats of arms no one would deny and whose authority seemed beautifully to gloss over the bloody and unpleasant side of Colleoni's mercenary life.

A more subtle method of underscoring the parallel with ancient models was the equestrian statue. Although the statue of Marcus Aurelius now standing in the Piazza del Campidoglio in Rome is the only complete surviving example, such works were frequently used in antiquity to emphasize the active military leadership, triumphant record, and justice of a particular figure, and-having fallen out of favor during the Middle Ages-they reemerged with renewed vigor as a mode of portrayal during the early Renaissance. With its implied associations with outstanding Roman emperors of the past, the equestrian statue (tried out earlier in pictorial form in Uccello's monument to Sir John Hawkwood) became a particular favorite of condottieri eager to cloak themselves in an unrealistic mantle of virtue. In 1475, Colleoni bequeathed a huge sum of money to have an equestrian statue of himself erected in Venice, and although his wish to be commemorated in the Piazza San Marco was ultimately unrealized, an imposing-even fearsome-piece designed by Andrea del Verrocchio still stands in the Campo Santi Giovanni e Paolo. His fellow general Erasmo da Narni (Gattamelata; 1370–1443) had a similar, if more placid-looking, statue by Donatello erected outside Il Santo in Padua, a city he had briefly ruled on Venice's behalf.

But other, yet more sophisticated and clever methods of linking condottieri with ancient paragons were also available, and no one was more willing to explore them than Federico da Montefeltro. Apart from Berruguete's painting, one of the more inventive approaches appears in a double-sided portrait of the duke and his wife painted by Piero della Francesca ca. 1474 (Uffizi, Florence). On the reverse of the panel showing Federico's profile, he is depicted being borne along on a triumphal chariot, seated in a folded chair in full armor and carrying a scepter. The allegorical figure of Victory holds a laurel crown above his head, while personifications of the four cardinal virtues sit in attendance at the front of the chariot. Heavily influenced by classical histories, it was a clever attempt to portray the "triumphant" Federico as the direct heir of the heroes of ancient Rome while simultaneously stressing that "victory" was as much a proof of the duke's moral rectitude as it had been for the Roman generals whom all admired. As the inscription below the scene expressed it: "He rides illustrious in glorious triumph—he whom, as he wields the sceptre in moderation, the eternal fame of his virtues celebrates as equal to the greatest generals."

In the second place, Berruguete's portrait of Federico also indicates that condottieri were eager to make military might not just heroic but respectable, even admirable in some respects. This was, of course, no easy task. As far as the Church was concerned, military might was only justifiable when linked with acts of virtuous heroism or holy war: the butchery favored by soldiers of fortune was categorically immoral, and they themselves were little more than killers for hire. Theologians from the earliest days of the Church had been united in condemning rape, pillage, torture, and murder as among the worst sins imaginable.

Since mercenaries showed absolutely no inclination to abandon their savage ways, the strictures of the Church were the source of a major image problem.

Quite apart from the lavish amounts of money habitually given to churches and religious institutions, the condottieri sensed that military saints represented a handy vehicle for giving their nefarious deeds a veneer of respectability. There was, of course, no shortage of soldiersaints to pick from. The Church had long celebrated figures such as Saint George, Saint Martin, and Saint Eustace, and had hailed the fighting skills of the archangel Michael. By nurturing the cult of such warlike heroes, condottieri could implicitly identify themselves with Christian virtue. No one with a deep attachment to such saints, it was thought, could possibly be wicked.

More direct was the technique of having a portrait included in an overtly religious painting. Like contemporary merchant bankers, condottieri were quite keen on having themselves depicted as witnesses to or participants in scenes from religious history. A good example is provided by Piero della Francesca's *Montefeltro Altarpiece* (Brera, Milan), which was commissioned by Federico da Montefeltro in 1472–74 (Fig. 28). Here, the Virgin Mary and the infant Christ once again take center stage, surrounded by a whole bevy of impressive saints, although none of them military in character. In the foreground, however, kneels Federico himself. Arrayed in full battle gear, his helmet and gauntlets lying on the ground before him, he is the very model of the devout worshipper. The intended implication is clear. Although a soldier by profession, he was a soldier for Christ; faith came first. To anyone acquainted with his nefarious personal history, it was patent nonsense, but it was nonetheless a highly effective visual strategy, and there is no reason to believe it did not get the desired message across to his subjects in Urbino.

But of all the ways of putting a positive moral spin on killing, none was better—or more exciting—than pure, unalloyed culture. Aping the manners of their signorial masters, condottieri strove to endow themselves with an air of justice and civilized sophistication by nurturing fully fledged courts, the artistic culture of which testified to the respectability they craved so desperately. The master at this was unquestionably Federico da Montefeltro, a fact vividly indicated by the inclusion of the codex in Pedro Berruguete's portrait.

After succeeding his half brother, Oddantonio, in 1444, Federico had transformed Urbino into one of the most brilliant cultural centers in northern Italy. He was a classical scholar who had been educated by the renowned Vittorino da Feltre in Mantua, and his passion for the new humanistic trends was well-known. He was a true bibliophile, as the lavish and telling decorations of his studioli in Urbino and Gubbio testify. According to Vespasiano da Bisticci, he devoted not less than 30,000 ducats (more than four thousand times the annual wage of a household servant) to assembling the largest library outside the Vatican. He surrounded himself with learned men and made his court a magnet for literary talent. An acquaintance of Cristoforo Landino (whose likeness was included in a double portrait), he directly employed the astrologer James of Spiers, Ficino's friend Paul of Middelburg, Francesco Filelfo and his son, the irascible poet laureate Gianmario, and rising stars such as Porcellio Pandoni, Lilio Tifernate, Agostino Fregoso, and Lodovico Odasio. Orators were unusually highly prized by the warlike duke. Indeed, one Latin oration made by Antonio Bonfini in 1478 was so esteemed by Federico that he had the event commemorated in a painting by Justus of Ghent (now in Hampton Court).

Perhaps as a result of a youth spent at the Gonzaga court in Mantua, Federico also had a deep sensitivity for art and architecture and, emulating Cosimo de' Medici's obsession with "magnificence," lavished money on every imaginable form of patronage. In 1464, he commissioned the Dalmatian architect Luciano Laurana (later replaced by Francesco di Giorgio Martini) to rebuild the Palazzo Ducale completely and, in doing so, created one of the most dramatic and impressive of all Renaissance palaces. Sumptuous almost to a fault, Federico's new residence was filled with the works of the best artists of the day, and he was to become a long-standing patron of painters including Piero della Francesca, Paolo Uccello, Justus of Ghent, and Pedro Berruguete himself. So fabulous was Federico's court that he was later acclaimed by the apostolic secretary Paolo Cortesi (1465–1510) as one of the two greatest patrons of art of the period (the other being Cosimo de' Medici).

Yet at the same time, Berruguete's portrait discreetly testifies to a very different side of Federico da Montefeltro's character. As in all other surviving depictions of the condottiere, Berruguete's portrait shows Federico in profile. Only the left part of his face is visible, while his nose seems strangely hooked. In his youth, he had been horribly wounded in a joust. His right eye had been torn out, leaving him with a huge and horrible scar across his face. Finding his field of vision severely restricted, and fearful of being surprised, he had surgeons hack out the bridge of his nose. Although he was careful only to be painted from the side from this point on, there was no disguising the personality traits that had been revealed by his injury. Despite his undoubted courage, he was impulsive and violent in the extreme. And perhaps most important, the lengths to which he was prepared to go to prevent anyone from sneaking up on him point not only toward a measure of paranoia, but also toward a ruthless character that viewed conspiracies and assassinations as a natural part of life.

Federico was not unusual. Although they had become more effective commanders and more attentive patrons, fifteenth-century condutieri were worse than their fourteenth-century counterparts in almost every respect, and it is no exaggeration to say that their enthusiasm for the arts grew in direct proportion to their mounting brutality.

Almost inevitably, the landed interests, long-term appointments, and progressive infeudation of condottieri conspired to politicize the role of the mercenary commander. Far from being more closely bound to their employers as a result of the emoluments and prizes they received, the condottieri of the fifteenth century became increasingly independent political actors. Although some—like Bartolomeo Colleoni—were to earn a reputation for loyalty, the majority recognized that they, too, were players in the great game of Italian politics and were in a position to make significant gains for themselves. Mercenaries had found themselves in similar situations before (Castruccio Castracani, *signore* of Lucca, being one of the more notorious examples), but the fact that the greater number were exiles or foreigners had meant instances of autonomous political action were few and far between: from the fifteenth century onward, they were more and more the norm.

This only served to compound many of the mercenary generals' worst character traits. Although they never entirely abandoned the time-honored practice of looting and pillaging, condottieri like Federico da Montefeltro were acutely conscious of the immense influence they wielded and had no compunction about manipulating it for their own ends. Even the best of them was prepared essentially to blackmail his employers for greater rewards, a fact that was excoriated by the Florentine chancellor Leonardo Bruni in his *De militia* (1421). As Niccolò Machiavelli complained in *The Prince* in the next century,

Mercenaries are disunited, thirsty for power, undisciplined, and disloyal; they are brave among their friends and cowards before the enemy; they have no fear of God; they do not keep faith with their fellows; they avoid defeat just so long as they avoid battle; in peacetime you are despoiled by them, and in wartime by the enemy ... if [condottieri] are [skilled], you cannot trust them, because they are anxious to advance their own greatness, either by coercing you, their employers, or by coercing others against your own wishes.

In contrast to the mercenary generals of earlier centuries, this new breed of condottieri often wanted more than just cash. Far from tightening their hold over their employees, *signori* often found that their openhanded displays of generosity obliged them to go cap-in-hand to their increasingly wealthy captains. In 1441, for example, Niccolò Piccinino (1386–1444) haughtily demanded to be invested with the fiefdom of Piacenza before he would deign to fight for Filippo Maria Visconti against the Papal States in the Fourth Lombard War. Furious, Visconti exclaimed,

These condottieri have now reached the stage when, if they are defeated, we pay for their failures, and, if victors, we must satisfy their demands and throw ourselves at their feet—even more than if they were our enemies. Must the Duke of Milan bargain for the victory of his own troops, and strip himself to receive favours from them?

Even when placed in positions of trust in peacetime, they were liable to abuse their authority in the most outrageous manner. On being appointed to the governorship of Bologna by the antipope John XXIII in 1411, Braccio da Montone (1368–1424) proceeded to exact what amounted to protection money from the towns nearby.

It would, however, be wrong to think that mercenary generals restricted themselves to extortion. Possessing territories of their own, noble condottieri lusted constantly for ever more lands and had no shame about nibbling away at the fringes of the greater Italian states amid the chaos of war. This, indeed, was a particularly pronounced phenomenon among those mercenary generals who came from the marches, a kind of no-man's-land between the Milanese, Venetian, and papal spheres of interest. Sometimes, urban centers would hand themselves over to a condottiere voluntarily, in the hope that by submitting, they would gain his assistance in ongoing feuds. In 1407, for example, Rocca Contrada (now Arcevia in the Marche) gave itself to Braccio da Montone in return for his aid against Fermo. But most of the time, condottieri were more than prepared to hold entire cities to ransom or simply to seize whatever towns took their fancy. Pandolfo III Malatesta-scion of one of the most notorious mercenary houses of all-was among the worst in this regard. Taking a break from his campaigns on behalf of Venice in the early years of the century, Pandolfo seized the papal towns of Narni and Todi and rampaged happily through Como, Brescia, and Bergamo over the next decades with the express intention of carving out a little empire of his own on his employers' doorstep. Similarly, in the confusion that reigned after the death of Duke Filippo Maria Visconti of Milan in 1447, Francesco Sforza did not hesitate to take the Milanese city of Pavia for himself, even though he was nominally the captain general of Milan. Nothing was sacred.

But most of all, the increasingly political autonomy of fifteenthcentury condottieri predisposed them toward coups, conspiracies, and the most brutal acts of murder. Although some, like Bartolomeo Colleoni and Erasmo da Narni, were unusually decent sorts in this regard, it was certainly not unknown for condottieri to hack down anyone who stood between them and their dreams of grandeur. After the death of his erstwhile patron, Francesco Sforza not only took Pavia but also turned against the short-lived Golden Ambrosian Republic, sided with Venice, and forced Milan to acclaim him duke. Those who had opposed him were immediately rounded up and executed, their heads put on display on spikes on the Broletto Nuovo as a grisly warning to anyone who thought about getting in Francesco's way.

To say that ambitious, independent-minded, and politically aware condotticri were prepared to butcher their way to power is, however, to tell only half the story. More often than not, they acknowledged no bonds of loyalty whatsoever, even where those bonds were grounded in blood. A surprising number of condottieri killed, captured, fought, or usurped members of their own families in the most coldhearted manner imaginable. Taddeo Manfredi (1431–ca. 1486), lord of Imola, was thought very mild merely for fighting a decades-long war against his uncle Astorre II Manfredi, who happened to control neighboring Faenza. Only a few years earlier, Pino I Ordelaffi (ca. 1356-1402) had seized power in Forlì after usurping and imprisoning his uncle Sinibaldo, and was later to poison his cousin Giovanni for similar ends. Worse still was Oliverotto da Fermo (1475–1502), who was to be held up as the paradigm of evil by Machiavelli. Unable to brook even the slightest restraint on his ambition, Oliverotto felt that it was "servile" to take orders from anyone, least of all from his maternal uncle Giovanni Fogliani, who was then in control of Fermo, albeit in a benign and protective capacity. As Machiavelli recorded, after returning to his native city from campaigning,

Oliverotto prepared a formal banquet to which he invited Giovanni Fogliani and the leading citizens of Fermo. After they had finished eating and all the other entertainment usual at such banquets was done with, Oliverotto artfully started to touch on subjects of grave importance . . . When Giovanni and the others began to discuss these subjects in turn, he got to his feet all of a sudden, saying that these were things to be spoken of somewhere more private, and he withdrew to another room, followed by Giovanni and all the other citizens. And no sooner were they seated than soldiers appeared from hidden recesses, and killed Giovanni and all the others. After this slaughter, Oliverotto mounted his horse, rode through the town, and laid siege to the palace of the governing council; consequently they were frightened into obeying him and into setting up a government of which he made himself the prince.

Federico da Montefeltro's supposed involvement in the assassination of his half brother was remarkable only in that he seems to have taken the trouble to employ a little subtlety.

Cruelty and murder in the service of broader political ends were one thing; an almost sadistic viciousness was quite another. And it seemed that mercenary captains' propensity for violence and brutality grew in proportion to their independence and military strength. Giovanni Bentivoglio (1443–1508), tyrant of Bologna, for example, earned notoriety for torturing and murdering the astrologer Luca Gaurico simply for giving an unfavorable prophecy, while his contemporary Everso II degli Anguillara (d. 1464) was "blasphemous and cruel and could kill a man as easily as he could a sheep." Indeed, Everso

raped [the] wives and daughters [of his subjects] in his palace; he constantly indulged in adultery and fornication and was even accused of incest, as if the chastity of his own daughters meant nothing. He often flogged his sons and threatened them with his sword.

Even worse was Braccio da Montone, whom Michael Mallett has rightly acclaimed as one of the two greatest condottieri of the period. Though he thought Braccio "pleasant and charming in conversation," Pius II observed that "in his heart, he was cruel":

He would laugh as he ordered men to be tortured and racked by the most excruciating torments, and he took pleasure in hurling his wretched victims off the tops of towers. At Spoleto, when a messenger brought him a hostile letter, he had him flung headlong from a high bridge. In Assisi, he pitched three men off the high tower in the piazza. When eighteen friars in the convent of the Minorites dared to oppose him, he had their testicles beaten to a pulp on an anvil.

Federico da Montefeltro might not have been so inventively savage, but he was certainly typical of fifteenth-century condottieri in concealing a very unpleasant nature behind his public persona. An illegitimate son, his path to power in Urbino had been paved with violence. When, in 1444, his younger half brother, Oddantonio, was unexpectedly assassinated by an angry mob, the twenty-two-year-old Federico immediately became count. Of course, he claimed that he had nothing to do with the plot. But there was no denying the fact that he happened to be waiting outside the city with a posse of soldiers at just the right moment to step quickly and easily into Oddantonio's still-warm shoes. Federico's bloody fingerprints were all over the affair, yet he does not appear to have been troubled by any pangs of guilt.

Not content with mere fratricide, Federico was among the most underhanded, backstabbing men of the age. Though charming to a fault, he lived and breathed treachery and never seems to have thought twice about spying, poisoning, and murder. The most dramatic example of his amorality is provided by his betrayal of some of his closest friends and allies. Despite his earlier collusion with Cosimo de' Medici, Federico conspired with Pope Sixtus IV to aid the Pazzi family in killing Cosimo's grandson Lorenzo and seizing control of Florence in 1478. Corresponding with his network of spies and cutthroats around Italy using a secret (and only recently deciphered) code, Federico arranged to maneuver some six hundred heavily armed troops outside Florence, ready to storm in as soon as the Medici had been given the coup de grâce. It was more by a stroke of luck than as a result of failure in the planning that Lorenzo de' Medici escaped with his life. But when confronted with his treacherous role in the conspiracy, Federico simply shrugged once again. For him, a condottiere could not afford to have friends. He may have lived by the sword, but he wasn't going to die by it or let the deaths of others trouble him too much. And this was precisely what he was trying to conceal with Berruguete's portrait.

The Ugly: Mercenaries on the Edge of Madness

If condottieri like Sir John Hawkwood and Federico da Montefeltro were bad, Sigismondo Pandolfo Malatesta was the paradigm of all that was truly dreadful about the Renaissance mercenary. He pushed the boundaries further than anyone else and was able to do so by virtue of the interplay between the peculiar balance of power in Renaissance Italy and his own unique psychology.

The changing character of fifteenth-century warfare had produced a generation of unusually determined and dangerous condottieri. With large, highly trained, and well-equipped armies at their disposal, they had not only become invaluable to the conduct of war but had also emerged as disproportionately important players on the political scene. These same developments had exacerbated the darker side of the mercenary generals' personalities. They possessed titles and land in abundance, which spurred their ambitious and acquisitive natures to new extremes. The greater the prizes were, the more violent and ruthless they became. At best, they were supercharged bandits, plundering, cheating, and extorting at will, and, at worst, they were cruel tyrants, given to conspiracies, poisoning, and murder.

There were, however, limits to how far most condottieri could go. Federico da Montefeltro and his ilk may have been uncompromising and savage, but they were businessmen first and foremost. They knew that too much wanton slaughter was bad for business, and while they could take advantage of Italy's fractious political condition to a certain extent, there was only so much that the other players would accept. There was, in other words, a brake holding back the mercenary juggernaut.

It was, after all, because mercenary generals knew they couldn't hope to live, thrive, and survive as murderous psychopaths that they sought to project an image of ancient valor, Christian virtue, and cultured refinement. And it was because the cities knew they had to find some way of working with these most dangerous of men that they occasionally hailed them as heroes, as a matter of artistic realpolitik.

This arrangement hinged on the condottieri's willingness to respect the balance of political power and to employ a measure of sound judgment. Restraint and, by extension, familiar patterns of patronage depended on their being held in check by more powerful political actors, and on their keeping a good grip on their sanity. Sigismondo Pandolfo Malatesta, however, was a law unto himself.

Fighting was in Sigismondo's blood: he came from a long line of condottieri. Although they could trace their origins as far back as the eighth century, his family had first risen to prominence in 1239, when his great-great-grandfather Malatesta da Verucchio had become podestà of Rimini. Since that moment the family's fortunes had relied exclusively on their peculiar brilliance as mercenary generals. War became the family's profession. They were all brave, resourceful, and ambitious and, by dint of a careful program of territorial acquisition, had managed to gain a secure hold of Rimini, Pesaro, Fano, Cesena, Fossombrone, and Cervia by the time Sigismondo was born in 1417.

Although highly respected as commanders, the Malatesta were no strangers to the violence and cruelty that tended to characterize Renaissance condottieri. Dante's account of Giovanni Malatesta's murder of his wife and brother in 1285 has already been mentioned, but it would be wrong to assume that this was anything out of the ordinary. Being a member of the Malatesta family was like living in a cross between a soap opera and *The Texas Chainsaw Massacre*. Malatesta II Malatesta (1299–1364) was known as Guastafamiglia (the family destroyer) for a very good reason. He locked up and deposed his cousin Ferrantino; he imprisoned and murdered Ferrantino's son, Malatestino Novello; and just to be sure, he even had Ferrantino's grandson Guido consigned to the same fate. Before he died, however, Malatestino Novello (d. 1335) had killed his uncle Ramberto, who had himself slaughtered his cousin Uberto.

The illegitimate son of the crusading *capitano generale* of the Venetian army, Pandolfo III Malatesta, Sigismondo was initiated into the arts of war from an early age. He took up arms for the first time when he was only thirteen and showed his precocious brilliance by leading a successful defense of Rimini against his kinsman Carlo II Malatesta before assuming the lordship of the city two years later. Swiftly launching himself into a career as a professional condottiere, he was rapidly recognized as the most outstanding member of an already remarkable family of mercenary generals. Throughout the 1430s, the young man augmented his growing reputation by waging a series of campaigns in the service of the papacy and Francesco Sforza, and even though there were a few minor slips here and there (such as his rather foolhardy seizure of papal Cervia), he looked set for a dazzling career.

Even in his youth, however, there were signs that military brilliance was not all that Sigismondo had inherited from his warlike forebears. The viciousness of the Malatesta had had a rather worrying effect on his state of mind. Although it is easy to dismiss Pius II's accusations of incest and murder as hyperbole, the pope's claims were grounded in fact. Still in his teens, Sigismondo married his own niece Ginevra d'Este in 1434, and while few doubted either her beauty or the brilliance of the match, the choice of so close a relative for his bride was greeted with surprise. By 1440, the twenty-one-year-old Ginevra was dead, leading to speculation that Sigismondo, having grown bored, had had her poisoned. It set the tone for what was to follow. His second wife, Polissena Sforza-the illegitimate daughter of Francesco-fared no better. After seven years of marriage, she, too, died in mysterious circumstances in 1449, not long after Sigismondo had begun an affair with the twelveyear-old Isotta degli Atti. It might all have been a coincidence, but it looked as if Sigismondo's temper were ruled not by good sense but by compulsive randiness and supremely reckless egotism.

Instability in Sigismondo's private life was matched by a growing intemperance in military affairs. While his brilliance as a commander was undiminished, it became clear he was hotheaded, untrustworthy, and totally self-obsessed.

In part, this was a consequence of his brazen, even arrogant, efforts at territorial acquisition. Longing to dominate the Romagna, Sigismondo set his sights on Urbino, of which Oddantonio da Montefeltro had become count in 1443. Taking advantage of the fifteen-year-old Oddantonio's political inexperience and limited financial resources, Sigismondo managed to persuade the naive adolescent not only that he was a true friend but also that he would protect Urbino from its Milanese enemies. It was obvious that Sigismondo was planning to make Oddantonio totally dependent on him before annexing Urbino for himself. It was a classic condottiere plot. But Sigismondo was simply too impulsive and overconfident to carry it off discreetly. He made almost no effort to conceal his scheme, and Federico da Montefeltro, Oddantonio's elder half brother, who had his own plans for Urbino, soon found out he was in danger of being beaten to the prize. In the wake of Oddantonio's suspiciously convenient assassination the following year, Federico wasted no time in seizing control of the city and foiling Sigismondo's plan. As a consequence, the Wolf had not merely lost Urbino but had also made an implacable enemy out of Federico da Montefeltro, a man with whom few would ever pick a fight. Over the next fourteen years, the two condottieri would engage in a series of bitterly fought campaigns against each other that did much to destabilize the political situation in Romagna and the Marche.

In part, however, Sigismondo's capacity for making enemies was simply the result of his being the most treacherous condottiere of the entire Renaissance. He seemed almost to enjoy betraying people simply for the fun of it, as if war itself were not entertainment enough for his perversely sadomasochistic approach to politics. As Pius II succinctly put it:

He broke faith with King Alfonso of Sicily and his son Ferrante; with Francesco, duke of Milan; and with the Venetians, the Florentines and the Sienese. Repeatedly he deceived the Church of Rome. Finally, when there was no one left in Italy for him to betray, he went over to the French who, out of hatred of Pope Pius, pursued an alliance with him; but they fared no better than the other princes. Once, when asked by his subjects if he would not at last retire to a peaceful life and thereby give some relief to the country which he had so often subjected to war, he replied, "Be off, and don't lose your nerve! As long as I'm alive you'll never have peace!"

Though he may have laughed with characteristic cockiness at wrongfooting his employers, Sigismondo had alienated every one of Italy's major powers and had turned some of the greatest condottieri of the age into his bitterest foes. But so great was his sense of self-importance that even this didn't seem to trouble him. The one opportunity he had to correct some of his errors—in Florence, in April 1459—was squandered, apparently just for the fun of it. Pius II's attempts to repair Sigismondo's relations with Alfonso of Aragon were contemptuously rejected, and abuse was heaped on all concerned. And when peace was finally established in northern Italy in 1454, he didn't seem to care that he was deliberately excluded from the terms of the Peace of Lodi. He seemed determined to be the scourge of all and the friend to none.

Sigismondo's behavior only got worse, and he seemed to delight in his outrages more with each passing day. Only a few years later, Pius II claimed that he

was a slave to avarice, prepared not only to plunder but to steal, so unbridled in his lust that he violated both his daughters and his sons-in-law. As a boy, he often played the bride; later, he who had so often taken the woman's part used other men like whores. No marriage was sacred to him. He raped Christian nuns and Jewish ladies alike; boys and girls who resisted him he would either murder or torture in terrible ways. Often, if he stood godfather to a child, he would compel the mother to commit adultery, then have her husband killed. He surpassed every barbarian in cruelty; his bloody hands wreaked dire torments on innocent and guilty alike ... He oppressed the poor and plundered the rich; neither widows nor orphans were spared. Under his tyranny no one was safe. A man blessed with wealth or a beautiful wife or handsome children would find himself facing a trumped-up criminal charge. He hated priests and despised religion ... Before taking Isotta for his mistress, he had two wives whom he killed in succession, using violence or poison . . . Once, not far from Verona, he met a noble lady on her way from Germany to Rome for the jubilee; he raped her (for she was very beautiful) and left her there in the road, wounded from her struggles and dripping with blood ... Truth was seldom in his mouth. He was a past master of pretense and dissimulation, a perjurer and a cheat.

That Pius II subsequently declared a crusade against him and had his effigy publicly burned in Rome only appears to have added to his entertainment.

At some level, Sigismondo was unhinged. He had absolutely no sense of restraint and pushed the already excessive habits of mercenary generals to extremes. He needed neither rhyme nor reason for his actions; it didn't matter that his behavior was outrageous, foolhardy, and dangerous. Nothing, he thought, could touch him.

It was, however, precisely because of Sigismondo's almost insane determination to pursue the worse aspects of the mercenary life further than anyone else had ever done that he was to transform himself into such a pioneering patron of the arts. Undoubtedly one of the most spectacular soldier-patrons of the period, Sigismondo did things his way. Just as he was determined to out-mercenary other mercenaries in war and politics, so he adopted and reconfigured familiar patterns of condottiere patronage to meet his own, rather extreme needs. Like other soldiers of fortune, he was aware that humanistically inspired art could address social and moral questions attendant on mercenary existence and could also play a major part in creating a "court" culture: it was just that he understood these things rather differently from everyone else. Rather than being troubled by a sense of sin, Sigismondo saw violence and war as virtues; rather than being ashamed of fighting for money, he saw himself as a semidivine hero; and rather than being interested in concealing his shocking offenses with a veneer of cultured respectability, he crafted an early version of a personality cult for himself that recognized no fault.

The architecture and decoration of the Tempio Malatestiano in Rimini are the most revealing illustration of Sigismondo's idiosyncratic approach to patronage. The building itself is unusually eloquent. Designed by Leon Battista Alberti, the "temple" was widely regarded as "one of the foremost churches in Italy" and initially appears to be an edifice "erected at . . . magnanimous expense" for the greater glory of God. But it was conceived principally as a shrine to Sigismondo himself. Instead of echoing the architectural devices common to other Italian churches, Sigismondo had Alberti use the triumphal arches of the emperors Constantine and Augustus as his models. Knowing that such arches had only been erected to commemorate a toweringly important victory in battle by a grateful Roman Senate, Sigismondo intended not to present himself as like ancient heroes but to indicate that he was, in fact, the living embodiment of a classical triumphator, the possessor of imperium, and the heir to the military achievements of the greatest generals in history. He wasn't making up for a perceived flaw in his choice of career but was actually celebrating his prowess as a condottiere without the least hint of shame. Merely by entering the Tempio Malatestiano, a worshipper was obliged to recognize the triumphal magnificence of his

soldierly genius, and thus to do homage to his status as an ideal, nearmythical commander.

The interior is no less surprising. Quite apart from the imposing tombs Sigismondo erected in his own honor and in memory of his wives, the fresco he commissioned from Piero della Francesca in 1451, which was painted on the interior wall of the facade, is of particular note (Fig. 29). In this fresco, Sigismondo is depicted kneeling in prayer before the seated figure of Saint Sigismund and is accompanied by a reclining hound and a stylized image of his eponymous castle. Once again, this work appears to continue themes of devotion and piety found in pieces of art commissioned by other condottieri; but once more, Sigismondo seems to have subverted the normal pattern of doing things in such a way that the fresco's superficial appearance belies its hidden meaning.

The most immediately striking feature of the work is that Sigismondo is doing homage not to the Virgin Mary or to Christ himself (as his rival was to be shown doing in the Montefeltro Altarpiece) but to a saint. That he should have venerated saints was, in itself, not so very remarkable-the Medici, for example, were fostering the cult of their own "family" saints at precisely the same time—but both the saint in question and the manner in which he is depicted are unusual. Here, Sigismondo is praying to Saint Sigismund, a figure with more than a few interesting characteristics. A comparatively uncommon object of veneration in northern Italy, Sigismund was the patron saint of soldiers, renowned for showing courage and fortitude in the face of overwhelming odds in the early sixth century. What was more, Sigismund had a rather peculiar history for a saint. Although he later abandoned the throne of Burgundy for a monastic life and was eventually martyred for his faith, he had had his own son strangled for insulting his wife and opposing his rule. No less intriguing is his appearance. The thin, flat halo above his hat notwithstanding, Sigismund doesn't look much like a saint. Seated on a throne and carrying an orb and scepter, he has the bearing of a king but none of the typical attributes of a holy man. In fact, the figure of Saint Sigismund is modeled directly on extant portraits of the contemporary Holy Roman Emperor Sigismund, whom Sigismondo Pandolfo Malatesta had served and by whom he had been knighted. The iconographical effect is significant. On the one hand, Sigismondo is unapologetically venerating warlike rulership as a

good in itself. On the other hand, Sigismondo wished to be seen doing homage to the Holy Roman Emperor. This was a pointed political dig. Although Sigismondo's title to Rimini officially derived from the pope, he is here showing his absolute allegiance to an entirely different source of higher authority. The fact that Sigismondo, Saint Sigismund, and the emperor Sigismond all shared the same name serves to heighten the sense of identification among the three figures: Sigismondo wanted to be seen not merely as a devotee of a saint and an emperor but also as the equivalent of both. He was the warlike prince, the paradigm of courage, unjustly persecuted for his campaigns, the perfect ruler, the summit of earthly authority. A pious Christian he was not; indeed, there's no sense in which the fresco sought to overcome—or even acknowledge—the immorality of Sigismondo's actions.

Strange though it may seem, Sigismondo's portrait in Gozzoli's Journey of the Magi to Bethlehem was conceived in the same vein. Few were more conscious of Sigismondo's treacherous, callous, and dangerous character than Cosimo de' Medici, but all of these things help to explain why the wily old banker wanted his portrait included in the fresco. Cosimo's motivations were very similar to those felt by the Florentine Signoria when deciding to commission an equestrian monument to Sir John Hawkwood, although once again the reasons were subtly different as a consequence of Sigismondo's distinctive character. It wasn't just that Cosimo wanted to signal his friendship with the Wolf of Rimini to his enemies. He wanted to do a lot more. Back in 1444. Sigismondo had been employed by Alfonso V of Aragon to lead his campaign against Florence and had been paid a hefty sum of money for his services. The city had had good reason to be afraid. But for reasons best known to himself, Sigismondo had suddenly switched sides. As Pius II later recorded, "There is no doubt that Sigismondo's perfidy was the salvation of the Florentine cause." Cosimo, who never forgot a favor, was thankful that the Wolf of Rimini was such a fantastically talented backstabber and wanted him commemorated. But Cosimo was also deeply afraid of Sigismondo. Although he had been beaten back by his rivals after the Peace of Lodi, he was still a dangerous and unpredictable figure capable of wreaking havoc in Tuscany should the whim so take him. What was more, Sigismondo's ongoing feud with Federico da Montefeltro (who had served both Florence and Milan in the 1440s and had entered the service of the Church in 1458) risked spilling over into

Florentine territory, with potentially devastating consequences. Given Sigismondo's volatile and vicious temper, it was essential that Cosimo maintain good relations, and by including his portrait in Gozzoli's fresco, the old banker was able to give a clear signal that he wanted to be shoulder to shoulder with the Wolf of Rimini for the foreseeable future. Just as Sigismondo celebrated his own excesses as a condottiere, so Gozzoli's fresco was a vivid testimony to the awe and dread he inspired.

THE UNHOLY CITY

9

T WOULD HAVE been easy for Galeazzo Maria Sforza to miss the last, and most important, of the figures in Gozzoli's *Journey of the Magi to Bethlehem*. Hidden deep in the crowd of faces behind Cosimo de' Medici, he was almost lost in the hubbub of the procession. But there, way back in the third row, was a dour-faced cardinal in an embroidered red coif peeking out from behind the portraits of Plethon and Gozzoli. His head slightly bowed and his features scrunched up into a look of discomfort, he seems to be doing his best to escape the viewer's gaze. Yet it would have been impossible to mistake the inimitable, pudgy features of Aeneas Silvius Piccolomini.

When Cosimo de' Medici had commissioned Gozzoli to paint the frescoes in his family chapel, there had been good cause for him to have insisted on the inclusion of Aeneas's portrait. An affable and generousminded cardinal, he richly deserved a place among the galaxy of influential scholars and artists depicted in the Magi's procession. He was one of the Church's rising stars. A trained humanist, he was a master of Latin composition and, having been crowned poet laureate in 1442, was already the author of a raft of works that covered every genre, from geography and pedagogy to history and drama. A connoisseur and patron of the arts, he was dazzlingly clever, fashionably well-read, and up to date with all the latest trends in visual and literary culture. In terms of sheer ability, he towered over his colleagues in the Curia. He was just the sort of intellectual superstar that Cosimo wanted to be seen to know, and although not exactly flattering, the portrait was still a delicate, well-intentioned compliment.

Recent events had, however, transformed the fresco into something more. On August 19, 1458, the portly, middle-aged Aeneas had been elected pope and had taken the name Pius II to signal his sense of Christian devotion. Gozzoli's portrait had unexpectedly become not only an affirmation of the new pope's enlightened sophistication but also a subtle acknowledgment of the cultural might of the Renaissance papacy.

Just eight days after Galeazzo Maria Sforza would have been welcomed into the Palazzo Medici Riccardi, on April 25, 1459, Pius II arrived in Florence for a short stopover on his way to Mantua. When he saw the pontiff in the flesh, however, the young Milanese count would have encountered a very different personality from that suggested by Gozzoli's portrait.

Far from being an upright, saintly figure, Pius was an arrogant mountain of human flesh. Massively overweight and crippled by gout, he was borne aloft on an enormous golden throne, surrounded by the very worst kinds of mercenaries Italy had to offer. His behavior was far from godly. Stopping briefly at the San Gallo gate, Pius forced the "noble lords and princes of the Romagna"—including Galeazzo Maria (who had to stand on tiptoes even to reach the papal chair)—to carry him into the city on their shoulders. Struggling under the weight, they grumbled resentfully the whole way. Sigismondo Pandolfo Malatesta, in particular, was furious. "See how we lords of cities have sunk!" he muttered under his breath.

Things were no better after Pius had been hoisted into the city. Although Cosimo de' Medici would have been hoping to solidify his bank's well-established relationship with the papacy, the main purpose of the pontiff's visit was to heal a long-standing rift between Sigismondo Pandolfo Malatesta, King Ferrante of Sicily, and Federico da Montefeltro. But while it would have been the perfect opportunity for the new pope to show off his credentials as a Christian peacemaker, he displayed none of the meekness or mildness that might have been expected of a servant of God. Instead, even Pius's own memoirs reveal him to have acted as a hotheaded, self-obsessed power broker. At the key meeting, he shouted everyone down, insulted Sigismondo, and washed his hands of the whole affair, before announcing he alone was capable of serving God's will and the people's best interests.

Pius was no better behaved at the cultural events that had been laid on for his entertainment. Although he appreciated the artistic spectacles for which Florence was famous and enjoyed conversing with some of its most learned citizens, he was more interested in the city's more earthly pleasures. Leering lecherously at the dances and banquets held in his honor, he passed numerous lascivious remarks about the beauty of Florence's womenfolk and gave himself wholeheartedly to the festivities. He delighted in a joust held in the Piazza Santa Croce at which "much more wine was drunk than blood spilled," and was impressed that Florence's lions had been brought out to tear some other animals to pieces for his amusement. But he showed not a trace of gratitude. Even though some 14,000 florins had been lavished on entertaining the pontiff, he complained bitterly that not enough had been spent and criticized the Florentines for their "tightfistedness." It was no surprise that Cosimo de' Medici decided to stay at home rather than risk the pope's dissatisfaction.

Paradoxical though it may seem, both Gozzoli's portrait and the overbearing personality of Pope Pius II are a potent reflection of the hidden character of the papacy's involvement with the arts. In the personality and career of Aeneas Silvius Piccolomini was captured the essence not only of the Renaissance papacy but also of the papal court's role as one of the powerhouses of Renaissance patronage. As the details of Aeneas's life are unpacked, what initially seems to be a tension between faith, cultural sophistication, and worldly excess resolves itself into a clear and coherent whole. But as this most remarkable of churchmen shows, the twisted and unexpected story of the papal court's contribution to the painting, sculpture, and architecture of the period was underpinned less by a disinterested and holy interest in learning than by a world of towering personal ambition, lusty passions, and aggressive power politics.

Absent Patrons

Aeneas Silvius Piccolomini was born on October 18, 1405, into an impoverished but respectable family of exiled Sienese nobles. Growing up in the little village of Corsignano in the Val d'Orcia, he lived in a world bounded by religion. Every Sunday, the family would attend Mass in the little church of San Francesco and listen attentively to the priest explaining the rudiments of the faith from the pulpit, and they dutifully offered up prayers for the pope's well-being. It was also a world in which religion, learning, and culture went hand in hand. Like his father and grandfather before him, Aeneas learned the rudiments of Latin grammar alongside his prayers, and while he was still playing in the hay, he was made aware that the classics were to be read as a vital aid to the pursuit of Christian morality. Later, while studying law at the University of Siena and perfecting his humanistic learning in Florence, he found the teachings of Christ glorified in the writings of men like Coluccio Salutati and celebrated in the artistic achievements of the age. Offering his devotions in the churches of these two great cities, he looked up to see the faith he cherished immortalized by artists such as Giotto and Duccio, Ghiberti and Masaccio, and nurtured by patrons such as the Medici, the Brancacci, and the Strozzi.

But while the young Aeneas would have appreciated the close bond between religion, art, and humanistic learning, he would have been aware that something was missing. New churches were, of course, springing up all over Italy; donations and bequests to ecclesiastical foundations ensured that worshippers were surrounded by frescoes and altarpieces of unparalleled beauty; and the tombs of bishops, cardinals, and pontiffs gave material form to the institution of the Church itself. But curiously enough, there was very little to suggest that the popes and cardinals engaged actively in artistic patronage. In Rome, this was even more pronounced. There was almost nothing that would have revealed the papal court's connection with painting, sculpture, and architecture. Indeed, a visitor to the Eternal City during this period of Aeneas's life would scarcely have realized that the papacy had any involvement in the arts at all.

There was a void at the heart of artistic patronage in early Renaissance Italy. Whereas everyone else was eagerly seizing the opportunity to buy into the culture business, the papal court seemed to be allowing the juggernaut of Renaissance culture to pass it by. In a sense, this was not altogether surprising. The papacy's apparent disinterest in Italian art stemmed from the fact that for much of the early Renaissance it was either absent or consumed by chaos.

Since 1309, the popes had resided not at Rome but in Avignon, in southern France. It was only meant to be a temporary move, but having established itself in the city, the papacy found it couldn't leave. Quite apart from the French crown's increasing influence over the papal court and the violent conflict between the popes and the Holy Roman Empire, Rome itself had become too hot to handle. Dominated by belligerent aristocratic families like the Orsini and the Colonna, the city was given over to street battles and Mafia-like intimidation. It was a frightful state of affairs. As an anonymous Roman chronicler observed in the middle of the century, The city of Rome was in agony ... men fought every day; robbers were everywhere; nuns were insulted; there was no refuge; little girls were assaulted and led away to dishonour; wives were taken from their husbands in their very beds; farmhands going out to work were robbed; ... pilgrims who had come to the holy churches for the good of their souls were not protected, but were murdered and robbed ... No justice, no law; there was no longer any escape; everyone was dying; the man who was strongest with the sword was most in the right.

Even had it been possible for them to free themselves from the domination of the French crown and resolve their differences with the Empire, Rome was simply too dangerous for the popes to contemplate leaving their "Babylonian Captivity" in Avignon.

After more than six decades in exile, however, Pope Gregory XI at last decided to return the Curia to Rome in 1376. But this only made things worse. After Gregory's death in 1378, the College of Cardinals was under pressure to elect an Italian successor. Fearing the anger of the mob that had gathered outside the Vatican and unable to agree on a candidate drawn from their own ranks, they chose an obscure Neapolitan archbishop as Pope Urban VI. A quiet, ascetic man, he seemed an ideal choice. But Urban turned out to suffer from a dangerously crazy persecution complex. Driven by an almost pathological hatred, he accused the cardinals who had elected him of corruption, moral degeneracy, and treachery. Six of them were locked up in the dungeons of Nocera, where they were tortured mercilessly. Urban even developed a fondness for sitting outside the cells so that he could listen to their screams of agony as he read his breviary.

The surviving cardinals had had enough. Unable to tolerate Urban's behavior any longer, they left for Avignon, electing a rival pope as they went. Urban had split the Church in two. It would remain bitterly divided for the next forty years.

Aeneas was brought up as a member of a Church consumed by chaos and disorder. With two (and, for a brief time, even three) popes vying for supremacy, Christendom as a whole seemed to be at war with itself. With popes and antipopes competing for control of the Church, all of Europe divided into different "obediences," each owing its allegiance to a different pontiff. Each side stubbornly defended its own legitimacy, and no one was prepared to back down.

What was to become known as the Great Schism was ended only by a series of general councils of the Church. But even this caused massive problems. In the wake of the Schism, a group of churchmen known as conciliarists had come to believe that it was simply too dangerous to give the pope too much power. Instead, they wanted a kind of ecclesiastical parliament, convened at regular intervals, to have the final say in matters of great importance. The problem was that this was the exact opposite of what the popes wanted. After the Schism had been healed in 1417, Martin V and his successors wanted to take up the reins of power without any interference, least of all from a council filled with rustic clerics from all over Europe. Mutual loathing between the two camps threw the papacy into yet another bout of internecine warfare.

The implications for the cultural life of the papal court were significant. It would, of course, be wrong to think that the papacy existed in a cultural vacuum during the years of exile and chaos between the Babylonian Captivity and the ascendancy of conciliarism. The popes were not insensitive to the radical changes occurring in early Renaissance art and thought. The papal court continued to attract prominent humanists eager for employment and preferment, and a number of Italian artists also found a place in the pontifical household. Petrarch, for example, spent the greater part of his life in or around Avignon and received several lucrative benefices, while, later, Leonardo Bruni served as a papal secretary for almost ten continuous years between 1405 and 1415. So, too, Simone Martini was an important presence in Avignon, and artists such as Matteo Giovanetti gave the flamboyant frescoes of the papal palace a distinctly "Italian" feel.

The papal court was nevertheless unable to exert anything more than a minimal and indirect impact on art in Italy at the time. It had neither the resources nor the inclination to engage in the sort of patronage practiced by merchant bankers and *signori*. Costly wars, cash-flow problems, exile, and division had left the papacy incapable of spending large sums of money beautifying churches or palaces that were either too distant to visit or in the hands of rival claimants.

Rome, in particular, was allowed to fall into disrepair. By the third decade of the fifteenth century—at which point the conciliar move-

ment seemed to be enjoying its greatest triumphs—the city was in a pitiable condition, and humanistically minded visitors were horrified by the neglect they observed. The Florentine Cristoforo Landino pictured the ghost of Augustus weeping at the sight of the city he had built sunk to the level of a cesspit. His compatriot Vespasiano da Bisticci was horrified to see that the Forum had been given over to pasturing cows, and that the great monuments of the past were crumbling into unrecognizable ruins. Even those buildings that were central to the identity of the medieval papacy had degenerated. During this period, the Archbasilica of Saint John Lateran—the pope's official seat in Rome—burned down twice (in 1307 and 1361) and was allowed to fall into a state of complete disrepair for the first time since antiquity. Far from seeing the city as a rival to Florence, Milan, or Venice, the diarist Stefano Infessura saw Rome as a hotbed of theft and murder in which the arts had long since decayed.

OUT OF THE WILDERNESS

Although the papal court had spent more than a century in the cultural wilderness, things were about to change by the time Aeneas Silvius Piccolomini began to make his mark as one of the Church's rising stars.

Before even taking holy orders, Aeneas had first made a name for himself as one of the leading conciliar theorists at the Council of Basel. But despite these inauspicious beginnings, his youthful opposition to papal authority was greatly outweighed by the obvious value of his literary talents. Before long, he was drawn inextricably into the papacy's orbit. After a brief period in the service of Pope Eugenius IV, he saw his fortunes take a turn for the better with the election of his old friend Tommaso Parentucelli da Sarzana as Pope Nicholas V in 1447. Appointed bishop of Trieste in the same year, Aeneas was transferred to the diocese of Siena in 1451 and entrusted with no end of important missions. He was given a cardinal's hat in 1456.

Aeneas's rapid ascent up the ecclesiastical ladder coincided with the reinvigoration of the papal court. In political, geographical, and financial terms, the papacy was finally ascending to a position of greater stability and strength. Despite some lingering difficulties, Eugenius IV had succeeded in stamping out the remaining vestiges of the conciliar movement, and the pope was at last reestablished as the unchallenged head of the Church. This success had allowed Eugenius to restore the Curia to Rome in 1445, and the fact that the papacy was once again resident in the Eternal City allowed the pontiffs to make good some of the damage that had been done to the nuts and bolts of papal governance. Unhindered by the disputes and divisions of the past and firmly established in Rome, Nicholas V and his successors were able to take active control of their lands in central Italy, and could set the recently refined papal bureaucracy to the task of regularizing papal incomes for the first time since 1308.

As he spent more and more time in Rome as a result of his rising status, Aeneas would have noted that these shifts in the papacy's condition were having a profound effect on the Curia's relationship both with the urban environment and with the arts. Rome was, in fact, a city in the grip of transformation. Well-known for "his learning and intellectual gifts," Nicholas V was acutely conscious that the years of chaos and exile had badly damaged the Church's reputation and might even have dented the piety of ordinary believers. Although the end of the Schism and the collapse of conciliarism had left the papacy in a stronger position than for almost a century and a half, it was clear that if the Church was to make up for the damage that had been done, something more would be required. As it stood, the pitiable state of early-fifteenthcentury Rome was hardly well suited to restoring public confidence in the faith. The narrow, dirty streets and tumbledown churches seemed a painful reminder of the bitter rivalries and ungodly squabbles that had marred the Church in the past. They seemed to radiate a sense of dejection and defeat. All that had to change. As the seat of the papacy and the epicenter of the Catholic world, Rome, Nicholas believed, should be a glittering emblem of everything the universal Church stood for, capable of instilling a fervent belief in the tenets of the Christian religion and a powerful respect for the Holy See. As he was reputed to have said on his deathbed.

Only the learned who have studied the origin and development of the authority of the Roman Church can really understand its greatness. Thus, to create solid and stable convictions in the minds of the uncultured masses, there must be something which appeals to the eye; a popular faith, sustained only on doctrines, will never be anything but feeble and vacillating. But if the authority of the Holy See were visibly displayed in majestic buildings, imperishable memorials and witnesses seemingly planted by the hand of God himself, belief would grow and strengthen from one generation to another, and all the world would accept and revere it. Noble edifices combining taste and beauty with imposing proportions would immensely conduce to the exaltation of the chair of St. Peter.

The truth of Christian teaching and the goodness of Christ's earthly vicar were to be encapsulated in beauty. Literature, music, and, above all, painting, sculpture, and architecture were to be visible illustrations of all that was meritorious about the Church and its head. The papacy's newfound wealth was to be invested in the patronage of the arts.

Some tentative steps in the right direction had already been taken by Nicholas's predecessors. In 1427, Gentile da Fabriano and Pisanello had been commissioned to adorn the nave of Saint John Lateran with scenes depicting the life of Saint John the Baptist, and in the following year Masaccio and Masolino completed an altarpiece for Santa Maria Maggiore for the family of Pope Martin V. At around the same time, Cardinal Giordano Orsini had become the focal point for a circle of humanists whose members included Lorenzo Valla, Leonardo Bruni, and Poggio Bracciolini, and had built an indoor theater (the first of its kind) in his palace decorated with frescoes of famous men by Masolino and Paolo Uccello. A little later, Eugenius IV even contracted Filarete to cast a set of new bronze doors for Saint Peter's Basilica. But while this was all very well in its way, it had been very piecemeal and uncertain. Something much more dramatic was needed, and now that the papacy could draw on the resources of the Papal States, it could set its sights a little higher.

Nicholas set about transforming the crumbling ruins of Rome into towering monuments of papal splendor. The epicenter of the Christian world was to be turned into a capital worthy of its vision of Christ the King himself. Taking up residence on the Vatican hill, he completely remodeled the Apostolic Palace. A vast new wing was added to the old, medieval structure to accommodate the rapidly expanding papal household and to provide a suitably grand set of apartments in which to receive ambassadors and potentates. A massive new tower (the remains of which are still standing) was added just east of the papal apartments. Fra Angelico—widely renowned as both a brilliant artist and a devout priest—was summoned from Florence to decorate the pope's private chapel with a magnificent cycle of frescoes depicting the lives of Saints Stephen and Lawrence. The basis of the Vatican Library was laid down. And, perhaps most important, the architect Bernardo Rossellino was commissioned to draw up plans for the reconstruction of Saint Peter's Basilica.

But Nicholas's ambitions extended well beyond the Vatican. He aimed at nothing less than the wholesale renovation of the entire city. Although Aeneas noted that he began more projects than he lived to see completed, Vasari rightly observed that he was positively "turning the city upside down with all his building." The ancient Acqua Virgine aqueduct was restored to its original glory, bringing much-needed freshwater into the heart of the city and running out into a beautiful new basin in the Piazza dei Crociferi designed by Nicholas's principal architectural adviser, Leon Battista Alberti. So, too, the Borgo, running adjacent to the Vatican, was earmarked for massive renovation. Everywhere Aeneas turned, tumbledown buildings were being demolished, and fresh, imposing structures were springing up under papal patronage.

This new flurry of artistic activity was not limited to the pope himself. Where Nicholas led, his cardinals followed. As Paolo Cortesi later argued in his De cardinalatu, those whose function it was to serve as Christ's standard-bearers had an obligation to be magnificent. As princes of the Church, they were expected to shine like stars in the ecclesiastical sky, mimicking the sun-like splendor of the papacy and adding luster to the culture of the Eternal City. A palace was, of course, essential. Many cardinals from older curial families—like the Colonna and the Orsini-or from established ruling dynasties already had at least one spacious palace in the center of Rome and gladly threw themselves into embellishing their already palatial homes with the latest artistic fashions. But even newer cardinals, like Aeneas Silvius Piccolomini, were compelled to rent, borrow, or build a property commensurate with their status and to decorate it in a fashion that would inspire a suitable degree of awe and respect. Huge, imposing palaces began to spring up all over the city, with each cardinal doing his best to outdo the others in taste and grandeur. Already, Cardinal Pietro Barbo-who would later rise to the papacy as Paul II, and who was the nephew of

Eugenius IV—had enlarged and enhanced the palazzo that bears his name, possibly employing Alberti for the task. Within forty years of Nicholas V's election, dozens more would follow: Cardinal Raffaele Riario would commence the construction of what is today known as the Palazzo della Cancelleria—often said to be the first "true" Renaissance palace—Cardinal Adriano Castellesi da Corneto would commission Andrea Bregno to design the imposing Palazzo Torlonia, and Cardinal Domenico della Rovere would start work on a huge palazzo close to the Vatican itself. Every one was stacked full of classical statuary and, more important, the very latest in Renaissance art. Artists were summoned from every corner of Italy to serve cardinals hungry for their work.

The Renaissance had well and truly arrived. Despite-or rather, because of-the years of exile and chaos that had gone before, the reign of Nicholas V marked the beginning of the papacy's emergence as a powerhouse of artistic patronage. Nicholas had set the tone for all of his successors. Almost without exception, they bought into his vision of a "new Rome" and followed his lead, often on an even more ambitious scale. Determined to glorify the Church and exalt the majesty of the papacy, the popes not only added ever more extensively to the Vatican complex but also continued reshaping the face of Rome. After Aeneas's death, Sixtus IV sponsored the construction of the chapel now named in his honor (the Sistine Chapel), oversaw the completion of a new bridge across the Tiber, massively enlarged the Vatican Library, and began a new papal tradition of collecting ancient statuary. His successor, Innocent VIII, commissioned Antonio Pollaiuolo to build the Belvedere villa, while Alexander VI was to employ nearly every well-known artist of the day in beautifying the papal apartments. Most impressively of all, Sixtus IV's nephew Julius II employed Michelangelo to decorate the ceiling of the Sistine Chapel, ordered Bramante to design two huge loggias linking the Belvedere with the Apostolic Palace, and took up Nicholas V's great dream of remodeling Saint Peter's Basilica, a project that all but bankrupted his successor, Leo X.

Whereas in previous years artists had been inclined to view Rome as a cultural backwater that was best avoided, the papacy's outlook on its return to the Eternal City turned the papal court into a magnet for artistic talent. Seduced by the promise of lavish payments and attracted by the prospect of working alongside some of the leading lights of the day, painters, sculptors, and architects began flocking to Rome in droves in the hope of picking up commissions that, they hoped, would make their careers. Before long, in fact, popes and cardinals were frantically competing for their services and making increasingly forceful demands in their bid to make the city the jewel in Christendom's crown. Everyone in the Curia was desperate to have the best artists' most brilliant works, and they would do anything to guarantee their services. In the midst of completing the Sistine Chapel ceiling, for example, Michelangelo once asked the pope's permission to go back to Florence for the feast of Saint John (always the highlight of the city's year) and experienced an encounter that encapsulated the papal court's infatuation with the arts:

"Well, what about this chapel? When will it be finished?" [asked the pope].

"When I can, Holy Father," said Michelangelo.

Then the pope struck Michelangelo with a staff he was holding and repeated:

"When I can! When I can! What do you mean? I will soon *make* you finish it."

However, after Michelangelo had gone back to his house to prepare for the journey to Florence, the pope immediately sent his chamberlain, Cursio, with five hundred crowns to calm him down . . . and the chamberlain made excuses for his holiness, explaining that such treatment was meant as a favour and a mark of affection. Then Michelangelo, because he understood the pope's nature and, after all, loved him dearly, laughed it off, seeing that everything redounded to his profit and advantage and that the pope would do anything to keep his friendship.

BEYOND BELIEF

In the space of a few short years, Rome had been put on the fast track to becoming a dazzling city of culture, packed with churches and palaces that advertised the learning, sophistication, and confidence of a rejuvenated papal court. Walking around the streets of Rome and gazing up at the buildings, frescoes, and altarpieces that were taking shape around him, Aeneas Silvius Piccolomini would have felt himself in the presence of a fitting monument to the faith he cherished. Rivaling the artistic wonders of Florence, Milan, and Venice, Rome had finally begun to radiate a sense of the Church's worthiness and of the godliness of its servants.

Yet while the new Rome taking shape around Aeneas was intended to display the strength and vigor of the newly rejuvenated Church, the massive growth of artistic patronage at the papal court wasn't just about faith. Beneath the surface of every fresco and behind the facade of every palace lurked an altogether different side to the papacy's interest in the arts.

Although Nicholas V's deathbed statement presented the pope as the spiritual head of the Christian faith, the reality was quite different: the pontiff was also a political leader. For centuries, the papacy had laid claim to sovereignty over huge tracts of land in the middle of the Italian peninsula that were collectively known as the Patrimony of St. Peter (or the Papal States for short) and had long asserted its supremacy over the Holy Roman Emperor himself. During the Babylonian Captivity and the Schism, these claims had existed only in the realm of theory. Impeded either by a distance of several hundred miles or by the existence of a number of rival claimants, the popes had been unable to actualize their right to govern the Papal States. Now that the wounds of the past had been healed and the papacy was firmly reestablished in Rome, however, things were different. The popes were determined to take up the reins of temporal power once again. No longer "merely" God's vicegerent on earth, the pontiff became a potentate of immense stature, a ruler whose word was law, and a sovereign lord to whom cities and signori owed allegiance. What was more, as the master of one of the largest territorial states in Italy, the pope also became a major player on the European political scene. Determined to protect the borders of the Papal States and maintain the delicate balance of power on which their security depended, the papacy came to be an arbiter of war and peace, a keen practitioner of international diplomacy, and the leader of Italy's largest armies.

While the damage wrought by the Babylonian Captivity and the Schism had given the popes an acute awareness of the need for spiritual regeneration, the Curia's return to Rome had also transformed it into a much more "secular" institution. The equal of kings and princes, the papal court became dominated by worldly concerns. At least until the advent of the Reformation, it was not devotional practices and liturgical reform that came uppermost in the minds of popes and cardinals but taxes, accounts, property rights, diplomacy, military campaigns, and territorial expansion. Though dressed up in terms of conserving the earthly health of the Holy Mother Church, these were matters of hardnosed politics of the most brutal kind.

This gave a different character to the papal court. Every aspect of life at the Curia was affected. The way popes and cardinals lived, worked, and played shifted to take account of the Church's temporal aspirations. The priorities, methods, and ambitions of the College of Cardinals lurched radically toward the ways of the world, and the proclivities of the most senior members of the ecclesiastical government drew ever closer to those of their secular counterparts. Indeed, the notoriously porous boundary between the "secular" and the "religious" all but broke down, with individuals and families moving freely between the two, with schemes, plots, and projects feeding from one to the other and back again. Seedy, unpleasant, and altogether un-priestly practices began to dominate the papal court as the papacy's vision of its role in the world metamorphosed into an almost unrecognizable form.

In turn, this transformed the manner in which the papal court engaged with the arts after its return to Rome. It was not that Nicholas V's desire to reinvigorate the faith of ordinary believers through art was in any way insincere, or that the churches, frescoes, and altarpieces commissioned in their hundreds were lacking in Christian devotion. But the religious "surface" of papal patronage coexisted with other, darker, and more sinister goals that had grown out of the worldly character of the Renaissance papacy. Just as merchant bankers and condottieri could use religious imagery or devotional bequests to craft an image that responded to the grim realities of their existence, so the papal court employed patronage for purposes that addressed the wholly unchristian objectives that had become part and parcel of curial life.

Despite their appearance, delicate paintings of saintly figures, fine statues of the Virgin Mary, and elegant buildings dedicated to the Sacred Heart of Christ himself were masks for materialistic ambition, rampant self-obsession, endemic corruption, lust, violence, and bloodshed. But just how dark and ugly were the hearts and minds of the men who fueled the "papal Renaissance" only becomes clear when the deep and unpleasant changes wrought by the papacy's return to Rome are excavated a little more.

COURTLY VICES

In taking up the reins of power in the Patrimony of St. Peter once again, the papacy assumed the burdens of government that were familiar to Italy's kingdoms, city-states, and *signorie*. This was, however, much more than a matter of bureaucracy, administration, and diplomacy. Authority was as much about creating a culture of power as anything else. If the papacy wanted to keep a firm grip on the Papal States and to deal with its counterparts from a position of strength, it had to project an image of solid rulership that its dependents and rivals could appreciate in their own terms.

A Renaissance state was nothing without courtly life. The court was a meeting place for the powerful, an arena for the resolution of disputes, and the threshing floor of ambitions; but most important, it was the setting for the display of temporal might. Kings, princes, *signori*, and even some communes took care to maintain magnificent courts as a manifestation of their power; and the papal court—comprising both the household of the pope himself and the satellite courts of his cardinals—had to operate just like its secular equivalents, only bigger and better. As courtly theorists such as Pietro Aretino and Paolo Cortesi argued, popes and cardinals had to live like lords if they wanted to be taken seriously, and to live like lords, they had to be every bit as magnificent as lords.

Taking up residence in the Eternal City as a new cardinal, Aeneas Silvius Piccolomini would have been sucked into the very heart of the rejuvenated papal court. In the corridors of ecclesiastical power, in the reception rooms of the Vatican Palace, and in the palazzi of his colleagues in the Sacred College, he would have been surrounded by grandeur and magnificence.

Everything about the Roman court was enormous—almost overpoweringly so. The Vatican Palace was "probably the most splendid of any government in Europe," and the cardinals' residences were hardly less impressive. Vast suites of reception rooms and great courtyards were essential to awe visiting diplomats, while facades and entrances needed to be both big and fashionably designed. And since no man of power could possibly be seen to eat, sleep, or converse in shabby little hallways, even "private" apartments (which were, naturally, anything but private) had to be on a grand scale. Every surface shimmered with frescoes and paintings; every niche revealed ancient statues or carvings in the latest style; every window was expertly set in the most elegant of frames.

The court buzzed with the hum of hordes of people. It was not just that the Curia was continually playing host to foreign potentates. The courtly life demanded that a palace throng with life and that its owner be at the center of a never-ending whirl of activity. The households of every one of its members were packed with dependents, as befitted the lifestyle of any great prince of the age. Shortly after the death of Callixtus III, the pontiff's household comprised no fewer than 150 "lords" and "ministers," together with 80 ancillary servants, whose activities were regulated with almost military precision. By the same token, no self-respecting cardinal would make do without a famiglia comprising at least 100-120 attendants and hangers-on, a sizable number of whom would ride out with him whenever he ventured forth into the city. If this weren't enough, it was also expected that each cardinal would throw his house open to all and sundry in a conspicuous display of munificence. As a sixteenth-century papal bull put it, "The dwelling of a cardinal should be an open house, a harbor and a refuge especially for upright and learned men, and for poor nobles and honest persons." At the upper end of the scale, dozens of petitioners seeking grants, benefices, or favors flocked through the doors of his palace each day from morning to night, in the hope that the great man would put in a good word or welcome them into his household. But at the lower end of the scale, there were crowds of poor, down-at-heel men and women gathered around the gates, begging for food or money, and a good cardinal had to provide for as many as possible.

Perhaps most impressive of all was the scale of the entertainments that the papal court laid on. The palace was ultimately a place of bacchanalian revelry. The Belvedere Courtyard in the Vatican Palace played host to enormous tournaments and bullfights throughout the Renaissance, the papal gardens housed great collections of exotic animals (including Hanno, the white elephant), and glamorously staged plays were a regular occurrence. More dramatically, popes and cardinals were all but obliged to hold bewilderingly regular banquets of colossal richness. There were dozens of rich courses, countless barrels of the finest wines, scores of musicians, and every opportunity for making merry until dawn. In June 1473, for example, Cardinal Pietro Riario held a vast banquet with more than forty different dishes, including (inexplicably) gilded bread and a roast bear.

Magnificent as it all may have been, however, the cultivation of courtly grandeur came at a price. However much the Curia tried to justify its opulent lifestyle by appealing to the respect and honor due to the Chair of Saint Peter, it simply wasn't possible to indulge the splendor of courtly life without also falling prey to the vices of secular courts. In Rome, the moral standards of the Curia degenerated at the same rate as the grandeur of the papacy increased.

Money was the greatest concern and the source of the greatest sin. There was, of course, no escaping the fact that cultivating an image of power cost a great deal of cash. Cardinals were not short of a penny or two. Although there was a good deal of variation, it has been estimated that the incomes of the twenty-five to thirty cardinals who lived in Rome at the beginning of the next century generally fell between 3,000 and 20,000 ducats (where a ducat was roughly equivalent in value to a florin). Yet even these enormous sums paled in comparison to the day-to-day running costs of courtly life. In the 1540s, the humanist Francesco Priscianese estimated that Cardinal Niccolò Ridolfi spent at least 6,500 scudi (the scudo was worth approximately the same as the ducat and the florin) each year on maintaining a household of one hundred retainers in a fitting style. This, however, only accounted for the bare necessities. Buying, renting, building, or maintaining a palace could cost thousands of ducats, while the pressure to commission artists to decorate a cardinal's apartments imposed a colossal additional burden. As time went on and competition between the cardinals increased, the financial pressure only mounted. By the beginning of the seventeenth century, Cardinal Ferdinando Gonzaga reckoned that it was nearly impossible for him to maintain his dignity in Rome on an annual income of less than 36,000 scudi, and protested that he would have to leave the city if he couldn't be sure of having the money to hand. As this rather late example suggests, almost from the moment of the papacy's return to Rome, cardinals—and, it must be said, popes—were perpetually short of cash. Despite the occasional subsidies provided to those who could not hope to draw on dynastic reserves, they often struggled

250

to make ends meet. As the Venetian ambassador Girolamo Soranzo noted in 1563, "There [are] some who are very poor who lack many of the things needed to maintain [their] rank."

This pressure to keep up appearances led cardinals to become inordinately preoccupied with increasing their incomes by fair means or foul. Greed swiftly became endemic at the papal court, and each of the princes of the Church became obsessed with accumulating ever more benefices, no matter how small or trifling the money they brought in. In his memoirs, Aeneas highlighted Pietro Barbo as the very archetype of the moneygrubbing cardinal. Having denounced the grotesquely fat Pietro as "an expert seeker of worldly preferment," Aeneas went on to describe how he demanded the relatively small church of Santa Maria in Impruneta after the death of its rector, and kicked up a tremendous row when he was turned down by the pope. In the same vein, in 1484, the Florentine humanist Bartolomeo della Fonte (Bartolomeo Fonzio) lamented the fact that at the papal court "faith in Christ flourishes no longer, nor love, piety, or charity; virtue, probity, and learning now have no place." "Need I mention," he asked Lorenzo il Magnifico, "the robberies that go unpunished, the honor in which greed and extravagance are held?" Writing to Bernardo Rucellai on the same day, he pointed to the "whirlpool of vice" that consumed the Curia, and observed that the cardinals, "in the guise of shepherds of vice ... destroy the flocks committed to their care" since "their greed ... can never be satisfied."

The Curia's other sins were even worse. Given the luxury and splendor of Renaissance courts, there was always a serious danger of overindulgence and excess. The more potentates endeavored to cultivate magnificence, the more tempting it was to give in to the pleasures of the body. As Castiglione observed in *The Book of the Courtier*, "Nowadays rulers are so corrupted by evil living . . . and it is so difficult to give them an insight into the truth and lead them to virtue." And what was true of secular courts was even more true of the papal court, which exceeded all others in opulence.

Gluttony was, as Bartolomeo della Fonte observed, all but universal. A typical example was that of Cardinal Jean Jouffroy, the bishop of Arras, of whom Aeneas provided a vivid portrait in his memoirs. Although Jouffroy "wished to seem devout," he was a "heedless, pernicious fellow" who could not resist the pleasures available at the tables of the papal court, but who was badly affected by the massive amounts he consumed:

When he was dining, he would be angered at the least offence and throw silver dishes and bread at the servants and sometimes, even though distinguished guests were present, in his rage he would hurl to the ground the table itself with all the dishes. For he was a glutton and an immoderate drinker and when heated with wine had no control of himself.

Although all were not quite so outrageous, drunkenness and overeating were quite normal faults for a Renaissance cardinal. Indeed, even after his election to the papacy, Alexander VI made it a regular practice to get horribly drunk. As Benvenuto Cellini noted, "It was his custom, once a week to indulge in a violent debauch, after which he would vomit." Similarly, Paul II ate and drank so much that even the most flattering portraits show him as a grotesquely overweight blob.

Lust, however, was the most prevalent of all the vices at the papal court. Admittedly, it was nothing new. During the Babylonian Captivity, Petrarch complained bitterly about the extent to which cardinals would give themselves over to sexual abandon. Condemning a personified Avignon as the paradigmatic example of sinfulness, he observed that "through your chambers young girls and old men go frisking and Beelzebub in the middle with bellows and fire and mirrors." But now that the papacy was back in Rome, things had got even worse. Palaces thronged with courtesans, and vows of chastity were regarded with amused disdain. In this regard, it is telling that one of Aeneas's most well-read works was actually an erotic novella, and he also penned a wild sexual comedy called Chrysis. It was quite normal for cardinals to keep mistresses openly, and the gossip that inevitably spread was more like that seen in modern soap operas than what might be expected of the Church. Aeneas himself had fathered at least two children before taking holy orders, but even he could not help recording a few little tidbits about the sexual habits of the notorious Cardinal Jouffroy, which provide a nice illustration of courtly norms:

He was fond of women and often passed days and nights among courtesans. When the Roman matrons saw him go by—tall, broad-chested, with a ruddy face and hairy limbs—they called him Venus' Achilles. A courtesan of Tivoli who had slept with him said she had lain with a wineskin. A Florentine woman who had been his mistress, the daughter of a countryman, angry with him for some unknown reasons, waited for the time when the cardinal on his way from the Curia should pass her house and then, as he was going by, she spat out on his hat saliva that she had held for a long time in her mouth and mixed with phlegm, marking him as an adulterer by that vilest of brands.

The popes were particularly renowned for their affairs. Julius II, for example, was the father of numerous children and did not trouble to hide the fact too carefully. Rather more famously, Alexander VI slept with virtually anything that moved, and is unique in having been suspected of having had sex with his mistress (Vannozza dei Cattanei), the daughter she bore him (Lucrezia), and her mother while making a virtue of siring several offspring.

Homosexual liaisons were as common as-if not more common than—heterosexual relationships. So endemic was sodomy at the papal court that the rumored homosexuality of various popes became a stock feature of satirical pasquinades. Of Leo X (Giovanni di Lorenzo de' Medici), Guicciardini remarked, "At the beginning of his pontificate, most people deemed him very chaste; however, he was afterwards discovered to be exceedingly devoted-and every day with less and less shame-to that kind of pleasure that for honour's sake may not be named." The unmentionable pleasure was reputedly a particular taste for young boys, a taste that was apparently shared by Julius II. Others took it to a different level. Sixtus IV was reputed to have given his cardinals special dispensation to commit sodomy during the summer months, perhaps to permit him to indulge his favorite predilections without fear of criticism. Worse still was Paul II, who was not only lampooned for wearing rouge in public but also rumored to have died while being sodomized by a page boy.

In the early days of Aeneas's cardinalate, the papal court thronged with rich, powerful churchmen who were utterly devoted to greed, gluttony, and lust. The magnificent halls of their palaces buzzed with every variety of sin, giving the Curia a very bad name, especially among humanists like Bartolomeo della Fonte who came to Rome to pursue their art. Vicious invectives were launched against the lifestyle of Renaissance cardinals by various learned litterateurs. Even among the ordinary people of the city, the court earned a rotten reputation, and despite the magnificence of curial palaces the very word "cardinal" became a term of abuse, as a dialogue from an anonymous pasquinade (a characteristically Roman satirical poem that took its name from the damaged remains of a statue unearthed in the fifteenth century and commonly known as Pasquino) shows:

MARFORIO: Why, Pasquino, you're armed to the teeth! PASQUINO: Because I've got the devil on my back With an insult that has placed me on the rack, And got my deadly knife out from its sheath. MARFORIO: But who insulted you, Pasquino, what runt? PASQUINO: He's a cunt! MARFORIO: Then what was it? PASQUINO: You stupid heel: I'd rather have been broken on the wheel Than ever be called by such a name. MARFORIO: He called you liar: what a shame! PASQUINO: Worse than that! MARFORIO: Thief? **PASOUINO: Worse!** MARFORIO: Cuckold? PASQUINO: Men of the world shrug off such sobriquets, You simpleton, and just go on their way. MARFORIO: Well, what then? Coiner? Simonist 'gainst God? Or did you get a little girl in pod? PASQUINO: Marforio, you're a babe who needs a nurse: Of all things evil there is nothing worse To call a man than—"Cardinal"! But he Who abused me so won't 'scape death, e'en if he flee.

But however shameful contemporaries may have thought the habits of the papal court, it is important to underscore the fact that they put a very different complexion on the Curia's patronage of the arts. Although grand, richly decorated palaces, antique statuary, and fine frescoes were essential to creating an appropriate setting for a Renaissance court, the intentions and daily lives of the patrons who commissioned these works went far beyond both the strict demands of the courtly life and the artistic vision set out by Nicholas V.

The magnificence of the papal court was, therefore, deceptive. The magnitude of the Apostolic Palace and its satellites concealed a court that was not only perennially short of cash, but that was also driven on by burning ambition and relentless greed, while the saints and angels depicted on the walls of curial residences looked down on men who willingly devoted themselves to wild sex and debauchery. In this regard it is telling that Raphael's *School of Athens*—perhaps the most striking affirmation of the papacy's ostentatious endeavor to establish itself as the focus of humanistic learning and to encourage a harmonious union between ancient philosophy and patristic theology—was commissioned by Julius II, an amorous, possibly homosexual pontiff whose rise to power had been fueled by greed. Indeed, it is arguable that the further the mores of the papal court degenerated, the more intense its need for such an unrealistic public image became.

The artistic tastes of popes and cardinals were, however, neither as one-dimensional as it might initially appear nor as clearly defined as Nicholas V's deathbed statement might suggest. Although courtly status and the well-being of the faith continued to provide a powerful reason for the preservation of a carefully designed public image, it was simply impossible for so worldly a group of people not to let their true feelings shine through once in a while.

As at secular courts elsewhere in Italy, the side effects of "courtly" behavior often crept out from behind the shadows to be celebrated and enjoyed for their own sake. Greed, gluttony, and lust found their way into decorative schemes that otherwise glossed over the sinfulness of life at the papal court. In decorating the bathroom of Cardinal Bibbiena in the Vatican Palace, for example, Raphael was requested to paint frescoes depicting episodes from classical mythology that were definitely not reflective of a celibate mind. Although now lost, one scene showed a voluptuous Venus lifting her leg in a highly provocative manner while extracting a thorn from her foot. Another showed Pan preparing to rape Syrinx. So, too, Michelangelo carved his *Bacchus*—a masterpiece

of drunken revelry-for Cardinal Raffaele Riario. Even more revealing were the decorations on the vault of the entrance loggia to the Palazzo Farnese executed by Giulio Romano, Giovanni da Udine, and others after a design by Raphael. In this case, the subject chosen was the erotic story of Cupid and Psyche, and the ceiling of this most elegant of rooms is divided up into panels depicting different scenes from the tale, each of which provides a hint of the daily life of the cardinals who lived in the palace. In The Council of the Gods, for example, the wine flows freely as gods recline in the company of bare-chested goddesses or canoodle under flowered canopies, while alluring maidens dance with desire in their eves (Fig. 30). In the corner of another scene, just above Mercury's raised hand, there is a yet more outrageous statement of curial tastes. Among the fruit and foliage of the border is hidden an obvious and totally uninhibited sexual parody: here, an unmistakably phallic vegetable plunges into a fig that has been split in half to present a plainly vaginal appearance. Subtle it was not, but-when they were left to their own devices away from the public gaze-that was what Renaissance popes and cardinals such as Aeneas Silvius Piccolomini liked.

FAMILY MATTERS

Aeneas would have had the opportunity to see the moral degeneracy of the papal court firsthand in his early years in Rome, but the debt, drunkenness, and debauchery he would have encountered in the grand palaces of popes and cardinals told only part of the dark story behind the papacy's patronage of the arts. In addition to causing a sudden and dramatic increase in the level of greed, gluttony, and lust in the Curia, the papacy's resumption of power in the Papal States had prompted a much more insidious transformation in the way in which the popes used their power and—by extension—in the way in which ambition shaped the character of the papal court.

It was not long before Aeneas caught his first glimpse of this even uglier side of the Renaissance papacy. Only two years after Aeneas was made a cardinal, Callixtus III died, and he was called upon to take part in the conclave summoned to elect the new pope. It was at this most important of Church gatherings that the internal politics of the Curia began to become clear.

Convened in accordance with the dignified traditions of the Church,

it looked like a very solemn occasion. As soon as the funeral was over, the College of Cardinals—dressed in their finest vestments—processed into a small suite of rooms in the Vatican Palace, where they would remain in secretive isolation until the election had been concluded. As the doors were locked behind them, all eighteen swore themselves to secrecy and obedience (the eight other living members of the College were unable to attend) and, after praying for divine guidance, began their deliberations in earnest. In Pinturicchio's later depiction of the proceedings for the Piccolomini Library in Siena, everything is presented as having been conducted with high-minded decorum, and although several cardinals were *papabili*, Aeneas himself seems to have regarded the whole affair as a foregone conclusion.

The conclave was anything but decorous, and it only took one round of voting for things to turn nasty. Given that none of the candidates had secured a clear majority, a victor would emerge only as a result of negotiation. But rather than considering the piety and holiness of the *papabili*, the cardinals threw themselves into a bout of un-priestly horse-trading. No sooner had the inconclusive results been announced than

the richer and more influential members of the College summoned others to their presence. Seeking the papacy for themselves or their friends, they begged, made promises, even tried threats. Some threw all decency aside, spared no blushes, and pleaded their own cases, claiming the papacy as their right.

Meeting secretly in the latrines, Cardinal d'Estouteville—the most fiercely ambitious member of the Sacred College—did his utmost to cajole others with threats and bribes. He promised to distribute a whole host of lucrative benefices to anyone who would vote for him, and made it clear that, if elected, he would dismiss those who did not support him from any Church offices they might hold. Even the redoubtable Cardinal Rodrigo Borgia—the vice-chancellor of the Church—was momentarily scared into offering his backing.

Despite d'Estouteville's efforts, however, the second round of voting only produced another deadlock. He received only six votes, while Aeneas—whose own techniques of "persuasion" are shrouded in mystery—garnered nine. It was clear that another vote would only drag things out, and since neither candidate had the requisite twothirds majority (twelve votes), the College decided to give the process of "accession" a try. This method allowed the cardinals to change their votes and "accede" to a different candidate. Rather than helping things run more smoothly, however, this only served to push the standard of behavior even lower still.

Sensing that d'Estouteville was unlikely to succeed, Rodrigo Borgia was the first to stand up and switch his support to Aeneas. Cardinal Giacomo Tebaldi followed suit. Aeneas now only needed one vote to take the throne. But at this point, the conclave descended into farce:

Cardinal Prospero Colonna decided to seize for himself the honor of acclaiming the next pontiff. He rose and was about to pronounce his vote . . . when the cardinals of Nicaea and Rouen [Bessarion and d'Estouteville] suddenly laid hands on him and rebuked him sharply for wanting to accede to Aeneas. When he persisted, they tried to get him out of the room by force, one seizing his right arm and the other his left . . . so determined were they to snatch the papacy from Aeneas.

Prospero was, however, determined. As he was being dragged out of the chapel by two of the most august personages in the whole of Christendom, he shouted his support for Aeneas. With the faint thud of ecclesiastical punches being thrown and d'Estouteville's cries of despair ringing in his ears, Aeneas found himself the new pope.

It was not an auspicious beginning for a papal reign. Far from being a model of Christian decorum, the conclave had been a violent, corrupt, and angry brawl that would shame even a modern rugby club. But it was certainly not anything out of the ordinary. Tempers at conclaves throughout the Renaissance always ran high, and shouts and punches were not unusual. What was more, bribery—or "simony," to give it its proper name—was quite normal. Baldassare Cossa had, after all, borrowed 10,000 florins from Giovanni di Bicci de' Medici in 1410 to ensure that he could become an antipope. After the reunification of the Church, things got worse, despite repeated attempts to stamp out simony at conclaves. D'Estouteville's attempts at bribery were, in fact, to pale by comparison to the simony practiced in 1492 by Rodrigo Borgia, when the successful Spanish cardinal was reputed to have offered four mule loads of silver and benefices worth over 10,000 ducats a year to Ascanio Sforza alone. By the standards of other conclaves, Pius II's election had actually gone fairly smoothly.

But it was not merely as a consequence of the papacy's spiritual prestige that Renaissance conclaves were so habitually fierce and crooked. The papal throne had become a prize of almost incalculable material and political value.

After the papacy's return to Rome, it was in a position to have a dramatic impact on the balance of power in Italy. As a matter of course, the pope was a major player in international politics, and his influence overshadowed the calculations of every other state. Any alliances into which he entered or any campaigns he undertook could threaten the stability of communes, kingdoms, and *signorie* throughout the peninsula. But the pope could also have a serious effect on the internal politics of individual states by directly interfering in the fortunes of individual families. He could make or break a family's hold on its territory by appointing a particular potentate to the vicariate of a particular city or by dismissing him from his post. He could confer titles of nobility on whomever he wished. And he could dramatically increase or decrease a family's revenues depending on the manner in which he distributed benefices or Church incomes.

This wouldn't have mattered all that much if the Curia had been an institution insulated from national and familial concerns or if the cardinals themselves were decent and upright men devoted to the spiritual well-being of the Church. But it wasn't, and they weren't. The popes not only clung to the interests of their native lands but were also very definitely "family" men, regardless of whether they hailed from established ruling dynasties or sprang from up-and-coming new clans. No sooner had they been crowned than they began using the immense authority that had been entrusted to them to favor the fortunes of their country, to fill their family's coffers (which often went hand in hand with "national" interests), and to build up networks of personal power.

Naturally, anyone who had a shred of ambition did his utmost to curry favor with the popes in the hope of receiving some of the crumbs that fell from the papal table, and the kings of France, England, Spain, and Hungary—as well as Italy's leading signorial families—all tried to have "their" men appointed cardinals. But perhaps the most obvious sign of the papacy's role as a rather shady source of money and power was the far more corrupt practice of nepotism. Although popes had

made a habit of appointing relatives to the College of Cardinals since the Middle Ages, the Renaissance papacy took it to new extremes, and the creation of "cardinal-nephews" reached epidemic proportions. Martin V, for example, not only gave his nephew Prospero Colonna a red hat but also used his influence to make sure his family had a stranglehold on Rome itself. Eugenius IV (who had been made a cardinal by his uncle Gregory XII) elevated two of his nephews to the Sacred College. Callixtus III had followed suit with such shamelessness that one of his protégés, Bernardo Roverio, was to condemn him as an "iniquitous pope" who had "befouled the Church of Rome with corruption." Even the redoubtable Nicholas V had raised his half brother to the cardinalate. In later centuries, things got even worse. Since he was absolutely determined to make the comparatively obscure della Rovere one of Italy's foremost noble families, Sixtus IV's propensity for elevating his relatives to the Sacred College surpassed that of even his most nepotistic predecessors. As Machiavelli recorded, he was "a man of very base and vile condition . . . the first to show how much a pontiff could do and how many things formerly called errors could be hidden under pontifical authority." No fewer than six direct kinsmen were elevated in the space of just under seven years and accounted for almost a quarter of the cardinals present at the conclave after his death. Similarly, Paul III did the same for two of his natural grandsons, one of whom-Ranucciowas only fifteen at the time. Even worse, Alexander VI-who was himself a cardinal-nephew of Callixtus III-raised a grand total of ten of his kinsmen to the College, including his son (Cesare Borgia) and two grandnephews. Between 1447 and 1534, six out of ten popes had previously been made cardinals by one of their relatives.

Every cardinal-nephew was loaded with lucrative benefices and grants of land, and this did much to enhance the power and prestige of the families from which they sprang. It was no coincidence that the della Rovere family owed its prominence in the later Renaissance entirely to the riches lavished on cardinal-nephews, and it is telling that Pietro Riario—who had received his cardinal's hat from Sixtus IV was one of the wealthiest men in Rome.

But this was not all. Quite apart from their willingness to pack the College of Cardinals with their relatives, popes who harbored strong family ambitions were more than prepared to give substantial support to kinsmen outside the Church, too. Not long after the Schism had ended, Martin V set the tone for the rest of the Renaissance by giving his Colonna relatives a free hand in Rome and by securing vast estates for them in the kingdom of Naples. So extreme did this become that even Machiavelli was appalled by the secular nepotism of Sixtus IV. Later, Julius II (a nephew of Sixtus IV's) secured the duchy of Urbino for his nephew Francesco Maria della Rovere in 1508; Clement VII made his illegitimate son, Alessandro de' Medici, duke of Florence; and Paul III made his bastard child, the condottiere Pier Luigi Farnese, duke of Parma. Most notorious of all, however, was Alexander VI. As Guicciardini observed, he possessed

neither sincerity nor shame nor truth nor faith nor religion, [but] insatiable avarice, immoderate ambition, . . . and a burning desire to advance his many children in any possible way.

Going well beyond the already excessive ambitions of his predecessors, Alexander aimed at nothing less than the creation of a Borgia empire in northern Italy. He made his second son, Juan, captain general of the Church and persuaded the king of Spain to create him duke of Gandia; on Juan's death, Cesare was permitted to leave the College of Cardinals to become duke of Valentinois and to conquer the Romagna. Even Alexander's daughter Lucrezia was used as a pawn and was married off three times to leading Italian families.

Aeneas Silvius Piccolomini was no exception to the rule. Despite his protestations of piety and humility, he was every bit as devoted to nepotism as every other pontiff of the period. He, too, wanted to ensure that his family would profit from the papacy's growing wealth. Some of his earliest actions as pope, in fact, concerned his own kinsmen. After elevating Siena to the status of an archdiocese, for example, he made Antonio d'Andrea da Modanella-Piccolomini its first archbishop, and on Antonio's death Pius named his sister's son, Francesco Todeschini Piccolomini, as his successor. The new pope then went on to make Francesco a cardinal, alongside Niccolò Forteguerri (a relative on his mother's side) and Jacopo Ammannati Piccolomini (an adopted member of a cadet branch of the family), whom he had previously made the bishops of Teano and Pavia, respectively. If this were not enough, he made his cousin Gregorio Lolli one of his most trusted secretaries and appointed his nephew Niccolò d'Andrea Piccolomini commander of the Castel Sant'Angelo in Rome. To cap it all, Pius even sent Niccolò Forteguerri to Naples on a secret mission to arrange the betrothal of yet another nephew, Antonio Todeschini Piccolomini, to the daughter of King Ferrante.

Given the enormous opportunities for familial enrichment, it is not difficult to see why competition for the papacy was so ferocious after the papal court returned to Rome. It was a prize worth fighting for, and since so much was at stake, simony and even violence were regular features of conclaves. It was a rare cardinal who did not aspire to the papacy, and it was almost unheard of for a cardinal with a good chance of election not to offer bribes to his colleagues. And while there is no direct evidence to suggest that Aeneas Silvius Piccolomini actually offered any financial inducements to his fellow cardinals in 1458, his subsequent nepotism makes it hard to believe he did not sneak the odd bribe to well-placed individuals to improve his chances of acceding to the papal throne and reviving the Piccolomini's flagging fortunes.

If the papacy's resumption of power in the Papal States led to the abuse of papal power and the corruption of papal elections, these insidious changes had the collective effect of transforming the papacy itself into the plaything of Italy's great noble families. Despite the massive expansion of the College of Cardinals during the Renaissance (it would increase in size from twenty-six in 1458 to thirty-two in 1513 and fifty-four in 1549) and the continuing influx of cardinals appointed at the request of European monarchs, it was dominated by a relatively small number of Italian clans determined to use the Church—and the papacy—to further their own interests. The della Rovere, the Borgias, the Medici, the Farnese, and, thanks to Pius II, the Piccolomini accounted for a dizzying number of red hats and sucked millions of florins out of the Church's coffers as a result. And the more they jockeyed for money, power, and influence, the more they each conspired to keep the papacy "in the family." Of the eighteen popes who reigned between 1431 and 1565, twelve were drawn from just five families, and no fewer than four pontiffs (Innocent VIII, Leo X, Clement VII, and Pius IV) were either direct members of or indirectly related to the Medici family alone. Pius II's election was merely the beginning of yet another attempt to make the elective monarchy that was the papacy into as hereditary an institution as possible.

All of this had a dramatic—and highly visible—impact on the papal

court's patronage of the arts. As the devastating criticisms leveled against the papacy by Savonarola and, later, by Calvin and Luther were to demonstrate, it was important to project an impression of good taste and Christian virtue, even if the reality was quite different. Working in parallel with this, a desire also emerged to consolidate familial gains by visual means. The more powerful and ambitious the families who dominated the Curia became, the more they longed to legitimate their position both in Rome and in their own lands by cultivating an image of justified authority. This entailed not only a propensity for lavishness and grandeur but also a willingness to highlight family ties in an almost dynastic fashion.

The most imposing manifestation of this was architectural. For the Curia's wealthiest cardinals, palaces were as much an expression of family prestige as they were settings for courtly revelry, and it was thus imperative that people viewing a palazzo know who was responsible for its studied magnificence. The owner of every palace took care to have his family coat of arms (or at least a suitably imposing inscription) displayed in as prominent a position as possible. Thus, when Cardinal Raffaele Riario built a new palace-today known as the Palazzo della Cancelleria—in 1496, he not only made sure it was far larger than anything else in Rome but also had a dedicatory epigraph included on an upper cornice to ensure that everyone would know that it was his palace and that he had been raised to his august position by his relative Pope Sixtus IV. So, too, in commissioning Antonio da Sangallo to design a suitable palace in 1515, Cardinal Alessandro Farnese (later Pope Paul III) instructed that the facade of the vast new structure—which is today the French embassy-be dominated by the family coat of arms placed above the main doorway.

Although they officially resided in the Apostolic Palace, and hence had slightly different needs, the popes took this tendency to an even higher level. Obsessed with putting his family's stamp on the Vatican itself, each pontiff strove to enlarge the complex with yet another addition, and endeavored to emphasize the splendor of his family by having its coat of arms emblazoned in a prominent location, as in the Sala Regia, where Pope Paul III had the Farnese crest placed high above the doorway. Indeed, later, when the new Saint Peter's Basilica was completed, Sixtus V had an inscription claiming the edifice as his own inscribed around the base of the lantern, while Paul V tried to take credit for the whole project by having both his regnal name and his family name written on the facade.

Yet identification often went much further than such crude signposting and was at once subtle and intense. The Borgia Apartments, which were decorated with an iconographically rich series of frescoes by Pinturicchio that even included a portrait of Alexander VI's mistress Giulia Farnese in the guise of the Virgin Mary, were, for example, so heavily associated with the pontiff's notorious family that they were subsequently abandoned for many years. But perhaps the best example is the Sistine Chapel, which—despite the addition of certain features by other popes—has a good claim to be regarded as a temple to the della Rovere. While Sixtus IV (Francesco della Rovere) ordered the construction of the chapel and had its walls decorated with frescoes by Botticelli, Ghirlandaio, and Perugino, it was his ambitious nephew Julius II (Giuliano della Rovere) who commissioned Michelangelo to paint its ceiling as a continuation of the programmatic glorification of the della Rovere's achievements.

Particularly when popes hailed from families that aspired to improve a previously limited role in their native region, architectural and decorative projects on a grand scale could also be instigated outside Rome. As part of his broader scheme to establish a Piccolomini "dynasty," for example, Pius II employed Bernardo Rossellino to remodel completely his hometown of Corsignano. Employing the very latest techniques in urban design, Rossellino transformed Corsignano (renamed Pienza) into an ideal Renaissance town to which Pius II could retire when he wanted to get away from Rome. Not only was his family's coat of arms emblazoned on almost every major building (even including the well in the piazza outside the Palazzo Comunale), but the new town was also dominated by a massive palace intended to serve as a residence for the Piccolomini family.

A more direct means of emphasizing "dynastic" power within the Curia was, however, the sophisticated use of portraiture and pictorial commemoration. On the one hand, second- and third-generation popes used the achievements of their pontifical ancestors to bolster the perceived strength of their "descent." Pope Pius III, for example, commissioned Pinturicchio to paint a magnificent hagiographical fresco cycle depicting the life and career of Pius II in the library of Siena Cathedral (today known as the Piccolomini Library) and underscored his ties to the alleged virtues of the first Piccolomini pontiff in a dedicatory inscription that made clear the family relationship between the two men. But on the other hand, popes of all stripes were fond of having portraits painted that showed them surrounded by other members of their family, particularly when they were also cardinals. The viewer was left in absolutely no doubt about the dynastic ambitions of the sitters. In 1477, for example, Melozzo da Forlì was commissioned to paint a fresco depicting Sixtus IV nominating Bartolomeo Platina as the first prefect of the Vatican Library (Fig. 31). Now housed in the Pinacoteca Vaticana, this painting not only shows the scholarly Platina kneeling before the pontiff but also includes portraits of four of the pope's nephews (Cardinals Pietro Riario and Giuliano della Rovere on the right, and Girolamo Riario, the lord of Imola and Forlì, and the condottiere Giovanni della Rovere on the left). Later, Raphael famously painted a portrait of the fat, shortsighted Leo X with his cousins Cardinals Giulio di Giuliano de' Medici (later Clement VII) and Luigi de' Rossi (Fig. 32), and Titian completed a rather more sinister-looking depiction of the decrepit Paul III in the company of his grandsons Cardinal Alessandro Farnese and the fawning Ottavio Farnese, duke of Parma, Piacenza, and Castro.

Just as gluttony, greed, and lust transformed the palaces of Rome into houses of pleasure and ill repute, so equally unpleasant (and unchristian) sentiments underpinned some of the most impressive examples of patronage at the papal court. Far from being reflections of highminded ideals or deep-seated faith, some of the most iconic works of Renaissance art—the Sistine Chapel, the Borgia Apartments, even Saint Peter's itself—were testaments to the overpowering sense of ambition that drove popes and cardinals to annex the power of the Church to their own family interests and to fill their pockets with the tithes of ordinary believers. Beautiful though the palaces, churches, and chapels of the papal court may have been, this side of the Renaissance papacy was—as Aeneas Silvius Piccolomini knew from the violence and simony that accompanied his own election—dark, devious, and utterly corrupt.

Secrets, Lies, and Bloodshed

As Pius II would have realized shortly after his coronation, however, being pope entailed more than wanton revelry and family aggrandizement. Far from being a locus for introspective navel-gazing, cut off from the outside world by its pleasure-seeking ways, the Roman court was one of the epicenters of Italian politics, and it was not long before Pius was compelled to engage with the challenges of international affairs.

The new pope was confronted with two major crises. On the one hand, there was the problem of Sicily. Shortly before Pius's election, a furious row had blown up between Callixtus III and King Alfonso. For reasons best known to himself, Alfonso had haughtily demanded not only that the pope confirm him as the rightful king of Sicily but also that the Church hand over the march of Ancona and a number of other ecclesiastical fiefdoms. Callixtus, of course, refused point-blank and, after Alfonso's untimely death on June 27, 1458, claimed that the island had reverted to the papacy on the grounds that the kingdom had long been a papal fief. Only Callixtus's death had prevented a full-scale papal invasion. Now that Pius was pope, he had to deal with the fallout. While Alfonso's son, Ferrante, wanted the pope to consent to his rule, the pope himself needed to safeguard the Church's possessions and calm the dogs of war.

On the other hand, there was the problem of the Papal States themselves. While the conclave had been going on, the condottiere Jacopo Piccinino had taken advantage of the momentary lack of leadership to invade the Church's lands in central Italy. In a lightning campaign, he had captured Assisi, Gualdo, and Nocera, and had terrorized the whole of Umbria. As a matter of urgency, Pius needed to drive Piccinino out of the Church's heartlands.

They were really two sides of the same coin, and the only way forward was to address both at once. In order to set the Papal States on a secure footing, Pius decided to strike a deal with Ferrante. Not only did this sort out the problem of Sicily, but it also set aside all of the dangers threatened by Alfonso. What was more, Ferrante promised to give Pius his help in getting Piccinino out of Umbria. The only remaining difficulty was that in return Pius agreed to sort out Ferrante's bitter feud with Sigismondo Pandolfo Malatesta and to stabilize affairs in the North. It was to deal with this particularly tricky piece of business that the pope stopped off in Florence en route to Mantua in the spring of 1459.

Now that he was pope, Pius had to keep a lot of political and diplomatic plates spinning at once, and everything was linked together. If one plate fell, the whole lot would come tumbling down. But Pius's

difficulties were merely an expression of the concerns that exercised the papacy throughout the Renaissance. Since the popes' return to Rome and resumption of power in the Papal States, they had been unable to avoid being swept along by the shifting currents of Italian political affairs. Indeed, the familial ambitions and drunken debauchery to which the papal court had become accustomed depended on the papacy's active involvement in the difficult and dangerous business of international relations. The Papal States were the key to everything. They provided the greater part of the income on which the papal court depended, and they needed to be protected, preserved, and-where possible-enlarged. Although it was obviously rather different in character, this naturally obliged the pope to conduct himself like the head of any other state in Italy and to take a keen interest in matters of diplomacy, defense, and property rights. The only problem was that the politicking involved was a very far cry from Nicholas V's vision of the Renaissance Church as a bastion of true faith and a paragon of unworldly virtue. If the daily life of the papal court was riddled with vice, corruption, and immorality, the practices on which everything depended were the most sinister of all that were found in Rome. And, like anything else in the Eternal City, the papacy lost no time in using the patronage of the arts either to mask or to celebrate its darkest and ugliest face.

Living a Lie

Underlying the crises that confronted Pius II in 1458–59 was the thorny problem of authority. Even though some—like Marsilius of Padua occasionally called it into question, the foundation of the popes' claims to spiritual supremacy was firmly established within the Church during the Renaissance. On the assumption that there was a direct line of succession between the first among the apostles and the pope himself, Christ's own words were inscribed in huge letters around the dome of Saint Peter's Basilica: "You are Peter, and upon this rock I will build my Church." But if the popes were able to justify their primacy in religious matters by appealing to Scripture, things were not quite so simple when it came to their claims to temporal authority. As the Spiritual Franciscans had been quick to point out in earlier centuries, there was absolutely nothing in the Bible to say that Christ had wanted his Church to possess anything at all, least of all several million acres of land in central Italy. In fact, several passages in the Gospels could be interpreted as affirmations of the need for absolute evangelical poverty.

Biblical exegesis being what it is, there were a host of cunning scriptural arguments on which the popes could—and did—draw to support their wealth and power. Given the ambiguity of the Gospels, the words of Christ could, after all, be used to justify almost anything. But even if they could show that it was legitimate for the Church to own property and even to wield temporal power in the abstract, nothing in the Bible suggested that God had endowed the popes with any actual title to such a colossal amount of land. To shore up its position, the papacy had to turn to something else entirely.

History provided the solution. There were lots of episodes from the past—such as Pope Leo I's repulse of Attila and the coronation of Charlemagne—that could be read as proof positive of the papacy's right to rule central Italy and of its superiority to all other forms of worldly authority. But one piece of "evidence" stood out. Throughout the Middle Ages and well into the Renaissance, the popes based their claims to temporal power on a document known as the Donation of Constantine. Purportedly written in the early fourth century, the text affirmed that in gratitude for having been cured of leprosy after being baptized and confirmed, the emperor Constantine had handed over the entire Roman Empire to Pope Sylvester I. After this point, it was thought, successive popes had retained sovereign rights over the Empire and had merely entrusted emperors down to the present day with custodianship of its territories, excepting—in later years—the territories that were to become known as the Papal States.

The snag was that the Donation was a forgery that had been written at some point in the early eleventh century. The Renaissance popes weren't ignorant of this fact. Even before the Schism had ended, Cardinal Nicholas of Cusa had questioned the document's veracity, and in 1439–40 Lorenzo Valla had used his philological expertise to prove its inauthenticity beyond all doubt. Before his election as Pius II, Aeneas Silvius Piccolomini himself had even written a tract on the invalidity of the text.

But the Donation of Constantine was too useful for the forgery to be acknowledged openly. Dismissing Valla's treatise and overlooking Aeneas's own work on the subject, Renaissance popes continued to behave as if the document were completely genuine, and even if papal bulls largely ceased to refer to it after the pontificate of Nicholas V, the papacy was relentless in its attempts to provide visual affirmations of the Donation's veracity. Art could give life to the claims embodied in the fraudulent text in a way that legal and philological arguments simply could not.

The most dramatic example is found in the so-called Sala di Costantino in the private apartments of the Apostolic Palace. Commissioned from Raphael's workshop by Pope Julius II, the frescoes in this chamber (the largest of those constructed) were intended to provide a very clear indication that—despite being a forgery—the Donation of Constantine remained the basis of papal policy. In the hands of the artists Giulio Romano, Raffaellino del Colle, and Gianfrancesco Penni, the story of Constantine's life became a celebration of the rightful supremacy of the Church in temporal matters, and especially in Italy. After Constantine's vision of the cross and subsequent victory at the Battle of the Milvian Bridge, the emperor's baptism and supposed donation of the Empire are depicted in two massive and dramatic scenes. Although some of the figures are attired in historically accurate costumes, Pope Sylvester and his clerical attendants are all painted in early-sixteenth-century vestments, as if to underscore the legal continuity linking the fourthcentury pontiff and Julius II.

The message was pointedly emphasized in another room in the new papal apartments, the Stanza d'Eliodoro. Painted by Raphael himself, the fresco cycle in this room extends the sense of the Donation of Constantine by illustrating the virtues and strength of the temporal power of the papacy through other historical and pseudo-historical episodes. In the *Expulsion of Heliodorus* and the *Repulse of Attila*, Julius II and Leo X are respectively cast as the enemies of godless tyrants and the protectors of Rome, while the *Mass at Bolsena* shows the second della Rovere pontiff witnessing a thirteenth-century miracle that was thought to evidence the supreme truth of the faith defended by the papacy. The final fresco—the *Deliverance of Saint Peter*—tops everything off by showing the "prince of the apostles" freed from prison by a merciful angel, an illustration of "the futility of the force used against the first Vicar of Christ."

Living by the Sword

However impressive their territorial claims may have been, the popes still had to back up their pretensions with something a little more tangible. There were dangers everywhere. The Papal States were threatened on all sides by powerful and aggressive states, and the popes were continually afraid of Neapolitan or French invasions; the Church's vassals in central Italy—cities and *signori* alike—were so troublesome and restive that their loyalty could never be counted upon; and the peninsula was full of avaricious condottieri like Jacopo Piccinino who were always on the lookout for an opportunity to ravage or seize the papacy's possessions. If the popes were going to continue enjoying and abusing—the Patrimony of St. Peter, they had to do something to maintain their control.

Diplomacy offered one solution. Recognizing that a stable balance of power represented the best (and most economical) means of protecting the Papal States, the popes initially sought to achieve the security they desired by acting as peacemakers. Perhaps motivated by a vestigial sense of Christian duty, Nicholas V did his utmost to broker a stable and lasting peace among the warring states of Italy, and dispatched the young Aeneas Silvius Piccolomini to calm tempers in Milan and Naples on a number of occasions. The resulting Peace of Lodi, agreed in the spring of 1454, was something of a triumph. Not only did it bring an end to the long and violent wars in Lombardy that had worried so many of Nicholas's predecessors, but it also seemed to offer hope that the Patrimony of St. Peter would remain secure for the foreseeable future.

The papacy's commitment to peace was, however, every bit as cynical as its use of the Donation of Constantine. The Peace of Lodi was only valuable insofar as it served the popes' interests, and even while the fragile truce held, Nicholas and his successors gladly donned armor to make sure the cash kept flowing from the Papal States. It was not merely that pontiffs had to maintain an army to fend off attacks from condottieri, as when Callixtus III sent Giovanni Ventimiglia to repel an invasion by Jacopo Piccinino. The popes were quite prepared to treat any hint of restiveness among their own subjects with the utmost brutality. Mercenary generals were hired with alarming regularity, and cardinals themselves—many of whom had inherited the martial interests of their noble forebears—began to take the field. Pius II sent his own nephew, Cardinal Niccolò Forteguerri, to lead the papal forces alongside Federico da Montefeltro against Sigismondo Pandolfo Malatesta, the papal vicar of Rimini, and the campaign appears to have been fearfully savage. Continuing in the same vein, Sixtus IV ordered the rebellious town of Spoleto to be sacked as a brutal warning to any other cities that might think about breaking free from their papal overlords.

But as they strengthened their position in the Papal States, the popes inadvertently left themselves vulnerable to a more insidious form of violence. Destabilizing alliances began to form behind the scenes. Increasingly on the receiving end of papal brutality, *signori* from the Papal States began conspiring with those farther afield whom Rome's bellicosity had begun to alarm. Plots abounded, and even so well regarded a pontiff as Pius II was not immune from danger. Having quarreled with the pontiff over the lordship of Vico, Everso degli Anguillara plotted with the condottiere Jacopo Piccinino and the Florentine merchant Piero de' Pazzi to assassinate Pius in 1461. Although it ultimately came to nothing, Piccinino's chancellor claimed he had discovered "a poison such that if a very little were rubbed on the pope's chair, it would kill him when he sat down."

Despite being bound by the terms of the Peace, the popes had to respond in kind. They became past masters in the art of conspiracy and had no hesitation in plotting coups and assassinations wherever they felt it might serve their interests. Although Pius II seems to have been comparatively restrained in this regard, Sixtus IV threw himself into plotting with unaccustomed zeal. Acting as a lightning rod for opposition to the Medici, Sixtus was ultimately behind the brutal Pazzi conspiracy in 1478.

After purchasing the border city of Imola and appointing his nephew Girolamo Riario as its new governor, Sixtus began scheming to remove the Medici from power in Florence with the Pazzi family, who had lent him the money to buy Imola, and Francesco Salviati, whom he had made archbishop of Pisa and who came from a family of papal bankers. Sixtus also secretly secured the backing of Federico da Montefeltro, who promised to contribute six hundred soldiers to the plot. Although Sixtus took care to distance himself from the details, he knew the Medici could never be ousted except by murderous means. Set into motion on April 26, the plan was devilishly simple. It began with death. In the middle of High Mass in the Duomo, Francesco de' Pazzi and Bernardo Bandi stabbed Giuliano de' Medici to death in front of hundreds of worshippers. They had intended to kill his brother, Lorenzo, too, but only succeeded in wounding him. Meanwhile, Francesco Salviati and his family were massing on the Palazzo Vecchio in the hope of seizing the heart of Florence's government and establishing a new regime at knifepoint. It was, in fact, only by the narrowest of margins—thanks to some swift action by Lorenzo de' Medici and his associates—that the plot failed. Even though Jacopo de' Pazzi was thrown from a window and Francesco Salviati was hanged from the walls of the Palazzo Vecchio, Sixtus and his successors were not deterred.

After the collapse of the Peace of Lodi, the papacy hurled itself into a series of relentless military campaigns that formed a part of what are now known as the Italian Wars, and that ultimately led the popes to become the greatest source of instability in peninsular affairs. Kicking off more than sixty years of warfare, Alexander VI allied with Naples against the armies of Milan and France (whose king, Charles VIII, wished to claim the kingdom of Naples for himself) and—through cataclysmic mismanagement-plunged the Papal States into near anarchy. Only a few years later, the aggressively warlike Julius II set his eyes on conquering Venice's possessions in the Romagna and agreed a pact with the Holy Roman Emperor, the king of France, and the king of Naples. The bloody Battle of Agnadello (1509) was a triumph for papal ambitions but only complicated the situation further and brought Julius into conflict with France, alongside Venice, his erstwhile enemy, a largely unnecessary development that was excoriated by Desiderius Erasmus in his satirical dialogue Julius exclusus de caelis (Julius excluded from heaven). Despite the hideous complexity of the conflict, Julius's Medici successors Leo X and Clement VII took up the baton with remarkable energy, broadening the scope of the Italian Wars and generating even more bloodshed, albeit with less military skill than earlier popes. Indeed, so terrible did things become that in 1527 the Holy Roman Emperor Charles V felt compelled to sack Rome itself and to imprison the terrified Clement.

Inflamed by the swirling confusion of almost constant military campaigns, the ambitions of the popes inclined them ever more strongly toward underhanded conspiracies. None, however, was fonder of nefarious schemes than Alexander VI, whom Machiavelli described in terms that were harsh even by his standards. In *The Prince*, he contended that the pontiff never did anything, or thought of anything, other than deceiving men; and he always found victims for his deceptions. There never was a man capable of such convincing asseverations, or so ready to swear to the truth of something, who would honour his word less. None the less his deceptions always had the result he intended, because he was a past master in the art.

Indeed, Machiavelli observed that Alexander only managed to add anything to the papacy's temporal power by ruining the descendants of those whom the Church had previously supported. It was, however, for his supposed mastery of the dark arts of poisoning and assassination that Alexander VI was most infamous. Although it is difficult to come by any conclusive proof, the pope's final days provide perhaps the strongest testimony to his reputed fondness for such methods. On August 10, 1503, Alexander VI and Cesare Borgia attended a sumptuous luncheon given by the fabulously wealthy Cardinal Adriano Castellesi da Corneto. The cardinal had, however, heard a rumor that the pope was planning to have him killed using a poisoned jam, and to seize his money and possessions. Attempting to forestall the papal plot, Castellesi bribed the man who had been paid to administer the poison to give the deadly jam to Alexander and Cesare instead. Within two days, the pope was found to be mortally ill, and Cesare, too, fell sick. But something had gone horribly wrong. While Alexander was fighting for his life (he eventually died on August 18), Castellesi discovered he had inadvertently ingested some of the poison as well and suffered grievously for many days.

From the moment of its return to Rome, therefore, the papacy had become a fundamentally militaristic institution and had found itself obliged to indulge in the conspiracies and bloodshed that were an integral part of Renaissance warfare. But while this reflected a decidedly unchristian dimension to the Renaissance papacy, the popes displayed a remarkable absence of shame. If anything, they actually showed a certain pride in their violent ways. Just as they were willing to use patronage to endow the fraudulent Donation of Constantine with a veneer of respectability, so they used the visual arts to celebrate, glorify, and legitimate their military and conspiratorial excesses.

The pattern was set at an early stage. In the frescoes commemorating the life of Pius II in the Piccolomini Library in Siena, for example, Pinturicchio devoted an entire scene to showing Aeneas Silvius Piccolomini urging Pope Callixtus III to muster his armies for war. Similarly, Sixtus IV—who seems to have shown no desire whatsoever to atone either for his aggression or for his cultivation of violent conspiracies began a papal trend for linking pontifical authority with the military achievements of the Roman emperors by commissioning commemorative medals conceived in imitation of ancient coins.

During the reign of Julius II, the exaltation of militarism and violence began to reach its zenith. Reveling in his reputation as the warrior pope, Julius never missed an opportunity to have himself portrayed as something of a soldierly superman. Vasari relates that once, when Michelangelo was completing a clay statue of the pope intended for display in Bologna, the two men struck up a conversation that revealed the true character of the pontiff's self-image:

When [Julius] saw the right hand raised in an imperious gesture, he asked whether it was meant to be giving a blessing or a curse. Michelangelo replied that the figure was admonishing the people of Bologna to behave sensibly. Then he asked the pope whether he should place a book in the left hand, and to this his holiness replied: "Put a sword there. I know nothing about reading."

The same sense of pride in all things military was evident in Julius's efforts to use art to draw visual parallels between his pontificate and the rule of Julius Caesar. Following the lead of his kinsman Sixtus IV, Julius commissioned Giancristoforo Romano and Cristoforo Caradosso to cast medals that explicitly identified him not only with the building of Saint Peter's Basilica, but also with the construction of fortifications at Civitavecchia and the "protection" of Church lands in central Italy.

In a similar vein, Julius's successors habitually commissioned depictions of historical victories as a means of celebrating or justifying their own actions or plans. One of the more striking examples is provided by the *Battle of Ostia*, one of the scenes painted by Raphael's workshop in the Stanza dell'Incendio del Borgo in the Vatican. Commemorating the victory of Leo IV over Sicilian Saracens in 849, this scene is remarkable for the fact that Leo X had himself depicted in the role of his eponymous forebear. This associated the first Medici pope with a triumph from the distant past and served to provide a striking visual justification for Leo X's military actions. However brutal and savage the popes were after their return from Rome, and however many lives their ambitions claimed, their careful manipulation of artistic patronage glossed over their sins and claimed violence, murder, and conspiracy as laudable necessities for the greater glory of the Church. A patent lie, of course, but in a sense, that was what the papal Renaissance was all about.

PART THREE

THE RENAISSANCE AND THE WORLD

FILIPPO AND THE PIRATES

IO

A LTHOUGH HE TOOK his vows as a Carmelite friar at the tender age of seventeen, Fra Filippo Lippi was not suited to the religious life. In contrast to his calm, pious brethren at the convent of Santa Maria del Carmine, he had a wild and restless spirit, and chafed at the routine lessons prescribed for novices in the years before being received into the Order. An excitable teenager, "he never spent any time studying his letters, which he regarded with distaste . . . but instead . . . spent all his time scrawling pictures on his own books and those of others." Even when he was given the opportunity to devote himself completely to painting, his imagination roamed far beyond the narrow confines of his cloister. Inspired by Masaccio's frescoes and conscious of his burgeoning artistic talent, he seems to have begun thinking about leaving his parochial life far behind and exploring the world.

Before turning eighteen (that is, in about 1423), Filippo made up his mind. "In response to the praises which he heard from all sides . . . he boldly threw off his friar's habit" and fled the convent. No records have survived to give any clue as to the roads he may have trodden, but—if Vasari is to be believed—he ventured east, through Umbria, and toward the tantalizing expanse of the Adriatic Sea.

Filippo's wanderlust was, however, to take him much farther than he might have expected. One day, he and a few friends were out in a little boat off the coast of Ancona and were no doubt having a whale of a time. Yet they were ignorant of the pirates who habitually haunted those waters. Accosted by a Moorish galley, they were taken captive and clapped in chains. Carried across the Mediterranean to the Barbary Coast, they were sold as slaves in the dusty markets of the Hafsid kingdom.

Filippo's life was "wretched." Far from his homeland and bereft of any rights, he would have been forced to endure backbreaking manual labor in the scorching heat of North Africa, and even though he had become "very familiar" with his master, it is difficult to believe that he did not long for Florence and the life he had left behind.

Yet even as a slave, Filippo was unable to repress his artistic instincts. One day, he picked up a piece of coal from the hearth and began drawing on a whitewashed wall. Before long, he had sketched out a fulllength portrait of his master, dressed in typical Moorish clothes.

Catching sight of what Filippo had drawn, the other slaves hurried to tell the very man he had depicted. Given the status of slaves in the Hafsid kingdom, Filippo could well have expected to be punished severely for defacing the walls of his master's house. But it proved to be his salvation. As Vasari later recorded,

Since neither drawing nor painting were known in those parts, everyone was astounded by what he had accomplished and he was, as a result, freed from the chains in which he had been kept so long. It was a glorious thing for the art of painting that it caused someone with the lawful authority to condemn and punish to do the opposite, giving his slave affection and liberty in the place of torture and death.

Released from the burdensome drudgery of household labor, Filippo was now charged only with painting and, delighting his erstwhile master with each fresh work, soon earned a position of honor and respect among the Berber people.

Eighteen months after his capture, Filippo was finally allowed to leave the Barbary Coast. Hopping on board a ship, he bade farewell to Africa and crossed the Mediterranean, finally disembarking in Naples, and from there he gradually worked his way back up through Italy to his native Florence. But while he had left the searing sun of the "Dark Continent" behind and was never again to smell the fetid aroma of crowded souks or hear the muezzin's haunting call to prayer, he had acquired an acute sensitivity for the exotic that would remain with him until his dying day. As he traveled north through the Italian peninsula, he would have been more alert to the "foreignness" of his own land than he had been as a mere boy.

Although Filippo may not have recognized it in his youth, fifteenthcentury Italy possessed a profoundly "international" character that it would have been difficult for him to ignore after his captivity in North Africa. In Naples-still a meeting place for the religions, cultures, and trades of the Mediterranean—Arabic was spoken by Moors from Spain, Hebrew was studied by scholars hungry for knowledge, and churches were heavy with the mysticism of Eastern Orthodoxy. In Florence, the "foreign" was, if anything, even more clearly evident. By the time Filippo returned to the city, it had become one of the most important crossroads of the world. Florence was a flourishing entrepôt: its markets bristled with pungent spices and luscious fabrics from the distant East; its merchants knew Constantinople, Moscow, and the Levant every bit as well as their native city; its palaces housed servants and slaves of every creed and color; and its streets and squares were abuzz with tales of strange and wonderful places far away. What was more, at the time Filippo reentered Santa Maria del Carmine, Florence was on the brink of playing host to the great Ecumenical Council that Gozzoli later celebrated in the Journey of the Magi to Bethlehem. Already, the streets would have been thronging with the bearded priests of Byzantium and the brightly colored silk caftans of the Eastern Empire's highest officials, while the taverns would have been filled with the buzz of Greek chatter and talk of the rapidly advancing Ottoman Turks.

Far from being cut off from the excitement of the wider world, cities like Naples and Florence, as Filippo would have recognized, were emporia in which the whole world was at play and in which people and ideas from the farthest-flung places came together. And just as his awareness of cultural exchange became more acute, so his art gradually began to reflect the interaction of the different societies he had encountered.

Painted in ca. 1438, the *Barbadori Altarpiece* (Louvre, Paris) reveals the extent to which Filippo was beginning to think in broader, crosscultural terms (Fig. 33). At first sight, it is a fairly typical example of earlyfifteenth-century Italian devotional art. In the center, the Virgin Mary stands on a slightly raised platform holding the infant Christ, receiving the prayers of the kneeling saints Augustine and Frediano. On the left and the right appear a host of angels and cherubs. But a closer look reveals a multitude of other, quite distinctly un-Italian features. There is a clear hint that Filippo was aware of recent developments in northern European art, which he had perhaps encountered through discussions with the many Florentine merchants who traveled there regularly.

In contrast to earlier Italian works, the figures are placed not against an impersonal gilt background but in a well-proportioned, accurately represented room, in the left-hand wall of which can be glimpsed a window looking out onto a rustic landscape, an innovation that was characteristic of the works of artists such as Jan van Eyck. More important, however, there is also a tantalizing sign not only of Filippo's continued fascination with the exotic but also of the extent to which he had come to understand religious norms in dialogue with the other cultures. Far from dressing her in a simple piece of cloth, Filippo gave the Virgin Mary a blue mantle with a finely painted golden hem that he adorned with a series of intricate symbols resembling an oriental script. Although meaningless, this lettering—an example of what is known as pseudo-Kufic-was intended to represent Arabic script and to endow the Virgin Mary with what Filippo (who would have encountered genuine Arabic in the Hafsid kingdom) perceived to be an authentically "Eastern" appearance, irrespective of the "Western" dress of the other figures. In that one, simple detail, East and West seem to have been brought together with sensitivity, care, and revealing astuteness.

> The Discovery of the "Other": The Renaissance Goes Global

Filippo Lippi's supposed experiences in Barbary show that, quite apart from being an age of tremendous artistic innovation, the Renaissance was also a period in which the boundaries of the known world were coming crashing down.

From antiquity through the late Middle Ages, Italy's heritage, trading links, and geographical position had brought it into frequent contact not only with other regions of the Mediterranean basin but also with much farther-flung reaches of the earth. From the writings of classical authors such as Pliny and Strabo had come knowledge of Alexander the Great's campaigns through Persia to the banks of the Indus, and of the distant provinces of the Roman Empire, extending from the northern shores of the British Isles to the scorching deserts of Nubia, and from the Atlantic coast of Spain to the shores of the Caspian Sea. From the commerce, confusion, and warfare of the Middle Ages had come a deeper familiarity with the fading splendor of the Byzantine Empire—the remains of which are still visible in the South and the former Exarchate of Ravenna—and an acquaintance with Muslims in al-Andalus, Sicily, Egypt, and the Holy Land, and with the strange, frozen wastes of Kievan Rus'. And from the sudden shock of the Mongol invasions of the thirteenth century, the medieval Italian mind had recovered the materials to extend the geographical limits of the imagination yet further. Facilitated by the Pax Mongolica, the Spice Road across central Asia to China had been opened up once more, and inquisitive explorers—including the Franciscan William of Rubruck and the Venetian Marco Polo—had brought back firsthand accounts of the outer edges of the earth.

Yet while medieval Italy was "wired in" to the wider world, as it were, the erratic, intermittent, and often violent nature of many of the most important routes for the transmission of knowledge not only guaranteed that links with other cultures were patchy at best, but also ensured that perceptions of the non-Italian world during the later Middle Ages remained dominated by the fantastical, the magical, and the downright unbelievable. Despite including a great many accurate and well-observed details, Marco Polo's account of his travels was, for example, riddled with fabulous inventions that owed more to the author's overexcited imagination than to any actual experience. Tales are told of unicorns, men with "tails full a palm in length . . . as thick as a dog's," a valley filled entirely with diamonds, and islanders who have dogs' faces, while even so recognizable an edifice as the Great Wall of China is shrouded in wild, mythological speculation. Such fanciful absurdities were far from being untypical. The world of the imagination was filled with extraordinary and implausible characters. The legend of Prester John-supposed to be a supremely virtuous and wealthy king who was descended from one of the three Magi—played a disarmingly prominent role in shaping ideas of the Orient and sub-Saharan Africa, and-thanks to his reputed Christianity-even had a part in international policy making. Similarly, the many versions of the Alexander romance featured the Macedonian king having an affair with the queen of the Amazons in the Near East and being borne aloft in a cage carried by eagles. So, too, Idrisi, a twelfth-century geographer at the court of Roger II of Sicily, argued that gold was so plentiful in Japan than even dogs wore collars made of the metal, while the (probably fictitious) Sir John Mandeville drew on earlier writings for his descriptions of lands filled with phoenixes, weeping crocodiles, and men with heads in their chests.

The dawning of the Renaissance, by contrast, is often held up by historians as having signaled a radical break with earlier centuries. Although contact with other lands, peoples, and cultures had not been lacking in the past, the fourteenth century saw the beginning of an unparalleled expansion of the horizons of knowledge that pushed back the boundaries of understanding further than ever before.

It was not just that the rediscovery of classical literature exposed Italians to the "foreignness" of Greek literature and the greater learning of the ancient world. "Other" peoples-especially Jews from Spain, Portugal, and, later, Germany-were flooding into the peninsula, opening as they did so the doors to greater socioeconomic vibrancy and to medical, linguistic, and philosophical learning of immense value. But most important, travel was the real mainspring of the broadening of the Renaissance mind, and it was in this respect that Lippi's journey to the Barbary Coast seems to exemplify the spirit of the age. The East, in particular, became a realm of almost unique promise. As early as 1338, the Florentine traveler Giovanni de' Marignolli became the first person since Marco Polo to visit and return from China and—at the behest of Pope Benedict XII—opened up diplomatic channels and brought back much commercially useful information. Trade with the Armenian kingdom of Cilicia, the Mamluk sultanate in Cairo, the Hafsid kingdom of North Africa, the Timurid Empire in central Asia, and the rising Ottoman Empire grew exponentially, catalyzing a passion for greater and more reliable knowledge of the peoples, languages, and customs that were encountered with mounting regularity. Sub-Saharan Africa, too, seemed suddenly to burst into life as travelers crossed the desert and the seas in pursuit of new lands and new riches. But it was in the West that the greatest strides were taken. After the settlement of the Canary Islands by Lancelotto Malocello (from whom Lanzarote takes its name) in 1312, all eyes looked toward the setting sun as thoughts turned to discovering another sea route to China, and it was left to the Genoese Christopher Columbus and his successors to reveal the true, breathtaking novelty of the Atlantic territories. In place of the mythmaking ignorance of the past, there emerged an increasingly rich and detailed picture of a world that was bigger, and more exhilarating, than anyone had ever imagined.

Historians have placed considerable emphasis on the colossal extent to which knowledge of "foreign" lands grew from the fourteenth century onward in giving shape to their notions of the Renaissance as a whole. In a sense, it has been only reasonable to see the pursuit of naturalism in art as having a counterpart in a growing consciousness of the realities of the wider world, and since the beginnings of modern critical scholarship the very idea of the "Renaissance" has been intimately connected with the idea of "discovery." As far back as the eighteenth century, for example, Girolamo Tiraboschi identified the broadening of intellectual and commercial horizons through exploration as one of the period's greatest, and most defining, characteristics. In the next century, the great Swiss historian Jacob Burckhardt followed Tiraboschi's lead and made what he termed the "discovery of the world and of man" central to his conception of the Renaissance. Today, when the advance of cross-cultural studies has eroded the excited spirit of Romanticism and Enlightenment, scholars continue to assert that the Renaissance was, indeed, the beginning of the "age of discovery," and despite expressing certain reservations, Peter Burke, for example, has not hesitated to draw a connection between the two.

The importance of the identification of "Renaissance" with "discovery" lies not so much in the coincidence of the two phenomena as in the vital impact that the exploration of other lands and cultures is thought to have had on the character of the period, and in the degree to which attitudes toward the wider world changed as a result of intercultural exchange. For Tiraboschi, the "discovery of America" was every bit as important as the "discovery of books" and the "discovery of antiquity" in giving rise to the self-consciousness that he believed was integral to the very essence of the Renaissance. So, too, Burckhardt made the broadening of intellectual horizons the centerpiece of his conception of Renaissance individualism, and although the work of scholars such as Edward Said has done much to bring to light the mutual nature of culture exchange, more modern historians have shown a general willingness to sustain the identification of the two. It has even been suggested that it would have been impossible for the men and women of the Renaissance to have been aware of their own distinctive identity without a clear and sophisticated knowledge of the "other."

The reason for this is not hard to appreciate, and it is indeed difficult to avoid the sense that here, at last, is one aspect of the Renaissance that lives up to familiar preconceptions of the period. Despite the grim realities of Renaissance society, it has been thought that the discovery

of new lands served to produce a fresh sense of openness and tolerance that found expression in both literature and the visual arts. Coming into contact with new peoples and cultures, Renaissance Italians, it has been argued, began to question their preconceived notions of humanity more intensively. When they were confronted with the civilization of the Ottoman Empire, the strange customs of Javanese islanders, and the unfamiliar habits of North American Indians, chauvinism was supplanted by a growing awareness that when superficial differences were stripped away, there was, in fact, an unchangeable human nature that was common to all men. Not only did this contribute to the development of the Renaissance conception of man as an independent, creative individual (most clearly evident in Giovanni Pico della Mirandola's Oration on the Dignity of Man), but it also went a long way toward weakening the fantastical prejudices of previous centuries. Men were men, no matter where they came from, and all had the same potential to reach the dizzy heights of human achievement envisaged by the Florentine Neoplatonists. Some, like Pico della Mirandola, were even moved to speculate about whether Christianity did not, in fact, share more with the pagan religions of diverse cultures than had previously been thought.

At first glance, the *Barbadori Altarpiece* and Vasari's account of Filippo Lippi's adventures in Barbary appear to fit nicely with this interpretation. By including a pseudo-Kufic inscription in his painting, Lippi seems to demonstrate his awareness of Muslim and Levantine culture, and to acknowledge a certain shared heritage linking Christian and Near Eastern traditions. That the Virgin Mary wears a distinctly Arabic-looking mantle points both to a certain willingness to root early Christian history in its proper geographical context, and to a recognition that both Christianity and Islam had common roots. Similarly, Vasari's decision to integrate the story of Lippi's captivity in the Hafsid kingdom of North Africa into his biography of the artist appears to testify to a sense that the aesthetic judgment of other peoples could evidence the talent of an Italian painter and a belief that the "foreign" was not altogether alien to the life of an artist.

Parallels are not hard to find, and the numerous literary examples are, perhaps, especially striking. As early as the mid-fourteenth century, hints that the horizons of the imagination were broadening to include a more positive view of other peoples and places became visible in Boc-

caccio's Decameron. In the first book, for example, a Jew named Abraham serves to illustrate the hypocrisy of the Church in Rome, while a co-religionist called Melchizedek outsmarts Saladin in the very next tale. Later in the collection, an even wider range of locations are chosen as settings for Boccaccio's tales, and the starring characters-among the most impressive and dramatic in the entire work-are both "foreign" and familiar. Thus, the reader is introduced to the sultan of Babylon's diplomatic links with the king of the Algarve, to Genoese trade in Alexandria, to the shipping interests of the king of Tunis, and to the dramas of everyday life in Cathay. So, too, the deliciously lusty tale of Alibech and Rustico (see chapter 5) takes place in Gafsa, in modern Tunisia, while the elopement of three beautiful sisters culminates in high drama in Crete. Such tendencies only became more pronounced in later centuries. Boiardo's Orlando innamorato (ca. 1476-83), for example, begins with the arrival of Angelica, the daughter of the king of Cathay, at Charlemagne's court and has as one of its main themes the struggle between her father and the Tartars, and between the Franks and the Moors. Similarly, in Tasso's Gerusalemme liberata (1581), the Christians' Muslim enemies in the Holy Land are accorded a degree of chivalry that is hard to ignore.

Examples from the visual arts are, however, certainly not lacking. It was not merely that paintings such as Gozzoli's Journey of the Magi to Bethlehem included both striking depictions of the Byzantine court and a liveried servant of obvious African descent. Familiar myths were, for example, also adapted and augmented to take account of growing knowledge of other lands. Depictions of the Cappadocian saint George-whose story not only was shared by different Christian traditions but also served as a cipher for East-West relations by virtue of the dragon having supposedly been slain in Libya-became a particularly prominent vehicle for the display of Near Eastern dress and crosscultural exchange. In this vein, Vittore Carpaccio's scenes from the life of Saint George, painted for the Chapel of Saint John in Venice in ca. 1504-7, included a host of turbaned Muslims set in an urban landscape that is a curiously revealing blend of the Italianate and the "oriental." Similarly, in Pinturicchio's Disputation of Saint Catherine (ca. 1492-94), painted for the Sala dei Santi in the Vatican's Borgia Apartments (Fig. 34), the emperor is shown surrounded by figures reflecting the full gamut

of late-fifteenth-century Mediterranean cultures, such as Greeks, North African Muslims, and Turks, an image that seems positively to radiate a sense that a world was being discovered without barriers of any kind.

Forever Foreign?

Yet as with so much else in the Renaissance, appearances are bewilderingly deceptive. Attractive though it may be to equate discovery with knowledge, and knowledge with tolerance, it's important to remember that such connections are more a testimony to modern sensibilities and Romantic tendencies than they are to Renaissance attitudes. Dramatic and extensive though the discoveries of the period may have been, there really was no objective reason why greater exposure to "foreign" cultures should either erode long-held and deeply felt prejudices or impinge on the moral standards of the day. The emergence of a genuine sense of intellectual curiosity about the world could quite easily coexist with ignorance, hatred, and exploitation. Far from looking on new lands with wide-eyed naïveté, travelers often saw exactly what they wanted to see and interpreted the scraps of what they saw through the lens of inherited ideas. What was more, the relationship between Renaissance travelers and foreign cultures was often framed by political conflict, economic self-interest, or cultural parasitism. Although information was accurately recovered and appreciated for its own sake on occasion, misunderstandings abounded, myths were adapted to take account of changing circumstances, and fresh forms of bigotry were crafted to take the place of the old with equal frequency. And as a result, lurking beneath the surface of those artworks that seem so innocent and openminded is a host of altogether more surprising and unpleasant views.

Regardless of how they initially appear, Lippi's *Barbadori Altarpiece* and Vasari's biography conceal signs not only that understanding was still tempered with ignorance, but also that relativism and tolerance were wafer-thin veneers for crude bigotry and unseemly prejudice. Whatever the nature of Lippi's acquaintance with Islamic culture, the *Barbadori Altarpiece* does not seem to point to any genuine sympathy. Intriguing though the pseudo-Kufic script on the Virgin's hem may be, it remains a rather crude and amateurish imitation of Arabic orthography and does not attempt to be anything more than a superficial stereotype capable of fooling the ignorant. An even more pronounced tendency to approach Islamic culture from the perspective of disdainful condescension is visible in the account of Lippi's life. Vasari's biography-which has proved impossible to verify from other evidence-is as much a display of ill-informed cultural caricatures as it is of intercultural relativism. While he might have accorded some weight to the aesthetic judgment of the Barbary slave master, Vasari's dramatization of that judgment relies on the persistence of notions of Islamic "barbarism." Even though the Muslim societies of North Africa consistently produced an exceptionally rich and varied range of artworks—from pottery and carpets to architecture, calligraphy, and manuscript illustrations-Vasari quite deliberately affirms that drawing and painting were totally unknown in the Hafsid kingdom, and goes so far as to make this manifestly absurd claim the linchpin of his biographical sketch. Not only is this caricature every bit as reliant on antiquated stereotypes as Lippi's own use of pseudo-Kufic script, but it also prioritizes the excitement of the narrative over accuracy to an almost ludicrous degree.

For both Lippi and Vasari, the imagination was still fenced in by the barriers of old. And yet their works are, in fact, perhaps among the "better" examples of artistic engagement with other cultures. Insofar as the arts were concerned, the fruits of discovery were mostly rotten. At the same time as Italian artists and writers came into closer contact with the wider world and experienced a greater sense of curiosity about the practices and habits of different peoples and religions, willful ignorance, hopeless prejudice, and rampant bigotry grew with mounting fervor and found expression in ever more insidious forms of art and literature.

The Florence in which Filippo Lippi lived and worked for the majority of his adult life was a microcosm of the environment in which Renaissance attitudes toward the "other" took shape. As one of the epicenters of international commerce and a crucial cultural center, the city was the locus for comings and goings from the farthest reaches of the known world, and was in the throes of the momentous changes that would transform the period's intellectual outlook beyond all recognition. But at the same time, these factors ensured that it was also the nexus for the development of the more unpleasant dimensions of crosscultural exchange.

The better to illustrate this, each of the following chapters will take one example of an encounter with "foreign" peoples (Jews, Muslims, black Africans, and Atlantic cultures) in Florence at about the time Lippi was completing the *Barbadori Altarpiece* as a starting point for setting the Renaissance relationship with the wider world in the broader context of culture, society, and ideas. And as the broadening horizons of Lippi's Florence are uncovered, it becomes clear that hidden beneath the civilized and sophisticated surface of contemporary art and literature lurked a very ugly Renaissance indeed.

SALOMONE'S CRIME

II

ALOMONE DI BONAVENTURA was a prosperous and, by all accounts, upstanding member of the community in earlyfifteenth-century Tuscany. He always put his family first. He was a dutiful son and was a good and caring husband. He was also a proud father and doted on his two young boys with a touching concern for their education and well-being. Like any decent chap of the period, Salomone worked hard to make sure that they wanted for nothing. Having gone into business with his own father, Bonaventura, in 1422, he had built a career as a successful moneylender whose honesty and integrity were respected by clients and partners alike.

The bulk of Salomone's business was done in the little town of Prato, about ten miles from Florence. Regular as clockwork, he handed over the annual payment of 150 florins to the Florentine treasury for the renewal of his license and ran a thoroughly respectable trade with few causes for complaint. Of course, like anyone, he had the odd enemy. But in itself this was nothing to worry about. Florence was a hotbed of malicious gossip and petty backbiting, and the competitive world of Renaissance commerce had always been riddled with jealousies and rivalry.

By 1439, Salomone was keen to expand his business. Profits had been rising steadily, and having purchased a privilege from the papal chancellery allowing him to extend his operations to Borgo San Sepolcro in 1430, he was now looking for fresh opportunities. Treasury officials had already hinted that he might soon be able to set up shop in Florence itself, and when his friend Abraham Dattili unexpectedly approached him about forming a partnership to lend money at the invitation of the Florentine government, Salomone jumped at the chance. It was too good to pass up.

From the surviving evidence, however, Salomone appears to have been a cautious man. Perhaps conscious of the fact that certain Floren-

291

tines might try to undermine him if he was too obvious about his ambitions, Salomone took the precaution of putting his sons' names down instead of his own when the contracts of incorporation were drawn up. It was, perhaps, a wise thing to do. At the time, the practice of money lending was strictly regulated, and although he himself did not yet have permission to trade in Florence, Salomone appears to have believed that by administering the business on his sons' behalf, he would be sure of staying within the bounds of the law.

For two years, everything went smoothly. But then, in 1441, Salomone's world suddenly and dramatically fell apart. What he thought was the perfect scheme really wasn't. Without any warning, he was hauled in front of the courts in Florence and falsely accused of breaking the law. Although his children were officially Dattili's partners, the prosecutors pointed out that Salomone was actually running the business. And since Salomone did not have permission to lend money in Florence, they said, he was clearly perpetrating a crime. Valiantly, Salomone tried to argue that since he had never traded in his own name, but merely on his children's behalf, he had done nothing worthy of censure. He was convinced that legal niceties would win through, and that trained lawyers would have to respect the city statutes. It was clearly a trumped-up charge lacking any basis in reality.

But Salomone could not have been more wrong. It didn't matter that he was innocent. The trial was a fix from the very beginning. Having set its heart on buying the town of Borgo San Sepolcro, the Florentine government needed money, and since it couldn't raise the necessary sum by any legitimate means, the priors were determined to steal it from a suitably rich patsy. Salomone was the sacrificial lamb, and the court's sole purpose was to strip him of every last penny.

Brushing his objections aside with a disdainful wave of the hand, the judge found Salomone guilty and handed him a fine of 20,000 florins. It was an incredible sum. It was twice what Giovanni di Bicci de' Medici had lent Baldassare Cossa to bribe his way to the papacy only thirty years before. It was, in fact, more than a king's ransom. Salomone was ruined. His dreams were destroyed, his family left destitute.

News of the trial would have spread fast. But it is doubtful that anyone would have been surprised or even particularly bothered by the miscarriage of justice. Far from it. The chancellor, Leonardo Bruni, had been kept informed about the progress of the trial, and—perhaps because he was excited by the prospect of acquiring Borgo San Sepolcro—his letters clearly show that he believed Salomone's condemnation to have been entirely justified. Yet it wasn't that Bruni and the Florentines seriously believed he had broken the law. Rather, everyone would have known he was being punished for a quite different offense. Salomone's "crime" was simply that he was Jewish.

TUSCANY AND THE JEWS

Despite his unusual prosperity and even more unusual persecution, Salomone di Bonaventura was a fairly typical member of Renaissance Italy's thriving Jewish community, and given the society in which he had grown up, it was perhaps only natural that he should have expected fairness and justice from the Florentine court.

Jews had been resident in the peninsula since antiquity, and a fairly steady, although unremarkable, population appears to have been present in various cities through the Middle Ages. As the Renaissance began to get under way, however, the number of Jews living in Italy started to rise steadily. Forced to flee their homes in Spain, Portugal, and (later) Germany, they were attracted by the growing prosperity of Italian towns. The North, especially, seems to have exerted a particular pull. Cities such as Bologna, Venice, Padua, and Milan welcomed Jewish groups not only from across the Alps but also from Rome and the kingdom of Sicily. By the mid-fifteenth century, it has been estimated that there were more than two hundred Jewish communities extant in northern Italy alone.

In contrast to many other regions, such as Emilia and Lombardy, Tuscany did not have a particularly long history of Jewish settlement, but it, too, found itself the beneficiary of considerable immigration, and it is more than likely that Salomone's father, Bonaventura, was among the many Jews who moved to Prato in the early fifteenth century. The commercial boom offered unrivaled opportunities for the growth of new businesses, and many of the trades in which Jews of the period tended to specialize found a natural home in the urban landscape of fifteenth-century Tuscany. At the time Salomone was embarking on his career as a moneylender, some four hundred had set themselves up in Florence, and perhaps only slightly fewer in Prato itself.

It was not the largest Jewish population in Italy—around 1,000 could be found in Venice, while no fewer than 12,500 were resident in the Papal

States at about the same time—but Jews nevertheless constituted a lively and vibrant part of urban society. In Florence, the majority tended to live in the northeast of the city, clustered around the site of the modern synagogue in the vicinity of Santa Croce, but a significant number of the less prosperous also found homes in the narrow, crowded streets near Filippo Lippi's convent in Oltr'Arno. Quickly putting down roots, they integrated themselves into the fabric of Florentine life with admirable speed and tremendous efficiency. As one historian has observed, "By the middle of the fifteenth century, it had become extremely difficult to distinguish Jews from Christians. They spoke the same language, lived in similar houses, and dressed with an eye to the same fashions." Indeed, "Jews who settled in Italy from German cities were . . . shocked by the extent of assimilation among their Italian co-religionists." This was, of course, no more true than of those Jews who practiced the most highly respected professions (such as medicine) or whose success in commerce put them on a par with Florence's wealthiest bankers, and the Jewish elite found a ready place in the upper echelons of civic society. Even from the few details known about his earlier life, it is at least clear that Salomone di Bonaventura was among the most readily assimilated.

Jewish integration into the urban life of northern Italian cities was undoubtedly facilitated by the valuable roles they played in Renaissance society. Taking advantage of the city's commercial prowess, many of Florence's Jews embarked on careers in speculative trade (particularly in precious stones and metals) and money lending, and it is no surprise that one of the earliest known Jewish residents, Emanuel ben Uzziel da Camerino, was engaged in exactly these professions. Often operating out of smaller settlements outside Florence itself, Jewish moneylenders, in particular, found themselves snowed under with clients. Since usury laws technically forbade Christians to charge interest, Jewish moneylenders fulfilled a necessary economic function, and because they were frequently willing to lend where others would not, they provided much-needed oil for the wheels of the Tuscan economy. Injecting essential capital into ventures of all sizes, some-like Salomone di Bonaventura-became so prosperous as a result that they were even able to extend loans of a scale to match that of the more established merchant bankers, and it was, indeed, Jewish moneylenders who were called upon to provide Pope Martin V with funds when Christians were unable to meet his requirements.

Yet the roles played by the Jewish community in Italian—and especially Florentine—society also went far beyond commerce. Jews often possessed skill sets in an abundance that made them quite indispensable to social existence. Particularly in the later Renaissance, Jewish doctors whose training had often brought them into closer contact with Arabic and Greek bodies of knowledge than their gentile colleagues—acquired a high standing and were much sought after. Elsewhere, such as in Mantua and Milan, "dynasties" of Jewish doctors proved themselves so invaluable that generations of medics were granted positions of favor and esteem at court.

Given the prominent role Jews played in Italian life, it was perhaps unsurprising that Jews should have enjoyed a certain measure of tolerance and respect that extended not only to commerce and patronage but also to the structures of law and politics. The papacy, for example, had long been eager to preserve the rights and privileges of Rome's Jewish population. As long ago as 598, Gregory the Great had declared that the Jews "should not encounter any prejudice with regard to those privileges that have been granted them," and this belief had moved thirteenth-century pontiffs to accord them the status of Roman citizens. Only three years before Salomone set up in business with his father—that is, in 1419—Pope Martin V had gone one step further and proclaimed that Jews

should not be molested by anyone in their synagogues; nor should their laws, statutes, customs and ordinances be interfered with . . . ; nor should they be molested in person or in any way beyond legal obligation; at no time should they be required by anybody to bear any distinctive sign.

As in Rome, so often in Florence. Though Jews were a distinct minority within the Florentine commune, their position was carefully set out in communal statutes, and they were occasionally entrusted with important ad hoc political positions when diplomatic or financial need required. Indeed, it is telling that one historian has been moved to observe that "by the standards of the age, Florence was a remarkably tolerant community," while another has optimistically noted that even toward the end of the period "the Jews felt protected by the legal system, and knew that they could find in the civil courts the principal defenders of their rights." It was not uncommon for Tuscan Jews to extol the merits both of Florence and of those Florentines who supported them, especially in later years. For the enthusiastically effusive Yohanan Alemanno, for example, Lorenzo de' Medici was a latter-day King Solomon, the archetype of the ideal Jewish ruler.

In addition to pragmatic concerns, there were powerful cultural reasons for cities like Florence to welcome Jews enthusiastically into the community. Particularly in the mid-fifteenth century, Jews played an increasingly important role in intellectual life. With many of them becoming influential humanists in their own right, they played a key part both as agents of cultural transmission and as disseminators of Hebraic knowledge. Following the itinerant life of many other contemporary scholars, Judah Messer Leon (Judah ben Jehiel Rofe; ca. 1420/5ca. 1498) wrote a number of important commentaries on philosophical works by Aristotle and Averroës, and composed a noted treatise on oratory (the Nofet zufim, or The Book of the Honeycomb's Flow) that drew on the paradigms of Latin eloquence and on Mosaic texts. In turn, Messer Leon's pupil Yohanan Alemanno (also known as Johanan Alemanno; ca. 1435-post 1504) was both the author of philosophically rich Kabbalistic commentaries on the Torah and an educator of some note, responsible for introducing Giovanni Pico della Mirandola-who "gathered a school of Jewish scholars who aided him in his search for religious syncretism"-to Hebrew.

Religious factors, too, provided strong encouragement for Jews to be welcomed into the social whole as equal and active participants in the drama of the Renaissance. It was, after all, an article of faith that Christ had been born a Jew and had been persecuted because of his supposed claim to be the "king of the Jews." It was impossible for even the crudest theologian to ignore the fact that—as Abrahamic faiths—Judaism and Christianity had common roots, and that the prophets of the Old Testament were celebrated in like fashion in the Torah. Later in the fifteenth century, Marsilio Ficino "maintained that the writings of Jewish Cabalists . . . were in agreement with the teachings of Christianity," and had no hesitation in writing of the shared truths of the two religions. Florentines were not ashamed of proclaiming the place of Jews within the Christian tradition in urban rituals. During the celebrations on the feast of Saint John the Baptist in 1454, for example, the pageant included a cycle of scenes from biblical history from the Creation to the Resurrection, each episode of which was represented by a group of prominent citizens thought to have particular ties to that moment in the religious drama. When it came to depicting Moses, the figure of the prophetic lawgiver was surrounded by "leaders of the people of Israel," all of whom were played by Florentine Jews. The city's Jewry, in other words, was accorded as visible a part in the celebration of Florence's urban identity as its Christian confraternities.

Such tolerance often found expression in the visual arts, and during the lifetimes of Salomone di Bonaventura and Filippo Lippi it was not uncommon for Tuscan churches to contain devotional works that not only testified to the shared features of Judaism and Christianity but also evidenced the cultural impact of social and legal integration. Of particular interest are depictions of the purification of the Virgin Mary and the presentation of Christ at the temple. This episode from biblical history was important in two respects. The story centers on a distinctively Jewish ritual. In contrast to Christian traditions, all Jewish women were required to go with their child to the temple to be purified in the eyes of the Lord within forty days of giving birth, and it was to fulfill this obligation as a dutiful Jewish mother that Mary took the baby Jesus to the temple. It was also a crucial moment in Christ's life. In the eyes of Christians such as Jacopo da Voragine, the presentation of the child symbolized the Virgin's humility before God, Christ's fulfillment of the Old Law, and the beginning of the Christian purification drama that was explicitly marked by the celebration of Candlemas. It was with an acute sensitivity for this bivalent meaning that Renaissance artists used this story as an opportunity both to underscore Christ's role as a bridge between Jews and Christians and to display an intense sensitivity for the norms of Jewish culture. Indeed, the Christian import of the scene relied on the artist's ability to emphasize the "Jewishness" of the drama. In the strikingly similar renditions by Ambrogio Lorenzetti (1342) (Fig. 35) and Giovanni di Paolo (1447-49)—both of which were painted in Siena but which are now in the Uffizi in Florence and the Pinacoteca Nazionale in Siena, respectively-the Virgin and Child are surrounded by key figures from Jewish history and practice. Preparing the offering in the center of Lorenzetti's painting stands a distinctively dressed high priest; above Mary appears a statue of Moses (who is also depicted on her left), bearing the tables of the Old Law; while above Christ can be seen a statuette of Joshua, the Jews' traditional deliverer, and to his left,

Malachi, who holds a scroll proclaiming his role as the promised son of God. Mary herself is endowed with identifiably Jewish characteristics that are shown in a markedly sensitive manner. In Lorenzetti's scene, she wears a richly embroidered dress in the Eastern style and carries a swaddling cloth that bears a passing resemblance to Jewish prayer shawls. Most important, Lorenzetti depicts the Virgin wearing earrings. Rarely worn by contemporary Christians, these were a visible sign of her belonging to the Jewish community, and of her being grounded in Hebraic law, while simultaneously bringing forth the Christian Messiah himself. Judaism and Christianity were thus woven together in a visual expression of tolerance and acceptance.

Bernardino's Rage

Despite the recognition of the common heritage of Judaism and Christianity, the source of Renaissance anti-Semitism remained religious in character. As far as churchmen like Filippo Lippi were concerned, it simply wasn't enough that Christianity grew out of Judaism: the Jews would always be different. Indeed, the very closeness of the two faiths emphasized that the Jews would forever be the "other." Although the Jews were believed to have stood witness to the truth of Christ's coming, the fact that they refused to accept Jesus as the Messiah who had been sent to fulfill the Old Law set them at an impossibly vast distance from the Christian faithful. As the rabidly anti-Semitic San Bernardino of Siena and his followers among the Observant Franciscans repeated ad nauseam from the pulpit of Florence's cathedral, no matter how much Judaism might otherwise have in common with Christianity, it would always be inferior, false, and even heretical so long as Christ's divinity was denied. It was a stain that could never be removed, and the metaphor of an impure mark was even written into artworks—like Lorenzetti's depiction of the presentation at the temple-that ostensibly presented Judaism in a positive light. While the whole point of Lorenzetti's altarpiece was to underscore the fact that Christ came forth to fulfill the Old Law that Moses had brought to the Jews, Mary's obviously Jewish appearance marked her out as standing at a distance from her own son and in need of purifying herself of the "stain" of her Hebraic heritage.

Indeed, for Christians like Filippo Lippi, the "problem" with the Jews was not simply that they denied Christ's divinity but that they bore

an inherited responsibility for Christ's persecution and death. The Passion drama—ritually and dramatically reenacted by Christians every Eastertide—revolved around Christ's betrayal by Judas and his unjust condemnation by the Sanhedrin. Since it had been unbelieving Jews who had tortured and killed the Son of God in antiquity, it was selfevident to Renaissance Christians that contemporary Jews—who also refused to accept Jesus as the Christ—bore the guilt of his suffering.

Yet the perception that Judaism was a wellspring of heretical untruth and inherited guilt did not exist merely as an abstract point; the very existence of Jewish "error" was thought to pose a pernicious threat to the Christian faith, and it was this that formed the basis of a more active variety of religious hatred. In the eyes of contemporary churchmen, Judaism was a disease that could all too easily spread throughout Christendom. Even if their influence on finance, culture, and medicine made them, in some sense, a "necessary evil" comparable to prostitutes, their presence in a Christian society was nevertheless held to be, at best, a serious risk to the integrity of the faith and, at worst, a malign cancer on the body social. It was this that was undoubtedly in the minds of Salomone di Bonaventura's unknown "enemies" in the years before his prosecution.

Inspired by the virulently anti-Semitic preaching of San Bernardino and his followers in the early fifteenth century, Florentine humanists believed it was incumbent upon them to find the right intellectual "medicine" with which to treat the Jewish "infection," and despite happily receiving loans, education, and treatment from the city's Jews, they devoted themselves to exposing and extirpating the falseness of Jewish belief. Even those Christian humanists who devoted most effort to learning Hebrew and who showed the most interest in the Kabbalah sought to annex the most sophisticated elements of Jewish thought to their own philosophy while acquiring an arsenal of knowledge that could be used to attack Judaism itself, both for the sake of encouraging conversion and for the purpose of downright persecution. In 1454—the very year in which the Florentine Signoria encouraged the Jews to take part in the carnival celebrations-Giannozzo Manetti penned the Contra iudeos et gentes, an unabashed attempt to use close biblical scholarship to attack the basic tenets of Hebrew thought and persuade the Jews of Florence to convert to Christianity. Later, Marsilio Ficino mined the Talmud, the Seder 'olam, and a selection of notable commentaries on

Hebrew theology for his *De religione christiana* but, like Manetti, did so primarily to hoist the Jews with their own petard, as he saw it. Though densely argued, the treatise was vituperative in the extreme and left no doubt about Ficino's belief in the absolute sinfulness of Judaism and the importance of stamping out the Hebrew faith for the sake of Christian truth. Jews, he claimed, had no excuse for their "heresy" and could expect mercy neither from God nor from man, for in the Mosaic Law they had been given the message that Christ came to fulfill, in the words of the prophets they had received foreknowledge of his coming, and in the signs attendant upon his incarnation they had seen clear evidence of God's will.

Yet while it was widely believed that invectives against the "errors" of Judaism could go some way toward staving off Christian apostasy and encouraging Jewish conversion, many of Salomone di Bonaventura's contemporaries felt that the threat posed by Judaism was more complex and subtle than it originally appeared. As San Bernardino continually stressed, it was not merely Jewish ideas but also—and more worryingly—the character of Jewish *practices* that endangered the Christian faith. Like a true disease, the "perfidious lies" of the Jews could, Bernardino stressed, be spread through contact with their daily habits.

Even to the most ignorant Renaissance observers, it was evident that the patterns of Jewish life were shaped by the complex series of rites set out in the books of the Talmud, many of which (particularly circumcision and food laws) were entirely alien to the Christian tradition, and all of which were thought to have the capacity to communicate the "illness" of Judaism to unsuspecting Christians, even though they were designed to protect the purity of the Jewish faith.

Since Jews had such strict dietary regulations, especially with regard to the preparation and consumption of meat, for example, it was thought that any Christian who inadvertently purchased animal flesh from a Jewish butcher ran the risk of being "contaminated" by the vendor's religion, and for this reason many cities legislated to ensure that each faith maintained its own, separate butcheries. Sex was no less pronounced an issue. The strictness of Jewish marriage rituals and the Hebraic preoccupation with purification ceremonies were turned back on the Jewish population to produce a total ban on sexual relations between Jews and Christians. And though prosecutions for this sort of "offense" appear to have been rare, the trials of those who were the victims of judicial attacks—such as Consilio, the son of Musetto, who was tried for having sex with prostitutes in Bologna in 1456 and in Lucca in 1467—indicate that Christian society was permeated by a latent sense of hysteria about cross-cultural promiscuity.

But in some instances Jewish ritualism was deliberately misrepresented as the already irrational sense of alterity was perverted yet further by the febrile imaginations of hate-fueled Christians. The most frighteningly absurd fabrications were invented, all of which were put to dangerous purposes and many of which found expression in the literary and visual arts. Among the more notorious stories was that recorded in Giovanni Villani's Nuova cronica and enshrined in Paolo Uccello's Miracle of the Profaned Host (ca. 1465–68), which was itself commissioned by Federico da Montefeltro as part of a broader campaign of anti-Semitic persecution (Fig. 36). In this patently ridiculous tale-which was itself a re-elaboration of the accusations of host desecration that had been leveled against Jews across Europe since at least 1247, and that had been a major feature of urban life in Germany throughout the fourteenth and early fifteenth centuries-a Jewish moneylender was supposed to have stolen a piece of the consecrated host from a nearby church and taken it home to cook for his family. On performing this most profane of actions, however, he was dismayed to find that blood miraculously poured forth from the bread and spread across his floor until it spilled out into the street. The sinister exsanguination having been spotted by passersby, soldiers were called to break down the door of the Jew's home while he and his impious family cowered in fear within. For all its falsity, Salomone's contemporaries felt that this story provided a clear illustration of the threat that Jewish rituals posed to Christian life.

For Franciscan anti-Semites like San Bernardino, the dangerousness of Judaism necessitated both the marginalization of the Jews and the strict segregation of Christian life from Hebraic traditions. This went far beyond the prohibition of sexual relations and the establishment of separate butcheries. Preaching in Padua in 1423, San Bernardino made the following, terrifying statement of his belief in the dangers of coming into contact with Jewish practices:

I hear that there are many Jews here in Padua; hence I want to state several truths about them. The first truth is that you commit a cardinal sin if you eat or drink with them; for just as they are forbidden to eat with us, so we must not consume food with them. The second truth is that a sick man seeking to regain his health must not repair to a Jew; for this, too, is a cardinal sin. The third truth is that one must not bathe together with a Jew.

Raging violently against the Jews of northern Italy, Bernardino and his followers asserted that it was necessary not only for Christians to avoid all contact with Judaic practices but also for Jews themselves to be marked out with sufficient clarity that all Christians would know to steer clear of them. This was, of course, not an altogether new idea. Since the Fourth Lateran Council of 1215, the Church had ordered that all Jews be required to wear a distinctive dress, and by 1257 the Jews of Rome (excepting doctors and a few other protected professionals) were obliged to wear circular yellow badges on pain of a hefty fine. Such early attempts to mark Jews so publicly were, however, rather halfhearted and never rigorously enforced. Finding it all but impossible to push through its designs, the papacy let things drop, and the cities of northern Italy were generally happy to forget all about it. But the vitriolic preaching of San Bernardino and the Observant Franciscans changed everything. Whipped into a frenzy of hatred for Jewish beliefs and practices, the cities of northern Italy hurried to enact a flurry of new anti-Semitic legislation. In 1427, Ancona forced all Jews to wear a yellow sign in response to the preaching of Fra Giacomo della Marca. Tracing the course of San Bernardino's itinerant preaching, Padua followed suit in 1430, and in 1432 Perugia, too, imposed tough dress laws. In 1439-the same year Salomone made his fateful agreement with Dattili—Florence itself was persuaded to introduce the same legislation, which was repeatedly reissued at various points after that, each time with greater severity. Indeed, in the next century, this frightening presentiment of the horrors of the twentieth century was to become so widespread that it would appear even in Michelangelo's depiction of Aminadab in one of the lunettes of the Sistine Chapel ceiling.

THE GREAT CRIME

Regardless of how well he had been integrated into Tuscan society, Salomone di Bonaventura would have been aware of a powerful sense of religious resentment against him whenever he traveled to Florence. Forced to wear a large yellow *O* on his left breast, he was marked out as a Jew and, even if he paid no heed to the jibes of the citizenry, would have been the unfortunate recipient of considerable prejudice. Yet what really paved the way for his ultimate persecution by the courts was a highly specific and extremely prominent refinement of growing anti-Semitic attitudes.

If the beliefs and rituals of Judaism were thought to pose a covert threat to the health of Christianity during the Renaissance, the Jews' commercial activities were perceived as an active danger to the wellbeing of Christian society. Money lending and usury were the greatest worry, even though it is somewhat surprising that Jews should ever have wanted to lend money to the Christians who regarded them with such hatred. Prejudices against Jewish moneylenders had existed in Europe since the Middle Ages, and the willingness to tar Jews with crude accusations of greed were decidedly old hat even by the early fourteenth century. In the thirteenth century, Saint Thomas Aquinas's ardent opposition to lending money at interest had given a theological basis to the widespread prohibitions on usury (see chapter 7 and above), and since money lending had become a business particularly favored by Jewish communities, such injunctions had often been the basis for waves of persecution. On at least two occasions during his reign, Louis IX of France ordered Jewish moneylenders to be arrested and their property confiscated to pay for the Seventh and Eighth Crusades, while Philip IV expelled all Jews from his kingdom on the basis of religious attitudes toward usury in 1306. So, too, Edward I of England's Statute of the Jewry (1275) forbade Jews to "blasphemously" lend money at interest, and the subsequent Edict of Expulsion (1290) was justified primarily with reference to the continuation of the practice. But the sudden and dramatic rise of money lending and merchant banking in early Renaissance Italy had given a new potency to this particular branch of bigotry, and the suggestion that by charging high rates of interest, Jews were somehow seeking to exploit "good" Christians out of a sense of religious or ethnic hatred acquired a distressing new vigor.

In the early fifteenth century, Observant Franciscans such as Giacomo della Marca (1391–1476), Giovanni da Capistrano (1386–1456), and Bernardino da Feltre (1439–1494) led the way in attacking Jewish usury and in giving this form of anti-Semitism a hideous veneer of public respectability. Once again, however, San Bernardino of Siena stood out both for the viciousness and for the popularity of his diatribes. In one particularly vitriolic sermon, he condemned the "concentration of money and wealth" into "fewer and fewer hands," and inveighed against Jews as the archetypes of anti-Christian usury with a fervor that would perhaps have made even medieval anti-Semites blanch. Firebrand sermons such as this set the tone for political action, and the Church's approval provided Florentine oligarchs with precisely the excuse they needed to make war on those Jewish moneylenders whom they viewed as dangerous business rivals or to whom they were indebted. Without sparing a thought for the hypocrisy of such policies, a campaign of political persecution was unleashed. In 1406—the year of Filippo Lippi's birth the Signoria promulgated a decree that categorically forbade any Jews to lend money at interest, a provision that was subsequently reissued for the sake of preventing "the poor people of Florence" from being "ruined" in 1430.

In practice, such decrees often proved unworkable. By placing harsh restrictions on usury, the Signoria unwittingly caused itself considerable financial damage. Without Jewish moneylenders keeping the economic wheels turning, the supply of credit quickly dried up, and the machinery of commerce groaned under the strain. Almost as soon as the decrees had been passed, exemptions were issued to allow some Jewish usurers to trade under license, while others were simply allowed to go on trading irrespective of legal restrictions, albeit with certain limitations on commercial practices and property ownership. It was these exemptions that permitted Salomone di Bonaventura to set himself up in business in Prato, and which created the conditions for the fateful partnership between Abraham Dattili and Salomone's sons in 1439. But far from restraining the vehemence of anti-Semitic sentiments, such experiences only compounded the hatred that was felt, and it was the visceral dislike of Jewish moneylenders that laid the foundations for Salomone's ultimate prosecution.

Later, however, even such monstrously disproportionate penalties were insufficient to sate the public passion for "vengeance." The mood was turning ugly. In March 1488, a vitriolic attack on usury by Bernardino da Feltre in the Duomo prompted a group of young men to launch a violent attack on a neighboring Jewish pawnshop, catalyzing a riot that was suppressed only with some difficulty. In such a febrile atmosphere, it was clear that more direct and wide-ranging measures were called for, and during the ascendancy of Girolamo Savonarola the monte di pietà was established in December 1495 as the first truly systematic effort to stamp out the "stain" of Jewish money lending once and for all. Modeled on the identically named bodies that had been set up throughout northern Italy since their first appearance in Perugia in 1462, the Florentine monte di pietà was essentially a state-run lending institution that offered loans to any reasonably respectable citizen who might apply. Its goal was to undercut the city's Jews without restricting the supply of credit, and so successful (if that is the right word) was the new strategy that Savonarola felt able to appropriate the worst forms of the rival Franciscans' arguments and to call for the outright expulsion of the Jewish population. Even at the time of Salomone di Bonaventura's prosecution in 1441, Christian artists such as Filippo Lippi would probably have seen a great deal of sense in such arguments, and would have found little to criticize about proposals for far-reaching reforms aimed at eliminating the "stain" of Jewish usury.

FROM HUMILIATION AND VIOLENCE TO THE GHETTO

As an expression of the virulent, hypocritical anti-Semitism that was endemic to early-fifteenth-century Florence, the trial and condemnation of Salomone di Bonaventura stands out as a powerful illustration of the cruelty that underpinned Renaissance perceptions of the "other." It was a short step to take from social stigmatization and economic marginalization to outright persecution. The casual hatred that was felt by so many fifteenth-century Italians, and that found expression in the art of Lorenzetti and Uccello, was shortly to metamorphose into something more chilling.

Thanks to the preaching of Observant Franciscans like Bernardino da Feltre, the prevalence of increasingly harsh anti-Semitism ensured that the limited tolerance of the past was replaced with a willingness to intimidate and humiliate Jews in an almost ritualized manner, and it became "fun" for Christians to torture the Jewish population in a grotesquely public fashion. Throughout the fourteenth century, for example, Jews had been integral to the celebration of the annual Roman *carnevale* and had been obliged to pay a special tax in atonement for the betrayal and persecution of Christ. But by the second half of the fifteenth century, anti-Jewish sentiments were sufficiently high for Pope Paul II to introduce an entirely new means of debasing the Jews into the carnival program in 1466. As the highlight of the five-hundred-meter races that were thenceforth held along the via Lata (now known as the Corso, literally "the Race"), Romans were treated to a special competition specifically for Jews. The "competitors" were obliged to run barefoot, wearing only a thin vest resembling a modern T-shirt. To ensure that Christian onlookers found it suitably amusing, the Jews taking part were frequently force-fed for hours before the race so that they would end up being sick and possibly even collapsing. As the years went on, further innovations were introduced to heighten the "entertainment." By the 1570s, as an English visitor later recorded, the Jews

runne starke naked . . . And all the way, [the Roman soldiers] gallop their great Horsses after them, and carie goades with sharpe pointes of steele . . . wherewith they will pricke the Iewes on the naked skin . . . [T]hen you shall see a hundred boyes, who have provided a number of Orrenges . . . [and] will . . . pelt the poor Iewe[s].

Worryingly, degrading episodes of public humiliation were just the thin end of the wedge.

Renaissance anti-Semitism was a powder keg, and it only took the smallest and most irrational of sparks to ignite a towering inferno of brutality. So intensive was the hysteria that had been stimulated by talk of strange rituals and heretical beliefs that violence was never very far from the surface of urban society, and Salomone was perhaps perversely fortunate that he lost only his fortune. But it was toward the end of the fifteenth century that the sporadic bursts of open aggression finally coalesced into a systematic pattern of persecution.

Shortly before Easter in 1475—that is, thirty-four years after Salomone's trial—a two-year-old Christian lad named Simon suddenly went missing from his home in Trent. His family was hysterical, and a huge search was initiated. But when little Simon's dead body was found in the cellar of a Jewish family's home on Easter Sunday, what had already become a tragedy metamorphosed into violent madness. Accusations of what was known as blood libel had been common in Europe since at least the early twelfth century, and having listened to a series of viciously anti-Semitic sermons delivered by Bernardino da Feltre only a few days before, Simon's father came to the conclusion that his son had been kidnapped by Jews, killed, and drained of his blood to use in certain, unspecified Passover rituals. All too ready to believe his accusation as a result of the historical fears of ritualized murder by Jews and the virulent prejudices with which Bernardino da Feltre had filled their minds, the city authorities immediately instigated an anti-Semitic manhunt. Eighteen Jewish men and five Jewish women were arrested and charged with ritual murder. The men were then subjected to months of horrific torture until, unable to bear the pain any longer, they "confessed." Thirteen of them were subsequently burned at the stake.

For his part, little Simon was later canonized, and the Church did its utmost to foster the growth of his cult. A spate of similar witch hunts against Jews up and down the Italian peninsula followed almost immediately. In common with many other cases of blood libel in earlier centuries (particularly in Germany), Simon's "martyrdom" served to validate all of the fears that Observant Franciscans like Bernardino da Feltre had been trying so hard to drum into a credulous populace, and effectively authorized the brutal and open persecution of the Jews. Indeed, the tragic story that unfolded in Trent was frequently commemorated in paintings and illustrations-for example, Gandolfino di Roreto d'Asti's Martyrdom of Simon of Trent (Israel Museum, Jerusalem)-as a means of ensuring that the perceived criminality of the Jewish "heretics" was ingrained in every Christian's mind and in the hope of guaranteeing that anti-Semitism would almost be consecrated as an article of faith. Preemptive violence was viewed with a certain measure of knowing approval.

More thoroughgoing attempts to marginalize, contain, and even exterminate the perceived Jewish "threat" were in the air. In the midst of the War of the League of Cambrai in 1516, Venice—the most cosmopolitan city in Italy—declared that Jews were to be confined within a new ghetto, which was the first of its kind in Europe and still stands as a visible witness to what would become more than four hundred years of continuous persecution. This trend only grew worse. As cities throughout Italy followed Venice's lead, Jews were expelled en masse from Naples in 1533. On Rosh Hashanah in 1553, all the copies of the Talmud in Rome were burned in public. Having banned them from *all* professions, Pope Paul IV used Jews as slave laborers in Rome, and as Luther's pernicious treatise *On the Jews and Their Lies* (1543) began to circulate, even those with protestant tendencies in Italy began to call for synagogues to be burned and Jewish houses to be destroyed.

* * *

Leaving the Palazzo Vecchio a ruined man, Salomone di Bonaventura walked out into a city that was basking in the radiance of Renaissance culture. It was a bustling urban metropolis, made rich by commerce, thronging with immigrants, and pullulating with artists like Filippo Lippi who were changing the world with their works. It was, moreover, the capital of a thriving territorial state that had gained much from cultural exchange between Jews and Christians. It would have been impossible not to have been dazzled by its sheer magnificence. But as Salomone's trial had illustrated, it was also a city in which wanton prejudice was growing in step with artistic innovation. Tolerance was little more than a facade that was kept in place only insofar as it satisfied the self-interest of Christians. No matter how much Jews like Salomone brought to Florence, they were regarded with disdain, contempt, and outright hatred, forced to wear humiliating yellow signs, pushed to the margins of society, and persecuted with complete disregard for justice. Indeed, Florence even seemed to revel both in its hypocrisy and in its bigotry. Churches were packed with altarpieces that showed Jews as strange, foreign, and reprehensible, while the city's monastic cloisters thronged with humanists who sucked Hebrew texts dry only so that their vitriolic pamphlets would meet with greater acclaim. In more senses than one, anti-Semitism was becoming an art form in Renaissance Florence.

What the embittered, broken moneylender could not know was that he was among the more fortunate Jews of the Renaissance. For though he lamented his misfortune and silently cursed the monstrous unfairness of his treatment, his co-religionists would shortly be ridiculed, confined, hunted, and killed on a scale that—despite some fluctuations in the later sixteenth century—would not be matched in Italy until the rise of Fascism. And what was worst of all, the artists of the period would lend their skill to celebrating—rather than condemning—this most shameful of episodes in human history.

THE RISING CRESCENT

12

N THE SUMMER of 1439, just as Salomone di Bonaventura was embarking on his ill-fated business relationship with Abraham Dattili and not long after Filippo Lippi had finished work on the Barbadori Altarpiece, Florence was visibly reaching out to the Islamic world. Indications of a vibrant two-way exchange with the "Muslim Empire"-encompassing everything from the lands of al-Andalus in Spain to the Hafsid kingdom, and from the Ottoman sultanate to the distant lands of Tartary-were everywhere to be found in the city's streets and squares. The grand palazzi of its richest citizens thronged with slaves and servants brought from Eastern shores, and hummed with the sound of alien tongues. Humanists gathered in convent cloisters were beginning to long for knowledge of Arabic texts, and church altarpieces like the Barbadori Altarpiece already included telling visual references to the culture of Islam. Merchants spoke freely of journeys across the seas to Alexandria, Constantinople, and beyond, into the dusty market towns of Timurid Persia. And, most strikingly of all, the markets were filled with a dazzling array of herbs and spices from the distant East. Filling the air with their pungent aroma were cloves from Indonesia, marjoram from Asia Minor, cumin seeds from the Levant, cinnamon from Arabia, and a host of other, even more exotic spices, such as cubeb and grains of paradise (Aframomum).

Islam and the West

As any Florentine observer would have been able to see, relations between the Italian peninsula and the kingdoms of the crescent had begun to bear forth tremendous fruits by the early fifteenth century.

Italians had been acutely aware of Islam both as a Mediterranean power and as a cultural and religious force for almost seven hundred years before Lippi's journey. Since the early Middle Ages, the Muslim faith had been a major force in European history, not only as a political and commercial player, but also as the object of conceptions of alterity and difference. It had been the invasion of al-Andalus from 710 onward that had brought Islam into contact with the Christian kingdoms of Western Europe for the first time, but it was the Arabs' arrival in Sicilv during the next century that had succeeded in embedding Muhammad's followers in the Italian imagination. Although Arabic raids had been launched against the island even before the fall of al-Andalus, divisions in the Byzantine hierarchy had allowed North African Muslims to embark on a full-scale campaign of conquest that culminated in Sicily's complete subjugation by 902. But even though this period of domination was to last only a little over a century and a half-brought to a close by the Norman conquest of southern Italy-it bequeathed a long-lasting legacy. The experience left a powerful impression on Sicily, and despite the years of fighting that had gone before, the doors had been thrown open to a genuine two-way exchange between Christian and Islamic culture. After the emirate of Sicily collapsed, a large Muslim population remained, and the cultural impact of Islam was so strong that many of its Christian kings felt compelled to learn Arabic and continued to patronize forms of art and architecture that bore the hallmarks of the Moorish style. Thanks largely to the influx of Arabic learning, the medical faculty at the University of Salerno towered above all other institutes of learning, and the impact of Arabic commentaries on Aristotle in particular set the philosophical development of the South apart from that of the North. But for all these positive influences, there was nevertheless a groundswell of contempt and even hatred. The experience of Sicily had brought home both the cultural "otherness" and the expansionist tendencies of Islam to Italy. The image of the Muslim as the most potent enemy of Italian Catholicism was cast in stone, and the idea that Italy was on the front line of a clash of cultures was given considerable currency. Medieval writings on history and geography were replete with commentaries that caricatured Muslims as barbaric heretics who threatened the very integrity of Christendom.

It was the Crusades, however, that propelled Islam to the forefront of the Italian worldview. The First Crusade was launched in 1095 with the express intention of recovering the Holy Land from its (admittedly, very tolerant) Muslim occupiers, and the waves of invasion that followed ensured that both Italians and their European counterparts came to perceive violent opposition to Islam as an obligation of their Christian faith. A multiplicity of insidious myths was generated to describe Muslims and justify hatred for their religion. The *Song of Roland*, for example, contended that "the Muslim loves not God, serves Mahound, and worships Apollon," while the *Gesta Francorum* accused Muslims of worshipping Muhammad himself as just one of a pantheon of gods. Tales were told of graven idols being set up in Christian churches, of magical cows being used to seduce believers into heresy, and of all manner of depraved sexual practices. "Barbaric" Muslims were even accused of being unmanly, effeminate characters, unworthy of respect, and the enemies of chivalric honor.

Yet despite the undoubtedly negative character of Christian perceptions of Islam in the Middle Ages, it seemed that the dawning of the Renaissance offered the opportunity for a more positive and constructive form of cultural exchange. Following the fall of the Latin Empire of Constantinople in 1261, the popular appetite for crusading ideology waned dramatically. As Giotto was first taking up his brush, few seriously entertained the belief that the Near East could-or should-be the object of military attentions, and even fewer were prepared to advocate anything like the all-out warfare of the past. Like it or not, the Muslim powers-though diverse and divided-held the Levant, and the Ottoman Turks were beginning to emerge as one of Anatolia's greatest forces, with designs set on Constantinople itself. What was more, as later medieval travelers had seen, Muslims of various stripes controlled the overwhelming majority of the territories between the Bosporus and China, and were not only massively diverse but also colossally strong in both military and economic terms. Now that merchant banking was beginning to emerge in the maritime republics of northern Italy, there was finally the means to embark on large-scale long-distance trade, and the quest for profit demanded a more sophisticated approach toward understanding Islam to achieve some sort of necessary coexistence, which became all the more vital as the years progressed.

Although Venetian traders had been doing business with the Muslim world for several hundred years, Italian merchants were really beginning to wake up to the immense amounts of cash that could be made from trade with the Near and Middle East by the early fourteenth century. With formal outposts already established in Constantinople and Pera, Venice and Genoa in particular were enthusiastically exploring the potential for importing raw materials (metals, alum, and so on), silks, and spices both via the maritime routes through the Black Sea and by land across Anatolia, while Florence and its competitors were beginning to appreciate the profits to be made from exporting finished cloths to Egypt and the Levant, and from importing grain and other much-needed foodstuffs. Indeed, by 1489, three-quarters of all the cloth produced in Florence was a modestly priced fabric that had been designed specifically to meet growing demand from the Ottoman Empire, a fact that naturally alerted Florentine merchants to the colossal importance of sustaining-if not expanding-commerce with the Turks, while the Ottomans' near monopoly on the supply of alum until the discovery of fresh reserves in Volterra in 1470 only served to further emphasize their central role in the Tuscan cloth trade. Slaves, too, were a major source of commercial interest, and both the Ottoman and the Mamluk kingdoms provided rich sources of indentured manpower through their own exploitation of neighboring peoples, such as the Tartars.

While the growing profitability of trade with Islamic-held territories drew cities like Florence into ever more ambitious commercial projects, political changes over the coming years intensified links between Italy and the Muslim East. With the Mamluk capture of the Armenian kingdom of Cilicia in 1375, one of the most important routes to the Silk Road fell into Muslim hands, and this vital source of valuable imports was accessible only through careful negotiation with its Islamic rulers. So, too, the massive expansion of Ottoman Turkish territory made it almost impossible to conduct any meaningful trade with southeastern Europe, the Black Sea region, or the Levant except through the maintenance of at least cordial relations with the sultans. By the close of the fourteenth century, the Ottomans had consolidated their grip on Anatolia and the Sea of Marmara and had surged up into the Balkans, and by 1453 had taken Constantinople itself. By the same token, Tamerlane's conquest of much of central Asia made the serious exploitation of commerce with the farther East contingent upon some sort of constructive engagement with the Timurid Empire. Diplomacy was essential to any sort of commerce. Having invested 5,000 florins in a trading venture with three relatives in 1452, for example, Cosimo de' Medici was eager to open negotiations with the Ottoman court to guarantee trading privileges, a strategy pursued with some energy by his grandson Lorenzo. So, too, Venice and Genoa both dispatched embassies to Muslim Constantinople in 1455 to plead for the rights to exploit the Ottomans' alum mines, essential to the cloth trade.

As this all gathered pace, knowledge became crucially important. In the earliest years of the Renaissance, a close acquaintance with the Muslim world was recognized as key. In his Pratica della mercatura, Pegolotti not only listed Muslim centers such as Alexandria, Damietta, Acri di Soria (modern Antalya), Laiazo d'Erminia (Ayas), and Torisi di Persia (Tabriz) as trading cities of vital importance to the ambitious merchant, but also devoted considerable time to describing the most profitable routes to follow between them. What was more, Pegolotti stressed the value of a good working knowledge of languages including Arabic, Persian, and Tartar, which were collectively the largest linguistic group other than the Italian dialects discussed in the treatise. Later, with the advance of the Mamluks and the Ottomans, the value of accurate information became almost incalculable, and commercial interests coalesced with the antiquarianism of the humanists to produce a powerful appetite for informative travelogues. Before the fall of Constantinople, it was "not uncommon for men of learning to travel to the Levant and record what . . . they had seen there." In 1419, for example, the Venetian merchant Niccolò da Conti went to Damascus, where he learned Arabic so that he could understand different cultures and traditions more easily. Traveling with Arab merchants, he then ventured to Baghdad and Persia (where he picked up the local language), before setting out for Southeast Asia, visiting India, Sumatra, Burma, and Java, and acquiring a wealth of useful knowledge about the spice trade and gold mining. Conti subsequently related his experiences to Poggio Bracciolini, who produced an exhaustive account that inspired many fifteenth-century cartographers-including the unusually brilliant Fra Mauro-to transform their understanding of the geography of the East. Later, the stream of humanistic travelers became a torrent, and travelogues of one complexion or another became one of the most vibrant forms of literature. Cyriac of Ancona (Ciriaco de' Pizzecolli), for example, was to record his experiences in the Near East in the most engaging and richly illustrated fashion after returning from travels throughout the Ottoman world in the service of the sultan, and figures including Guarino Veronese, Giovanni Aurispa, Francesco Filelfo, Cristoforo Buondelmonti, Bernardo Michelozzi, and Bonsignore Bonsignori were all to tread a similar path.

When the Ottoman capture of Constantinople brought Islam into direct conflict with Italian states, military engagement often served to bring the two cultures into closer contact. Forcing them to face the "other" across the battlefield, and across the negotiating table, it had the corollary effect of exposing Italians to the inner workings of Muslim society. Artists and humanists-particularly from Venice and Naplesjourneyed to the East in the wake of conflict. As part of a peace deal in 1479, for example, the Venetian Senate dispatched Gentile Bellini as a kind of roving cultural envoy to Constantinople, where he made a number of careful observations of the Ottoman court and even completed a striking portrait of Sultan Mehmed II (now in the National Gallery in London). Similarly, post-conflict diplomatic relations between Mehmed and King Ferrante of Naples resulted in Costanzo da Ferrara being sent on a comparable cultural mission in ca. 1475–78. There, Costanzo completed a series of important and revealing works, including a flattering portrait medal of the sultan (National Gallery of Art, Washington, D.C.) and a remarkably detailed study of a court figure (Standing Ottoman; Louvre, Paris) (Fig. 37). But conflict and divisions within the Ottoman court could also lead to even more profound exchange of personnel across the ravages of war. After an unsuccessful attempt to seize the throne from his half brother, Bayezid II, Cem Sultan (1459–95) was banished first to Rhodes and then to Italy itself. He was handed over to Pope Innocent VIII, and his captivity was ensured by regular, massive payments by Bayezid, but his presence in Rome opened the doors to a wave of fascination for all things Eastern in the Christian capital.

From time to time, however, the accidents of proximity could throw up rare but extraordinary occasions for cultural interaction between Christians and Muslims that transcended the limits of commerce and conflict. Echoing the tale of Filippo Lippi's capture and enslavement, al-Hasan ibn Muhammad al-Wazzan—a Spanish-born Muslim raised in Fez and better known as Leo Africanus—was offered as a gift to Pope Leo X after being seized by pirates in the early sixteenth century. In Rome, Leo Africanus acquiesced in attempts to convert him to Christianity and provided a valuable, firsthand insight into the character of the Arabic language and his native Islamic faith. With notable care, he completed a Latin translation of the Koran for Egidio da Viterbo and wrote an Arabic translation of the Pauline epistles for Alberto Pio.

But if high-profile individuals went back and forth between East and West with increasing ease and frequency during the Renaissance, there was also a more mundane—though no less important—exchange of personnel. The reignition of the slave trade in Italy served to make Muslims of all stripes seem a good deal less "foreign" to Renaissance Italians. Indeed, by virtue of the vicissitudes of conquest and trade agreements, the overwhelming majority of the slaves trafficked across the eastern Mediterranean were Muslim, and it was by this route that many wellto-do merchant households in northern Italy came to own a Muslim slave. While the status of slaves in Italian society perhaps precluded any meaningful exchange of ideas and customs, the fact of an Islamic presence—of whatever legal character—helped to rob the peoples of the East of some of the mystique with which they had previously been surrounded, and made their dress, habits, and language more familiar to Italian society.

From the early fourteenth century onward, trade, diplomacy, politics, war, and even coincidence all conspired to bring Islam-and especially the culture of the Ottoman Empire-into sharper focus than ever before. Knowledge of the Muslim world was growing exponentially, and it was not long before an appreciation of the Near and Middle East began to make itself felt both in literature and in the visual arts. Particularly due to its commercial links to the eastern Mediterranean, Venice was especially receptive to Islamic influences, and although it is perhaps harder to uncover the precise trajectory of cultural transmission than some have supposed, it is certainly not difficult to sense a palpable effort to integrate the forms and motifs of Muslim buildings into the architectural fabric of the Serene Republic. In the tracery of palatial windows along the Grand Canal and in the haunting interior spaces of San Marco can be found a willingness to absorb, assimilate, and transform the artistic achievements of the Islamic world. So, too, with painting. Even from the portraits painted by Bellini and Costanzo da Ferrara, it can be seen that Italian art began to show a much greater enthusiasm for both the inclusion and the accurate representation of Muslims from the Near and Middle East, be they Ottoman courtiers, Mamluk soldiers, or Timurid subjects. In Ambrogio Lorenzetti's fresco the Martyrdom of the Franciscans for the church of San Francesco

in Siena, for example, care has been taken to depict both Mediterranean Moors and the Tartars who had recently conquered the port of Tana in as realistic a manner as possible. Later, Gentile and Giovanni Bellini's Saint Mark Preaching in Alexandria (Pinacoteca di Brera, Milan), painted in ca. 1504-7 (Fig. 38), is-despite its conscious echoes of Venetian architecture-the product of an assiduous study and appreciation of Muslim costume and mores. But the impact of Christian-Muslim cultural exchange can also be detected in more varied and subtle features of the visual arts. In a refreshingly daring and original study, Lisa Jardine and Jerry Brotton have, for example, detected strong signs that the equestrian art of the Renaissance was as heavily influenced by contact with the Islamic world as it was by a knowledge of classical sculpture. Yet one of the most intriguing-and perhaps unexpected-instances of the open-minded assimilation of Islamic influences is provided by the appearance of oriental carpets in Italian paintings. From the fourteenth century onward, growing contact with the Near and Far East led artists to integrate depictions of Persian and Turkish floor coverings into their scenes as an indication of the status of the subject or the location of the drama. Works such as Carlo Crivelli's Annunciation. Piero della Francesca's Montefeltro Altarpiece, and Lorenzo Lotto's Alms of Saint Anthony, for example, all feature richly decorated oriental rugs of various types and seem to testify to a genuine sense of a positive meeting of cultures.

Clash of Civilizations

But if the growth of knowledge and cultural exchange evidenced by such artistic representations of the Muslim East has led some scholars to posit that the Renaissance witnessed the collapse of negative, "orientalist" attitudes toward the Islamic world, and the fragmentation of earlier prejudices, the veneer of tolerance was only wafer thin. Behind the facade of openness and assimilation lurked a degree of intolerance toward and hatred for Islamic culture that far surpassed anything that had been witnessed before. Indeed, "Renaissance thinkers adopted an attitude toward Muslims that was more hostile on the whole than was that of their medieval predecessors."

As with the Jews, the fundamental obstacle to the acceptance of Muslims as true cultural partners was religion, and this fact alone facilitated the perpetuation of earlier prejudices. However much or little individ-

ual humanists knew about the details of Islamic theology, they were fully conscious that Muslims denied the divinity of Christ, and as such perceived Islam's very existence to strike at the heart of all that they held dear. Indeed, for precisely this reason, humanists of the fourteenth and fifteenth centuries felt justified not only in likening Islam to the greatest heresies in history (Judaism and Arianism) but also in attacking Muhammad himself as being a vicious, lust-driven adulterer hell-bent on sin and deviance. In the De vita solitaria, for example, Petrarch condemned the Prophet as "an adulterous and licentious fellow," a "wicked, infamous robber," a "butcher," the "creator of a wicked superstition," the author of "poisonous teaching," and "an accomplished voluptuary and an instigator of every obscene lust." Writing a century later, Pope Pius II offered a yet more ludicrous and critical view of the origins of the Islamic faith that missed not a single opportunity to tarnish it with the stain of heresy and sin. Pius not only drew attention to the Prophet's rejection of the doctrine of the Trinity but also asserted that

Muhammad [was] an Arab steeped in gentile error and Jewish perfidy, who received instruction in the Nestorian and Arian heresies. He advanced his fortunes by seducing a rich widow and grew notorious for his infidelities; his reputation attracted a band of brigands to his side, and with their help he made himself lord of the Arabs. Acquainted as he was with the Old and New Testaments, he perverted them both; he had the effrontery to call himself a prophet . . . He cast such a spell over this primitive nation that he was able to persuade them to abandon Christ the Savior and accept instead the new religion he devised for them. To this end he employed magic spells and tricks and gave his sanction to sex in all sorts of unspeakable combinations; by these means he easily seduced the common people, who are slaves to sensual pleasure.

Not merely a false prophet, but also a heresiarch, a witch, a thief, a tyrant, and a sexual deviant, Muhammad was also, Pius and his contemporaries believed, the source of all that was opposed to the Christian religion and the purest evidence that all Muslims were "enemies of the Cross." The sins of the Prophet were, by implication, the sins of his believers: to condemn one was to condemn all.

Whereas the coexistence of Christians and Muslims in the crusader states of the Middle Ages had predisposed many medieval historians to make a careful study of Islamic history in both its religious and its secular forms, the Renaissance humanists' interest in writing the history of the Muslim peoples was not matched by a comparable interest in acquiring a reliable understanding of the Muslim past. Despite the massive amounts of knowledge at their disposal, early-fifteenth-century historians such as Andrea Biglia and Flavio Biondo "took little interest in the accuracy or even the historical plausibility of the narratives of Islamic history they constructed." Their objective was not scholarly but polemical, and their tone was vituperative in the extreme. They sought simply to use pseudo-history to present Muslims-especially the Mamluks and the Ottomans-as barbaric, almost subhuman peoples who embodied the very opposite of civilization, and who existed simply for the sake of inflicting cruelty and suffering. Brushing aside both the evidence of eyewitness testimonies and the accounts found in classical treatises, the humanists took the very worst fantasies from medieval texts, stripped away anything that was balanced or reasonable, and amplified the bad with a liberal dose of bile. Thus, even a figure such as Niccolò Sagundino—who had actually spent some time in Ottoman society-could ignore his own experience and instead depict the Turks as a people who had always been evil, barbaric, and savage. For the humanists of the age, there was no such thing as a good Muslim, and there never had been, either.

To the Death

Renaissance humanists were filled with a burning desire to rekindle the flames of the crusading movement, and longed to recapture Jerusalem from the Egyptian Mamluks. Throughout the early fourteenth century, the idea of launching a new crusade had been mooted by various European powers on several occasions—most notably by King Philip IV of France, who claimed he wanted to swap France for Jerusalem—but because of their unusually strong links with the East, the early humanists soon began to take the lead in whipping up popular agitation for brutal reprisals against the Muslims. In the wake of calls announced at the Council of Vienne, for example, a Venetian merchant named Marino Sanudo Torsello presented Pope John XXII with a copy of his

recently completed Liber secretorum fidelium crucis (The Book of the Secrets of the Faithful of the Cross) in 1321. Bursting with pious exhortations and virulent hatred, the treatise explained the need for the "protection of the faithful, the conversion and destruction of the infidel, and the acquisition and retention of the Holy Land." It struck a chord. Within a very few years, humanists up and down Italy were calling for a fresh expedition against the Islamic occupiers of the Holy City. Petrarch was among the most enthusiastic. Despite having passed up an opportunity to go on a pilgrimage to the Levant, he vented his pent-up fury at the Islamic faith in a lengthy digression in the De vita solitaria aimed at stirring Europe's Catholic princes into crusading action. Berating kings and potentates for being unmoved by Jerusalem's plight, he lamented that Christianity's "holy places" were being "trampled on" and "mangled with impunity by the Egyptian dog," and mourned that "impious feet" were "insulting the sanctuary of Jesus Christ." Overlooking the fact that this was patently untrue-the Mamluks being tolerant of Christians and respectful of Christian sites, many of which they themselves venerated—Petrarch urged all Europe to rise up in a mighty campaign to wipe out the "stain" of Islam from the Holy Land. It was a dream later shared and elaborated by Petrarch's great admirer Coluccio Salutati. Extending his gaze to encompass the Ottomans as well as the Mamluks, Salutati agitated for an even more ambitious crusade headed by both pope and emperor. As the Ottomans advanced steadily throughout Anatolia and around the Sea of Marmara, he came to believe that the Holy Land should be recovered as a matter of extreme urgency, and that the Christian nations of the world should unite in exterminating the Muslim threat before it reached any further. Unless something were done, he warned, the "vile" enemies of the cross would soon threaten Italy itself.

Salutati was ahead of the curve. The Muslims were indeed on the march. The Ottoman advance through Anatolia, the Near East, and the Balkans soon brought the humanistic hatred of Islam into sharp focus. For the first time since the early Middle Ages, a powerful Islamic state seemed to threaten the territorial integrity of Western Christendom, and the risk of Europe being conquered by the Muslims appeared to be a very real possibility. The Council of Florence in 1439—memorialized by Gozzoli's *Journey of the Magi to Bethlehem*—had been a last-ditch attempt to reconcile the Eastern and Western Churches in the hope of providing

a united Christian front to meet the Turkish onslaught. But the fall of Constantinople in 1453 illustrated the magnitude of the threat and the futility of such theological quibbling. The capital of Rome's first Christian emperor had been lost to the infidel after more than a thousand years. As the last vestiges of the Roman Empire tumbled to the ground, shock waves swept throughout Italy. Action, the humanists felt, was needed. Now. The earlier desire to avenge the inglorious failure of the crusading movement metamorphosed into a broader longing to crush the Ottoman Empire by whatever means necessary, or Italy might be next.

Almost immediately after his coronation in 1455, Callixtus III began "to prepare himself to support Christendom, which, it was seen, was about to be oppressed by the Turks." To this end, preachers such as Fra Giovanni da Napoli, Michele Carcano, Fra Roberto Caracciolo da Lecce, and San Bernardino of Siena were sent throughout Italy "to persuade princes and peoples to arm themselves on behalf of their religion and to support an undertaking against the common enemy with their money and their persons." Although this ultimately came to nothing, the baton was taken up with greater fervor by Callixtus's successor, Pius II. Claiming that Mehmed the Conqueror aspired "to rule all of Europe" and "to stamp out the holy gospel and sacred law of Christ," Pius sought to unite all of Christendom for the sacred task of conquering the Turks, and it was for the sole purpose of announcing the war that a diet was convened in Mantua in 1459. Reminding the princes present that "once the Hungarians were conquered, the Germans, Italians, and indeed all Europe would be subdued, a calamity that must bring with it the destruction of [the Christian] faith," Pius did his best to impress upon them the urgent religious need for an immediate campaign against the Ottoman Turks.

Although the response from Italy's warring potentates was initially lukewarm, the art of the period was not slow to catch up with the virulent hatred that was felt among believers on the ground. In 1439, Pisanello was completing his now sadly damaged fresco of *Saint George and the Princess* for Sant'Anastasia in Verona as a visual illustration of the resurgent crusading spirit. Saint George, the archetype of the warlike Christian saint, is shown having come to the rescue of the princess of Trebizond, a city that—in the late 1430s—was ruled by the exiled Komnenoi family as one of the last outposts of Christendom, and

The Rising Crescent

that was immediately threatened by the advance of the Ottoman Turk. Taken together, the two panels of the fresco were a powerful reminder of the need for Italian Christians to come to the rescue of regions like Trebizond in the hope of stopping the Islamic advance before it was too late. Only a few years later, Apollonio di Giovanni and Marco del Buono painted an exceptionally detailed *cassone* panel (the *Conquest of Trebizond*, Metropolitan Museum of Art, New York)—perhaps for the Strozzi of Florence—that used the theme of the Turkish threat to Trebizond as a means of echoing the same call to arms, possibly with the added rider that the aid of the Timurids should be invoked in the name of the cross.

Soon, however, events conspired to impress upon Renaissance Italians that the perceived threat was closer and even more real than such artworks suggested. On July 28, 1480, an Ottoman fleet of more than a hundred heavily armed vessels fresh from the capture of Rhodes attacked the port of Otranto in the kingdom of Naples. Within two weeks, the entire city had fallen. The bishop and the military commander were cut in two, and some eight hundred citizens who refused to convert to Islam were butchered en masse. Buoyed by his recent, dazzling successes, Sultan Mehmed II wanted to use Otranto as a bridgehead from which to launch a campaign to conquer Rome. Panic ensued. Christianity itself was faced with a real and present danger. There was to be no more procrastination. Rapidly assembling an army of Italian allies, Ferrante of Naples launched a counterattack that, thanks to Mehmed's unexpected death on May 3, 1481, retook the city. It was the first step in what was to be a long-lasting and bitter conflict. Even though trade with the Ottoman Empire continued, and domestic affairs often dissuaded them from undertaking large-scale military action, the states of Italy would wage near-continuous war against the Ottoman Empire for the next ninety years, ending only with the bloody, hard-fought victory at the Battle of Lepanto (1571).

Throughout it all, Otranto remained the touchstone of memory, and its legacy perhaps provides a concise summary of Renaissance attitudes toward Islam. The eight hundred Christians who had been killed for refusing to surrender their faith were commemorated as martyrs. Their bones were encased in massive glass displays behind the high altar in Otranto Cathedral, and they became revered as a warning of what could happen unless the Ottomans were stopped. But most important, this most grisly of ecclesiastical monuments served as a potent reminder that—despite the powerful economic ties that continued to bind Italy to the Near East—Renaissance Christians frequently wanted not merely to crush but to exterminate Islam. Magnificent though Ottoman culture may have been, and important as Islamic states were to Italian trade, artists and humanists continued to view the Muslim faith as a potent threat to Christendom, and, more often than not, were happy to put their cultural skills at the disposal of those who wished to take war to Islam, even if calls for a new crusade often fell on deaf ears in subsequent decades.

Of Human Bondage

13

N AUGUST 26, 1441, a Franciscan friar named Alberto da Sarteano shuffled into Florence after an absence of more than two years. A quiet fifty-six-year-old mendicant, he was not the sort of person who usually attracted a great deal of attention, and in any other circumstances the arrival of so humble a figure would almost certainly have passed unnoticed. Yet almost as soon as he entered the city gates, he was surrounded by crowds of people gasping in amazement and jostling for a better look. But while Alberto himself enjoyed a modest degree of celebrity in Florence for his humanistic learning and his earlier voyages to Byzantium and Palestine, it was not the friar himself who attracted the mob's attention. Instead, it was Alberto's traveling companions who were the object of the Florentines' fascination. For not only was he accompanied by a delegation of Egyptian Copts headed by a bearded abbot named Anthony, but he also brought with him two black Africans from Ethiopia.

Although Florence was already "full of unusual faces and costumes," Alberto's little procession was the subject of intense scrutiny from all and sundry, with particular fascination being exerted by the darkskinned Ethiopians. While they were inclined to sneer at the Africans (one noted that they were "dry and awkward in their bearing" and "very weak"), even the most sophisticated humanists came out of doors especially to see the strange and unfamiliar apparitions walking through the city streets.

It was, however, no accident that Alberto had returned to Florence with such exotic and remarkable companions at just that moment. Together with his Coptic and Ethiopian friends, he had come to fulfill an important mission at the great ecumenical council then being held in the city. Back in the summer of 1439, Pope Eugenius IV had decided that the time had come to unite the whole of Christendom against the Ottoman Turks and set out to bring together *all* Christian believers, no matter where they were to be found. This being so, he had sent Alberto on a momentous mission to the very edges of the known world. Not only was Alberto to announce the ecumenical council to Copts and Melkites in Jerusalem and Alexandria, but he was also to make contact with the semilegendary Christian realms that were believed to exist somewhere beyond Egypt. He was specifically charged with delivering messages to the shadowy figure of "Prester John" and to the equally mysterious "Thomas of the Indies," both of whom were thought to be followers of the cross.

Despite his years traveling in the Near East, Alberto had set out on his journey armed with very little in the way of reliable information. At the time, Africa was shrouded in mystery. Little, if anything, was known about what lay beyond the great southern desert, and in the absence of anyone who could have acted as a guide, he had only the vaguest notion of where he might find Prester John or Thomas of the Indies.

Yet he had exceeded all expectations. Venturing through Egypt then ruled by the Mamluk sultan Sayf al-Din Jaqmaq—he had not found any trace of the legendary potentates to whom Eugenius had written, but had instead managed to identify the Ethiopian Emperor Zara Yaqob, whose Christianity was established beyond question and whose claims to descend from King Solomon became apparent. Ethiopian Christians—many of whom lived in Jerusalem—were deeply interested in the ecumenical council, and it was clear there was scope for securing solid links between Christian Italy and the hitherto-mythical realm beyond the desert.

Pope Eugenius was thrilled by Alberto's success. With tremendous pomp, he formally received the Coptic delegation in Santa Maria Novella on August 31, and two days later he greeted the intriguing Ethiopian representatives with even greater excitement. Despite their perplexing language and rather unexpected habits, Eugenius's sub-Saharan visitors were a palpable sign that Christendom was larger than had previously been imagined. And for a brief moment, it would have seemed possible that all the nations of the Christian world—Italian, Greek, Levantine, Egyptian, even Ethiopian—would be bound together by the ties of a common faith in the holy cause of defeating the hated Turks.

Although the negotiations failed to produce a lasting union, the bar-

riers of myth had been broken down, and points of commonality had been found with peoples and cultures never before seen at such close quarters. As a mark of the momentousness of the occasion, the pope commissioned Filarete to immortalize the attendance of the Copts and Ethiopians on the bronze doors of Saint Peter's Basilica. Depicting the travelers with a sharp eye for detail, Filarete made sure that the two scenes captured both the extraordinary exoticism of the sub-Saharan Africans and the warmth with which Eugenius had received them as brothers in Christ. What his Ethiopian friends made of this encounter, however, may not have been exactly the same.

LIGHT ON THE DARK CONTINENT

Taken together, Alberto da Sarteano's journey and the Ethiopians' arrival in Florence in 1441 were emblematic of Renaissance interactions with sub-Saharan Africa, and though often overlooked by historians, the encounter with Pope Eugenius marked a leap forward in the exploration of a continent that had, until then, remained opaque to Europeans.

It was not that the interior of Africa was completely unknown to Italians before Alberto returned from his travels. Those of a humanistic bent were aware of classical interactions with black African peoples in antiquity. From Greek texts such as Herodotus's Histories, Italians gained a knowledge of ancient Egyptian attempts to explore farther south, while from Roman accounts they derived an understanding of antique trade with peoples beyond the Mediterranean shore. Italians had also encountered black Africans before. Diplomacy had already opened a few channels. The states of Italy had tentatively begun to reach out to others they supposed to lie in the far South. In 1291, for example, Genoa dispatched an embassy to modern Mogadishu in an attempt to determine the whereabouts of the Vivaldi brothers, who had gone missing some time before. Similarly, Africans themselves had nervously begun to extend the hand of friendship. Envoys sent to Spain by Emperor Wedem Arad of Ethiopia had accidentally ended up in Genoa in 1306, and happily imparted tales of their native land to inquisitive citizens. What was more, a small population of sub-Saharan Africans had actually been resident in the Italian peninsula for several centuries. By virtue of Sicily's position as a major Mediterranean trading hub, a limited number had been welcomed into the medieval courts, and

in the late 1430s trade with Arab merchants ensured that at least some colored individuals were known in Florence. Along with Moors and Berbers, a few black African slave girls intermittently found their way across the Mediterranean via Spain and Portugal, and by 1427 some 360 slave girls—mostly from the Caucasus, but including a small number of African descent—were owned by Florentine households.

But despite this, Italian knowledge of the continent south of the desert was limited at best. Maps of the period rarely showed any serious understanding of African geography beyond the former Roman colonies, and display no consciousness of the sheer extent of what remained to be discovered. A now lost portolan chart drawn in 1306 by the Genoese priest Giovanni da Carignano shows nothing below the upper Egyptian Nile, while Pietro Vesconte's mappa mundi (ca. 1320) simply assumes that only sea lay beyond the Sahara. Apart from the settlements along the North African coast and the lower Nile, there seems to be no knowledge of any major towns, and no awareness is shown of any of the peoples of the interior. Until the time of Alberto da Sarteano's return to Florence, the gaps left by such ignorance were filled more by mythmaking than by any serious investigation. In 1367, for example, the Venetians Domenico and Francesco Pizzigano produced a telling portolan chart showing a river of gold that connected up with the Nile and had its source in the "Mountains of the Moon" described by Ptolemy. In an attempt to add extra color, the brothers also relocated the legendary Christian king Prester John (whom Marco Polo had described as living in the Orient) to the shady regions of West Africa and postulated that his realm, too, was littered with so much gold that it lacked almost any value. Even as late as the 1430s, such fantasies were accepted at face value, and in this respect it is telling that the letters Eugenius IV entrusted to Alberto were informed by vague rumors of Prester John rather than by factual information.

The reappearance of Alberto da Sarteano and his Ethiopian companions was a sign that change was in the air. The rise of the Ottoman Turks in the Near East had provided a crucial spur. At a religious level, the desire to find new Christian allies had motivated Italians to test the waters of legend and to acquire a deeper knowledge of under-explored lands. But the desire for commercial profit swiftly took center stage in driving discovery. The fall of Constantinople in 1453 had a major impact on trade. On the one hand, the overland gateway to the Silk Road was more vulnerable than ever before, and the vital trade in spices and raw materials from the Far East was in jeopardy. And on the other hand, the Ottoman seizure of the Bosporus barred the way to the Caucasus, which until then had been the major source of (officially illegal) slaves. The need for solutions provided the spur to exploration. In the quest for a new sea route to the Indies that would bypass the Ottoman-controlled Near East, Portuguese seamen penetrated the interior of modern Sierra Leone, Ghana, and the Gold Coast, and discovered not only a rich, hitherto-unknown land but also vast potential for exporting precious metals and slaves. The obvious moneymaking opportunities accelerated the desire for exploration, and though Portuguese sailors continued to lead the way, Italian explorers such as Alvise Ca'da Mosto and Antoniotto Usodimare—who navigated the river Gambia and discovered the Cape Verde Islands in 1455 and 1456—avidly took up the baton.

Although Renaissance Italians had previously had only a limited understanding of sub-Saharan Africa, both their exposure to and their knowledge of the continent and its peoples now increased dramatically. Travelers to the new lands brought back a torrent of information. African travelogues enjoyed a tremendous popularity, and works such as Ca'da Mosto's Navigazioni became instant hits. Despite clinging to a few old legends, Ca'da Mosto's account contained remarkably detailed descriptions. His sensitivity for commercially useful observations was particularly pronounced. Identifying the two-way trade in gold and salt linking the Songhay kingdom of Mali with Morocco, Tunisia, and Egypt, he painted a vivid picture of the hot, dry atmosphere of market towns such as Timbuktu, Teghaza, and Ouadane, and conjured up clear images of Berber caravans wending their way lazily across the Sahara. The kingdom of the Wolof (Senegal) was analyzed with a similarly searching eye for precision, and unfamiliar customs, dances, and patterns of cultivation were laid bare for the first time. His remarks on topography, flora, and fauna were no less striking for their exactitude. To the amazement of his readers, he described the rivers Senegal and Gambia, the African elephant, the hippopotamus, and the multitude of new plants and flowers he had encountered on an almost daily basis.

But even those Italians who were neither travelers nor avid readers came into growing contact with the peoples of sub-Saharan Africa. It was in the decades after Alberto da Sarteano's voyage that Italy saw "the . . . trade in black slaves become big business"; and though it

undoubtedly constitutes the starting point of "one of the most heartrending and shameful episodes in world history," it also provided the greatest opportunity yet for Renaissance Italians to encounter sub-Saharan Africans at close quarters. With ever-growing regularity, a stream of Portuguese ships bearing human cargoes began to reach the ports of Livorno. Venice, and Genoa, bringing those wealthy enough to own slaves face-to-face with black Africans. Despite the Church's reservations about slavery, Florentine banks-ever alert to the potential for profit—took a particularly keen interest in human merchandise and hurried to secure as many colored bondswomen (and sometimes bondsmen) as possible to meet the growing appetite for exotic domestics. In July 1461, for example, Giovanni Guidetti, a business agent for the Cambini bank, reported that the Portuguese ship Santa Maria di Nazarette had arrived in Livorno carrying a cargo that included three black female slaves who had been named Isabell, Barbera, and Marta. Valued at between 8,500 and 6,500 reals in proportion to their perceived "blackness" ("comparable to the annual salary of a qualified craftsman"), these girls were subsequently dispatched to perform domestic chores in the households of the Cambini family, Giovanni degli Albizzi, and Ridolfo di ser Gabriello. Similarly, in September 1464, the Cambini account books reveal that Piero and Giuliano di Francesco Salviati paid the princely sum of 36.18 fiorini di suggello "for a black head they received from us . . . for their own domestic use." Indeed, by the late fifteenth century, virtually every ambitious merchant family had at least one black slave, and none of Italy's great noble houses would have thought its court complete without a fair smattering of Africans.

THE CHILDREN OF GOD

As the veil of mystery began to fall from the face of sub-Saharan Africa, Italians were compelled to question how they perceived its peoples, and in this regard, too, Alberto da Sarteano's arrival at the Council of Florence with the Ethiopian delegates testifies not merely to the curiosity that the peoples of the African interior generated, but also to the extent to which Renaissance Italians were prepared to look on black Africans in a markedly positive fashion.

Both the reason for Alberto's mission and the warmth with which Eugenius IV received the Ethiopians are revealing. In marked contrast

Of Human Bondage

to views of Jews and Muslims, perceptions of black Africans were never tainted by religious prejudices. Indeed, quite the opposite. A deep sense of Christian friendship persuaded Renaissance Italians to view sub-Saharan Africans in a manner that was both welcoming and enthusiastic.

Although travelers such as Alvise Ca'da Mosto remarked upon the prevalence of pagan animism in kingdoms such as Benin, for example, black Africans tended to be viewed from the very first as children of God, regardless of whether they were known to adhere to the Christian faith or not. For churchmen of Filippo Lippi's generation, their supposed origins revealed they were kindred spirits. Elaborating on the biblical story of Ham's exile, Renaissance Italians imagined that Noah's son had wandered from the Holy Land into Africa, where he ultimately settled, married, and had children. His descendants were, they believed, the ancestors of the fifteenth-century Ethiopians who arrived in Florence. Indeed, since few distinctions were drawn between different sub-Saharan peoples, all black Africans were thought to be authentic children of Ham and were thus viewed as members of the broader Christian family.

If their supposed descent from Noah's son was not enough, there was plenty of other evidence suggesting that black Africans should be regarded as authentic Christian brethren. The Queen of Sheba, for example, was just one instance of a close scriptural link between Africa and Old Testament history, and the story of the journey of the Magi to Bethlehem stands out as being of particular importance. Although the biblical narrative contains no mention either of the Magi's names or of their points of origin, early Christian writers swiftly filled the gap and began to associate the newly dubbed Caspar, Melchior, and Balthazar with the three corners of the known world. While Caspar and Melchior were often linked with India and Persia, respectively, Balthazar came to be cast in the role of an African from a surprisingly early date. By the fourth century, for example, Saint Hilary had postulated that Balthazar was from sub-Saharan Africa, and slowly but surely the idea of the "black Magus" gained ground, until it received wide acceptance in the fourteenth century. As Italians' exposure to the peoples of the continent increased after Alberto da Sarteano's arrival in Florence, the art of the period began to embrace the notion of a black Balthazar with tremendous enthusiasm. In Mantegna's Adoration of the Magi (Uffizi, Florence) (Fig. 39)—which is most commonly dated to ca. 1489 but may be as early as ca. 1462–70—the kneeling figure of Balthazar is a black African, and it is clear that both artist and viewer accepted him as an emblem of colored people's integral role in the wider Christian drama.

It was an idea that only grew stronger as the years went by. From the mid-fifteenth century onward, the prevailing sense that black Africans were historically part of the Christian family persuaded some of the more adventurous artists and humanists to integrate them more firmly into biblical stories, even where supporting evidence was nonexistent. Perhaps as a consequence of Isabella d'Este's growing interest in having black servants at her court in Mantua, for example, Mantegna cut new ground in introducing a black African maid into the tale of Judith's decapitation of Holofernes. In a pen-and-ink drawing dated to February 1492 (Uffizi, Florence), Judith's maidservant is depicted with identifiably African features, a motif that Mantegna subsequently repeated in at least three other works and that was later imitated by artists such as Correggio. Since Judith was a paradigmatic example of self-sacrificing virtue thanks to her seduction and slaughter of the Assyrian general, the presence of a black African attendant in a representation of the scene indicates a willingness to attribute a reflected glory to colored peoples and to further emphasize their part in the scriptural tradition.

That sub-Saharan Africans were increasingly perceived as the children of God provided the Church with a powerful reason to reach out positively to newly discovered nations, and to encourage a constructive, welcoming attitude toward black Africans in Africa and in Italy itself. Within sixty years of Alberto da Sarteano's arrival in Florence, the Church was actively embracing the idea that the entrance of colored people into full communion with the Roman Catholic faith was one more proof that the Golden Age had arrived.

Building on Eugenius IV's desire to unite Christendom and strengthen the integrity of Christianity worldwide, the Church began to explore any and all methods of propagating Catholicism among peoples who were either known to be believers in Christ or who were at least thought to be "instinctively" amenable to conversion. By the early sixteenth century, Saint Ignatius of Loyola had expressed an interest in going on a mission to Ethiopia to strengthen the ties first glimpsed at the Council of Florence, and before long, Jesuits were setting out to spread the word in West Africa. Some attempt was even made to adapt the Church's message to local customs, and there is a sense in which tolerance was recognized as an essential precondition of a Christian Africa. In 1518, for example, Pope Leo X was petitioned by King Manuel of Portugal to consecrate the twenty-three-year-old Ndoadidiki Ne-Kinu a Mumemba—the illegitimate son of the native king of the Congo—as a bishop and to provide him with a staff of missionaries. Even though Ndoadidiki (better known as Henrique) was debarred from the episcopal office by virtue of his illegitimacy and his youth, Leo evidently thought this was a brilliant idea and not only had him appointed titular bishop of Utica but also sent a host of theologians to advise the young man until he reached the canonically acceptable age of twenty-seven. Africa, Leo seems to have believed, was better served by native-born prelates, an apparently clear sign of cross-cultural openness.

At home in Italy, too, the supposition of an inherent religious kinship with black Africans led to a sensitive and broadly encouraging approach on the Church's part. Particularly from the early fifteenth century onward, serious attention was given to providing adequate pastoral care for sub-Saharan Africans, especially among the very large numbers of slaves and ex-slaves in Sicily and Naples. Children were baptized, preachers made visits to fields, markets, and shipyards, and later black slaves were even encouraged to form their own confraternities, such as the one founded at the church of San Marco in Messina in 1584. Yet more strikingly, both slaves and former slaves were actively welcomed into the religious orders. Perhaps the most remarkable example is that of San Benedetto il Moro (ca. 1524–89), who was born into a largely illiterate family of slaves or freed slaves in Sicily, and who entered the Franciscan Order at the age of twenty-one. So outstanding was his pious asceticism (accompanied by regular bouts of extreme self-flagellation) that after his death Benedetto was eventually venerated as a saint by the overwhelmingly white congregations of southern Italy.

The atmosphere of religious openness that surrounded black Africans in the Italian peninsula occasionally bled out into other spheres of existence and informed a wider acknowledgment of their shared humanity. Although their status as slaves or freedmen necessarily restricted the range of occupations in which they were employed, black Africans were perceived to possess a multitude of skills that were not only integral to the courtly life of Renaissance cities but also closely related to ideals of martial virtue celebrated by authors such as Castiglione. In addition to finding places as wrestlers and divers, they were particularly admired for their prowess as horsemen and soldiers, sure marks of an admirable and "civilized" character. In 1553, for example, the Medici employed a certain Grazzico "il Moretto" of Africa as a horseman and page, while an African slave known as Bastiano was commanded to stand guard over the tomb of Cardinal Jaime of Portugal in San Miniato al Monte in Oltr'Arno because of his evident military acumen. Even more remarkable is a woodcut from ca. 1505 in which a black page is shown valiantly (but vainly) defending Galeazzo Maria Sforza from his assassins in 1476. So, too, black Africans were widely thought to be unusually skilled at music and dancing, two activities that were highly prized in courtiers.

So closely were black Africans ingrained in the society of Renaissance Italy that suspicion of mixed parentage was not regarded as a serious issue, even among the upper echelons of the urban elite. Created duke of Florence in 1532, Alessandro de' Medici was widely (and perhaps not inaccurately) rumored to have been the natural child of Pope Clement VII and a black African woman, and the frequency with which portraits openly showed him with identifiably "African" features seems to suggest that a certain level of social acceptance had grown out of the broader sense of religious familiarity that had begun with Alberto da Sarteano's arrival in Florence with the Ethiopian delegation in 1441.

Human, but Not Too Human

Black Africans were in many senses greeted with a more positive attitude than either Jews or Muslims, but there was another, more insidious dimension to Renaissance Italy's relationship with sub-Saharan Africa. That Alberto da Sarteano's Ethiopian delegation was greeted with wide-eyed amazement and even a measure of bemusement by onlookers was itself a sign that previous points of contact had only gone a small way toward facilitating a proper acceptance of black Africans; but that the city's cultured humanists persisted in viewing them with derision, almost as one might treat a scientific specimen, suggests that they remained "foreign" in a way that was not altogether heartwarming.

Lurking beneath the facade of Christian fellow feeling and Catholic ecumenicalism was a deep sense of disdain and condescension. Although the peoples of sub-Saharan Africa were widely regarded as kindred members of the wider Christian family, this did not mean Italians viewed black Africans as equals. They were, in fact, viewed as little more than oversized infants, and since Italian humanists refused to acknowledge any sub-Saharan culture worth speaking of, they tended to cast black Africans in the role of uncivilized barbarians.

The pattern was set by the earliest explorers. Despite the keenness with which they observed the social habits of the Wolof or the Songhay, for example, the first travelers looked on sub-Saharan Africa through the lens of crude prejudice rather than of objective interest. In his account of his journey across the desert, Antonio Malfante spitefully made much of the fact that the black Africans he encountered were "unlettered, and without books," and drew a parallel between a perceived cultural primitivism and demonic witchcraft by observing that they were "great magicians, evoking by incense diabolical spirits." For his part, Alvise Ca'da Mosto was repulsed by what he saw as "lascivious" traits in the peoples of the region, and tempered his admiration of their Christian ancestry with contempt for their "barbaric" practices.

Such views found a willing audience in Italy. Exposed to evergrowing numbers of black Africans, Renaissance Italians gladly absorbed the assertion of base primitivism at the same time as they freely acknowledged a religious kinship. Every imaginable stereotype was deployed to cast colored peoples as uncivilized simpletons who could never hope to occupy a position of parity with the white majority. Quite apart from the Portuguese trope of the "happy black"-which equated unconstrained mirth with childishness or savagery-there was a widespread belief that all sub-Saharan Africans were lazy and thus incapable of accomplishing anything of lasting value. In his 1480 tax return, for example, the heirs of the Florentine Matteo di Giovanni di Marcho Strozzi listed among their chattels a black female slave "who works badly and is of little worth"; "she is lazy," they claimed, "as are all black females." More disturbingly, there was a widespread belief that all Africans were morally incontinent and simply incapable of restraining either their propensity for gluttony or their sexual appetite. Drawing on Ca'da Mosto's contention that incest was widespread south of the Sahara, humanists began to equate the physical strength and unlettered "savagery" of black Africans with an insatiable lust that sought relief at every available opportunity. It was even believed that Africans' supposed musicality could be explained away as a vain attempt to channel their libidinous urges into some form of rhythmical dance. Similarly,

the Africans' native propensity for wearing gold earrings gave weight to the suspicion that they may have had something in common with the hated Jews, who were associated with the same form of jewelry in the popular imagination.

The perception of cultural inferiority, barbarism, and savagery had a number of important implications for the manner in which black Africans were treated in everyday life. Since there was no doubt in most Italians' minds that they were somehow "less human" than white Christians, it was manifestly obvious that no degree of autonomy or independence could be attributed to any colored person, no matter how positive his or her behavior or manner might be. Thus, while black Africans frequently appear in the art of the period, colored individuals-with the exception of Balthazar-are presented only in the role of supporting or subsidiary characters. In Mantegna's various renditions of Judith beheading Holofernes, for example, it is of considerable significance that the rather passive servant girl is black, and Judith-who would surely have been of the same ethnic origin-is not. So, too, in Gozzoli's Journey of the Magi to Bethlehem, the only black face in the entire scene is that of a rather weedy-looking page gamely running alongside the Medici's horses. This lack of autonomy necessarily carried with it a sense that blacks could, and should, be treated in whatever way their "natural" superiors wished. Female black slaves were habitually subject to sexual advances and even sexual attacks from their masters, and in each case blame was foisted on the victim rather than on the perpetrator.

Yet perhaps the most important implication of this perception of cultural and moral inferiority was with regard to the legal status of black Africans. Although there was always a mixture of free and unfree among the colored population of Renaissance Italy, the belief in a "natural" barbarism gave rise to the contention that colored people were somehow "naturally" slaves. Building on a perversion of Platonic and Aristotelian ideas of slavery, humanists, lawyers, and churchmen accepted that the uncivilized societies of the Dark Continent had been ordained by nature to be ruled over by white, civilized men. And no matter how strong the sense of Christian fellowship may have been, the pernicious idea of a race of natural slaves shaped Renaissance encounters with sub-Saharan Africa.

The enslavement of Christians was categorically forbidden by the

Church, but theologians quickly came to believe that sub-Saharan Africans constituted a special case because of their supposed character. Only eleven years after Alberto da Sarteano arrived back in Florence with the Ethiopian delegation, Pope Nicholas V promulgated the bull Dum diversas in an attempt to mediate between the competing claims of Spain and Portugal to supremacy in the new lands being discovered. In the course of this wide-ranging and far-reaching proclamation, Nicholas affirmed that the kings of both nations had the absolute right to invade whatever kingdoms they wished and to reduce the entire population of any territory to slavery, irrespective of creed. Although this was subsequently overturned by Pius II, it was later reaffirmed with even greater insistence in a sequence of bulls that effectively condemned Africans to perpetual and unremitting slavery and set in motion a centuries-long trend that constitutes one of the most unpleasant and vile episodes in human history. It was, indeed, the openness of the Renaissance that led to one of humanity's greatest evils.

* * *

As Alberto da Sarteano and his Ethiopian companions left Florence after the heady excitement of the ecumenical council, the friar could have been forgiven for feeling satisfied. Consciously and unconsciously, he had been responsible for pushing back the boundaries of the Renaissance world and for breaking down the barriers of myth and legend. In adding to the humanistic understanding of sub-Saharan Africa, he had paved the way for generations of explorers and for the growth of genuine ties with entirely new lands. He was, moreover, overjoyed that Christendom itself seemed to have grown massively larger, almost overnight.

Although no written testimony has survived to give any indication of what they made of their Italian sojourn, the Ethiopians would perhaps have been less excited. Despite having been feted in lavish style, they would certainly have been put off by the servile condition into which fellow Africans were being forced, and distressed by the disdain with which they had been treated in the street. They were Christians like any others, but it would have been obvious that they were not viewed as Christians of quite the same stripe. The attraction of learning from and trading with white Italians would perhaps have given them cause for hope, but a sense of fear and anxiety would have been inescapable. It was to their credit as Christians that they put aside such concerns, but it would undoubtedly have been much better had they turned their backs on Florence and run as fast as they could to warn their people of what was already in the air. Tolerance and acceptance were just a facade, and as they may already have suspected, it would have been much better for Africans everywhere if the Renaissance had just left them alone.

BRAVE NEW WORLDS

14

T ABOUT THE time he was completing the Barbadori Altarpiece, Filippo Lippi was unconsciously standing on the threshold of one of the greatest periods of adventure and discovery in human history. Although Renaissance Italy had come into progressively closer contact with Hebraic, Islamic, and black African cultures over the past century, its entire worldview was about to be shattered by a series of staggering voyages that would transform the earth for ever more. In a little over fifty years, the Atlantic would open, and an Italian navigator would set foot on the unimagined shores of America.

Despite the monumental scale of the discoveries that were beginning to take shape, they had comparatively little impact on the cultural imagination of the period. From the late 1430s onward, Italians nurtured only the most distracted form of curiosity about the new and unknown lands being explored. Not only had very little hard evidence of the mysterious new islands reached the peninsula by that stage, but a sense of intellectual arrogance also conspired to keep expectations of the Atlantic world low. There was little willingness to believe that explorers could find anything more than a different route to already familiar lands. At best, it was thought that a few vague references to shadowy islets in the classical histories might be fleshed out and a new means of trading with the East might be discovered, but nothing more. And even if there actually were something unexpected out there, it was firmly believed that all that was civilized had already been found.

Filled with supreme self-confidence, humanists were happy to extol the heroism of pioneering navigators, but fell back on fantasy and disdain when it came to the peoples and territories being explored. Artists like Filippo Lippi, however, failed even to register the changing fate of humanity. Cartography aside, not a single trace of the Atlantic world is to be found in fourteenth- or fifteenth-century art, and it seems almost

337

as if a conscious effort were made to ignore the voyages of discovery in their entirety.

With the benefit of hindsight, this is perhaps the most surprising and counterintuitive feature of the Renaissance. But in unpicking the various strands of this story, we can see that in coming into contact with the undreamed-of lands and peoples of the western ocean, the men and women of the Renaissance revealed the truest extent of their intellectual ambivalence and cultural cynicism.

Expanding Horizons

Before about 1300, the Atlantic Ocean had been treated only with the most indirect interest and was seen primarily through the lens of the trade with the Far East. Although Pliny the Elder and Isidore of Seville had hinted vaguely about a few scattered islands off the African coast, and the Nordic sagas had told of a shadowy area that they dubbed Vinland, Italians had had little time for such apparently fanciful myths. To them, the Atlantic was a watery void that separated Europe from China, Java, and "Cipangu" (Japan), a notion readily enshrined in carefully prepared but grotesquely ill-conceived maps. Back in the thirteenth century, Marco Polo had authoritatively stated that Cipangu was an island that was likely to be reached well before China if one were to sail west from Portugal, and whenever medieval writers spoke of islands out in the Atlantic—such as the "Isle of the Seven Cities," allegedly colonized by Christians who had fled from Muslim Spain-the presumption was that they were merely part of the giant, little-known archipelago east of India from which spices were brought. And while perceptions of these "Indian" islands were still dominated by ideas of dog-headed men and rivers of gold, there was little sense that anything totally unexpected was out there.

The allure of a sea route to the Indies was, however, to provide the impetus that led to a more searching exploration of the Atlantic world. Thoughts had begun to turn to discovering a new means of trading with the East even before the Renaissance bore its first fruits. As early as 1291, two Venetian brothers—Vandino and Ugolino Vivaldi—had set sail in two galleys in the hope of reaching India by voyaging around the Moroccan coast, and though the expedition disappeared without a trace, the appetites of seagoing states had been whetted by the first

whiff of possibility. By the dawn of the fourteenth century, more concerted efforts were already being made. The discovery of Lanzarote in 1312 by the Genoese sailor Lancelotto Malocello marked something of a watershed. Although his journey, too, failed to reveal the hopedfor route to the Indies, it nevertheless showed that there was more to ancient and medieval tales than anyone had previously supposed, an impression further strengthened by a subsequent, more systematic expedition to the Canary Islands in 1341. The Atlantic wasn't just an empty void. There was definitely something else out there. And what was more, the inhabitants of the Fortunate Isles (as the Canaries were known) had shown that there were *people* out there, too.

By the time Filippo Lippi had completed the Barbadori Altarpiece, exploration west of the Pillars of Hercules was gaining pace, and as the steady rise of the Ottoman Turks put ever more obstacles in the way of the Silk Road, the urge for maritime adventurism grew ever stronger. While hopes for a new passage to the East were still running high, it was becoming increasingly clear that the Atlantic was a much busier and richer place than even people of Lippi's grandparents' generation had dared dream. Although the Spanish and the Portuguese were taking the lead, Italian sailors were taking part in ever more farreaching expeditions, and a veritable torrent of news of new and exciting lands was reaching Florence every day. In 1418-19, João Goncalves Zarco and Tristão Vaz Teixeira discovered Porto Santo and Madeira, and barely eight years later, in 1427, Diogo de Silves found the Azores while venturing even farther west of the African coast. In the years that followed, Prince Henry the Navigator set his sights on exploiting the resources of the new lands and sent out a number of expeditions both to document the precise character of the islands and-if possible-to establish permanent trading settlements in the name of the Portuguese crown. The full-scale conquest of the Canary Islands-beginning with the 1402 expedition of Jean de Béthencourt and Gadifer de la Salle and continuing throughout the century-opened the doors to an ever more direct and searching quest for commercially and militarily valuable information.

By the autumn of 1492, an almost unknown Genoese captain would cross the Atlantic and change the world forever. Despite not being altogether sure at first about the identity of the new lands he had discovered, Christopher Columbus landed at San Salvador on the morning of October 12 and became the first European to set foot on Cuba just over two weeks later, on October 28. Irrespective of the inaccuracies and vagaries of his initial stabs at geography, Columbus opened the doors to a completely new world, and the floodgates to the full-blown exploration of the Americas were blown open. On his subsequent voyages in 1493–94, Columbus followed up his first successes with the discovery of modern-day Jamaica, Puerto Rico, and the Lesser Antilles. Barely three years later, Zuan Chabotto (John Cabot) made landfall in Newfoundland, and in the last years of the fifteenth century Columbus, Alonso de Ojeda, and the Florentine Amerigo Vespucci had begun to penetrate the mysterious depths of South America. And by the time the sixteenth century was under way, the Atlantic had become a veritable superhighway of adventure and exploration.

NEWS TRAVELS

In terms of importance and magnitude, the voyages of discovery that began in the early fourteenth century and continued well into the sixteenth were far greater than the first manned mission to the moon, and it is perhaps difficult to appreciate the sense of wonder felt by Europeans. This being so, it is perhaps no surprise that "discovery" should have become so integral to the way in which the Renaissance as a whole has come to be seen, and there remains a peculiar resonance to Burckhardt's view of its impact. "Yet ever and again," the Swiss historian wrote, thinking of Columbus,

we turn with admiration to the august figure of the great Genoese, by whom a new continent beyond the ocean was demanded, sought, and found, and who was the first to be able to say: "il mondo è poco"—the world is not so large as men thought.

As new horizons were opened to the imagination, and new peoples were encountered with every passing year, both the world and humanity itself gradually assumed an entirely different character, and though often mediated by the great maritime nations of Portugal and Spain, news of the new discoveries was absorbed with tremendous enthusiasm by Italians from Venice to Naples, before finding expression in the writings of humanists and scholars up and down the peninsula.

Even before the discovery of the Madeira archipelago and the Azores, fourteenth-century Florentines, in particular, had shown a marked appetite for knowledge of the oceanic territories and their peoples, and Peter Burke has rightly observed that from the beginning Italians "played an important role" not only in "the process of discovery" but also "in spreading the news." Drawing on the tales of a maritime adventurer named Niccolò da Recco, Boccaccio penned an excited account of a journey to the Canary Islands (the De Canaria) that was replete with details about the inhabitants' exotic dress, social institutions, agricultural practices, and musical habits. A little later, even Petrarch-whose source of information appears to have been a "man of noble stock mixed of the royal blood of Spain and France," presumably Luis de la Cerdadisplayed his excitement about the new lands, by including an excursus on the habits of the Canary Islanders in his De vita solitaria. Both texts revealed a close interest in recording precise-and, on occasion, even pedantic-details about the new lands, and displayed a hunger for knowledge about the topography and anthropology of the Atlantic territories that is redolent of a wide-eyed inquisitiveness.

During Filippo Lippi's own lifetime, the speed with which information began to arrive from the Canary Islands and the Azores seems to have stimulated an even greater interest in the recovery of exact knowledge. In this regard, it is telling that the two canon lawyers appointed by Pope Eugenius IV to inquire into the future legal status of the islanders at the Council of Basel—Antonio Minucci da Pratovecchio and Antonio Roselli—were preoccupied with identifying the religious and social habits of the Canarian natives. Similarly, richly illustrated accounts of the conquests of Béthencourt and de la Salle (especially *Le Canarien*, by Jean Le Verrier and Pierre Bontier) not only became wildly popular throughout Europe but also helped to meet a growing fascination for the new Atlantic world among lettered men.

Not only did literary appetites grow ever stronger after Lippi's death, but the feast that was offered to sate the hunger of Italians avid for news also became richer in almost every respect. Even before Columbus made landfall on San Salvador, Poliziano wrote to the king of Portugal with breathless excitement about the "discoveries of new lands, new seas, new worlds," and one can only imagine the palpitations of amazement that followed the announcement of the Genoese captain's great finds. The sixteenth century had barely begun when firsthand accounts

started to circulate, first in manuscript form, then in finely turned printed volumes. Columbus's account of his travels rapidly circulated; Vespucci's description of his own voyage enjoyed considerable popularity; and the narrative of the Florentine Giovanni da Verrazzano (who concentrated on the North American coast) was enthusiastically read, despite its relative obscurity today. Even secondhand accounts were phenomenally popular (possibly more so than their better-informed source texts) and testify to the excitement that was abroad. Swiftly following in the wake of Vespucci's letters, the Italian-born Pietro Martire d'Anghiera (1457–1526) published a raft of works on the exploration of the Americas-including the Decades and the De orbe novo-which constituted an important vehicle for disseminating information about the new lands to a wider audience. And in a similar vein, the Venetian bureaucrat Gianbattista Ramusio responded to the popular desire for more specific accounts of the topographical and anthropological character of the Americas with his multivolume *Delle navigationi et viaggi* (1550–59), often described as one of the first truly modern works of geography. Everyone, it seemed, wanted to know just how small the world was becoming.

Thrilled by these discoveries, cartographers such as Paolo del Pozzo Toscanelli (1397–1482) and Giovanni Matteo Contarini (d. 1507) rushed to improve their art so as to provide more accurate representations of a changing world, and humanists competed with one another in a bid to celebrate the "heroic" achievements of contemporary explorers in a fittingly classical fashion. In 1589, for example, Giulio Cesare Stella (1564– 1624) was obliged to rush into print with an unfinished version of part of his *Columbeis*—the first attempt to cast Columbus's voyages in the mold of pseudo-Virgilian epic—to head off a pirated edition that was already hitting the market in response to heavy demand. If ancient conquerors and sailors deserved high praise, how much more praise did those who made the world a smaller place deserve?

INVISIBLE WORLDS

Yet to say that there was a natural hunger for information about the discoveries being made is not to say that curiosity succeeded in firing the imagination quite as much as modern historians are often inclined to believe. Indeed, it is not implausible to suggest that the cultural impact Renaissance explorers are often thought to have exerted is more a construct of recent perceptions of the intrinsic value of "scientific" novelty than of the realities of the artistic imagination of the period. Remarkable though the opening of the Atlantic world may have been, artists both before and after Lippi's lifetime simply weren't all that gripped by the idea of the new lands in the West.

It was not that the adventures of Malocello, de Silves, Béthencourt, Columbus, and Vespucci completely failed to find visual expression on Italian soil. After the advent of the printing press, editions of geographical works, chronicles, and first- and secondhand narratives-many of which were published on Italian soil-habitually included not only a selection of detailed maps but also a smattering of carefully crafted woodcuts or engravings by way of illustration. Thus, in the third volume of Ramusio's Delle navigationi et viaggi (Venice, 1556), for example, there were detailed pictures of unfamiliar plants, such as maize and plantain leaves, and images of distinctive aboriginal tools, such as the fire drill. But for the most part, such visual images of the New World seldom merit description as serious works of representation. They were almost never drawn from direct observation (artists not being thought essential to voyages of discovery) and were habitually cobbled together from a mixture of hearsay and fantasy with a view more to titillating the reader than to recording any meaningful information. To make matters worse, a great number of woodcuts included in narrative accounts of early Atlantic encounters were simply recycled from other printed texts, most of which had absolutely nothing to do with the New World. Hence, in some of the earliest printings of Vespucci's Quattuor navigationes, the explorer meets a host of cannibalistic natives busily hacking up human limbs ready for their evening meal, while other texts commonly include depictions of Native Americans canoeing in bathtubs and inland waterways populated by mermaids.

Such hackneyed scrawls accounted for most of what was on offer. No one except the most amateurish of wood-carvers seems to have had the slightest concern for anything coming from across the Atlantic. For almost the entire Renaissance, the lands to the west of the Pillars of Hercules failed to make any significant impact on art in any of its forms, and it is in vain that even the most dedicated of connoisseurs may search for some trace of the Canaries, the Azores, or even the Americas in the painting and sculpture of the period. Even though a smattering of exotic artifacts had made their way across the Atlantic into the collections of some of the more noted courtly collectors by the mid-sixteenth century, nothing seemed capable of stirring a single Italian artist into taking up his brush, charcoal, or chisel in the service of the New World, and it was with some alarm that the Spanish chronicler Gonzalo Fernández de Oviedo y Valdés (1478–1557) lamented the fact that neither Leonardo da Vinci nor the otherwise acutely sensitive Andrea Mantegna had bothered to capture anything "American" on canvas. No other area of the world, no other culture, and no other people was so poorly served by the arts. Even Jews, Muslims, and black Africans—all of whom were the objects of bigotry and hatred—were better represented in fifteenth- and sixteenth-century painting. Indeed, if the works of the Renaissance's greatest artists were the only evidence used, it might seem as if the voyages of discovery never happened at all.

SCARCELY PROFITABLE AND BARELY HUMAN

If the dreadful treatment meted out to Jews, Muslims, and black Africans seems to contradict the familiar image of the Renaissance as a time of open-mindedness and tolerance, the complete disregard shown by artists of the period for the Atlantic world appears to raise even more challenging questions about the extent to which "discovery" really played a role in shaping the character of the age that has become renowned for its sense of curiosity and learning. The paradox of Renaissance artists' knowledge of and disregard for the leaps being made into the oceanic void demands some sort of explanation, if only to try desperately to rescue something from the ghastly mess in which Renaissance interactions with the "other" have become mired.

But explaining why something did *not* happen is a precarious business, simply because the evidence—by definition—does not exist. Although it is clear that Renaissance artists all but ignored the voyages of discovery, the absence of visual references to the Atlantic world makes it difficult to determine *why* they did so. Yet even though conclusive proof may be hard to find, two parallel developments seem to offer an attractive—if not wholly encouraging—explanation for the staggeringly blinkered view of artists.

The first revolves around that most characteristically Renaissance preoccupation: money. Even more so than today, cash was king, and as previous chapters have shown, artists followed the financial interests

of their patrons with the same enthusiasm that starved puppies chase meat carts. And the simple fact was that-insofar as Renaissance Italy was concerned-the voyages of discovery could pretty much go hang. Although the influx of gold and silver bullion from the New World kept all Europe afloat through the destructive warfare of later centuries, the first, tentative journeys into the Atlantic world didn't generate very much in the way of money. It wasn't that they didn't put out feelers. The Genoese, for example, enthusiastically supported Portuguese and Spanish ventures from the early fifteenth century onward (partly in response to growing Venetian domination of the eastern Mediterranean), while a number of early transatlantic crossings were made by flotillas carrying Florentine prospectors-such as Giovanni da Empoli, who was sent into the unknown by his merchant-banking employers for the first time in 1503-4-in search of monetary reward. But despite this, none of Italy's great trading centers felt any significant financial benefit from the opening of the Atlantic islands and the early trips to the American mainland except through the granting of loans to Catalan adventurers at spectacularly exorbitant rates of interest. Although the coastal territories of West Africa generated no end of cash, the Canary Islands, the Azores, the newly dubbed West Indies, and the Americas seemed to be all but barren, and even indirect trade through the Iberian powers (between whom the New World had already been divided up) brought little of any real value to the markets of Florence, Rome, and Milan. It was not until well into the sixteenth century that any signs of genuine profit began to emerge, and that men like the Florentine merchant banker Luca Giraldi (d. 1565) were tempted to seek their fortunes in the New World. And by then, the Renaissance proper was already on the wane. Since their patrons showed little more than a vague, peripheral curiosity in the Atlantic world, artists lacked any monetary incentive to show any interest either.

But if the first of the possible reasons for the absence of "discovery" from Renaissance art appears cynical, the second is disturbing. For if Italians of Lippi's generation were money obsessed, they were also completely unwilling to open their minds up to novelty unless they were positively forced to do so.

At root, the belief that discovery, objective knowledge, and tolerant relativism are inescapably connected is a modern fiction. As previous chapters have suggested in relation to other peoples encountered by Renaissance Italians, the acquisition of knowledge was seldom anything less than highly subjective, and almost never led to anything like the self-questioning tolerance that post-Enlightenment individuals might feel to be natural. Indeed, if anything, the growth of understanding only led to the refinement of prejudice and the strengthening of hatred. The discovery of the Atlantic world simply put a new and even more sinister spin on an already well-established tendency.

Far from being a pure source of fresh and unblemished learning, the potentially invaluable contribution of explorers' observations of the new worlds of the Atlantic sat "as a very small edifice on top of an enormous mountain of hearsay, rumor, convention and endlessly recycled fable." It was not just that the fragments of useful information they brought back were habitually twisted into altogether more fantastical forms by authors more willing to trust their imaginations than firsthand accounts, but also that explorers themselves were all too happy to use myth, fable, and downright prejudice as a lens through which to survey the new lands. A whole host of "bastard" sources were employed as intellectual crutches by explorers and their glossatorsfrom woefully outdated classical geographies to medieval legends and old wives' tales-but it was perhaps the prevailing religious sentiments of still deeply Catholic Europe that provided the greatest and most important filter for knowledge of the new western territories and their peoples. And, at root, religious prejudices really did stack the odds against the aboriginal inhabitants both of the Canary Islands and of the Americas ever being regarded as truly "human," let alone civilized.

On the one hand, there was always a niggling suspicion that previously unknown territories were home to monsters who were either manifestly hideous or otherwise bereft of the physiological "humanity" possessed by all those in Europe. The Bible was, after all, replete with stories of strange giants and horrific creatures who lived before the Flood, and it was hard to shake the feeling that perhaps some of them had survived unscathed in the distant lands of the West. On the other hand, even if new peoples passed the test of "physical or biological anthropology," that did not mean they were automatically entitled to be regarded as full members of the human race. A rather peculiar reading of the early chapters of Genesis could lead Renaissance thinkers to equate humanity with certain fairly rigid standards of existence. Although "evidence of social anthropology"—in terms of "behaviour, conduct, [and] technology"—was one of the principal criteria upon which the human status of new peoples was judged, David Abulafia has observed (with characteristic brilliance) that any deviation from accepted norms of "civilized" existence could be taken as proof that superficially manlike beings were actually "inhuman" creatures who lacked the soul that was possessed even by such hated heretics as Jews and Muslims. Judged against such criteria, any new cultures were always going to have difficulty coming off well. Indeed, it was nigh on impossible for any aboriginal person to convince a Renaissance explorer of his humanity unless he appeared dressed in the latest European fashion, speaking flawless Latin from the threshold of his stone-built town house.

Although Boccaccio seems to have been comparatively ahead of his time in attempting to present the Canary Islanders as the inhabitants of some sort of pastoral idyll, untouched by the sins of Italian city life, the general Renaissance attitude toward the peoples of the Atlantic was unsurprisingly—overwhelmingly negative. Both eyewitness testimonies and secondhand accounts seemed to go out of their way to stress the unchristian barbarity and subhuman savagery of the aboriginals of the Atlantic world. Taking an uncharacteristic swipe at his friend Boccaccio, Petrarch wasted few words in dismissing the Canary Islanders as scarcely worth the consideration of Christian believers. Though noting that they were, in some senses, exemplars of a certain version of the *vita solitaria* he wished to praise, Petrarch observed that the inhabitants of the "Fortunate Isles"

are without refinement in their habits and so little unlike brute beasts that their action is more the outcome of natural instinct than of rational choice, and you might say that they did not so much lead the solitary life as roam about in solitudes either with wild beasts or with their flocks.

It was hardly a ringing endorsement of even the most limited sense of "humanity," but it was still an awful lot more positive than the statements that were shortly to follow. Only two years before Lippi completed the *Barbadori Altarpiece*, that is, in 1436, King Duarte of Portugal wrote to Eugenius IV in an attempt to persuade the pope to give him exclusive rights to own the Canary Islands, and, in doing so, endeavored to justify the total enslavement of their inhabitants by making their bestial savagery all too plain. If their complete ignorance of the most basic norms of civilized existence (metalworking, boatbuilding, writing) were not sufficient to highlight their distance from the Christian understanding of human nature, Duarte contended they were "nearly wild men" who lacked all understanding of law and lived "in the country like wild animals."

But worse was yet to come. Although less openly abusive than Duarte's letter to Eugenius IV, Amerigo Vespucci's narrative of his first voyage to the Americas contained a description of an aboriginal people that was, if anything, even more scathing in its implications. Every last point upon which their claim to "humanity" could be based was demolished with breezy insouciance:

They observe most barbarous customs in their eating: indeed, they do not take their meals at any fixed hours, but eat whenever they are so inclined, whether it be day or night. At meals they recline on the ground and do not use either tablecloths or napkins, being entirely unacquainted with linen and other kinds of cloth. The food is served in earthen pots which they make themselves, or else in receptacles made out of half-gourds . . . In their sexual intercourse, they have no legal obligations. In fact, each man has as many wives as he covets, and he can repudiate them later whenever he pleases, without it being considered an injustice or disgrace, and the women enjoy the same rights as the men. The men are not very jealous; they are, however, very sensual. The women are even more so than the men. I have deemed it best (in the name of decency) to pass over in silence their many arts to gratify their insatiable lust.

Irregular eating hours, the absence of table linen, gender equality, and free love may not seem like the be-all and end-all of human nature today, but for a man of Vespucci's Florentine upbringing they were sure signs of savage, even frightening bestiality, and it is hard to escape the suspicion that he may have woven in a few prejudices applied to other peoples (the echo of criticisms of Islamic polygamy is, for example, a tempting case in point) just to make his point all the clearer. But even if this were not enough, Vespucci felt it necessary to stress the total inhumanity of the Native Americans he encountered by adding a brief description of their religious—or, rather, irreligious—habits:

No one of this race, as far as we saw, observed any religious law. They can not justly be called either Jews or Muslims; nay, they are far worse than the gentiles themselves or the pagans, for we could not discover that they performed any sacrifices, nor that they had any special places or houses of worship. Since their life is so entirely given over to pleasure, I should style it Epicurean.

Vespucci could hardly have been more damning if he tried. In the eyes of his Florentine contemporaries, such pleasure-loving aboriginals were infinitely more abhorrent than Jews or Muslims. A people without religion barely deserved to be called human.

Even had the Atlantic world had any real monetary interest for the cities of northern Italy before the late sixteenth century, such attitudes ensured that artists like Filippo Lippi would never really have any interest in depicting Canary Islanders or Native Americans in their works. Lacking any semblance of culture, apparently despising the norms of civilized existence, and seemingly contemptuous of any form of religion, these peoples were scarcely recognizable as men and were hence, as Lippi and his contemporaries suspected, beneath the attention of any self-respecting Renaissance artist. In contrast to Jews, Muslims, and black Africans-all of whom were thought to have at least some underlying humanity worth exploiting, irrespective of the ghastly prejudices to which they were subject-the Atlantic peoples and their lands were simply not thought worthy of artistic attention. Their invisibility was the most damning form of condemnation and bigotry that could have been imagined, and, perversely, an eloquent statement of the attitudes that not only allowed the New World to be pillaged with such impunity by "civilized" Europeans in the coming years, but that also permitted its peoples to be enslaved, brutalized, and slaughtered with such wanton abandon for centuries to come.

* * *

Disdain for epoch-making discoveries that were gathering pace during the fifteenth century may not have been unusual, but it was nevertheless a revealing testimony to the true manner in which many Renaissance Italians perceived their relationship with the broadening horizons of the Atlantic world. Far from being the centerpiece of a new age of openness, filled with intellectual curiosity and learning that provided the stimulus for an unparalleled sense of self-reflection and self-discovery, the voyages of discovery were the opportunity for some of the worst sentiments imaginable. Minds were closed, the bounds of humanity were fenced in ever more tightly, and entire peoples were written off as unworthy of inclusion in the human race; and all the while, explorers were hailed as heroes and their horrific excesses glossed over in the most deadening artistic silence of all time.

But what is so remarkable is that the fate of the Atlantic peoples was merely the most extreme and breathtakingly underappreciated example of a broader trend in the history of the ugly Renaissance. It was an age not of tolerance and understanding but of exploitation and rapine. In the space of only a few brief years in Florence alone—the epicenter of the staggering cultural innovations that have come to cloak the period as a whole with such an aura of brilliance-Salomone di Bonaventura experienced the first worrying signs of violent anti-Semitism, Alberto da Sarteano ushered in some of the earliest witnesses to the oppression of sub-Saharan Africa, and Filippo Lippi himself embraced the tide of Islamophobia while nodding quietly at the dispatch of the Atlantic. It may have been an age of unparalleled cultural encounters, but as far as artists like Lippi were concerned, everyone was fair game, and no people could ever expect more in return for their sufferings than the most patronizing of nods in the corner of a painting. Far from highlighting the glory of a period habitually celebrated for its "modernity," the art of men like Filippo Lippi concealed a Renaissance that was, if anything, beyond merely ugly.

Epilogue

THE WINDOW AND THE MIRROR

F ALL LEON Battista Alberti's many and varied achievements, his most important and enduring contribution to the Renaissance was his contention that the ideal painting should be so vivid a representation of reality that when fixed to a wall, it could be mistaken for an "open window" (*finestra aperta*). The painter's skill, he believed, lay in persuading the viewer that what he was looking at was, in fact, not a picture but the world itself.

The ultimate refinement of Alberti's preoccupation with perspective, this idea was the foundation on which the edifice of Renaissance art was erected. It was the illusionistic effects of linear perspective extolled so highly in Alberti's *De pictura*—that permitted the art of the Renaissance not only to imitate the perceived perfection of classical statuary but also to imitate nature itself. And it was this unprecedented combination of breathtaking classicism and staggering naturalism that endowed Renaissance art with the aura of sublime beauty for which it has become famed.

By virtue of its impact on the visual arts, Alberti's image of the painting as a *finestra aperta* has also come to play an important role in the way that the period as a whole has come to be viewed. When one is confronted with any of the great artworks of the age—from the anonymous *Ideal City* and Piero della Francesca's *Flagellation of Christ* to Michelangelo's *Doni Tondo* and Leonardo da Vinci's *Mona Lisa*—it is all too easy to be seduced into thinking that one is, in fact, looking at a window onto the Renaissance as it really was, and to regard the lives of men like Alberti with the admiring awe that such paintings inspire.

But what was really important about Alberti's idea of the "open window" was that it was an illusion. Although a skillful artist could delude the viewer into thinking that a painting was a window onto reality, the painting always remained just a painting. It showed the world not as it was but as the artist and his patron wished it to be. It was a fantasy.

That Alberti's perfect artist was an illusionist par excellence, however, is not to say that the visual arts do not provide a window onto the Renaissance. Quite the reverse. If we look behind the facade of beauty, the social world on which the artist's imagination fed shines through in the circumstances of composition, in the attitudes embodied in the scene, and in incidental details that are included (or omitted). And it is in this that the true character of the Renaissance becomes clear. Far from being an age of unalloyed wonder, it was a period of sex, scandal, and suffering. Its cities were filled with depravity and inequality, its streets pullulated with prostitutes and perverted priests, and its houses played home to seduction, sickness, shady backroom deals, and conspiracies of every variety. Bending artists to their will, its foremost patrons were corrupt bankers yearning for power, murderous mercenary generals teetering on the edge of sanity, and irreligious popes hankering after money and influence. And it was an age in which other peoples and cultures were mercilessly raped, while anti-Semitism and Islamophobia reached fever pitch, and ever more insidious forms of bigotry and prejudice were developed to accommodate the discovery of new lands. If Alberti's window looks onto the Renaissance, it looks onto a very ugly Renaissance indeed.

Although at some considerable remove from familiar perceptions of the period, this is not an indictment of the Renaissance. Nor does it mean that the artistic and literary accomplishments of men like Filippo Lippi, Michelangelo, Petrarch, and Boccaccio should be downplayed. Far from it. By understanding the true awfulness of the social life of the Renaissance, we can appreciate its achievements all the more. While not everything about the Renaissance may be praiseworthy, or even particularly pleasant, it is far more impressive that artists and litterateurs should have created works that can still be admired for their brilliance and beauty, despite their having lived in an age of ghastliness, suffering, bigotry, and intolerance. Indeed, this only seems to lend an even greater sense of excitement and exhilaration to the Renaissance as a whole. Had the period's cultural actors been living gods inhabiting a heavenly land, their quest for the sublime would seem neither surprising nor particularly impressive. When the ugliness of the period is brought to light, it seems all the more inspiring that men and women

Epilogue

should have aspired to the perfect and the ideal, and dreamed of creating something better and more radiant than anything they had ever experienced. To put this rather differently, it is more impressive that a man lying in the gutter should reach for the stars than that a god atop Olympus should shape cherubs from clouds.

Yet if the visual arts can be used as a window onto the Renaissance as it really was, the culture of this most remarkable of periods can also serve as a mirror for today's world, and it is at this point that the exaltation of the past must give way to an indictment of the present.

One of the most striking things about the "ugly" Renaissance is that—with the exception of technology—it was not so very different from the modern world. There is certainly no less suffering than there was in Italy six hundred years ago. The streets still crawl with vice, and the city squares are still home to rape, robbery, and murder. Politicians are still corrupt, shady characters, mercenaries still rampage around certain parts of the world, and bankers are still growing fat from their ill-gotten gains. Even though popes may be rather nicer than they were in the past, there is still no paucity of intrigue and sexual scandal in the Vatican. What is more, there is no less intolerance, no less bigotry, no less sickness, no less inequality. Poverty still abounds, and racism is still a terrifyingly common feature of daily life. Hatred between nations still grows, and appreciation of other cultures floats on the surface of a deep well of crude stereotypes and prejudicial ignorance.

But whereas the vileness of the Renaissance inspired both patrons and artists to strive for something more, today's world seems all too comfortable to surround itself with an ocean of unimaginative grayness. Even though technological developments have made it possible to achieve more than ever before, there is no real aspiration to go beyond function, no desire to aspire to anything better or more perfect. Indeed, if anything, there is a sense of contented mediocrity, of self-satisfied cultural stagnation, and of deliberate disdain for beauty and excellence.

History is admittedly a poor teacher, and such lessons as it can impart should usually be treated with extreme caution. But when we hold the mirror of the Renaissance up to the face of the modern world, it is hard not to be roused by a sense that there is, in fact, a lesson that needs to be learned, and urgently. However dreadful contemporary life may be, it is essential never to be deluded into thinking that material suffering necessitates cultural mediocrity, unabashed ugliness, or the abandonment of the ideal. Exactly the opposite is true. The darker the night may seem, the more fervently should men yearn for the clear light of the dawn, and the more avidly should they long to fill it with beauty and wonder. If scandal, suffering, and corruption must exist, let them do so while filling the world with monuments to the indomitable brilliance of the human imagination, transforming the earth into a living, breathing monument to the sublime, so that in six hundred years' time men may look back at this age and sigh with amazement to think that such miracles were possible. In short, dreams must be dreamed again. A new Renaissance is long overdue.

Appendix A

THE MEDICI

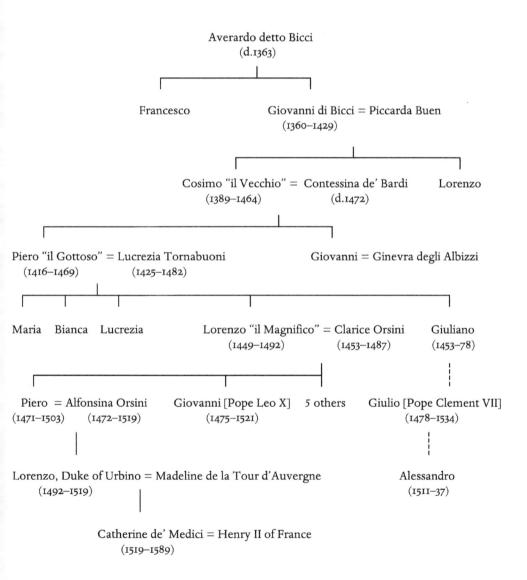

Appendix B

RENAISSANCE POPES

THE AVIGNON PAPACY

Clement V	1305–14
John XXII	1316-34
[Antipope Nicholas V	1328–30]
Benedict XII	1334-42
Clement VI	1342-52
Innocent VI	1352–62
Urban V	1362–70
Gregory XI	1370–78

THE GREAT SCHISM

Rоме

Urban VI	1378-89
Boniface IX	1389–1404
Innocent VII	1404–6
Gregory XII	1406–15
Martin V	1417-31

Avignon

Clement VII	1378–94
Benedict XIII	1394–1423

Pisa

Alexander V	1409–10
John XXIII	1410-15

The Roman Return

Eugenius IV	Gabriele Condulmer	1431-47
	(nephew of Gregory XII)	
[Felix V	Amadeo of Savoy	1440–49]
Nicholas V	Tommaso Parentucelli	1447-55
Callixtus III	Alfonso de Borja	1455-58
Pius II	Aeneas Silvius Piccolomini	1458–64
Paul II	Pietro Barbo	1464–71
	(nephew of Eugenius IV)	
Sixtus IV	Francesco della Rovere	1471-84
Innocent VIII	Giovanni Battista Cibo	1484-92
Alexander VI	Roderic Llançol de Borja	1492–1503
	(nephew of Callixtus III)	
Pius III	Francesco Todeschini Piccolomini	1503
	(nephew of Pius II)	
Julius II	Giuliano della Rovere	1503-13
	(nephew of Sixtus IV)	
Leo X	Giovanni di Lorenzo de' Medici	1513-21
	(relative of Innocent VIII)	
Adrian VI	Adriaan Florenszoon Boeyens	1522-23
Clement VII	Giulio di Giuliano de' Medici	1523-34
	(cousin of Leo X)	
Paul III	Alessandro Farnese	1534-49
Julius III	Giovanni Maria Ciocchi del Monte	1550-55
Marcellus II	Marcello Cervini degli Spannochi	1555
Paul IV	Giovanni Pietro Carafa	1555-59
Pius IV	Giovanni Angelo Medici	1559–65
	(distant relative of Leo X and	
	Clement VII)	

ACKNOWLEDGMENTS

This book has grown out of a long-standing passion for the history of the Italian Renaissance, and has its origins in countless days spent poring over dusty books in libraries the world over. But it has also grown out of something more fundamental. Illuminating though academic research undoubtedly is, the excitement and encouragement of friends and family have always brought me home to the real thrills of the period, and have opened my eyes to the immense possibilities of the "ugly" Renaissance. Without the many long conversations, without the laughter and the tears, without the loves and the sorrows of recent years, this book would never have occurred to me, much less come to fruition, and it is for the profound humanity of those with whom I have shared so many times that I am so tremendously grateful.

My family has been a pillar of almost incalculable strength and support, and has always been a source of boundless inspiration. Chris and Ingrid Lee, my brother Piers, Shindo Scarrott, Joe and Sophie, and Anna Edwards will perhaps never know how very much this book is indebted to them.

I will forever feel lucky to have some of the dearest and kindest friends anyone could wish for. James O'Connor, Pit Péporté, Christina Reuterskiöld, Alexander Millar, Luke Houghton, and Tim Stanley read early drafts of various chapters with incredible patience, and endured countless discussions of arcane details, always with great warmth of heart. Their suggestions and advice have been priceless, and there is not a page that does not bear the imprint of their wisdom. But perhaps more important, they have all kept me going through some of the darkest times, and have kept the light burning at the end of a tunnel that sometimes seemed endless. They have shown me what true friendship really is, and it means the world to me. Especial thanks are, however, due to Marie Sebban, whose kindness, love, and support in recent months have defied all description and have touched my heart more than I could possibly say.

I have been tremendously fortunate to have had the opportunity to be attached to the universities of Luxembourg and Warwick while completing this volume, and to have had the chance to discuss elements of its argument with some truly remarkable Renaissance scholars. Particular thanks are due to Stephen Bowd, who has perhaps done more than anyone else to enlarge my understanding of the period over the years, and to Luc Deitz, whose scholarly precision and excellent company have been genuinely inspiring. Although he is not himself a Renaissance specialist, I would also like to thank Paul Lay, whose enthusiasm for "public" history and whose unparalleled grasp of the fine balance between the scholarly and the accessible have been a vital example.

In bringing The Ugly Renaissance to publication, I am grateful to have had the opportunity to work with a number of exceptional people. Leanda de Lisle first gave me the nudge toward pursuing this project further, and was kind enough to provide me with the vital introduction that allowed it all to get off the ground. At Capel & Land, Rachel Conway and Romily Must have been touchingly patient and staggeringly efficient at every turn. At Doubleday, I feel extremely privileged to have been able to work with William Thomas and Coralie Hunter, editors of incomparable skill and taste, whose cheerful counsel and helpful suggestions have made the preparation of the text a sheer delight. No author could ask for more sensitive or friendly editors. And last, but most definitely not least, my agent, Georgina Capel, has been quite extraordinary. No words will quite do justice either to my gratitude or to her virtues. Her unique combination of great kindness and extreme professionalism has been both a vital spur and an invaluable source of support, while her constant encouragement and immense generosity of spirit have helped make this project a pleasure from start to finish.

Notes

INTRODUCTION: BETWEEN HEAVEN AND EARTH

- I Giovanni Pico della Mirandola: The best introduction to Pico's life remains Garin, *Giovanni Pico della Mirandola*.
- 2 "I have read in the records": Giovanni Pico della Mirandola, Oration on the Dignity of Man, trans. E. Livermore Forbes, in Cassirer, Kristeller, and Randall, Renaissance Philosophy of Man, 223.
- 3 "the nature of all other beings is limited": Ibid., 225.
- 4 "You shall have the power": Ibid.

1. MICHELANGELO'S NOSE

- 9 he was busy copying: Vasari, Lives, 1:332.
- 9 "surpassed and vanquished the ancients": Ibid., 1:418.
- 9 "the work not of a young man": Ibid., 1:331; Wallace, Michelangelo, 53n4.
- 9 the envy of his schoolfellows: Vasari, *Lives*, 1:332.
- 10 spoken derisively of Pietro's sketches: Cellini, Autobiography, 18.
- ¹⁰ "Jealous [at] seeing him more honoured": Vasari, *Lives*, 1:332.
- ¹⁰ "almost tore off the cartilage": Condivi, *Michelangelo*, 72–73.
- 10 his nose "broken and crushed": Vasari, *Lives*, 1:332.
- 10 lying "as if dead": Condivi, Michelangelo, 72.
- II The son of a comparatively modest bureaucrat: Michelangelo's family claimed to be able to trace an "ancient and noble lineage," but this seems to have been little more than wishful thinking. Wallace, *Michelangelo*, 36; cf. Michelangelo, *Carteggio*, 4:249–50.
- 11 Although some early Renaissance artists: Siena provides a number of especially 11 interesting examples of artists who served in communal government. Duccio 13 di Buoninsegna (1255/60–1318/19) appears to have been a member of the Sienese 13 Council of the People in 1289, and his name is listed in connection with two other 13 civic bodies in 1292 and 1295. By the same token, Simone and Donato Martini 13 were named procurators to the papal Curia on February 8, 1340. The same city 13 also provides examples of unusually highborn individuals becoming artists. Bar-14 tolommeo Bulgarini (d. 1378), for instance, is listed as being of noble birth in the 15 records of the Painters' Guild, and his family had previously been banned from 16 of the Early 17 Sienese Painter, 76–82.

- 12 Giotto di Bondone, for example, was rumored: Schwartz and Theis, "Giotto's Father."
- 12 Three of Duccio di Buoninsegna's sons: Maginnis, *World of the Early Sienese Painter*, 46–47.
- 12 autonomous creative agents endowed: See especially Martindale, *Rise of the Artist in the Middle Ages and Early Renaissance.*
- 12 When Giotto was made *capomaestro*: Rubin, *Giorgio Vasari*, 292–93; Larner, *Culture and Society in Italy*, 305; Maginnis, *World of the Early Sienese Painter*, 80–81.
- 12 Similarly, writing in his *De origine civitatis Florentiae*: Larner, *Culture and Society*, 279–80; Maginnis, *World of the Early Sienese Painter*, 80.
- 12 Although still reliant on the favor of patrons: For an excellent discussion of contractual relationships between artists and patrons, see Welch, Art and Society in Italy, 103–30.
- ¹² "not be subjected to the law": Cellini, *Autobiography*, 130.
- 13 As his biographer Paolo Giovio recorded: Barocchi, Scritti d'arte del cinquecento, 1:10.
- 13 He was a man of undoubted piety: Vasari, *Lives*, 1:423.
- 13 "Here in your lovely face": Michelangelo, verse 83, lines 1-4, in Poems and Letters, 23.
- 13 A devotee of illicit magic: On the accusation of sodomy made against Leonardo, see Crompton, Homosexuality and Civilization, 265; Creighton and Marisi da Caravaggio, Caravaggio and His Two Cardinals, 303n96; Wittkower and Wittkower, Born Under Saturn, 170–71.
- 13 Benvenuto Cellini was convicted of the same offense twice: For a detailed discussion of Cellini's sexual life, see Rossi, "Writer and the Man." It is also worth noting that Cellini was also accused of sodomizing a certain Caterina in 1543: Cellini, Autobiography, 281–83.
- 14 he killed at least two men: Cellini, *Autobiography*, 91, 128–29.
- 14 accused of stealing the papal jewels: Ibid., 184–89.
- 14 the music of the aristocratic composer Carlo Gesualdo: See Grey and Heseltine, Carlo Gesualdo, Musician and Murderer.
- 14 While the Middle Ages could be thought of as a period: Burckhardt, *Civilization of the Renaissance in Italy*, 87, 90–91.
- 15 the social contexts of artistic production: Burckhardt's view of the "discovery of the individual" has been subject to considerable question. For some of the more important arguments against it, see Baron, "Burckhardt's Civilization of the Renaissance a Century After Its Publication"; Maginnis, World of the Early Sienese Painter, 83–113; Baxandall, Painting and Experience in Fifteenth-Century Italy; Cole, Renaissance Artist at Work from Pisano to Titian; Thomas, Painter's Practice in Renaissance Tuscany; Becker, "Essay on the Quest for Identity in the Early Italian Renaissance"; Sheard and Paoletti, Collaboration in Italian Renaissance Art; Bullard, "Heroes and Their Workshops"; Guidotti, "Pubblico e privato, committenza e clientele."
- 15 Stephen Greenblatt has recast: Greenblatt, Renaissance Self-Fashioning.
- the elaboration of a complete theoretical understanding: Edgerton, *Renaissance Rediscovery of Linear Perspective*; Panofsky, "Die Perspektive als symbolische Form."
 For further on Panofsky's view of linear perspective in the Renaissance, see Landauer, "Erwin Panofsky and the Renascence of the Renaissance," esp. 265–66; Moxey, "Perspective, Panofsky, and the Philosophy of History."

- 15 This explosion of enthusiasm for visual exuberance: Wohl, *Aesthetics of Italian Renaissance Art*; see also the review by Mack, *Renaissance Quarterly*.
- 16 a close—and even incestuous—relationship: On this connection, see Gombrich, "From the Revival of Letters to the Reform of the Arts"; Weiss, *Renaissance Discovery of Classical Antiquity*; Rowland, *Classical Tradition in Western Art*.
- 16 As a number of eminent scholars have observed: Panofsky, Renaissance and Renascences in Western Art, 9; Baxandall, Giotto and the Orators; Gilbert, Poets Seeing Artists' Work.
- 16 While Dante Alighieri celebrated the renown: Dante, Purg. 11.91–96.
- 16 the language of "darkness" and "light": R. W. Lee, "Ut Pictura Poesis," 199–200; Haight, "Horace on Art"; Trimpi, "Meaning of Horace's Ut Pictura Poesis"; Ferguson, "Humanist Views of the Renaissance"; McLaughlin, "Humanist Concepts of Renaissance and Middle Ages in the Tre- and Quattrocento."
- 16 Petrarch is often thought to have inaugurated: Petrarch, Africa, 9.451–57. The classic interpretation of this passage remains Mommsen, "Petrarch's Conception of the 'Dark Ages.'" There is, however, some doubt as to how fully Mommsen's reading should be accepted: see A. Lee, "Petrarch, Rome, and the 'Dark Ages,'" esp. 14–17.
- 16 he was celebrated alongside Giotto: Boccaccio, *Lettere edite ed inedite*, 187; *Decameron*, 6.5.
- 16 "Our Plato in The Republic": Ficino, Opera omnia, 974, trans. in A. Brown, Renaissance, 101.
- 17 "the first person with a talent": Leonardo Bruni, Le vite di Dante e di Petrarca, in Baron, Humanistisch-philosophische Schriften, 66, trans. in Thompson and Nagel, Three Crowns of Florence, 77; on Bruni's view of Petrarch and Dante, see Ianziti, Writing History in Renaissance Italy, 177–78.
- ¹⁷ "before Giotto, painting was dead": Palmieri, *Vita civile*, ed. Belloni, 43–44, trans. in A. Brown, *Renaissance*, 102.

2. IN PETER'S SHADOW

- 21 Francesco Granacci: Michelangelo had known Francesco Granacci (1469–1543) from childhood. They studied together in the workshop of Domenico Ghirlandaio and were sent to Bertoldo di Giovanni's school at the same time. See Vasari, *Lives*, 1:330. Francesco subsequently completed several works for San Marco at the behest of Lorenzo de' Medici, and later traveled to Rome to assist Michelangelo with the painting of the Sistine Chapel.
- 21 Because he was already ailing from an unknown illness: Beyond a few scattered examples of his work (principally as a medalist), little has survived of the life of Bertoldo di Giovanni (ca. 1440–1491). Although ambiguous, a comment by Vasari suggests that he had already fallen sick some years before 1491, and that he was unable to continue his own work by the time of Michelangelo's arrival. That he accompanied Lorenzo de' Medici—who suffered from gout—to take the waters in a place referred to as Bagni di Morba in 1485 is beyond question: it is tempting to see this as more than an indication of the bond between the two men. There is, indeed, every indication that he was ailing for some months before he died at the age of around fifty-one on December 28, 1491, at Lorenzo's villa at Poggio a

Caiano, and—this being so—Acts 5:12–16, which Masaccio depicted in *Saint Peter Healing the Sick with His Shadow*, would have had a particular resonance.

- 22 After emerging as independent states: For a survey of the origins of the northern Italian city-states, see Waley, *Italian City-Republics*; Jones, "Communes and Despots"; Jones, *Italian City-State*; Hyde, *Society and Politics in Medieval Italy*; Martines, *Power and Imagination*.
- 22 Public officials like the Florentines: There are two classic—if contrasting explorations of this trend: Baron, *Crisis of the Early Italian Renaissance*; Skinner, *Foundations of Modern Political Thought*. Although eminently readable, they should be read with care. Each has been controversial in its own way, and scholarly debate continues apace.
- 22 Great public buildings: A useful and accessible introduction to this topic can be found in Norman, *Siena, Florence, and Padua*, esp. 2:7–55.
- As early as 1338, as the chronicler: Brucker, Renaissance Florence, 51.
- 24 In the same year, eighty banks: Ibid., 52.
- 24 Although there were intermittent crises: Franceschi, "Economy," 129. There has, of course, been some fairly intensive scholarly debate as to the long-term strength of the Florentine economy, especially in the aftermath of the crises of the mid-fourteenth century, but the balance of evidence appears to suggest that there was no significant or lasting decline in business activity before the mid-sixteenth century. For an interesting and rather intimate view of Florentine economic history, see Goldthwaite, *Private Wealth in Renaissance Florence*.
- 24 In the *catasto* of 1427: Black, "Education and the Emergence of a Literate Society," 18.
- ²⁵ "What city," he asked: Translation quoted in Brucker, *Renaissance Florence*, 29.
- 25 Despite having some doubts: Leonardo Bruni, *Panegyric to the City of Florence*, in Kohl and Witt, *Earthly Republic*, 135.
- 26 "What in the whole world": Ibid., 139.
- 26 The private houses that lined the streets: Ibid., 140.
- 26 "every traveler arriving": Ugolino Verino, *De illustratione urbis Florentiae*, in Baldassarri and Saiber, *Images of Quattrocento Florence*, 210.
- ²⁷ "many people believe that our age": Rucellai, *Zibaldone*, 1:60, in Baldassarri and Saiber, *Images of Quattrocento Florence*, 73.
- ²⁷ "Golden Age is inferior": Ugolino Verino, "Ad Andream Alamannum de laudibus poetarum et de felicitate sui saeculi," in Baldassarri and Saiber, *Images of Quattrocento Florence*, 94.
- 27 Girolamo Savonarola, whose attacks on the rich: Martines, Scourge and Fire, 103.
- 27 As mercantile fortunes rose: The inadequacy of surviving evidence has made a fully comparative survey of prices and wages between the fourteenth and the sixteenth centuries virtually impossible. There is, however, sufficient information to see a general downward trend in the real wages of unskilled workers throughout this period with some clarity. See Goldthwaite, *Economy of Renaissance Florence*, 570–74; La Roncière, "Poveri e povertà a Firenze nel XIV secolo"; Tognetti, "Prezzi e salari nella Firenze tardomedievale."
- 27 Poverty was always around the corner: Brucker, Society of Renaissance Florence, 214– 18, docs. 102–4.
- 28 After receiving the massive sum: Vasari, Lives, 2:42. According to Vespasiano da Bis-

ticci, Cosimo had donated such a large amount of money because he was eager to atone for the nefarious means by which he had accumulated his fortune. Brucker, *Renaissance Florence*, 108. In the opinion of Domenico di Giovanni da Corella, however, Cosimo's munificence had exceeded even that of kings. Domenico di Giovanni da Corella, *Theotocon*, in Baldassarri and Saiber, *Images of Quattrocento Florence*, 250.

- 28 "so many thousands of volumes": Verino, *De illustratione urbis Florentiae*, in Baldassarri and Saiber, *Images of Quattrocento Florence*, 210.
- 28 "where the Muses dwell": Ibid.
- 28 centerpiece of the city's annual Epiphany celebrations: Corella, *Theotocon*, in Baldassarri and Saiber, *Images of Quattrocento Florence*, 250.
- 28 "paradise was in these friaries": Trexler, Public Life in Renaissance Florence, 190.
- 29 Savonarola was elected prior: For excellent surveys of Savonarola's life and career, see Martines, *Scourge and Fire*; and, more recently, Weinstein, *Savonarola*.
- 29 briefly gave up painting: Vasari, Lives, 1:227.
- the sound of Savonarola's powerful voice: Condivi, Vita di Michelangelo Buonarroti,
 62; Hirst, Achievement of Fame, 25–26.
- an angry mob laid siege: For a wonderfully vivid account of the siege of San Marco, see Martines, *Scourge and Fire*, 231–43.
- 30 "Around my door, I find huge piles": Michelangelo, verse 267, lines 7–9, in *Poems and Letters*, 56.
- 30 the dome of Santa Maria del Fiore: Vasari, *Lives*, 1:160.
- 31 "worthy of heaven": Ibid., 1:123.
- 32 "Pandolfo lost eighteen florins": Baldassarri and Saiber, Images of Quattrocento Florence, 63.
- 34 Michelangelo would tell Miniato Pitti: Hirst, Achievement of Fame, 7.
- 36 "Every morning the street is jammed": Brucker, Renaissance Florence, 40-41.
- 36 the story of Antonio Rinaldeschi: Here, I follow Connell and Constable, "Sacrilege and Redemption in Renaissance Florence."
- 37 the guileless Tommaso never saw: Brucker, Society of Renaissance Florence, 156–57.
- 37 "six little shops": The report itself appears in translation in ibid., 190, doc. 89.
- 37 "Here is the congenial whorehouse": Beccadelli, *Hermaphrodite*, II, xxxvii (lines 9–18, 21–32), 108–11. Even though some of the more striking lines have been left out, this is one of Beccadelli's tamest and most restrained verses.
- 38 It was planned by the priors: The document authorizing the foundation of this brothel is given in translation at Brucker, *Society of Renaissance Florence*, 190, doc. 88.
- 39 "this life seems the hardened ground": Petrarch, Sen. 11.11, in Petrarch, Letters of Old Age, 2:414–15.
- 40 the city magistrates fined three men: Brucker, Renaissance Florence, 29-30.
- 40 Indeed, in advising Francesco "il Vecchio" da Carrara: Petrarch, *Sen.* 14.1, in Kohl and Witt, *Earthly Republic*, 52.
- 40 families renting a few cramped rooms: The Florentine *catasto* indicates that the average annual rent in the quarter of San Frediano, in Oltr'Arno, was somewhere between 1 and 2 florins per year. Brucker, *Renaissance Florence*, 25.

3. What David Saw

- 43 "He was not only hated by his enemies": Guicciardini, *Storie fiorentine*, 94, trans. in A. Brown, "Early Years of Piero di Lorenzo," 209.
- 43 Sensing the danger, Michelangelo fled Florence: On Michelangelo's flight, see Hirst, Achievement of Fame, 21–22.
- 43 "Buonarroto tells me that you live": Michelangelo, Carteggio, 1:9.
- 44 There, his fortunes might improve: Ibid., 1:8.
- 44 When the committee granted: Hirst, Achievement of Fame, 44.
- 44 The best weavers in Florence: Goldthwaite, *Economy of Renaissance Florence*, 576.
- 44 to discuss . . . transferring the completed work: On the *deliberazione* of the *operai* in January 1504, see Hirst, *Achievement of Fame*, 45–46.
- 46 "lived more like a prince": Vasari, *Lives*, 1:322.
- 46 Luca della Robbia became rich: Ibid., 2:32.
- 46 Correggio was forced to become: Ibid., 1:282.
- 46 Andrea del Sarto had to content himself: Ibid., 2:167.
- 46 Piero Lorentino d'Angelo: Ibid., 1:197.
- 47 Within decades, super-companies had been formed: For an excellent overview, see Goldthwaite, *Economy of Renaissance Florence*, 204–62.
- 47 Although the Salviati family's interests: Ibid., 74–75.
- 48 In the period 1346–50, the company founded: Ibid., 308–9.
- 48 Giovanni Rucellai estimated that the city: Rucellai, *Zibaldone*, 1:62, in Baldassarri and Saiber, *Images of Quattrocento Florence*, 75.
- about \$270.5 million: Finding a modern equivalent for the price of the florin is a 48 difficult business. Not only did Florence use a variety of different coins (in silver and gold), the relative value of which fluctuated over time, but the purchasing power of the florin itself also underwent considerable variation over the centuries. Goldthwaite, Economy of Renaissance Florence, 609-14. That said, some (very rough) approximations are possible. A gold florin contained an average of 3.536 grams of gold. At the current price of \$51 per gram, this made the coin itself worth the equivalent of around \$180. The purchasing power of the florin was, however, much higher, and while a variety of different points of comparison could be used, the average daily wage of an unskilled construction worker (see table at Goldthwaite, Economy of Renaissance Florence, 613, and Goldthwaite, The Building of Renaissance Florence, 436-37) is a convenient—if not completely satisfactory benchmark. Given a going rate of 10 soldi per day—that is, about 0.12 florin per day in 1450—and comparing this against a minimum wage of about \$58 per day today, it is reasonable to postulate that the purchasing power of the florin in the mid-fifteenth-century labor market was the equivalent of around \$493.
- 48 in 1514, Michelangelo provided 1,000 florins: Hirst, Achievement of Fame, 132–33.
- 48 Most people listed in the commune's tax records: Franceschi, "Economy," 141.
- 48 accounted for the employment of 21 percent: Herlihy and Klapisch-Zuber, *Les Toscans et leurs familles*, 295.
- 49 Individual artisans, such as weavers: On the working conditions of the lower socioeconomic strata of Florentine society, see Cohn, *Laboring Classes in Renaissance Florence*.
- 49 Niccolò Strozzi and Giovanni di Credi: Brucker, Renaissance Florence, 61–62.

- 49 women, who accounted for a growing percentage: See Brown and Goodman, "Women and Industry in Florence."
- 50 "the condition of the artisans": Brucker, Renaissance Florence, 26.
- 50 wages consistently failed to keep pace: Goldthwaite, *Economy of Renaissance Flor*ence, 362–63.
- 50 the laborers known as "Stumpy" and "Knobby": Wallace, Michelangelo, 140–41.
- 52 "Together with many others who were seduced": Brucker, Society of Renaissance Florence, 235.
- 53 "outrages . . . [against] those citizens": Ibid.
- 53 "combers, carders, trimmers": Ibid., 236.
- ⁵³ "a wool-comber . . . who sold provisions": Ibid., 237–38.
- 53 an even more dramatic reorganization: Ibid., 239.
- 54 Michelangelo was every bit in thrall: Artists like Michelangelo occupied a somewhat ambiguous place in this schema. Although some of those who worked with him on his sculpting projects between 1501 and 1505 either had a natural home in the guild structure or naturally sat outside it entirely, Michelangelo himself was in a curious position. As yet, there was no artists' guild in Florence. The nearest thing that existed, the Compagnia di San Luca—of which Piero di Cosimo was a member—was principally a lay fraternity and was separate from the guilds. It was not until the foundation of the Accademia del Disegno much later in the sixteenth century that artists were brought together under the same organizational roof. Perhaps because of the confusion surrounding his status, Michelangelo was not a member of any guild. Jack, "Accademia del Disegno in Late Renaissance Florence." For the foundation of the Accademia, see Barzman, *Florentine Academy and the Early Modern State*, 23–59.
- 54 Soderini was the head of the Florentine state: On Soderini's life and career, see Cooper, "Pier Soderini." Perhaps the clearest overview of Florentine politics in this general period remains Butters, *Governors and Government in Early Sixteenth-Century Florence*.
- 54 Soderini saw that commissions such as the *David*: Although Vasari notes that Soderini had a key role in reviving the project, Hirst has rightly cast doubt on the veracity of this suggestion. Vasari, *Lives*, 1:337; Hirst, *Achievement of Fame*, 43.
- 54 Ambrogio Lorenzetti's Allegory of Good and Bad Government: The political import of Lorenzetti's frescoes has attracted considerable scholarly interest, and has been the subject of intense debate. Two of the most important interpretations are Rubinstein, "Political Ideas in Sienese Art"; Skinner, "Ambrogio Lorenzetti."
- 55 "unlimited power and authority": Dati, Istoria di Firenze dall'anno MCCCLXXX all'anno MCCCCV, ix, in Baldassarri and Saiber, Images of Quattrocento Florence, 48.
- 56 a rising young man by the name of Niccolò Machiavelli: Machiavelli had been appointed second chancellor on June 19, 1489. On Machiavelli's role in Florentine government in this period, see Bertelli, "Machiavelli and Soderini"; Rubinstein, "Beginning of Niccolò Machiavelli's Career in the Florentine Chancery."
- 56 Consisting of a staggering three thousand members: Brucker, *Renaissance Florence*, 268.
- 56 a high turnover of personnel: On this point, see Najemy, Corporatism and Consensus, 301–18, esp. 305–6; see also D. Kent, "Florentine Reggimento in the Fifteenth Century," 612.

- 56 "Equal liberty exists for all": Baron, Crisis of the Early Italian Renaissance, 419.
- 57 In 1361, eight people were convicted: Najemy, Corporatism and Consensus, 180–81; Brucker, Florentine Politics and Society, 213.
- 57 "Citizens of simple mind": Najemy, Corporatism and Consensus, 203.
- 58 Dante's exile at the hands of his factional rivals: Dante took great pleasure in condemning his arch-nemesis, Filippo Argenti, to the filthy waters of the river Styx in the *Inferno*. Dante, *Inf*. 8.32–63.
- 59 the Medici family came to overshadow Florentine politics: The classic survey of the Medici reggimento remains Rubinstein, *Government of Florence Under the Medici*; note also Hale, *Florence and the Medici*.
- ⁵⁹ "not so much a citizen": Pius II, Secret Memoirs of a Renaissance Pope, II, 101.
- 59 "Political councils," Piccolomini noted: Ibid.
- 59 the bloody but abortive Pazzi Conspiracy: The most recent, and perhaps most readable, account of the Pazzi Conspiracy is Martines, *April Blood*.
- 59 "a sort of servitude": Baldassarri and Saiber, Images of Quattrocento Florence, 70.
- 60 Alamanno Rinuccini launched a vitriolic attack: The most relevant extracts are translated in ibid., 103–14.
- 60 Outlining his views in the Trattato: Savonarola, Trattato circa il reggimento e governo della città di Firenze; for a general introduction to Savonarola's political views, see Martines, Scourge and Fire, 106–10; Garfagnini, Savonarola e la politica; Fletcher and Shaw, World of Savonarola.
- 60 introduction of "new" families: Najemy, Corporatism and Consensus, 323.
- 61 dissent was treated with uncompromising severity: Although no political "traitors" were executed in the period 1498–1512, it is striking that there is a marked rise in the frequency with which "treason" was punished with death (as opposed to fines/exile) in the wake of the Pazzi Conspiracy (three executions in 1481), at the height of Savonarola's ascendancy (six executions in 1497), and after the restoration of the Medici after Soderini's fall. For an excellent study of this topic, see Baker, "For Reasons of State."
- 62 the competition over the adornment of Orsanmichele: See Brucker, Society of Renaissance Florence, 93–94, doc. 45.
- 62 Saint Zenobius was the source of enormous urban pride: Verino, De illustratione urbis Florentiae, II, in Baldassarri and Saiber, Images of Quattrocento Florence, 241-42.
- 63 On reaching maturity: Vasari, Lives, 1:214, 216.
- 63 Although monks and friars are sometimes presented: For example, Boccaccio, *Decameron*, 3.3.
- 63 a Tuscan abbot conceives a passionate love: Ibid., 3.8.
- 64 a Benedictine monk is caught having an affair: Ibid., 1.4.
- 64 Poggio Bracciolini and Leonardo Bruni: Brucker, Renaissance Florence, 180-81.
- 64 "a cloth factory in the Via Maggio": Ibid., 176.
- 64 The Umiliati friars, for example, owned and ran: Goldthwaite, *Economy of Renaissance Florence*, 370.
- 64 Francesco di Marco Datini's wife once wrote: Ibid., 368.
- 64 no fewer than 263 dioceses: Hay, Church in Italy in the Fifteenth Century, 10.
- 66 "all the miseries of the world": Debby, "Political Views in the Preaching of Giovanni Dominici in Renaissance Florence," 36–37.

- 66 "there is no justice but deception": Ibid., 40.
- 66 Savonarola struck out at the rich: Martines, Scourge and Fire, 103.

4. The Workshop of the World

- 69 "a partition of planks and trestles": Vasari, *Lives*, 1:338, amended.
- 69 "accompanied by great sweat": Kemp, Leonardo on Painting, 39.
- 70 "always having to contend": Vasari, *Lives*, 1:173.
- 70 "he would rather die of hunger": Ibid., 1:186–87.
- 71 "a comprehensive array of human needs": Cohen and Cohen, Daily Life in Renaissance Italy, 54.
- 71 the average size of the domestic sphere: Herlihy and Klapisch-Zuber, *Tuscans and Their Families*.
- 71 households comprising an average of five people: Kirshner, "Family and Marriage," 90.
- 71 the letter he sent to Michelangelo in late 1500: Michelangelo, Carteggio, 1:9.
- 72 "I must love myself first": Ibid., 1:7–8, trans. in Wallace, *Michelangelo*, 25.
- 72 "for the sake of his family": Vasari, *Lives*, 1:278.
- 72 Only on rare occasions: Michelangelo, Carteggio, 1:140-41.
- 72 Lodovico himself had served: Hatfield, Wealth of Michelangelo, 207.
- 72 Although he felt that it was beneath his status: Brucker, "Florentine Voices from the *Catasto*," 11–13, 31.
- 72 Happy as he was to accept: From the summer of 1497 onward, Lodovico frequently accepted financial assistance from his successful second son: Hirst, *Achievement of Fame*, 32, 95, 101, 108–9, 128–33, 180–83. Yet it is evident not merely that Lodovico had little comprehension of Michelangelo's work but also that the latter felt aggrieved by the former's offhandedness. In late 1512, for example, Michelangelo complained bitterly that despite laboring on his family's behalf for fifteen solid years, he had received not a single word of gratitude, and it is clear from the context of the letter that Lodovico was the primary target of his ire: ibid., 109. By 1521–22, relations between the two men had deteriorated so much that they seem to have come to blows over money: ibid., 180–81.
- 73 "that bitch": Michelangelo, Carteggio, 1:88.
- 73 "much rarer and more precious": Petrarch, Fam. 7.11.4.
- 73 he was "another self": On Petrarch's view of friendship, see A. Lee, *Petrarch and St. Augustine*, 229–75.
- 73 The ideal friend was chosen: On Renaissance friendship in general, see Hyatte, Arts of Friendship.
- 73 Boccaccio was even able to imagine: Boccaccio, Decameron, 10.8.
- 73 As the lively correspondence: Origo, Merchant of Prato; Trexler, Public Life in Renaissance Florence, 131–58.
- 73 offered Datini extensive advice: Mazzei, Lettere di un notaro a un mercante del secolo XIV, con alter lettere e documenti, 1:62, 67, 163, 169, 248, 393.
- 73 In return, Datini sent Mazzei: Ibid., 1:7, 29, 148, 184.
- 73 Petrarch recommended his friend Laelius: Petrarch, *Fam.* 19.4. The nickname "Laelius" was a testimony to the closeness of the bond between Petrarch and Lello di Pietro Stefano Tosetti. The historical friendship between Scipio Africanus

368

(236–183 B.C.) and Gaius Laelius during the Second Punic War had long been held up as the paradigmatic example of the ideal, and had been celebrated most extensively in Cicero's *De amicitia* (sometimes known as the *Laelius*). Petrarch made much of the relationship between the two in his verse epic, the *Africa*.

- 73 Fra Bartolomeo of San Marco taught Raphael: Vasari, *Lives*, 1:290.
- 73 "entertaining his many friends": Ibid., 1:276.
- 74 "deformed and dwarf-like": Boccaccio, Decameron, 6.5, trans. McWilliam, 457.
- 74 Although in later life he was to befriend: Vasari, *Lives*, 1:421.
- 75 Patrons not only habitually demanded sketches: See Welch, Art and Society in Italy, 103–30.
- 75 chimney decorations or wickerwork chests: Vasari, *Lives*, 1:185.
- 75 bronze knife that Piero Aldobrandini was later to commission: Wallace, "Manoeuvering for Patronage." Michelangelo and Aldobrandini ultimately fell out over the knife.
- 75 In his autobiography, Cellini was scathing: Cellini, Autobiography, 377.
- 75 Donatello smashed a bronze bust: Vasari, Lives, 1:180.
- 76 Francesco Filelfo was even forced to beg his friend: It is worth quoting the passage in full: "Sweet hope nourished me: the hope that you, Cicco, always, bring me with kind words feeds my heart. For the aediles and the quaestor have tricked me so often that I cough up bile. You come at a good time, since now my anger has reached a boil and my mind stirred up by evil begins to rage. I can't very well put up with what justice and piety forbid me from enduring. Starvation is not a thing to be tolerated. Why should I speak of the contagion of the deadly disease that a man without money can't avoid? The prince issues worthy orders which the men he has placed in charge of his treasury refuse to carry out. 'Go and come back again,' they say. 'Your money will be paid and a supplement worthy of your services will be paid you.' And so I go away and again I return. And again, like a fool, I return again, three or four times a day." Filelfo, Odes, IV.2, lines I-I6, pp. 229–31.
- 76 While painting some scenes from the lives: Vasari, *Lives*, 1:97–98.
- 76 "Now look at it": Ibid., 1:339.
- 76 he employed a minimum of twelve people: Wallace, Michelangelo, 91.
- "I should be glad if you would see": Michelangelo, Carteggio, 1:145, in Michelangelo, Letters of Michelangelo, 1:82.
- 77 "a stuck-up little turd": Wallace, Michelangelo, 46.
- 77 Michelangelo had to turn people away: Michelangelo, Carteggio, 1:153; q.v. Wallace, Michelangelo, 46.
- 77 On one occasion, he and one of his apprentices: Vasari, *Lives*, 1:228.
- 78 Botticelli, for example, was enraged: Ibid., 1:229.
- 79 as was the case with Raphael: Ibid., 1:320.
- 80 "If we grant that men deserve praise": Boccaccio, Famous Women, pref., 9.
- 80 "Book learning" remained a man's preserve: In Venice in the period 1587–88, for example, four thousand six hundred boys and only thirty girls—mostly of high status—attended the city's schools. Wiesner, Women and Gender in Early Modern Europe, 122–23.
- 80 "had some knowledge of drawing": Vasari, *Lives*, 1:104.
- 81 Giovanni d'Amerigo Del Bene complained: See Brucker, Society of Renaissance Florence, 32–33.

- 81 Although the poor girl's mother was unhappy: Ibid., 34–35.
- 82 "love for her husband": Francesco Barbaro, *On Wifely Duties*, in Kohl and Witt, *Earthly Republic*, 192.
- 82 women, being "by nature weak": Ibid., 215.
- 82 A noblewoman like Ginevra: Ibid., 215–20.
- 82 "wear and esteem all those fine garments": Ibid., 208.
- 82 "he very often attired her": Vasari, *Lives*, 2:100.
- 82 "behavior, speech, dress, eating": Barbaro, On Wifely Duties, in Kohl and Witt, Earthly Republic, 202.
- 82 even the faintest hint of infidelity: Palmieri, Vita civile, ed. Battaglia, 133.
- 83 "love her husband with such great delight": Barbaro, On Wifely Duties, in Kohl and Witt, Earthly Republic, 196.
- 83 "take great care that they do not entertain suspicion": Ibid., 194.
- 83 Boccaccio went to great lengths: Boccaccio, Decameron, 10.10.
- 83 "good women and bad women": Sacchetti, Il trecentonovelle, 233.

84 the theory didn't quite match the reality: Perhaps the classic introduction to this subject remains Rocke, "Gender and Sexual Culture in Renaissance Italy."

84 Although subject to legal restrictions: For useful overviews of this topic—which has been the subject of no small degree of academic debate—see Cohn, "Women and Work in Renaissance Italy"; J. C. Brown, "Woman's Place Was in the Home."

- 85 he warmly encouraged Sofonisba Anguissola: Michelangelo, Carteggio, 5:92–93.
- 85 "A wife . . . wears out her husband's ears": Filelfo, Odes, III.3, pp. 175-77.
- 85 "to restrain the barbarous": Brucker, Society of Renaissance Florence, 180-81.
- 86 Savonarola inveighed forcefully against female luxury: See the account of Luca Landucci given in Baldassarri and Saiber, *Images of Quattrocento Florence*, 276–83, esp. 277.
- 86 "Me, congealed already by cold age": Pontano, Baiae, I.4, lines 3–10, p. 13.
- 88 "utterly non-productive as investments": Goldthwaite, "Florentine Palace as Domestic Architecture," 995.
- 88 as Leon Battista Alberti explained: Leon Battista Alberti, De re aedificatoria, 9.1.
- 89 the Palazzo Strozzi, covers an area: Goldthwaite, "Florentine Palace as Domestic Architecture," 1005, fig. 8.
- 89 "the luxurious inflation of private space": Ibid., 1004–5.
- 89 Pagolo di Baccuccio Vettori found that the structure: ASF Carte Riccardi, no. 521, fol. 267; Goldthwaite, "Florentine Palace as Domestic Architecture," 983n13.
- 90 Although there was certainly a disparity of scale: The following is indebted to D. Kent, "'Lodging House of All Memories.'"
- 90 "viewing the material worlds": See Cavallo, "Artisan's Casa."
- 90 He was also to purchase three examples: Hatfield, Wealth of Michelangelo, 65ff.
- 90 Above street level, Michele the accountant's house: D. Kent, "'Lodging House of All Memories,'" 451.
- 91 It was only by the time Michele purchased: See Albala, Eating Right in the Renaissance.
- 91 It is an illustration of the brutality: D. Kent, "'Lodging House of All Memories,'" 453; Granato, "Location of the Armoury in the Italian Renaissance Palace."
- 92 "a poor little house": Vasari, *Lives*, 1:187.
- 93 Piero di Cosimo was living and working: Fermor, Piero di Cosimo, 14. It is interest-

ing to note that in early 1504, Piero sat on the committee that met to determine a suitable location for Michelangelo's *David*.

- 93 It was also shortly after completing the David: Hirst, "Michelangelo in 1505," 762.
- 93 When he ultimately left Florence: Michelangelo, *Carteggio*, 1:19.
- 94 "Live carefully and wisely": Ibid., 1:9, trans. in Wallace, Michelangelo, 26.
- 94 As a child he was somewhat sickly: Vasari, *Lives*, 1:430.
- 94 While painting the Sistine Chapel: Michelangelo, verse 5, lines 1-4, in Poems and Letters, 3:

I've got a goitre from this job I'm in bad water does it up in Lombardy to peasants, there or in some other country because my belly's shoved up against my chin.

- 94 by 1516 was lamenting that sickness: Michelangelo, Carteggio, 2:7–8.
- 94 "a sack for gristle": Michelangelo, verse 267, lines 34-45, in Poems and Letters, 57.
- 95 "Urine! How well I know it": Michelangelo, verse, 267, lines 10–12, trans. in Wallace, *Michelangelo*, 175.
- 95 friends began to fear for his life: Hirst, Achievement of Fame, 252–53.
- 95 "went blind through an attack of catarrh": Vasari, *Lives*, 1:197.
- 95 Similarly, dropsy (edema), caused by malnutrition: Ibid., 2:271.
- 95 It hardly needs saying that tooth decay: Cellini, Autobiography, 217.
- 96 As Alessandra Strozzi recorded in her correspondence: Brucker, Society of Renaissance Florence, 47–49.
- 96 One of its more prominent sufferers: Cellini, Autobiography, 16–17.
- 96 Subsequent attacks left him "raving": Ibid., 71–72.
- 96 Finding himself unable to work: Ibid., 147–54, 347–48.
- 97 "In the majority of cases, small ulcers": Arrizabalaga, Henderson, and French, *Great Pox*, 205–6.
- 98 Historians estimate that 30 percent: For a useful survey of the impact of the plague—and other diseases—on the lives of the lowest socioeconomic groups of the period, see Carmichael, *Plague and the Poor in Renaissance Florence*.
- 98 the outbreak of 1400: Cohn, "Black Death," 725.
- 98 Giorgione fell victim to the pestilence: Vasari, Lives, 1:276.
- 98 After sleeping with the adolescent maid: Cellini, Autobiography, 45-46.
- 99 Never one to contemplate marriage, Raphael: Vasari, Lives, 1:320.
- 99 "so lustful that he would give anything": Ibid., 1:216.
- 99 "His lust was so violent": Ibid.
- 99 So rampant was the sexual experimentation: Rocke, "Gender and Sexual Culture in Renaissance Italy," 157; Brundage, Law, Sex, and Christian Society in Medieval Europe, 492.
- 99 "over one-third of the forty-nine documented victims": Rocke, "Gender and Sexual Culture in Renaissance Italy," 163.
- 100 advocated celibacy even within wedlock: Mario Filelfo, Epithalamion pro domino Francisco Ferrario et Constantia Cimisella, MS Vat. Apost., Chig. I VII 241, fols. 140v–143r, here fol. 141v, trans. in D'Elia, "Marriage, Sexual Pleasure, and Learned Brides," 411.

- 100 "Wife, your elderly husband's delight": Pontano, Baiae, I.13, lines 1–10, p. 39.
- 100 Oral sex was definitely taboo: Rocke, "Gender and Sexual Culture in Renaissance Italy," 161; Rocke, *Forbidden Friendships*, 118–20.
- 100 Not only was he a cautious enthusiast: Beccadelli, Hermaphrodite, 1.5, esp. lines 1–2, p. 11: "When my Ursa wants to be fucked, she climbs on top of my Priapus. / I play her role, she plays mine." Unfortunately, Beccadelli feared that his penis was not up to the strain of Ursa's apparently insatiable sexual appetite in this position.
- 101 "Why," the character Lepidinus asked: Ibid., 1.14, lines 1–2, p. 21.
- 101 Even a devoted husband like Pontano: See especially Pontano, *Baiae*, II.29, pp. 166–67.
- 101 "a man can use a young woman": Wallace, Michelangelo, 110.
- 101 "powerful yearning for semen": Rocke, "Gender and Sexual Culture in Renaissance Italy," 151.
- 102 "It is much easier to defend": Domenico Sabino, De uxorum commodis et incommodis, MS Vat. Apost., Chis. H IV 111, fols. 108v–117v, here, fol. 110v, trans. in D'Elia, "Marriage, Sexual Pleasure, and Learned Brides," 407.
- "Is it any wonder, Marco": Cristoforo Landino, Xandra, II.13, in Poems, 105.
- "a lamb entrusted to a wolf": Landino, Xandra, II.24, line 2, in Poems, 125.
- In one tale loosely derived: Boccaccio, *Decameron*, 7.2.
- "in the manner of a hot-blooded stallion": Ibid., trans. McWilliam, 494.
- 103 In another tale, one Madonna Filippa: Boccaccio, Decameron, 6.7.
- "If he has always taken": Ibid., trans. McWilliam, 464.
- 104 Boccaccio's Decameron includes at least two stories: Boccaccio, Decameron, 2.5, 9.5; the character of Madonna Jancofiore in 8.10 is similar to a prostitute but is more of a sexual deceiver.
- Prostitutes were expelled from Venice: Davidsohn, Storia di Firenze, 7:616–17;
 Brackett, "Florentine Onestà and the Control of Prostitution," 277.
- 104 By 1384, the priors had acknowledged: Rezasco, "Segno delle meretrici," 165.
- 104 Though prosecutions were not irregular: See Brucker, Society of Renaissance Florence, 191–98.
- 104 On April 30, 1403, the city established a magistracy: For an excellent overview of the history of this magistracy, see Brackett "Florentine Onestà and the Control of Prostitution."
- 104 Barely thirty years later, seventy-six women: Trexler, "La prostitution florentine au XV^e siècle," 985–88.
- 105 By 1566, the acceptance of prostitution: Brackett, "Florentine Onestà and the Control of Prostitution," 287n64.
- 105 Prosecutions for "unofficial" prostitution: For example, in 1416, Bartolomeo di Lorenzo was convicted of attempting to sell his wife, Stella, to a brothel owner named Checco; see Brucker, *Society of Renaissance Florence*, 199–201.
- 105 Michelangelo's own sexual orientation: See Liebert, Michelangelo; Saslow, "'Veil of Ice Between My Heart and the Fire'"; Francese, "On Homoerotic Tension in Michelangelo's Poetry."
- 105 Normally grouped together with masturbation and bestiality: D'Elia, "Marriage, Sexual Pleasure, and Learned Brides," 409.
- 106 In a series of Lenten sermons: Hughes, "Bodies, Disease, and Society," 113.
- 106 "To the fire!": Trexler, Public Life in Renaissance Florence, 381.

- 106 Having established a special magistracy: The provision authorizing the establishment of the Office of the Night can be found at Brucker, *Society of Renaissance Florence*, 203–4, doc. 95.
- 106 Jacopo di Cristofano was found guilty: The court record for this case is given at ibid., 204–5, doc. 96.
- "106 "carried out the most extensive": Rocke, Forbidden Friendships, 4.
- 107 "men are not satisfied with servant girls": Sabino, De uxorum commodis et incommodis, fol. 115r, trans. in D'Elia, "Marriage, Sexual Pleasure, and Learned Brides," 408.
- 107 As a reflection of the moral distinction: Brackett, *Criminal Justice and Crime in Late Renaissance Florence*, 131.
- 107 the Platonic Academy: On historiographical debates surrounding the Platonic Academy, see the penetrating essay by Hankins, "Myth of the Platonic Academy of Florence."
- 107 Ficino suggested that homoerotic attraction: On this topic, see Maggi, "On Kissing and Sighing."
- 108 There is some evidence that same-sex unions: Rocke, Forbidden Friendships, 171.

5. MICHELANGELO IN LOVE

- 110 Pier Antonio Cecchini: For Cecchini, see Frommel, Michelangelo und Tommaso dei Cavalieri, 14–15; Michelangelo, Carteggio, 3:419–20.
- 110 In a break with habit: Although it is not absolutely certain that Cecchini effected the meeting between Michelangelo and Tommaso de' Cavalieri, the surviving evidence suggests that it was likely. Michelangelo and Tommaso can, after all, only have met within a relatively brief window of time. While the date of their first encounter is unclear, it can only have happened in the autumn, between Michelangelo's arrival in Rome (at some point between mid-August, when his house at Macel de' Corvi was made ready, and mid-September 1532, when a letter was addressed to him in the Eternal City) and January 1, 1533, by which point the relationship had already gathered steam. As Wallace has noted, this fact recommends the suggestion that they were introduced by a mutual friend (Wallace, Michelangelo, 177). Of those who could have brought them together, Cecchini is certainly the most likely. Cecchini was undoubtedly one of Michelangelo's closest friends in Rome during this period (see the familiarity of Michelangelo, Carteggio, 4:69) and knew Cavalieri prior to his meeting the artist (the acquaintance between Cecchini and Cavalieri may have been made through Cardinal Niccolò Ridolfi, to whose household Cecchini belonged). Most tellingly, however, Cecchini is referred to as a mutual friend and acted as a go-between for the two men on a number of occasions, both of which seem to lend weight to the supposition that he facilitated their friendship in a meaningful enough manner to have enjoyed the trust of both men as a matter of course (Michelangelo, Carteggio, 3:443-44; 4:3). That Cecchini introduced Cavalieri to Michelangelo is a suggestion that has recently been endorsed by Hirst, Achievement of Fame, 261.
- 110 the Cavalieri were noted collectors: On the Cavalieri family's collection, see Hirst, Achievement of Fame, 261; Steinmann and Pogatscher, "Dokumente und Forschungen zu Michelangelo, IV, Cavalieri-Dokumente," 502–4.
- 111 Having received the thorough humanistic education: This is evident from the

tenor of Michelangelo's later poetry but is, in any case, entirely consistent with the educational program followed by Roman nobles in this period. On the latter, see Grendler, *Schooling in Renaissance Italy*; Grafton and Jardine, *From Humanism to the Humanities*; Kallendorf, *Humanist Educational Treatises*; note also the rather brief comments at Castiglione, *Book of the Courtier*, IV, 291, 306.

- 111 he remarked upon Tommaso's "fear": Michelangelo, Poems and Letters, letter 30.
- "would provoke a poetic outpouring": Hirst, Achievement of Fame, 260.
- 113 "brought back dead poetry": Guido da Pisa, Expositiones et glose super Comediam Dantis, 4: "Ipse enim mortuam poesiam de tenebris reduxit ad lucem."
- 113 Having studied the Commedia: Wallace, Michelangelo, 41.
- II3 Cristoforo Landino's highly influential commentary: On Landino's Comento ... sopra la Comedia di Danthe Alighieri poeta fiorentino (1481), see Gilson, Dante and Renaissance Florence, 163–230.
- II3 In later years, he would deepen his knowledge: Hirst, Achievement of Fame, 23.
- 114 "radiant star" whose "splendour burned": Michelangelo, *Poems and Letters*, nos. 248 and 250.
- 114 Indeed, for Michelangelo, as for Boccaccio: On Dante's reception, see Gilson, *Dante and Renaissance Florence*, esp. chaps. 1–2.
- Running around playing at a May Day party: The date of this event is known only through Boccaccio's biography of Dante but has since become "traditional." That the party was held at the house of Folco dei Portinari is similarly inferred from other evidence: Dante never mentioned Beatrice's family name, and Boccaccio indicates only that the celebration was held at her father's house.
- "114 "the vital spirit, which dwells": Dante, La Vita Nuova, II, 3.
- "II4 "From then on," Dante confessed: Ibid., II, 4.
- "i14 "dressed in purest white": Ibid., III, 5.
- "Joyful Love seemed to me": Ibid., III, sonnet 1, 6.
- "I was so overwhelmed with grief": Ibid., XII, 14.
- 115 At a wedding, his rather affected swooning: Ibid., XIV, 18–20.
- 115 After he endured this humiliating episode: Ibid., XVIII, 24–25.
- "116 "expositor, ... Beatrice is a superior intelligence": Pope-Hennessy, Paradiso, 35.
- 117 As Bartolomeo Angiolini observed: Michelangelo, *Carteggio*, 3:53–54.
- 117 Although he claimed to esteem: Cavalieri's comments are at ibid., 3:445–46.
- 117 Tommaso even teased him: See, for example, Michelangelo's response to Tommaso's teasing after his return to Florence: ibid., 4:26.
- 118 In Michelangelo's gift drawing: Although Ovid remains the most obvious point of reference for Michelangelo to have used, the sources for the myth of Tityus are many and varied: Ovid, Met. 4.457–58; Virgil, Aen. 6.595–600; Lucretius, De rerum nat. 3.984–94; Homer, Od. 11.576–81. Curiously, however, the reference to Tityus's crime—the attempted rape of Leto—appears only in Homer. In order for the gift portraits to make coherent sense as a pair, it seems essential that Tityus's offense is known. Consequently, it appears reasonable to postulate that Michelangelo had direct or indirect knowledge of Homer.
- 118 It was in Avignon on April 6, 1327: The date is known from an inscription that Petrarch wrote on the flyleaf of his manuscript copy of Virgil (the so-called Ambrosian Virgil) and from a later verse. It is worth noting that although Petrarch was subsequently to associate April 6, 1327, with Good Friday, the ascription is mis-

taken (albeit deliberately so): it was, in fact, Easter Sunday. Petrarch, *Canzoniere*, poems 3, 211, in *Petrarch's Lyric Poems*, 38–39, 364–65.

- 118 As he later reminisced: Petrarch, Fam. 10.3; Wilkins, Life of Petrarch, 8.
- 119 But even though he was well placed: Petrarch, *Posteritati (Sen.* 18.1); text in *Prose*, 8–10.
- Petrarch gives us little clue: That Petrarch's Laura is to be identified with Laura de Noves (1310–48) was first suggested by Maurice Scève in 1533 (Mann, *Petrarch*, 58). But while the association is widely accepted—and even more widely cited—there has never been any conclusive proof.
- 119 "such lovely eyes": Petrarch, *Canzoniere*, poem 30, lines 19–21, in *Petrarch's Lyric Poems*, 86–87.
- 119 From that moment, he was in love: Q.v. Petrarch, *Canzoniere*, poem 3, lines 4, 9–11, in *Petrarch's Lyric Poems*, 38–39.
- 120 But despite his bucolic solitude: See Petrarch, *Canzoniere*, poem 35, in *Petrarch's Lyric Poems*, 94–95.
- 120 he even compares himself to Actaeon: Petrarch, *Canzoniere*, poem 52, in *Petrarch's Lyric Poems*, 122–23.
- 120 "through fields and across hills," and "from mountain to mountain": Petrarch, *Canzoniere*, poems 125, line 9; 129, line 1, in *Petrarch's Lyric Poems*, 238–39, 264–65.
- 120 His thoughts were no longer his own: Note Petrarch, *Canzoniere*, poem 29, line 36, in *Petrarch's Lyric Poems*, 84–85: "Da me son fatti i miei pensier diveri" (My thoughts have become alien to me).
- 120 "in the clear water": Petrarch, *Canzoniere*, poem 129, lines 40–47, in *Petrarch's Lyric Poems*, 266–67.
- 121 "want, grief, ignominy": Petrarch, Secretum, I, in Prose, 30.
- 121 Equipped with a proper understanding: Summarizing this same sentiment in the *De otio religioso (On Religious Leisure)*, Petrarch explained that "no thought is more useful than the thought of one's own death, nor has it been said without purpose 'Be mindful of your end, and you will not sin for eternity.'" Petrarch, *De otio religioso*, II, 3, lines 12–14, p. 78, in *On Religious Leisure*, 110, quoting *Ecclesiasticus* 7:40.
- 122 Marchionne di Coppo Stefani estimated: Stefani, Cronaca fiorentina, 230, r. 635.
- 123 on hearing of the death of his kinsman: Petrarch, Fam. 7.10.
- "My lady is dead": Petrarch, *Canzoniere*, poem 268, line 4.
- 124 "Life flees and does not stop": Petrarch, *Canzoniere*, poem 272, in *Petrarch's Lyric Poems*, 450 (adapted).
- 124 From beyond the grave, Laura pointed: Petrarch, *Canzoniere*, poem 142.
- "125 "the kinds of beauty": Castiglione, Book of the Courtier, IV, 340–42.
- "Your soul," he claimed in a poem: Michelangelo, Poems and Letters, no. 72, lines 5-7.
- 126 Distraught, Michelangelo felt obliged: Ibid., no. 58.
- "my sweet and longed-for lord": Ibid., no. 72, lines 12–14.
- 126 "If only blest when caught": Ibid., no. 98, lines 12–14.
- 127 "was to drink heavily": Boccaccio, Decameron, prologue, trans. McWilliam, 7.
- 127 "the rules of obedience": Ibid., 15.
- 127 Although many of his early works: Muscetta, Giovanni Boccaccio, 147; Wilkins, History of Italian Literature, 106.
- 128 "a frivolous and scatterbrained young woman": Boccaccio, *Decameron*, 4.2, trans. McWilliam, 304.

- 128 But while the storyteller (Pampinea) observes: Ibid., 312.
- ¹²⁹ "putting the devil back into Hell": Boccaccio, *Decameron*, 3.10, trans. McWilliam, 276.
- "what is that thing I see sticking out": Ibid., 276–77.
- 130 "learn to put the devil back in Hell": Ibid., 279.
- 130 Performed on a positively funereal carriage: For a discussion of this *canto*, see Prizer, "Reading Carnival." The text—with translation—is given at ibid., 185–87.
- 131 "How beautiful is youth": Medici, *Poesie*, 261:

Quant'è bella giovinezza Che si fugge tuttavia! Chi vuol esser lieto, sia; Di doman non c'è certezza.

- ¹³² "forgetful of their excellence": Bartolomeo Facio, *De hominis excellentia*, trans. in Trinkaus, *In Our Image and Likeness*, 1:227.
- 132 Opposing the tough and uncompromising morality: There is some evidence to suggest that Manetti composed at least some of the *De dignitate et excellentia hominis* as early as 1449, but it is generally accepted that the work—in its final form was prompted by a discussion that Manetti had with King Alfonso of Naples during the former's embassy in 1452. Although Alfonso had read Bartolomeo Facio's *De hominis excellentia*, it seems he had become rather disaffected with the author and asked Manetti to write a response. Happy to oblige, Manetti finished his demolition of Facio's argument in late 1452 or early 1453. For a general survey of Manetti's life and career, see Martines, *Social World of the Florentine Humanists*, 131–38.
- 132 "the most beautiful, the most ingenious": Giannozzo Manetti, De dignitate et excellentia hominis, trans. in Trinkaus, In Our Image and Likeness, 1:245.
- 133 Aurelio Lippo Brandolini: On Brandolini, see Mayer, Un umanista italiano della corte di Mattia Corvino, Aurelio Brandolino Lippo. The Dialogus de humanae vitae conditione et toleranda corporis aegritudine was composed while Brandolini was living in Budapest and was dedicated to the Hungarian king Matthias Corvinus. It proved to be rather popular and was printed several times from 1498 on.
- 133 "Since a certain pleasure": Aurelio Lippo Brandolini, Dialogus de humanae vitae conditione et toleranda corporis aegritudine, trans. in Trinkaus, In Our Image and Likeness, 1:302–3 (amended).
- 133 "It will be difficult": Manetti, De dignitate et excellentia hominis, trans. in Trinkaus, In Our Image and Likeness, 1:254–55 (amended).
- "Those [pleasures] which are generally": Ibid.
- ¹³⁴ Truculent, irascible, and powerfully argumentative: Valla had a rather frustrating habit of continually revising and updating his works, and seems almost never to have settled on a final text for any of his treatises. The *De voluptate* is no exception. Although it was first written in 1431, he subsequently reworked the text in its entirety, issuing it under the title *De vero falsoque bono* some years later. In what follows, I shall refer only to the original *De voluptate*. The text can be found (with facing German translation) in Valla, *Von der Lust*. The classic survey of Valla's life and thought remains Camporeale, *Lorenzo Valla*.
- 134 Conceived as a dialogue between three friends: An accessible and thorough discus-

sion of the place of Valla's treatise in the context of the *vita activa/vita contemplativa* debate can be found in Panizza, "Active and Contemplative in Lorenzo Valla."

- 135 Valla began by observing that Aristotle: Valla, De voluptate, 2.28.2; Valla, Von der Lust, 210; cf. Aristotle, Nicomachean Ethics, 1097b1-4.
- 135 Since happiness had to be an absolute state: Valla, De voluptate, 2.28.3; Valla, Von der Lust, 210.
- 135 Even if one could speak of a contemplative life: Valla, *De voluptate*, 2.28.5; Valla, *Von der Lust*, 212.
- 136 "Here in your lovely face": Michelangelo, Poems and Letters, no. 83.
- 137 But far from showing any surprise, Ganymede: Michelangelo's source for the story is Ovid's Metamorphoses, which he probably knew best in the Italian translation of 1497. Ovid, Met. 10.143–66. On Michelangelo's knowledge of Ovid, see Wallace, Michelangelo, 41; Hirst, Achievement of Fame, 17.
- 137 As a young man in the household: For a lively and general introduction to Michelangelo's relationship with the Florentine Neoplatonists, see Panofsky, "The Neoplatonic Movement and Michelangelo," in *Studies in Iconology*, 171–230.
- 138 "Neo-Neoplatonists": Mackenney, Renaissances, 146-49.
- 138 Although there has been some doubt: See Hankins, "Myth of the Platonic Academy of Florence."
- ¹³⁹ "a divine influence emanating": Marsilio Ficino, *Theologia Platonica*, 10.7; the remainder of this book repays close study; see Ficino, *Platonic Theology*, 3:106–96.
- 140 "Everything which is in the totality": Pico della Mirandola, *Heptaplus*, 188, trans. in Gombrich, "Icones Symbolicae," 168.
- 140 This was all a matter of contemplation: See Ficino, *Theologia Platonica*, 2.2; Pico della Mirandola, *Oration on the Dignity of Man*.
- 140 "the soul withdraws from the body": Kristeller, Renaissance Thought and the Arts, 94.

6. The Art of Power

- 145 On the afternoon of April 17, 1459: This description of Galeazzo Maria Sforza is derived from Pius II, *Commentaries*, II.26, 1:311.
- 145 an important diplomatic mission: Galeazzo Maria Sforza had officially been sent to escort Pope Pius II on his journey from Florence to Mantua, where the pontiff had convened a diet to proclaim a crusade against the Ottoman Turks. Pius arrived in Florence eight days later, on April 25, 1459. An account of Galeazzo Maria Sforza's arrival in Florence can be found in Francesco Filarete's *Libro cerimoniale*; a translation of the relevant section is given at Baldassarri and Saiber, *Images of Quattrocento Florence*, 77–82.
- ¹⁴⁵ "fairy world of gaiety": Gombrich, Story of Art, 256.
- 146 Absolutely no expense had been spared: On the decoration of the Magi Chapel, see Hatfield, "Cosimo de' Medici and the Chapel of His Palace."
- 146 Although there was a deliberate echo: Since at least 1390, the Compagnia de' Magi had staged spectacular processions through the city each Epiphany, and the pageantry of the event had provided a focal point for the affirmation of political and social unity. From the mid-1420s onward, the Medici had forcibly assumed a central role in these events. Muir, "Representations of Power," 228; Trexler, *Public Life in Renaissance Florence*, 298, 401–3, 423–25; Hatfield, "Compagnia de' Magi."

- ¹⁴⁷ "participants in, or witnesses to": Najemy, *History of Florence*, 330. Florence was, indeed, full of examples. Masaccio, for instance, depicted two donors leaning on either side of Saint John and the Virgin Mary in the *Trinity* (ca. 1425–27). The identity of these two figures is, however, not known with any certainty. It has, however, been suggested that they might be members of either the Lenzi or the Berti family. For a recent discussion of their identities, see Comanducci, "'L'Altare Nostro de la Trinità.'"
- 147 "never before had an entire family": Najemy, History of Florence, 330.
- 148 "When giving an audience": Hibbert, Rise and Fall of the House of Medici, 97–98.
- 148 "Ah, how much discretion": Landino, Xandra, III.1, lines 23-24, in Poems, 141.
- 150 Petrarch advised Francesco "il Vecchio" da Carrara: Petrarch, *Sen*. 14.1, in Kohl and Witt, *Earthly Republic*, 74–76.
- 150 Machiavelli viewed the true prince: Machiavelli, Prince, chap. 21, pp. 70–73.
- 150 "I should like our courtier": Castiglione, Book of the Courtier, I, p. 90.
- 150 For Castiglione, it behooved the courtier: Ibid., 96–97.
- ¹⁵¹ "large and very beautiful model": Vasari, *Lives*, 1:164–65.
- ¹⁵² "legitimate [the Medici's] domination": Muir, "Representations of Power," 228.
- 153 "Cosimo was refused nothing": Pius II, Commentaries, II.28, 1:317.
- 153 By surrounding themselves with portraits: See Muir, "Representations of Power."
- ¹⁵³ "presented themselves as worthy companions": Ibid., 228.
- 153 The collapse of imperial authority: The classic accounts of this process remain Jones, "Communes and Despots"; Jones, Italian City-State; Waley, Italian City-Republics; Hyde, Society and Politics in Medieval Italy; Martines, Power and Imagination. Despite the serious questions that have been raised about the interpretation contained therein, much profit can be derived from the early chapters of Skinner, Foundations of Modern Political Thought.
- 155 "sophisticated and, in some cases, highly professional": Muir, "Representations of Power," 227.
- 155 The town halls of Florence: For a useful introduction to the conception and design of civic palazzi, see Cunningham, "For the Honour and Beauty of the City."
- 155 the Council of Nine called in Ambrogio Lorenzetti: Lorenzetti's frescoes have been the subject of intense and ongoing debate. The classic readings remain Rubinstein, "Political Ideas in Sienese Art"; Rubinstein, "Le allegorie di Ambrogio Lorenzetti nella Sala della Pace e il pensiero politico del suo tempo"; Skinner, "Ambrogio Lorenzetti"; Skinner, "Ambrogio Lorenzetti's Buon Governo Frescoes."
- 158 But even though he tried to do some good: Marco Parenti, *Memorie*; the relevant section is translated in Baldassarri and Saiber, *Images of Quattrocento Florence*, 69–71, here 70.
- 158 "illegitimate lord": Pius II, Commentaries, II.28, 1:319.
- 159 "He was most magnificent": Lubkin, Renaissance Court, 87.
- 159 Galeazzo Maria took it into his head: Ibid., 102. On the Sforza family's patronage of the arts more generally, see Welch, *Art and Authority in Renaissance Milan*.
- 159 Filled always with the sound: Lubkin, *Renaissance Court*, 102–21; Merkley and Merkley, *Music and Patronage in the Sforza Court*.
- 160 Suspecting him (not without reason): Machiavelli, *Florentine Histories*, 7.33, p. 313: "Galeazzo was lecherous and cruel; frequent examples of these two things made him very much hated, because not only was it not enough for him to corrupt noble

women, but he also took pleasure in making this public. Neither was he content to put men to death unless he killed them in some cruel mode. Nor did he escape the infamy of having killed his mother, because it did not appear to him that he was prince so long as she was there. He behaved toward her in such a mode that she came to want to retire to her own dower residence in Cremona, on the journey to which she was suddenly taken ill and died—whereupon many judged that her son had had her killed."

160 Even nuns were not safe: For a pleasant overview of Galeazzo Maria Sforza's foibles, see Simonetta, *Montefeltro Conspiracy*, 9–16.

7. The Men with the Midas Touch

- 163 "anxious to remain in the background": Gutkind, Cosimo de' Medici, 124.
- 163 Galeazzo Maria would have heard rumors: See Hale, Florence and the Medici, 23–24, 31–32.
- 164 "indecipherable sphinx": Padgett and Ansell, "Robust Action and the Rise of the Medici," 1262.
- 165 Cosimo de' Medici personally made a profit: Najemy, *History of Florence*, 265; see also de Roover, *Rise and Decline of the Medici Bank*, 35–70.
- 165 If Giovanni Rucellai's estimate is to be believed: Rucellai, Zibaldone, 1:62, in Baldassarri and Saiber, *Images of Quattrocento Florence*, 75.
- 165 they had begun as humble pawnbrokers: This is given credence by the Medici's coat of arms. Although the seven red *palle* (balls) that appear against a golden field could symbolize pills, it is more plausible to suppose that they represent coins, the traditional emblem of pawnbrokers.
- 166 Although Pegolotti's Pratica della mercatura included: Pegolotti, La pratica della mercatura, 287–92.
- 166 Two Medici, Ugo and Galgano, set up shop: Brucker, "Medici in the Fourteenth Century," 3.
- 166 It was this profession that offered: See Hunt and Murray, *History of Business in Medieval Europe*, 63–67; Spufford, "Trade in Fourteenth-Century Europe," 178.
- 167 This all made trade a good deal easier: What follows is a highly simplified account of the extremely complex changes of the period. For fuller details of the general European context of these developments, see de Roover, *L'évolution de la lettre de change*; Spufford, *Money and Its Use in Medieval Europe*. For the specifically Florentine dimension, see Goldthwaite, *Economy of Renaissance Florence*, 408–83.
- 168 Saint Francis of Assisi's celebration of poverty: One of the best—and most eminently readable—introductions to Saint Francis's views on this subject remains Lambert, Franciscan Poverty.
- 168 Florence provided an ideal setting for the reception: See Baron, "Franciscan Poverty and Civic Wealth as Factors in the Rise of Humanistic Thought."
- 168 Bracciolini devoted an entire treatise: Poggio Bracciolini, De avaritia, in Kohl and Witt, Earthly Republic, 241–89.
- 168 Landino penned a savage verse: Landino, Xandra, 2.3, in Poems, 72-73.
- 169 This practice of "usury": Hunt and Murray, *History of Business in Medieval Europe*, 70–71; for a brief and broad survey of the concept, see Taeusch, "Concept of 'Usury.'"

- 169 "To take interest for money": Thomas Aquinas, Summa theologica II-II, q.78, a.1, in On Law, Morality, and Politics, 199.
- 169 This, indeed, was precisely the line: See de Roover, "Scholastics, Usury, and Foreign Exchange."
- 169 In the De avaritia: Bracciolini, De avaritia, in Kohl and Witt, Earthly Republic, 247.
- 169 In the Inferno, Dante described the fate: Dante, Inf. 17.1–78.
- 169 Only a little before the explosion: Note especially Le Goff, Birth of Purgatory.
- 170 In the Decameron, Boccaccio gleefully tells: Boccaccio, Decameron, 1.1.
- 171 This practice was later condemned: See Fraser Jenkins, "Cosimo de' Medici's Patronage of Architecture and the Theory of Magnificence," 162–63.
- 171 "I bequeath 100 florins": Brucker, Society of Renaissance Florence, 55.
- 172 Thus, Niccolò Acciaiuoli: Leoncini, La certosa di Firenze nei suoi rapporti con l'architettura certosina, 213; Welch, Art and Society in Italy, 191.
- 172 "If I spend 2,000 florins": F. W. Kent, "Individuals and Families as Patrons of Culture in Quattrocento Florence," 183; Welch, *Art and Society in Italy*, 193.
- 172 At least from the beginning of the fourteenth century: See Kempers, *Painting*, *Power*, and *Patronage*, 74–77, 182–92.
- 172 In the years after the Black Death: Najemy, History of Florence, 325.
- 173 "Peruzzi, Baroncelli, Cavalcanti": Ibid.
- 173 The Strozzi Chapel in Santa Maria Novella: See Giles, "Strozzi Chapel in Santa Maria Novella."
- 173 A towering jewel of early Renaissance art: For useful discussions of the circumstances of the Arena Chapel's construction, see Stubblebine, *Giotto*, esp. 72–74; Harrison, "Arena Chapel," 88–93.
- 173 And to ensure that the devout: Translations of the papal bull and the complaints of the monks at the Eremitani Church are given at Stubblebine, *Giotto*, 105–7.
- 175 limited involvement in artistic patronage: On which see Gombrich, "Early Medici as Patrons of Art."
- 175 Although a respected member of communal society: Brucker, "Medici in the Fourteenth Century," 1.
- 175 "a large proportion of the Medici": Ibid., 6.
- 176 The Peruzzi, for example, agreed to lend: See Hunt, Medieval Super-Companies.
- 176 the grain trade with southern Italy: Abulafia, "Southern Italy and the Florentine Economy."
- 176 124,000 lire a fiorino in 1300–1308: A lira a fiorino was worth approximately 0.69 florin. Najemy, History of Florence, 113–15; in general, Hunt, Medieval Super-Companies.
- 177 In 1427, Antonio di Salvestro di ser Ristoro: For the Serristori, see Najemy, *History* of *Florence*, 312–13; Tognetti, *Da Figline a Firenze*.
- 177 It was, however, in Rome that Giovanni: Najemy, History of Florence, 263.
- 178 Giovanni's strategy revealed not only his astuteness: For what follows, see Holmes, "How the Medici Became the Pope's Bankers."
- 178 Taking over the family's business interests: The classic study of the Medici bank, particularly under Cosimo, remains de Roover, *Rise and Decline of the Medici Bank*.
- 178 Reestablishing the bank on a new footing: Najemy, *History of Florence*, 264–65.
- 179 "probably not only the richest Florentine": Rucellai, Zibaldone, 1:61, in Baldassarri and Saiber, Images of Quattrocento Florence, 74.
- 181 Although contemporaries such as Palla Strozzi: On these figures, see Gregory,

"Palla Strozzi's Patronage and Pre-Medicean Florence"; Saalman, "Tommaso Spinelli, Michelozzo, Manetti, and Rosselino"; for a discussion of the construction of the Pazzi Chapel in Santa Croce, see Sanpaolesi, *Brunelleschi*, 82ff.

- 181 In 1419, Giovanni agreed to pay: For Brunelleschi's involvement with San Lorenzo, and his apparent success in persuading Giovanni di Bicci de' Medici to finance the project, see Vasari, *Lives*, 1:161–62.
- 181 after 1440, Cosimo assumed responsibility: See Elam, "Cosimo de' Medici and San Lorenzo."
- 181 a gigantic shrine to the Medici family: The association between San Lorenzo and the Medici was widely acknowledged by fifteenth-century Florentines. See, for example, Francesco Albertini's description of the church in his *Memoriale di molte* statue et picture sono nella inclyta ciptà di Florentia (1510), the text of which is given in Baldassarri and Saiber, *Images of Quattrocento Florence*, 218–19.
- 181 Cosimo had paid for the remodeling of San Marco: See Ullman and Stadter, *Public Library of Florence*.
- 181 The competition between merchant bankers: On the Badia Fiorentina, see Leader, *Badia of Florence.*
- 182 comparatively unremarkable house in the via Larga: See Saalman and Mattox, "First Medici Palace."
- 182 the average merchant banker's palazzo: Figures from Goldthwaite, "Florentine Palace as Domestic Architecture," 993.
- 182 "I think I have given myself": Rucellai, Zibaldone, 1:118, trans. in Goldthwaite, "Florentine Palace as Domestic Architecture," 990–91.
- 182 "it has comfortably accommodated kings": Vasari, *Lives*, 2:35–36. Indeed, it was no surprise that when King Charles VIII of France entered Florence after Piero di Lorenzo de' Medici's flight in 1494, he instinctively took up residence in the abandoned Palazzo Medici Riccardi, on the grounds that it was the only private home with sufficient majesty to house a monarch.
- 182 "restored the palace of Careggi": Vasari, Lives, 2:43.
- 183 In the *De seculo et religione*: For a useful introduction to this work, see Witt, *Hercules at the Crossroads*, 195–208.
- 183 "riches bring no satiety": Bartolomeo Facio, *De vitae felicitate*, trans. in Trinkaus, *In Our Image and Likeness*, 1:201.
- 183 preachers such as Fra Giovanni Dominici: Fraser Jenkins, "Cosimo de' Medici's Patronage of Architecture and the Theory of Magnificence," 162–63.
- 184 In his commentary on the pseudo-Aristotelian *Economics*: Ibid., 162. The following paragraphs are indebted to Fraser Jenkins's work.
- 184 For Leon Battista Alberti: Alberti, I libri della famiglia; Cena familiaris; Villa, 210.
- 184 the efforts to justify the lavishness: See Green, "Galvano Fiamma, Azzone Visconti, and the Revival of the Classical Theory of Magnificence."
- 185 complete "theory of magnificence": The current consensus among scholars is that a full-fledged theory of magnificence emerged in Florence during the 1450s—that is, by the time of Galeazzo Maria Sforza's visit. See Fraser Jenkins, "Cosimo de' Medici's Patronage of Architecture and the Theory of Magnificence"; Gombrich, "Early Medici as Patrons of Art"; D. Kent, *Cosimo de' Medici and the Florentine Renaissance*; Lindow, *Renaissance Palace in Florence*, esp. 1–76. Recently, however, some suggestion has been made that the first signs of the theory can be detected some

decades earlier in the preaching of Antonino Pierozzi: see P. Howard, "Preaching Magnificence in Renaissance Florence."

- 185 "All these things deserve extraordinary praise": Timoteo Maffei, In magnificentiae Cosmi Medicei Florentini detractores, trans. in Fraser Jenkins, "Cosimo de' Medici's Patronage of Architecture and the Theory of Magnificence," 166.
- 186 Splendor was thus thought: See Lindow, Renaissance Palace in Florence.
- 186 "The magnificent man": Pontano, I tratti delle virtue sociali, 234–42, trans. in Welch, Art and Society in Italy, 221–23.
- 188 "it governed for the benefit": Brucker, Renaissance Florence, 137.
- 188 Conscious that the Florentine constitution: The following paragraph is a highly attenuated account of a rather complex series of developments. For further details, see Molho, "Politics and the Ruling Class in Early Renaissance Florence"; Witt, "Florentine Politics and the Ruling Class"; Najemy, *Corporatism and Consensus*, 263–300; Najemy, *History of Florence*, 182–87.
- 189 By stacking the government: As an anonymous Florentine chronicler observed, those whom "the powerful" selected for inclusion in the *borsellini* "were very loyal to their regime," where "regime" refers to the rule of the dominant patricians rather than to the Signoria as an abstract concept. Cronica volgare di anonimo fiorentino, 35, trans. in Najemy, History of Florence, 183.
- 189 "Many were elected to the offices": Cavalcanti, Istorie fiorentine, 1:30.
- 190 After a destructive civil war: See Epstein, *Genoa and the Genoese*, 194–211, 221–27, 242–53.
- 190 The first member of the family to be elected: Najemy, Corporatism and Consensus, 323.
- 190 Salvestro de' Medici: Najemy, History of Florence, 161, 173–74, 184; Najemy, Corporatism and Consensus, 272.
- 191 Cavalcanti's tale of how the patrician Niccolò da Uzzano: Cavalcanti, Istorie fiorentine, 1:28–29.
- 191 "in Florence, it has always happened": Bruni, Panegyric, in Kohl and Witt, Earthly Republic, 158.
- 191 "Do not appear to give advice": Hibbert, Rise and Fall of the House of Medici, 40-41.
- 192 Only a few years later, in 1400: Anonymous, Alle bocche della piazza, 218–21.
- 194 For much of the war, Florence faced bills: Najemy, History of Florence, 255–56.
- 194 As the surviving records show: For sample declarations, see Brucker, Society of Renaissance Florence, 6–13 (which contains the returns for Conte di Giovanni Compagni, Francesco di Messer Giovanni Milanese, Lorenzo Ghiberti, Agnolo di Jacopo, weaver, and Biagio di Niccolò, wool carder). For a study of the 1427 catasto as a whole, see Herlihy and Klapisch-Zuber, Les Toscans et leurs familles.
- 194 Whereas some owed no more than a few soldi: Najemy, History of Florence, 259; Martines, Social World of the Florentine Humanists, 365–78.
- 194 Between 1428 and 1433, it has been calculated: Molho, *Florentine Public Finances in the Early Renaissance*, 157–60.
- "194 "entire patrimonies were being consumed": Najemy, History of Florence, 261.
- 195 Cosimo de' Medici and his business associates: D. Kent, Rise of the Medici, 352-57.
- 196 nothing more than a very wealthy *padrino*: This description is derived from Molho, "Cosimo de' Medici."
- 198 "even the monks' privies": Hibbert, Rise and Fall of the House of Medici, 48.
- 200 After commissioning Sandro Botticelli: On the Adoration of the Magi and the figures

depicted, see Hatfield, Botticelli's Uffizi "Adoration," 68–110; Lightbown, Sandro Botticelli, 2:35–37.

201 "the most convincing and natural": Vasari, Lives, 1:226.

8. Mercenaries and Madmen

- 203 "in both mind and body": Pius II, Commentaries, II.32, 1:327.
- 203 "the evil side of his character": Ibid., 1:329.
- 204 "the worst of all men": Ibid.
- 204 "no tolerance for peace": Ibid.
- 206 From around 1300, "professional mercenaries": Mallett, Mercenaries and Their Masters, 15–16.
- 207 The earliest known companies: See ibid., 25ff.
- 207 the deliciously named Diego de Rat: Diego de Rat (or della Ratta) features in one of Boccaccio's stories, peddling forged currency. Boccaccio, *Decameron*, 6.3.
- 207 Hermann Vesternich: Caferro, "Continuity, Long-Term Service, and Permanent Forces," 230, table 1.
- 208 "A beautiful work of extraordinary grandeur": Vasari, Lives, 1:101.
- 208 although moved on a number of occasions: On the movement of the fresco, see Meiss, "Original Position of Uccello's *John Hawkwood*."
- 208 Although the Duomo was the epicenter: In contrast to Santa Croce—rightly reputed as the pantheon of dead Italian greats—Santa Maria del Fiore contains almost no monuments to lay figures. Aside from Domenico di Michelino's fresco *Dante Before the City of Florence*, only Filippo Brunelleschi (the dome's architect), Giotto di Bondone (the architect of the campanile), and Marsilio Ficino were commemorated with memorials. The remaining funerary monuments are those of saints or senior ecclesiastical figures (such as Pope Nicholas II and Pope Stephen IX). By the early fifteenth century, there was even a growing feeling that the laity should never be commemorated in churches: Leon Battista Alberti's discussion of this topic is, of course, the most prominent example of such sentiments. On Alberti's remarks, see Wegener, "That the Practice of Arms Is Most Excellent Declare the Statues of Valiant Men," 136.
- 209 As the inscription: It is worth noting that Hawkwood was known to Italians as "Giovanni Acuto" and was commemorated by the Latinized name "Ioannes Actus." The terms of the inscription have deliberately classical echoes, on which see Hudson, "Politics of War," 25.
- 209 Born somewhere in southeast England: For a thorough treatment of Hawkwood's career, see Caferro, *John Hawkwood*.
- 209 It was while campaigning with the White Company: His campaign against the papacy and his bravery are both noted by Froissart. Froissart, *Chronicles*, 282–83.
- 209 it was in 1377 that he found his métier: On Hawkwood's hiring by Florence in 1377, see Caferro, "Continuity, Long-Term Service, and Permanent Forces," 224–25.
- 209 "most effective captain": Ibid., 224.
- 210 To avoid such a devastating eventuality: See Najemy, History of Florence, 151-52.
- 210 Yet by leading a band of marauders: This is described by Marchionne di Coppo Stefani, Cronaca fiorentina, 345. See Caferro, "Continuity, Long-Term Service, and Permanent Forces," 226.

- 211 "behaved more unforgivingly": Leonardo Bruni, Historiarum florentini populi libri XII, II.72, in History of the Florentine People, 1:183. See Ianziti, Writing History in Renaissance Italy, 132–33.
- 211 In 1377, Hawkwood was responsible: Mallett, Mercenaries and Their Masters, 40–41.
- 211 Lamenting the use of German mercenaries: Petrarch, *Canzoniere*, poem 128, lines 17–38, in *Petrarch's Lyric Poems*, 257–59. On the context of "Italia mia," see Mommsen, "Date of Petrarch's Canzone Italia Mia."
- 211 Indeed, it was no coincidence: Mallett rightly notes that "in Florence the caricatures painted on the walls of the Palazzo della Signoria of condottieri hanging upside down in chains were not uncommon sights. Niccolò Piccinino was the object of such a painting in 1428... In Venice, it was not the Doge's Palace which was chosen for such gestures, but the walls of the public brothel at the Rialto." Mallett, Mercenaries and Their Masters, 94–95.
- 211 Malatesta da Verucchio: Dante, Inf. 27.44–46.
- 211 On discovering that his wife, Francesca da Polenta: Ibid., 5.73–142. On this episode, see Barolini, "Dante and Francesca da Rimini."
- 212 Pedro Berruguete's *Portrait of Duke Federico*: The portrait is sometimes attributed to Justus of Ghent.
- 212 In depicting his patron in such a manner: For Federico's life, see Tommasoli, *La vita di Federico da Montefeltro*; La Sizeranne, *Federico di Montefeltro*.
- 212 Campaigns had become more brutal: As Mallett has rightly observed, "The major factor in the decline of the influence of the companies was the growth of a more organised political structure in late fourteenth-century Italy." Mallett, Mercenaries and Their Masters, 51. The remainder of this paragraph is indebted to Mallett's insights.
- 213 Quite apart from the vast sums: The kingdom of Naples appears to have pioneered this technique—King Ladislaus made Francesco Sforza (son of Muzio Attendolo) marquis of Tricarico, in Basilicata, in 1412—but it was certainly not uncommon in the North. The papacy regularly granted vicariates to those who had rendered outstanding service, or who were most liable to turn tail, and the Malatesta of Rimini were among the more prominent examples of those who received such ecclesiastical grants. So, too, the Visconi—and later the Sforza—of Milan habit-ually gave titles and estates to their commanders. On the especially interesting example of the Malatesta, see Jones, "Vicariate of the Malatesta of Rimini."
- So towering a figure: Clough, "Federigo da Montefeltro's Patronage of the Arts,"
 130.
- 214 As early as 1464, Gianmario Filelfo: Zannoni, "I due libri della Martiados di Giovan Mario Filelfo," esp. 657–59. On the younger Filelfo's relationship with Federico da Montefeltro, see, for example, Clough, "Federigo da Montefeltro's Patronage of the Arts," 133–34.
- 214 Paltroni's laudatory biography: Paltroni, Commentari della vita e gesti dell'illustrissimo Federico Duca d'Urbino.
- ²¹⁴ "worth comparing to the best captains": Simonetta, Montefeltro Conspiracy, 51.
- "to his prudence, humanity": Castiglione, Book of the Courtier, I, p. 41.
- 215 Apocryphal though the tale may be: For a good survey of the chapel's broader function, see Knox, "Colleoni Chapel in Bergamo and the Politics of Urban Space." See also Schofield and Burnett, "Decoration of the Colleoni Chapel"; Piel, La Cap-

384

pella Colleoni e il Luogo della Pietà in Bergamo; Bernstein, "Patronage, Autobiography, and Iconography."

- 216 a double-sided portrait of the duke and his wife: On these panels, see Kempers, *Power, Painting, and Patronage*, 235–37.
- 218 He was a true bibliophile: On the *studioli*, see Remington, "Private Study of Federigo da Montefeltro"; Fabiański, "Federigo da Montefeltro's 'Studiolo' in Gubbio Reconsidered."
- 218 According to Vespasiano da Bisticci: Kempers, *Painting, Power, and Patronage*, 360n7; Clough, "Federigo da Montefeltro's Patronage of the Arts," 138.
- 218 An acquaintance of Cristoforo Landino: Clough, "Federigo da Montefeltro's Patronage of the Arts," 131–37.
- 219 Perhaps as a result of a youth: On Federico's fondness for architecture, see Heydenreich, "Federico da Montefeltro as a Building Patron."
- 219 In 1464, he commissioned the Dalmatian architect: On the palazzo itself, see Rotondi, *Ducal Palace of Urbino*.
- 219 So fabulous was Federico's court: See Weil-Garris and d'Amico, "Renaissance Cardinal's Ideal Palace," 87.
- 220 excoriated by the Florentine chancellor, Leonardo Bruni: On the *De militia*, see Bayley, *War and Society in Renaissance Florence*; Viti, "'Bonus miles et fortis ac civium suorum amator.'"
- 220 "Mercenaries are disunited": Machiavelli, *Prince*, chap. 12, pp. 38–39. Similar statements about mercenary generals can be found in Machiavelli, *The Art of War*, 1; *Discourses*, 2.20.
- 221 "These condottieri have now reached": Mallett, Mercenaries and Their Masters, 105.
- ²²² "Oliverotto prepared a formal banquet": Machiavelli, Prince, chap. 8, pp. 28–29.
- 223 "blasphemous and cruel": Pius II, Commentaries, II.12, 1:253.
- 223 "raped [the] wives and daughters": Ibid.
- 223 Even worse was Braccio da Montone: Mallett, Mercenaries and Their Masters, 66.
- 223 "pleasant and charming": Pius II, Commentaries, II.18, 1:273.
- 224 Corresponding with his network: See Simonetta, Montefeltro Conspiracy.
- 226 Fighting was in Sigismondo's blood: For a survey of the Malatesta family in general, see Jones, *Malatesta of Rimini and the Papal State*.
- 227 after Sigismondo had begun an affair: Sigismondo was to marry Isotta in 1456. The couple had four known children, one of whom (Antonia) was subsequently beheaded by her husband for adultery. Isotta was not, however, Sigismondo's only mistress. He is reputed to have bedded dozens of women in his time, but only Vannetta dei Toschi is known.
- 228 Over the next fourteen years, the two condottieri: For an engaging, if flawed, treatment of the rivalry between the two men, see Pernis and Adams, *Federico da Montefeltro and Sigismondo Malatesta*.
- 228 "He broke faith": Pius II, Commentaries, II.32, 1:329.
- 229 "was a slave to avarice": Ibid., 1:327–29.
- 230 Tempio Malatestiano: The classic study of the church remains Ricci, *Il Tempio Malatestiano*.
- 230 "one of the foremost churches": Vasari, Lives, 1:210.
- 230 "erected at . . . magnanimous expense": The full Greek inscription reads: "Sigismondo Pandolfo Malatesta, son of Pandolfo, Bringer of Victory, having survived

many and most grave dangers during the Italic War, in recognition of his deeds accomplished so felicitously and with such courage, for he obtained what he had prayed for in such a critical juncture, has erected at his magnanimous expense this temple to the Immortal God and to the City, and left a memorial worthy of fame and full of piety." Trans. in Lavin, "Piero della Francesca's Fresco of Sigismondo Pandolfo Malatesta Before St. Sigismund," 345.

- 231 the fresco he commissioned from Piero della Francesca: For an interesting and recent reevaluation of this work, see ibid.
- ²³² "There is no doubt that Sigismondo's perfidy": Pius II, Commentaries, II.32, 1:331.

9. The Unholy City

- 234 Aeneus Silvius Piccolomini: For biographical treatments of Aeneas, see Mitchell, Laurels and the Tiara, and Paparelli, Enea Silvio Piccolomini.
- 235 Far from being an upright, saintly figure: For what follows, see Francesco Filarete and Angelo Manfidi, "Libro Cerimoniale" of the Florentine Republic, 76–77; Baldassarri and Saiber, Images of Quattrocento Florence, 79–80.
- 235 "See how we lords of cities have sunk!": Pius II, Commentaries, II.26, 1:311.
- 235 Although Cosimo de' Medici would have been hoping: See Holmes, "Cosimo and the Popes."
- 235 At the key meeting, he shouted everyone down: Pius II, Commentaries, II.32, 1:327-35.
- 236 He delighted in a joust: Ibid., II.31, 1:327.
- 236 Even though some 14,000 florins: Ibid.; Filarete and Manfidi, "Libro Cerimoniale" of the Florentine Republic, 78.
- 237 Since 1309, the popes had resided not at Rome: For what follows, see Mollat, *Popes at Avignon*; Renouard, *Avignon Papacy*.
- 238 "The city of Rome was in agony": Anonimo Romano, Life of Cola di Rienzo, 40.
- 238 Urban had split the Church in two: For further details on the beginnings of the schism, see Ullmann, Short History of the Papacy in the Middle Ages, 279–305; Ullmann, Origins of the Great Schism.
- 239 Petrarch, for example, spent the greater part of his life: On Petrarch's periods of residence in or near Avignon, see Wilkins, *Life of Petrarch*, 1–5, 8–24, 32–39, 53–81, 106–27; on his benefices and other sources of ecclesiastical income, see Wilkins, "Petrarch's Ecclesiastical Career."
- 239 Leonardo Bruni served as a papal secretary: On Bruni's career at the Roman Curia, see Bruni, *Humanism of Leonardo Bruni*, 25–35; Gualdo, "Leonardo Bruni segretario papale."
- 239 Simone Martini was an important presence: The standard work on Martini's life and career remains Martindale, *Simone Martini*.
- 239 artists such as Matteo Giovanetti: Enaud, "Les fresques du Palais des Papes d'Avignon"; Laclotte and Thiébaut, *L'école d'Avignon*.
- 240 Landino pictured the ghost: Landino, Xandra, II.30, in Poems, 136-39.
- 240 Vespasiano da Bisticci was horrified: Bisticci, Vite di uomini illustri del secolo XV, 20.
- 240 Far from seeing the city as a rival: Infessura, Diario della città di Roma.
- 240 Before even taking holy orders: Aeneas even wrote a history of the Council of Basel as a means of setting out his passionate attachment to the conciliar movement's ideals. Piccolomini, *De gestis Concilii Basiliensis commentariorum libri II*. This

edition also contains a helpful and lucid introduction to Aeneas's contribution to conciliar thought.

- ²⁴¹ "his learning and intellectual gifts": Pius II, Commentaries, I.28, 1:139.
- ²⁴¹ "Only the learned who have studied": Partner, *Renaissance Rome*, 16.
- 242 In 1427, Gentile da Fabriano and Pisanello: Welch, Art and Society in Renaissance Milan, 242-43.
- 242 Cardinal Giordano Orsini: See Simpson, "Cardinal Giordano Orsini (+1438) as a Prince of the Church and a Patron of the Arts"; Mode, "Masolino, Uccello, and the Orsini *Uomini Famosi.*"
- 243 Fra Angelico—widely renowned: On Fra Angelico's dual reputation, see Vasari, *Lives*, 1:198. For his frescoes, see ibid., 1:203. It is worth noting that Fra Angelico's services had initially been sought out by Nicholas's predecessor, Eugenius IV. The chapel is today known as the Niccoline Chapel. For further details on the artist's works in Rome during this period, see Gilbert, "Fra Angelico's Fresco Cycles in Rome."
- 243 The basis of the Vatican Library: See Grafton, *Rome Reborn*, 3–46.
- 243 Although Aeneas noted that he began more projects: Pius II, *Commentaries*, I.28, 1:139.
- 243 "turning the city upside down": Vasari, *Lives*, 1:209.
- 243 So, too, the Borgo, running adjacent to the Vatican: See Magnuson, "Project of Nicholas V for Rebuilding the Borgo Leonino in Rome."
- 243 As princes of the Church: As one historian has recently put it, "The magnificence that was required of cardinals must . . . be seen as part of a coherent, long-term program for bringing the image of Rome into line with its new function as the capital of the Papal State as well as the capital of Christendom . . . The creation of a constellation of satellite courts was thus meant to contribute to the splendor of the papal court, whose real and symbolic dimensions had been notably increased." Fragnito, "Cardinals' Courts in Sixteenth-Century Rome," 37–38.
- 244 Sixtus IV sponsored the construction: On Sixtus IV's legendarily lavish contributions to the remodeling of Renaissance Rome, see Benzi, Sisto IV renovator urbis; Benzi, Sisto IV: Le arti a Roma nel primo rinascimento; Blondin, "Power Made Visible"; Miglio et al., Un Pontificato ed una città; Egmont, Sixtus IV and Men of Letters.
- 244 His successor, Innocent VIII, commissioned Antonio Pollaiuolo: Vasari, Lives, 2:76.
- 245 "'Well, what about this chapel?'": Vasari, Lives, 1:361.
- 248 "probably the most splendid": Partner, Renaissance Rome, 118.
- 249 Shortly after the death of Callixtus III: Ibid.
- 249 By the same token, no self-respecting cardinal: Fragnito, "Cardinals' Courts in Sixteenth-Century Rome," 40.
- 249 "The dwelling of a cardinal": From *Supernae dispositionis arbitrio* (1514), in Alberigo et al., *Conciliorum oecumenicorum decreta*, 618–19, trans. in Fragnito, "Cardinals' Courts in Sixteenth-Century Rome," 33.
- 249 But at the lower end of the scale: On curial hospitality, see Byatt, "Concept of Hospitality in a Cardinal's Household in Renaissance Rome."
- 249 The Belvedere Courtyard: Partner, Renaissance Rome, 119.
- 250 Cardinal Pietro Riario held a vast banquet: Dickie, Delizia!, 65.
- 250 it has been estimated that the incomes: Partner, Renaissance Rome, 137.
- 250 Francesco Priscianese estimated: Ibid., 138.

- 250 Cardinal Ferdinando Gonzaga reckoned: Fragnito, "Cardinals' Courts in Sixteenth-Century Rome," 42n51.
- 250 perpetually short of cash: See Chambers, "Economic Predicament of Renaissance Cardinals."
- 251 "There [are] some who are very poor": Fragnito, "Cardinals' Courts in Sixteenth-Century Rome," 41050.
- 251 "an expert seeker of worldly preferment": Pius II, Commentaries, I.34, 1:173.
- 251 Aeneas went on to describe: Ibid., II.8, 1:239.
- 251 "faith in Christ flourishes no longer": Fonte, Letters to Friends, II.4.7, p. 81.
- 251 "whirlpool of vice": Ibid., II.5.5–6, p. 87.
- 251 "Nowadays rulers are so corrupted": Castiglione, Book of the Courtier, IV, 288.
- Gluttony was, as Bartolomeo della Fonte observed: Fonte, *Letters to Friends*, II.5.5–6,
 p. 87.
- 251 "wished to seem devout": Pius II, Secret Memoirs of a Renaissance Pope, VII, XII, 218, 356–57.
- 252 "It was his custom": Cellini, Autobiography, 228.
- 252 "through your chambers young girls": Petrarch, *Canzoniere*, poem 136, lines 1–11, in *Petrarch's Lyric Poems*, 280.
- 252 one of Aeneas's most well-read works: Morrall, "Aeneas Silvius Piccolomini (Pius II), *Historia de Duobus Amantibus.*"
- 253 "He was fond of women": Pius II, Secret Memoirs of a Renaissance Pope, XII, 357.
- 253 So endemic was sodomy: Partner, Renaissance Rome, 203.
- 253 "At the beginning of his pontificate": Aldrich and Wotherspoon, *Who's Who in Gay and Lesbian History*, 264.
- 253 Sixtus IV was reputed to have given: See Jordan, Silence of Sodom, 118.
- 254 "Why, Pasquino, you're armed": Cesareo, Pasquino e Pasquinate nella Roma di Leone X, 168–69, trans. in Partner, Renaissance Rome, 204. This pasquinade was probably composed in around 1512.
- 255 Although now lost, one scene showed: On the decoration of the bathroom, see Jones and Penny, *Raphael*, 192–93.
- 256 Among the fruit and foliage: Ibid., 184–85.
- 257 Aeneas himself seems to have regarded the whole affair: Pius II, Commentaries, I.36, I:179: "It was common talk that Aeneas of Siena would be pope. No one was held in higher esteem."
- 257 "the richer and more influential members": Ibid.
- 258 "Cardinal Prospero Colonna decided to seize": Ibid., 1:197.
- 258 the simony practiced in 1492 by Rodrigo Borgia: Guicciardini's account of the 1492 conclave gives a sense of the scale of Borgia's simony: "In [Innocent VIII's] place was elected Rodrigo Borgia of Valencia, the nephew of Pope Callixtus, who rose to this eminence with the favour of Signor Lodovico [Sforza] and Monsignor Ascanio [Sforza], who as a reward was made Vice-Chancellor. But his principal means to this end was simony, because with money, offices, benefices, promises, and all his powers and resources he suborned and bought the votes of the cardinals and the college: a hideous and abominable thing, and a most apt beginning to his future deplorable proceedings and behaviour." Guicciardini, *Storie fiorentine*, X, in *History of Italy and History of Florence*, 13.
- 259 Although popes had made a habit: The earliest cardinal-nephews seem to have

been created during the pontificate of Benedict VIII (1012–24). Until the papacy's return to Rome, the most nepotistic pope was undoubtedly Clement VI (1342–52), who raised no fewer than eleven of his relatives to the cardinalate, including six on a single day.

- 260 Callixtus III had followed suit: Pius II, Commentaries, II.7, 1:235.
- 260 "a man of very base and vile condition": Machiavelli, Florentine Histories, 7.23, p. 301.
- 260 the della Rovere family owed its prominence: See Verstegen, ed., Patronage and Dynasty.
- 261 So extreme did this become that even Machiavelli: Machiavelli, Florentine Histories, 7.23, p. 301: "He had in his household Piero and Girolamo, who, according to what everyone believed, were his sons . . . to Girolamo he gave the city of Forlì and took it away from Antonio Ordelaffi, whose ancestors had for a long time been the princes of that city. This ambitious mode of proceeding made him more esteemed by the princes of Italy, and each tried to make him his friend; and this was why the duke of Milan gave Caterina, his natural daughter, to Girolamo and, for her dowry, the city of Imola, which he had taken in spoil from Taddeo degli Alidosi."
- 261 "neither sincerity nor shame": Francesco Guicciardini, *Storia d'Italia*, I.2, in *History* of *Italy and History of Florence*, 90.
- After elevating Siena: It is worth noting that after Pius's election the Piccolomini family supplied every one of Siena's archbishops for the next 139 years (1458–1597). A further two members of the clan occupied the see between 1628 and 1671.
- 261 he made his cousin Gregorio Lolli: Indeed, Pius became so mistrustful of various members of the papal household that he refused to grant access to anyone but Gregorio Lolli and Jacopo Ammannati Piccolomini. See Pius II, *Commentaries*, II.6, 1:233.
- 263 when Cardinal Raffaele Riario built a new palace: On the Palazzo della Cancelleria, see M. D. Davis, "'Opus Isodomum' at the Palazzo della Cancelleria."
- 263 the new Saint Peter's Basilica was completed: The inscription beneath the lantern reads, "S. Petri gloriae Sixtus P.P. V. A. M. D. XC. Pontif. V" (To the glory of Saint Peter, Pope Sixtus V, in the year 1590, in the fifth year of his pontifical reign). The facade inscription reads, "In honorem principis apost. Paulus V Burghesius Romanus Pont. Max. an. MDCXII Pont. VII" (In honor of the prince of the apostles, Paul V Borghese, in the year 1612, in the seventh year of his pontificate).
- 264 The Borgia Apartments, which were decorated: Vasari, Lives, 2:82-83.
- 264 As part of his broader scheme: See Adams, "Acquisition of Pienza"; Adams, "Construction of Pienza (1459–1464) and the Consequences of *Renovatio*." On Pius's decision, see Pius II, *Commentaries*, II.20, 281–82.
- 264 commissioned Pinturicchio to paint: See Vasari, Lives, 2:81: "And in a very large picture over the door of the library . . . Pinturicchio painted the coronation of Pius III with many portraits from life, and with these words written below: 'Pius III Senensis, Pii II nepos, MDIII Septembris XXI apertis electus suffragiis, octavo Otobris coronatus est' [Pius III of Siena, nephew of Pius II, after being duly elected on September 21, 1503, was crowned on October 8]."
- 266 Callixtus, of course, refused point-blank: Guicciardini, Storia d'Italia, I.3, in History of Italy and History of Florence, 94; Machiavelli, Florentine Histories, 6.36, pp. 272–73.
- 266 While Alfonso's son, Ferrante, wanted the pope to consent: Pius II, *Commentaries*, II.3, 5, 1:218-23, 226-29.

266 In a lightning campaign, he had captured: Ibid., II.4, 1:222-29.

- 268 Valla had used his philological expertise: Valla, De falso credita et ementita Constantini donatione; Valla, Treatise of Lorenzo Valla on the Donation of Constantine.
- 269 the so-called Sala di Costantino: See Jones and Penny, *Raphael*, 239–45. The frescoes in this room were only completed after Raphael's death and during the reign of Julius II's successor, Leo X.
- 269 The message was pointedly emphasized: For a helpful introduction to the decorative scheme in the Stanza d'Eliodoro, see ibid., 113–32.
- 269 "the futility of the force": Ibid., 118.
- 270 Perhaps motivated by a vestigial sense: Machiavelli, *Florentine Histories*, 6.14, 32, pp. 244, 267; Pius II, *Commentaries*, I.18–20, 1:78–99.
- 270 as when Callixtus III sent Giovanni Ventimiglia: Machiavelli, *Florentine Histories*, 6.34, p. 269.
- 270 Pius II sent his own nephew, Cardinal Niccolò Forteguerri: Pius II, Secret Memoirs of a Renaissance Pope, XII, 353.
- 271 Sixtus IV ordered the rebellious: Machiavelli, Florentine Histories, 7.31, pp. 309–10.
- ²⁷¹ "a poison such that": Pius II, Secret Memoirs of a Renaissance Pope, XI, 305–6.
- 271 Acting as a lightning rod: For the liveliest account of the Pazzi conspiracy, see Martines, *April Blood*. On the secret deal with Federico da Montefeltro, see Simonetta, *Montefeltro Conspiracy*.
- 272 Kicking off more than sixty years of warfare: Guicciardini opines that Alexander VI was, in fact, "full of violent hatred for the name of France." Guicciardini, Storia d'Italia, I.17; in History of Italy and History of Florence, 181.
- ²⁷³ "never did anything": Machiavelli, Prince, chap. 18, p. 55.
- 273 Machiavelli observed that Alexander: Machiavelli, Florentine Histories, 1.30, p. 42.
- 274 Sixtus IV-who seems to have shown: See Weiss, Medals of Pope Sixtus IV.
- "When [Julius] saw the right hand": Vasari, Lives, 1:349.
- 274 Julius commissioned Giancristoforo Romano: Weiss, "Medals of Pope Julius II."

10. FILIPPO AND THE PIRATES

- 279 Although he took his vows: For biographical treatments of the artist, see Marchini, *Filippo Lippi*; Oertel, *Fra Filippo Lippi*.
- 279 "he never spent any time": Vasari, Lives, 1:214.
- 279 "In response to the praises": Ibid., 1:215.
- 279 Filippo's wanderlust: What follows is based on Vasari, Lives, 1:215.
- 279 Carried across the Mediterranean: Particularly toward the end of the Renaissance, this was certainly not an unusual phenomenon. See R. C. Davis, *Christian Slaves, Muslim Martyrs.*
- 280 "Since neither drawing nor painting": Vasari, Lives, 1:215.
- 283 "tails full a palm in length": Polo, Travels, 256, 272–73, 258.
- 283 The legend of Prester John: See Slessarev, Prester John.
- 283 Idrisi, a twelfth-century geographer: Abulafia, Discovery of Mankind, 24.
- 283 Sir John Mandeville: Ibid., 25; Mandeville, Travels of John Mandeville.
- 284 the rediscovery of classical literature exposed Italians: In the early fourteenth century, for example, Petrarch made a valiant—if doomed—effort to learn Greek under the tutelage of Leontius Pilatus, and his endeavors were later followed—

equally unsuccessfully—by Coluccio Salutati. Thanks to closer links with the ailing Byzantine Empire and, later, to an exodus of scholars from the East, however, matters suddenly became rather easier. The arrival of such eminent personages as John Argyropoulos, Manuel Chrysoloras, Teodoro Gaza, and Cardinal Bessarion made it possible for Salutati's intellectual heirs—particularly Leonardo Bruni, Marsilio Ficino, and Giovanni Pico della Mirandola—to study Greek literature for the first time at first hand. Pertusi, *Leonzio Pilato tra Petrarca e Boccaccio*; Ullman, *Humanism of Coluccio Salutati*, 118–24; Witt, *Hercules at the Crossroads*, esp. 252–53, 302–9; Monfasani, *Byzantine Scholars in Renaissance Italy*; Harris, *Greek Émigrés in the West*.

- 284 After the settlement of the Canary Islands: For a useful introduction to this subject, see Fernández-Armesto, *Before Columbus*.
- 285 Girolamo Tiraboschi identified: Tiraboschi, *Storia della letteratura italiana*, vols. 5 and 6; see Burke, *European Renaissance*, 18.
- 285 the great Swiss historian Jacob Burckhardt: Burckhardt, Civilization of the Renaissance in Italy, 183–231.
- 285 Today, when the advance of cross-cultural studies has eroded: Burke, *European Renaissance*, 209–20.
- 287 In the first book, for example, a Jew named Abraham: Boccaccio, Decameron, 1.2-3.
- 287 Thus, the reader is introduced to the sultan: Ibid., 2.7, 2.9, 4.4, 10.3.
- 287 So, too, the deliciously lusty tale of Alibech and Rustico: Ibid., 3.10, 4.3.
- 287 Depictions of the Cappadocian saint George: The importance of Jacobus de Voragine's Legenda aurea in establishing the central features of Saint George's story cannot be overstated in this regard: Voragine, Golden Legend: Readings on the Saints, 1:238–42. For an introductory discussion of the tale's role in Renaissance art, see Jardine and Brotton, Global Interests, 16–20.

II. SALOMONE'S CRIME

- 291 Salomone di Bonaventura was a prosperous: What follows is drawn from Gow and Griffiths, "Pope Eugenius IV and Jewish Money-Lending in Florence."
- 291 Perhaps conscious of the fact: Ibid., 308.
- 292 But Salomone could not have been more wrong: There have been a variety of different interpretations of Salomone's prosecution. Here, I follow ibid., but see also Panella, "Una sentenza di Niccolò Porcinari, potestà di Firenze"; Cassuto, *Gli ebrei a Firenze nell'età del Rinascimento.*
- 292 The chancellor, Leonardo Bruni, had been kept informed: Gow and Griffiths, "Pope Eugenius IV and Jewish Money-Lending in Florence," 311.
- 293 By the mid-fifteenth century, it has been estimated: Milano, *Storia degli ebrei in Italia*, 109–46.
- 293 At the time Salomone was embarking: Shulvass, Jews in the World of the Renaissance,22, 27.
- "By the middle of the fifteenth century": Hughes, "Distinguishing Signs," 16.
- 294 This was, of course, no more true: As Renata Segre has observed, "The elite elements of Jewish society—bankers, doctors, and so on—were most thoroughly integrated into the surrounding world." Segre, "Banchi ebraici e monti di pietà," quoted in Vivanti, "History of the Jews in Italy and the History of Italy," 340.

- 294 Taking advantage of the city's commercial prowess: Shulvass, Jews in the World of the Renaissance, 139.
- 295 "should not encounter any prejudice": Hughes, "Distinguishing Signs," 294.
- 295 accord them the status of Roman citizens: Simonsohn, Apostolic See and the Jews: History, 403; Hughes, "Distinguishing Signs," 291.
- 295 "should not be molested": Simonsohn, Apostolic See and the Jews: History, 69; Simonsohn, Apostolic See and the Jews: Documents, doc. 596; Hughes, "Distinguishing Signs," 295. On Martin V's attitude toward the Jews more generally, see Vernet, "Le pape Martin V et les Juifs."
- 295 "by the standards of the age": Brucker, Society of Renaissance Florence, 240.
- 295 "the Jews felt protected": Colorni, *Judaica minora*, 503; quoted in Gow and Griffiths,"Pope Eugenius IV and Jewish Money-Lending in Florence," 285.
- 296 For the enthusiastically effusive Yohanan Alemanno: Shulvass, Jews in the World of the Renaissance, 334–35.
- 296 the Nofet zufim, or The Book of the Honeycomb's Flow: Leon, Book of the Honeycomb's Flow. A useful starting point for further reading on Jewish approaches to Renaissance rhetoric can be found in Rabinowitz, "Pre-modern Jewish Study of Rhetoric."
- 296 "gathered a school of Jewish scholars": Hughes, "Bodies, Disease, and Society," 116.
- 296 "maintained that the writings": Kristeller, Renaissance Thought and the Arts, 64.
- 297 When it came to depicting Moses: Hughes, "Bodies, Disease, and Society," 112; Palmieri, *Liber de temporibus*, 172–73.
- 297 In the eyes of Christians: Voragine, Golden Legend, trans. Ryan and Ripperbar, 1:150.
- 298 Rarely worn by contemporary Christians: For a fuller discussion of this altarpiece and its hidden layers of meaning, see Hughes, "Distinguishing Signs," esp. 3–12.
- 298 the rabidly anti-Semitic San Bernardino of Siena: For a survey of San Bernardino's anti-Semitism, see Mormando, *Preacher's Demons*, chap. 4.
- 299 Even if their influence on finance: Hughes, "Bodies, Disease, and Society," 110-17.
- 299 Giannozzo Manetti penned the *Contra iudeos et gentes*: For an introduction to Manetti's *Contra iudeos et gentes*, see Trinkaus, *In Our Image and Likeness*, 2:726–34.
- 300 Since Jews had such strict dietary regulations: Dean, Crime and Justice in Late Medieval Italy, 149.
- 300 And though prosecutions for this sort of "offense": Ibid., 146–49.
- 301 enshrined in Paolo Uccello's *Miracle of the Profaned Host*: For a detailed discussion of Uccello's work, see Katz, "Contours of Tolerance"; Katz, *Jew in the Art of the Italian Renaissance*, chap. 1.
- 301 "I hear that there are many Jews": Bernardino of Siena, *Opera omnia*, 3:362, trans. in Hughes, "Distinguishing Signs," 19.
- 302 Since the Fourth Lateran Council of 1215: See Grayzel, *Church and the Jews in the XIIIth Century*, 60–70, 308–9.
- 302 San Bernardino's itinerant preaching: Hughes, "Distinguishing Signs," 20; Pacetti,"La predicazione di S. Bernardino in Toscano."
- 302 In 1439—the same year Salomone made his fateful agreement: The Florentine provisions of 1463 give an indication of just how seriously this was taken: "[The priors] have considered that a large number of Jews have come to settle in Florence, and scarcely any of them wear a sign, so that there is considerable confusion, and it is difficult to distinguish between Jews and Christians... They are determined to

remedy this unsatisfactory situation . . . [and therefore e]very Jew, male or female above the age of twelve, whether or not named in the Florentine agreement, and whether or not a resident of the city of Florence, shall be required to wear a sign of O in the city of Florence. This yellow O shall be worn on the left breast, over the clothing in a visible place; it shall be at least one foot in circumference and as wide as the thickness of a finger. A penalty of 25 lire shall be levied on every occasion that this sign is not worn, with two witnesses required." Brucker, *Society of Renaissance Florence*, 241–42, doc. 118.

- 302 Michelangelo's depiction of Aminadab: On which, see Wisch, "Vested Interests."
- 303 Money lending and usury were the greatest worry: One thinks particularly of *The Merchant of Venice*, 1.3.123–26: "Fair sir, you spit on me on Wednesday last; / You spurn'd me such a day; another time / You call'd me dog; and for these courtesies / I'll lend you thus much moneys?"
- 304 In one particularly vitriolic sermon: Hughes, "Bodies, Disease, and Society," 119.
- 304 the Signoria promulgated a decree: Brucker, *Society of Renaissance Florence*, 240–41, doc. 117.
- 304 Almost as soon as the decrees had been passed: Jews were, for example, not allowed to own property above the value of 500 (later 1,000) gold florins and were permitted to lend money only on the basis of a pledge pawned. Salter, "Jews in Fifteenth-Century Florence and Savonarola's Establishment of a Mons Pietatis," 197.
- 304 In March 1488, a vitriolic attack on usury: Landucci, *Diario fiorentino dal 1450 al* 1516, 54.
- 305 the *monte di pietà* was established: Najemy, *History of Florence*, 396–97; Salter, "Jews in Fifteenth-Century Florence."
- 305 Its goal was to undercut the city's Jews: See Polizzotto, Elect Nation, 35-37.
- 305 Jews had been integral: Clementi, *Il carnevale romano nelle cronache contemporanee dale origini al secolo XVII*; Boiteux, "Les Juifs dans le Carneval de la Rome moderne."
- 306 "runne starke naked": Wisch, "Vested Interests," 153.
- 306 Shortly before Easter in 1475: For what follows, see Hsia, Trent 1475.
- 307 In the midst of the War of the League of Cambrai: For the background to the Venetian ghetto, see Finlay, "Foundation of the Ghetto."

12. THE RISING CRESCENT

- 311 "Barbaric" Muslims were even accused: Munro, "Western Attitude Towards Islam During the Period of the Crusades." More generally, see Southern, Western Views of Islam in the Middle Ages; Daniel, Islam and the West.
- 312 Indeed, by 1489, three-quarters of all the cloth: Franceschi, "Economy," 130.
- 312 Slaves, too, were a major source of commercial interest: For an interesting perspective on the growth of the slave trade and its character, see Origo, "Domestic Enemy."
- 312 While the growing profitability of trade: See Goldthwaite, *Economy of Renaissance Florence*, 180–84.
- 312 With the Mamluk capture: Hunt and Murray, *History of Business in Medieval Europe*, 180.
- 312 Having invested 5,000 florins: Goldthwaite, *Economy of Renaissance Florence*, 183; Babinger, "Lorenzo de' Medici e la corte ottomana."

- 313 Pegolotti stressed the value of a good: Pegolotti, La pratica della mercatura, esp. 14–19, 21–23.
- ³¹³ "not uncommon for men of learning": Borstook, "Travels of Bernardo Michelozzi and Bonsignore Bonsignori in the Levant," 145.
- 313 Conti subsequently related his experiences: Bracciolini, De l'Inde. On Fra Mauro's cartography, see Falchetta, Fra Mauro's World Map.
- 313 Cyriac of Ancona: Cyriac of Ancona, Later Travels.
- 313 figures including Guarino Veronese, Giovanni Aurispa: Borstook, "Travels of Bernardo Michelozzi and Bonsignore Bonsignori in the Levant," 145.
- 314 Costanzo completed a series: On Costanzo da Ferrara's works in Constantinople, see Jardine and Brotton, *Global Interests*, 32, 40–41. Some care, however, should be taken with some of the statements made in this account. No justification is provided for the rather bold assertion that the portrait medal of Mehmed II "is a resolutely Ottoman artefact, yet in a strenuously Western European artistic tradition": what defines "resolutely Ottoman" is, for instance, never explained.
- 314 After an unsuccessful attempt: Freely, Jem Sultan.
- 315 a Latin translation of the Koran: Trivellato, "Renaissance Italy and the Muslim Mediterranean in Recent Historical Work," 146–48; N. Z. Davis, *Trickster Travels*.
- The reignition of the slave trade in Italy: The most accessible introduction to this topic is Origo, "Domestic Enemy."
- 315 Particularly due to its commercial links: See D. Howard, Venice and the East; Burnett and Contadini, Islam and the Italian Renaissance.
- 316 In a refreshingly daring and original study: Jardine and Brotton, *Global Interests*, 132–85.
- 316 the appearance of oriental carpets: See King and Sylvester, *Eastern Carpet in the Western World from the 15th to the 17th Century.* More generally, see R. E. Mack, *Bazaar to Piazza.*
- 316 "Renaissance thinkers adopted an attitude": Bisaha, Creating East and West, 19.
- 317 In the De vita solitaria: Petrarch, De vita solitaria, Z II, iv, 6; P II, ix; Prose, 496; trans. Zeitlin, 247–48. Latin text for the De vita solitaria, ed. G. Martellotti, Prose, 286–593; English translation, Life of Solitude, trans. Zeitlin. In what follows, references to the De vita solitaria will indicate the relevant portion of text according to Jacob Zeitlin's translation (Z), according to the division of the work by Martellotti in Prose (P), according to the page number in the Prose edition (Prose), and—where appropriate—according to the page number of the relevant passage in Zeitlin's translation (trans. Zeitlin). For a reasonably enlightening introduction to this theme in Petrarch's writings, see Bisaha, "Petrarch's Vision of the Muslim and Byzantine East."
- 317 "Muhammad [was] an Arab": Pius II, Commentaries, II.1, 1:211.
- 318 "took little interest": Meserve, Empires of Islam in Renaissance Historical Thought, 239.
- 318 Niccolò Sagundino: Ibid., 107.
- 319 "protection of the faithful": Tyerman, "Marino Sanudo Torsello and the Lost Crusade," 57.
- 319 Petrarch was among the most enthusiastic: Petrarch hated traveling by sea, and hence rejected the idea of so long a journey out of hand. This did not, however, stop him from writing a guidebook to the Holy Land. Petrarca, *Itinerario in Terra Santa*.

394

- 319 Berating kings and potentates: Petrarch, *De vita solitaria*, Z II, iv, 4; P II, ix; *Prose*, 492–94; trans. Zeitlin, 245.
- 319 Unless something were done: Ullman, Humanism of Coluccio Salutati, 79.
- 320 "to persuade princes and peoples": Machiavelli, *Florentine Histories*, 6.33, p. 269. On the sermons delivered by itinerant preachers, see Hankins, "Renaissance Crusaders," 111–24.
- 320 Although this ultimately came to nothing: The best study of Pius's attitudes toward the Turks is unquestionably Helmrath, "Pius II und die Türken."
- 320 "to rule all of Europe": Pius II, Commentaries, II.1, 1:211.
- 320 "once the Hungarians were conquered": Pius II, Secret Memoirs of a Renaissance Pope, III, 113.
- 321 Apollonio di Giovanni and Marco del Buono: On this *cassone* front, see Callmann, *Apollonio di Giovanni*, 48–51, 63–64. For a general overview of themes in the art of *cassone* fronts, see Campbell, *Love and Marriage in Renaissance Florence*.

13. Of Human Bondage

- 323 Alberto da Sarteano: Biccellari, "Un francescano umanista"; Biccellari, "Missioni del b. Alberto in Oriente per l'Unione della Chiesa Greca e il ristabilimento dell'Osservanza nell'Ordine francescano."
- 323 "full of unusual faces and costumes": Trexler, Journey of the Magi, 129.
- 323 "dry and awkward in their bearing": Ibid.
- 324 Pope Eugenius was thrilled: See Cerulli, "L'Etiopia del sec. XV in nuovi documenti storici"; Cerulli, "Eugenio IV e gli Etiopi al Concilio di Firenze nel 1441"; Tedeschi, "Etiopi e copti al concilio di Firenze"; Gill, *Council of Florence*, 310, 318, 321, 326, 346.
- 325 the pope commissioned Filarete: For a broader contextual view of Filarete's commemorative reliefs, see Lowe, "'Representing' Africa."
- 325 From Greek texts such as Herodotus's Histories: Herodotus, Histories, 4.42–43.
- 325 while from Roman accounts they derived: See Yamauchi, *Africa and Africans in Antiquity*; Thompson and Ferguson, *Africa in Classical Antiquity*.
- 326 Along with Moors and Berbers, a few black African slave girls: Klapisch-Zuber, "Women Servants in Florence," 69.
- 326 Even as late as the 1430s, such fantasies: For example, Slessarev, Prester John.
- 327 works such as Ca'da Mosto's *Navigazioni*: For an English translation, see Ca'da Mosto, *Voyages of Cadamosto*.
- 327 "the . . . trade in black slaves": Abulafia, Discovery of Mankind, 91.
- 328 In July 1461, for example, Giovanni Guidetti: For the following, see Tognetti, "Trade in Black African Slaves in Fifteenth-Century Florence," 217–18.
- 328 "for a black head they received from us": Ibid., 218.
- 329 authentic children of Ham: Abulafia, Discovery of Mankind, 95; Schorsch, Jews and Blacks in the Early Modern World, 17–49.
- 329 While Caspar and Melchior were often linked: For what follows, see the excellent study by Kaplan, *Rise of the Black Magus in Western Art.*
- 330 Isabella d'Este's growing interest: See Kaplan, "Isabella d'Este and Black African Women."
- 330 one more proof that the Golden Age had arrived: O'Malley, "Fulfilment of the Christian Golden Age Under Pope Julius II," 323–25.

- 331 Pope Leo X was petitioned by King Manuel: See Filesi, "Enrico, figlio del re del Congo, primo vescovo dell'Africa nero (1518)"; de Witte, "Henri de Congo, évêque titulaire d'Utique (+ c. 1531), d'après les documents romains"; Bontinck, "Ndoadidiki Ne-Kinu a Mumemba, premier évêque du Kongo."
- 331 Particularly from the early fifteenth century onward: For a useful introduction to this subject, see Minnich, "Catholic Church and the Pastoral Care of Black Africans in Renaissance Italy."
- 331 Children were baptized: Ibid., 296.
- 331 San Benedetto il Moro: See Mariani, San Benedetto da Palermo, il moro Etiope, nato a S. Fratello; Fiume and Modica, San Benedetto il moro.
- 331 In addition to finding places as wrestlers: Lowe, "Stereotyping of Black Africans in Renaissance Europe," 34.
- 332 the Medici employed a certain Grazzico "il Moretto": Ibid., 33.
- 332 black Africans were widely thought: See Castiglione, Book of the Courtier, I, p. 96.
- 332 Created duke of Florence in 1532: For a discussion of Alessandro's parentage, see Brackett, "Race and Rulership."
- 333 In his account of his journey: Abulafia, Discovery of Mankind, 94.
- 333 Alvise Ca'da Mosto was repulsed: Ibid.
- 333 In his 1480 tax return: Rubiés, "Giovanni di Buonagrazia's Letter to His Father," 107, trans. in Lowe, "Stereotyping of Black Africans," 28.
- 333 Drawing on Ca'da Mosto's contention: Ca'da Mosto, Voyages of Cadamosto, 89.
- 333 Africans' supposed musicality: Lowe, "Stereotyping of Black Africans," 35.

14. BRAVE NEW WORLDS

- 338 Marco Polo had authoritatively stated: Polo, Travels, 243–44; see also Abulafia, Discovery of Mankind, 24–27.
- 338 whenever medieval writers spoke of islands: Fuson, *Legendary Islands of the Ocean* Sea, 118–19.
- 338 As early as 1291, two Venetian brothers: Moore, "La spedizione dei fratelli Vivaldi e nuovi documenti d'archivio."
- 339 The discovery of Lanzarote: Verlinden, "Lanzarotto Malocello et la découverte portugaise des Canaries"; Abulafia, *Discovery of Mankind*, esp. 33–39.
- 339 While hopes for a new passage: For a fuller survey of the topics covered in the following paragraphs, see Fernández-Armesto, *Before Columbus*.
- 339 João Gonçalves Zarco and Tristão Vaz Teixeira: For an overview, see Parry, Age of Reconnaissance, 146–48.
- 340 "Yet ever and again": Burckhardt, Civilization of the Renaissance in Italy, 184.
- 341 Even before the discovery: Burke, European Renaissance, 210.
- 341 Drawing on the tales of a maritime adventurer: Pastore Stocchi, "Il *De Canaria* boccaccesco e un 'locus deperditus' nel *De insulis* di Domenico Silvestri"; for further discussion of this text, see Abulafia, *Discovery of Mankind*, 36–41; Abulafia, "Neolithic Meets Medieval."
- 341 "man of noble stock": Petrarch, De vita solitaria, Z II, vi, 3; P II, xi; Prose, 522–24.
- 341 the two canon lawyers appointed: See Williams, American Indian in Western Legal Thought, 71–72.
- 341 "discoveries of new lands, new seas": Burke, European Renaissance, 210.

- 342 Columbus's account of his travels: The accounts of all three men are found in Firpo, Prime relazioni di navigatori italiani.
- 342 Thrilled by these discoveries, cartographers: On Toscanelli, see Edgerton, "Florentine Interest in Ptolemaic Cartography as Background for Renaissance Painting, Architecture, and the Discovery of America." The Contarini-Rosselli map—the sole surviving copy of which is held by the British Library—is the first known cartographical work to show the Americas.
- 342 Giulio Cesare Stella: On the *Columbeis*, see Hofmann, "La scoperta del nuovo mondo nella poesia neolatina"; Hofmann, "Aeneas in Amerika."
- 343 Hence, in some of the earliest printings: For an intriguing introduction to this subject, see Turner, "Forgotten Treasure from the Indies."
- 343 Even though a smattering of exotic artifacts: Burke, European Renaissance, 212; Olmi, L'inventario del mondo, 211–52.
- 345 The Genoese, for example, enthusiastically supported: Hunt and Murray, *History* of Business in Medieval Europe, 181, 221.
- 345 Giovanni da Empoli: Goldthwaite, Economy of Renaissance Florence, 159.
- 345 Although the coastal territories of West Africa: Ibid., 146.
- 345 Luca Giraldi: Ibid., 159–60; V. Rau, "Um grande mercador-banqueiro italiano em Portugal: Lucas Giraldi," in *Estudos de história*, 75–129.
- 346 "as a very small edifice": S. Greenblatt, foreword to *Mapping the Renaissance World*, by Lestringant, xi.
- 346 "evidence of social anthropology": Abulafia, Discovery of Mankind, 14-18.
- 347 Although Boccaccio seems to have been: Ibid., 36-41.
- 347 "are without refinement": Petrarch, *De vita solitaria*, Z II, vi, 3; P II, xi; Prose, 524; trans. Zeitlin, 267.
- 348 If their complete ignorance: Muldoon, *Popes, Lawyers, and Infidels,* 121; quotation at Abulafia, *Discovery of Mankind,* 86–87.
- 348 "They observe most barbarous customs": Original text in Firpo, Prime relazioni di navigatori italiani, 88, trans. in A. Brown, Renaissance, 122.
- 349 "No one of this race": Ibid.

Epilogue: The Window and the Mirror

351 "open window" (finestra aperta): Alberti, De pictura, 1.19, p. 55.

BIBLIOGRAPHY

PRIMARY SOURCES

Alberigo, G., et al., eds. *Conciliorum oecumenicorum decreta*. Reprint, Bologna, 1973. Alberti, Leon Battista. *De pictura*. Edited by C. Grayson. Rome, 1975.

——. De re aedificatoria. On the Art of Building in Ten Books. Translated by J. Rykwert, N. Leach, and R. Tavernor. Cambridge, Mass., 1988.

- Alighieri, Dante. *The Divine Comedy*. Translated by G. L. Bickersteth. New ed. Oxford, 1981.
 - . La Vita Nuova. Translated by B. Reynolds. Rev. ed. London, 2004.

Anonimo Romano. The Life of Cola di Rienzo. Translated by J. Wright. Toronto, 1975.

Anonymous. Alle bocche della piazza: Diario di anonimo fiorentino (1382–1401). Edited by A. Molho and F. Sznura. Florence, 1986.

R. J. Regan SJ. Indianapolis, 1988.

Aristotle. *Nicomachean Ethics*. Translated and edited by R. Crisp. Cambridge Texts in the History of Philosophy. Cambridge, U.K., 2000.

Baldassarri, S. U., and A. Saiber, eds. Images of Quattrocento Florence: Selected Writings in Literature, History, and Art. New Haven, Conn., 2000.

Barocchi, P., ed. Scritti d'arte del cinquecento. 3 vols. Milan and Naples, 1971-77.

Beccadelli, Antonio. *The Hermaphrodite*. Edited and translated by H. Parker. Cambridge, Mass., 2010.

Bernardino of Siena. Opera omnia. Edited by Collegio San Bonaventura. 9 vols. Florence, 1950–65.

Bisticci, Vespasiano da. *Vite di uomini illustri del secolo XV*. Edited by P. D'Ancona and E. Aeschlimann. Milan, 1951.

Boccaccio, Giovanni. Decameron. Edited by V. Branca. New ed. 2 vols. Turin, 1992.

. Decameron. Translated by G. H. McWilliam. 2nd ed. London, 1995.

------. Famous Women. Edited and translated by V. Brown. Cambridge, Mass., 2001.

. Lettere edite ed inedite. Edited by F. Corazzini. Florence, 1877.

Bracciolini, Poggio. *De l'Inde: Les voyages en Asie de Niccolò de Conti*. Edited by M. Guéret-Laferté. Turnhout, 2004.

Brucker, G. A., ed. The Society of Renaissance Florence: A Documentary Study. New York, 1971.

- Bruni, Leonardo. *History of the Florentine People*. Edited and translated by J. Hankins. 3 vols. Cambridge, Mass., 2001–7.
 - ----. The Humanism of Leonardo Bruni: Selected Texts. Translated by G. Griffiths, J. Hankins, and D. Thompson. Binghamton, N.Y., 1987.
- Ca'da Mosto, Alvise. The Voyages of Cadamosto. Edited by G. R. Crone. London, 1937.

Cassirer, E., P. O. Kristeller, and J. H. Randall Jr., eds. *The Renaissance Philosophy of Man*. Chicago, 1948.

Castiglione, Baldassare. *The Book of the Courtier*. Translated by G. Bull. New ed. London, 1976.

Cavalcanti, Giovanni. Istorie fiorentine. Edited by F. Polidori. 2 vols. Florence, 1838.

Cellini, Benvenuto. Autobiography. Translated by G. Bull. Rev. ed. London, 1998.

Condivi, Ascanio. *Michelangelo: Life, Letters, and Poetry*. Translated by G. Bull. New York, 1987.

—. Vita di Michelangelo Buonarroti. Edited by G. Nencioni. Florence, 1998.

Cyriac of Ancona. *Later Travels*. Edited and translated by E. W. Bodnar with C. Foss. Cambridge, Mass., 2003.

Dati, Gregorio. Istoria di Firenze dall'anno MCCCLXXX all'anno MCCCCV. Edited by G. Bianchini. Florence, 1735.

Ficino, Marsilio. Opera omnia. Basel, 1576. Reprint, Turin, 1962.

—. Platonic Theology. Translated by M. J. B. Allen. Edited by J. Hankins. 6 vols. Cambridge, Mass., 2001–6.

Filarete, Francesco, and Angelo Manfidi, The "Libro Ceremoniale" of the Florentine Republic by Francesco Filarete and Angelo Manfidi. Edited by R. C. Trexler. Geneva, 1978.

Filelfo, Francesco. Odes. Edited and translated by D. Robin. Cambridge, Mass., 2009.

Firpo, L., ed. Prime relazioni di navigatori italiani sulla scoperta dell'America: Colombo— Vespucci—Verazzano. Turin, 1966.

Fonte, Bartolomeo della [Bartolomeo Fonzio]. *Letters to Friends*. Edited by A. Daneloni. Translated by M. Davis. Cambridge, Mass., 2011.

Froissart, Jean. Chronicles. Translated by G. Brereton. London, 1978.

Guicciardini, Francesco. *History of Italy and History of Florence*. Translated by C. Grayson. Edited by J. R. Hale. Chalfont St. Giles, 1966.

—. Storie fiorentine. Edited by R. Palmarocchi. Bari, 1931.

Guido da Pisa. Expositiones et glose super Comediam Dantis. Edited by V. Cioffari. Albany, N.Y., 1974.

Infessura, Stefano. Diario della città di Roma. Edited by O. Tommasini. Rome, 1890.

Kallendorf, C. W., ed. and trans. *Humanist Educational Treatises*. Cambridge, Mass., 2002. Kemp, M., ed. *Leonardo on Painting*. New Haven, Conn., 1989.

- Kohl, B. G., and R. G. Witt, eds. The Earthly Republic: Italian Humanists on Government and Society. Philadelphia, 1978.
- Landino, Cristoforo. Poems. Translated by M. P. Chatfield. Cambridge, Mass., 2008.

Landucci, Luca. Diario fiorentino dal 1450 al 1516. Edited by I. Del Badia. Florence, 1883.

Leon, Judah Messer. *The Book of the Honeycomb's Flow*. Edited and translated by I. Rabinowitz. Ithaca, N.Y., 1983.

Machiavelli, Niccolò. *Florentine Histories*. Translated by L. F. Banfield and H. C. Mansfield Jr. Princeton, N.J., 1990. —. The Prince. Translated by G. Bull. London, 1961.

- Mandeville, John. *The Travels of John Mandeville*. Translated by C. W. R. D. Moseley. Harmondsworth, 1983.
- Mazzei, Lapo. Lettere di un notaro a un mercante del secolo XIV, con altre lettere e documenti. Edited by C. Guasti. 2 vols. Florence, 1880.

Medici, Lorenzo de'. Poesie. Edited by I. Caliaro. 2nd ed. Milan, 2011.

- Michelangelo Buonarroti. *Il carteggio di Michelangelo*. Edited by P. Barocchi and R. Ristori. 5 vols. Florence, 1965–83.
 - -----. The Letters of Michelangelo. Translated by E. H. Ramsden. 2 vols. Stanford, Calif., 1963.

—. Poems and Letters. Translated by A. Mortimer. London, 2007.

Ovid. *Metamorphoses*. Translated by F. J. Miller. 2 vols. Loeb Classical Library. London, 1916.

Palmieri, Matteo. Liber de temporibus. Edited by G. Scaramella. Città di Castello, 1906.

------. Vita civile. Edited by F. Battaglia. Bologna, 1944.

——. Vita civile. Edited by G. Belloni. Florence, 1982.

Paltroni, Pierantonio. Commentari della vita e gesti dell'illustrissimo Federico Duca d'Urbino. Edited by W. Tommasoli. Urbino, 1966.

Pegolotti, Francesco Balducci. *La pratica della mercatura*. Edited by A. Evans. Cambridge, Mass., 1936.

Petrarca, Francesco. *Africa*. Edited by N. Festa. Edizione Nazionale delle Opere di Francesco Petrarca. Florence, 1936.

- ------. De otio religioso. Edited by G. Rotondi. Vatican City, 1958.
- . Letters of Old Age: Rerum senilium libri I-XVIII. Translated by A. S. Bernardo,
- S. Levin, and R. A. Bernardo. 2 vols. Baltimore, 1992.
- . Life of Solitude. Translated by J. Zeitlin. Urbana, Ill., 1924.
- ———. Petrarch's Lyric Poems: The "Rime Sparse" and Other Lyrics. Translated and edited by R. M. Durling. Cambridge, Mass., 1976.
- ------. *Prose*. Edited by G. Martellotti, P. G. Ricci, E. Carrara, and E. Bianchi. Milan and Naples, 1955.

Pico della Mirandola, Giovanni. Heptaplus. Edited by E. Garin. Florence, 1942.

Pius II, Pope [Aeneas Silvius Piccolomini]. *Commentaries*. Vol. 1. Edited by M. Meserve and M. Simonetta. Cambridge, Mass., 2003.

- —. De gestis Concilii Basiliensis commentariorum libri II. Edited by D. Hay and W. K. Smith. Oxford, 1967.
- —. Secret Memoirs of a Renaissance Pope: The "Commentaries" of Aeneas Silvius Piccolomini, Pius II. Translated by F. A. Gragg. Edited by L. C. Gabel. London, 1988.

Polo, Marco. The Travels of Marco Polo. Translated by R. Latham. London, 1958.

Pontano, Giovanni Gioviano. *Baiae*. Translated by R. G. Dennis. Cambridge, Mass., 2006. ———. *I tratti delle virtue sociali*. Edited by F. Tateo. Rome, 1965.

Rucellai, Giovanni. Zibaldone. Edited by A. Perosa. 2 vols. London, 1960.

Sacchetti, Franco. Il trecentonovelle. Edited by E. Faccioli. Turin, 1970.

Salutati, Coluccio. De seculo et religione. Edited by B. L. Ullman. Florence, 1957.

Savonarola, Girolamo. Trattato circa il reggimento e governo della città di Firenze. Edited by

L. Firpo. Turin, 1963.

Stefani, Marchione di Coppo. *Cronaca fiorentina*. Rerum Italicarum Scriptores 30.1. Città di Castello, 1927.

Thompson, D., and A. F. Nagel, eds. and trans. *The Three Crowns of Florence: Humanist Assessments of Dante, Petrarca, and Boccaccio.* New York, 1972.

Valla, Lorenzo. *De falso credita et ementita Constantini donatione*. Edited by W. Setz. Monumenta Germaniae Historica: Quellen zur Geistesgeschichte des Mittelalters 10. Weimar, 1976.

—. *The Treatise of Lorenzo Valla on the Donation of Constantine*. Edited and translated by C. B. Coleman. New Haven, Conn., 1922. Reprint, Toronto, 1993.

Vasari, Giorgio. Lives of the Artists. Translated by G. Bull. 2 vols. London, 1987.

Voragine, Jacobus de. *The Golden Legend*. Translated by G. Ryan and H. Ripperbar. 2 vols. London, 1941.

---. The Golden Legend: Readings on the Saints. Translated by W. G. Ryan. 2 vols. Princeton, N.J., 1993.

SECONDARY SOURCES

Abulafia, D. The Discovery of Mankind: Atlantic Encounters in the Age of Columbus. New Haven, Conn., 2008.

—. "Neolithic Meets Medieval: First Encounters in the Canary Islands." In *Medieval Frontiers: Concepts and Practices*, edited by D. Abulafia and N. Berend, 255–78. Aldershot, 2002.

——. "Southern Italy and the Florentine Economy, 1265–1370." *Economic History Review* 33 (1981): 377–88.

- Adams, N. "The Acquisition of Pienza, 1459–1464." Journal of the Society of Architectural Historians 44 (1985): 99–110.
 - —. "The Construction of Pienza (1459–1464) and the Consequences of *Renovatio*." In Urban Life in the Renaissance, edited by S. Zimmerman and R. Weissman, 50–79. Newark, Del., 1989.

Albala, K. Eating Right in the Renaissance. Berkeley, Calif., 2002.

Aldrich, R. F., and G. Wotherspoon, eds. *Who's Who in Gay and Lesbian History*. London, 2000.

Ames-Lewis, F., ed. Cosimo "il Vecchio" de' Medici, 1389–1464. Oxford, 1992.

Arrizabalaga, J., J. Henderson, and R. French. *The Great Pox: The French Disease in Renaissance Europe*. New Haven, Conn., 1997.

Babinger, F. "Lorenzo de' Medici e la corte ottomana." ASI 121 (1963): 305-61.

Baker, N. S. "For Reasons of State: Political Executions, Republicanism, and the Medici in Florence, 1480–1560." *Renaissance Quarterly* 62, no. 2 (2009): 444–78.

- Barolini, T. "Dante and Francesca da Rimini: Realpolitik, Romance, Gender." *Speculum* 75, no. 1 (2000): 1–28.
- Baron, H. "Burckhardt's *Civilization of the Renaissance* a Century After Its Publication." *Renaissance News* 13 (1960): 207–22.
 - ——. The Crisis of the Early Italian Renaissance. Rev. ed. Princeton, N.J., 1966.
 - ——. "Franciscan Poverty and Civic Wealth as Factors in the Rise of Humanistic Thought." Speculum 13 (1938): 1–37.

–. Humanistisch-philosophische Schriften. Berlin, 1928.

Barzman, K. E. The Florentine Academy and the Early Modern State. Cambridge, U.K., 2000.

Baxandall, M. Giotto and the Orators: Humanist Observers of Painting in Italy and the Discovery of Pictorial Composition, 1350–1450. Oxford, 1971.

—. Painting and Experience in Fifteenth-Century Italy. Oxford, 1972.

Bayley, C. C. War and Society in Renaissance Florence: The "De Militia" of Leonardo Bruni. Toronto, 1961.

Becker, M. "An Essay on the Quest for Identity in the Early Italian Renaissance." In Florilegium Historiale: Essays Presented to Wallace K. Ferguson, edited by J. G. Rowe and W. H. Stockdale, 296–308. Toronto, 1971.

Benzi, F., ed. Sisto IV: Le arti a Roma nel primo rinascimento. Rome, 2000.

Bernstein, J. G. "Patronage, Autobiography, and Iconography: The Facade of the Colleoni Chapel." In Giovanni Antonio Amadeo: Scultura e architettura del suo tempo, edited by J. Shell and L. Castelfranchi, 157–73. Milan, 1993.

Bertelli, S. "Machiavelli and Soderini." Renaissance Quarterly 28, no. 1 (1975): 1-16.

Biccellari, F. "Un francescano umanista: Il beato Alberto da Sarteano." Studi francescani 10 (1938): 22–48.

—. "Missioni del b. Alberto in Oriente per l'Unione della Chiesa Greca e il ristabilimento dell'Osservanza nell'Ordine francescano." Studi francescani II (1939): 159–73.

Bisaha, N. Creating East and West: Renaissance Humanists and the Ottoman Turks. Philadelphia, 2004.

------. "Petrarch's Vision of the Muslim and Byzantine East." Speculum 76, no. 2 (2001): 284–314.

Black, R. "Education and the Emergence of a Literate Society." In Najemy, Italy in the Age of the Renaissance, 18–36.

- Blondin, J. E. "Power Made Visible: Pope Sixtus IV as Urbis Restaurator in Quattrocento Rome." *Catholic Historical Review* 91 (2005): 1–25.
- Boiteux, M. "Les Juifs dans le Carneval de la Rome moderne (XV^e-XVIII^e siècles)." *Mélanges de l'École Française de Rome* 88 (1976): 745-87.

Bontinck, F. "Ndoadidiki Ne-Kinu a Mumemba, premier évêque du Kongo (ca. 1495– c. 1531)." *Revue africaine de théologie* 3 (1979): 149–69.

Borstook, E. "The Travels of Bernardo Michelozzi and Bonsignore Bonsignori in the Levant (1497–98)." Journal of the Warburg and Courtauld Institutes 36 (1973): 145–97.

Brackett, J. K. Criminal Justice and Crime in Late Renaissance Florence, 1537–1609. Cambridge, U.K., 1992.

—. "The Florentine Onestà and the Control of Prostitution." Sixteenth Century Journal 24, no. 2 (1993): 273–300.

—. "Race and Rulership: Alessandro de' Medici, First Medici Duke of Florence, 1529–1537." In Earle and Lowe, *Black Africans in Renaissance Europe*, 303–25.

Brown, A. "The Early Years of Piero di Lorenzo, 1472–1492: Between Florentine Citizen and Medici Prince." In *Communes and Despots in Medieval and Renaissance Italy*, edited by J. E. Law and B. Paton, 209–22. Farnham, 2011.

—. The Renaissance. 2nd ed. London, 1999.

Brown, J. C. "A Woman's Place Was in the Home: Women's Work in Renaissance Tus-

cany." In Rewriting the Renaissance: The Discourses of Sexual Difference in Early Modern Europe, edited by M. W. Ferguson, M. Quilligan, and N. J. Vickers, 206–24. Chicago, 1986.

Brown, J. C., and R. C. Davis, eds. Gender and Society in Renaissance Italy. Harlow, 1998.

Brown, J. C., and J. Goodman. "Women and Industry in Florence." *Journal of Economic History* 40, no. 1 (1980): 73–80.

Brucker, G. A. Florentine Politics and Society, 1343-1378. Princeton, N.J., 1963.

------. "The Medici in the Fourteenth Century." Speculum 32, no. 1 (1957): 1–26.

——. Renaissance Florence. Berkeley, Calif., 1969.

Brundage, J. A. Law, Sex, and Christian Society in Medieval Europe. Chicago, 1987.

Bullard, M. M. "Heroes and Their Workshops: Medici Patronage and the Problem of Shared Agency." *Journal of Medieval and Renaissance Studies* 24 (1994): 179–98.

Burckhardt, J. The Civilization of the Renaissance in Italy. Translated by S. G. C. Middlemore. London, 1995.

Burke, P. The European Renaissance: Centres and Peripheries. Oxford, 1998.

Burnett, C., and A. Contadini, eds. Islam and the Italian Renaissance. London, 1999.

Butters, H. C. Governors and Government in Early Sixteenth-Century Florence, 1502–1519. Oxford, 1985.

Byatt, M. C. "The Concept of Hospitality in a Cardinal's Household in Renaissance Rome." *Renaissance Studies* 2 (1988): 312–20.

Caferro, W. "Continuity, Long-Term Service, and Permanent Forces: A Reassessment of the Florentine Army in the Fourteenth Century." *Journal of Modern History* 80, no. 2 (2008): 219–51.

———. John Hawkwood: An English Mercenary in Fourteenth-Century Italy. Baltimore, 2006. Callmann, E. Apollonio di Giovanni. Oxford, 1974.

Campbell, C. Love and Marriage in Renaissance Florence: The Courtauld Wedding Chests. London, 2009.

Camporeale, S. I. Lorenzo Valla: Umanesimo e teologia. Florence, 1971.

Carmichael, A. G. Plague and the Poor in Renaissance Florence. Cambridge, U.K., 1986.

Cassuto, U. Gli ebrei a Firenze nell'età del Rinascimento. Florence, 1918.

Cavallo, S. "The Artisan's Casa." In At Home in Renaissance Italy, edited by M. Ajmar-Wollheim and F. Dennis, 66–75. London, 2006.

Cerulli, E. "L'Etiopia del sec. XV in nuovi documenti storici." *Africa italiana* 5 (1933): 58–80.

—. "Eugenio IV e gli Etiopi al Concilio di Firenze nel 1441." Rendiconti della Reale Accademia dei Lincei: Classe di scienze morali, storiche e filologiche 6, no. 9 (1933): 346–68.

Cesareo, G. A. Pasquino e Pasquinate nella Roma di Leone X. Rome, 1938.

Chambers, D. S. "The Economic Predicament of Renaissance Cardinals." Studies in Medieval and Renaissance History 3 (1966): 289-313.

Clementi, F. Il carnevale romano nelle cronache contemporanee dalle origini al secolo XVII. Città di Castello, 1939.

Clough, C. H. "Federigo da Montefeltro's Patronage of the Arts, 1468–1485." Journal of the Warburg and Courtauld Institutes 36 (1973): 129–44.

Cohen, E. S., and T. V. Cohen. Daily Life in Renaissance Italy. Westport, Conn., 2001.

Bibliography

- Cohn, S. K., Jr. "The Black Death: End of a Paradigm." American Historical Review 107, no. 3 (2002): 703-38.
 - ——. The Laboring Classes in Renaissance Florence. New York, 1980.
- . "Women and Work in Renaissance Italy." In Brown and Davis, *Gender and Society*, 107–27.
- Cole, B. The Renaissance Artist at Work from Pisano to Titian. London, 1983.
- Colorni, V. Judaica minora: Saggi sulla storia dell'ebraismo italiano dall'antichità all'età moderna. Milan, 1983.
- Comanducci, R. M. "'L'Altare Nostro de la Trinità': Masaccio's Trinity and the Berti Family." Burlington Magazine 145 (2003): 14-21.
- Connell, W. J., and G. Constable. "Sacrilege and Redemption in Renaissance Florence: The Case of Antonio Rinaldeschi." *Journal of the Warburg and Courtauld Institutes* 61 (1998): 63–92.
- Cooper, R. "Pier Soderini: Aspiring Prince to Civic Leader." Studies in Medieval and Renaissance History, n.s., 1 (1978): 67–126.

Creighton, G., and M. Merisi da Caravaggio. Caravaggio and His Two Cardinals. Philadelphia, 1995.

Crompton, L. Homosexuality and Civilization. Cambridge, Mass., 2006.

Cunningham, C. "For the Honour and Beauty of the City: The Design of Town Halls." In Norman, Siena, Florence, and Padua, 2:29–54.

Daniel, N. Islam and the West: The Making of an Image. Edinburgh, 1960.

Davidsohn, R. Storia di Firenze. 8 vols. Florence, 1956–68.

Davis, M. D. "'Opus Isodomum' at the Palazzo della Cancelleria: Vitruvian Studies and Archaeological and Antiquarian Interests at the Court of Raffael Riario." In *Roma, centro ideale della cultura dell'antico nei secoli XV e XVI*, edited by S. Danesi Squarzina, 442–57. Milan, 1989.

Davis, N. Z. Trickster Travels: A Sixteenth-Century Muslim Across Worlds. New York, 2006.

- Davis, R. C. Christian Slaves, Muslim Martyrs: White Slavery in the Mediterranean, the Barbary Coast, and Italy, 1500–1800. New York, 2003.
- Dean, T. Crime and Justice in Late Medieval Italy. Cambridge, U.K., 2007.
- Debby, N. B.-A. "Political Views in the Preaching of Giovanni Dominici in Renaissance Florence, 1400–1406." *Renaissance Quarterly* 55, no. 1 (2002): 19–48.

D'Elia, A. F. "Marriage, Sexual Pleasure, and Learned Brides in the Wedding Orations of Fifteenth-Century Italy." *Renaissance Quarterly* 55, no. 2 (2002): 379-433.

de Roover, R. L'évolution de la lettre de change (XIV^e-XVIII^e siècles). Paris, 1953.

- _____. The Rise and Decline of the Medici Bank, 1397–1494. New York, 1966.
- de Witte, C.-M. "Henri de Congo, évêque titulaire d'Utique (+ c. 1531), d'après les documents romains." *Euntes docete* 21 (1968): 587–99.
- Dickie, J. Delizia! The Epic History of the Italians and Their Food. New York, 2008.
- Earle, T. F., and K. J. P. Lowe, eds. *Black Africans in Renaissance Europe*. Cambridge, U.K., 2005.
- Edgerton, S. Y. "Florentine Interest in Ptolemaic Cartography as Background for Renaissance Painting, Architecture, and the Discovery of America." *Journal of the Society of Architectural Historians* 33, no. 4 (1974): 275–92.

—. The Renaissance Rediscovery of Linear Perspective. New York, 1975.

Egmont, L. Sixtus IV and Men of Letters. Rome, 1978.

- Elam, C. "Cosimo de' Medici and San Lorenzo." In Ames-Lewis, *Cosimo "il Vecchio" de' Medici*, 157–80.
- Enaud, F. "Les fresques du Palais des Papes d'Avignon." Les monuments historiques de la France 17, nos. 2-3 (1971): 1-139.
- Epstein, S. A. Genoa and the Genoese, 958-1528. Chapel Hill, N.C., 1996.
- Fabiański, M. "Federigo da Montefeltro's 'Studiolo' in Gubbio Reconsidered: Its Decoration and Its Iconographic Program: An Interpretation." *Artibus et historiae* 11, no. 21 (1990): 199–214.
- Falchetta, P. Fra Mauro's World Map. Turnhout, 2006.
- Ferguson, W. K. "Humanist Views of the Renaissance." American Historical Review 4 (1939): 1–28.
- Fermor, S. Piero di Cosimo: Fiction, Invention, and Fantasia. London, 1993.

Fernández-Armesto, F. Before Columbus: Exploration and Colonisation from the Mediterranean to the Atlantic, 1229–1492. London, 1987.

Filesi, T. "Enrico, figlio del re del Congo, primo vescovo dell'Africa nero (1518)." *Euntes docete* 19 (1966): 365–85.

Finlay, R. "The Foundation of the Ghetto: Venice, the Jews, and the War of the League of Cambrai." *Proceedings of the American Philosophical Society* 126, no. 2 (1982): 140–54.

- Fletcher, S., and C. Shaw, eds. The World of Savonarola: Italian Elites and Perceptions of Crisis. Aldershot, 2000.
- Fragnito, G. "Cardinals' Courts in Sixteenth-Century Rome." *Journal of Modern History* 65, no. 1 (1993): 26–56.
- Franceschi, F. "The Economy: Work and Wealth." In Najemy, Italy in the Age of the Renaissance, 124–44.
- Francese, J. "On Homoerotic Tension in Michelangelo's Poetry." *MLN* 117, no. 1 (2002): 17–47.
- Fraser Jenkins, A. D. "Cosimo de' Medici's Patronage of Architecture and the Theory of Magnificence." *Journal of the Warburg and Courtauld Institutes* 33 (1970): 162–70.
- Freely, J. Jem Sultan: The Adventures of a Captive Turkish Prince in Renaissance Europe. London, 2004.
- Frommel, C. L. Michelangelo und Tommaso dei Cavalieri. Amsterdam, 1979.

Fuson, R. H. Legendary Islands of the Ocean Sea. Sarasota, Fla., 1995.

- Garfagnini, G. C., ed. Savonarola e la politica. Florence, 1997.
- Garin, E. Giovanni Pico della Mirandola: Vita e dottrina. Florence, 1937.
- Gilbert, C. E. "Fra Angelico's Fresco Cycles in Rome: Their Number and Dates." Zeitschrift für Kunstgeschichte 38, nos. 3–4 (1975): 245–65.
 - —. Poets Seeing Artists' Work: Instances in the Italian Renaissance. Florence, 1991.
- Giles, K. A. "The Strozzi Chapel in Santa Maria Novella: Florentine Painting and Patronage, 1340–1355." PhD diss., New York University, 1977.
- Gill, J. The Council of Florence. Cambridge, U.K., 1959.
- Gilson, S. Dante and Renaissance Florence. Cambridge, U.K., 2005.
- Goldthwaite, R. A. The Building of Renaissance Florence: An Economic and Social History. Baltimore, 1980.
 - —. The Economy of Renaissance Florence. Baltimore, 2009.

Fiume, G., and M. Modica, eds. San Benedetto il moro: Santità, agiografia e primi processi di canonizzazione. Palermo, 1998.

Bibliography

 –. "The Florentine Palace as Domestic Architecture." American Historical Review 77, no. 4 (1972): 977–1012.

----. Private Wealth in Renaissance Florence: A Study of Four Families. Princeton, N.J., 1968.

Gombrich, E. H. "The Early Medici as Patrons of Art." In Italian Renaissance Studies, edited by E. F. Jacobs, 279–311. London, 1960.

—. "From the Revival of Letters to the Reform of the Arts." In *Essays in the History of Art Presented to Rudolf Wittkower*, edited by D. Fraser, H. Hibbard, and M. J. Lewine, 71–82. London, 1967.

—. "Icones Symbolicae: The Visual Image in Neo-Platonic Thought." Journal of the Warburg and Courtauld Institutes 11 (1948): 163–92.

—. The Story of Art. 15th ed. London, 1989.

Gow, A., and G. Griffiths. "Pope Eugenius IV and Jewish Money-Lending in Florence: The Case of Salomone di Bonaventura During the Chancellorship of Leonardo Bruni." *Renaissance Quarterly* 47, no. 2 (1994): 282–329.

Grafton, A., ed. Rome Reborn: The Vatican Library and Renaissance Culture. Washington, D.C., 1993.

Grafton, A., and L. Jardine. From Humanism to the Humanities: Education and the Liberal Arts in Fifteenth- and Sixteenth-Century Europe. Cambridge, Mass., 1986.

Granato, L. R. "Location of the Armoury in the Italian Renaissance Palace." Waffen und *Kostumkunde* 24 (1982): 152–53.

Grayzel, S. The Church and the Jews in the XIIIth Century. Philadelphia, 1933.

Green, L. "Galvano Fiamma, Azzone Visconti, and the Revival of the Classical Theory of Magnificence." *Journal of the Warburg and Courtauld Institutes* 53 (1990): 98–113.

Greenblatt, S. Renaissance Self-Fashioning: From More to Shakespeare. Chicago, 1984.

Gregory, H. "Palla Strozzi's Patronage and Pre-Medicean Florence." In *Patronage, Art, and Society in Renaissance Italy*, edited by F. W. Kent and P. Simmons, 201–20. Oxford, 1987.

Grendler, P. Schooling in Renaissance Italy: Literacy and Learning, 1300–1600. Baltimore, 1989.

Grey, C., and P. Heseltine. Carlo Gesualdo, Musician and Murderer. London, 1926.

Gualdo, G. "Leonardo Bruni segretario papale (1405–1415)." In *Leonardo Bruni, cancelliere della Repubblica di Firenze*, edited by P. Viti, 73–93. Florence, 1990.

Guidotti, A. "Pubblico e privato, committenza e clientele: Botteghe e produzione artistica a Firenze tra XV e XVI secolo." *Richerche storiche* 16 (1986): 535–50.

Gutkind, C. Cosimo de' Medici: Pater Patriae, 1389–1464. Oxford, 1938.

Haight, E. H. "Horace on Art: Ut Pictura Poesis." *Classical Journal* 47, no. 5 (1952): 157–62, 201–2.

Hale, J. R. Florence and the Medici: The Pattern of Control. London, 1977.

Hankins, J. "The Myth of the Platonic Academy of Florence." *Renaissance Quarterly* 44, no. 3 (1991): 429-47.

-. "Renaissance Crusaders: Humanist Crusade Literature in the Age of Mehmed

II." Dumbarton Oaks Papers 49 (1995): 111–207.

Harris, J. Greek Émigrés in the West, 1400–1520. Camberley, 1995.

Harrison, C. "The Arena Chapel: Patronage and Authorship." In Norman, Siena, Florence, and Padua, 2:83–104.

Hatfield, R. Botticelli's Uffizi "Adoration": A Study in Pictorial Content. Princeton, N.J., 1976.

"The Compagnia de' Magi." Journal of the Warburg and Courtauld Institutes 33
(1970): 107–61.
"Cosimo de' Medici and the Chapel of His Palace." In Ames-Lewis, Cosimo "il
Vecchio" de' Medici, 221–44.
The Wealth of Michelangelo. Rome, 2002.
Hay, D. The Church in Italy in the Fifteenth Century. Cambridge, U.K., 1977.
Helmrath, J. "Pius II und die Türken." In Europa und die Türken in der Renaissance, edited
by B. Guthmüller and W. Kühlmann, 79–138. Tübingen, 2000.
Herlihy, D., and C. Klapisch-Zuber. Les Toscans et leurs familles. Paris, 1978.
Tuscans and Their Families: A Study of the Florentine Catasto of 1427. New Haven,
Conn., 1985.
Heydenreich, L. H. "Federico da Montefeltro as a Building Patron." In Studies in Renais-
sance and Baroque Art Presented to Anthony Blunt on His 60th Birthday, 1–6. London,
1967.
Hibbert, C. The Rise and Fall of the House of Medici. London, 1979.
Hirst, M. The Achievement of Fame. Vol. 1 of Michelangelo. New Haven, Conn., 2011.
"Michelangelo in 1505." Burlington Magazine 133, no. 1064 (1991): 760–66.
Hofmann, H. "Aeneas in Amerika: De 'Columbeis' van Julius Caesar Stella." Hermeneus
64 (1992): 315–22.
"La scoperta del nuovo mondo nella poesia neolatina: I 'Columbeidos libri pri-
ores duo' di Giulio Cesare Stella." In <i>Columbeis III</i> , 71–94. Genoa, 1988.
Holmes, G. "Cosimo and the Popes." In Ames-Lewis, Cosimo "il Vecchio" de' Medici, 21–31.
"How the Medici Became the Pope's Bankers." In Florentine Studies, edited by
N. Rubinstein, 357–80. Evanston, Ill., 1968.
Howard, D. Venice and the East: The Impact of the Islamic World on Venetian Architecture,
1100–1500. New Haven, Conn., 2000.

Howard, P. "Preaching Magnificence in Renaissance Florence." Renaissance Quarterly 61, no. 2 (2008): 325-69.

Hsia, R. P.-C. Trent 1475: Stories of a Ritual Murder Trial. New Haven, Conn., 1992.

Hudson, H. "The Politics of War: Paolo Uccello's Equestrian Monument for Sir John Hawkwood in the Cathedral of Florence." *Parergon 23*, no. 2 (2006): I–28.

Hughes, D. O. "Bodies, Disease, and Society." In Najemy, Italy in the Age of the Renaissance, 103–23.

—. "Distinguishing Signs: Ear-Rings, Jews, and Franciscan Rhetoric in the Italian Renaissance Cities." *Past and Present* 112 (1986): 3–59.

Hunt, E. S. The Medieval Super-Companies: A Study of the Peruzzi Company of Florence. Cambridge, U.K., 1994.

Hunt, E. S., and J. M. Murray. A History of Business in Medieval Europe, 1200–1550. Cambridge, U.K., 1999.

Hyatte, R. The Arts of Friendship: The Idealization of Friendship in Medieval and Early Renaissance Literature. Leiden, 1994.

Hyde, J. K. Society and Politics in Medieval Italy: The Evolution of the Civil Life, 1000–1350. London, 1973.

Ianziti, G. Writing History in Renaissance Italy: Leonardo Bruni and the Uses of the Past. Cambridge, Mass., 2012.

Jack, M. A. "The Accademia del Disegno in Late Renaissance Florence." Sixteenth Century Journal 7, no. 2 (1976): 3–20.

Bibliography

Jardine, L., and J. Brotton. *Global Interests: Renaissance Art Between East and West*. London, 2000.

Jones, P. J. "Communes and Despots: The City State in Late-Medieval Italy." *Transac tions of the Royal Historical Society*, 5th ser., 15 (1965): 71–96.

_____. The Italian City-State: From Commune to Signoria. Oxford, 1997.

—. The Malatesta of Rimini and the Papal State. Cambridge, U.K., 1974.

Jones, R., and N. Penny. Raphael. New Haven, Conn., 1983.

Jordan, M. D. The Silence of Sodom: Homosexuality in Modern Catholicism. Chicago, 2000.

Kaplan, P. H. D. "Isabella d'Este and Black African Women." In Earle and Lowe, *Black Africans in Renaissance Europe*, 125–54.

—. The Rise of the Black Magus in Western Art. Ann Arbor, Mich., 1985.

Katz, D. E. "The Contours of Tolerance: Jews and the Corpus Domini Altarpiece in Urbino." Art Bulletin 85, no. 4 (2003): 646–61.

—. The Jew in the Art of the Italian Renaissance. Philadelphia, 2008.

Kempers, B. Painting, Power, and Patronage: The Rise of the Professional Artist in Renaissance Italy. Translated by B. Jackson. London, 1994.

Kent, D. Cosimo de' Medici and the Florentine Renaissance. New Haven, Conn., 2000.

-----. " "The Lodging House of All Memories": An Accountant's Home in Renaissance Florence." Journal of the Society of Architectural Historians 66, no. 4 (2007): 444–63.

—. The Rise of the Medici: Faction in Florence, 1426–1434. Oxford, 1978.

Kent, F. W. "Individuals and Families as Patrons of Culture in Quattrocento Florence." In Language and Images of Renaissance Italy, edited by A. Brown, 171–92. Oxford, 1995.

King, D., and D. Sylvester, eds. The Eastern Carpet in the Western World from the 15th to the 17th Century. London, 1983.

Kirshner, J. "Family and Marriage: A Socio-legal Perspective." In Najemy, Italy in the Age of the Renaissance, 82–102.

Klapisch-Zuber, C. "Women Servants in Florence (Fourteenth and Fifteenth Centuries)." In *Women and Work in Preindustrial Europe*, edited by B. Hanawalt, 56–80. Bloomington, Ind., 1986.

Knox, G. "The Colleoni Chapel in Bergamo and the Politics of Urban Space." Journal of the Society of Architectural Historians 60, no. 3 (2001): 290–309.

Kristeller, P. O. Renaissance Thought and the Arts. New ed. Princeton, N.J., 1990.

Laclotte, M., and D. Thiébaut. L'école d'Avignon. Tours, 1983.

Lambert, M. D. Franciscan Poverty: The Doctrine of the Absolute Poverty of Christ and the Apostles in the Franciscan Order, 1210–1323. London, 1961.

Landauer, C. "Erwin Panofsky and the Renascence of the Renaissance." Renaissance Quarterly 47, no. 1 (1994): 255-81.

Larner, J. Culture and Society in Italy, 1290–1420. London, 1971.

La Roncière, C.-M. de. "Poveri e povertà a Firenze nel XIV secolo." In *Tra preghiera e rivolta: Le folle toscane nel XIV secolo*, edited by C.-M. de la Roncière, G. Cherubini, and G. Barone, 197–281. Rome, 1993.

La Sizeranne, R. de. Federico di Montefeltro: Capitano, principe, mecenate, 1422–1482. Edited by C. Zeppieri. Urbino, 1972.

408

- Lavin, M. A. "Piero della Francesca's Fresco of Sigismondo Pandolfo Malatesta Before St. Sigismund: ΘΕΩΙ ΑΘΑΝΑΤΩΙ ΚΑΙ ΤΗΙ ΠΟΛΕΙ." *Art Bulletin* 56, no. 3 (1974): 345–74.
- Leader, A. The Badia of Florence: Art and Observance in a Renaissance Monastery. Bloomington, Ind., 2012.

Lee, A. Petrarch and St. Augustine: Classical Scholarship, Christian Theology, and the Origins of the Renaissance in Italy. Leiden, 2012.

—. "Petrarch, Rome, and the 'Dark Ages.'" In *Early Modern Rome, 1341–1667*, edited by P. Prebys, 9–26. Ferrara, 2012.

Lee, R. W. "Ut Pictura Poesis: The Humanistic Theory of Painting." Art Bulletin 22, no. 4 (1940): 197–269.

Le Goff, J. The Birth of Purgatory. Translated by A. Goldhammer. Chicago, 1984.

Leoncini, G. La certosa di Firenze nei suoi rapporti con l'architettura certosina. Salzburg, 1980. Lestringant, F. Mapping the Renaissance World. Berkeley, Calif., 1994.

Liebert, R. S. Michelangelo: A Psychoanalytic Study of His Life and Images. New Haven, Conn., 1983.

Lightbown, R. A. Sandro Botticelli. 2 vols. London, 1978.

Lindow, J. R. The Renaissance Palace in Florence: Magnificence and Splendour in Fifteenth-Century Italy. London, 2007.

Lowe, K. "'Representing' Africa: Ambassadors and Princes from Christian Africa to Italy and Portugal, 1402–1608." *Transactions of the Royal Historical Society* 6, no. 17 (2007): 101–28.

-----. "The Stereotyping of Black Africans in Renaissance Europe." In Earle and Lowe, Black Africans in Renaissance Europe, 17–47.

Lubkin, G. A Renaissance Court: Milan Under Galleazzo Maria Sforza. Berkeley, Calif., 1994.

Mack, C. R. Review of The Aesthetics of Renaissance Art: A Reconsideration of Style, by H. Wohl. Renaissance Quarterly 53, no. 2 (2000): 569–71.

Mack, R. E. Bazaar to Piazza: Islamic Trade and Italian Art, 1300–1600. Berkeley, Calif., 2002.

Mackenney, R. Renaissances: The Cultures of Italy, c. 1300-c. 1600. Houndmills, 2005.

Maggi, A. "On Kissing and Sighing: Renaissance Homoerotic Love from Ficino's De Amore and Sopra Lo Amore to Cesare Trevisani's L'Impresa (1569)." Journal of Homosexuality 49, nos. 3–4 (2005): 315–39.

Maginnis, H. B. J. The World of the Early Sienese Painter. Philadelphia, 2001.

Magnuson, T. "The Project of Nicholas V for Rebuilding the Borgo Leonino in Rome." Art Bulletin 36, no. 2 (1954): 89–115.

Mallett, M. Mercenaries and Their Masters: Warfare in Renaissance Italy. New ed. Barnsley, 2009.

Mann, N. Petrarch. Oxford, 1984.

Marchini, G. Filippo Lippi. Milan, 1975.

Mariani, L. M. San Benedetto da Palermo, il moro Etiope, nato a S. Fratello. Palermo, 1989.

Martindale, A. The Rise of the Artist in the Middle Ages and Early Renaissance. London, 1972. ———. Simone Martini. Oxford, 1988.

Martines, L. April Blood: Florence and the Plot Against the Medici. New York, 2003.

———. Power and Imagination: City-States in Renaissance Italy. London, 1980.

-------. Scourge and Fire: Savonarola and Renaissance Italy. London, 2007.

———. The Social World of the Florentine Humanists, 1390–1460. Princeton, N.J., 1963.

Bibliography

Mayer, E. Un umanista italiano della corte di Mattia Corvino: Aurelio Brandolino Lippo. Rome, 1938.

McLaughlin, M. L. "Humanist Concepts of Renaissance and Middle Ages in the Treand Quattrocento." *Renaissance Studies* 2 (1988): 131–42.

Meiss, M. "The Original Position of Uccello's John Hawkwood." Art Bulletin 52 (1970): 231. Merkley, P., and L. L. M. Merkley. Music and Patronage in the Sforza Court. Turnhout, 1999. Meserve, M. Empires of Islam in Renaissance Historical Thought. Cambridge, Mass., 2008. Miglio, M., et al., eds. Un Pontificato ed una città: Sisto IV (1471–1484). Vatican City, 1986. Milano, A. Storia degli ebrei in Italia. Turin, 1963.

Minnich, N. H. "The Catholic Church and the Pastoral Care of Black Africans in Renaissance Italy." In Earle and Lowe, *Black Africans in Renaissance Europe*, 280–300.

Mitchell, R. J. The Laurels and the Tiara: Pope Pius II, 1458–1464. London, 1962.

Mode, R. L. "Masolino, Uccello, and the Orsini *Uomini Famosi.*" Burlington Magazine 114 (1972): 369–78.

Molho, A. "Cosimo de' Medici: Pater Patriae or Padrino?" Stanford Italian Review 1 (1979): 13–14.

------. Florentine Public Finances in the Early Renaissance, 1400–1433. Cambridge, Mass., 1971.

——. "Politics and the Ruling Class in Early Renaissance Florence." Nuova rivista storica 52 (1968): 401–20.

Mollat, G. The Popes at Avignon, 1305–1378. Translated by J. Love. London, 1963.

Mommsen, T. E. "The Date of Petrarch's Canzone Italia Mia." Speculum 14, no. 1 (1939): 28–37.

---. "Petrarch's Conception of the 'Dark Ages.'" Speculum 17 (1942): 226-42.

Monfasani, J. Byzantine Scholars in Renaissance Italy: Cardinal Bessarion and Other Émigrés. Aldershot, 1995.

Moore, G. "La spedizione dei fratelli Vivaldi e nuovi documenti d'archivio." *Atti della Società Ligure di Storia Patria*, n.s., 12 (1972): 387–400.

Mormando, F. The Preacher's Demons: Bernardino of Siena and the Social Underworld of Early Renaissance Italy. Chicago, 1999.

Morrall, E. J. "Aeneas Silvius Piccolomini (Pius II), *Historia de Duobus Amantibus.*" *Library*, 6th ser., 18, no. 3 (1996): 216–29.

Moxey, K. P. F. "Perspective, Panofsky, and the Philosophy of History." *New Literary History* 26, no. 4 (1995): 775-86.

Muir, E. "Representations of Power." In Najemy, Italy in the Age of the Renaissance, 226-45.

Muldoon, J. Popes, Lawyers, and Infidels: The Church and the Non-Christian World, 1250–1500. Liverpool, 1979.

Munro, D. C. "The Western Attitude Towards Islam During the Period of the Crusades." Speculum 6, no. 3 (1931): 329-43.

Muscetta, C. Giovanni Boccaccio. 2nd ed. Bari, 1974.

Najemy, J. Corporatism and Consensus in Florentine Electoral Politics, 1280–1400. Chapel Hill, N.C., 1982.

——. A History of Florence, 1200–1575. Oxford, 2008.

—, ed. Italy in the Age of the Renaissance, 1300–1550. Oxford, 2004.

Norman, D., ed. Siena, Florence, and Padua: Art, Society, and Religion, 1280–1400. 2 vols. New Haven, Conn., 1995. Oertel, R. Fra Filippo Lippi. Vienna, 1942.

- Olmi, G. L'inventario del mondo: Catalogazione della natura e luoghi del sapere nella prima età moderna. Bologna, 1992.
- O'Malley, J. W. "Fulfilment of the Christian Golden Age Under Pope Julius II: Text of a Discourse of Giles of Viterbo, 1507." *Traditio* 25 (1969): 265–338.

Origo, I. "The Domestic Enemy: The Eastern Slaves in Tuscany in the Fourteenth and Fifteenth Centuries." *Speculum* 30, no. 3 (1955): 321–66.

–. The Merchant of Prato: Francesco di Marco Datini, 1335–1410. New York, 1957.

Pacetti, D. "La predicazione di S. Bernardino in Toscano." Archivum franciscanum historicum 30 (1940): 282–318.

Padgett, J. F., and C. K. Ansell. "Robust Action and the Rise of the Medici, 1400–1434." American Journal of Sociology 98, no. 6 (1993): 1259–319.

Panella, A. "Una sentenza di Niccolò Porcinari, podestà di Firenze." *Rivista abruzzese di scienze, lettere ed arti* 24 (1909): 337–67.

Panizza, L. "Active and Contemplative in Lorenzo Valla: The Fusion of Opposites." In Arbeit, Musse, Meditation: Betrachtungen zur "Vita activa" und "Vita contemplativa," edited by B. Vickers, 181–223. Zurich, 1985.

Panofsky, E. "Die Perspektive als symbolische Form." Vorträge der Bibliothek Warburg 1924–25 (1927): 258–330.

—. Renaissance and Renascences in Western Art. 2nd ed. New York, 1969.

——. Studies in Iconology: Humanistic Themes in the Art of the Renaissance. New ed. New York, 1962.

Paparelli, G. Enea Silvio Piccolomini: L'umanesimo sul soglio di Pietro. 2nd ed. Ravenna, 1978.

Parry, J. H. The Age of Reconnaissance: Discovery, Exploration, and Settlement, 1450–1650. New ed. London, 2000.

- Partner, P. Renaissance Rome, 1500-1559. Berkeley, Calif., 1976.
- Pastore Stocchi, M. "Il *De Canaria* boccaccesco e un 'locus deperditus' nel *De insulis* di Domenico Silvestri." *Rinsascimento* 10 (1959): 153–56.
- Pernis, M. G., and L. S. Adams. Federico da Montefeltro and Sigismondo Malatesta: The Eagle and the Elephant. New York, 1996.

Pertusi, A. Leonzio Pilato tra Petrarca e Boccaccio. Venice and Rome, 1964.

Piel, F. La Cappella Colleoni e il Luogo della Pietà in Bergamo. Bergamo, 1975.

Polizzotto, L. The Elect Nation: The Savonarolan Movement in Florence, 1494–1545. Oxford, 1994.

Pope-Hennessy, J. Paradiso: The Illuminations to Dante's "Divine Comedy" by Giovanni di Paolo. London, 1993.

- Prizer, W. F. "Reading Carnival: The Creation of a Florentine Carnival Song." Early Music History 23 (2004): 185–252.
- Rabinowitz, I. "Pre-modern Jewish Study of Rhetoric: An Introductory Bibliography." Rhetorica 3 (1985): 137–44.

Rau, V. Estudos de história. Lisbon, 1968.

- Remington, P. "The Private Study of Federigo da Montefeltro." Bulletin of the Metropolitan Museum of Art 36, no. 2 (1941): 3–13.
- Renouard, Y. The Avignon Papacy, 1305-1403. Translated by D. Bethell. London, 1970.

Rezasco, G. "Segno delle meretrici." Giornale ligustico 17 (1980): 161-220.

Ricci, C. Il Tempio Malatestiano. Milan and Rome, 1925.

Bibliography

Rocke, M. Forbidden Friendships: Homosexuality and Male Culture in Renaissance Florence. New York, 1996.

——. "Gender and Sexual Culture in Renaissance Italy." In Brown and Davis, Gender and Society, 150–70.

Rossi, P. L. "The Writer and the Man: Real Crimes and Mitigating Circumstances: *Il Caso Cellini*." In *Crime, Society, and the Law in Renaissance Italy,* edited by K. Lowe and T. Dean, 157–83. Cambridge, U.K., 1994.

Rotondi, P. The Ducal Palace of Urbino: Its Architecture and Decoration. London, 1969.

Rowland, B. The Classical Tradition in Western Art. Cambridge, Mass., 1963.

Rubiés, J. P. "Giovanni di Buonagrazia's Letter to His Father Concerning His Participation in the Second Expedition of Vasco da Gama." *Mare liberum* 16 (1998): 87–112.

Rubin, P. L. Giorgio Vasari: Art and History. London, 1995.

Rubinstein, N. "Le allegorie di Ambrogio Lorenzetti nella Sala della Pace e il pensiero politico del suo tempo." *Rivista storica italiana* 109 (1997): 781–802.

—. "The Beginning of Niccolò Machiavelli's Career in the Florentine Chancery." Italian Studies 11 (1956): 72–91.

——. The Government of Florence Under the Medici (1434 to 1494). Oxford, 1966.

----. "Political Ideas in Sienese Art: The Frescoes by Ambrogio Lorenzetti and Taddeo

di Bartolo in the Palazzo Pubblico." Journal of the Warburg and Courtauld Institutes 21 (1958): 179–207.

Saalman, H. "Tommaso Spinelli, Michelozzo, Manetti, and Rosselino." Journal of the Society of Architectural Historians 25, no. 3 (1966): 151–64.

Saalman, H., and P. Mattox. "The First Medici Palace." Journal of the Society of Architectural Historians 44, no. 4 (1985): 329-45.

Salter, F. R. "The Jews in Fifteenth-Century Florence and Savonarola's Establishment of a Mons Pietatis." *Historical Journal* 5, no. 2 (1936): 193–211.

Sanpaolesi, P. Brunelleschi. Milan, 1962.

Saslow, J. M. "'A Veil of Ice Between My Heart and the Fire': Michelangelo's Sexual Identity and Early Constructions of Homosexuality." *Genders* 2 (1998): 77–90.

Schofield, R., and A. Burnett. "The Decoration of the Colleoni Chapel." Arte lombarda 126 (1999): 61–89.

Schorsch, J. Jews and Blacks in the Early Modern World. Cambridge, U.K., 2004.

Schwartz, M. V., and P. Theis. "Giotto's Father: Old Stories and New Documents." Burlington Magazine 141 (1999): 676–77.

Segre, R. "Banchi ebraici e monti di pietà." In *Gli ebrei a Venezia, secoli XIV–XVIII*, edited by G. Cozzi, 565–70. Milan, 1987.

Shulvass, M. A. The Jews in the World of the Renaissance. Translated by E. I. Kose. Leiden, 1973.

Simonetta, M. The Montefeltro Conspiracy: A Renaissance Mystery Decoded. New York, 2008.

Simonsohn, S. The Apostolic See and the Jews: Documents, 1394–1464. Toronto, 1991.

. The Apostolic See and the Jews: History. Toronto, 1991.

Simpson, W. A. "Cardinal Giordano Orsini (+1438) as a Prince of the Church and a Patron of the Arts." *Journal of the Warburg and Courtauld Institutes* 29 (1966): 135–59.

Skinner, Q. R. D. "Ambrogio Lorenzetti: The Artist as Political Philosopher." Proceedings of the British Academy 72 (1986): 1–56.

Sheard, W. S., and J. T. Paoletti, eds. *Collaboration in Italian Renaissance Art*. New Haven, Conn., 1978.

Bibliography

—. "Ambrogio Lorenzetti's Buon Governo Frescoes: Two Old Questions, Two New Answers." Journal of the Warburg and Courtauld Institutes 62 (1999): 1–28.

——. The Foundations of Modern Political Thought. 2 vols. Cambridge, U.K., 1978.

Slessarev, V. Prester John: The Letter and the Legend. Minneapolis, 1959.

Southern, R. W. Western Views of Islam in the Middle Ages. Cambridge, Mass., 1962.

Spufford, P. Money and Its Use in Medieval Europe. Cambridge, U.K., 1988.

—. "Trade in Fourteenth-Century Europe." In *The New Cambridge Medieval History*, vol. 6, *c.* 1300–*c.* 1415, edited by M. Jones, 155–208. Cambridge, U.K., 2000.

Steinmann, E., and H. Pogatscher. "Dokumente und Forschungen zu Michelangelo, IV, Cavalieri-Dokumente." *Repertorium für Kunstwissenschaft* 29 (1906): 496–517.

Stubblebine, J., ed. Giotto: The Arena Chapel Frescoes. New York, 1969.

Taeusch, C. F. "The Concept of 'Usury': The History of an Idea." *Journal of the History of Ideas* 3, no. 3 (1942): 291–318.

Tedeschi, S. "Etiopi e copti al concilio di Firenze." Annuarium historiae conciliorum 21 (1989): 380–97.

Thomas, A. The Painter's Practice in Renaissance Tuscany. Cambridge, U.K., 1995.

Thompson, L. A., and J. Ferguson. *Africa in Classical Antiquity: Nine Studies*. Ibadan, 1969. Tiraboschi, G. *Storia della letteratura italiana*. 9 vols. Venice, 1795–96.

Tognetti, S. Da Figline a Firenze: Ascesa economica e politica della famiglia Serristori (secoli XIV–XVI). Figline, 2003.

—. "Prezzi e salari nella Firenze tardomedievale: Un profile." ASI 153 (1999): 263–333.

——. "The Trade in Black African Slaves in Fifteenth-Century Florence." In Earle and Lowe, *Black Africans in Renaissance Europe*, 213–24.

Tommasoli, W. La vita di Federico da Montefeltro, 1422–1482. Urbino, 1978.

Trexler, R. The Journey of the Magi: Meanings in History of a Christian Story. Princeton, N.J., 1997.

—. "La prostitution florentine au XV^e siècle: Patronages et clientèles." *Annales ESC* 36 (1981): 983–1015.

—. Public Life in Renaissance Florence. New York, 1980.

Trimpi, W. "The Meaning of Horace's Ut Pictura Poesis." Journal of the Warburg and Courtauld Institutes 36 (1973): 1–34.

Trinkaus, C. In Our Image and Likeness: Humanity and Divinity in Italian Humanist Thought. 2 vols. Chicago, 1970.

Trivellato, F. "Renaissance Italy and the Muslim Mediterranean in Recent Historical Work." *Journal of Modern History* 82, no. 1 (2010): 127–55.

Turner, D. "Forgotten Treasure from the Indies: The Illustrations and Drawings of Fernández de Oviedo." *Huntington Library Quarterly* 48, no. 1 (1985): 1–46.

Tyerman, C. J. "Marino Sanudo Torsello and the Lost Crusade: Lobbying in the Fourteenth Century." *Transactions of the Royal Historical Society*, 5th ser., 32 (1982): 57–73.

Ullman, B. L. The Humanism of Coluccio Salutati. Padua, 1963.

Ullman, B. L., and P. Stadter. The Public Library of Florence: Niccolò Niccoli, Cosimo de' Medici, and the Library of San Marco. Padua, 1972.

Ullmann, W. The Origins of the Great Schism: A Study in Fourteenth-Century Ecclesiastical History. Reprint, Hamden, Conn., 1972.

—. A Short History of the Papacy in the Middle Ages. Rev. ed. London, 1974.

Verlinden, C. "Lanzarotto Malocello et la découverte portugaise des Canaries." *Revue belge de philologie et d'histoire* 36 (1958): 1173–209.

Vernet, F. "Le pape Martin V et les Juifs." Revue des questions historiques 51 (1892): 373-423.

- Verstegen, I. F., ed. Patronage and Dynasty: The Rise of the della Rovere in Renaissance Italy. Kirksville, Mo., 2007.
- Viti, P. "'Bonus miles et fortis ac civium suorum amator': La figura del condottiero nell'opera di Leonardo Bruni." In *Condottieri e uomini d'arme dell'Italia del Rinascimento*, edited by M. del Treppo, 75–91. Naples, 2001.
- Vivanti, C. "The History of the Jews in Italy and the History of Italy." *Journal of Modern History* 67, no. 2 (1995): 309–57.
- Waley, D. The Italian City-Republics. 3rd ed. London, 1988.
- Wallace, W. "Manoeuvering for Patronage: Michelangelo's Dagger." *Renaissance Studies* 11 (1997): 20–26.

—. Michelangelo: The Artist, the Man, and His Times. Cambridge, U.K., 2010.

Wegener, W. J. "That the Practice of Arms Is Most Excellent Declare the Statues of Valiant Men: The Luccan War and Florentine Political Ideology in Paintings by Uccello and Castagno." *Renaissance Studies* 7, no. 2 (1993): 129–67.

Weil-Garris, K., and J. F. d'Amico. "The Renaissance Cardinal's Ideal Palace: A Chapter from Cortesi's *De Cardinalatu*." In *Studies in Italian Art and Architecture, Fifteenth Through Eighteenth Centuries*, edited by H. A. Millon, 45–123. Rome, 1980.

- Weinstein, D. Savonarola: The Rise and Fall of a Renaissance Prophet. New Haven, Conn., 2011.
- Weiss, R. "The Medals of Pope Julius II (1503–1513)." Journal of the Warburg and Courtauld Institutes 28 (1965): 163–82.
 - ——. The Medals of Pope Sixtus IV, 1417–1484. Rome, 1961.
 - ——. The Renaissance Discovery of Classical Antiquity. New York, 1969.
- Welch, E. S. Art and Authority in Renaissance Milan. New Haven, Conn., 1996.
 - —. Art and Society in Italy, 1350–1500. Oxford, 1997.
- Wiesner, M. E. Women and Gender in Early Modern Europe. Cambridge, U.K., 1993.
- Wilkins, E. H. A History of Italian Literature. Rev. ed. Cambridge, Mass., 1974.
 - —. *Life of Petrarch*. Chicago, 1961.
 - . "Petrarch's Ecclesiastical Career." Speculum 28, no. 4 (1953): 754–75.
- Williams, R. The American Indian in Western Legal Thought: The Discourses of Conquest. Oxford, 1990.
- Wisch, B. "Vested Interests: Redressing Jews on Michelangelo's Sistine Ceiling." Artibus et historiae 24, no. 48 (2003): 143–72.
- Witt, R. G. "Florentine Politics and the Ruling Class, 1382–1407." Journal of Medieval and Renaissance Studies 6 (1976): 243–67.
 - —. Hercules at the Crossroads: The Life, Works, and Thought of Coluccio Salutati. Durham, N.C., 1983.

Wittkower, R., and M. Wittkower. Born Under Saturn: The Character and Conduct of Artists: A Documented History from Antiquity to the French Revolution. New York, 2006.

Wohl, H. The Aesthetics of Italian Renaissance Art: A Reconsideration of Style. Cambridge, U.K., 1999.

Yamauchi, E. M., ed. Africa and Africans in Antiquity. East Lansing, Mich., 2001.

Zannoni, G. "I due libri della Martiados di Giovan Mario Filelfo." Rendiconti della Reale Accademia dei Lincei: Classe di scienze morali, storiche e filologiche, 5th ser., 3 (1895): 650–71.

Illustration Credits

- 1. Florence, S. Maria del Carmine, Brancacci Chapel. De Agostini/Getty Images
- 2. Urbino, Galleria Nazionale delle Marche. The Bridgeman Art Library/Getty Images
- 3. Berlin, Kupferstichkabinett. Alinari/Getty Images
- 4. Florence, S. Spirito. The Bridgeman Art Library/Getty Images
- 5. Florence, S. Maria Novella. Florence, Galleria degli Uffizi. The Bridgeman Art Library/Getty Images
- 6. Venice, Gallerie dell'Accademia. De Agostini/Getty Images
- 7. Chantilly, Musée Condé. Universal Images Group/Getty Images
- 8. Frankfurt, Städel. SuperStock/Getty Images
- 9. Florence, Galleria degli Uffizi. De Agostini/Getty Images
- 10. Florence, S. Maria Novella, Tornabuoni Chapel. The Bridgeman Art Library/ Getty Images
- 11. Washington, D.C., National Gallery of Art. Andrew W. Mellon Collection 1937.1.19, National
- 12. Ferrara, Palazzo Schifanoia. De Agostini/Getty Images
- 13. Windsor, Royal Collection. Royal Collection Trust/© Her Majesty Queen Elizabeth II 2013
- 14. Windsor, Royal Collection. Royal Collection Trust/© Her Majesty Queen Elizabeth II 2013
- 15. London, National Gallery. De Agostini/Getty Images
- 16. London, National Gallery. National Gallery Picture Library, London
- 17. Cambridge, Massachusetts, Fogg Art Museum, Harvard University Art Museums, Gifts for Special Uses Fund. © President and Fellows of Harvard College
- 18. Florence, Palazzo Medici-Riccardi, Capella dei Magi. De Agostini/Getty Images
- 19. Madrid, Prado. De Agostini/Getty Images
- 20. Florence, S. Maria del Carmine, Brancacci Chapel. De Agostini/Getty Images
- 21. Florence, S. Maria Novella, Tornabuoni Chapel. Out of copyright.
- 22. Florence, S. Maria Novella, Tornabuoni Chapel. De Agostini/Getty Images
- 23. London, National Gallery. De Agostini/Getty Images
- 24. Florence, Galleria degli Uffizi. Universal Images Group/Getty Images
- 25. Paris, Musée du Louvre. De Agostini/Getty Images
- 26. Florence, S. Maria del Carmine. The Bridgeman Art Library/Getty Images
- 27. Urbino, Galleria Nazionale delle Marche. De Agostini/Getty Images
- 28. Milan, Pinacoteca di Brera. De Agostini/Getty Images

Illustration Credits

- 29. Rimini, Tempio Malatestiano. The Bridgeman Art Library
- 30. Villa Farnesina, Rome/The Bridgeman Art Library
- 31. Vatican City, Pinacoteca Vaticana. De Agostini/Getty Images
- 32. Florence, Galleria degli Uffizi. De Agostini/Getty Images
- 33. Paris, Musée du Louvre. De Agostini/Getty Images
- 34. Borgia Apartments, Vatican Palace, Vatican City/© Leemage/The Bridgeman Art Library
- 35. Florence, Galleria degli Uffizi. De Agostini/Getty Images
- 36. Urbino, Galleria Nazionale delle Marche. Alinari/The Bridgeman Art Library
- 37. Paris, Musée du Louvre. Titre/artiste/© RMN—Grand Palais/nom du photographe/nom du muse où l'œuvre est conservée
- 38. Milan, Pinacoteca di Brera. Alinari/Getty Images
- 39. Florence, Galleria degli Uffizi. De Agostini/Getty Images

INDEX

Page numbers beginning with 360 refer to notes.

Abulafia, David, 347 Accademia del Disegno, 366 Acciaiuoli, Donato, 192 Acciaiuoli, Niccolò, 172 Acciaiuoli family, 24, 175 Adoration of the Magi (Botticelli), 79, 200 Adoration of the Magi (Mantegna), 329-30 Africa, 324 Catholic missionaries in, 330-31 North, 279-80, 284, 286 sub-Saharan, 325-31 Africa (Petrarch), 16, 369 Agincourt, Battle of, 205 Agnadello, Battle of (1509), 272 Alamanno di Iacopo, 47 al-Andalus, 283, 309, 310 Alberti, Leon Battista, 71, 88, 182, 184, 185, 186, 230, 243, 351-52, 383 Alberto da Sarteano, 323–25, 326, 328–29, 332, 335, 350 Albizzi, Antonio di Lando degli, 48, 49 Albizzi, Franceschino degli, 123 Albizzi, Giovanni degli, 328 Albizzi, Maso degli, 192 Albizzi, Rinaldo degli, 157, 195–96 Aldobrandini, Piero, 75 Aldovrandi, Giovanfrancesco, 113, 118 Alemanno, Yohanan (Johanan), 296 Alexander V, Pope, 178 Alexander VI, Pope, 244, 252, 253, 260, 261, 272-73 Alfonso, king of Sicily (Alfonso V of Aragon), 228, 232, 266, 376 Allegory of Good and Bad Government (Lorenzetti), 54-55, 155

Alms of Saint Anthony (Lotto), 316 Amadeo, Giovanni Antonio, 216 Americas, 337, 339-40 Ancona, 302 Andrea del Sarto, 46 Angelico, Fra, 28, 147, 180, 242-43, 387 Anghiera, Pietro Martire d', 342 Angiolini, Bartolomeo, 117 Anguissola, Sofonisba, 84-85 Annunciation (Crivelli), 316 anti-Semitism, 298-308, 350 Antonio da Sangallo, 263 Apollo, 119-20 Apollo and Daphne (Pollaiuolo), 119 Apollonio di Giovanni, 321 Apostolic Palace, Vatican, 242-43, 244, 248-49, 255, 263, 269 Apparition of the Angel to Zechariah (Ghirlandaio), 200 April (Cossa), 105 Apuleius, Lucius, 102 Aquila, Serafino Ciminelli dell', 124-25 architecture, patrons and, 179-84, 263 - 64Arena Chapel, Padua, 173-74 Aretino, Pietro, 248 Argyropoulos, 146 Aristotle, 135, 138, 296, 310 armor, 206 Ars poetica (Horace), 16 art, Renaissance: Atlantic peoples ignored in, 337-38, 343-50 as atonement, 171-75, 179-80, 187, 363-64

art, Renaissance (continued): as conspicuous consumption, 180-81, 183-84 crusader spirit in, 320-21 dissimulation in, 198–202 finestra aperta concept in, 351 as illusion, 351-52 Islamic influences on, 315-16 naturalism in, 15, 351 papal militarism glorified by, 273-74 as public relations, 152-53, 154-55, 156, 181 Arte della Lana, 32, 44, 47, 50, 51, 53 Arte della Seta, 32 artists: homes of, 92-94 patrons' relationships with, 45-46, 75-76, 148-49, 151, 156, 174, 344-45 social circles of, 70-79 social status of, 11-13 workshops of, 69-70, 75-77, 109 Atlantic Ocean, 338 Atlantic peoples, 337-50 as absent from Renaissance art, 337-38, 343-50 prejudice against, 346-50 atonement, art as, 171-75, 179-80, 187, 363-64 Attendolo, Micheletto, 206 Atti, Isotta degli, 227, 385 Augustine, Saint, 104, 124 Aurispa, Giovanni, 313 Autobiography (Cellini), 104 Averroës, 296 Avignon, 118, 119, 237-39, 252 Azores, 339, 341

Babylonian Captivity, 237–38, 246, 252 Bacchus (Michelangelo), 255–56 Badia Fiesolana, 181 Badia Fiorentina, 181–82 Baghdad, 313 Bandi, Bernardo, 271–72 banks, bankers, 23–24 as arts patrons, 147 papacy and, 66 slave trade and, 328 usury and, 66, 167–75 see also merchant bankers

Baptistery, Florence, 21, 30-31, 79 Barbadori Altarpiece (Flippo Lippi), 281-82, 286, 288-90, 309, 337, 339 Barbaro, Francesco, 81-82, 83, 85, 87 Barbary Coast, 279-80, 284, 286 Barbo, Pietro, see Paul II, Pope Bardi family, 24, 47, 173, 175, 176, 180 Baroncelli, Bernardo di Bandino, 34 Baroncelli Chapel, Florence, 79 Bartolomeo, Fra, 73 Bastari, Filippo, 192 Battle of Cascina (Michelangelo), 45 Battle of Ostia (workshop of Raphael), 274 Battle of San Romano (Uccello), 205, 206 Battle of the Centaurs (Michelangelo), 15 Bayezid II, Ottoman sultan, 45, 314 Beatrice (Dante's beloved), 114-17 beauty, 141 Beccadelli, Antonio (Panormita), 37-38, 100-101, 103-4, 105, 107 Bellini, Gentile, 314, 315, 316 Bellini, Giovanni, 316 Belluno, 99 Belvedere Courtyard, Vatican, 249 Belvedere villa, 244 Bembo, Bonifacio, 159 Bembo, Pietro, 124-25 Bene, Francesco del, 65 Benedetto il Moro, Saint, 331 Benedict VIII, Pope, 388-89 Benedict XII, Pope, 284 Benti, Donato, 74 Bentivoglio, Giovanni, 223 Berbers, 326, 327 Bergamo, 215-16, 221 Bernardino da Feltre, 303, 304, 305, 306-7 Bernardino of Siena, Saint, 98, 106, 169, 320 anti-Semitism of, 298-302 Berruguete, Pedro, 212, 213, 214-15, 217, 218, 219, 224 Bertoldo di Giovanni, 9, 10, 21, 43, 362 Berwick, John, 208 Béthencourt, Jean de, 339, 341, 343 Bibbiena, cardinal, 255 Biglia, Andrea, 318 bills of exchange, 167 Biondo, Flavio, 318

Birth of Mary (Ghirlandaio), 89 Birth of Venus (Botticelli), 2, 141 black Africans, 349, 350 as children of God, 329, 330 in Italy, 323-26, 328-32, 333-36 in religious orders, 331 seen as inferior to whites, 332-36 as slaves, 326, 327-28, 331, 333, 334-35 Black Death, 24, 98, 122–25, 127–31, 175 Black Guelfs, 58 blood libel, 306-7 Boccaccio, Giovanni, 4, 16, 63-64, 73, 74, 80, 83, 85, 102-3, 114, 127-30, 136, 142, 170, 287-88, 341, 347 Boccanegra, Simone, 190 Boiardo, Matteo Maria, 1, 124–25, 287 Bologna, 93, 98, 118, 122, 221 Bonfini, Antonio, 218 "Bonfire of the Vanities," 86 Bonsignori, Bonsignore, 313-14 Bontier, Pierre, 341 Book of the Courtier, The (Castiglione), 150, 251 Borgia, Cesare, 260, 273 Borgia, Juan, 261 Borgia, Lucrezia, 97, 101, 261 Borgia, Rodrigo, cardinal, 257-59 Borgia Apartments, Vatican, 264, 287 Borgia family, 262 Borgo San Jacopo, Florence, 39 Borgo San Sepolcro, 291, 292 borsellini, 189 Botticelli, Sandro, 2, 29, 77, 79, 87-88, 95, 141, 200, 264 Braccio da Montone, 221, 223-24 Bramante, Donato, 244 Brancacci, Felice di Michele, 199 Brancacci Chapel, Florence, 9–10, 21, 41, 95, 199 Brandini, Ciuto, 52-53 Brandolini, Aurelio Lippo, 133 Bregno, Andrea, 244 Brescia, 221 Brotton, Jerry, 316 Brucker, Gene, 188 Brunelleschi, Filippo, 1, 2, 15, 21, 24, 70, 147, 151, 181, 182, 383 Bruni, Francesco, 65

Bruni, Leonardo, 17, 18, 19, 22, 25-26, 27, 35, 42, 55, 56, 64, 73, 74, 150, 184, 191, 211, 220, 239, 242, 292-93, 391 bubonic plague, 24, 97-98, 122-25, 127-31 Bugiardini, Giuliano, 74 Buiamonte, Gianni, 169 Bulgarini, Bartolommeo, 360 Buonarroti, Buonarroto, 43-44, 48, 60, 71, 72, 101 Buonarroti, Cassandra, 71, 79, 80, 83 Buonarroti, Francesca, 63 Buonarroti, Giovansimone, 71, 72, 93 Buonarroti, Gismondo, 71, 72-73 Buonarroti, Lionardo, 63, 71 Buonarroti, Lodovico, 43-44, 70, 71-72, 94, 100, 368 Buonarroti, Michelangelo, see Michelangelo Buonarroti family, 90 Buondelmonti, Cristoforo, 313-14 Buoninsegna, Duccio di, 360 buonuomini, 55, 57 Burckhardt, Jacob, 15, 285, 340, 361 bureaucracy, bureaucrats, rise of, 24, 55-56, 150, 154 Burke, Peter, 285, 341 Burma, 313 Byzantine Empire, 282-83, 310 Caccini, Francesco, 32

Ca'da Mosto, Alvise, 327, 329, 333 Cafaggiolo, Medici villa at, 183 Cairo, 284 Callixtus III, Pope, 249, 256, 260, 266, 270, 274, 320 Cambini family, 328 Camera degli Sposi, Mantua, 155 campanile, Florence, 30 Campo Santi Giovanni e Paolo, Venice, 216 Camposanto, Pisa, 123 Canarien, Le (Le Verrier and Bontier), 341 Canary Islands, Canary Islanders, 284, 339, 341, 347-48 Cane, Facino, 213 canti carnascialeschi (carnival songs), 130 "Canzona de' morti," 130 Canzoniere (Petrarch), 120 Cape Verde Islands, 327

Caracciolo da Lecce, Roberto, 320 Caradosso, Cristoforo, 274 Carcano, Michele, 320 Carda, Bernardino Ubaldini della, 206 Careggi palace, 138-39, 182-83 carnival songs (canti carnascialeschi), 130 Carpaccio, Vittore, 287 Carrara, Francesco da (il Vecchio), 40, 150 cartography, 337, 342, 343 Castellani, Michele di Vanni, 171 Castellesi da Corneto, Adriano, cardinal, 244, 273 Castello da Quarata, Andrea di, 81 Castello Sforzesco, Milan, 155 Castiglione, Baldassare, 125, 150, 214, 251, 331 Castracani, Castruccio, 220 Catania, 122 catarrh, prevalence of, 95 catasto (property tax), 24, 194-95, 364 Catholic Church (the Church): business and property interests of, 64-66 missionaries of, 330-31 pursuit of wealth condemned by, 168-70, 174 Cavalcanti, Ginevra, 81-82 Cavalcanti, Giovanni, 138, 189, 191 Cavalieri, Tommaso de', 13, 110-13, 117-18, 125-26, 131, 136-37, 142, 373 cavalry, 206 Cecchini, Pier Antonio, 110, 373 Cederni, Bartolommeo, 32 Cellini, Benvenuto, 12, 13-14, 19, 75, 95, 96, 104, 252, 361 Cem Sultan, 314 Cesena, 211 Chabotto, Zuan (John Cabot), 340 Chalcondyles, Demetrius, 200 Chapel of Saint John, Venice, 287 chapels, bankers' endowments of, 172-73 Charlemagne, 268 Charles IV, Holy Roman Emperor, 73 Charles V, Holy Roman Emperor, 272 Charles VIII, king of France, 272 China, 284, 338 Christian I, king of Denmark, 155 Christianity: Muslims as enemy of, 310-11, 317, 323-24 see also Catholic Church

Chronicon Estense, 122 Chrysis (Pius II), 252 Cilicia, 284, 312 Cimabue, 16 Ciompi Revolt, 33-34, 53-54, 58, 183, 188, 189, 190 Cione, Andrea di (Orcagna), 173 Cione, Benci di, 33 Cione, Nardo di, 173 city-states: as arts patrons, 155 as despotisms, 154, 198 government debt and, 193-94 independence of, 22 as republics, 154, 198 rise of, 153-54, 165 warfare between, 205 Clement VI, Pope, 389 Clement VII, Pope, 11, 261, 262, 265, 272, 332 clergy: merchant and banking elites as members of, 65 sex and, 63-64 see also Catholic Church; papacy; papal court cloth industry, 23–24, 39, 47–50, 67, 154, 165, 176, 199, 363 coins, coinage, 166, 365 Colleoni, Bartolomeo, 213, 215-16, 220, 222 Colonelli, Cornelia, 84 Colonna, Prospero, cardinal, 258, 260 Colonna, Vittoria, marchesa of Pescara, 13.84 Colonna family, 237, 243, 261 Columbeis (Stella), 342 Columbus, Christopher, 284, 339-40, 341, 342, 343 Combat of Love and Chastity, The (Gherardo), 125 Commedia (Dante), 113, 118 Commentaries (Pius II), 158 Como, 221 Compagnia de' Magi, 377 Compagnia di San Luca, 366 Company of Siena, 207 Company of the Cerruglio, 207 Company of the Star, 207

secularism of, 247, 248

see also papacy; papal court

condottieri, 194, 203-33, 384 as arts patrons, 204-5, 214-19 brutality of, 210-11, 217, 219-20, 223 extortion and switching of sides by, 210, 220-21 murders and coups by, 222-24 and need for respectability, 214-15, 217 palaces and lands given to, 213 papacy's hiring of, 270-71 political autonomy of, 220, 221-22, 225-26 Conquest of Trebizond (Apollonio di Giovanni and Marco del Buono), 321 Consiglio Maggiore, 56, 58, 59 consiliarism, 239-41, 386-87 Constantine, emperor of Rome, 268, 269 Constantinople, 311-12 Ottoman capture of, 314, 320, 326-27 Contarini, Giovanni Matteo, 342 contemplation, idea and life of, 140-41 Conti, Niccolò da, 313 Contra iudeos et gentes (Manetti), 299 Convenevole da Prato, 119 Copts, 323, 324-25 Corbaccio (Boccaccio), 127 Corner, Marco, 190 Correggio, Antonio, 46, 72 Corso, 306 Cortesi, Paolo, 219, 243, 248 Cossa, Baldassare, see John XXIII, Pope Cossa, Francesco del, 105 Costanzo da Ferrara, 314, 315 cotton industry, 48 Council of Basel (1431), 341 Council of Florence (1439), 149, 281, 319-20, 323-25, 328-29, 330 Council of Nicaea (325), 169 Council of the Nine (Siena), 155, 378 Credi, Giovanni di, 49 Crivelli, Carlo, 316 crossbows (balestieri), 205–6 Crusades, 310-11 humanist call for renewal of, 318-20 Cuba, 340 Curia, 179, 234, 238, 241 conclaves of, 256-58 corruption of, 179, 258-59, 262, 265, 388

Cyriac of Ancona, 313 Damascus, 313 Dante Alighieri, 16, 33, 58, 113-17, 118, 120, 126, 169, 211, 226 Dante Before the City of Florence (Domenico di Michelino), 383 Daphne, 119-20 Dati, Gregorio, 55 Datini, Francesco di Marco, 64, 73 Dattili, Abraham, 291, 302, 304, 309 David (Michelangelo), 2, 33, 44, 45, 46, 47, 48, 50, 55, 60-61, 62, 67-68, 69, 75, 76, 84, 151 De amore (Ficino), 107-8 De architectura (Vitruvius), 24-25 De avarita (Poggio Bracciolini), 169 Decades (Anghiera), 342 Decameron (Boccaccio), 63-64, 74, 102-3, 104, 127-30, 170, 286-87 De Canaria (Boccaccio), 341 De cardinalatu (Cortesi), 243 De contagione (Fracastoro), 96 De dignitate et excellentia hominis (Manetti), 132-34, 376 De hominis excellentia (Facio), 131-32, 376 Dei, Benedetto, 200 De illustratione urbis Florentiae (Verino), 26-27, 28 de la Salle, Gadifer, 339, 341 Del Bene, Giovanni d'Amerigo, 81 Deliverance of Saint Peter (Raphael), 269 della Robbia, Luca, 46 della Rovere, Domenico, cardinal, 244 della Rovere, Francesco Maria, duke of Urbino, 261 della Rovere, Giovanni, 265 della Rovere, Giuliano, cardinal, 265 della Rovere family, 260, 262, 264 Delle navigationi et viaggi (Ramusio), 342, 343 del Sera family, 72 De militia (Bruni), 220 De mulieribus claris (Boccaccio), 80 De nobilitate (Poggio Bracciolini), 184 Dente, Vitaliano del, 169

De orbe novo (Anghiera), 342

De origine civitatis Florentiae et eiusdem famosis civibus (Villani), 12 De paupertate (F. Filelfo), 184 De pictura (Alberti), 351 De religione christiana (Ficino), 299-300 De seculo et religione (Salutati), 183 de Silves, Diogo, 339, 343 De vita solitaria (Petrarch), 317, 319, 341 De voluptate (Valla), 134-35, 376 Dialogus de humanae vitae conditione et toleranda corporis aegritudine (Brandolini), 133 Dialogus de libertate (Rinuccini), 60 discovery: idea of, 285-86 voyages of, 337-50 disease, 94-98 Disputationes Camaldulenses (Landino), 2.14 Disputation of Saint Catherine (Pinturicchio), 287-88 Domenico da Corella, 28, 364 Domenico di Michelino, 383 Dominican friars, 27-28 Dominici, Giovanni, 66, 171, 183-84 Donatello, 1, 19, 70, 75-76, 92, 147, 216 Donation of Constantine, 268-69, 270, 273 Doni, Agnolo, 45, 75 Doni Tondo (Michelangelo), 45, 79, 351 dropsy (edema), 95 Duarte, king of Portugal, 347-48 Duccio di Buoninsegna, 12, 237, 360 Dum diversas (papal bull), 335 Duomo, see Santa Maria del Fiore Cathedral, Florence

Economics (pseudo-Artistotle), 184 Edict of Expulsion (1290), 303 education, *see* learning Edward I, king of England, 303 Edward III, king of England, 176–77, 209 Edward IV, king of England, 212 Egidio da Viterbo, 315 Egypt, 283, 323, 324, 327 Emanuel ben Uzziel da Camerino, 294 England: cloth industry in, 47 Jews in, 303 Epicurus, 135 equestrian statues, 216 Erasmo da Narni, 216, 222 Erasmus, Desiderius, 272 Este, Alfonso d', marquis of Mantua, 97 Este, Ginevra d', 227 Este, Isabella d', 84, 330 Estouteville, d', cardinal, 257-58 Ethiopia, Ethiopians, 323, 324, 325, 326, 328-29, 330, 335 Eugenius IV, Pope, 240-41, 242, 260, 323-25, 326, 328-29, 330, 341, 347-48 Eustace, Saint, 217 Everso degli Anguillara, 271 Everso II degli Anguillara, 223 Expulsion of Heliodorus (Raphael), 269 Expulsion of Joachim (Ghirlandaio), 200 Eyck, Jan van, 282 Facio, Bartolomeo, 131-32, 183

Fall of Phaethon, The (Michelangelo), 117 family, 71-73 fanciulli, 86 Far East, 327, 338 Farnese, Alessandro, cardinal, 265 Farnese, Giulia, 264 Farnese, Ottavio, duke of Parma, 265 Farnese, Pier Luigi, duke of Parma, 261 Farnese family, 262, 263 Fattucci, Giovanfrancesco, 74 Fermo, 222-23 Fernández de Oviedo y Valdés, Gonzalo, 344 Ferrante, king of Sicily, 228, 235, 262, 266 Ferrante I of Aragon, king of Naples, 212, 314, 321 Ficino, Marsilio, 1, 9, 16-17, 18, 107-8, 137-42, 200, 296, 299-300, 383, 391 Filarete, 242, 325 Filelfo, Francesco, 76, 85, 100, 184, 185, 198, 218, 313, 369 Filelfo, Gianmario, 214, 218 finestra aperta (open window), painting as, 351 Flagellation of Christ (Piero della Francesca), 351 Flanders, cloth industry in, 47 Florence, 21-42, 122, 155, 363 black Africans in, 323-25, 326 crime in, 27, 35, 36-37

houses and palazzi in, 88-94, 182 international character of 281 Jews in, 291-93, 294-96, 392-93 Medici domination of, 152-53, 157-58 Milan wars of, 191, 194, 209 old city in, 35-39 oligarchic tendencies, i, 27, 57, 58, 59 political system of, see politics, Florentine Renaissance descriptions of, 25-27 socioeconomic inequalities in, 27, 33, 48, 49, 57, 67, 68, 188, 363 in War of the Eight Saints (1375-78), 209, 210 florin, value of, 365 Fogliani, Giovanni, 222-23 Fonte, Bartolomeo della, 251, 254 Foppa, Vincenzo, 159 Forese da Rabatta, 74 Forteguerri, Niccolò, cardinal, 261-62, 270-71 Fourth Lateran Council (1215), 302 Fracastoro, Girolamo, 96, 97 Francis I, king of France, 46 Franciscans, 171, 267, 298, 302, 303, 305, 307 Francis of Assisi, Saint, 168 Frederick III, Holy Roman Emperor, 155 free will, Pico's view of, 3-4 friendship, 73-74, 107 funerary art, 215-16

Gaddi, Taddeo, 79 Gallo, Jacopo, 44 Gambia river, 327 Gandolfino di Roreto d'Asti, 307 Gaurico, Luca, 223 Genoa, 122, 167, 190, 193-94, 311-12, 313, 325, 345 Gentile da Fabriano, 242 George, Saint, 217, 287, 320 Germany, 284, 293 Gerusalemme liberata (Tasso), 287 Gesta Francorum, 311 Gesualdo, Carlo, 14 Ghana, 327 Gherardo di Giovanni del Fora, 125 Ghiberti, Lorenzo, 15, 31, 79, 82, 237 Ghirlandaio, Domenico, 9, 89, 174, 200, 264, 362

Giacomo della Marca, 302, 303 Gianfigliazzi, Rinaldo, 192 Gianfigliazzi family, 169 Giorgione, 73, 83-84, 87, 96 Giotto di Bondone, 9, 12, 16, 17, 18, 30, 74, 173, 237, 311, 383 Giovanetti, Matteo, 239 Giovanni da Capistrano, 303 Giovanni da Carignano, 326 Giovanni da Empoli, 345 Giovanni da Napoli, 320 Giovanni da Udine, 256 Giovanni di Paolo, 297–98 Giovio, Paolo, 13 Giraldi, Luca, 345 Gold Coast, 327 gonfaloniere di giustizia, 33, 45, 54 gonfalonieri, 55 Gonzaga, Ferdinando, cardinal, 250 Gonzaga, Francesco, cardinal, 155 Gonzaga, Francesco II, marquis of Mantua, 101 Gonzaga, Ludovico, 155 Gozzoli, Benozzo, 145-47, 148-49, 151, 152-53, 156, 158-59, 160-62, 163, 175, 187, 198–99, 202, 203–4, 232–33, 234–35, 236, 281, 287, 319, 334 grain trade, 176 Granacci, Francesco, 21, 74, 76, 362 Grazzico "il Moretto," 332 Great Schism (1378–1418), 178, 238–39, 246, 268 Greenblatt, Stephen, 15 Gregory I (the Great), Pope, 295 Gregory XI, Pope, 210, 238 Gregory XII, Pope, 260 Guicciardini, Francesco, 43, 253, 261 Guicciardini, Piero di Iacopo, 199 Guidalotti family, 172 Guidetti, Giovanni, 328 Guidoriccio da Fogliano at the Siege of Montemassi (artist unknown), 209 guilds, guild system, 32, 50-54, 57, 62, 68, 188 Hafsid kingdom, 279-80, 284, 286, 309

Hawkwood, Sir John, 207, 208, 200, 309 Hawkwood, Sir John, 207, 208–10, 211, 216, 225 Head of a Faun (Michelangelo), 15

Henrique (Ndoadidiki Ne-Kinu a Mumemba), 331 Henry the Navigator, prince of Portugal, 330 Heptaplus (Pico della Mirandola), 139–40 Hermaphrodite. The (Beccadelli), 37–38. 104.107 Hermes Trismegistus, 138 Herodotus, 325 Hilary, Saint, 329 Histories (Herodotus), 325 Holy Land, 283 Holy Roman Empire, 237, 246 homosexuality, 3, 13-14, 105-6, 117-18, 253 Horace, 16 houses, 88-94, 182-83 humanism, humanists, 15-16, 24, 28, 74, 107, 111, 112, 113, 137-42, 150, 154, 215 anti-Muslim rhetoric of, 316-20 anti-Semitism of, 299-300 Arabic texts and, 309 black Africans disdained by, 333 papacy and, 234-35, 237, 242 and theory of magnificence, 184-87 and voyages of discovery, 342 Hundred Years' War, 209 hygiene, 39-40, 93-94 Ideal City, The (artist unknown), 25, 351 Idrisi, 283 Ignatius of Loyola, Saint, 330 Imola, 271 India, 313 Inferno (Dante), 169, 211 Infessura, Stefano, 240 infeudation, 213 In magnificentiae Cosmi Medicei Florentini detractores (Maffei), 185 Innocent VIII, Pope, 138, 244, 262, 314 Invective Against Antonio Loschi (Salutari), 25 Isidore of Kiev, 146 Isidore of Seville, 338 Islam, 316-17 see also Muslims, Muslim world Italian Wars (1494–1549), 272 Italy:

black Africans in, 323–26 international character of, 280–81

lews in, 293-98, 392-93 Norman conquests in, 310 James of Spiers, 218 Japan, 338 Iardine, Lisa, 316 Java, 313, 338 Ierusalem, 318 lesuits, 330 lews, 291-308, 349 anti-Semitism and, 298-308, 350 blood libel and, 306-7 as doctors, 205 dress laws and, 302, 392-93 "errors" of, 299-302, 303 as moneylenders, 291–92, 294, 303–5 as responsible for murder of Christ. 298-99 violence against, 304, 305-7 John the Baptist, Saint, 296–97 feast of, 31-32, 33, 62 John VIII Palaeologus, Byzantine emperor, 146, 153 John XXIII, Pope, 178, 221, 292, 318-19 Joseph II, Patriarch of Constantinople, 146, 153 Jouffroy, Jean, cardinal, 251-53 Journey of the Magi to Bethlehem (Gozzoli), 145-47, 148-49, 151, 152-53, 156, 158-59, 160-62, 163, 164, 175, 187, 198-99, 202, 203-4, 232-33, 234-35, 236, 281, 287, 319, 334 Julius II, Pope, 45, 110, 244, 253, 261, 264, 269, 272, 274 Iulius exclusus de caelis (Erasmus), 272 Justus of Ghent, 218, 219 Kabbalah, 138, 296, 299

Kabbalan, 138, 296, 299 Kievan Rus', 283

Ladislaus, king of Naples, 384 Lama, Gaspare di Zanobi del, 200 Lampugnani, Giovanni Andrea, 160 Landino, Cristoforo, 102, 113, 138, 168, 200, 214, 218, 240 Lando, Michele di, 34, 53 Lanzarote, 284, 339 Latin Empire of Constantinople, 311 Laura (Petrarch's beloved), 119–20, 123–24

424

Laurana, Luciano, 219 learning, 24, 150-51, 214, 218-19 Leo I, Pope, 268 Leo IV, Pope, 274 Leo X, Pope, 11, 244, 253, 262, 265, 269, 272, 274, 314, 331 Leo Africanus, 314–15 Leonardo da Vinci, 34, 44, 69, 95, 107, 344, 351 Lepanto, Battle of (1571), 321 lepers, 95-96 Le Verrier, Jean, 341 Liber secretorum fidelium crucis (Torsello), 318-19 Lippi, Filippino, 10, 199 Lippi, Filippo, 63, 99, 147, 289-90, 297, 298, 308, 309, 337, 339 Barbary Coast enslavement of, 279-80, 282, 284, 286, 288-89 Liverpool, Johnny, 208 loans, see usury Lodi, Peace of, 228–29, 232, 270, 272 Loggia dei Lanzi, Florence, 19, 33 Lolli, Gregorio, 261, 264 Lombard Wars (ca. 1425–54), 212, 270 longbows, 205-6 Lorentino d'Angelo, Piero, 46 Lorenzetti, Ambrogio, 54-55, 155, 297-98, 305, 315-16, 378 Lotto, Lorenzo, 316 Louis IX, king of France, 303 love, 112, 113 idealization and, 113-17, 136 Neoplatonic view of, 140-41 resolution of conflicting desires in, 136-42 sexual desire and, 125-27, 136 suffering and, 117-25, 136 Luther, Martin, 263, 307-8 Machiavelli, Niccolò, 31, 56, 150, 160, 215,

220, 222–23, 260, 261, 272–73, 366 Mackenney, Richard, 138 Madeira, 339, 341 *Madonna and Saints* (Angelico), 180 *Madonna del Carmine* (Filippino Lippi), 40–41 Maffei, Timoteo, 185, 186 malaria, 96

Malatesta, Giovanni, 211, 226 Malatesta, Pandolfo III, 221, 226 Malatesta, Paolo, 211, 226 Malatesta, Sigismondo Pandolfo, 146, 203-4, 213, 225-33, 235, 266, 271, 385 as arts patron, 204, 230-31 treacherousness of, 228, 232 viciousness of, 227, 233 Malatesta da Verucchio, 211, 226 Malatesta family, 226, 227, 384 Malfante, Antonio, 333 Mallet, Michael, 223 Malocello, Lancelotto, 284, 339, 343 Mamluk sultanate, 284, 312, 313, 318, 319, 324 man, Renaissance conception of, 2-5, 286 Mandeville, Sir John, 283 Manetti, Giannozzo, 132–34, 135, 299, 376 Manfredi, Astorre II, 222 Manfredi, Taddeo, 222 Mantegna, Andrea, 12, 155, 329-30, 334, 344 Mantua, 155, 295, 320 Manuel, king of Portugal, 331 Map of the Chain, The, 35 mappa mundi (Vesconte), 326 Marco del Buono, 321 Marignolli, Giovanni de', 284 marriage, 81-82, 85, 100-101 Marsilius of Padua, 267 Martiados (G. Filelfo), 214 Martin, Saint, 217 Martin V, Pope, 239, 242, 260–61, 294, 295 Martini, Donato, 360 Martini, Francesco di Giorgio, 219 Martini, Simone, 12, 239, 360 Martyrdom of Simon of Trent (Gandolfino di Roreto d'Asti), 307 Martyrdom of the Franciscans (Lorenzetti), 315-16 Masaccio, 2, 9, 10, 21, 41-42, 95, 237, 242, 279 Masolino, 242 Mass at Bolsena (Raphael), 269 Matsys, Quentin, 95 Mauro, Fra, 313 Mazzei, Lapo, 73 Medici, Alessandro de', duke of Florence, 54, 261, 332 Medici, Andrea de', 200

Medici, Ardingo de', 166 Medici, Averado de', 196 Medici, Chiarissimo de', 105 Medici, Cosimo de', 28, 30, 59-60, 79, 178, 193, 200-201, 224, 232, 235, 312-13 as arts patron, 145, 147-49, 151, 156, 157, 161, 180, 181, 182–83, 185, 187, 198–99, 204 exile and recall of, 196 political power of, 152-53, 157-58, 187, 195, 197, 198 public image of, 146-47, 163-64, 175, 198-99 wealth of, 178-79, 363-64 Medici, Foligno di Conte de', 175 Medici, Galgano de', 166 Medici, Giovanni de', 79, 201 Medici. Giovanni di Bicci de', 170, 177-78, 180, 181, 182, 194, 258, 292 political power of, 190, 191-92 Medici, Giuliano de', 34, 59, 101, 201, 271-72 Medici, Lorenzo de' (the Elder), 81, 195, 106 Medici, Lorenzo de' (the Magnificent), I, 11, 28, 34, 43, 59, 60, 65, 75, 113, 130-31, 136, 137, 139, 153, 160, 200, 201, 224, 251, 272, 296, 313, 362 Medici, Piero de', 3, 29, 43, 59, 60, 79, 148, 151, 163, 201 Medici, Piero di Lorenzo de', 200 Medici, Salvestro de', 190, 192 Medici, Ugo de', 166 Medici, Vieri di Cambio de', 177, 190, 192 Medici family, 24, 29, 34, 59, 72, 149, 175, 262 as arts patrons, 180, 181 origins of, 165, 166-67 as papal bankers, 178, 193, 235 Sforza family and, 158-59 wealth of, 165, 180 Mehmed II (the Conqueror), Ottoman sultan, 314, 320, 321 Melkites, 324 Melozzo da Forlì, 265 Memorie (Parenti), 59-60 Mercato Vecchio, Florence, 35-36, 105, 166 mercenaries, 206-8, 210, 217 commanders of, see condottieri

merchant bankers, 46-47, 163-79 as arts patrons, 179-87, 198-202 conspicuous consumption by, 180-81, 186-87 government debt and, 193-95, 196-97, 201 and need for legitimacy, 154 politics and, 187-97 see also banks, bankers; specific families merchant elite: as arts patrons, 22-23 and need for legitimacy, 154, 198 ostentatious displays of wealth by, 27 political power of, 57-59 wealth of, 53 Messer Leon, Judah, 296 Messina, 122 Metamorphoses (Apuleius), 102 Metamorphoses (Ovid), 137 Michael, archangel, 217 Michelangelo, 34, 50, 255-56, 351, 366 as archetypical Renaissance artist, 18-20 arrogance of, 12-13 Cavalieri and, 110-13, 117-18, 125-26, 131, 136-37, 142, 373 Dante's influence on, 113-14, 118 David of, 2, 33, 44, 45, 46, 47, 48, 50, 55, 60-61, 62, 67-68, 69, 75, 76, 84, 151 family relationships of, 71-73, 368 friendships and social contacts of, 69-70, 77-79, 84-85 health of, 94-95 humanism and, 15-16, 113 patrons of, 56, 70, 151 poetry of, 111-12, 113, 126, 136-37, 142, 371 in Rome, 43-44, 110 secrecy of, 69 sexuality of, 13, 84, 105, 108, 117-18, 125-27 Sistine Chapel and, 94, 110, 244, 245, 264, 302, 371 tomb of Pope Juilius II by, 110 workshop of, 69, 76-77 youth of, 9-11, 21-23, 29, 30, 88, 362 Michele di Nofri di Michele di Mato, 90-91

426

Michelozzi, Bernardo, 313–14 Michelozzo di Bartolommeo, 28, 30, 147, 182-83 Middle Ages, 11, 14–15, 282, 310 Milan, 122, 155, 158, 191, 194, 272, 295 Milvian Bridge, Battle of the, 269 Mini, Antonio, 74 Minucci da Pratovecchio, Antonio, 341 Miracle of the Profaned Host (Uccello), 301 Modanella-Piccolomini, Antonio d'Andrea da. 261 Modena, 104 Mogadishu, 325 Mona Lisa (Leonardo), 351 Moneychanger and His Wife, The (Reymerswaele), 167 money changers, 24, 166-67 money lending, see usury Mongol invasions, 283 Monte, 188 monte di pietà, 305 Montefeltro, Federico III da, duke of Urbino, 212, 213-14, 223, 224, 225, 227-28, 232, 235, 271 as arts patron, 214-15, 216-17, 218-19, 301 learning of, 214, 218-19 Montefeltro, Guidantonio da, 213 Montefeltro, Oddantonio da, count of Urbino, 218, 223, 224, 227-28 Montefeltro Altarpiece (Piero della Francesca), 217-18, 231, 316 Moors, 326 Morelli, Giovanni, 72 Moriale, Fra, 207 Morocco, 327 Muhammad, Prophet, 317 Muslims, Muslim world, 283, 286, 287, 288-89, 309-22, 349 art of, 315-16 Crusades and, 310-11 as enemies of Christianity, 311, 317 expansion of, 309, 310 influence of, on Western culture, 310, 315-16 intolerance toward, 316-22 Italian trade with, 311-12, 325-26 learning in, 309, 310 prejudice against, 316-22, 350 as slaves, 315

Najemy, John, 194-95 Naples, kingdom of, 23, 272, 307, 321 Narni, 221 Nasi, Alessandro, 200 Native Americans, 286, 349 Navigazioni (Ca'da Mosto), 327 Ndoadidiki Ne-Kinu a Mumemba (Henrique), 331 Neoplatonists, 137-42 nepotism, papacy and, 259-62, 388-89 Newfoundland, 340 Niccolò da Recco, 341 Nicholas of Cusa, cardinal, 268 Nicholas V, Pope, 240, 241-44, 247, 255, 260, 267, 269, 270, 335 North Africa, 279-80, 284, 286 Nuova cronica (Villani), 301 Obriachi family, 169 Observant Franciscans, 298, 302, 303, 305, 307 Office of the Night, 106, 107, 108 Officials of the Bank, 195 Ognissanti, Florence, 22 Ojeda, Alonso de, 340 Old Woman, The (Giorgione), 83-84, 87 Olgiati, Girolamo, 160 Oliverotto da Fermo, 222-23 Oltr'Arno, Florence, 22, 38, 39-41, 92, 294 Onestà (Office of Decency), Florence, 32, 104-5 On the Conveniences and Inconveniences of Wives (Sabino), 102 On the Family (Alberti), 71 On the Jews and Their Lies (Luther), 307-8 On Wifely Duties (Barbaro), 81-82 Opera del Duomo, 44, 50, 55, 69-70, 75, 93 Oration on the Dignity of Man (Pico della Mirandola), 2, 3-4, 286

Orcagna (Andrea di Cione), 173

Ordelaffi, Giovanni, 222

Ordelaffi, Pino I, 222

Ordelaffi, Sinibaldo, 222

oriental carpets, 316

Orlando innamorato (Boiardo), 124–25, 287

Orsanmichele, Florence, 22, 32, 51, 62, 156

Orsini, Giordano, cardinal, 242

Orsini, Rinaldo, archbishop of Florence, 46, 61–65, 67, 68

Orsini family, 237, 243 Orvieto, 122-23 Ospedale degli Innocenti, Florence, 21, 22, 24.99 "other," Renaissance experience of, 280-90 ignorance regarding, 288-89 travel and, 284, 288, 313-14, 327, 333 see also Atlantic peoples: black Africans: **Iews:** Muslims Otranto, 321-22 Ottoman Empire, 281, 284, 286, 309, 311, 312, 313, 315, 318, 319-22, 323-24, 339 Constantinople captured by, 314, 320, 326-27 Ouadane, 327 Ovid, 137

Padua, 302 Paget's disease, 95 palazzi, 88-90, 182-83 Palazzo dei Nerli, Florence, 40-41 Palazzo della Cancelleria, Rome, 244, 263 Palazzo dell'Arte della Lana, Florence, 51 Palazzo della Signoria, Florence, 195–96 Palazzo Ducale, Mantua, 155 Palazzo Ducale, Urbino, 212, 219 Palazzo Farnese, Rome, 256 Palazzo Gondi, Florence, 46 Palazzo Medici Riccardi, Florence, 21, 24, 30, 88, 138, 139, 145-47, 151, 182, 235 Palazzo Strozzi, Florence, 89, 182 Palazzo Torlonia, Rome, 244 Palazzo Vecchio, Florence, 22, 26, 33, 34, 272 Palmieri, Matteo, 17, 18, 19, 82-83 Paltroni, Pierantonio, 214 Panegyric to the City of Florence (Bruni), 25-26, 191 Panofsky, Erwin, 18 papacy, 23, 234-75 as arts patron, 155-56, 236, 242-46, 269, 273-75 in Avignon, 119, 237-39, 246, 252 bankers and, 66 conspiracies and assassinations by, 271-73 Great Schism in, 178, 238-39, 246, 268 humanism and, 242 Medici as bankers for, 177-78, 193, 235

military might of, 246, 270-71, 272 nepotism of, 259-62, 388-89 political role of, 246-47, 248, 256, 259. 265-67. 270-74 sexual exploits of, 253 temporal authority of, 267-69 papal court: as arts patron, 236-37, 244-45, 246, 247, 262-65 cultural and social life of, 239, 245-46. 248, 249-50, 387 humanists at, 73, 239 immorality of, 250-55 money problems of, 250-51, 255 secularism of, 246-47 see also Curia Papal States, 65, 66, 248, 256, 262, 266-67, 270-71, 272, 293-94 Paradiso (Dante), 116 Parenti, Marco, 59-60, 158 parlamenti, 58, 59, 157 Parma, 123, 211 patrons, patronage: artists' relationships with, 45-46, 75-76, 148-49, 151, 156, 174, 344-45 bankers as, 147, 179-87, 198-202 condottieri as. 204-5. 214-19 as manifestation of public virtue, 184-86 merchants as, 147 and need for legitimacy, 152-55, 157, 161 papacy as, 155-56, 236-37, 242-46, 247, 262-65, 269, 273-75 political power of, 246-47 portraits of, in historical and religious scenes, 146-47, 174, 199-202, 203, 217-18 rise of, 147-52, 160-62 voyages of discovery as lacking interest for, 345-46 women as, 84 Paul II, Pope, 243-44, 251, 252, 253, 305-6 Paul III, Pope, 12, 260, 261, 263, 265 Paul IV, Pope, 307 Paul V, Pope, 263-64 Paul of Middelburg, 218 Pavia, 222 Pazzi, Francesco de', 271-72 Pazzi, Jacopo de', 34, 59

Pazzi, Piero de', 271 Pazzi Conspiracy, 34, 59, 60, 66, 224, 271-72, 367 Pazzi family, 181 Pegolotti, Francesco Balducci, 165–66, 313 Penni, Gianfrancesco, 269 Pera. 311-12 Persia, 313 perspective, 15, 351 Perugia, 302 Perugino, 82, 264 Peruzzi family, 24, 175-77, 180 Petrarch (Francesco Petrarca), 14, 16, 17, 38-39, 40, 73, 118-25, 126, 130, 131, 142, 211, 239, 252, 317, 319, 341, 347, 368, 390 Philip IV, king of France, 303, 318 Piazza dei Crociferi, Rome, 243 Piazza del Duomo, Florence, 30, 32 Piazza della Signoria, Florence, 19, 22, 32-34, 51, 67-68 Piazza San Marco, Florence, school for artists at, 9, 21, 28 Piccinino, Jacopo, 266, 270, 271 Piccinino, Niccolò, 220-21, 384 Piccolomini, Aeneas Silvius, see Pius II, Pope Piccolomini, Antonio Todeschini, 262 Piccolomini, Francecso Todeschini, cardinal, 261 Piccolomini, Jacopo Ammannati, 261 Piccolomini, Niccolò d'Andrea, 261–62 Piccolomini family, 262 Piccolomini Library, Siena, 264-65, 273-74 Pico della Mirandola, Giovanni, 1–5, 9, 28, 137-42, 286, 296, 391 Pienza (Corsignano), 264 Piero della Francesca, 1, 46, 95, 204, 216-18, 219, 231, 316, 351 Piero di Cosimo, 18, 70, 79, 86, 93, 366 Pierozzi, Antonio (Antonino), 163, 171, 183-84 Pietà (Michelangelo), 43 Pinturicchio, 257, 264, 273-74, 287-88 Pippo, Michele di Piero, 50, 74, 92 Pisanello, 242, 320 Pistoia, 122 Pitti, Bartolomeo, 45, 75, 88 Pitti, Buonaccorso, 65 Pitti, Miniato, 34

Pitti family, 182 Pius II, Pope, 59-60, 146, 152-53, 158, 203-4, 213, 223-24, 228-29, 232, 251-52, 264-65, 268-69, 273-74, 320, 335, 377, 386 background of, 236-37 ecclesiastical career of, 240-41 elected pope, 256-58 humanist education of, 234-35, 237 nepotism of, 261-62 political role of, 265–67, 270–71 secular writings of, 252 Pius III, Pope, 264-65 Pius IV, Pope, 262 Pizzigano, Domenico and Francesco, 326 Platina, Barolomeo, 265 Plato, 107, 138, 140, 141 Platonic Academy, 107 platonic friendship, 107 pleasure, pursuit of: Black Death and, 127-31 philosophical justification of, 132-36 Plethon, Georgius Gemistus, 138, 146 Pliny the Elder, 338 Poggio Bracciolini, Gian Francesco, 24–25, 64, 73, 74, 105-6, 168, 169, 184, 242, 313 Polenta, Francesca da, 211 politics: condottieri and, 220, 221–22, 225–26 papacy and, 246-47, 248, 256, 259, 265-67 politics, Florentine, 54-61, 68, 187-97 committees of scrutiny and, 57, 58, 59, 189 consensus politics in, 190-91 corruption in, 57-58, 188-89 factionalism in, 192-93, 195-96 government debt and, 188, 194-95, 196-97, 201 guild system in, 32, 50-54, 57, 68, 188 Medici and, 152-53, 157-58, 187, 190, 191-93, 195, 197 republican constitution and, 188 Savonarola regime in, 29, 33, 43, 54, 60, 62, 67, 367 taxes and, 188, 193, 194-95, 197 Poliziano, Angelo, 1, 3, 9, 28, 34, 200, 341 Pollaiuolo, Antonio, 119, 160, 244 Polo, Marco, 283, 284

Pontano, Giovanni Gioviano, 86, 100, 101, 186 Ponte Vecchio, Florence, 22, 35 Pontormo, Jacopo, 74, 95 popolo minuto, 52, 53, 57, 67, 82 Portinari, Folco dei, 114 Portinari Chapel, Milan, 159 Porto Santo, 339 Portrait of a Lady Known as Smeralda Bandinelli (Botticelli), 87 Portrait of a Young Man (Botticelli), 95 Portrait of a Young Woman (Botticelli), 87 Portrait of Duke Federico and His Son Guidobaldo (Berruguete), 212, 213, 214-15, 217, 218, 224 portraits of patrons in historical and religious scenes, 146-47, 174, 199-202, 203. 217-18 Portugal, Portuguese, 284, 293, 327, 339 Pratica della mercatura (Pergolotti), 165-66, 313 Prato, 291, 293, 304 Prester John, 324, 326 Prince, The (Machiavelli), 215, 220, 272-73 priors, see Signoria Priscianese, Francesco, 250 prostitution, 35, 36, 37-38, 103-5, 108 Ptolemy, 326 Pucci, Antonio, 35-36 Pucci, Giannozzo, 200 Pugliese, Piero di Francesco del, 199 Pulci, Luigi, 199 Punishment of Tityus, The (Michelangelo), 118, 125 Purgatory, 169-70, 171 Quattuor navigationes (Vespucci), 343 Raffaellino del Colle, 269 Raising of the Son of Theophilus and Saint Peter Enthroned (Filippino Lippi), 199 Ramusio, Gianbattista, 342, 343 rape, 99, 108 Rape of Ganymede, The (Michelangelo), 137 Raphael, 46, 73, 79-80, 99, 255-56, 265, 269, 274 Rat, Diego de, 207

Ravenna, 282-83

religion, in daily life, 61-67

religious orders, 63-64, 66 Renaissance: conception of man in, 2-5, 286 experience of the "other" in, see "other," Renaissance experience of hostility to new knowledge, 345-46, 350 and idea of "discovery," 285-86 individualism as defining characteristic of, 14-15, 361 as mirror for modern world, 353-54 rediscovery of classical world in, 15-16, 284, 351 as self-conscious rebirth, 16-19 as term, 14 two sides of, 4-5 visual exuberance in, 15 see also art, Renaissance Renaissance man, 1-2, 3, 11, 138 Repulse of Attila (Raphael), 269 Return of Judith (Botticelli), 87–88 Reymerswaele, Marinus van, 167 Rhodes, 321 Riario, Girolamo, 265, 271 Riario, Pietro, cardinal, 250, 260, 265 Riario, Raffaele, cardinal, 244, 256, 263 Riccardina, Battle of (1467), 213 Ricci family, 172 Ridolfi, Gianfancesco, 200 Ridolfi, Niccolò, cardinal, 250 Rimini, 226 Rinaldeschi, Antonio, 36 Rinuccini, Alamanno, 59-60 Rocca Contrada, 221 Roger II, king of Sicily, 283 Romano, Giulio, 256, 269, 274 Rome, 43-44, 110 disrepair of, 239-40 Jewish population of, 295, 307 lawlessness in, 237-38, 240 rebuilding of, 241-46 Roselli, Antonio, 341 Rossellino, Antonio, 181 Rossellino, Bernardo, 243, 264 Rossi, Luigi de', cardinal, 265 Rovere family, see della Rovere Roverio, Bernardo, 260 Rucellai, Bernardo, 251 Rucellai, Giovanni, 27, 48, 179, 182 Rucellai family, 72, 172, 182

Sabino, Domenico, 102, 107 Sacchetti, Franco, 83 Saggi, Zaccaria, 160 Sagundino, Niccolò, 318 Said, Edward, 285 Saint George and the Princess (Pisanello), 320 Saint John Lateran Archbasilica, Rome, 240, 242 Saint Mark Preaching in Alexandria (Bellini), 316 Saint Peter Healing the Sick with His Shadow (Masaccio), 21, 41-42, 95 Saint Peter's Basilica, Rome, 242, 243, 244, 263, 267, 274, 325 Sala dei Nove, Siena, 155 Sala dei Santi, Vatican, 287 Sala di Costantino, Vatican, 269 Sala Regia, Vatican, 263 Salimbene, Bartolini, 200 Salomone di Bonaventura, 291–93, 294, 297, 299, 302-3, 304, 305, 308, 309, 350 Salutati, Coluccio, 22, 25, 27, 35, 42, 55, 73, 74, 150, 183, 199, 237, 319, 390-91 Salviati, Francesco, archbishop of Pisa, 34, 65, 66, 271, 272 Salviati, Jacopo, 45, 46-54, 68, 74 Salviati family, 328 San Francesco, Siena, 315-16 San Lorenzo, Florence, 21, 110, 180, 181 San Marco, Florence, 27-29, 33, 181 San Salvador, 339-40, 341 Sansovino, Jacopo, 74 Santa Croce, Florence, 79, 173, 180 Santa Maria degli Alberighi, 36 Santa Maria del Carmine, Florence, 9, 20, 21, 22, 41-42, 92, 199, 279, 281 Santa Maria del Fiore Cathedral, Florence, 2, 12, 22, 30, 34, 59, 208-9, 383 Santa Maria Gloriosa dei Frari Basilica. Venice, 190 Santa Maria Maggiore, Bergamo, 215–16 Santa Maria Maggiore, Rome, 242 Santa Maria Novella, Florence, 28, 89, 172, 173, 174, 199-200 Sant'Anastasia, Verona, 320 Santo Spirito, Florence, 39 Sassetti, Federico, 200 Sassetti, Francesco, 181

Savonarola, Girolamo, 1, 27, 29, 33, 43, 44, 54, 60, 62, 66-67, 86, 305, 367 Sayf al-Din Jaqmaq, Mamluk sultan, 324 School of Athens (Raphael), 255 Scrovegni, Enrico degli, 169, 173-74 Scrovegni, Reginaldo degli, 169, 173-74 scrutiny, committees of, 57, 58, 59, 189 Secretum (Petrarch), 121-22, 124 ser Gabriello, Ridolfo di, 328 Serristori family, 177 ser Ristoro, Antonio di Salvestro di, 177 Seta, Lombardo della, 39 sex, 98–109, 112, 113 clergy and, 63-64, 252-53 extramarital, 101-3 homosexual, 3, 13-14, 105-6, 117-18, 253 love and, 125-27 oral. 100-101 premarital, 98-99 prostitution, 35, 36, 37-38, 103-5, 108 rape, 99, 108 sodomy, 13-14, 100, 106 Sforza, Ascanio, 258-59 Sforza, Bianca Maria, 160 Sforza, Francesco, duke of Milan, 158, 159, 203, 221-22, 226, 384 Sforza, Galeazzo Maria, duke of Milan, 145-47, 151, 152, 158, 159-60, 161, 163, 164, 202, 203, 234, 235, 332, 377, 378-79 Sforza, Muzio Attendolo, 213 Sforza, Polissena, 227 Sforza family, 158-59, 384 Sheba, Queen of, 329 Sicily, 176, 266, 283, 326 Muslim conquest of, 310 Siena, 155, 209, 236-37, 261, 360 Siena Cathedral, 264-65, 273-74 Sierra Leone, 327 Sigismund, Holy Roman Emperor, 231-32 Sigismund, Saint, 231, 232 Signoria, 33, 53, 55, 57, 59, 152, 157, 188, 189, 190, 192, 195, 208, 232, 304 silk industry, 24, 47, 48, 199 Silk Road, 312, 326-27, 339 Simonetta, Cicco, 76 simony, 179, 258-59, 262, 265, 388 Sistine Chapel, Vatican, 76, 94, 110, 244, 245, 264, 302, 371

Sixtus IV, Pope, 65, 66, 200, 224, 244, 253, 260, 261, 263, 264, 265, 271-72, 274 Sixtus V. Pope. 263 slaves, slavery: black Africans as, 326, 327-28, 331, 333, 334-35 Muslims as, 315 Soderini, Piero, 45, 46, 54-56, 60, 68, 70, 75, 76, 151 Soderini, Tommaso, 199 sodomy, 13-14, 100, 106, 253 Songhay kingdom, 327, 333 Song of Roland, 311 Soranzo, Girolamo, 251 soul. Renaissance conceptions of, 131-32 Southeast Asia, 313 Spain, 284, 293, 339 cloth industry in, 47 spice trade, 283, 309, 313, 327 Spinelli, Tommaso, 181 Standing Ottoman (Costanzo da Ferrara), 314 Stanza d'Eliodoro, Vatican, 269 Stanza dell'Incendio del Borgo, Vatican, 2.74 Statute of the Jewry (1275), 303 Stefani, Marchionne di Coppo, 122 Stella, Giulio Cesare, 342 Stinche, 90, 96 Strozzi, Albiera, 105 Strozzi, Alessandra, 96 Strozzi, Filippo, 182, 201 Strozzi, Niccolò, 49 Strozzi, Palla, 157, 179, 181, 194, 195-96 Strozzi, Rosello, 173, 174 Strozzi, Tommaso, 173, 174 Strozzi Chapel, Florence, 173 Strozzi family, 24, 172, 333 Stufa, Andrea della, 32 Sumatra, 313 Summa theologiae (Thomas Aquinas), 185 sumptuary laws, 85-86, 87, 127 Sylvester I, Pope, 268 Symposium (Plato), 107, 141 syphilis, 96-97

Taddei, Taddeo, 45, 70, 75, 88 Talenti, Simone di Francesco, 33 Talmud, 300, 307 Tamerlane, 312 Tasso, Torquato, 287 taverns, 36-37 taxation, 24, 188, 193, 197 Tebaldi, Giacomo, cardinal, 258 Teghaza, 327 Tempio Malatestiano, Rimini, 230-31 Thomas Aquinas, Saint, 104, 169, 185, 303 Thomas of the Indies, 324 Timbuktu, 327 Timurid Empire, 284, 312 Tiraboschi, Girolamo, 285 Titian, 265 Todi 221 Tolentino, Niccolò Mauruzi da. 206 tombs, 110, 171-72, 180 Topolino, 50, 69, 74, 76, 92 Tornabuoni, Giovanni, 174, 199-200, 201 Tornabuoni, Lorenzo, 200, 201 Tornabuoni Chapel, Florence, 89, 174, 199-200 Tornabuoni family, 182, 200 Tornaquinci family, 172 Torre, William della, 207 Torrigiano, Pietro, 9-10, 20 Torsello, Marino Sanudo, 318-19 Tosa, Alessandro della, 105 Toscanelli, Paolo del Pozzo, 342 Tovaglia, Piero del, 172 trade, international, 165-66, 178, 193 Traini, Francesco, 123 Trattato circa il reggimento e governo della città di Firenze (Savonarola), 60 travel, and Renaissance encounters with the "other," 284, 288, 313-14, 327, 333 Trebbio, Il. 195 Trebizond, 320-21 Trecento novelle, Il (Sacchetti), 83 Trinity (Masaccio), 2 Trionfo di Bacco e Arianna (Lorenzo de' Medici), 130-31 Tron, Niccolò, 190 Tunisia, 327 Tuscany, Jews in, 293-99 typhus, 96

Uberti, Farinata degli, 211 Uccello, Paolo, 76, 80, 82, 205, 206, 208–9, 211, 216, 219, 242, 301, 305

Uffizi Gallery, Florence, 19 Urban VI, Pope, 238 Urbino, 218, 227 usury, 66, 167–71, 174 art as atonement for, 171-75, 179-80, 187 Jews and, 291–92, 294, 303–5 Uzzano, Niccolò da, 65, 191 Valla, Lorenzo, 134-35, 142, 242, 268, 376 Vasari, Giorgio, 11, 12, 17-19, 70, 74, 75-76, 79, 95, 99, 182, 243, 274, 279-80, 286, 288-89, 362 Vatican Palace, see Apostolic Palace Vaz Teixeira, Tristão, 339 Venice, 104, 190, 213-14, 216, 272, 293, 307, 311-12, 313, 315, 345 Ventimiglia, Giovanni, 270 Verino, Ugolino, 26-27, 28, 62 Verme, Jacopo dal, 213 Verona, 123 Veronese, Guarino, 313 Verrazzano, Giovanni da, 342 Verrocchio, Andrea del, 216 Vesconte, Pietro, 326 Vespasiano da Bisticci, 147-48, 218, 240, 363-64 Vespucci, Amerigo, 340, 342, 343, 348-49 Vespucci, Simonetta, 86, 95, 101 Vesternich, Hermann, 207-8 Vettori, Pagolo di Baccuccio, 89 via dei Calzaioli, Florence, 32-33 via Larga, Florence, 30 Villani, Filippo, 12, 57 Villani, Giovanni, 23–24, 176, 301 Villani, Matteo, 57-58 villas, 182-83 Vinland, 338 Virgin Mary, 297-98 Visconti, Carlo, 160 Visconti, Filippo Maria, duke of Milan, 221-22

Visconti family, 158, 384 Vita nuova, La (Dante), 114, 115, 116, 118 Vitruvius, 24-25 Vittorino da Feltre, 218 Vivaldi, Vandino and Ugolino, 325, 338 Volterra, 213 voyages of discovery, 337-50 artists' lack of interest in, 337-38, 343-50 warfare, Renaissance, 205-14, 225, 272 War of the Eight Saints (1375-78), 209, 210 War of the League of Cambrai (1516), 307 wealth, pursuit of: humanist justification of, 184-87 moral disapproval of, 168-70, 183-84, 201

Wedem Arad, emperor of Ethiopia, 325 Werner of Urslingen, 207 White Company, 207, 209 William of Rubruck, 283 Wolof kingdom, 327, 333 women and girls, 79-88 as arts patrons, 84 chauvinistic attitudes toward, 80 dress of, 82, 85-86, 87 economic roles of, 84 education of, 80, 84, 87 empowerment of, 87-88 and extramarital sex, 101-2 legal status of, 80-81 love and, 83, 85 marriage and, 80-83, 85 violence against, 83, 86, 99 virginity of, 81, 99 wool industry, 47-48, 176

Zara Yaqob, emperor of Ethiopia, 324 Zarco, João Gonçalves, 339 Zenobius, Saint, 62

About the Author

ALEXANDER LEE is a stipendiary lecturer in early modern history at St. Catherine's College, Oxford. A specialist in the history of the Italian Renaissance, he completed his first two degrees at Trinity College, University of Cambridge-where he was a senior scholar and winner of the Earl of Derby Prize for Outstanding Performance in the Tripos Examinations, the James Webb Prize for the History of Ideas, and the Bowen Prize for History-before proceeding to undertake his doctoral research at the University of Edinburgh. He is the author of Petrarch and St. Augustine: Classical Scholarship, Christian Theology, and the Origins of the Renaissance in Italy, the co-editor of Renaissance? Perceptions of Continuity and Discontinuity in Europe, c. 1300-c. 1550, and the co-author of The End of Politics: Triangulation, Realignment, and the Battle for the Centre Ground. He has also published numerous scholarly articles on the Italian Renaissance and has written extensively on historical subjects and Italian culture for History Today, the Daily, the Wall Street Journal, the Guardian, the New Statesman, the Times Literary Supplement, and Dissent.